MARGARET BOURKE-WHITE

MARGARET BOURKE-WHITE

A BIOGRAPHY

VICKI GOLDBERG

HARPER & ROW, PUBLISHERS, New York
Cambridge, Philadelphia, San Francisco,
1817 London, Mexico City, São Paulo, Singapore, Sydney

Copyright acknowledgments follow the Index.

Designer: C. Linda Dingler

Library of Congress Cataloging-in-Publication Data

Goldberg, Vicki.
 Margaret Bourke-White.

 Includes index.
 1. Bourke-White, Margaret, 1904–1971. 2. News
photographers—United States—Biography. I. Title.
TR140.B6G65 1986 770'.92'4 [B] 85-45199
ISBN 0-06-015513-2

For Eric, Jeremy, and Loring

Contents

viii Contents

Preface

Margaret Bourke-White became a historic figure while she was still making history. Her name, face, and photographs were known to millions, Hollywood made movies loosely based on her exploits, Edward R. Murrow interviewed her on *Person to Person*. A pioneer, she always seemed to be first: the first one to do it, and then first in her field. She dared to become an industrial photographer and a photojournalist at a time when men thought they had exclusive rights to those titles, then rose with startling speed to the top of both professions. In 1930, she was the first photographer for *Fortune* magazine; six years later, she took the cover photograph and lead story for the first issue of *Life* magazine. *U.S. Camera* proclaimed that "strange indeed is the fate that has chosen a woman to be the most famous on-the-spot reporter the world over."

Women everywhere regarded Bourke-White as their ideal. From 1936, when she was named one of the ten outstanding American women, to 1965, when she was chosen as one of the top ten living American women of the twentieth century, she was constantly in the public eye as a woman of achievement.

Her adventures and her derring-do were breathtaking. Camera in hand, she galloped on horseback across Russia, climbed onto an ornamental gargoyle sixty-one stories above a New York sidewalk, survived a torpedo attack and accompanied a major bombing mission in World War II. She was a true American heroine, larger than life—perhaps even larger than *Life*.

If she had an outsize career, she had an outsize personality as well. People had an astonishing range of reactions to her, as if she were some sort of magnetic force that alternately attracted and repelled. There are those who remember an impossibly arrogant woman, wholly self-centered, utterly unfeeling. Some of her colleagues thought her manipulative but so charming and so hugely talented that it did not really matter. Friends and lovers merely recall her as magnificent. They never met

anyone like her, they say, and it sounds like the truth—no one so enthusiastic, so strong, so endlessly attentive, so extraordinarily courageous. The one response no one ever registered to Margaret Bourke-White was indifference.

Her life, career, and photographs vividly mirrored the history of her times. She became a photojournalist in the 1930s in response to a new nationwide pressure to keep abreast of current events. Afterward, she never moved out of the center of the news, covering the Second World War, the breakup of the British Empire in India, the Korean War. Her career was crucial to a vital change in the history of communications, when the photograph and the picture magazine became prime carriers of news and information.

Bourke-White also contributed significantly to a change in the public's estimate of photojournalism and of photography itself. Beginning in the thirties, her photographs and publicity convinced an enormous audience that photographers could be brave, beautiful, and glamorous. The profession was on the verge of becoming respectable, a status that would owe a great deal to Bourke-White's labors on behalf of her own image.

She labored hard on that behalf. She collaborated with Erskine Caldwell on three books and wrote six of her own, including an autobiography, *Portrait of Myself*, published in 1963. Of course her autobiography kept its secrets and left out much that was relevant to her story and her time. Some of her omissions were of the kind most people then would have kept quiet. Others seem not so much private as inconvenient; they flawed the handsome picture she had drawn of herself.

As she burned her diaries before she died, certain details were meant to go to the grave with her, and undoubtedly many did. Yet perhaps despite herself, Bourke-White left behind an intensely personal record of her journey to success, of the unconventional, liberated life she invented for herself as a woman on men's territory, and of her attempts to fulfill both her professional ambitions and her domestic yearnings. Fragments of diaries still exist in her papers, and two complete diaries in private hands were made available to me. Also among her papers are a mass of notes she wrote to herself, sometimes in pencil in script that would try the patience of a cryptographer.

These private scribbles reveal how powerfully the failure of her first marriage shaped her life, her career, and her attitude to love. Men were endlessly attracted to her, and eventually she married again, this time Erskine Caldwell, one of the most brilliant writers of the thirties. But her first divorce had permanently altered her priorities and strongly marked her approach to life.

The evidence also makes clear that Margaret Bourke-White carefully molded her public image, constructing an attractive, subtly misleading myth about herself as a photographer. The unadorned facts would have sufficed for a contemporary fable, but her success was more deliberately planned and more becomingly polished than the ordinary kind. In the end, when she faced a tragic, incurable illness, her spirit shone so brightly that it alone eclipsed any myth she could ever have invented.

MARGARET BOURKE-WHITE

1

Minnie and Joseph

Joseph White was twenty-seven years old when he fell in love for the first time, and he hadn't enough small talk to fill up his watch pocket. On occasion he carried a copy of Plato with him to read aloud to his beloved should their own dialogues fail them. He thought, quite correctly, that he had found in Minnie Bourke a woman who could share his noble goals and his singular devotion to reason.

As Joseph lived uptown in the Bronx and Minnie in lower New York, he wooed her by mail. The telephone was already a fixture in offices but still a sign of vast wealth in private homes, so postmen trudged the city carrying Joseph's daily love letters from August of 1897, when he proposed, until he married Minnie in June of '98. He wrote with enormous affection—"the sunshine and joy of my life," "the dearest part of myself" —and mapped out for the two of them the shared life of philosophers.

Happiness, he instructed her in a letter, is not an object to strive for. "The idea of duty which I think is another way of saying a devotion to right is what we should always have in mind and if that brings happiness enjoyment contentment with it then well and good." (His letters tended to be breathless, for his schooling had stopped a bit shy of punctuation. He had had to drop out at fourteen for lack of funds; afterward, he studied on his own.) "Many will make it their aim in life," he admonished, "to strive for as much ease and comfort as possible, which is often equivalent to making life as purposeless as possible. . . . Our object is to create a perfect mental and moral home where that confidence [in each other] will always have the place of honor. The physical surrounding to that home must be simple plain and sweet. . . . We must also jointly use part of the time for intellectual development, we must jointly conduct some study in common."

Minnie Bourke and Joseph White were both immigrants' children whose feet had been firmly set on the road to improvement. They cherished the nineteenth-century belief in personal and social progress. The

1

great wave of public and popular education that spread across America in the last third of the century, bringing with it an enormous increase in literacy and a swell of democratic hopes for the betterment of the American people, had marked them both for life.

Minnie Bourke's family came over from Ireland in the 1860s. Her father, Joseph Edward Bourke, the second son of a wealthy carpenter and builder in Dublin, had run away to sea in his midteens and stayed there for twenty years.

When he was nearly forty, he courted Isabella Burroughs, a cook, by long-distance mail from the Indian Ocean to England. Isabella, who had been put to work at the age of six or seven and found life hard, wrote him that she thought he would find it difficult to settle down in a home of his own (she was right; he seldom stayed home with her for longer than it took to produce another child), that he should go to church when he could, and that her real anxiety was that he give up "that horrid drink." He promised that for her sake he would become a "Steady Man."

In pursuit of steadiness he became a "house joiner," which entailed a certain amount of Christian humility, for his brother, John Bourke, was a well-known architect who designed a hospital, additions to a Catholic church, and several other public and private buildings in Dublin. Joseph Bourke married Isabella in 1864; by 1870 they had emigrated to New York, and four years later, Minnie, their fourth child, was born.

Minnie was not yet ten years old when Joseph Bourke, carpenter and house joiner, at work on "a great big building" in downtown New York in 1883, lost his footing, plunged several stories to the sidewalk, and died. He must have been on the crew of one of the city's early skyscrapers, those nine- and ten-story buildings that began going up in the 1870s when the elevator made it possible to build higher than men would walk and thus initiated the city's climb to metropolitan heights and fame. Joseph Bourke's granddaughter, Margaret Bourke-White, liked to claim the great-uncle who built buildings in Dublin but not this grandfather who fell from a web of scaffolding like those she later strode across in high-heeled shoes.

Isabella Bourke, who after her husband's death worked as a private nurse and midwife, considered her daughter Minnie an uppity and improper young woman. The girl was much too independent and too curious to suit an uneducated immigrant who had lost her husband to progress. Margaret wrote that her father said he was first attracted to Minnie by her open and inquiring mind. She was a woman who wished to improve herself; this might have made her mother proud but instead made her resentful. Minnie enrolled at Pratt Institute to learn typing,

stenography, and cooking. She read a lot. She attended lectures. Her eagerness to learn was too intense for a family of such dim ambitions. They complained more than once that she made them feel inferior.

Minnie, who no doubt would have preferred being beautiful, had to make do with being advanced. She thought herself so plain—chestnut-brown hair, full lips, large eyes that were sharp to reassess whatever she saw—that as she got older she made a point of avoiding mirrors. Looking back later, Margaret decided her mother was merely unselfconsciously beautiful. Minnie liked pretty clothes; Isabella thought her tastes risqué. Although as a girl Minnie Bourke hadn't the means for luxury and as a woman considered it harmful to character development, she wore pretty hats and starched shirtwaists with lacy jabots at a time when the shirt-waist was thought to be not quite nice.

She took up bicycling in the great bicycle mania that hit America in the 1890s, when for a while it looked as if the entire country, or at least the masculine side of it, was wobbling on two wheels, and social clubs for jolly young men held meetings on the road. As if bicycling were not improper enough for the young daughter of an Englishwoman at the time, Minnie shortened her cycling skirts to an indecent three inches above the ground and took off on the unholy machine on Sundays. Isabella Bourke, standing at the gate of her modest house and watching her disobedient daughter's silhouette diminish with unseemly speed, would exclaim with passionate certainty, "Minnie is going to the Devil!"

Drivers of horse-drawn trucks and vans shared Isabella Bourke's feelings about young women on bicycles. For sport, two of them would pin Minnie on her imprudent contraption between them; she had to struggle to stay astride while they cried out that she ought to be ashamed of herself. But stay astride she did. Minnie learned fearlessness in the streets, where instruction is not easily forgotten. She made it into a creed. "I want to go ahead," she told her mother. Such a clear-cut want in a young woman signals a certain degree of courage and determination.

Isabella Bourke's daughter not only bared her ankles in the street, she seemed not to consider the world's regard an urgent matter. Her brother Fred was a scandalous drunk. "Mama," Minnie wrote to Joseph, "goes on about the disgrace to us of Fred's actions. I say it does not matter so much that people *do* know what he has done and are talking about it—It is a great deal worse that Fred has ruined his whole life. . . . Of course this is disregard for public opinion again and Mama withdraws into her little shell and I go back into mine." Joseph White shared Minnie's disdain for public opinion. Once when his future mother-in-law caught him chastely embracing Minnie and lambasted him for impropriety, he wrote her sternly that "we were our own judges of our actions

and would with the aid of our conscience continue to depend on our-
selves."

Most of the time Joseph White kept his own background as tightly
buttoned as his vest. His parents were Orthodox Jews who rigorously
observed the dietary laws and other rituals of the faith. By the time he
met Minnie Bourke, he considered himself neither a good Jew nor a
good Christian and thought nothing of intermarriage, but he did not
deny his origins. However, he seems to have been quite willing to keep
quiet and ride out into the Christian world on the good English name of
White. Evidence suggests that Minnie strongly encouraged this.

In the sixteenth century, when the Poles handed out last names to
Jews, one of Joseph's ancestors had been a miller. The clerk who knocked
at his door found him covered with flour and dubbed him Weiss (white).
Three centuries later, in 1851, one David Solomon Weiss emigrated to
England with his son, Max, Joseph White's father. David Weiss brought
a case in an English court and lost by default because he did not under-
stand that the bailiff who called out "Wees! Wees! Wees!" was trying to
say his name, properly pronounced *vice*. He changed it to something the
English could pronounce.

Max White, a tailor, came to America in 1853 and embarked on a
series of business ventures that ended in disaster with alarming regular-
ity. He married and fathered six children, among them Joseph White,
born in 1870 in Rochester, N.Y. It was the children who, as they grew
up, introduced rationalism, skepticism about the Orthodox religion, and
Ethical Culture into the home, the children who began to unburden
themselves of theologies. But then their mother followed suit, "and she
became," as Max White wrote, "a most bitter Enemy to all religions and
did not believe that there is a Supreme Being and will not do the least
thing pertaining to religion."

What she would not do, after twenty-nine years of marriage and
observing the dietary laws, was to keep a kosher household. "So I stopped
to Eat at the table," Max wrote in his diary, "and I lived on ten cents
worth of bread and cold water over a week." The age of belief had run
headlong into the age of rationalism and was in some danger of starva-
tion. Max and his wife were reconciled for a time and moved to New
York City, but in 1894, when Max was sixty, his patience snapped and
he decamped, never to return.

An anguish so prodigal must have seemed irrational in the extreme
to Joseph White, a man who valued reason and self-control above all
else. He did not care much for Judaism or religion in general. "I have no
regrets," he wrote Minnie during their engagement, "in saying that I will

do my share in dissipating the race and the idea it stands for satisfied that if there is any special virtue inherent in that race, that it will find better field if merged into the American spirit, the American virtue, of the regenerating American type." (Minnie Bourke, daughter of a drunken Irish ship's carpenter and an impoverished English cook, might not have been everyone's symbolic American.) "So you see dear I wish *my* boys, or girls, to be Americans . . . to feel they are such even though they will know what stock they sprung from and the virtues of that stock."

He was well aware of the difficulties society had placed in the way of Christians embracing Jews. He wrote Minnie: "A Jew who becomes liberal is but sensible while the Christian who would do so achieved a moral victory of which he may well be proud. That's why I am so proud of you with all the inducements and pressure to prevent it your conquest has been so complete, so graceful, so dignified, so grand, that it alone would exalt you in my estimation." This seems to have been a lover's grateful overestimate. If he cared little for Judaism, she cared a good deal less, and eventually, in one way and another, she made her feelings perfectly clear. Their children would be raised as Christians and would scarcely see their father's relatives.

Yet the dream of reason that guided Joseph White's life was essentially a religious dream, based on the newest religion in America: Ethical Culture, founded in 1876. This secular, activist, nontheistic philosophy that had sundered his parents' marriage found a rapt acolyte in Joseph. As a young man, he faithfully attended the weekly lectures give by Felix Adler, the founder of Ethical Culture, absorbing Adler's moral lessons directly into his personal beliefs as if they had been given by transfusion. Adler declared that a man should enter marriage as pure as he would expect his wife to be; that happiness could not be the chief goal of marriage, for the object of marriage as of life was a striving for ethical growth; that the release of spiritual energies could best be achieved in work. He also supported women's rights to careers but placed the career of homemaker on equal footing as a vocation.

Joseph White accepted Adler's teachings with the fervor of a convert. He vowed to create "a perfect mental and moral home"; he spoke of work as "our salvation." After his engagement, when he invited Minnie to listen to Adler with him for the first time, he promised her their union at the lecture would be comparable to the moment when they had pledged to marry. They asked Dr. Adler to marry them, and apparently he did, for Minnie's cousin recalls that they were married by an "atheist minister." Adler was fixed in Joseph White's code and in his home like an invisible household god, setting his high goals, his blessings, and his strictures like a stamp on Margaret's childhood.

Joseph White was a man as wedded to high purpose as to his wife. There rings through his letters a late-Victorian belief in human perfectibility, a belief running parallel to the nineteenth century's faith in technological progress. During his engagement, he wrote Minnie Bourke that he envied her going to cooking school, "for you know you are working for a definite and noble result, that of make[ing] a home as perfect as possible." He assured her they could conquer whatever obstacles lay in their way by sheer force of self-control. They won their first victory on the field of sex.

Joseph acknowledged that sex was powerful, as even the most repressive of Victorians had never dared deny, and he was too enlightened to consider the physical functions wholly base. "[Some] argue that the more removed from the animal we are the better," he wrote Minnie. "I deny this. The animal has its part; its just, its moral part and should not be ignored or starved. I am a creature of this earth and I believe that the animal and spiritual are interdependent and that the problem . . . is to give each its proper place. . . . Were I to embrace you with sensual intentions, that is for physical reasons only, I would be committing a crime." Young and in love, he was having something of a struggle with his criminal nature.

Felix Adler had provided him with an enlightened view of virginity that might also have served as an elegant rationalization for a repressed nature: "Why should I not keep my person just as sacred to my future wife as my wife keeps hers for me." Above all else, Joseph believed in *control*. "I have often told you," he wrote his fiancée, "how I despise an irrational and uncontrolled display of the affections; on the part of a mother with a young infant or with grown up children. Anything that is unreasonable, that is beyond the control of reason is of course irrational and therefore dangerous. . . . I am sorry dear I must say it but last night I despised myself as I would a foolish mother. . . . I will only say that I do not like the hall way or prolonged leave takings. . . . When we know it is time for me to leave, let us try and part as rational beings who are their own lords; with due recognition of our love for each other and relation to one another of *course*, but let us control; not be controlled." Joseph White believed that a man should be morally armed for the struggle with life.

Joseph and Minnie agreed while they were still engaged that they would have intercourse only when they wished to have a child. (Between 1901 and 1911 they had three.) "When there is intercourse between the sexes for any other reason than this it is an immoral act just as truly whether it be committed in wedlock as without"—so Joseph wrote to

Minnie's mother when she discovered them embracing and accused him bitterly. How Isabella Bourke received her future son-in-law's diatribe has gone mercifully unrecorded.

Joseph courted Minnie on a bicycle, wheeling off to the Catskills with her in the company of his assorted sisters, brothers, and friends, copies of Emerson carefully packed in with their provisions. On one of these trips, in August of 1897, on the summit of a mountain, he asked her to marry him and she said yes.

Margaret Bourke-White's autobiography opens with these words: " 'Margaret, you can always be proud that you were invited into the world,' my mother told me. I don't know where she got this fine philosophy that children should come because they were wanted and should not be the result of accidents." It is a good beginning in life, to be wanted, whatever the unknown costs to one's parents. On June 14, 1898, the night of Minnie and Joseph's wedding, the marriage had been consummated—to ensure a union both physical and spiritual. Luckily, Minnie did not conceive. After that, they seem to have clung to their convictions for some time, for the first child, a daughter named Ruth, was not born until August 27, 1901.

But Margaret also wrote that her mother believed in warmth and ardor between married partners. And over the years, Joseph White's strictures on immorality did give way before the animal part of his nature, at least when his wife was pregnant and they no longer had to decide whether they wanted a child. Minnie White, trained as a stenographer, meticulously recorded in a 1911 diary not only the dates of intercourse that produced her third and last child but also the dates of intercourse during that pregnancy and whether both partners had orgasm or Joe had one alone.

Margaret arrived on June 14, 1904, at Harrison Avenue in the Bronx, where her parents had set up housekeeping. (Later, she liked to tell reporters that she was born a stone's throw from the Hall of Fame.) In fact her invitation into the world had been set for June 13, when Minnie went into labor, but once the doctor learned that the next day was the Whites' anniversary he put Minnie to bed and delayed things just long enough. Years afterward, Margaret said her friends complained that she had never been on time since; still, she never once missed an important date with history.

Joseph White, engineer and inventor, worked at R. Hoe and Co., a major manufacturer of printing presses. He continued to take courses after marrying, and Minnie did too. Margaret later wrote that although Ruth was not born until 1901, she had come a little early and cut off the

night-school education that Minnie wanted so badly. Minnie must have always felt constrained by her lack of education; she spent a lifetime filling the gaps with assiduous reading and course work in practical matters. A woman in need of a vocation, she made one of her married life.

Joseph had advanced ideas on women's equality. He spoke of his support of Minnie's daily work and of her ambitions as well, although like many forward-looking men his actions did not always quite live up to his principles. In their "perfect mental and moral home," he told her, her job would be to maintain the physical state of the house and his would be to furnish the funds and to help her with her work. He also understood that his wife's prodigious energy needed to be channeled. "You complain," he wrote her when they were engaged, "of a storehouse of energy so intense as to strain that weak vessel that contains it. Do not fear, dear, that energy will find its way into your activities. . . . I believe if you had been going to school and so developing in a direction you long to, some of this energy would not be felt by you." In time, that energy would find outlet in many activities: the house, the children, her husband's work, the PTA, a new town charter, her local reading group.

A perfectionist, Minnie sometimes seemed to march on for the sake of marching, as if perfection were a question of movement rather than of goal. Roger White, her son, would later report of her: "She always goes into things with such determination to do everything with exact thoroughness and completeness, and she wears herself out trying to live up to this even where she should see that the task is totally impossible." Margaret seems to have realized at an early age that her mother's energies were misplaced and that women were generally fated to live within what looked like narrow boundaries. While still a child, she dreamed of enlarging the territory, and no one said a word to discourage her dreams.

The family moved to Bound Brook, New Jersey, when Margaret was little, to be closer to the factory where Joseph White did most of his work. They rented at first, but Joseph himself soon designed a stucco house on Beechwood Avenue, trimmed with dark wood inside and out, and there the children grew up. In the living room were cabinets where books, neatly locked behind glass doors, faced a massive fireplace he had built with irregular stones, topped by a long mantelpiece he'd cut from a single tree. On the front lawn, seedling tulip trees transplanted from the woods struggled to grow stout.

The big back porch that served the family as a dining room in the warm months faced the dovecotes where Father raised squab for the table and a large garden crowded with his asparagus. Beyond were the distant woods where he took his nature walks, and off against the horizon,

about a mile and a half away, the Watchung Mountains, a mountain range of rather modest aspirations, sloped away to left and right. From the Whites' house the street led down to the trolley that clattered to Plainfield and beyond gripping its overhead wire. A few blocks farther along sat the railroad station; trains whistled in and out all day, carrying commuters an hour and some to New York.

The nearest big town on the trolley line was Plainfield, where professionals gathered on barbered lawns to chat of music and finance. Plainfield was a couple of stops closer to New York; some of the men with the perfectly trimmed lawns spent their less idle hours in Manhattan. Plainfield had sidewalks, Bound Brook did not. Bound Brook was a smaller town, more rural than suburban, populated by prosperous farmers and a smattering of lawyers, bordered by woods of hickory and chestnut trees. The Raritan River ran alongside the town, and little brooks jumped down ravines to join it from the far edges of yards and farms. The west end of town was an Italian Catholic neighborhood, the rest was staunchly Protestant. If you didn't go to church on Sunday, you kept your counsel and didn't go out to play ball or split logs that morning either.

Many people in the town and on the Whites' block had never finished high school; although Joseph White had dropped out himself, he and his wife were immediately marked out as highly educated people. Minnie and Joseph ran everyday life as if it were a private educational enterprise. Minnie put maps up so the very walls could teach the children. Alive with inquiry herself, she had such a bountiful supply of curiosity she gave it freely to her offspring, praising it as a standard measure of a good life. Margaret wrote, "She believed in training children to be self resourceful, to enjoy solitude, to be unprejudiced against new or foreign things, to have constructive curiosity." In her notes she added, "Mother would say OPEN ALL THE DOORS. Search out. . . ."

Minnie White had a rare talent for teaching, and in particular for teaching such moral and social virtues as courage and the determination to lead a worthwhile existence. Margaret when little was timid and fearful, frightened of the dark, afraid of staying alone in the company of terrors she could not name. The Whites having struck fear from their list of permissible emotions, Minnie decided to instill in Margaret the courage required for life. She began what her daughter later referred to as a crusade. Before bedtime one night she took Margaret to the front doorstep. A full moon was putting the stars to shame—a good bright night for banishing fear. "Let's play a game, Margaret," Minnie said. "I'll go this way, you go that. Let's see who can run fastest." The child, a bit hesitant confronting the night, was pleased enough to play a game. Minnie, taking a quick head start, tore around the house in time to reach the

first corner just as her faltering child was reaching it from the other direction. Minnie snatched Margaret into her arms with a laugh. Before the girl could decide not to ask, her mother promised they would play again soon.

And so they began to play the new game regularly. Soon Minnie hung back to meet her daughter at the second corner, and then the third. Margaret discovered the giddy charms of beating her mother in a race. By the time the child would run alone to the last corner on her swift little legs, victory had come to both. Margaret by then would play happily by herself outdoors long after night had fallen; the dark was as congenial to her as the day.

Then Minnie, who was endlessly inventive, thought of a way to quiet Margaret's fears of being alone in the house at night. Once the child was settled down with the fairy tales she loved, the parents would go out for a walk. Each night the walks grew longer, until one night they stayed away for four hours straight. Margaret was too enchanted by the magical forest of Grimm to notice.

This carefully planned and meticulously executed psychological experiment had worked: Margaret was no longer afraid. She even liked being alone, with only her own concentration for company. The girl had acquired, along with the primary lesson, a love of solitude.

The primary lesson was powerfully transmitted. Both Minnie and Joseph told Margaret more than once, "The only real handicap is fear. Be unafraid." Minnie gave her daughter explicit instructions. "Go right up and look your fears in the face—and then *do* something!"

Life in that household was not something to be lived lightly. Minnie trained on family and household management all her resources of research and imagination. A firm believer in good nutrition, she sent for every available government pamphlet on the subject, read them studiously, and extracted from each a discipline. No fried foods: frying destroyed both vitamins and digestion. (The majority of the American public would not discover vitamins until the twenties.) No potatoes: too much starch. She experimented with an all-fish diet, then all vegetables. When Roger was five or six, she took him with her to a neighbor's house for tea, where he gorged himself past the bounds of politeness on what he thought was cake. In fact it was only white bread, but to Roger, who had never seen that before, it seemed a rare delicacy.

Chewing gum and silk stockings were forbidden, movies were severely limited. Slang was forbidden: a waste of time. So were cards, also a waste of time. And funny papers; not only a waste of time but a corrupting influence on a child's artistic taste. Minnie enforced *that* rule by

forbidding her children to play in homes where there were funny papers. Margaret said later, perhaps a bit wistfully, that if she had a child she would definitely permit the funnies.

Perfectionism being what it is, it was not possible to live up to Minnie's shining standards. And the path she mapped out to moral virtue and other high achievements was necessarily a thorny one. Roger recalls that "she was terribly critical, and I never did anything right." Her ready criticism took a heavy toll on her firstborn daughter, who never seemed able to satisfy Minnie's expectations. Ruth's childhood and adolescence were littered with notes asking her mother not to scold her or call her "a nasty, sloppy girl." In round, childish letters, she said over and over that she wanted to be helpful and prayed that Minnie would not be ashamed of her all her life. Minnie never responded.

The White children were required to fortify themselves with goodness. "I hope you will think I am good this summer," Margaret wrote her mother at thirteen. But Margaret earned Minnie's approval more often than Ruth or Roger did, or perhaps simply avoided disapproval with greater ease. Her enormous funds of energy and curiosity lived up to her mother's. Margaret, who noted that neither Ruth nor Roger had much influence on her early life, was Minnie's equal in some way the other children never were.

Minnie taught her children lessons of moral responsibility and a combative stance toward the challenges of life. Margaret, who always chose to remember or select what was best from a mixed bag of memories, expressed her gratitude in *Portrait of Myself:* "When I was a very small child, if I broke a soup plate, Mother would say, 'Margaret, was it an accident or was it carelessness?' If I said it was carelessness, I was punished; an accident, I was forgiven. I am proud of Mother's vision in knowing how important it is to learn to be judge of one's own behavior. She did well to see that a habit of truth throughout life is more important than the broken soup plates." If honesty was difficult, Minnie taught, its achievement was sweet. She educated her children to take the hard road at almost every crossing, for the savor of the bigger victory. "If my sister or I," Margaret wrote, "took one of those school examinations where you are required to answer only ten questions out of twelve, Mother's comment on hearing of this would be 'I hope you chose the ten hardest ones.' Reject the easy path! Do it the hard way!" Her parents obviously had an extraordinary life in mind.

Although Minnie's educational forays filled up the days, the house on Beechwood Avenue revolved around Joseph White, who sat by the hour with his work reeling through his mind. He was as silent as thought

itself, and his thought held the family in thrall. Registers, cams, clamps, cylinders, gauges danced in his head all day. Margaret's cousin Florence Connolly recalls that "even if the supper was on the table, and he got an idea, all right, you can finish your meal if you want to, but he and [Minnie] had to run, to get it all down." Minnie, who respected her husband's intellect, recorded his valuable ideas in shorthand. She also carefully placed a notepad at his bedside every evening. At two, at three in the morning, he would wake with a sudden idea, scribble it down, then slip back into his whirring and clicking dreams.

His concentration was so deep and inward he scarcely noticed what was happening in the world outside his mind. His silence amounted to a kind of oppression. Minnie, a good talker, suffered enforced isolation. "If only Father would *talk* more," she would say in exasperation. In later years she wrote Margaret about the misery of a wife whose husband would not reply to questions. Once he had ignored her when she asked him something important. Out of long habit, she had swallowed her need. The following afternoon, in the midst of a silence, he suddenly replied to the question; it took her a moment to remember what she'd asked.

He would go to a restaurant with his family, order a full meal like everyone else, then engage in a private dialogue with the tablecloth, drawing mysterious sketches around his plate. At last, thoughtfully tucking his pencil into his breast pocket, he would rise, put on his overcoat, and go home without ever having touched his food.

His concentration was partly a matter of high principle. "Work, work, work," he wrote Minnie during their engagement. "That's the watchword, that's the cry. Work for pleasure, work for punishment, work that you may enjoy the fruits of your life, work as an end, work as a means to an end, but work; that's what we hear from all sides, that's what we know to be our salvation."

His mind was wedded to the printing press. Beginning in 1900, twenty-five years' worth of patents were registered to Joseph White's name in the U.S. Patent Office, most of them improvements for the rotary press. By 1901 he had begun a long struggle to get the separate color sheets for color printing into perfect register. Margaret remembered the house filled with color tests—red Maxfield Parrish calendars, or yellow ones, or "strident blues." Joseph invented the first Braille press, then during World War I, when, Margaret wrote, he "would not use his inventive genius for something to kill men," he invented small presses mounted on trucks for frontline use. These mobile presses produced maps instantly from aerial reconnaissance photographs; earlier, maps made behind the lines had been outdated by the events of war before officers ever saw them.

His inventions never made him rich, but he did not care; at any rate, he managed a comfortable living. His burning devotion to invention went hand in hand with a smothering indifference to everything else. Years after he died, Minnie wrote Margaret about his limited fame: "Father had so few of 'life's satisfactions,' didn't he? How I wish he could know the success of his daughter!" But Margaret, who would court fame herself with the ardor of a lover, was proud of her father's immunity to conventional recognition. Her notes say her father "cared . . . little about [money and] the other accepted badges of success. When he was promoted from superintendent of the plant where he worked to first vice-president, he forgot to tell my mother, and only six months later she discovered this advance. . . . She was deeply hurt and offended that he hadn't told her. I was secretly proud, because even then as a small child I sensed that there were inner things more important than the published labels of position and prominence."

Joseph White, indifferent to success if never to perfection, did like some of the things that money could buy. Every other Sunday he'd rent a carriage and take the family wheeling out in style. He bought a car before there were many in Bound Brook and erected such a dazzling assortment of rods and shafts atop the hood in experiments with the headlights that it looked like a cat's cradle on wheels. The family dog decided that its mission in life was to follow them, making as much noise as its throat would allow; when the Whites in their linen dusters drove out behind the miniature jungle gym on the hood, they amounted to a kind of private parade.

Her father introduced Margaret to the world of machines that sparked his silent passion. He would take her on long walks to a point where they looked out on factories hard at work below. The beauty of machinery, he said, is as great as that of nature itself, for in both the beauty derives from utility.

When she was eight, he took her inside a foundry to watch the manufacture of the presses. She already had a taste for adventure and the sense that everything she did with her father was adventurous, but factories came first, for he loved them best of all. The big machines that hissed and shuddered in front of her that day like animals impatient for release were both the content and the product of his mind. He steered her quietly up a metal stairway, nodding absently at the workmen. Joseph White was a handsome man, with an athlete's build, black hair, and black eyes set deep beneath his brows and perpetually focused on some invisible point of thought. Margaret had the same deep-set eyes, but hers were fixed on the world, to take in as much as she could manage.

Her father seemed to her like some kind of god. He knew everything

that she wanted to know. He commanded the great machines they looked down on at that moment from an iron balcony; he had brought her into a secret world that other girls had never seen.

Sunlight slanting through the high factory windows that afternoon got so tangled in smoke and dust that it turned to haze before it reached the foundry floor. Suddenly, a flame leaped high and crimson across the dark. Molten iron poured down in a river of fire. While the brilliant light sent sparks and curls of smoke against the feeble daylight, Margaret was speechless with joy. Her father had shown her the most beautiful thing in the world: fire that ran like water. As she pressed against him, her eyes shone with the reflected light of liquid flame. The memory would burn in her mind like a star for years to come.

Despite her fearfulness, Margaret had a taste for adventure which showed up early. "In my case," she wrote, "running away began when I was such a tiny girl—I usually managed to negotiate a block or two before Mother caught up with me—that she began dressing me in a bright red sweater with a sign sewed on the back: 'My name is Margaret Bourke-White. I live at 210 North Mountain Avenue [the Whites' address before Beechwood Avenue]. Please bring me home.' This amused passers-by so much that I stopped running away, but I never stopped wanting to travel."

Her next preoccupation was dressing up. She played only one role: princess. Except on the occasions when she played queen. She made herself crowns of flowers, of horseshoes and feathers and bows, and always wore a train as well, concocted of old curtains, waterproof capes, anything sufficiently royal. She quizzed her mother on the habits and manners of princesses, so as to be prepared.

The truth was that she was a plain little girl, with a face too old for a young child. Through early high school she was a bit plump and wore her long hair severely parted in the middle and pulled back into pigtails. Her face was exceptionally broad, her jaw what is called determined. She was very shy, a trifle solemn, often alone. Recognition, however, comes early to children who are articulate, and from grade school on, her classmates knew she was smart.

Ruth and Margaret took music lessons, Minnie gave them and their friends sewing and cooking lessons, they were sent to concerts and to gym. Margaret's coordination and sense of balance, fine to begin with, acquired polish as she went along. When the Raritan Canal was drained in winter, the water that remained froze solid, and the girls skated ten miles between the high cliffs. Margaret and Ruth had a daily game: they walked to grade school and back along the narrow top edges of board

fences, returning to ground only when they had to cross a road or one of the little brooks that skittered across Bound Brook.

Joseph taught his daughters the scientific approach to checkers, then taught them chess, trying to coax their minds to visualize five moves in advance. He himself could hold an entire game in his mind's eye. He was also an ardent naturalist who would temporarily shelve even his precious camshafts to spend an hour examining the intricacies of monarch butterfly and tree toad. He knew the myths of every star and flower and tree; he could weave fables about the entire out-of-doors. The hours Margaret spent with him in the woods when he showed her which snakes were harmless and how to pick them up without fear, or called a bird with a sound so like its own that it came to him, were an unparalleled delight. Minnie, that unsung equivalent of an educational force, would casually leave such classics as Henri Fabre's *The Hunting Wasps* and *The Life of the Grasshopper* where a child was sure to light on them. Margaret also read her father's science books before she was quite old enough to understand them, because she thought he'd be pleased.

Ruth soon had turtles, Margaret had rabbits and hamsters, then two turtles named Attila and Alaric, which lived under the piano. Margaret brought home egg masses—polliwogs, moths, butterflies—and, in hope of butterflies, fed and tended two hundred caterpillars housed under upturned glasses on the dining room windowsill.

She brought garter snakes home the way other children bring friends. Her father built them cages and bought her a baby boa constrictor in a pet shop. She acquired a puff adder that inflated its neck, rose up, and hissed to convince the children that it was large and poisonous (though it was neither), and when that failed, rolled belly up and played dead. When Margaret turned it right side up, the snake turned over once more to convince her it was truly dead. Eventually it gave up, became completely tame, and curled up on her mother's lap on Sundays while Minnie read the paper beside the fire.

All her life Margaret had a highly developed sense of drama. Even when young she knew that a girl with a snake made an arresting tableau; she took the snakes to school with her until they caused so much fright the principal ordered her to leave them home. "With Father's introduction to snake lore," she wrote in her autobiography, "I decided to be a herpetologist and become so much of an expert that I would be sent on expeditions and have a chance to travel. I knew I *had* to travel. I pictured myself as a scientist (or sometimes as the helpful wife of a scientist), going to the jungle, bringing back specimens for natural history museums, and 'doing all the things that women never do,' I used to say to myself." She had already mapped out a life.

Joseph White's chief recreation perfectly suited his scientific bent of mind: he was an amateur photographer. In the late nineteenth century, when he took up the camera, photography's popularity was soaring. In 1888, George Eastman had introduced the Kodak, a hand-held camera so simple to use that he could accurately advertise: "You Press the Button, We Do the Rest." The camera was loaded when sold, and when the one-hundred-frame roll was finished, the entire camera was shipped back to Eastman Kodak for development of the film. This was an enormous change from the days of heavy cameras, glass plates, and elaborate printing procedures with cantankerous chemicals. Photography, Eastman remarked, "is thus brought within reach of every human being who desires to preserve a record of what he has seen." So many responded to the call that Alfred Stieglitz, the great propagandist for photography as an art, remarked with disgust that the true amateurs, the lovers of the craft, were being asked to turn their attention instead to bicycling.

Joseph had room in his life for both bicycles and cameras. He was no snapshooter with a cheap little box in his hand, but an engineer intrigued by optics, with a big camera, a tripod, and a bathtub full of chemicals. Some Sundays during his engagement, he stayed home to tone his photographs rather than visit Minnie. Later, he photographed Minnie indoors by flashlight, he photographed the children, birds that sat still long enough, flowers, his inventions. The walls of the Bound Brook house were full of his photographs. In 1920 he applied for a patent for indexing and controlling devices he had designed for a camera. Margaret recalled his experimenting with three-dimensional movies, pressing his delighted children into service before the strange prisms and viewing lenses that were meant to set them deep in space.

Margaret repeatedly claimed that she never took a photograph until her father died. In the strictest sense, that is probably true. Yet she was much more involved in her father's photography than she ever admitted. As a girl, she had merely pretended to take photographs with an empty cigar box. But her cousin Florence remembered Margaret helping her father develop his pictures in the bathtub. If it interested Joseph, it interested Margaret too.

1917: Evening settled softly over Beechwood Avenue. Lights glowed in dining rooms as families fortified themselves against the night. Minnie White finished washing the supper dishes and settled down to sew beside the fire. Joseph sat in his chair by the window, stoking the remote machinery of his thought.

Suddenly he uttered an odd sound and appeared to tilt in his chair

for a moment at an awkward angle. His face was a mask of pain and bafflement, its symmetry peculiarly diminished. "What is it, Joe?" Minnie asked, her voice unnaturally high with alarm. His mouth moved but said nothing. Minnie went pale and rushed to him. The children ran up, stunned, blurting out questions he seemed to understand but could not answer. Faint animal sounds escaped between his lips. Minnie collected herself long enough to order the children to get paper, pencil, and the doctor. Joseph picked up the pencil and wrote—nothing. Marks. Scrawls. Nothing. Clearly he thought it meant something they ought to understand.

It was extremely difficult to get him to bed. His left side, leg, arm— all of it was useless. The doctor said it was a stroke.

For twelve days, while Minnie strained to make him comfortable and whole, he was unable to talk. She soon understood that he was not merely trying to talk but to say something specific. He was quite desperate to get a point across. She tried to guess, to say it for him, but nothing eased his mute distress. Then it occurred to her to talk to his boss. Yes, she was told, Mr. White was deep in a big project, with testing in the early stages. Maybe he was bothered about that: tell him testing would stop until he was better. When she told Joseph, some of the tension in the good half of his body simply let go; she had found the key. His first thought, his biggest struggle at the gateway of paralysis and death was for his work.

His speech gradually returned. The left side, which had been impervious to his will, began to move, very reluctantly. For a long while he could not get around without help, and he used a cane for a time but gradually inched back to a more normal life. Enforced idleness and the continued frustration of not being able to do simple things like pulling up his trousers made him cranky and impatient.

Yet his mind still snapped as it roved over his new problems. He told his wife to fiddle with elastic, with whatever, until she'd devised a way for him to put on his trousers. When his muscles would not respond properly he worked out exercises to bring back their strength. He never lost his confidence in his ability to surmount obstacles. In time he went back to work.

1919: By the time Margaret was fifteen, her father had recovered sufficiently to take the three children on a trip to Niagara and across the Great Lakes by steamer to Montreal and Quebec. Minnie stayed home. Throughout the trip, Joseph's camera devoured the sights. Margaret made notes on his photographs in her diary. "Near the lock was a pile of pig iron that was more than Father ever saw in his life before. . . . The

pile was three times as high as a telegraph pole and very long. Father took a picture of it." She collected pictures too, stacks of postcards, including two of grain elevators and seven of the bridge in Quebec under construction.

She described one incident in Quebec: "We passed a group of tiny children who held out their hands, palms upwards, waved them up and down steadily, and murmured monotonously and unintelligibly—'I wan'a, I wan'a, I wan'a,' etc., etc., etc.

"Here was a picture. We stopped the gig and Father focused the camera. As soon as Father showed the camera all the children stood perfectly still and stared—they froze. Then half of them retreated into dingy doorways. More followed. I held up a penny—a generous Canadian penny that you can see, and they came running. The 'I wan'a,' and the stretching of the hands began again. I tossed the penny—there was a scramble and the picture was taken." She was her father's perfect assistant.

2

A Photographer Is Born

There was always something special about the Whites. They felt it themselves. Roger says he recognized early that the family was different from others, largely in "doing worthwhile things that lived up to standards that weren't other people's. First, not to give up easily, and second, not to be casual about the objectives of what you were going to accomplish." The perfect home that Joseph White had envisioned became a kind of embattled paradise, where being good amounted to a struggle the children were expected to fight and win each day. The chief lesson the family taught was the lesson of how to be good. Hard on its heels came the lesson that being good was not enough; you could always do, could always *be*, better.

Bragging was not approved of; performing well was. And Margaret wanted to perform. She wanted to be out in front of an audience, where she could not be lonely. In grade school—the first eight grades of school in Bound Brook met in a four-room schoolhouse—she already knew how to get attention easily enough; she'd walk into school with a puff adder in her hand, and the snake in its fright would rear up, inflate its neck, and hiss fiercely at the children. No one forgot her after that.

Years later, she remembered bitterly a program in the school auditorium that was mistakenly brought to a close before she did her dance solo. All her mother could think to say for consolation was, "Your bow was tied very badly in back. It was wrinkled, Margaret. I'm glad you didn't do your dance in front of all those people." Margaret scarcely heard her. She had lost her time in the limelight.

She was a child marked out for respect rather than popularity. The Plainfield high school, where she was called Peg, was divided neatly into three ranks: the crystal-chandelier children, who dressed modishly, went to theater regularly, and ran the school; the no-nonsense, linsey-woolsey children, intent on books, with somewhat less time and money for high culture and a lot less for social rounds; and the vocational students. Margaret was a linsey-woolsey child. One schoolmate said of her, "They

dressed her abominably, very unbecoming, just something to clothe her." A blue pleated skirt, a middy blouse, a black tie, black cotton stockings, and high-laced shoes—like a proper English schoolgirl. Margaret was already plain enough, a little too plump, and she didn't wear makeup as some girls did, or display the curves that catch a young man's eye.

But her classmates soon knew who she was. She was an excellent student in English and biology and spoke well in class. She turned up in school again with a snake on her arm, causing a near-panic; the authorities, as might be expected, were outraged. So she found other ways to attract notice: she joined the debating club, played Maid Marian in the senior play, became an editor of the yearbook and president of the Dramatic Club.

Margaret attended high school through World War I and the influenza epidemic that swept across America in 1918. Her father avoided the war, her family apparently avoided the flu, and her papers say not a word of either. A poem she wrote in 1918 promised to bake pies and cakes to earn money for the war effort; that is all. Of course there was no radio then, no television to bring the news home daily, no newsmagazines with mammoth circulations, but newspapers kept the public generously informed. Margaret was simply not paying attention. It had not yet occurred to her that contemporary events might have a bearing on her life.

She was not looking for insight into the world but into herself. At eleven, she read a book on handwriting analysis and decided that her character was a mixture of Dramatic Talents, Science and Electricity, and Business Ability—a description with a certain precision. She learned to read palms too, and then in 1919, with a friend, went to have the bumps on her head read by an expert.

Phrenology promised wonders, and Miss Jessie Fowler of the Phrenology Institute did not disappoint. "You are always ready to go any place that is suggested," she wrote, "to gather news and information, and you do not mind the trouble that you have to take in gaining that information if it is what you want." Miss Fowler was even more prescient: "It would pay you to travel and see the world. . . . You should always take photographs of places you have been to so as to give lectures on them afterwards . . . as a means of entertaining your friends."

Miss Fowler went on to remark on Margaret's energy and suggested she'd be skilled at educating young children, but she rather blunted her predictions by assuring her she could have a veritable encyclopedia of careers, from music to home decoration to children's diseases. She came closer with this: "You criticize yourself quite as much as you do other people, and this capacity to correct your own work will help you to

progress." Years later, the friend who went with her recalled, not quite correctly, that Miss Fowler had told Margaret, "You will never let anyone get ahead of you in any undertaking you consider worth while."

While her classmates wandered restlessly through adolescence, Margaret looked like someone with a destination. One schoolmate was certain she meant to be a writer. The English teacher, Ariadne Gilbert, who was an author herself, had already inspired and encouraged her. "She infused all of us," Margaret said, "with the idea that you never leave a task until you have done it as well as possible." One day in class, Miss Gilbert took Margaret aside and told her she had talent. It was a heady moment, with a lasting effect: "It was largely through Miss Gilbert's influence that, in addition to photography, I felt the need to write books."

In her sophomore year, Margaret won the school prize "for excellence in literary composition" by writing an eight-hundred-word story in the two hours before the deadline for turning it in. A friend sat beside her watching the time and the word count as Margaret wrote. In her tale, a boy who loved turtles wanted a dog, but his overworked mother said no. He tried running away to make her sorry, he tried helping with the dishes, but nothing moved her until she recalled her own dead brother and the dog he'd loved. In the end, the boy got his puppy. The story showed a nice flair for minor drama and had touches of understated humor, the first indication of any sort that Margaret had a humorous side.

Her prize, fifteen dollars' worth of books, would be awarded at commencement, just before the traditional dance. Margaret chose her books —the Dickerson *Frog Book*, the Holland *Moth Book*, the Ditmars *Reptile Book*—and waited for the presentation and the dance. But literary success was not her prime ambition; she wished to be a *star*. She looked on stardom as her key to acceptance, certain that her prize would be her "passport to popularity" and the end of her wallflower existence. For all Margaret's perfectionism, for all her high quests, the lack that bit most fiercely was the absence of romance.

Her schoolmates thought her indifferent to such things as tacky clothes and an outsider's status. They thought her too secure to care, too modest—if also too successful—too private and self-sufficient. But the air of invincible security Margaret wore like armor hid a hurt so deep and painful that in her fifties she said she could hardly write about it yet. She had never been asked to a dance. She thought the cotton stockings might have been responsible, or the ignorance of funny papers, or the Spartan upbringing she could no more shed than a birthmark.

Commencement night she received her prize and stood expectantly

beside the dance floor, all three heavy books displayed in her arms—unusual props for a seduction, perhaps, but Margaret had used her off-beat interests to gain attention before. Yet no one asked her to dance all evening. She stood still, hugging her prize, while the stag line grew longer and her confidence cracked.

At length, a girl who was a friend of Ruth's and conscious of Margaret's distress offered to dance with her. A girl! Margaret's humiliation was complete; at that instant she wanted nothing so much in the world as to become suddenly, totally, invisible.

Apparently she was going to have to find some more dexterous way to address stardom.

In the fall of 1921, Margaret enrolled as a freshman at Columbia University in New York. Having spent the summer at Rutgers for swimming classes and "aesthetic dance," she was still waiting for a man to ask her to dance. "College," she noted later, "the usual problems—I felt left out—work not dates." At last, at Christmas, someone asked.

Gil—F. A. Gilfillan—was a biochemist, serious about science, quiet, full of curiosity, just enough like her father to catch her eye. Despite her shyness, she had an odd and attractive air of self-assurance that caught his. He was almost twenty-nine, she just seventeen, but according to Madge Jacobson, a friend from Columbia, Margaret was one of those people born mature. Gil took her out all spring, then in the summer he moved west. She wondered rather idly whether she was in love with him.

To Margaret's regret, in that second semester of freshman year, Gil never kissed her. She pondered what it was about her that kept men at an honorable distance. Though poised on the verge of popularity, she continued to be dogged by respect. Kisses still called for an element of daring at a time when the pure flame of Victorian propriety had not quite guttered out. In her second year of college, still unkissed, Margaret would decide that girls who kissed were more popular but love was greater if not foolishly spoiled along the way. That was the proper line for a girl from her background, but longings did confuse the issue.

Margaret already had the advantages and disadvantages of ambition. Her self-sufficiency, her inner reserve, her plans to "do all the things that women never do," singled her out. She hoped to visit Gil after he moved away, "but if I talk a lot about my plans for the future, as I did this past year," she wrote in her diary, "it will have the same effect that I think it did then. He won't dare to tell me if he cares for me because he'll be convinced I don't need him."

That spring she had discovered not just Gil but a number of now-

and-then boys. They liked her—all the shiny, scrubbed YMCA boys liked her a lot. She must not have cared about any of them enough to unleash her ambitions on them. In the beginning, they did not convince her she was worth all that attention; she still thought of herself as a shy, drab creature from Plainfield High. Her gaze was clear, confident, unflinching. Ralph Steiner, a photographer who met her in her first photography class, found that gaze unnerving and said she had "terrible, intense, staring eyes that didn't blink," like the cold-blooded animals she fancied. Madge Jacobson says that at that time the girl she knew as Peggy White, who had no idea that she was beautiful, first began to realize that she must be attractive to men. The grounds of her confidence shifted sideward. The outward evidence of her shyness started, just barely started, to burn away in the longed-for and by now unexpected light of popularity.

On January 17, 1922, a second, more massive stroke hit Joseph White while he was at work among his beloved presses. At first only his right side was affected, but he soon slipped into a coma and was paralyzed on both sides. By morning he was gone.

He had been working on a design so complex that after his death no one was ever able to complete it. Someone at the factory told Margaret the best minds in the country hadn't been able to finish up Joseph White's work. This merely confirmed his superhuman stature for her— at the very moment that she lost him.

Margaret thought of her father as the man who gave her, and in effect invented for her, the great triad of her life: work, truth, and beauty. "I realize now," she wrote, "how his entire purpose was focused toward attaining this self-set standard, how deep in him the philosophy was: never leave a job until you have done it to suit yourself and better than anyone else requires you to do it. Perhaps this unspoken creed was the most valuable inheritance a child could receive from her father. That, and the love of truth."

When she wrote this, she had begun to understand the anguish that dogged his perfectionism: the experiments that didn't work, the answers that would not come, the improvements that were not good enough. Her childhood impression had clearly been that work at her father's level of intensity was inevitably rewarded with success; it was a notion she carried about with her like a talisman. She said his watchword was "YOU CAN." It was not a watchword for men alone; he gave it to her for her own. He bequeathed her a great legacy: confidence, an open mind, and the promise of mastery.

She always gave him credit. Early in her career, an interviewer

wrote that "her father is the chief reason for all Margaret Bourke-White has become." And in Margaret's first brief essay in autobiography, written for a newspaper in 1930 or '31, she did not bother to mention her mother but did say she adored her father, as if that would explain everything.

She never had a chance to mourn his death in '22; too much responsibility fell immediately on her shoulders. It was soon apparent that her father had left his family only the gloomiest of financial prospects; he never managed money well. Margaret, seventeen, went to the family lawyer to straighten things out for her mother, but there wasn't much to straighten. Sometime during the second semester, Uncle Lazar, Joseph's brother, seems to have stepped in to help with her tuition.

Margaret went back to school soon after her father died, and took up his hobby. In conjunction with an art course, she signed up for a two-hour-a-week course in photography with Clarence H. White. "I think," she wrote in her notes, "my great love for my father and the fact that he was so much interested in photography was a strong added incentive when I began work at the Clarence H. White School." In *Portrait of Myself*, however, she wrote that she chose the course not because she wanted to take photographs but because the emphasis was on design and composition.

Many regard Clarence H. White as the finest photographer of the group known as the Photo-Secession, which Alfred Stieglitz founded in 1902. Photography, which officially began with the Daguerreotype in 1839, had undergone many changes in its scant sixty-odd years of life before the Photo-Secession began. By the last quarter of the nineteenth century, studio photographers were multiplying with the rapidity of photographic reproduction. Their major business lay in supplying the burgeoning middle classes with what had previously been the privilege of the rich alone: their portraits. Once photography became relatively easy and lucrative, an expectable decline in standards set in. Studio photographers late in the century cranked out endless portraits against columns and painted backdrops. Then in 1888, the Kodak camera made photographs so easy anyone could take them, which put photography in some danger of losing what prestige it had left.

From the beginning, there were many who said photography could not be "art" because it was mechanical. In 1859, Baudelaire cried that "this industry, by invading the territories of art, has become art's most mortal enemy." In response, between about 1890 and 1910, an international movement known as pictorialism sprang up to prove that photographs were indeed artistic because the photographer's hand could intervene as actively as the artist's, and the results—and here was proof

positive—didn't even *look* like photographs. Soft focus, Vaseline on the lens, blurs, dyes, scratches, print techniques that looked like watercolors, every kind of darkroom manipulation, would prove that no mere machine had produced such close approximations to Whistler and the Impressionists.

The Photo-Secession, founded as part of Stieglitz's strenuous campaign to elevate photography to the status of art, was a group of pictorialist photographers that included Edward Steichen, Gertrude Käsebier, and Clarence H. White. Clarence White's lyrical play of light and unerring sense of space confer on minor domestic subjects an exquisite formal poise and dignity. His pictures of family and friends are touched with a faintly elegiac grace.

A brilliant teacher of inscrutable methods and singular results, White encouraged the commercial use of the camera. He has a good claim to having run the first important school of photography in the United States, teaching such outstanding photographers of the twenties and thirties as Anton Bruehl, Laura Gilpin, Dorothea Lange, Paul Outerbridge, Ralph Steiner, and Karl Struss. Margaret made an impression. Clarence White's wife remembered the day the young woman walked into the house with a pet snake coiled about each arm, looking, one would think, rather like the ancient image of the Minoan goddess, dressed for the day in frumpy clothes.

White was a short man, sweet, gentle, as self-effacing as a well-trained servant. He was never critical of his students; he had neither the will nor the words for it. He would start off by saying, "Well, you know . . . to be sure. To be sure, that's quite right . . . To be sure, that's quite right," and he would rarely get much beyond that. Although he taught very little technique, he did stress design and composition; this suited Margaret perfectly, for she had scant interest in technical matters, but her sense of pattern and balance was already highly refined.

Max Weber, the American cubist painter, had taught in the White School before Margaret enrolled, and his devotion to design still permeated the course. It must have been a mysterious education, what with White murmuring, "To be sure, to be sure," and Weber urging students, "Don't photograph things the way they are. Photograph the on and onness of things and the in-betweenness of things." In his less mystical moments, Weber said, "Constant effort is made to help the student in design to bring as much of the abstract into his expression as the photographic means will allow." Margaret heard the artist and educator Arthur Wesley Dow lecture about the balance of dark against light, shape against shape, solid against void. The White School grounded her thoroughly in modern design and principles of abstraction.

She was asked to pose nude in class one day, and did. Nudity was

capital-A Art; any museum could tell you that. Certainly the pose would have been decorous—a back view, as likely as not—and probably she was provided with a strategic bit of gauze or drapery here and there. Although chaste, unkissed, and shy, she had been taught that conventional opinion was beneath her notice. She had also developed a desire to be bohemian that she was not yet prepared to live up to, and had begun to make a few acquaintances in Greenwich Village, where people lived beyond her emotional means.

Minnie consented to Margaret's posing. Minnie, of course, thought indifference to public opinion a high moral position. Doubtless the cameras the day her daughter posed were out of focus; that, too, was considered art of an exalted order, for it brought the photograph closer to the gods of painting. Whatever the guarantees, Minnie must have consented readily, for posing nude seemed to Margaret a natural thing to do, and not especially important. A few years later she claimed to have forgotten she'd ever done it.

One proof of Clarence White's stature as a teacher is that in the end none of his students made photographs that looked like his. But young people learn by modeling themselves on their masters, and Margaret's freshman-year photographs have studied poses, blurred backgrounds, soft light, and rhythmic designs influenced by White. Minnie, who had made an art of encouragement, heard her daughter's new enthusiasm as an echo from her husband's life. Strapped as she was for money, she bought Margaret a secondhand camera for twenty dollars—a $3\frac{1}{4} \times 4\frac{1}{4}$ Ica Reflex with a crack running across the lens. The crack wasn't important to someone who was trying to make pictures that looked like Whistler's *Battersea Bridge* or Clarence H. White's misty photographs.

Her first pictures were taken on glass plates, evidence of how old-fashioned White was and how devoted to the purity of the craft. He taught her that every photograph should be strictly controlled by the photographer. White planned his own pictures with enormous care and repeatedly said that "Chance is a poor photographer." As it happened, Margaret had already been indoctrinated in control.

"You somehow absorbed from him," she wrote, "that feeling that any picture that was important enough to make was one that the photographer should work on until he had made it as perfect as he could possibly make it." As if she needed another lesson in perfectionism.

At one point Margaret wrote that she never considered becoming a professional photographer until her senior year in college. From the end of the twenties on, story after story was published saying that because her father had died shortly before her final year of school (when in fact

he died in the middle of her freshman year), she'd had to support herself, had picked up her old camera and experienced the delicious surprise of making money. Only once or twice did she slip and say she'd continued to photograph as a hobby all through college. The way she usually told the story, she studied with Clarence White for a couple of months, then forgot about the camera until senior year, when she picked it up again and lo, a photographer was born. It was a very convenient story.

In fact she had decided to become a photographer soon after walking into Clarence White's house. The great lure was still herpetology—reptiles, snakes, and adventure. She knew that the positions on the safari were normally reserved for men, but it had occurred to her that there had to be a place for a photographer.

In need of a job the summer after freshman year, Margaret was hired as the photography counselor at Camp Agaming on Lake Bantam, Connecticut. She also filled in as nature counselor. She could quiet an unruly group by asking if they wanted to hear about "beauty sleeps," then pulling a butterfly chrysalis from her pocket and charming them with tales of a caterpillar that woke to beauty. She taught them about flowers, repeating the legends she'd learned from her father. The children thought her the final authority on just about everything under the sun. She already had a strong desire to communicate, and her skills were being honed to match it.

Margaret taught photography and, with Madge Jacobson as assistant, did the developing herself. At eighteen, she was determined, tenacious, and patient. She thought nothing of staying up all night to capture on film the sun lifting itself up from Lake Bantam at dawn. If the morning brought rain, she would return that night, and yet again the following night, till the sun provided the impulsive burst of light she was after. She did not hesitate to take risks in pursuit of a picture. At the end of a hike to a mountaintop, she wanted a view out over the sheer drop to the valley below. A fence was set at the edge of the cliff to protect unwary viewers; Margaret simply climbed atop it and balanced her camera to take in the panorama.

That summer, she organized a tidy little photography business. She made picture postcards of the camp, some portraits of campers, and pictures of each bunk, so every child could buy a picture of her cabin to send home. By late August, Margaret had sold two gross of postcards and confirmed an order for five hundred for the following year. She envisioned a bigger market: the two closest towns. On "wobbly knees," she set out with her sample cards to try the drugstores and gift shops.

The two elderly women who ran a gift shop in Litchfield, where Margaret thought "the very air felt refined," looked at her cards and

treated her as if she were Clarence H. White himself. They asked if she took interiors. In fact she had taken only one, so, sounding utterly confident, she said yes. But her confidence waned when it came to money, and she offered to do portraits for less than she'd planned to ask. Her father had said "YOU CAN" but had not extended the lesson to money matters.

Margaret went back to camp with an order for five hundred cards at five cents apiece. "I am so proud of myself now," she wrote in her diary. "I feel as if I could make my living anywhere." Instinctively aware of how to win anyone's assistance, she could get others to do prodigious labors for her. As she had goals to reach, she merely assumed that the people around her would want to reach them too. Her friend Madge Jacobson worked long hours in the darkroom without extra pay just for the fun of being with Margaret, then after hours was sent to town to pick up hypo. (In gratitude, Margaret gave her a camera at summer's end.) When the campers went home and Margaret still had orders to fill, she took on two young children and told them unending stories to keep them at their work while they washed the prints. Sometimes she herself worked through the night. By the end of the summer she had printed nearly two thousand cards.

Her money problems were not over. Minnie was trying to sell insurance and had plans to send Roger to a private school. Even if Uncle Lazar continued to help, there wasn't enough money for Margaret's second year of college. Then in September, she had an unexpected phone call.

It was from Mr. Munger, a bachelor gentleman of what used to be called "good circumstances," who lived nearby with his sister, a maiden lady. He asked Margaret to come by. She was uneasy; their front parlor spoke discreetly but unmistakably of money. The Mungers, however, were gracious, and she took heart. When Mr. Munger asked what she wanted to do, she answered "herpetology," and then told him about her postcard work as well. To her total surprise, he then announced that he and Miss Munger were going to put her through college for one year and possibly more. He said she had been recommended to them by a mutual friend, who had already spoken to her mother. Minnie wanted to consider this a loan, but Mr. Munger said Margaret could repay them by sending someone else to college if and when she was able to. They would consider her an investment. She did not know that Mr. and Miss Munger ran what amounted to a private charity, supporting several young people through college.

It is hard to imagine a gift more unanticipated or more kindly given. The Mungers instructed Margaret to get everything she could from col-

lege, including a good social life. Miss Munger asked her please to forgo the postcards because she'd need to save her eyes for the microscope. They urged her not to stint. Just ask for money, they said; we will tell you if we think you are extravagant. And what kind of clothes do you need right now?

For years, Margaret referred to Jessie Munger as Mother Munger. In 1944 she dedicated one of her books to her. That evening in 1929, she wrote in her diary: "I felt like a regular investment—just like any other investment, as tho I were a nice little gold mine that had intelligence enough to understand that if it was to do the right thing by the people who had paid to have it opened up, it must give forth rich veins of true metal instead of fool's gold."

In less than two weeks they had sent her on her way to the University of Michigan to study herpetology. Having been told in New York to sit at the feet of the zoologist Alexander G. Ruthven, she went to look for the key to all the things that women never do.

> *October 1922:*
> Dot sewed me into my new black crepe knit dress and I felt just like a queen. It is a beautiful dress, with a long draped skirt, and transparent draped sleeves of a rose indistinctly figured voile. I wore the little rose colored earrings . . . and I carried a rose colored handkerchief. . . . Dot lent me a stunning black heavy crepe evening cape, and I felt *irresistible*!!
> I guess I was too, from the way he seemed to drink me all in.

Margaret had discovered clothes. It was a discovery she hadn't the means, will, or imagination to make full use of yet. She was still plain Peggy White, her long hair pulled straight back from her face. (Long hair was an emblem of propriety, as Scott Fitzgerald made luminously clear in 1920 in "Bernice Bobs Her Hair.") She wore black and drab most days, dresses so simple and uninspired they might have been handed down by an edict against luxury. One undergraduate who took her out a couple of times thought she dressed rather like the Amish.

That was the old everyday Margaret, who seems to have been left behind in the closet in the evenings. She had discovered a world beyond cotton stockings. Notes on what she wore accumulate in her diary. She went dancing in her "Maxfield Parrish blue" dress with the orange girdle. "Beknickered," she fulfilled a secret ambition to hop a freight car. Like an explorer who had found a new continent and given it her name, she never again let go of her claim to the land of fancy clothes. The edict against luxury eventually fell from her pocketbook and slipped unlamented from her mind.

At eighteen years old, Margaret was electric with longing. In Octo-

ber, she wrote in her diary: "I want to 'belong.' That is, I think, my highest ambition in college life. And I don't want to just *lead*, I want to belong. Like Eugene O'Neill's 'Hairy Ape.' This summer I didn't belong, and I have a craving to now." One disadvantage of the respect she inspired was that it placed her a bit above and apart from the coziness of crowds. Leadership still came high on her list, but at eighteen she thought she might like a little comfort as she ascended.

The only real fear Margaret's training had not erased was that she would be the wallflower at the dance. In Ann Arbor, that fear melted away in the prolonged heat of a waltz. She never understood what made her suddenly popular. Men at the university far outnumbered women, which helped her cause. She went to the local church dances to meet them, and they cut in on her continuously, tall men and short, young and younger, football players and business students. One of them solemnly informed her that men were more attracted to girls than girls to men. She liked that idea; it promised an end to longing. As if to prove his point, the young man tried to put his arm around her, but she demurred.

She was smart, studied hard, and pulled down reasonably good grades, A's in literature, C's in astronomy. Some thought her odd, if interesting—largely because she kept a snake in her room as a pet. One visitor was alarmed to find a milk snake slithering lazily across the bathtub. If she no longer had a good excuse for carrying her creatures about, she could still pique people's interest by talking of them, as Fitzgerald's Bernice talked about taking a bath so that men might imagine her naked.

She had an unusual passion for railroads and asked her afternoon dates to walk her to the station. There she watched unblinking as the black engines shuddered, gathered their energies, and sang their breathy songs. She dreamed of doing something, though she did not yet know what, with the chanting engines that sang of travel, adventure, and the power of machines.

Margaret ignored Miss Munger's injunction to spare her eyes. She was determined to take pictures. Soon after arriving in Ann Arbor, she went to the office of the *Michiganensian*, the student yearbook, to announce that she took photographs. The editor said they needed good pictures of some of the campus buildings. Why didn't she bring him some samples? She did. He had never seen anything like them before.

Instead of the flat-faced, detailed portraits of patient stone walls that the editor was accustomed to, Margaret presented him with bold compositions in which the shadows themselves made geometric designs and the focus was so blurred that the buildings dissolved into silhouette and

abstraction. These pictures are softer than many of Clarence White's own works of twenty years earlier. Margaret tried everything for a painterly effect. A piece of thin cloth, such as gray georgette, over the lens gave her diffusion; that should soften the harsh edges of a building. One of her pictures was a night scene, something the editor hadn't thought possible.

The 'Ensian took her on. She photographed for them throughout the school year. At the end of the year they published a sheaf of her photographs and reaped a plentiful harvest of compliments. Margaret herself was not so pleased; she thought the work amateurish. Her standards were already nearly unattainable.

The camera went with her almost everywhere. Once, at a hockey game, the light wasn't good enough; she and her date were reduced to conversation. Joe Vlack, who also took pictures for the 'Ensian, took her under his wing. He thought her attractive and could always persuade her to spend time with him if photography was the object. First she photographed fraternity mascot dogs with him. Then he proceeded to confirm her notion that photography meant adventure.

Together they photographed the clock tower from a window in a fourth-floor men's toilet; they thought for a while they'd got themselves locked in for the night. Another evening, Vlack told her that a perfect view lay on the other side of the engineering building's roof. They squeezed out a window and clambered up a rope to the pitched roof. (The first time, her arms weren't strong enough, but she worked on it incessantly in gym class.) They ran, slipping, to the peak of the roof, then slid down the other side. Margaret was scared. She loved it. Afterward, he opened a manhole and the two of them climbed down the clammy ladder in pitch dark to take pictures in the tunnel.

Joe Vlack wrote the primer for her career. It was he who introduced her to the world of machines that was her natural heritage and later her camera's home. That first semester he called her to come photograph a steam engine when the lab got it running (unhappily, it broke down by the time she got there) and took her through the engineering shop on a search for powerful subjects. He was also the first man to stir high the flames of her professional ambition. He had his reasons: if she worked all day on photography, she couldn't keep a date with his rival. She was amused but listened seriously when he said the work was for the sake of her future fame. Fame was a word with its own shape, as solid as stone, as beautifully articulated as a landmark.

In January, Margaret told Dr. Ruthven she wanted to be a herpetologist. Ruthven, too discreet to name her, recalled in his autobiography:

"After a few weeks, both the lady and myself recognized that while an earnest student she was not the kind of clay that could be molded into a successful herpetologist." He asked her what she most wanted to do in the world.

"I would like to be a photographer," she said.

"A scientific artist, I presume," the zoologist said, "not, heaven help us, a family picture taker?"

"Neither, Dr. Ruthven," she told him. "I should like to be a news photographer–reporter and a good one." By the beginning of 1923, she had already extended her dream of a photographic safari into a global junket. She went on to tell the distinguished zoologist that she wanted to write, and that it would help if she could make pictures of worldwide significance.

Ruthven's horror of empty enterprise was laid to rest by her large and serious scheme. He got her a job printing negatives for the university museum at sixty cents an hour, asked her to make some enlargements for him, and also asked her to take pictures to illustrate an article he was writing on crowded museum conditions.

Ruthven must have seen in Margaret a determination that would carry her past ordinary restrictions and limits. The breadth of her plans may have frightened her first boyfriend, but people like Joe Vlack and Dr. Ruthven relished the possibility of shaping a sizable future. They began to give back to her an enlarged image of herself. When Margaret told Ruthven she wanted to give nature-study lectures to schoolchildren, he countered with an idea so compelling it would lure her for almost two decades: that she should write nature stories for children and illustrate them with her own photographs, to fill the gap in attractive educational literature for the young.

She worked hard on her photographs that year, lying in wait for shadows, intent on simplifying compositions, and fired up with the romance of stormy skies, ragged clouds, and the moon struggling to shine through. She made up a portfolio: architecture, portraits, and images she had coaxed from the thick Ann Arbor fog. Her diary notes that she took "flashlight pictures" of her friends indoors. The flashbulb was not yet invented. She would have had to use flash powder, a raucous and smoky way of lighting up the world.

Dr. Ruthven, she wrote in her diary, "is helping me on one condition, that I make a 'world figure' of myself. A good vocation for a married woman. Everybody expects so much of me—I will be a success." And so she decreed, when she was eighteen years old, that she would conquer the world.

3

First Love and Secrets

Before conquering the world, Margaret needed badly to belong, and she was working on it. Among the girls she lived with at Michigan, she had a reputation for judging character lightning fast and right on the mark. Her game spirit, her odd interests and talents, the quiet certainty that she was going someplace, made an impression. On February 18, 1923, she was pledged to AOII; that same day, she was elected house president.

Not once that year did she lack for a dancing partner. Although what she claimed to remember of college was work and no dates, by sophomore year her diary was dotted page by page with the names of men. Despite her shyness and her drab daytime appearance, her confidence was magnetic. When she was being self-critical, she worried that conceit was her overriding fault, but that belief in her own importance was contagious. Just behind Margaret's quiet facade stood a talkative, outgoing woman with an unusually strong sense of direction, an adventurous spirit, and an intensity that flared up in her conversation.

Her heart's desires—belonging, popularity—were achieved in her first semester at Michigan. She was on the way up and fully conscious of it; popularity meant to her not just men but important men. In November, she chatted one afternoon with three fellows who were presidents or past presidents of college organizations: "Felt so popular," she wrote in her diary, "perfectly happy." In December, a senior asked her out. "Thrilled—the summit of my ambitions—he's probably the biggest man in the university."

A man had even asked to kiss her at last—in the darkroom, appropriately enough—but she thought him the wrong man, and she refused. Margaret, whose parents feared nothing so much as losing control when they touched each other, grew up in a generation that dearly hoped to be offered the opportunity. By 1922 the Jazz Age was in full swing. In the Midwest, bobbed hair was still risqué, but within a year or so, more and more chic and daring women recklessly hacked off their long tresses

and tucked most of the remaining evidence of hair beneath close-fitting cloches. The entire wardrobe of pinched Victorian moralities was discarded and flung into the dustbin to rest beside the unmourned corset.

Well-brought-up women began to wear rouge openly and to drink with men—at almost precisely the moment that drinking with anyone anywhere was outlawed. Young people ignored the proper and elegant distance between men and women on the ballroom floor to dance close to one another. Petting parties were the rage in college circles; some of the students' parents envied the younger generation and began partying on their own. Not that everyone shucked off a rigorous upbringing as fast and happily as a hobble skirt, but everyone knew or knew about some unbuttoned creature like the well-born flapper in *This Side of Paradise* who said, "I've kissed dozens of men, I suppose I'll kiss dozens more."

Margaret would have frowned. Sent out into the world with all the baggage of a strict and idealistic upbringing, she could still speak of "a compromising position," and she would not pet. But she was eighteen years old, and she pined for love and the right man's kisses. What would have pleased her most was exactly what would have pleased many "good" girls then and in years to come: a man who wanted her badly yet held back, thus confirming nature, desire, and honor all at once.

Her unwillingness to pet was not based on a simple moral stricture. She feared she would lose her individuality if she gave herself away too easily. Individuality loomed large in Margaret's scheme of things; it had become a commanding issue, and she would not put it at risk.

"We met in a revolving door," she wrote. "I was on my way into the cafeteria on the University of Michigan campus and he on his way out, and he kept the door turning around with me in it until I made a date with him. From that minute on we fell in love so fast there wasn't time to breathe."

Margaret met Everett Chapman in late '22 or early '23 and started dating him in February. He was six feet tall, with broad shoulders, good, clean, regular features, dark hair, darker eyes, glasses; a good-looking young man, even very good-looking, but not so immodest as to be handsome. Talkative, easy to be with, he was nonetheless a little diffident, a trifle reserved—a man who preferred to play a supporting role in the social theater while others took the spotlight and applause. He was a senior majoring in electrical engineering, a student who worked hard, got good grades, was respectful to his elders, and behaved in general as if life were a serious business. Surprisingly, he had a lively and rather antic taste for fun, even a sense of whimsy. Everyone called him Chappie.

His specialty was electric welding, and he would eventually contribute to the manufacture of the streamlined trains that replaced the rotund steam-belchers Margaret found so enchanting. She wrote that although he talked much more than her father did, when she saw his concentration in the lab she knew he was just the same. What she recognized instantly was that zealous devotion to work that her father's example had made both comfortable and sacred to her. Of course Chappie was also in Joseph White's profession.

His good looks and his gaiety attracted her right away. "He is the cutest and nicest being I ever went out with," she wrote in her diary less than three weeks after their first date. With delight she discovered from his math notes that he thought even math was fun: he had scribbled such comments as "Isn't that nice" and "Let's play with x." Best of all, they had fun together—not simply good times but unbridled laughter: "Giggled like kids all evening." Giggles and tomfoolery not being staples in the White household, Margaret's childhood, especially her adolescence, had been preempted by seriousness. Here was a man who could look and act like "an adorable little boy."

She liked his ideas, she liked his attitudes, she loved the way he danced. They read the same books, and soon they were reading aloud to each other for hours at a time: Milton, the letters of Henry James, Sandburg. They went to movies, theater, concerts, dances. They took long walks in the wooded outskirts of Ann Arbor. His taste for every kind of discovery lived up to her own prodigious curiosity; by spring they were hunting for snakes together in the woods.

Chappie was a photographer too; he photographed for a campus publication and at least once covered sports for the town newspaper. His chief interest being microphotography, he had taken highly magnified pictures of brass and steel in the army, and at Ann Arbor he photographed the tongue of a fly, as well as the fusion of steel particles under intense heat. Much better versed in technical matters than Margaret, he gave her frequent pointers and assistance. When she had to photograph skeletons in the museum, he borrowed arc lights from the engineering building and advised her on the lighting. Soon they began to work with each other in the darkroom. By the end of the term, they were photographing together.

She had found a man who filled the prescription. Diary, April 1, 1923: "Chappie didn't try to pet then, so I know he's all right, because I know from the way he holds me when we're dancing that he'd like to." The perfect, honorable, burning knight, modeled on her dreams and her upbringing. She was buoyant with excitement and delight, but her desires were beginning to get in her way. Within days of this entry she was wondering if it was wrong to be so thrilled when she danced with him.

She would let him hold her hand, she admitted she liked his arms about her, yet she had uneasy stirrings. Another young man had already told her he'd heard she was "all desire and all fear"; she fairly quivered with both.

In May, Chappie told her he loved her. Margaret wasn't quite prepared for that. He was more tightly woven into her life, more unsettling to her composure, more tangled up in her desire than she knew how to handle, but she wasn't ready to plunge headlong into love. There were other men on her doorstep every day; it was a heady experience for a wallflower to be the choicest bloom in the garden. It suited her to have a number of men paying court.

Chappie, pouring all his energy into winning her, trying to be unselfish, trying to be decent and honest—all the virtues she would have respected—understood all too well that she was too young for a love as serious and exclusive as his. Madly, hopelessly in love with her, he told her that the part of him that cared for her told the rest of him that he was selfish. He knew her reasons for reluctance without her voicing them; that was one of the things she liked him for. He loved her so much he said he would wait for her three years while she finished school and he began his career. Then he made one of the most generous declarations a lover can make: he said he did not want her bound to him. He expected her to see other men, but he wanted to know that he could look forward to having her exclusively when her education was complete.

Having been too grand for his own natural impulses, he was instantly plunged into gloom. "Chappie torn between uncertainty lest I want someone else at the end of three years, and consciousness that he is standing in the way of my college life." In a desperate moment, to prove he loved her more than himself, he offered to drop out for three years if that would make it easier for her.

His selflessness is more than a little surprising, for he would prove in time the most jealous of men. Once he was grindingly angry for two days straight because she had dinner with another man. Margaret wrote in her diary that one day as she was happily reading a book, "Chappie saw something in my face that he thought meant I was shutting him out for just a minute. . . . Said he wanted me to be his absolutely and every minute; got quite savage and said I must understand that I could never get away from him, which filled me with a fierce joy."

Suddenly Margaret was in over her head. Uncertain whether she was in love, she knew only that her emotions had broken loose and could not be easily controlled. She was never comfortable when she was not in control. One day she realized how little she knew about men, and the next moment the most attractive one of all, whose every phone call made

her heart beat at a crazy rate, said he wanted her forever. Life was happening to her much too fast. It was unfair for fate to throw everything her way at once: she had just begun to discover her own powers, the variety of lives available to her, and how vast her ambition was, when the prospect of love and lifetime commitment opened up.

The night Chappie confessed the depth of his love for her, she felt "so small and funny" that she wanted to cry but willed herself not to. In the next weeks her emotional temperature ran up in a fever, down again, up. She was happy, she was torn, and most of all she was uncertain. Margaret had fully expected from childhood to fall in love, to marry and have children, but her family had not taught her a great deal about how to receive affection. Chappie, however, was the most romantic of lovers. He told her he could get nothing done, for she made him forget everything. He told her he saw in her eyes the color he wanted his life to be. He sent her "mental telepathy roses" every morning at eight; she woke up to a fantasy of flowers, certain she knew the shade of the bouquet in his mind at that moment.

The town of Ann Arbor is cut by a river and surrounded by rolling hills, woods, open meadows, and lakes. The two of them took walks to the bridges at night to watch the river turn silver with stars. Chappie had an old car with a chronic wheeze and regular breakdowns; they would drive out into the sunset or chase a lovers' moon. One night they stayed up all night to meet the dawn together; Margaret crept back into the sorority house at six-thirty in the morning. He pursued her with the fervor of youth and the kindly assistance of all of nature's glories.

Chappie told her he had kept himself clean and promised to stay so for three years for her sake. The sexual revolution had barely touched these two, but sexual tension never cares much what the times are like. He roused her flesh till her mind was uneasy and she had trouble quieting his ardor and her own. She told him he must stop kissing her, for kisses would make it harder. She wrote in her diary: "Think I will have to stop Chappie's putting his arms around me, but I like to feel him crush the breath out of me. If he would kiss me on the lips more quietly I might let him do it occasionally."

He graduated that spring, with the promise of a teaching job and graduate school in engineering at Michigan the following fall. When Minnie White came to visit Margaret in June, Chappie arranged an hour alone with her; they got along well enough to come back together with a milk snake. He took care to tell Minnie, too, that he'd led a clean life; Minnie, whose husband had said just that to her own mother, was pleased. Once back in Bound Brook, she wrote Margaret that it was clear from the sound of her voice that she was in love. After Margaret read

that letter, she told Chappie for the first time that she loved him. Not quite nineteen, she still needed her mother to certify something so perilously adult.

As she and Chappie were parting for the summer, she recalled the day four years earlier when she had won the high-school literary prize. Suddenly that seemed like a long time ago. Where once she had been alone, stranded on the dance floor, for what she feared might be eternity, now she was loved by a man who claimed he could see treetops in her eyes and would walk her home on the pretext of honoring a sliver of a moon. At last she belonged. How could she not love him too?

Chappie went home to Detroit in June, Margaret to Bound Brook, and each to a summer job. (As poor as she, he played traps in a band to help pay his way through college.) Margaret took another camp counseling job and set up another darkroom. She began work on a book that was to have thirty-six photographs of insects, with short paragraphs that children could grasp. Bringing to bear all her resources of drama and design, she chloroformed a dragonfly and placed it by a miniature waterfall, then with great care glued a spider to a stone in a brook. A book like the one she had in mind had never been done. It might turn into a series and set her on the road to fame. One Sunday at camp she heard a sermon on Emerson's "an institution is the lengthening shadow of a man." Afterward, she wrote in her diary: "Believe I want to produce my book so as to 'cast my shadow over the world.' "

Margaret could always call on astonishing reserves of energy, yet for months in 1923, at the boisterous age of eighteen and then nineteen, she was tired, dragging, nearly paralyzed with fatigue, and often unable to sleep. The strain of sorting out so many futures at once wasted her strength; her system was in danger of collapse. Chappie, who asked her too soon to decide on a life, crowded her emotions out of their carefully poised balance. Accepting his offer would erase forever her acute dread of not being asked to dance, but it would also close off the wide horizons that had recently opened up before her eyes. Her training in perfectionism had not prepared her for imperfect sensations.

To onlookers, Margaret must have seemed the most resolute, self-confident, and capable of young women, yet in mid-August she broke down completely. One morning when she was scheduled to give a sermon at camp, she was overcome with fear that she could not get herself to the chapel, much less speak. Suddenly she could not bear to be alone at any time; at night, nothing calmed her down but a massage. She could not last through an entire meal without collapsing. Her upbringing had been so steeped in self-reliance and courage that she seems an unlikely candidate for a breakdown, yet that summer when the careful construct

of her life fell apart she could neither sleep nor tolerate the solitude she had learned to cherish. She went to the local physician, who pronounced her mind and nerves shot. He told her she was not to use her brain, a prescription rather more original than his diagnosis.

At the end of the summer, Chappie came to visit her at home. Minnie had torn up roots that summer and moved to Cleveland, found a house that would accommodate a boarder, and begun to study Braille in order to prepare herself for a career teaching the blind. When Chappie walked in the door of the Cleveland house, Margaret took one look at him, choked up, and lost the power of speech. At supper she still could not muster strength to talk. Such agony was unexpected; she felt shaky, disconnected, weak. For a couple of days she slept fitfully and sobbed as if sorrow had struck her in the face. She had never been in love before, nor ever been so miserable.

By fall she was worse. She would wake in the night, sob till morning, end up stuttering hopelessly. Sometimes she shook beyond control. She still photographed, still studied, still held court for the young men plying her with flowers and fraternity pins while her mind stumbled between romance and an unwillingness to be engaged so young. She loved Chappie, but love would not hold her fraying nerves together. A mind that is running full tilt at a problem cannot be so easily stopped as the doctor had suggested. "It came like a flash of light," she wrote in early October, "that the reason for the trouble was due to my idea that possession kills interest. If I could get rid of the vague fear that if Ch[appie] is sure of me I shall lose him, I would cease to want not to be engaged. Everything points to it. With it came a beautiful certainty that I love Chappie."

He was unfailingly tender and gentle with her when she was troubled, but he too was feeling the strain of her uncertainty, and the dark side of his character came forward. For a man capable of such whimsy, he was exceedingly morose; once he apologized to her for being unhappy all the time. Margaret wondered if the childish soul she loved so must always be accompanied by a childish peevishness. He was given to crying jags. "Chappie can't stand the uncertainty of feeling that he is standing around with the rest of the world waiting for me to choose. That if he could try to forget me it might be a solution. Sobbed like a baby."

She found herself powerless before his leaden moods. Chappie's absorption in his work may have resembled her father's, but his temperament was almost an exaggeration of Joseph White's. It was something of a feat to overstate the temperament of a man who had worn silence like everyday clothing. Chappie was normally a talkative man but also emotionally volatile, and when he retreated across the borders of withdrawal he made certain the cost would be high for her as well.

He demanded Margaret's full attention at every moment. "Chappie

felt as though he couldn't get enough of me that night, and there was something that made him suspect I wasn't his. We went through it all again: he was resentful that the evening was spoiled; I was distressed and he was repentant." He would lock himself away in some fastness of silence and cold she could not penetrate. After a while, she referred to these spells as his "recessives." Her distress would have the frantic quality of powerlessness, and his repentance, which could be touching, could also leave him so gloomy he wouldn't say much for two days, so that she suffered as much from the aftermath as from the anger. One night when she criticized him for forgetting something, he barricaded himself instantly in cold and sullen resentment. Margaret's suffering was so intense that he soon fell into a paroxysm of self-hate and at last called on God to damn him for being able to hurt her.

Margaret herself precipitated these calamitous and punishing retreats with her sarcasm and her ever-ready criticism. She vowed to reform in order to be worthy of Chappie's adoration: ". . . my acid tongue. I must get rid of it, along with the conceit. It makes Chappie resentful, which seems to be the worst thing that could happen. I shall need all the years we have to prepare myself for him. Shall try to be as helpful as possible in ways that won't bring me any returns. . . . I love Chappie too well to inflict these faults on him. I want to get rid of them more than anything I have ever done."

Nothing she had read, none of the popular songs she sang, had led her to expect that love would load her down with such excess drama and pain.

At the beginning of the school year, Margaret went to see a psychiatrist. At that time, in the 1920s, a watered-down version of Freud had captured the imagination of educated Americans; psychiatry itself, however, remained more than a little exotic and intimidating. Women who were at once rich, neurotic, and eccentric enough to travel to Vienna in search of a chance to talk nonstop did indeed go to psychiatrists. So did some of the gentry with intellectual pretensions in a few large metropolitan centers. Ordinary people did not.

It was probably Minnie's idea for Margaret to see a psychiatrist. Minnie had always kept abreast of the latest means for self-improvement. In the twenties, she sent all three of her children to psychiatrists. Parental guilt having also come into fashion, Minnie may have been feeling some twinge of responsibility.

Margaret went to the doctor to talk of love, of misery, of Chappie. In October, she made the momentous decision that her love was large enough to grow and that she would indeed marry Chappie in three years'

time. Her pain only increased. She talked to the psychiatrist about her problems with the sorority. She thought the rules ridiculous, which was what she thought of rules in general, and she thought so many of her sisters dull that she soon dropped out. (A year later, Margaret noted that she was so intolerant of boredom she thought she'd have few friends in life.) Still she shook and sobbed. She spoke to the doctor about her inferiority complex, which was the companion to her conceit, and about the insurmountable obstacles she dreamed of every night.

But she had a secret that gnawed at her mind and threatened to topple what equilibrium she had left, a secret she had kept completely hidden from Chappie and for a long time kept from the psychiatrist as well: the fact that she was half Jewish. Her father had kept his religion hidden, her mother was calmly anti-Semitic. Minnie never liked her Jewish in-laws, whom she thought critical and "curious," which apparently meant prying. Margaret's cousin Florence Connolly, recalling that Joseph's mother never stayed at Minnie's house, says with a laugh, "I think she was afraid she'd get shot." When Mrs. White senior did come to visit, and she did, Minnie simply declined to talk to her. Joseph's children seldom saw his family until after his death, when his brothers and sisters were both generous and hospitable.

Traces of Minnie's general attitude to Jews escape from her letters to Margaret about the people who bought her house in 1930: "In their Jewish way of driving a hard bargain . . ." and ". . . as she is the peevish type of Jewess, I can't abide her very well." Although her son remembers that she advocated a wide-ranging tolerance, she did not hesitate to communicate this particular stereotyped distaste to her daughter, and it must have been evident earlier as well.

A woman who had once been bold enough, under the liberating influence of first love, to throw off prejudice, yet still harbored a contempt for her husband's background, must have created small, continuous tensions in her household. The moral victory Joseph said Minnie won in marrying a Jew grew smaller with the years. So did her tolerance of mixed marriages. Ruth, who a family member said was "homely as a mud fence" and never attractive to men, fell in love with a Chinese when she was twenty-one. Minnie closed this down, firmly and finally. No one remembers Ruth ever having another romance.

Joseph White must have passed as a Christian; certainly Margaret's schoolmates assumed he was. Perhaps he had feared he could not get ahead if it was known that he was Jewish, although his brother Lazarus was a far better known engineer than he and proud of his religion. (Of course Lazar had not married Minnie Bourke.) When Joseph married Minnie, Jews were pouring into this country in ever-increasing numbers,

and hatred of them was on the rise. Henry Adams, a staunch representative of the old guard, felt so menaced by the swelling Jewish population that he called for a *Götterdämmerung* in which "men of our kind might have some chance to be honorably killed in battle" rather than suffer Jewish enslavement.

Not only were the White children brought up as Christians, but Joseph's Jewish origins remained a secret even in his own home. Although he had originally said he wished his children to know what stock they sprang from, they did not. Roger White, who was eleven when his father died, says his mother did not tell him his father was Jewish until years after Joseph's death. She meant to wait until Roger could "handle the situation with his contemporaries."

But Margaret, who was seven years older than Roger, must have known before he did; certainly she knew shortly after her father died. Either the knowledge gave her an early sense of shame or her mother passed the shame on with the dark secret. Margaret's love for her father was boundless, yet she must have felt he had bequeathed her a flawed inheritance. All her life she would be expert at covering up flaws; this one she covered over with special care.

Not conventionally religious, she considered herself Christian. In her early years at college, she shopped around for churches as if for bargains, picking the minister who preached most persuasively. She would have liked to be tolerant, but she did not like Jews very much. By and large, she avoided them. Arriving in Ann Arbor her sophomore year, she reached the boardinghouse where she planned to stay, "and behold—" she wrote in her diary, "a synagog! Seven Israelites to three of us Christian soldiers! Had a long indignation meeting with the other two." The three soldiers moved out but managed to convince the dean they did so not from prejudice but from a feeling of being numerically overwhelmed. As a camp counselor the previous summer, Margaret had had some unpleasant run-in that confirmed her feeling: "Jews repel me more since my camp experience."

She tried to be rational, liberal, large enough to judge on merits: when a Jewish fellow with an important reputation on campus asked her out, she thought she wouldn't let his being a Jew stand in the way because she could tell she'd like him very much. She was, as must be clear by now, prejudiced in favor of importance; possibly in this case that prejudice outweighed her anti-Semitism. She may even have thought herself liberal. The decade from 1915 to 1925 saw the most violent anti-Semitism in American history. The Ku Klux Klan went on the march against Jews; the Red scare stirred up passions against Jews, who had already been branded as greedy capitalists and usurers and now were

further stigmatized as Communists; and Henry Ford led so virulent a hate campaign that the Nazis would use it for their own purposes. Next to such symptoms, Margaret's sentiments seem almost delicate.

While Chappie was still pressing her for an answer, she read St. John Ervine's *Mixed Marriage*, a play about the love of a Protestant boy for a Catholic girl in Ireland. It ended tragically; Margaret could find nothing either in literature or in life to reassure her.

In November of 1923, she finally revealed her secret to the psychiatrist. The notes in her diary are brief: "Told the dr. Father was a Jew. He amazed—thinks it at the base of my inferiority complex—that I will now improve." The confession lifted a heavy burden from her mind; her spirits rose instantly.

If the doctor's response sounds like a remarkably prejudiced opinion from a professional, it was also, if perhaps inadvertently, shrewd. Her interior conflict was obviously intense and at least partially responsible for her breakdown; her secret added an intolerable pressure to the weight of deciding between belonging forever or exploring the immense, uncertain possibilities of fame. The background that she thought sullied her trapped her as well: she could not come to terms with her father, and she feared she would lose Chappie. Her sense of inferiority had been papered over with a dislike for Jews, a dislike tacitly sanctioned by her mother. In the end, the cost was excessive.

Confessing to the psychiatrist came as a great relief. The next day she told Chappie at last. He said he loved her so much he didn't care what she was. Late in the month the doctor's prediction came true. He found her so improved that he cut back the number of her visits. Her secret was no longer poised to crush her life.

Margaret told Chappie about her father because she planned to marry him someday, but only so compelling a reason could pry the information from her. Her heritage became a weighty secret, revealed during her lifetime only to a handful of people when she deemed it necessary or useful. Ralph Steiner, who met her in 1922 and gave her technical advice for years, was stunned to find out eleven years after her death that she had Jewish blood; he said instantly that that explained the sense he always had that deep down Margaret felt like an outsider. Edward Stanley, who was an intimate friend for two decades, was startled and puzzled to learn of her background years after she died. Friends, lovers, editors, colleagues—almost no one knew.

When she began her career in the late twenties, anti-Semitism was so strong a force in this country that she might well have seen her background as a handicap. Whatever her initial reasons, she rapidly left

behind anti-Semitism and any other prejudice she may have harbored. From the thirties on, she spoke out for blacks and for oppressed people everywhere, and she fell in love more than once with Jewish men. She also professed, publicly and often, a devotion to the truth: "It is [the photographer's] sacred duty to look on two sides of a question and find the truth." She could scarcely be called unique for having decided which of her personal truths she wanted known; this one she did not. In 1963, when *Portrait of Myself* was published, it spoke of an English-Irish grandmother but never breathed a word about a grandfather named Weiss.

4

White Fires, Red Fires

All fall and into the winter, Margaret struggled through a quicksand of shaky feelings. She was prone to sobbing fits that reduced her to a sense of uselessness. A woman of passionate feeling, she had been taught to value reason but had not been equipped to deal with the immensity of her emotions.

Chappie made her both happy and miserable. The happiness was unlike anything she had ever known. "Lay awake a couple of hours thinking joyously. I can love Chappie, and I love to show him that I love him. I think he can feel the wings of my joy beating against his face." They talked about marriage often, although she still wished to be free to choose from the whole world so that if she decided on Chappie it would indeed be a choice. Her dreams of domesticity had acquired firm outlines. From her diary, September 18, 1923: "Talked at last about how I wanted to have children and how I wanted to bring them up. Chappie was very happy and it brought us very close. We are going to take a month vacation sometime, and Chappie will make furniture and I shall make curtains and things. . . . It was a very happy day and I shall always remember when we first talked over the children that are going to be a part of both of us. I love Chappie dearly and I want them to be very much like him."

From childhood she had planned on marriage, even figuring it into her career calculations. But life had come at her too swiftly and brought too much pain. The loss of the father she had not mourned came back to haunt her. In November, she saw A. S. M. Hutchinson's *If Winter Comes* with Chappie. "Where Mark says: 'Something has happened—I can't get up' was reminded of Father and got a sobbing spell. So exhausted after it I could hardly speak. Chappie drove out and held on to me for an hour."

Part of Margaret's tension must have been simple sexual frustration. She and Chappie were drawn to each other at the headlong speed of first

love, but the times and their upbringing forced them to slow down. Chappie had a tortured code that boded ill. "Told me he wanted his love for me, until after marriage, to be all white fires and no red ones. Put in peculiar position of having to try to make him see how the physical element was not only natural but beautiful and right. Wish the things he's heard hadn't mangled his ideas up so."

Whatever Minnie White's original ideas on sex, she had made sure that her daughter would know what was necessary and assume it was beautiful. Margaret, after all, had been "invited into the world." Minnie had introduced both her daughters to the birds and bees by plunging them into physiology. "To be given a glimpse into the radiant mysteries of the Medical Book," Margaret wrote, "was a reward for good behavior. On such days, my older sister Ruth and I were treated to a graphically unfolding diagram of the physiology of a woman, in which successive leaves were folded back to reveal the muscles, nerves, blood vessels, that lay underneath. On some rare occasions when we had been supremely good children, the last leaves of the chart were folded back, and my sister and I would exclaim rapturously over 'the dear little baby' at the bottom of the diagram, waiting to be born."

Chappie shared many of Margaret's convictions, including her sense that the world's conventions existed mainly to be flouted. When they went to a formal and overblown wedding, she remarked that they were greatly impressed by its "barbarism." They also thought the sacred wedding night an inane tradition; once they had decided to marry, they began to talk of ways to circumvent it. They spoke of going off together to try things out. They talked over the merits of unmarried sex. They were bursting with desire and wild with love, but she was shaking and he morose. His fanatic possessiveness and morbid sensitivity to rejection were inflamed by her generally unsympathetic nature. All too often he was hurt by slights she had not intended and scarcely understood. Once in a movie she got so engrossed in the exciting part of the plot she didn't answer a question he asked; he sulked for the entire evening. It was a pattern they followed endlessly. Later he would be humble, self-flagellating, sweetly apologetic.

The emotional roller coaster they were riding threatened to shake them apart in time. Chappie would end up crying almost as often as she. Early in 1924 they made a decision: they would marry that June, long before Margaret was due to graduate.

Her love once unleashed sent her emotions soaring; she experienced "an almost unearthly joy," "a queer feeling—this unendurable happiness." And still she sobbed, and still he sulked and cried. The marriage having been set, the wedding night loomed larger still. Sexual tensions

were exhausting their slender nervous reserves. They thought of waiting a week after marriage to make love—anything to overturn a doddering tradition. Together they read a book on "the art of love" which merely intensified their desire and increased the strain. Chappie asked her to run away with him; he was "almost desperate for want [of] relief." He left her notes, sometimes on top of her camera: "Life seems so empty. I ache for you. And I am not happy, Your lover." She wrote in her diary that "We must stop these caresses—leave us impatient and unresponsive afterwards."

By May, no longer able to contain themselves, they decided to "run away" for one night before the wedding. Margaret read up on contraception. She had posed nude in a classroom, but this was different, and she had her fears. The mere fact that she did filled her with contempt for herself, fear having supposedly been erased from her lexicon by Minnie's training. It was doubly shameful to be afraid of what she knew to be natural and beautiful. One night at last they reached their favorite spot on a green hill above the river, just as evening stretched across the sky. The uncertainties and prohibitions of generations buckled under the pressure of their longing. Quickly they undressed. As the last button was unbuttoned and the last stocking ungartered, as passion and curiosity were finally about to be satisfied, picnickers arrived to claim the hill.

Margaret and Chappie, like a film run off in reverse, broke some sort of record for fast dressing. There is nothing like farce for holding desire in check; they buttoned themselves into respectability again just in time to evade the party of picnickers, who would certainly have been startled to know they had interfered with a loss of virginity. The lovers, however, could no longer be stopped by anything so small as an interruption. They promptly found a more private reach of grass for their own version of the nuptial rites. "Chappie very contented," she wrote that evening, "and I very happy for his sake. Think our difficulties over at last." Soon she was climbing out her window in the middle of the night to join him on the hilltop.

They had decided to marry on Friday the thirteenth of June, another gauntlet thrown down at tradition. On the day after the wedding, which was both her parents' anniversary and her birthday, she would turn twenty. The night before the wedding they worked in the darkroom from eight o'clock until two in the morning on orders for their photographs. At nine the next morning they got up, washed their faces, and appeared as bride and groom.

They were young, poor, and defiantly untraditional, which did not leave a great deal of leeway for romance on so public an occasion as a

wedding. The wedding was as tiny as their exchequer: just three of Margaret's friends, Chappie's parents, who had driven from Detroit, and the Moores. A. D. Moore, one of Chappie's professors, and his wife, Jo, were fond of Chappie and Margaret and offered their house for the wedding. (Neither of them ever considered a church.) It is not clear why Minnie White did not come from Cleveland to her daughter's wedding. Chappie had no friends there but the Moores, but then he didn't have very close friends.

The bride wore something borrowed. The bride wore *everything* borrowed. Mrs. Moore lent Margaret her bridesmaid's dress, her shoes, even her stockings, to save them the expense. A week earlier, the bride and groom had picked out a gold nugget for Chappie to fashion into a wedding ring. The night before the wedding he gave it a light finishing stroke with a tiny hammer. The ring broke cleanly into two pieces. Friday the thirteenth and a broken ring . . . Mrs. Moore came to the rescue, lending Margaret her wedding ring for the ceremony.

Margaret wrote her mother after the ceremony: "Why do people have to go through silly messes like this anyway. I don't see what the whole business, from the rigamarole we went through to get the license to the meaningless congratulations we received afterwards have to do with getting married. I hope in our children's day, marriage will be only a matter of registration."

She had reason to complain. The ceremony proceeded like some bad play in which the minor characters hog the stage and recite roles they learned for another theater. The minister Professor Moore had found them had insisted on a rehearsal, which made both of them nervous. During the ceremony he coached them every step of the way in roles they already knew, with loudly whispered and perfectly audible stage directions. A few seconds into the ceremony, Mrs. Chapman began to cry noisily, and would not stop until they were duly united. She did not weep in the ordinary, decorous fashion prescribed for weddings but sobbed at full tilt, heaving and blowing. Each choked intake of breath announced to all assembled that her son had been stolen away from her and that, besides, no one was paying the proper amount of attention to her and she meant to change that situation right away.

Mrs. Chapman was not only a formidable weeper but a woman who had inflated the idea of motherhood to monstrous proportions. An outsize example of the stereotypic possessive mother, she meant to own her son outright. Margaret thought her beautiful and aristocratic, her silver hair massed high on her head as if it were a crown. She thought that if her mother-in-law had given her a chance she could have loved her, but even before the wedding there had been warning signs. In May, Mrs. Chapman had accused her son of selfishness for wanting to get married

when he had responsibilities at home. Both the Chapmans felt this way, but Mrs. Chapman had a certain vehemence of expression that her husband wisely deferred to, as only a great dramatist might have been able to match her fervor. At the beginning of the year he wrote Everett that he had made an investment in a davenport because of the support they expected their son would soon be able to give them.

Margaret had already observed Mr. and Mrs. Chapman's marriage with dismay. On the whole, Mrs. Chapman simply ignored the mild-mannered insurance salesman she was married to, treating him like some slightly scuffed piece of household furniture. "She was waiting," Margaret noted, "for her son to come home from college to take her to parties, to buy her 'a new overstuffed living room suit,' to give her the things she felt she had not received from her husband." When Everett Chapman married Margaret instead, Mrs. Chapman came home to her son.

All year Margaret and Chappie had been taking photographs and printing them together. He was still more technically competent than she; undoubtedly she had the better eye. They took pictures separately and together for the 'Ensian, and they took pictures to earn money. In May they had arranged two private shows at school to try to sell their scenic photographs of campus buildings and the surrounding area; they earned about twenty dollars in orders each time. She had been offered the post of photography editor of the magazine but declined it. Chappie, however, accepted a position on the advisory board. When he took photographs for a school magazine and the town newspaper, she spent so much time developing them that her course work suffered, a sacrifice she thought necessary to fatten their lean wallets.

She had not forgotten that a large fate was in store for her. Her talent and her reach were visible even then to the discerning. Miss Munger wrote not long before the marriage to say that the Lord had gifted Margaret with unusual powers.

On the day of their wedding, as soon as they were pronounced man and wife, they had changed into working clothes and returned to the darkroom to finish printing their commissions, which earned them seventy-five cents to a dollar and a half a picture. Two days later they were at commencement exercises with cameras in their hands, and on the eighteenth they spent the whole day in darkness between the hypo and the safety light. Work came first for both of them, and a little ritual like a wedding was not going to be allowed to interfere, but Margaret's autobiography never once mentions her taking photographs with Chappie, nor breathes a word about making money with her camera in Ann Arbor.

A week after the wedding, they finally finished their darkroom labors and embarked on their delayed honeymoon, coaxing Chappie's old car across seventeen miles to a cottage the Chapmans owned on a lake near Ann Arbor. Their honeymoon would have made the perfect subject for drawing room comedy had they not been living it. A day and a half after it began, Mrs. Chapman arrived with Marian, Chappie's sister, and settled in for a vacation.

So Margaret began her honeymoon with her mother-in-law and sister-in-law in attendance. Marian, four months pregnant, had recently had a bitter break with her husband; she told the newlyweds she'd been crying for a solid week. As an afterthought, she added that she had nothing left to live for. Embarrassed, Chappie took his hand off Margaret's shoulder. He did not put it back for days. They stopped making love too, for every sound carried in the thin-walled cottage.

Mrs. Chapman was eager to display her own grandiose set of personal troubles. She recounted one morning in brilliant detail the luxury, the beauty, the prestige of the new furniture her neighbors had just bought. Her own house, she added darkly, lay under a blight of poverty, waiting for Everett to come back to its rescue.

Chappie never once stood up to his mother. In this case, that would have been rather like standing up to an entire Roman legion. Still, only bravery could have saved him from attack, and his courage was in notably short supply. On the other hand, he had a generous store of guilt, enough to beg for God's damnation when he was base enough to hurt his wife's feelings. Exceptionally vulnerable to attack, to threat, to imagined slights, he had a tenuous hold on the side of himself that was charming and loving. After the tirade on divans and poverty, he and Margaret left the cottage in a stupor of guilt and helplessness. He was sick to his stomach. His head ached. She was so shaky her hands could not manage a knife and fork well. By evening he was raving hysterically, then lapsed into a daze from which she could not rouse him to speak. Mrs. Chapman was worried. "He studies too much," she said.

Two weeks to the day after the wedding, Chappie had to leave early one morning to work at the university. Margaret woke to hear her mother-in-law cleaning the cottage. The sound had a brusque and military ring, as if a mop were being wielded as a weapon of protest. Margaret, aware that her record for tidiness was little better than the wind's, took the cue. She quickly dressed, raced to the kitchen, and, afraid to appear so self-indulgent as to eat breakfast, picked up the iron and went to work.

She wrote about what happened next:

"Well, Margaret," my mother-in-law's rich contralto sounded from the next room, "how did your mother feel when she heard you were going to be married?"

I tried to answer, knowing how different would be the point of view of the two mothers. "Mother was very concerned at first because she wanted us to finish school, and because she thought we were both so young. But when she saw Chappie and me together and could see we were truly in love, she was glad."

"She's gained a son and I've lost a son. . . . You got him away from me."

At this point the speaker's voice rose to a shriek. "I never want to see you again."

Margaret, too frightened to say a word, stole from the cottage without stopping for food or money and walked seventeen miles into Ann Arbor. Bedraggled, she reached the Moores' house just as twilight was beginning to fall. No one was home. She waited on the doorstep, hungry, tired, and in a frenzy of emotion, for several hours until their car turned into the driveway. A. D. Moore opened the car door to ask what was the matter. Margaret leaned in and burst into tears on his shoulder.

After the honeymoon, Mrs. Chapman went back to Detroit. From there she pursued them by mail. They would have had their share of difficulties without her, but she was always there. Some say there are six in every marriage, the husband, the wife, and the parents of both, but Mrs. Chapman won the lion's share of the attention in this one, exactly as she wished to.

To make the marriage work, Margaret spent lavishly of her love, her energy, her determination—every resource that she had. She hadn't enough. Her ambition to succeed included everything she undertook, not least her marriage, and she and Chappie were deeply in love despite the immensity of their problems. More than a year and a half after the wedding she could still speak of "this passion of ours." She would save out of her small budget to cook her husband surprises. She planned menus with as much care, though perhaps not quite as much finesse, as a palace chef, then wrote about them in letters to her nutrition-minded mother: "A lovely salad with deviled eggs in the center and a mixture of apple, salted peanuts and pickles in mayonnaise piled around the edges. This course with sauted [sic] bananas with lemon butter and whole wheat muffins and tea." When Chappie had been especially sweet, she sewed pillows or curtains in a burst of domesticity, filling in piece by piece her picture of a happy home. A couple of times, when he raged about living in a hog pen, she stopped leaving the dishes all day in the bathtub. She

may not have been ideally suited to domestic routine, but part of her always yearned for a proper bourgeois life and the pleasures of "lovely salads" she had prepared herself.

In their happy times they were blissful, but sorrow maintained a sharp edge. A month after the incident with Chappie's mother at the cottage, Margaret thought her sweet husband once more as charmingly foolish as he'd been before they married. But within two weeks she was leaving blank pages in her diary, finally jotted down, "We have agreed to forget this day." She tried to tiptoe around his moods, which wasn't easy. She noted early in the marriage that they were only all right together when sex was all right, but her appetites were too hearty and healthy for him. "We woke up in beautiful shape this morning, but I spoiled the day by persisting in making advances and we started a session which we couldn't complete. I must learn to be careful for it only makes Chappie disgusted and me desperate."

Often she lived in fear that whatever she said or did would start him sobbing or plunge him into one of his withering withdrawals. Mrs. Chapman inserted herself into the struggle, controlling her son by playing victim; afterward, he tried the same game on Margaret. He was trapped in his ancient relationship with his mother and incapable of breaking free. A month after the wedding he told Margaret he didn't trust her in matters of his mother. Later he would send money to Detroit without telling his wife, once blamed their problems on something she had said about his mother. Margaret felt powerless, a poisonous state for anyone but insupportable for a woman who had been brought up to believe in control and in solutions.

Margaret wrote that neither she nor Chappie was equipped to deal with the problem of the silver cord that bound him to his mother. Mrs. Chapman, deprived of furniture, parties, and an escort by the son she had counted on to provide them for her, sank into a depression from which she sent him endless cries of blame. She wrote that she knew he was never satisfied with his home because it was commonplace and she was too. She told him she'd worn hand-me-down underwear and a hand-me-down pair of shoes for years to provide better for him and his sister. "There is no happiness for me," she wrote him. "There is no future now and I have made the others unhappy. Someday you will know what it has all done to me. Goodby Everett. We did want you so—we need you so—goodby—I wish I had not loved you so."

His father wrote him that her mental condition was poor, that she made life frightful for him and for Marian, and that if Chappie did not live up to his promise to write her once a week he must accept the responsibility for her condition as well as for the "ULTIMATE RESULTS."

Even a stronger man than Chappie might have crumbled under such an assault. His weakness made Margaret frantic with a sense of loss and helplessness, and she was soon under additional pressure. Three months after the wedding they moved to Purdue, where Chappie had won a good teaching position. Here, in her fourth year of school, Margaret was a freshman for the third time. Being a professor's wife cut her off from friendships with other students; being twenty years old cut her off from friendships with other professors' wives. She was alone with Chappie, whose brooding left her more alone than she had ever been.

One night early in 1925, he locked himself in his room. The door rattled under her hand but would not give. The closed door that would not let her pass, the silence, her loneliness, drove her half crazy. She climbed out onto the roof with ideas going off in her head like firecrackers: she would throw herself to the ground, she would be badly hurt, he would be sorry. She paused at the edge of the roof, staring wildly at the ground below her in the dark. Even the roof had betrayed her. It was too low to cause her a worthwhile injury. She had nothing to gain from such a fall but ridicule. Exhausted and rueful, she climbed back into the house.

They decided to put the marriage on trial until June. In March, she began a "Diary of Disappointment."

There were days when Margaret spoke of Chappie as her lover all day long. She fiercely wanted the man she had changed her life plans for, but she was losing him to a woman with prior claims. Her hopes, her expectations, her ideal of a well-plotted domestic life, her trust in her own ability to find solutions, all were slipping away. In the beginning of 1925 she felt for a time she might have the love she wanted: "Now I'm crying with joy. He isn't growing indifferent toward me. He isn't growing toward his mother and away from me. Everything seemed to show that she was more and more taking my place and I was wrong. I have been planning ways of filling my life without him—and I won't have to. I can have him. Oh God, make this come right."

Not long after they moved to Purdue in the fall of '24, they reached a crisis. Through clenched teeth Chappie told her there were things about her that he hated, and added bitterly that he was through with marriage. Margaret, in almost unbearable anguish, said she would not let him support her if he did not love her. Even at the young age of twenty, her first thought was for her independence. True to his code of decency, Chappie tried to insist that he would put her through college to meet his obligations. (His ideas about supporting a wife conformed to the prevailing doctrine. When the job offer for Purdue came through

with a good salary, he was irritated that Margaret should want to continue with a little money-making scheme she was working on.)

The air having been cleared a bit, the crisis passed for the moment. The marriage went on, lurching this way and that. Through it all, there was one idea that constantly recurred to her: "I gave it a great deal of thought. Perhaps if I decided to have a baby that would swing Chappie's first loyalty to our child, and give our marriage a chance. . . . I decided it would be wrong . . . to invite the child, and then find it had entered an unhappy home. That was an immoral use of a baby, I thought." (These were notes for her autobiography. The book itself never mentioned her wish for a child.) She had always planned to have a family. The idea came back to her again and again.

Contraception, although illegal since the Comstock laws of 1873, had been in general use among married couples for years. Margaret Sanger's pamphlet on family limitation, which had sent her husband to jail in 1914 when it was published and Sanger herself to jail in 1916, had reached its twelfth edition by the twenties. Margaret, whose inquiring mind always researched a subject thoroughly, owned a copy of the pamphlet. As one might expect of her, she knew perfectly well how to invite a child into the world and how not to.

In December of 1924 she realized she was pregnant. At the time, her marriage was like an earthquake threatening to crack open again without warning. She who refused to be dependent must have thought about the impossibility of raising a child on her own if the marriage should split apart. She decided she had no choice.

She asked Chappie to get her some ergot, a drug that causes uterine contractions. All day she sat in a sitz bath. At meals she put her feet into a bath of hot mustard. The remedies were old-fashioned; they persisted because they sometimes worked. Three hours after taking the ergot, she miscarried without pain. Laconically, she wrote in her diary, "We'll never know the cause."

She did not record a sense of loss. Instead, her diary went blank for seven days, as it had once for two months when she said the hurt was too intense to set down. But she did not fall to pieces again. Having never got into a habit of mourning, she was now in the process of growing a tougher skin to protect her from storms. She tried to train her mind on the future, imagining a good life by herself. At any rate, she had suffered so many losses in the six months she'd been married, having soared high on passion and idealism and fallen against the stones of a hard reality, that the loss of a baby might not have seemed much greater than the loss of love, or trust, or hope.

Yet she continued to dream of a child. When she first saw Chappie's

sister Marian's baby two weeks after she had lost her own, she jotted down, "Adore the baby." She still wanted Chappie, still wanted her marriage, still wanted a child. Little more than a month after the episode with the ergot and the sitz bath, she thought she was pregnant again and was prepared to take the same remedies, but it turned out not to be necessary. She played the same script again in June of '25, and yet again in September, when she lied to get some free medicine, in case it should be necessary sometime. She was playing a game of risk with herself. A woman in her situation, with her knowledge and capacity for control, who risks becoming pregnant more than once must want a child badly, and sorely want her marriage to succeed.

She feared she was in danger of losing her separate identity. "I was always afraid of marriage," she wrote in her diary, "because . . . the woman so often loses her individuality." (Is that what had happened to Minnie White, who jumped up and let her dinner grow cold whenever her husband had an idea and needed her to take it down?) "I had not a single fear," Margaret went on, "that that would happen with Chappie, yet here I am afraid [to] express myself for fear of differing from him in any way and incurring those expressions of his displeasure which I have come to dread so much. Oh God."

Margaret had been fighting to protect her identity ever since she had begun to establish it. Instinctively she grappled with one of the most basic of feminist issues—how a woman is to keep herself whole in relations of sex and love, when society prefers that she give up her separateness and when her mind and fantasies tempt her with thoughts of losing herself in one who is stronger. Twice her diary noted group conversations on the subject at Michigan, and shortly before she married she discussed with friends the ways a wife might keep her individuality. In a later conversation, she decided that women who cared more for the value of a group than for the needs of the individual were no better than sheep.

Her radical fear of submergence was allied to her early and passionate determination to make a name for herself in a man's world. She never claimed to be a feminist, and in fact she often acted in ways no self-respecting feminist could approve, but at almost precisely the moment that she decided on marriage, she took an eager interest in the movement, as if indeed to protect her separate female identity from the dangers inherent in alliance.

The movement was on a new upswing. In 1920, the women of America finally won the privilege of the vote. Strengthened, the movement gathered yet more strength. Late in 1923, Margaret read Jane Addams's *A New Conscience and an Ancient Evil*, Frances Donovan's *The Woman*

Who Waits, and Ellen Key's *The Woman Movement*. A woman determined to enter a man's field needed a firm foundation from which to begin. Aware at every point in her life of the opportunities her particular moment in history offered her, Margaret saw history opening the way to women at the very instant she was ready to set forth.

She found herself intuitively protecting her individuality. Soon after her marriage she discovered that she was offended when someone wrote her as Margaret W. Chapman—"as though I couldn't bear to have my precious little identity merged even into that of the man I love." The movement could have informed her on that subject. Ellen Key wrote, in *The Woman Movement:* "Certainly the family has often been a torture chamber for individuality" and "For today young girls *live to apply* the principle of the woman movement—individualism" and "The modern young woman desires above all else the elevation of her own personality." As her marriage splintered, Margaret pieced together her identity once more. Life with Chappie had shriveled her sense of self; slowly it began to blossom again. Around the time that she arranged to lose the baby, she was already imagining an independent life, which grew better and better in her dreams.

On New Year's Eve 1924, she wished for a better year or for a quick end to the marriage. "And may I have the buoyancy," she wrote in her diary, "to start in on a new life with my old feeling of power." There was the nub of the problem, the grip of powerlessness. Her distrust of marriage as a program to leach away individuality had been confirmed. She had not only forfeited control but had been forced into emotional dependency by a kind of psychological violence. The debilitating pattern had been set in the courtship but had not stopped her; some part of her responded familiarly to such treatment, perhaps that part accustomed to the dry trickle of her mother's sympathy and love, her father's distance and the necessity to perform for his favor.

Margaret wanted scope for achievement. Even her ambition and accomplishment had been damped down in the confines of her marriage. She had sent some articles to newspapers; nothing seems to have come of that. All along, she photographed and earned money with her camera, but her diary does not mention the insect book again after marriage. Technical weakness stood in her way; once she could not fill her orders for sorority pictures at Purdue because her photographs were overexposed. (Light meters as we now know them did not yet exist. Most photographers worked on instinct and experience.) In the summer of '24, she had roamed the Cleveland docks, steel foundries, and stores, and planned a photographic series on the city; other pressures kept her from

beginning work on it. But as her marriage wound down, her ambition wound up again.

In 1925, when Chappie took a job with the Lincoln Electric Company, they moved to Cleveland and scraped across a second abrasive year of marriage. That the marriage lasted two years was a testimony to hope, love, the stigma of divorce, and perhaps to the attractions of suffering. Margaret managed to land a job teaching public-school children at Cleveland's Museum of Natural History when one of the teachers fell ill. Thinking of leaving Chappie, she would have needed a job to establish her financial independence. When love would not suffice, independence was all.

At night she took classes at Case Western Reserve—her fifth school so far. This year she majored in education; teaching must have seemed more immediate than world-class journalism to a young woman who might have to be on her own at any time. The time came soon. Somewhere between Mrs. Chapman's overblown self-pity and Chappie's pinched silences, she found the strength to move out.

Years later she recalled how she felt when she knew the marriage had failed: "[To] reapproach life again as an individual—and because I am an individual again an upsurge of wanting to do—sense of release." Here was the source of power: the individual who acted and accomplished. She was released to be herself.

She wrote about the end of the marriage:

> And now that I was facing life again as an individual, I made a great discovery. . . . It was as though everything that could really be hard in my life had been packed into those two short years, and nothing would ever seem so hard again. . . .
>
> I owe a peculiar debt to my mother-in-law. She left me strong, knowing I could deal with a difficult experience, learning from it, and leaving it behind without bitterness, in a neat closed room. As I look back, I believe this beautiful rather tragic woman was the greatest single influence in my life. I am grateful to her because, all unknowing, she opened the door to a more spacious life than I could ever have dreamed.

This is the first evidence of Margaret's remarkable ability to package life's bad news and store it out of sight. Her marriage to Chappie was the first and greatest failure of her life. Her plans had never taken failure into account; she was both too young and too certain of solutions, and she had loved Chappie with the indelible and explosive force of first love. She who made large plans had changed hers for her husband, and all she ended up with was her self and a few shreds of an old hope. With characteristic fortitude and optimism, Margaret chose to see the future as a larger place.

She singled out Chappie's mother rather than Chappie himself as the strongest influence on her life. Among other things, she said her mother-in-law's example taught her how wrong it was to try to possess someone, a lesson Mrs. Chapman surely wrote in capital letters, and one that would influence Margaret's relations with men for the rest of her life.

She claimed that she had not deliberately chosen between marriage and a career, that had she stayed married she would never have been a professional photographer. That cannot be entirely correct. Before and during her marriage to Chappie, she planned a career as a writer-photographer, although for a while she was so mired in sorrow that she could not do much to advance her ambitions. In 1927, when she was considering a reconciliation with Chappie, her aunt discussed with her the potential for combining a career in photography with life as a housekeeper. But Margaret did not stay married and did become famous in a career that would have been hard to tuck a marriage into; it suited her to think it was one or the other, and that Mrs. Chapman had thrust her out of her marriage into what she considered her destiny.

It was time to live up to the success that was expected of her. From this point on, she trained her immense energies on her mission to show the world—or perhaps to show Mrs. Chapman. Betty Cronander, a friend who worked with Margaret on her autobiography in the fifties, says, "When her husband's mother said, 'I never want to see you again,' I really think a lot of her drive for the success she got later was to show that woman. . . . I think she was going to show that woman she was wrong."

It would have been like Margaret to pose herself such a challenge. She had come to her marriage with an image of herself to live up to; afterward, she was left with an image to live down. Her mother-in-law had tangled her in a web of rejection and inadequacy from which she hoped to break free by winning acceptance and fame. Mrs. Chapman had thought it freakish for Margaret to stay in college after her marriage, freakish, in short, to have ambitions of her own. Margaret's ambitions simply grew larger.

If Margaret's father had endowed her with respect for hard work, her mother-in-law gave her a reason to work hard. Before the older woman had said, "I never want to see you again," Margaret White had a strong drive to reach the top. Afterward, she was driven.

The Region Occupied by Stieglitz

When Margaret moved out on her own, she moved as far away as possible—to Cornell University. There was a good biology program at the college in 1926 and the visual luxury of waterfalls right on campus. The waterfalls caught her romantic fancy. No one in Ithaca would have any idea that she was a married woman. She would be a student like other students; she would belong.

But when she was there, it didn't work; she never belonged. As a classmate remarked, "She alienated the other girls in the residential hall by her stony attitude toward them." She had no interest in joining their activities. Another woman "remembers Peg as never making any effort to be agreeable or attractive unless there was a man around, and that she was hungry for dates." She still hoped to save her marriage, but she kept it secret while she tried to repair the broken image of her self.

Her view of herself, her confidence in achievement, had been badly shaken. She had reverted to shyness. Margaret's brand of exhibitionism required either a friendly audience or some connection to her work. She had not yet learned to fill in the intervals between shy silence and the dramatic display of snakes or the unfolding of tales of the safari. At Cornell, she was too quiet and retiring—"a shy person with a will of iron," as a classmate described her—too unhappy, too preoccupied with herself, too busy, too determined; there was no room left for ordinary agreeableness.

Don Hershey, the student manager of the Student Supply Store who arranged to sell her pictures there, says that "Margaret was very withdrawing because of her awful shyness, and would perspire easily. Her handshakes were slimy and limp." He recalls that another classmate, who he thinks dated her, said to him, "You know how Margaret is. She's

tight. She doesn't blossom out." This man called her Peggy because he thought it would help to make her more human. "She's so involved in what she's doing," he said, "that she doesn't want to give out in any other way."

Among students casually trying on various ideas of what life might be about, Margaret was excessively single-minded. Helen Huston Shedrick, who lived in the same residential hall, says that "photography was her whole life. I liked Peg, but even as a student it was obvious that she planned to get to the top no matter what obstacle or person stood in her way. . . . I feel that a career in photography was all that mattered. That it could supply some money for school was convenient, but I don't think she ever doubted her ability to be tops in her field."

Even her table manners were determined. The object seemed to be to ingest as much food as possible at every meal. She ate relentlessly, without enjoyment, and it wasn't pleasant to watch; some thought it disgusting. Yet she was thin, sometimes painfully so, for her energy and drive burned up all the fuel she could consume. Gone were her baby-fat days; for the rest of her life she would be slim. Her hunger has one fairly simple explanation: she worked with such unbroken concentration that she forgot to eat and took her meals when she remembered or when she could.

Margaret's mind was always elsewhere, stung by a recurring sense that her life was a "puttering mess" and doomed to embarrassing failure. Failure stuck in her craw. She was at Cornell only for a diploma, and wanted a diploma only because she was used to finishing things. By now, she thought college a waste of her time. There were worlds to conquer, someplace else, if she could shake off the sense of failure that marriage and mother-in-law had stamped on her heart. Margaret did eventually wrestle her life into some vague order that last year of school, but she never did manage to belong. The only thing she achieved that year was success.

> Arriving in Ithaca, I did what other college students do who are broke. I tried to get a job as a waitress. . . . The waitress jobs were all taken. . . . I wept some secret tears, and turned to my camera.
> . . . I knew so little about photography it seemed almost impudent to think about taking pictures to sell. (Portrait of Myself)

In the years after college, Margaret forged the extremely useful habit of finding good luck in the bad, as in this story of the glorious consequences of unemployment. This habit of mind was so advantageous that she began to write, perhaps to think, perhaps even to live her life that way, as a series of obstacles brilliantly overcome. In fact she waited on tables three hours a day in return for meals and worked at the front desk

in her dorm. She began to photograph early in the year. It soon took up so much of her time that she had to give up waitressing.

She would stay up all night, or rise before dawn, or sit calmly through a snowstorm until the right light fell or the right figure passed by her camera. She cut classes if the weather was especially good for photography, and she took advantage of winter by walking through the snow in front of the Hall of Science at night, purposefully making long curving trails that would set off the building's angles in her picture. She became known for photographs of campus towers and halls transformed by her lens into enchanted castles. Cornell was a stately place, one of those grandly improbable mixtures of pseudo Renaissance and pseudo medieval that seem to house American higher education most comfortably. The football stadium had a dramatic sweep, the campus was amply graced with trees and open spaces, and from the tower of Willard Straight Hall the view swept down to Lake Cayuga.

Margaret found the drama and the views almost immediately, and proceeded to endow the campus with the romance that some of its architects, longing for a better time they had not lived in, clearly had in mind. She printed through sheets of celluloid that made the details muzzy. She wrote notes on how to make the prints still more blurred, until architecture almost dissolved into dream. Or she took distant vistas under a theatrical sweep of sky. Her strong compositional sense presented Cornell as a set of geometric designs embedded in natural settings —she spoke of her "campus pattern pictures"—while her romantic outlook veiled the college in instant nostalgia. "Pseudo-Corots" she said she made, and was proud of it at the time, locked as she was in the dying embrace of pictorialism.

She always knew where and how to get elaborate amounts of assistance. The Department of Residential Halls at the college, which had found the waitress job for her, soon helped her get started selling pictures of the dorms (a project not unlike her Camp Agaming pictures of the various bunks), and she had one of her first Cornell shows in their offices. The school administration introduced her to Don Hershey, who arranged for her to use the Student Supply Store's darkroom (she had been using her dorm's washtubs for developing), then sold her pictures there and made fancy displays of her photographs in the store windows, with floodlights at night so you couldn't miss the Bourke Whites. (She already wanted to be called by both names and told him so, but she hadn't yet stapled the two together with a hyphen.)

Hershey says, "She never had any sex appeal. She wasn't a good flirt. She might compromise to get her way, but she wouldn't give anything for it. She would just be nice about it, and persistent . . . a good salesman. She was forceful and couldn't be pushed over. She wasn't any

meek and mild person." Hershey adds that "she could be coy. If she got a job she would be a lady and use her charm. She could turn on the hot water or the cold water." He says that for all her caution and withdrawal, when it came to photography she suddenly became an important person, and the shyness turned off automatically. She had already merged her identity with her work.

Don Hershey helped Margaret unfailingly, and others did too. Her talent was clear; that helped her get what she wanted. Her determination was also obvious, and it must have been impressive in one so young. She did little enough to ingratiate herself. Hershey says, "Margaret never gave compliments, and could hold a grudge if someone hurt her." If he asked her how she liked the store window, which he had arranged with great effort to set off her pictures, she'd say, "Well, that's nice, but I think that should be moved up." So he'd move it. He thought her so absorbed in herself she was not conscious that more might be expected; on the other hand, she never criticized anyone, preferring silence to the risk of hurting someone's feelings.

She set up a booth in her dormitory at Christmas, and Hershey organized a team of some twenty student salesmen who took her images around to frat houses and anywhere promising. Sales moved smartly, but she hadn't any more business sense than her father had, and without stopping to think the demand might be tied to the holiday, she laid out what cash she had for print stocks she couldn't use up for months. Still she couldn't stop taking pictures. Hershey's boss, nervous at finding her so diligent in the darkroom almost anytime he happened by, even at seven-thirty in the morning when she'd stayed up all night to print, finally closed the store's darkroom to her.

So she made an arrangement with a commercial photographer in Ithaca, who in exchange for a share of her business gave her darkroom privileges and all manner of technical advice. Margaret had a knack for finding some expert eager to assist her. The expert was always a man.

"Only men," she told Don Hershey, "seem to be successful in this profession. I hope to be the first woman to do so." She was not quite correct. Photography had long been an acceptable career for women and was at that time accruing greater prestige. A year after Margaret remarked that only men were successful photographers, a women's magazine advertised to the young working woman: "What has become of the useful maiden aunt? She isn't darning anybody's stockings, not even her own. She is a draftsman or an author, a photographer or a real estate agent."

It is true that women were more likely to be baby photographers, or animal or portrait photographers, than anything else, but some women

had achieved artistic as well as financial success in the field. In the late nineteenth and early twentieth centuries, Frances Benjamin Johnston photographed in a coal mine, took pictures of iron mining, women in factories, life aboard a battleship, poor black families in the South, and other subjects that prefigure Bourke-White's own. In 1897 she wrote an article in the *Ladies' Home Journal* advising women about becoming photographers, and in the teens she specialized in architectural photography. Jessie Tarbox Beals, one of America's early women photojournalists, focused on social reform at the turn of the century.

Anne Brigman, Eva Watson-Schütze, and Gertrude Käsebier had all been members of Stieglitz's Photo-Secession. Käsebier, a friend of Clarence H. White's, had an international reputation and an active studio into the 1920s. Brigman's photographs were then being published as magazine illustrations. Clara Sipprell, Imogen Cunningham, and Laura Gilpin, to name a few, were all active at the time.

As usual, Margaret, whose timing was superb whether she engineered it or not, was poised on the cusp of historical change. In the thirties, several American women would leave their distinctive marks on photography, among them Berenice Abbott, Dorothea Lange, Doris Ulmann. The time was certainly ripe—it is always appropriate but not always ripe—for a woman to make a contribution to the field.

If ambition is an integral part of success, Margaret was fully equipped. She had in mind at an early age a model of the kind of fame she later achieved. At Cornell, through the web of failure that had descended on her life, she still had a clear view of the top. Her drive was as visible as if she wore a placard. Don Hershey recalls that "she absolutely cared to be outstanding. She said she was going to make photography her life's work. 'People think I'm strange,' she said." She told him she wanted to be somewhere up in the region occupied by Stieglitz. Back in Michigan, a famous professor had told her he expected her to be a world figure. So did she.

At Cornell, she took a course in journalism and submitted a "photo-feature." Soon the *Cornell Alumni News* was paying her five dollars regularly for photographs of campus buildings. She attracted the attention of the dean of the architecture school, photographed his home, got letters of recommendation from him. Graduate architects looked at her photographs and wrote to say she should go into the business. Photographers of architecture tended to see buildings as good, clean, dry, and necessary facts. Margaret made them appear the products of a romantic imagination.

"Never had I thought of becoming a professional photographer," she wrote without great fidelity to fact. She had, however, hedged her

bets by applying for a job at the American Museum of Natural History in New York, which gave her some encouragement, but she was thinking seriously of returning to Cleveland. Her husband, to whom she was still legally married, was there. She thought perhaps she could go back to him and combine photography and marriage. At the end of the school year, Chappie visited her at Cornell as part of their attempt at reconciliation, which ultimately proved impossible. Nobody at the school had known he existed.

How large the failure of Margaret's marriage loomed in her life can be judged by the silence with which she surrounded it. The first time she mentioned this marriage publicly was in *Portrait of Myself*, published in 1963. Friends knew earlier that she'd been married, but she seldom talked much about it. When she did, it was without apparent rancor, for she was that rare species, a woman who seldom speaks ill of anyone and even more seldom speaks ill of the past. Margaret seems to have lived her life in an almost perpetual present in which little space was allowed for regret.

When she and Chappie separated, she began a lifelong project: the creation of the myth of Margaret Bourke-White. It may have been more a matter of expediency than myth-making in the beginning, but it was not long before she understood the value of her story. She did not mention her husband to any of the countless interviewers who dogged her heels in years to come. From here on in, she would not admit that she had taken photographs at any time between her freshman course with Clarence H. White and her senior year at Cornell.

There were advantages to be gained from silence. Although the 1920s saw a sizable increase in divorce in America, a young woman on the way up would have a better chance and a better press as a single woman than as a divorcée. And if she never mentioned Chappie, no one would ever know he'd helped her learn to photograph. By dropping two years and a long dossier of student photographs from her biography, she could make her career even more meteoric than it was. (Doubtless this explains why she also cut two years off her age while still in her twenties.) She became a kind of glamorous prodigy who in a fit of poverty picked up a camera and achieved fame.

Chappie was not only her first love but in some ways her last. Betty Cronander, who worked with her on *Portrait of Myself*, says that Margaret never again let anyone get so close to her as Chappie had: "It must have been absolutely devastating. Still her eyes filled with tears. . . . Such pain and humiliation . . . And she said, 'I swore I would never let anyone do that to me again. And I haven't.' "

More than a quarter of a century after the marriage collapsed, she

told Cronander that the failure of her marriage had either destroyed her or made her strong. She added that she hadn't seen Chappie for years but hoped he was following her career.

At Easter vacation in 1927, Margaret went to New York to try to establish connections in the photography world. Smart enough to know that the Cornell alumni who so liked her photographs might simply be sentimental about the campus, she sought an objective opinion. An architect named Benjamin Moskowitz was elected to become a milestone in Margaret's career. Someone had told her to ask for him at York and Sawyer, a large architectural firm, and she did so, at the tag end of the day. He came out to the waiting room, his mind on his commuter train; while she delivered her prepared speech, he edged his way toward the elevator and stole a glance at his watch. Margaret trotted behind, her portfolio in her hand. Numbly she watched him press the elevator button.

The elevator did not come. Had it responded right away, she thought later, her photographic career probably would have been delayed. But as the two of them waited side by side for the elevator, the silence proved embarrassing. Margaret opened her portfolio to her picture of the view down to the river through the library tower grillwork. She had climbed that tower repeatedly at dawn to get the picture right.

He asked if she had taken the photograph. Indeed she had, she said, and she needed to know if she was good enough to be a professional. Moskowitz let the elevator go, forgot his train, bustled her back into the office and called in his colleagues to look at her pictures. "After the kind of golden hour one remembers for a lifetime, I left with the assurance of Messrs. York, Sawyer and associates that I could walk into any architect's office in the country with that portfolio and get work."

That September she took the night boat across the Great Lakes from Buffalo to Cleveland. As the boat drew in to shore, the towers and construction derricks of the city reared up above the morning mists: a modern city built on technology and industrial power. Margaret said she felt she was coming to her promised land; it had the look of tomorrow, the outlines of the territory she meant to make her own.

6

Cleveland: "This Feeling of Rising Excitement"

I earnestly advise women of artistic tastes to train for the unworked field of modern photography. It seems to be especially adapted to them and the few who have entered it are meeting with gratifying and profitable success. . . . Besides, consider the advantage of a vocation which necessitates one's being a taking woman.

Gertrude Käsebier, 1898

Cleveland in 1927 was a city in motion—downriver on barges, westward along railroad tracks, and upward weld by weld along steel scaffolds. Trains shuttled across the Midwest bearing the rich and business-minded into the new Union Terminal, with its unfinished tower that punched a hole through the Ohio sky. Ore boats heading for the Great Lakes slid in solemn procession along the Cuyahoga, the river that bisects the city. All day long the city sang and chuffed a noisy song of construction, sweet music for an aspiring architectural photographer. In the years to come, Margaret would tell reporters she had moved to Cleveland rather than New York because she feared New York was so fiercely competitive she'd be forced to do hackwork just to earn her keep, thus strangling any chance she had of a real photographic education. More likely it was the hope of repairing her broken marriage that brought her to Ohio. The marriage could no more be made whole again than spilled mercury can be made to reunite, but its failure could no longer throttle her ambitions.

Margaret, who had long looked older than she was, at twenty-three looked younger. She had in hand a portfolio of pictures that bore the stamp of maturity. She had reconnoitered her prospects and found Cleveland a good city for architects, particularly for architects trained at Cornell. A sheaf of recommendations helped ease the way for a young woman trying to break into a man's profession, carrying with her dramatic, vividly designed photographs, some of them seen through a filter of mist. Her bold gaze was surprising in one so young, her speech was

rapid and self-assured, her earnestness conspicuous. All that was still visible of her shyness was a slight diffidence, a hesitation that lingered just long enough to make her seem girlish, and innocent, and charming. With her eternally wide eyes and rapid walk, she seemed to be composed of equal parts of wonder, enthusiasm, and determination.

Knowing perfectly well she was selling herself as well as her photographs, she tended her appearance as if she were the curator of a traveling exhibition. Clothes became for her both signature and support. In Cleveland, at the beginning, she had not much to tend: one gray suit that she wore with blue hat and blue gloves, or the same suit with red hat and red gloves. She kept note cards on which combination she'd worn when, so she wouldn't repeat the performance for the same audience. (In the thirties, by which time her wardrobe had multiplied geometrically, she was still jotting down after each day's work and its evening's outing what she'd worn to meet her public.) When the money first began to come in after some months in Cleveland, Margaret made herself a purple dress—and sewed a purple velvet camera cloth to match, so that when she tucked her head under the cloth to focus her large view camera, the entire operation would be color coordinated. Entranced with her own chic, she then sewed up a blue velvet cloth to match the blue gloves and hat, a black to go with the red. Clearly she was most comfortable attracting the most attention.

Her photographic style changed almost immediately. Ralph Steiner, with impassioned scorn, talked her out of soft-focus pictorialism and into straight, sharp-focus photography. In effect, he made it possible for her to be fully modern. Up to that moment, Margaret had clung to the conflicting tenets of Clarence H. White's late years, when he believed that the two great recent contributions to photography were the soft-focus lens and better picture construction, by which he meant the cubist-derived compositions favored by Max Weber and Arthur Wesley Dow. Soft focus, however, was falling from grace even as he praised it.

Straight photography came to the fore in the teens and became a polemical issue in the twenties. Paul Strand, whose work was vital to the shift, argued in 1923 that pictorialism was "an evasion of everything photographic." The camera, he said, had its own, inherent properties, totally unlike those of painting. The camera was a machine that was meant to transcribe tone and texture with brilliant clarity. The photographer could make an image live only if he was true to the nature of his instrument.

This modernist notion of truth to materials became the rallying cry for photography throughout the twenties and thirties. Ralph Steiner recalls Strand telling him that Stieglitz thought using a soft-focus lens was

equivalent to a refusal to relate to the world. When Margaret was at Michigan and Cornell, her photographs had tended to be as soft as Impressionist paintings and sometimes so picturesque as to be old-fashioned. She knew very little about modern art; the odd thing was, she'd been trained in its theories, having studied art and listened to Dow in freshman year. In sophomore year, she noted in her diary one day, "Looked at Cubist pictures in futurist Russian magazines." She was capable of turning architecture into flat, planar abstractions and could create images with the unclear ground lines, ambiguous spaces, and dissolving planes of cubism, but still she veiled them in an archaic haze. Steiner casually remarks that these mistier pictures were going out of style and wouldn't have made her any money; she'd have learned that fast. She was not naturally shrewd about business, but her sense of what was central to the culture at any moment amounted to perfect pitch.

She had to earn a living, and she was quick to turn each bit of luck to her advantage. On her rounds with her portfolio one day, she saw in the middle of a public square a black preacher on a soapbox cutting the air with his hands as he exhorted an audience of—pigeons. No one was in the square. Only the birds flittered off the pavement as he sent forth his message of salvation. A photograph, a sure-fire photograph! Margaret had left her camera at home. She raced down the street to a camera shop, burst in, and begged the clerk to rent her or lend her a camera. Bemused, the man handed her a Graflex. One more stop, for a bag of peanuts. Ah—the preacher was still there, preaching the return of the prodigal son.

The pigeons, unsatisfied with the sermon, had retreated across the square. Quickly Margaret corralled some small boys and instructed them to toss peanuts before the orator, much as she had once thrown pennies before a crowd of ragamuffins in Canada. The pigeons returned, and a congregation gathered round, outside her camera range, to see what was going on. She could always attract a crowd, and she was already adept at keeping an event going long enough to be recorded by a slow and bulky camera. The magazine of the Cleveland Chamber of Commerce bought her photograph for ten dollars, the first photograph she ever sold commercially. Although the career she was about to forge had little to do with human interest or momentary events, the preacher and the pigeons did foreshadow her later exploits in photojournalism.

She returned the camera to the store. "Everything about the camera clerk," she wrote, "seemed stepped up above the ordinary." Alfred Hall Bemis was short, stocky, and as powerfully built as a wrestler, his hair was thin and his glasses thick, he never spoke but he declaimed, and his enthusiasm knew no bounds. Margaret thought that had she not met

him someone else would have come along to guide her, for she believed that "a burning purpose attracts others who are drawn along with it and help fulfill it. But one would need ten others to replace a single Bemis." She had found another mentor.

Beme, as Margaret called him, was clearly enchanted with the young woman with the blazing eyes and ambition. With cast-off bits and pieces, he built her an enlarger. He gave her pointers on technique. He hammered home a lesson that became a kind of underpinning for her career: "Listen, child, you can make a million technicians but not photographers, and that's the truth."

In fact he provided her with a set of photographic rules that became a permanent part of her equipment. "If it's a picture you want," he said, "why not blow the whole blooming roll on it. If it ain't worth a dollar it ain't worth taking." She never stopped after that; she took more photographs than anyone thought reasonable. He told her, too, that one camera would not, could not, do everything she'd want to do; she'd need "a pot full of them." And so she traveled ever after with something like five cameras in tow. He gave her one piece of advice over and over until it was burned into her receptive brain: "Go ahead, little girl. Shoot off your own cannon." It doesn't matter what others are doing, what others have done—her parents would have said the same—"Shoot off your own cannon." The exaggerated camera clerk with an enthusiasm as elastic as her own was an apt teacher and Margaret a student to match his intensity.

He took care of her too. After she'd walked her portfolio so far across Cleveland each day that she needed new heels on her shoes every afternoon, Beme, knowing her thoughts were on her career to the exclusion of ordinary matters, would sit her down to a good hot meal. When she told him she needed something special to keep up her morale, he signed for a fur jacket she couldn't afford. (Margaret never forgot a mentor. In 1955 she was still sending Beme money.) He also got Earl Leiter, a crackerjack photofinisher, to help her with the tasks beyond her skills.

Earl, a married man, fell half in love with her. "It has been very odd about Earl," she wrote in her diary. "From the beginning when he seized me and astonished me with a kiss such as I had never received before, through the time when he would look into my face sadly and intently, shaking his head and murmuring repeatedly—'Those eyes,—I can't understand the eyes. . . . They are stern, there is no expression in them . . .' to now, when he calls me 'Pretty kiddo, such a little kiddo,' and does everything for me . . ." Earl, who had no idea that she was a married woman, understood that she had built a wall around her emotions. She said that Earl "wouldn't take me if he could have me, because 'It

wouldn't be all of me.' " But she relished the adventure in flirtation, the new sense of power and the possibilities of abandon. When Earl came in late one evening hopelessly drunk, Margaret tucked him onto her couch for the night, exulting in the new bohemian estate of being alone with a man in her apartment—never mind that alcohol had rendered the man incurably safe.

Men had strong reactions to Margaret. Conscious of her own attractiveness, wound up like a coiled spring, impatient with energy, she created around herself a magnetic field of excitement. She appeared at first naive but had already seen too much and was eager for more. Men who came into her orbit began to love her, or, in a few cases, to fear her.

Beme and Earl were Margaret's champions. They would work through the night on her projects and fill in where her skills petered out. The next day, Earl would come back in the morning to run her carpet sweeper.

Margaret landed a job from Pitkin and Mott, two young Cornell architects who had built a school that *Architecture* magazine had offered to feature. It had been photographed, but the pictures weren't satisfactory, so the two architects offered a very happy young woman five dollars a picture for better photographs.

She soon discovered the difficulty. The unlandscaped schoolhouse stood in a most inglorious field of muck and debris. Margaret had a solution: photograph the building silhouetted against the sunset. Alas, the sun set on the wrong side. Ever resourceful, she went to the school four mornings in a row at dawn to catch the sunrise. Only clouds greeted her. At last the sun blazed over the horizon—and revealed piles of litter straight in the path of every good view.

Margaret's father had given her the mind-set of a problem solver. She bought an armful of asters, planted the cut stems in the mud, got down on the ground (as she often did for architecture), and shot the building through a fringe of flowers. A movable landscape, the asters were planted in one place and another until the job was done and the flowers sagged on their stems. The architects were delighted with their newly landscaped building.

Architects began to hire her to photograph the houses they had built for Cleveland's landed gentry. She knew so little of technique she ruined negatives over and over and did not dare accept a job unless it gave her leeway to take the same pictures repeatedly. She lived in a tiny studio apartment (her mother and brother lived in Cleveland, but Margaret was far too independent to move back home) and developed her films in the kitchen sink, rinsing them in the bathtub. This operation always took

place at night, for she had ruined yet more negatives before realizing that she could not make the kitchen light-tight.

She had tried living with Chappie again, briefly; it did not take. And so they became friends. He would drop in to visit her while other friends and suitors buzzed about. Decked out in red gloves and hat and a charming air of eagerness, Margaret was the sole woman in a world of male architects, businessmen, and photographic technicians. Having attracted a clutch of admirers who wished to win her favor, she rapidly learned how to make use of them for carpentry, moving, household chores. Neither Chappie nor Margaret ever let on in the presence of her admirers that they were husband and wife. It was their private, ironic game, and it gave a mischievous fillip to the obvious popularity of a former wallflower.

"It amuses me also," she wrote in her diary, "to have this semi ex-husband of mine come up and sit around quite sociably, his status quite unknown to the others. I have a traffic cop that I give my No Parking tickets to. Chappie suggests that I bring my cop up here with his semaphore to keep order in my place while my boyfriends do my work." She was entranced with her newfound power over men. "What a funny time I could have when I go to New York, if the several gentlemen in the Union Trust Building who expect me to let them know when I go so that they can be there to take me to the night clubs should be directed to meet me at the same time and the same place."

Her photographs of gardens and estates began to bring in a little money. They were marked by strong design, vigorous contrast, clarity, and, at times, the orientalizing design principles of Arthur Wesley Dow. These pictures never reached the level of abstraction of some of her college photographs. Made on commission, they had to put a good face on the elements of status and design which were dearest to the hearts of patron and architect, rather than on the pattern that could be extracted from them. She never failed to give the places romance, taking every advantage of lacy foliage, dappled shade patterns, reflecting pools, views through grillwork. Then, ever conscious of appearance, she packaged the portfolios like unique and high-class artifacts. For a home with a carved oak door and massive hinges, she had a craftsman carve a small wooden replica of the door, which she used as the cover for the book of photographs.

Convinced from the outset that she was an artist and therefore a cut above her patrons, she was learning to take appropriate advantage of the rich. "I am realizing more and more," she confided to her diary, "that the only way to make ninety per cent of my wealthy clients appreciate the work is to charge simply unheard of prices. I suppose I shall often

hate turning these things over to them, which seem so intimate a part of myself. It is almost prostituting oneself for money. I get back at them, however, by enjoying their estates more than they ever can. I am not fond of their so prevalent attitude, that *your* art is something they can buy with *their* money. Art was never meant to be bought."

The estate pictures are highly competent and might ultimately have made her a decent living, but they would not have made her a world figure, and she was learning too fast to stay with them. Already in 1929, when it appears she was still photographing estates, she told a reporter that she refused to photograph babies, gardens, or sunken pools. "I dislike bothering with obvious prettiness. Why shouldn't a garden or a lily pond or a lovely old doorway make a beautiful picture? Some architect or decorator has already created it and labelled it beautiful."

Margaret, who had never fastened on minor goals, was peculiarly well equipped for the major ones. She was like a Geiger counter of her times, instantly responsive to cultural change and possessed of an extraordinary sense of timing. Highly intelligent, she was not an intellectual, a theorist, or an original thinker, but because her interests ran in the mainstream a small distance ahead of the great popular tide, and because she had an unerring intuition about the new uses of mass communication, she pioneered in more than one area. One small step ahead is quite sufficient to ensure frontline status.

Margaret won her first fame not from the houses of rich men but from the major construction and major industries that supported them, which were far more vast, more urgent, and more alive in the public imagination. "I loved it [the estate work] but I felt that wasn't the ultimate goal, [but] the means to an end. The thing I really wanted to do was to take industrial photographs. I knew that from the beginning. I didn't know whether I would ever be able to sell them. I didn't even realize I was doing something very new. But the impulse was so strong that I had to take industrial pictures."

Fame came fast, but first she courted it with the exacting devotion to work she had learned from her father. "It was an exceedingly happy time (though I was working terribly hard—took my pictures and saw people during the day—spent most of the night, and sometimes all night, catching up on developing and printing. I remember I didn't even stop for Christmas Day.)" Hard work was part of her happiness. A lot of Americans in 1927 had the idea they were supposed to be happy—jazz babies, liberated women and loose-talking men, trusting in Calvin Coolidge and singing the popular songs of that year, "Hallelujah," "Blue Skies," "Let a Smile Be Your Umbrella." Margaret was locked in her own world, and it suited her perfectly.

In the summer of '24, Margaret had roamed the docks and steel foundries of Cleveland and dreamed of a photographic essay of the city. Now she was let loose on the magical wasteland known as the Flats, which beckoned like the Emerald City of Oz. Cleveland stands on a site designed by God for an industrial era: the city fronts on Lake Erie and is bisected by the Cuyahoga River, thus lying endlessly open to the shipment of raw materials and finished goods. Ore loading, iron smelting, a variety of manufacture and industrial processes, long ago sprang up in the river bottomlands to stare directly at stout and proper office buildings a few hundred feet across the water. Industry is unavoidable in Cleveland. From the highways, from the boardrooms of insurance and real estate companies, the view fans out over a landscape of inverted cones and humpbacked pipes, belching smokestacks, grinding trains. Only the Cuyahoga separates the two worlds, and sometimes not very well—from time to time the river would start to burn and the fire department would dash out to squelch it.

In the industrial flatlands, dark buildings and huge pipes rise up like monsters. Steam blasts from hidden openings, and at unpredictable intervals sudden bursts of flame cast a lurid and flickering light across the metallic landscape. The place has the barren beauty of a demonic invention. Margaret was drawn to the Flats repeatedly in a state of high excitement; she spent every spare minute, every Sunday, and every spare dime there with her camera. The trains that had fascinated her so for years, with their promise of progress and travel, slid between loading platforms and docks with shrill cries. She photographed engines, bridges, smokestacks, hulking factories, the whole mechanical desert before her eyes. She had walked into her element.

With her bobbed hair (she had finally cut it at Cornell) and her high heels, she cut an odd figure wandering down by the riverfront at night. Suspicious policemen followed her; when she explained in her intense and innocent way what she was after, they became her escorts and assistants. During the day she spent hours clearing garbage out of the path of her viewfinder, a one-woman committee to beautify the Flats. An audience would gather to watch this unlikely performance. She was back on stage, and it was heady.

The new Terminal Tower, lording it over the Flats from across the river, drew her camera like a magnet. The twenties were the skyscraper era: across the country, cities lifted new profiles high and jagged into the air. The twenty-eight-story Terminal Tower seemed to her "the most beautiful thing in my entire life." It signaled the fortune and daring of the two Van Sweringen brothers, recluses who shared a fanatical dedi-

cation to the holy realms of work, money, and railroads. When they built a new Cleveland suburb, the brothers had had to build a railroad to make it accessible. That whetted their appetites. By the late twenties they owned more railroad mileage than anyone in the United States, by 1930 were included on one diplomat's list of the sixty-four men who "ruled America," and with the Terminal Tower they marked Cleveland's transition to an entirely modern metropolis. The Tower was the first attempt ever made in this country to unify the entire mass-transportation system of a city—through trains, local trains, and streetcars—under one roof. Margaret surely knew what the Tower signified for the city's economy and its pride.

In 1927, the Tower was not quite finished, which doubled its fascination in her eyes. "I always loved things that were under construction better than things that were finished," she said. She looked at the Tower, looked at the Flats, with the eyes of a lover who is lifted out of the reach of ordinary responses. "I can't describe the feeling of rapture and real ecstasy that I had when I got to all that industrial activity."

Ten years later she would say, "I worshipped my father. Those childhood Sundays in the printing plants, where he was superintending the installation of rotary color presses he had invented, are the happiest memories of my early life. And now, whenever I go on a job, I always see machinery through my father's eyes. And so I worship factories."

Amazingly, Margaret had arranged to recreate for herself, over and over with a camera in her hands, what amounted to a peak experience of her childhood, when machines turned magical and poured flame. In the industrial zone, with her eye to her camera and the fires of technology dancing on her ground glass, her sense of life expanded infinitely, as if at her command.

Her father had blessed the entire industrial landscape. Once, in the Flats, she passed a great ore pile with a view across it to smokestacks and a steaming train. She took one photograph and knew immediately that was enough. In 1919, on the trip to Niagara, her father, too, had photographed an ore pile and she had noted it down in her diary; she saw the whole environment through his eyes. Her preference for things under construction rather than things finished might also have been born at the moment her father revealed to her the wonder of industrial processes. At any rate, that preference explains much about her industrial photographs, which concentrate on movement, dynamism, construction, process—pouring metal, teeming steel, coke being quenched; scaffolds; derricks; and always a gust of steam as the factory fires up or the train cuts across the field.

She photographed the Terminal Tower by day and by night as it

neared completion, through the arches of bridges, from across the waters of Lake Erie, past engines steaming along the Flats. She had tried to take its portrait up close, but she did not yet have the effrontery, the clout, and the ability to move mountains that would be her stock-in-trade. Policemen would not let her stop traffic to set up her camera, watchmen sternly shooed her away from dangerous perches on nearby buildings. She took to the Flats from necessity, and immediately saw that the drawback of distance could be turned to brilliant advantage.

> In that last of all places . . . I found contrast, or at least the beginning of an understanding of contrast, and on a gigantic scale. This is an essential quality in the making of a great photograph. . . . It is what the late Joseph Pennell sought, and found, in his immortal etchings of derricks, dumps and smoke stacks. It is the reason why I like to take pictures of industrial scenes —or at least a major reason.
> Contrast lends itself to description graphically more easily than it does with words. Even in its most complex combinations, anyone can understand most photographs.

Margaret remarked often that she was untutored, uninfluenced, and mercifully free of art directors' demands in the beginning, when she was forming her style. "I have never been hampered by too much knowledge. I don't know the traditions of photography. I've had to work out my own technique." She liked to believe she was her own invention. And indeed there were few direct influences on her, although visual artists are often more subtly inspired. This solitary mention of Pennell is the only hint she ever dropped of an artistic influence on her early industrial work, nor has his name been cited elsewhere in connection with her work.

A printmaker and illustrator of note, he published *Joseph Pennell's Pictures of the Wonder of Work* in 1916. The opening sentence would have gladdened the hearts of both Joseph White and his daughter: "Work to-day is the greatest thing in the world, and the artist who best records it will be best remembered." An early advocate of the industrial scene in art, Pennell wrote beside his print of a steelworks: "Yet these are the subjects of our age—naturally, scarcely anyone ever looks at them, especially artists." The titles of his prints often speak of the desolation of work, but the images are of enormous, mysterious factories where bursts of light erupt against velvet blacks and power goes hand in hand with theatrics. Pennell's industrial pictures were widely published, some in *The Dial*, which Margaret read. His images were so popular that Charles and Mary Beard cited them in their 1927 history of the industrial era: "Joseph Pennell's urban and industrial etchings, wreathed in steam and smudged with smoke . . . blared forth a new emphasis on materials."

"Wreathed in steam and smudged with smoke"—like a description of Bourke-White's work. Pennell drew smoke and smokestacks, trains and train tracks, steelworks from afar and on the inside, where white fires boiled in the midst of blackness. Margaret would have been struck by his sense of drama, which was the major part of what she called contrast, and by the theatrical effects he could get with a well-placed cloud of steam. Her Cleveland pictures are full of vapors, haloes, puffs of steam. Steam and smoke assured her the momentary, shifting quality and ambiguous space she sought and also stamped her photographs with the impress of romanticism.

She had found her subject and was rapidly finding her style. In the early fall, a friend suggested she take her industrial pictures to the Union Trust Company, which was desperate for covers for its monthly magazine, *Trade Winds*. The public relations officer picked out a shot of the High Level Bridge for a cover, offered her fifty dollars—her fee up till then had been ten—published it in November of 1927, and every month after that for almost five years bought a cover from her. With an assured income, Margaret made herself a new purple dress, bought a beat-up Chevrolet coupe (and christened it Patrick), and saw glimmering before her a career she had scarcely known existed, doing what excited her beyond measure. The bank gave her no direction; she simply brought in pictures, and they chose. She was free to roam between the slag thimbles and ore bridges of the Flats and let her eye decide where beauty and value composed themselves; it was the way she always preferred to work.

She was in over her head, but she never doubted she would learn to swim. Union Trust hired her to photograph a prize black steer that was magnificently, unhappily, and incongruously on exhibit in the bank lobby. The lobby was of pure white marble, the steer an inky black. The contrast was impossible. Beme said she'd need flash powder. In those days a photographer set off a pan of magnesium, which had its dangers and even when properly used made a sound like an explosion and raised a thick cloud of smoke. Margaret had tried flash at college but knew so little and showed so little aptitude that Beme lent her Earl to ensure her safety.

At the bank she had an uncharacteristic moment of stage fright. Earl sized her up quickly. It wasn't hard; she was blank. He slipped a hand under the camera cloth (blue, to match her hat and gloves), letting it look as if she were still doing the work, focused, and with his free hand set off the powder. A gratifying flash was followed by a gentle rain of ashes over the steer, the camera cloth, and the crowd that had gathered round.

Back at the darkroom, Earl rushed out a proof. The bank officials

were so pleased to see their surly steer on paper they ordered 485 copies
to distribute for publicity the next morning. It couldn't be done. No one
had the capacity to make that many enlargements that fast. Margaret
must have put on the steely determination that was part of her work
armor and could galvanize others, for Beme swung into action. That
night he borrowed every ferrotype tin from the store he worked in,
rounded up every available electric fan for drying prints, and he and Earl
worked through the night developing and enlarging. Margaret rinsed the
prints, the only job she was fully competent to do. The bank got its 485
steers and paid her enough to upgrade her photographic equipment.
Beme and Earl had lifted her up on the wings of their devotion and the
sacrifice of their sleep.

The Terminal Tower launched Margaret's career: by the end of the
year she was appointed official photographer for the Van Sweringen
interests. She was not only free to photograph the Tower from any angle,
any place, no matter how close; she was expected to portray its every
intimate moment and dazzling angle. The Van Sweringens were paying
her to feed her own excitement. In January, she asked to rent a studio at
the very top of the Tower itself, where a doughnut-shaped room sur-
rounded the central core of the building's machinery. Her request was
refused; no one could sit above the heads of the Van Sweringens in their
top-floor office. Margaret settled for the twelfth floor. By March, six
months after arriving in Cleveland, she had the best address in town and
no longer needed to develop in her kitchen sink.

On December 6, 1927, she wrote in her diary: "I want to become
famous and I want to become wealthy." From the beginning, fame came
first. "I am fortunate in my profession; thru it I can express anything I
want to, and turn my expressions into cash. I can think of no other way
in which my many sidedness could be brought into such complete use,
my ability to walk into anybody's office, my inclination to word myself in
ways that are not quite ordinary, my knowledge of how to dress, my
ability to make friends of bridge tenders, of coons, of photographers
assistants"—she would shed her prejudice later, but her shyness never
extended to the lower classes—"and Financiers"—and besides, success
was burnishing her manner—"and what Mr. Hill calls my 'passion for
perfection.' This last would be an impractical nuisance with anything
else. With Mother it has led her into a maze of petty detail that will last
her a lifetime. With me it makes me an artist instead of a photographer."

The constricting sense of failure after the breakdown of her marriage
had been vanquished by early success and expanding ambition. By now
Margaret was smug and smart and confident she could achieve whatever
goals should occur to her along the way. Life itself rose up in her exu-

berantly until it seemed to overflow: ". . . this feeling of rising excitement —I knew that I was creating a very interesting life. I knew that I had started on a path that was going to rise higher and higher although I didn't know just what it was. . . . In the beginning I didn't know that I had any special ability and I could see that growing too and I didn't know exactly in what direction I was headed except that it was upward. I didn't know exactly what my goal was. I didn't see a fixed goal but I knew that I was progressing and that I would succeed." She was traveling at exhilarating speed. "I can remember getting into my little third hand Chevrolet which I had named 'Patrick' and singing from the top of my lungs from sheer happiness and adventure and this feeling that my horizon was enlarging."

7

"Machinery Is the
New Messiah"

Margaret's diary of March 24, 1923, when she was still at Michigan, remarked that she'd spent the day reading *Broom* and *The Dial*. She did not say what issues. *The Dial* published Joseph Pennell, and *Broom* had much to say on the new aesthetic of the time: "*The Machine* in its practical and material function comes to have today in human concepts and thought the significance of an ideal and spiritual inspiration." (Enrico Prampolini, August 1922) And: "Through [the scientist] men consummated a new creative act, a new Trinity: God the Machine, Materialistic Empiricism the Son, and Science the Holy Ghost. [The machine is being revalued] and significantly, one might almost say ironically enough, not among the least important, is the emerging demonstration on the part of the artist, of the immense possibilities in the creative control of one form of the machine, the camera. For he it is who . . . has taken to himself with love a dead thing unwittingly contributed by the scientist, and through its conscious use, is revealing a new and living act of vision." (Paul Strand, August 1922) The article by Strand was accompanied by several of his close-up photographs of machinery and machine-tooled parts.

Margaret never undervalued the good luck that clung to her, in large events and small, throughout most of her life. Her diary for October 27, 1928, noted that "It never fails to work. I come back with a lean seven dollars in my pocketbook and an even 68¢ in the bank, and ten minutes after my return the mailman brings in a check for a hundred twenty." And she always understood that her timing was lucky. She said that her father's imprint was so strong she would probably have found industrial photography no matter what the business climate, but in fact she had

begun in the best of all possible circumstances. In 1927, American industry had reached a peak of productivity and profits. The respect that business commanded had been elevated to a kind of national reverence. The time had come for the photographer to inform the capitalist that in the means of production lay the seeds of high art.

From 1923 to 1929, Americans lived on a rising tide of prosperity, swelled by great increases in the efficiency of production. Although employment scarcely increased, industrial production nearly doubled between 1921 and 1929. On October 31, 1925, the Ford Motor Company, which had revolutionized production in 1914 by assembling an entire Model T in a mere ninety-three minutes, began to roll a complete automobile off the assembly line at the rate of one every ten seconds. Throughout the decade, electrification and construction raced forward. Homes that still did not have indoor plumbing were wired for radios and vacuum cleaners. Office buildings mounted story by story toward the sky. Good times began to seem like a way of life. It was thought in many circles that businessmen, harnessing the new technology as well as technologies still to be invented, would soon be capable of abolishing poverty for the first time in the history of the world.

As the cars streamed off the assembly lines into more and more driveways, and electrical turbines generated increasing amounts of energy and cash, business became a kind of religion in America and businessmen the new priests, or at least the reigning social class. As Stuart Chase put it, the businessman in the twenties was "the dictator of our destinies . . . the creator of standards of ethics and behavior" who had become "the final authority on the conduct of American society." Calvin Coolidge, the businessman's champion, was, as usual, more succinct. "The man who builds a factory," he said, "builds a temple, the man who works there worships there." But a writer named Bruce Barton had the final word in 1925: Christ, he said, had "picked up twelve men from the bottom ranks of business and forged them into an organization that conquered the world."

Henry Adams called one chapter of his autobiography "The Virgin and the Dynamo." Margaret had read *The Education of Henry Adams* in college; years later, she mentioned it when asked what five books had most strongly influenced her ideas. Adams wrote that he "began to feel the forty-foot dynamos as a moral force, much as the early Christians felt the cross. Before the end, one began to pray to it; inherited instinct taught the natural expression of man before silent and infinite force." On the whole, Adams was pessimistic about the new force and what it might do to society, but Margaret missed that; she saw only a man bent in prayer before dynamos. In 1928, her pictures of dynamos at the Ni-

agara Falls Power Plant, taken for the stage set of Eugene O'Neill's *Dynamo*, earned her the reputation of "the girl who discovered the dynamo."

O'Neill himself saw the dynamo as both god and devil. The younger intellectuals of the twenties, and many of the more established, had turned against the machine after World War I had unleashed its destructive power and proved the puniness of reason. Once the high-Victorian faith in progress and rational thought died in the trenches of France, the new voices of disillusion and bitterness could be heard in T. S. Eliot's "The Waste Land" and Elmer Rice's *The Adding Machine*. But as so often happens, the majority had not yet heard the news that faith in progress was dead. Pessimism was not a popular stance in the twenties, when the weighty evidence of improvement jingled in so many pockets and the streets were clogged with the new, closed automobiles that made petting a cozy sport for young people in cold weather. In 1927, technology appeared to most people as a cornucopia of endless promise. In January of that year, commercial telephone service was opened up between New York and London. In April, the first successful demonstration of television took place, with the President visible on one experimental screen. In May, Charles Lindbergh flew the *Spirit of St. Louis* across the Atlantic without stop. Most of the nation preferred to believe with Henry Ford that "machinery is the new Messiah."

Margaret did not hear or did not care about the anguished disappointment of the literati. Her role was to express the hopes, beliefs, and interests of the large popular audience that would soon belong to her. All her life she had been preparing unwittingly for the moment in the late twenties when America worshiped industry and wished to be told how mighty was its god.

When she carried her heavy 4 × 5 view camera down to the Flats in '27, the culture had caught up with her reverence for machines, and the artistic community had been exploring both the godly and the demonic sides of technology for some time. In 1909, the Italian Futurists declared that "a roaring automobile is more beautiful than the *Victory of Samothrace*." A few years later, the Dada movement and painters like Francis Picabia examined the world of mechanical production with wit, distrust, and irony; an American, Morton Schamberg, displayed a plumbing trap he labeled "God."

In the twenties, a loosely-knit group of American painters known as the Precisionists responded with admiration to the clean shapes, the implicit geometry, the power and the promise of machine forms. Such artists as Charles Sheeler, Charles Demuth, Ralston Crawford, Louis Lozowick, Elsie Driggs, celebrated the triumph of the industrial age in

highly abstracted compositions. Europeans—painters like Léger and the Russian Malevich—had led the way. The arts experimented with machinery. When Léger made an abstract film called *Ballet Mechanique*, George Anteil wrote the music, scoring for orchestra and a siren. Even the avant-garde had fallen in love with the machine.

Photographers were no less fascinated. In the first and second decades of the century, Stieglitz and Alvin Langdon Coburn had focused admiring lenses on a world dominated by technology. In the second and third decades, as straight photography and modernism in general achieved artistic dominance, European and Russian photographers such as László Moholy-Nagy, Alexander Rodchenko, Albert Renger-Patzsch, and E. O. Hoppé led the way to a modernist machine aesthetic. Americans joined in. Strand (who believed the camera had an advantage in the new art because it was a machine portraying a machine), Edward Weston, his son Brett, Paul Outerbridge, Ralph Steiner, and other photographers found a new source of beauty in smokestacks and ball bearings. In the twenties, a photographic tradition akin to Precisionism gained a secure, if narrow, foothold in this country.

In the early thirties, when Archibald MacLeish worked with Margaret at *Fortune*, he would express shock at how little she knew of painters who were working in a similarly modern idiom, and he whisked her off to museums to take a look. But the machine aesthetic had crept into commercial illustration and design long before Margaret saw its high-art sources; like modernism itself, machine art reached a popular level before the populace could define it.

The aesthetic was consolidated in the Machine-Age Exposition in New York in May of 1927, shortly before Margaret graduated from Cornell, a show that gathered together the marvels of technology and their reflections in art. Works of art by Sheeler, Demuth, and Lozowick, Archipenko, Duchamp, and Man Ray were exhibited side by side with photographs of modern skyscrapers, grain elevators, Russian industrial architecture, the interior of an electrical plant. Also on view were a machine gun, industrial safety garments and masks, a tractor, an airplane engine—the industrial revolution as a way of life.

The catalogue declared: "There is a great new race of men in America: the Engineer. He has created a new mechanical world. . . . It is inevitable and important to the civilization of today that he make a union with the architect and the artist." Ralph Steiner, who saw Margaret frequently in Cleveland, was on the artists' committee for the exposition and had a one-man show within it. He was not the kind of man to keep his ideas about the machine aesthetic to himself.

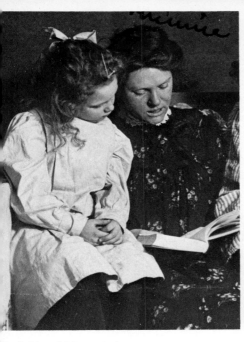

Ruth (?) and Minnie White

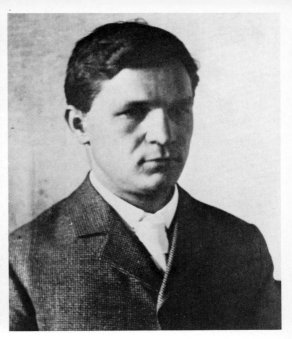

2. Joseph White

Margaret as a baby

4. Roger White

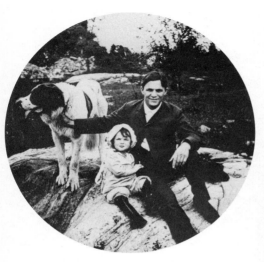

5. Joseph, Ruth, and the family dog

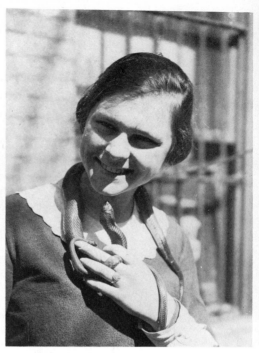

6. Margaret, 1921 or '22

7. Margaret, 1921 or '22

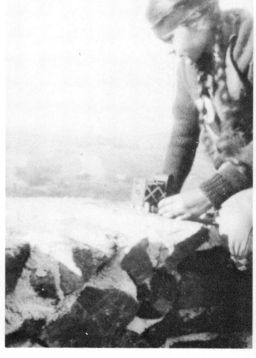

8. Margaret, Camp Agaming, 1922

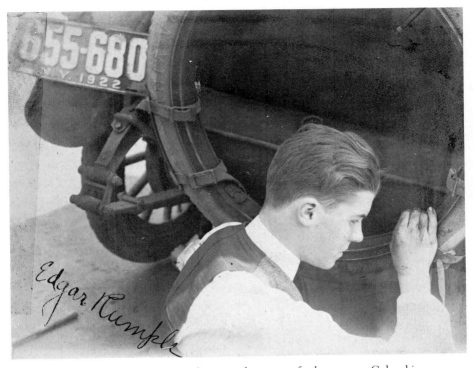

Edgar Rumple

9. One of Margaret's earliest photographs, second semester, freshman year, Columbia
 University, 1922

10. Margaret at the University of Michigan, 1924

11. Everett Chapman

12. Cornell University, taken by Margaret, 1926 or '27

13. Margaret, Cleveland, c. 1928–9

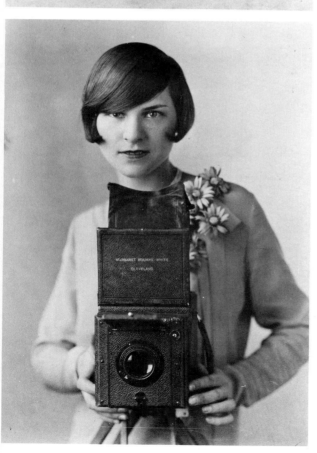

14. Publicity photograph, Cleveland, c. 1928–29

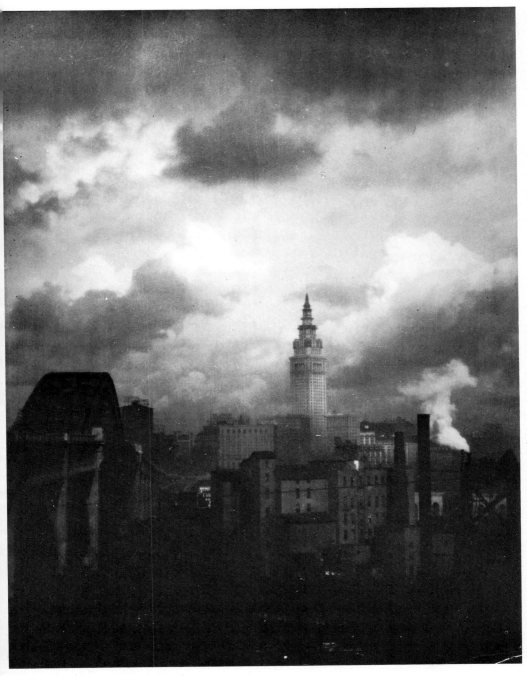

15. Terminal Tower, Cleveland, 1928

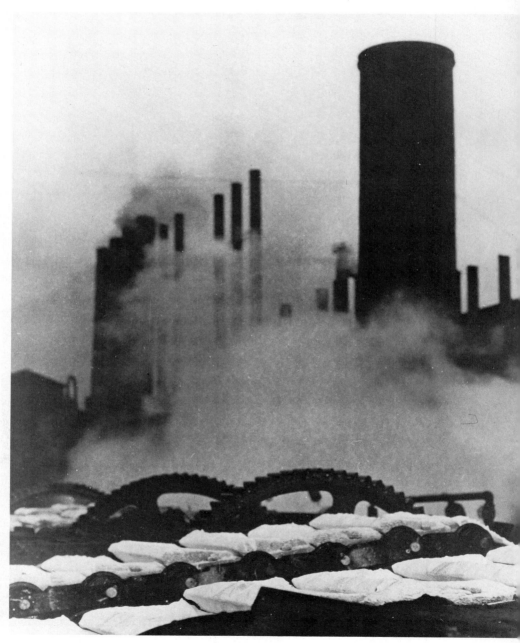

16. "Hot Pigs," Otis Steel Co., c. 1927–28

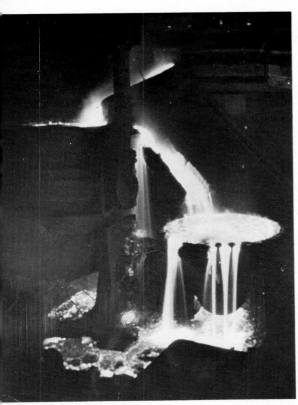

17. Molten slag overflows from ladle,
Otis Steel Co., c. 1927–28

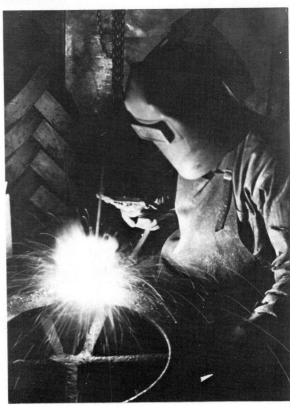

18. Arc welder, Lincoln Electric
Company, 1929

19. Plow blades, Oliver Chilled Plow Co., 1929

Down on the Flats, tracking the industrial age with her camera, Margaret watched the slag thimbles dance away from the mill with their burning wastes and began to think the steel mills must be magical places. Her father's factory had been magical once; now she used the word again. But the mills were fenced and guarded, and the guards would not let her past the gate to the enchanted interior. She wrote in her autobiography that she wangled an introduction to Elroy Kulas, the head of Otis Steel, from the president of Union Trust, whose garden she had photographed. It's more likely, to judge by her diary and letters, that she was introduced by John Hill, a young man beginning a new kind of career, in corporate publicity.

In his autobiography, Hill wrote that he had suggested to his client, Otis Steel, that Margaret take pictures for advertising and for a booklet on the company. In the postwar world, advertising grew prodigiously on a steady diet of new products, consumer prosperity, and new highs in circulation figures for newspapers and magazines. From 1918 to 1920 alone, total advertising volume in America nearly doubled.

Corporate advertising changed because corporate ownership had changed. By the end of the twenties, American business was no longer controlled by autocratic adventurers like Andrew Carnegie and John D. Rockefeller but by a new class of managers who no longer concentrated all the glamour and rapacity of the entrepreneur into one public figure. The institutional advertisement became an important vehicle for promoting a corporate name. You couldn't sell I-beams directly to the public, but you could sell the name of Otis Steel for quality and leadership if you could find an image the public could read easily and fast.

Primed for her interview at Otis Steel and wanting to look right for Elroy Kulas, Margaret rushed to the furrier and insisted he baste her immediately into a high-morale jacket Beme had financed for her. She had to fancy-talk her way into the factory. Kulas recalled that the last woman who'd been inside had promptly fainted away from the heat; Margaret swore she wasn't the fainting kind. He doubted that a steel mill was the right place to look for art. Her excitement and conviction would have made her eloquent on that subject; Kulas agreed to give her the chance to find whatever beauty she could among his blast furnaces. He instructed top officers of the company to see that she was admitted whenever she came, then he went off to Europe. Until she got into the mills, she had no idea what an extraordinarily difficult task she had set herself or how ill equipped she was to perform it. But Kulas's trip—he was away for at least two months—bought her the time to experiment.

She needed all the time she could get. When the great ladle poured its stream of molten metal, the fire blazed up like the light from a plum-

meting comet. Later, Beme remembered her delight the first night as they watched from a balcony:

> You weren't exactly dressed for the occasion. You had on some kind of a flimsy skirt and high-heeled slippers. And there you were dancing on the edge of the fiery crater in your velvet slippers, taking pictures like blazes and singing for joy.

But the pictures were unreadable. She was working with a slow lens, a slow emulsion, a paper that could not handle the contrast. The pouring metal that seemed so brilliant in fact gave off much more heat than light; she hadn't sufficient light for the exposure. Photography itself was ill prepared at that stage to record the industrial processes that could move Margaret to song. Beme and Earl went back to the mills with her several nights in a row with floodlights, flash powder, a faster lens, better equipment. Nothing worked. The officials at Otis, never happy with the idea of a woman in their male domain, watched the young woman who used to climb fences venture up into places they'd forbidden her to go. She would not stop. They threw her out of the mill.

"A few days after she started," John Hill wrote, "I had a call from the night superintendent of the mill. He demanded that I keep 'that girl out of the plant.'

" 'She's crawling all over the place,' he said, 'and the men are stumbling around gawking up at her. Someone is going to get hurt, and besides, they're not getting any work done.' "

Margaret coolly assessed the problem. "I'll wear blue jeans," she said, and went back into the mill. She used Kulas's name for everything it was worth—anything to buck the opposition. Soon she was living for the mills, night after night, struggling to put the high drama down on paper. She does not mention paying Beme or Earl, but they trudged into the factory with her at night to lay cable for the lights, then limped home at late hours to develop film that refused to register the momentary inferno in the mill. Margaret had been trained in fearlessness and brought up to believe in solutions. She moved in closer to the source of light.

"There were times when the men erected a metal partition to ward off the intense heat while I set up my camera close to the pouring metal" —she had already convinced more men than the two who came with her to aid her quest—"and occasions when I stood on the floor amid the flying sparks with a great 200-ton ladle towering above, spilling the fiery contents into the ingot molds, a man on each side of me ready to snatch me away if anything happened."

Sometimes the cab of the crane would shudder and her pictures

blur. Sometimes she crept so close to the flame that the varnish on her camera blistered and her face turned red as if from sunburn. Nothing stopped her—and nothing came out on her film. Beme got discouraged first and said he was leaving to go read the book of Job.

Beme found the answers not in the Bible but in a new technology. A traveling salesman came through Cleveland bound for Hollywood with a dozen samples of new flares he claimed could light up a hole in Hades. Beme talked him into the steel mill, and Margaret, with her youth, her enthusiasm, her certainty, must have talked him into the rest. He tried two flares for one shot; it wasn't enough. Throwing caution away, he used four flares at a time during the pouring of the heat, thirty seconds to a flare, while Margaret steadied her Ensign Reflex on a rail and set exposures of eight seconds, then four, then two, and at the end of the pour raced to get closer with a hand-held camera. At the last moment, as flaming steel streamed down and sparks rocketed across the gloom, the salesman lit the eleventh of his twelfth flares.

When they developed the film, Margaret had it all: liquid metal, vaporous heat, and the hulking shapes of industry. The negative taken with the sacrificial eleventh flare was curiously blank, with black lines curving across it in regular patterns. They stared at it with misgiving. "Suddenly Beme started dancing up and down. 'Kiddo I know what those are. Those are sparks.'. . . I HAD PHOTOGRAPHED THE PATH OF THE SPARKS."

The triumph of the negative died away in the prints. The spectacle she had wrested from the steel mill with extravagant light and unyielding effort turned dreary and staid on paper. Beme said the paper hadn't enough latitude; the film had captured a far greater range of light than photographic paper would reproduce. Beme pulled another traveling salesman out of his capacious hat, this one a retired fellow who had taken up proselytizing for a newly imported paper with a richer emulsion and a longer scale of grays. He made Margaret's prints sing. The steel mills were now hers by right; it was almost as good as owning them.

This second salesman also taught her about printing, how to keep her fingers moving while dodging the deep shadow areas, how to burn through the highlights that were too dense in the negative. She had never before understood that a photograph is a continuous creation, from its composition on the ground glass to the balance and sonority achieved in the darkroom. Margaret would never be a master printer, and after the early thirties she rarely printed again, but from this time she knew exactly what she wanted in a print and had a firm idea of how to achieve it.

At the end of February 1928, as she pulled the photographs of ladles

and mud guns from the developing tray, Margaret was so emotionally exhausted she could no longer tell if the pictures were good or bad. Doubts grew, larger than the obstacles she had overcome. John Hill came to look, studied the photographs for some time, then announced: "I feel like jumping up and *shouting*." There. There! She was launched into the still-new field of industrial photography.

All her dreams coalesced; her lifework would be worthwhile. "It gives me an immense amount of satisfaction to work with these things which are vital and at the very heart of the life of today. It seems a healthy and true place to find art." In the midst of industry she burned up excitement the way some people burn calories. "I particularly love the view that shows nothing but a forest of smokestacks. I am glad that it is good, because it was so exciting to go up and take it through the carbon monoxide gas, on the top of a coke oven, with my guide posted at the foot of the step to run up and catch me if I should keel over."

The woman who walked into Elroy Kulas's office after he returned from Europe was nervous but refused to show it. She carried with her a large fund of confidence and as if to show it wore a new, short dress she had made for the occasion—red, not precisely a retiring color. Certain her pictures were good, certain they could convince Kulas that his dim, noisy factory was an object of art, she presented the photographs for his inspection. In her autobiography she wrote that when she first requested entry to the mill she assured him she wasn't trying to sell him anything, and that when she showed him the prints she said he could have them for nothing, but if he chose to pay they would cost him a lot. Her diary, however, doesn't mention any gestures so grand as offering to give her pictures away.

Saw Kulas today with the finished steel series.

"And what is the basis on which we are doing this work?"

"You are simply to choose from the finished pictures I submit, however few or many you wish.

"I am afraid you will fall over when you hear my price. . . ."

And he protested that he did not fall over, but felt that not only were the pictures worth it, but I deserved to be encouraged for my pioneering work.

So I am getting—the hundred dollars a picture. (Shades of a year ago: peddling 8 × 10's at a dollar each.)

She was quick to pick up the relations between appearance and money. The publicity director of the Union Trust had advised her to wear her most expensive clothes when she negotiated the rent for a studio in the Terminal Tower. "Things are cheaper when you wear good clothes," he told her. She used the advice so expertly she talked the

rental agent out of sixty dollars' worth of tiles to match her favorite dresses, then bought a luxurious and deep armchair for people to sit in when signing checks. "It is so comfortable that my clients will not get up and leave when I name my price."

She asked Kulas a hundred dollars a picture—John Hill said he suggested the figure—to set the seal on the value of her photographs. Two years later these pictures were made into the booklet Hill had in mind, a small limited edition for the corporate clients of Otis Steel. A perfect example of the new emphasis on institutional advertising in the age of the managerial revolution, *The Story of Steel* was as beautifully produced as any book of art masterworks. It spread Margaret Bourke-White's newly hyphenated name among large industries and brought her a good deal of work.

(Margaret had given herself the double name when she began her career. She was born plain Margaret White, but Minnie might have given her Bourke as a middle name early on. The name Margaret Bourke-White, certainly more memorable than Margaret White, was a good business decision, but it was more than that. Bourke-White assured her an image she was pleased to convey, what with its Irish beginning, its English finale, and its shortcut to the British upper classes in the middle.)

In May of '28, her picture of the mill's two-hundred-ton ladle won first prize at the Cleveland Museum of Art show. Six years later she wrote Kulas to thank him and John Hill again for their patience and faith in her. "I feel," she wrote, "that my experimental work at Otis Steel was more important to me than any other single thing in my photographic development."

At almost the exact moment that Margaret was wrestling with light values and recalcitrant equipment in the Otis Steel plant, Charles Sheeler was taking pictures of the Ford River Rouge plant which would become known all over the world and would give industrial photography a small boost in status. It is most unlikely that Margaret knew Sheeler's photographs before she began working in the mills, but they would not have escaped her notice long. In 1930 she herself photographed the River Rouge plant and won the Art Directors Club medal for one of her pictures. This recognition must have confirmed for her that her work was on a level with Sheeler's and with the best in the field, for seven years later she chose that prize-winning photograph for publication as her best picture. In the late forties, Margaret inscribed a copy of one of her books to Sheeler: "It is a pleasure to sign this book for Charles Sheeler, whose work has taught me so much."

Both Sheeler's work and Bourke-White's celebrate the force and the splendid design of technology without paying any attention to the worker. (Precisionist art in general ignored the men who made the machines perform their splendid services.) Occasionally, Bourke-White's pictures do show workers tending the ladles and ovens or standing about to give scale, pointing up the vastness of technology and the smallness of man, but machines are the true subject. A new utopia had opened up in the mind and art of the twenties, a utopia whose beauty, sanctified by the artist, had absolved it of problems. Cool and clean, it had been swept free of the men for whose salvation it had been erected.

Margaret could have learned from Sheeler how to depict complex structures with pristine clarity. His work might have reinforced her father's lesson that industrial forms were beautiful precisely because they were functional, but her style was essentially different from his. Sheeler's River Rouge plant is a place in stasis, its powers only implicit. Bourke-White's Otis Steel and much of her other early work defies measurement and easy comprehension. She photographed from below and above, through barriers, against the light. She climbed on tiny platforms, she lay on the ground to look up at a ladle or a derrick as once she had looked up through flowers at a school building. She moved in close for abstraction and for drama. Consequently her pictures lack the easy reference points of floor or earth and horizon. Often the viewer seems to hover with the photographer six or ten feet off the ground, like an angel that is slowly dropping ballast.

Space, cut off from its moorings, is even more ambiguous. Near and far objects overlap in silhouette, preventing the eye from reading distances. Hot iron pigs cut across the foreground of one picture, smokestacks floating on steam march behind into an unfathomable sky. These are the unclear, interpenetrating spaces of cubism.

Everything in these photographs—the light, the clouds, the tilting ladle, running metal, bursts of steam, trains in the valley—is moving, shifting, changing. Margaret's pictures, taken with a relatively slow and cumbersome camera, convey the excitement of the photographer's struggle with and triumph over the moment, a struggle that is both the glory and the limitation of photography. Sheeler, Weston, and Strand were interested primarily in forms; she preferred process. The beauty of functional design swayed her too, and her eye and mind instantly grasped its potential, but it was the dynamism of industry that made her heart leap. "I can't describe the feeling of rapture and real ecstasy that I had when I got to all that industrial *activity*." (Italics added.) The pouring metal of her childhood, her preference for things under construction rather than things finished—these crowd into her early work. Hers is an

industry that teems, runs, pours, a place where heat flares and sparks beat a tattoo against the surrounding dark. It is a place of vivid drama, presented by a photographer whose dramatic sense had been sharpened years before.

Margaret's Cleveland pictures, full of vapors, clouds, and dramatic contrasts, stamp industry with high romance. It was this romanticism, this juxtaposition of strength and softness, drama and mystery, as much as her apparent artistry, that made her images so accessible and so immediately successful. (This accounts, too, for the fact that some of them seem dated and the lesser images rather overblown.) A nation that had come to worship at the altar of industry was delighted to discover that the world of technology was neither so cold and alien nor so drab and dull as had been supposed, but instead was an eloquent spectacle contrived by the new visionaries.

Margaret herself had a touch of the romantic and visionary. Reporters who interviewed her often claimed, incorrectly, that she was the first industrial photographer. She never made such claims herself, yet from the beginning she cast herself in the role of a prophet of the new age, calling upon others to gaze steadfastly at the future with her. In 1928, she met an older man whose devotion to "the classics" was so intense she thought he had "backward turning eyes." She wrote in her diary that she wished to show him "the glorious beauty of this newborn industrial age. . . . It is for people like Elvin that I am taking pictures of steel mills and ore piles. The beauty of the past belongs to the past. It cannot be imitated today and live."

No wonder her confidence in herself was as large and galvanic as an industrial process. Industry, photography, and Margaret Bourke-White dwelt in the living center of the age. In 1930, asked for her views on industry and art, she sent this telegram: "BELIEVE ANY IMPORTANT ART COMING OUT OF THIS INDUSTRIAL AGE WILL DRAW INSPIRATION FROM INDUSTRY BECAUSE INDUSTRY ALIVE, VITAL—STOP. ART MUST HAVE FLESH AND BLOOD—STOP. INDUSTRIAL SUBJECTS CLOSE TO HEART OF LIFE TODAY —STOP. PHOTOGRAPHY SUITABLE PORTRAY INDUSTRY BECAUSE AN HONEST KIND OF MEDIUM—STOP. BEAUTY OF INDUSTRY LIES IN ITS TRUTH AND SIMPLICITY. . . ." Margaret had arrived at the kingdom her father had promised her, where her personal benefit contributed to the benefit of all, and where the great triad of work, truth, and beauty eternally held sway.

"I Can Do Anything I Want to with These Men"

I feel that I should make a note of the date of my divorce so that I shall not forget it. (Feb. 18) The whole affair seems so little a part of my life any longer. Yet I do feel that it was somewhat dramatic, what with John Sherwin off in Florida, planning to seduce me upon his return, my several admirers in Cleveland knowing only the little inexperienced girl just out of college, I should slip down to the courthouse on a windy Saturday morning and divorce the old life that exists now as only part of the raw material of me.

(Diary, March 5, 1928)

In 1929, Margaret was hired to photograph the Lincoln Electric Company, where her ex-husband specialized in electric welding. Among the best of these pictures are her photographs of arc welders in sleek industrial masks amid rioting sparks. She must have enjoyed the irony of these pictures, her own private tip-of-the-hat to the man whose loss she thought had thrust her into career and fame.

She was explosively happy that year, with the happiness of those who have lived through such a long stretch of misery and self-doubt that they are convinced life has forever closed its doors to them, only to find the gates swinging wide and success beckoning. Putting failure behind her required a monumental discipline. She deliberately chose to set aside her feelings so she could concentrate on engraving her name on history, for the romance of industry loomed larger in her mind than the transient mortal image of romance, and her experience seemed to have warned her that she could not manage both.

In the twenties, it was becoming more common for women to postpone commitment and marriage until they had built a solid foundation for their careers. A 1926 article in *Harper's* declared that women's colleges were discouraging women from marrying altogether. "A visitor," the writer said, "once asked a woman official in a certain college what became of the girl students after they had left college. The college official

replied that one third profited by their education, another third gained very little, and the remaining third were failures. 'What becomes of the failures?' asked the visitor. 'Oh, they marry,' replied the college official.' "

Women were quite aware, out in the marketplace that had recently widened for them, that they would have to work harder and generally perform better than men if they were to succeed. But ambition alone did not impel Margaret to postpone romance. She was thrust into this decision by the high cost of losing at love; having been through a severe emotional audit, she could not balance her accounts.

Sometime in 1928 she met Nikolai Sokoloff, conductor of the Cleveland Symphony Orchestra. Rather to her own surprise, she threw herself at him one weekend, then drafted a letter of explanation. (It is not clear whether she ever sent it.)

> You have never seen me at work. You cannot know how my work has been all of me, and how unwilling I have been to let anything outside of my work seem important to me—Everyone here knows how independent I am and how unapproachable I am. I made up my mind that I would not allow myself to get fond of anyone until I am over thirty. I shall abide by that, because nothing is so important to me just now as to do something in pictures in black and white with the romance and beauty of industry that has never been done before. . . . I have made up my mind quite definitely that I cannot fall in love with anyone until I am thirty. . . .
>
> You would understand how completely I have gone into exile with my pictures in the first year of mine in business (although I had lots and lots of friends—ever so many of them) . . . I am glad to step out of this intense life I have been living as business woman and artist, and be my human and sincere self for a little while.

The work, her success, expanded as if it were never going to stop. In the first six months of 1928, she had the monthly covers of *Trade Winds* to her credit, photographs in magazines published for Cleveland residents, a two-page spread in the rotogravure section of the *Cleveland Plain Dealer*, and several estate photographs in *House and Garden*. (The first of her pictures in *House and Garden* were credited to "White," but she took care of that fast, and she next appeared with the byline "Margaret Bourke-White.") She was already being called a pioneer. "GIRL'S PHOTOGRAPHS OF STEEL MANUFACTURE HAILED AS NEW ART," read a headline of May 12, 1928.

Margaret's upbringing had endowed her with an apparent simplicity and sincerity. By the end of college she had added a layer of culture, stashed her cotton stockings in the wastebasket, and shed her baby fat for good. The linsey-woolsey child was entranced to find herself a most attractive, silk-stocking woman. Diary, January 13, 1928: "Jeoffrey of-

fered me five dollars a click for the use of my legs in hosiery ads. Will put them in Golden double pointed heels to make my lovely slender ankles even lovelier and slenderer."

She had grown up to fit her generous features. Her hair was fashionably bobbed, and deep side bangs hung down over one heavy eyebrow, emphasizing her large and deep-set eyes. She measured out her life in eye-catching outfits: "Put on my new green dress and green slippers and walked into his office." "Stopped into his office in red dress and gloves." In photographs of the time, she looks confident and smiling, a woman pleased to be looking at the world and pleased to think that it was looking back. In one picture, wearing the purple dress she made herself, she sits with her skirt casually drawn up over her knees and her legs arranged to the best effect.

Margaret knew who was important and cared fervently, and she knew who could be useful. A large cadre of men was working for her in one way or another, or hoping for her favors, or both:

I have two groups of friends, both indispensable: my high hat friends and my low hat friends. My high hat friends are my advertisers, and as long as I have the publicity counselor and the advertising manager of the Union Trust Co., the secretary of the Chamber of Commerce and the Treasurer of the East Ohio Gas company, the publicity manager of the new Union Terminal and the president of the Otis Steel, talking about me at luncheon, I shall never need to buy any advertising in Cleveland. And when they not only talk about me at lunch but invite me to lunch . . .

But my low hat friends do all my hack work. The amount I have had done for me is marvelous, and I could scarcely buy for money all the little fussy jobs that have gone into making my little apartment into the BOURKE-WHITE STUDIO.

Men were virtually lined up at the door to take her dancing or to do her carpentry work. Margaret loved to dance, and never again did she have to wait on the dance floor with her prizes on display—but she had been right, even in high school, about the attractions of being at the top, and now her rising star was always evident. She seemed innocent and eager, yet had an edge of daring. Of course all the executives she worked with were men. In no time at all she discovered the uses and adversities of being a woman in a man's world.

She said many times in her life that women had a more difficult time getting started in the profession but a number of advantages once they did. She remarked that women have to overcome the male notion that females are generally less worthy of confidence because they so often take a fling at something and then quickly throw it over. (Margaret in fact lived her whole life as if to disprove this idea.) A woman's greatest advantage, she went on, is that people are much more willing to help

her, and she might have added that oh yes, please, she'd be ever so delighted if you helped *her*. She was five foot five, smaller than most men, and she used heavy cameras, tripod, lights; gentlemen everywhere rushed to relieve the little lady of her burdens.

George Bernard Shaw once defined the expectations men had of women: "If we have come to think that the nursery and the kitchen are the natural sphere of a woman, we have done so exactly as English children come to think of a cage as the natural sphere of a parrot: because they have never seen one anywhere else." A woman on the industrial scene was an anomaly, and Margaret complained that men's reactions to her interfered with her work: "The chief disadvantage of being a woman in this work is the gallantry and protection which men think they must offer. It's sometimes fairly simple to get permission to take a picture of this and that, but they insist on a workman going along. He thinks he must keep me from so-called 'danger,' and, of course, unless I can go where that is, I can't often get my picture." Corporate officers did not expect a woman to tell them she could wake the beauty sleeping in their factories. When she got inside their offices, however, she made them think. They thought about corporate prestige, institutional advertising, the dubious claims of art. Then they took another look at Margaret and they thought about sex.

Sex was a new element in her business equations, one she quickly realized she could use to her advantage. If men had designs on her, Margaret savored that as a sign of power she had only recently acquired. It is always gratifying for a woman to discover she is sexually attractive to men; for Margaret, who had been rejected in a marriage where sex was a struggle she could not negotiate, it would have been a special triumph. Like everyone else, she would use what she had to get what she wanted, but the fragments of a diary that remain from this time give no evidence that she ever exchanged her sexual favors for the advantages a man in power could offer. John Hill, the corporate publicist who so boosted her career, once tried to kiss her and she refused. "Which was good, and my refusal was good—for it establishes me. And oh how profuse he was in his quite unsolicited protestations that he was not helping me for the hope of any physical return. What a lucky lady I am. I can do anything I want to with these men, and through it all I like them."

She admired and in a way worshiped the businessmen who controlled empires, for she had a taste for power and was prejudiced in favor of those who held it although not blind to what she thought were their limitations: "I stand amazed at the simplemindedness of business men as I come to know them. They remind me of the gods of old: childlike, headstrong, and mighty. Admirable like magnificent buffaloes."

Daily she was increasing her powers of doing anything she wanted

to with them, daily increasing her wish to. She had just discovered, almost a decade after Prohibition began, that she could drink wanton amounts without getting drunk, while all about her the important men whose company she kept were unbuttoning their tongues and telling her everything she wished to know. "It is my great good fortune that I have a good stomach and that drink does not make me talkative. I should be much too interesting." She learned from their drunken chatter that John Sherwin, president of Union Trust, cheated randomly on his wife and knew he could get any woman he wanted. "Isn't it too bad," she asked her diary, "I can't get to Johnnie. How I should love to be the exception." Within three months, she remarked gleefully that Sherwin was planning to seduce her when he returned from vacation. It appears she was waiting to refuse him with a good deal of satisfaction. No mere bank president, however like the gods of old, would find her so easy as the women he was used to.

When a man cast his eye at her, she took a wild, sardonic pleasure in the look. "So Kulas has muttered to John: 'She'd make a damn fine piece of tail.' Oh delicious." Kulas, in fact, had a businessman's small view of the world as a place of barter. One of Margaret's informants reported that when Kulas heard the Van Sweringens were paying her five thousand dollars for her photographs of the Tower, he wondered who was getting her favors in return. "The fact," she noted, "is unshakable, unmistakable to him. Oh gorgeous world." It appeared he would make her an offer himself, and she planned her answer. " 'Yes I have a price. But I am very expensive.' And to his obvious thought that a lady could hardly be too expensive to E. J. Kulas, the multimillionaire, 'My price is ten dollars more than you've got.' " The diary is incomplete, but it seems that fate unkindly denied her the opportunity to make this brilliant speech.

Having learned what her clients were willing to buy, Margaret factored it into her sales pitch. She made herself another new dress, this time with a rather low and very loose neckline. Late in the twenties, when women were just beginning to wear brassieres, some flappers were still binding their breasts, but not everyone obeyed that dictate of fashion. When Margaret took her photographs into the office of some chief executive who she suspected regarded both women and photographs as commodities, she would place the work before him, seat herself on the edge of his desk with a fine informality, and be forced to lean far over in order to point out the particulars of her pictures. She thought this tactic so clever and effective she related it with pride and relish to a friend who thought her pride only slightly less shocking than her relish.

In a few months Margaret had learned just about everything useful

to an ambitious young woman: how to drink, smoke, dress, keep her counsel, use her attractions and promise what she had no intention of delivering, and how to get what she wanted from men in power without paying too high a price. A driven businesswoman and artist both day and night, she hadn't time, as she told Nikolai Sokoloff, for the human side. But sometime late in the summer of 1928, a man touched her emotions once again. Miles Carter (not his real name) was a lawyer with connections to several of the big corporations she worked for in Cleveland, a married man, vastly unhappy, and estranged from his wife.

She fell in love with him against her better intentions. "You know what it meant to me," she wrote him, "to give my trust to you after I had learned to mistrust." If her own observations are reliable, he loved her more humanly, more generously and openly, than he had ever loved before. Margaret was a passionate woman in every respect. She had damped down and trimmed back her feelings only with difficulty; when she allowed them full compass, their depth and clarity were unmistakable. The distilled concentration she brought to her work she could also bring to a lover; more than one man was transformed by the immense flattery of her unwavering attention. And although she had blamed herself for lack of sympathy, she could show in love and friendship a remarkable thoughtfulness in small matters and an almost unending eagerness to please. As Chappie's wife, she had happily sewn curtains and pondered menus; as a lover, she could adopt traditional feminine tactics, girlish flirtation and worshipful manner, a manner that belied her aggressive career image, as it was surely meant to do.

More than one man over the years said she had taught him to love more deeply than he had ever thought possible, yet she herself seems not to have gone so far. She could make a man feel he was her universe, when in fact he might be only the brightest star in her firmament, and only for a moment.

Miles Carter had lived too long with a more restricted view of himself to be able to maintain the better one she offered outside of marriage; not long after their romance began, he dropped her. Hurt and enraged and unwilling to suffer passively through the mounting storm of tension caused by his silence, she determined to talk things out with him. She stopped by his house.

It was a very odd little act that I unwittingly staged on Sunday morning. Having traced him to his home I was delighted to see the little white Chrysler in the yard. He did not answer the bell. I did not expect him to. But I had provided myself thoroughly with cigarettes and the Life of Napoleon, and I made myself quite comfortable in the Chrysler. It had reached the stage of light comedy by then. I knew I had lost my man, but that sooner or

later I would win my explanation, and my head was working clear as a bell so I was all ready for the unfolding of the play. And the play unfolded. Finally the back door opened and a young woman came out.

"Did you ring the bell. It doesn't work. I've been taking a nap—excuse me. Won't you please come in."

I came in, and succeeded excellently in talking about the untimely cold weather . . . and the fact that I had to see Mr. Carter on a business matter that day. After some little time . . . he drove into the yard in the new car he was trying out.

Mrs. Carter went out to tell her husband there was a young lady to see him.

Whereupon he informed her that he was going to drive the new car around the block once more, and that was the last I saw of him—and ever shall see, probably.

Of course the drama of a thing of this kind helps. It was a little funny —my not dreaming that his wife was there. And it must have been a great treat for him to come home and find the newly reconciled and unloved wife with the recently abandoned and adored lover. The odd part of it is that she will be a little nicer to him now that there is "a woman in the case." What a surprise it must have been to her! And a woman in red hat and red tailored dress and matching gloves at that.

This brief love affair graved in stone her sense that love was inimical to work and that emotions in general were too obstreperous to control. "The thing I dreaded most after the close of the episode was the disintegrating process that would block my work, until I could pick up again. . . . Today I have started on the rebound. Again at last I have the love of work and the love of life, and life is a bracing moving thing." But even after she wrote this she stayed in thrall to her unhappiness and humiliation. "Am I, after my past experiences that I had thought such a valuable protection, going to be chained to the memory of a short love like this." She had imagined she had taken such a massive dose of unhappiness in her marriage that it would act as a vaccination and render her immune. She was not so entirely in control of herself as she wished.

Years later there was a bizarre coda to this affair. It had not taken her long to become friends with Carter again; she had a talent for keeping a lover as a friend. In the early thirties, his car hit a pedestrian and he went to jail for some two years. Margaret sent him photographs and corresponded with him during his imprisonment and after, and he told her her support meant more to him than anything else in the dread years in prison. Margaret was like that. She who seemed so self-involved, whose career used up free assistance as fast as film, did not forget a close friend. She had a capacity for loyalty and thoughtfulness that was narrowly directed but infinitely deep.

In Margaret's early years in Cleveland, when she bound a few people to her with strong ties of affection, she also took a certain sly pleasure in seeing people in general as mere objects in her environment, useful or important objects, perhaps, but objects nonetheless. She had a notion that she could manipulate her life as if it were a chessboard and she the player moving pieces. Once installed in her Terminal Tower studio, she decided to run a salon. At this point, the tone of her diary becomes remarkably arch: "I shall serve Thursday afternoon teas to the architects, my artist friends, and the presidents of the banks. And John Sherwin himself promises to pour. And he will, too."

Next she turned to the decor. "Now I must run down the Japanese assistant, who will add just the proper aura to the tea pouring, withall remaining as impersonally in the background as a parchment lamp shade. Only an Oriental would be willing to wear green or purple or orange smocks to match my floor." When she failed to find the requisite Japanese she made do with a blond American. By now her tongue was pressed so far into her cheek that it should have bothered her as she wrote. "I am of course fortunate to have found a big blond assistant to match my interior decorating. I am wondering if he will submit to a green smock, for the sake of the ivory and green work room."

Her photographs were little more concerned with people than her diaries. "During the rapturous period when I was discovering the beauty of industrial shapes," she wrote in her autobiography, "people were only incidental to me"—in more ways than she would have admitted—"and in retrospect I believe I had not much feeling for them in my earlier work." In notes for the book she was more explicit: "I think the important thing is that what I was interested in was the pattern of industrial subjects. I hadn't even noticed there was a man behind the machine unless I put one in for scale." In 1930 she'd urged that art must have "flesh and blood," but the flesh and blood of her art were constructed of cogwheels and flame.

The twenties were like that; pure aesthetics took up much more space than social concerns. When Margaret began her career, Lewis Hine was the only major photographer in industry whose primary interest was the worker, but he came from a background of sociology rather than art. Margaret thought of herself as an artist and had an artist's single-minded tunnel vision: nothing in sight but her art, which did not leave great room for compassion. A newspaper profile in '33 reported that Margaret Bourke-White "prefers industrial subjects to people because she feels they are more truly expressive of our age."

This was partly a matter of politics. At the age of twenty-three Margaret seems not to have formulated a social philosophy, not to have

developed a social conscience, not to have been any more alert to world events than she had been in her teens. Her diaries and letters are crammed with personal events but blank on the execution of Sacco and Vanzetti in 1927, the election of Herbert Hoover in 1928. The working-man did not matter much yet to her career. Elroy Kulas mattered. John Sherwin mattered. They controlled the future, and they poured her tea.

She was ever a creature of her time. Scott Fitzgerald said that it was characteristic of the Jazz Age "that it had no interest in politics at all." James Branch Cabell wrote, in the twenties: "I burn with a generous indignation over this world's pig-headedness and injustice at no time whatever."

In 1929, when Margaret was traveling back and forth to New York, she had dinner several times at her Uncle Lazar's house. Lazar's daughter, Felicia (now Felicia Gossman), had graduated from college that year and was working as a social worker. One evening Margaret spoke with mounting excitement about her work: on a recent industrial job, the company had ordered all the machinery stopped for two minutes while she took her pictures. The wheels of industry turned, or did not turn, for her alone. She regaled the family with the account of how many thousands of dollars this corporation had lost by shutting down production for two minutes to give Margaret Bourke-White's camera scope. Felicia was struck by a thought.

"Gee, Margaret," she said, "it's ironic. You're working for the people who make the people that I work for suffer and who command their lives."

Margaret, attacked, shot back defensively, "I'm working for the people that count."

A year and a half after the start of Margaret's career, the bare outlines of her legend began to take shape. First of all there was her daring. She waltzed over heights like an aerialist in high-heeled velvet slippers. Photographs exist of her poised, in a neat, head-hugging cloche, on a Cleveland rooftop with her camera and tripod. Other photographs show her standing on ledges high above the city with both hands on her camera. None of this was merely a stunt; she would do anything to get the best picture. A ledge high in the sky might be so narrow she couldn't get her camera out far enough to take the picture without falling off; sometimes a man would sit on her legs while she hung out, but in general she preferred not to be held, for she felt safest when relying on her own responses. Besides, she always felt secure with a camera in her hands. She'd be so preoccupied with the work that she wouldn't have time to think about small things like safety.

She was ever testing herself, ever in search of a challenge. "I love the stuff," she wrote in 1928, "and I feel that I am at the beginning of something that will be always new and always vital and always difficult." Later she said, "I was buried up to my neck in iron dust once, trying to get the view I wanted of some smokestacks seen from there. But they pulled me out and I've learned how to pick firmer footholds, I guess." Stories like that, about a girl photographer who wouldn't take a hint from danger, began to circulate.

Then there was the fact that she was a woman in a man's area of expertise. Not the first woman to take photographs of industrial subjects, Margaret was the first and at the time the only woman who was successful in the field. She was a pioneer, for she brought the image of industry to the attention of the American public and gave it a glamour and force it had not had before.

She said she didn't remember any resentment about her being a woman and that other photographers were very generous to her. No doubt in the beginning that was true, but a rumor spread that she was just a front for some man who knew how to photograph, and that a clever publicity agent had concocted her story and taught her how to make it look as if she was actually operating the camera. It took her a long time to live that story down. No one wanted to believe a woman could do a man's job, much less that she could do it better.

By 1929, the press began to smell a story. "DIZZY HEIGHTS HAVE NO TERRORS FOR THIS GIRL PHOTOGRAPHER, WHO BRAVES NUMEROUS PERILS TO FILM THE BEAUTY OF IRON AND STEEL," headlined the *New York Sun* on April 25, 1929. "LITTLE GIRL PHOTOGRAPHER," sang NEA magazine that same year, "RIDING JACKKNIFE BRIDGES, CRAWLING OVER SKYSCRAPERS AND PUSHING HER LENSES INTO WHITE HOT STEEL MILLS FOR JUST THE RIGHT SHOTS MADE MARGARET BOURKE-WHITE A LEADER AMONG INDUS-TRIAL CAMERA ARTISTS OF AMERICA, THOUGH SHE'S ONLY 23 AND JUST A YEAR OR SO OUT OF COLLEGE." (She wasn't twenty-three. She was twenty-five that year, but already she was beginning to take control of her personal history and her legend.)

Her photographs appeared as advertisements in national magazines. *Architectural Record* published a portfolio of her industrial pictures in 1929. Roy Stryker, who would have a powerful influence on 1930s photography through the Farm Security Administration's photographic section, selected a number of her photographs for an economics textbook that was published in 1930. That year, her work was included in the "Men and Machines" exhibition at the Museum of Peaceful Arts in New York.

It must have been in 1929, as her star was in the ascendant, that

Ralph Steiner at last bullied her out of her endless matching color schemes—hat, gloves, dress; walls, floor, assistant; hat, gloves, camera cloth. "We were walking in Greenwich Village," he says, "the first time I ever saw a weakness in Margaret Bourke-White, that stainless-steel backbone, and she said to me, 'You know, I'm having a little dressmaker make a whole lot of dresses, and I'm having the same material used for my focusing cloths.' I started to laugh, and she said, 'I think I'm the best-dressed woman in America.' I exploded!" Steiner stops to think about his explosion. "She had no taste. . . . But she cried. She wept. She said, 'You're the only person in America who doesn't think I'm a great, great photographer.'

"And that's why she came for help all the time," he goes on, "because I didn't think she was a great photographer."

Margaret was smart enough to know she could learn the most from her critics. If she really thought she had only one, that must have been some comfort.

Fortune and Men's Eyes

During his lifetime, Joseph White had pledged his heart and mind to a tangled love affair with the rotary press. His daughter reserved her passion for the camera, which, small as it was, gave her access to the entire, mysterious world of technology. But the machine that assured her fame was the same machine that set her father dreaming: the printing press, which gave her camera its great audience and scope.

Margaret's photographs appeared in tens of exhibitions during the thirties, but these were merely an adjunct to her printed work. She made her name as a magazine photographer. Her early industrial photographs are singularly beautiful in their overall tone, ranging from a deep golden brown through charcoal and sepia to umber, partly because of age, partly because her darkroom man experimented with printing papers. But very few people ever saw the actual photographs. What they saw were the images mechanically reproduced in newspapers, magazines, books. Her career depended on the increased use of photographs in magazines; she was as wedded to the printing press as to her camera.

In early 1929, Henry Luce saw her Otis Steel pictures in the rotogravure section of a midwestern newspaper. The Sunday rotogravure supplement had first appeared in America barely fifteen years earlier, when the *New York Times* began printing on European presses that gave photographs a full range of tones and much finer reproduction than standard newspaper prints. By 1930, successful tabloids had so accustomed readers to seeing photographs in newspapers that eighty weekend papers regularly carried several pages of news, society, and human interest decked out in the pale brown splendor of rotogravure.

Margaret received a cable on May 8, 1929: "HAROLD WENGLER HAS SHOWN ME YOUR PHOTOGRAPHS STOP WOULD LIKE TO SEE YOU STOP COULD YOU COME TO NEW YORK WITHIN A WEEK AT OUR EXPENSE PLEASE TELEGRAPH WHEN —HENRY R LUCE PUBLISHER TIME THE WEEKLY NEWS MAGAZINE." She raced to New York to meet him.

Two tall men were waiting for her in *Time*'s little office. Parker Lloyd-Smith, Margaret said, was lithe, classically handsome, and gifted with a sense of "delight in the ridiculous." He also had the mind, the tailor, and the inclinations of a dandy, having once boasted that at Princeton during the Harvard-Princeton game he had read Greek to a coterie of friends in his room, encouraged by intermittent and wild cheers from the nearby stadium.

Henry Luce would later be described by a Time Inc. man as a "pale, timber-wolf kind of man, quick in his movements, and very decisive in his speech, as frequently happens with men who are afraid they might fall into a stammer." (In fact Luce had a bad stutter that could unexpectedly undermine his machine-gun verbal delivery.) "He had shaggy, reddish eyebrows and cold, pale-gray eyes that hardly ever participated in his rare smiles. . . . It was also instantly obvious that he didn't have a shred of humor to cover any part of his almost frenzied intensity." His mind moved so fast that he leaped from subject to subject without transition, and his desire for facts and information amounted to a kind of avarice. The moment Margaret walked in, he began to talk about the business magazine he had in mind.

Luce intended to produce a magazine as beautiful as any in America. Better still, more beautiful. Business magazines of the day occasionally illustrated their stories with a few straightforward photographs of factories and railroads and a few more of imperious gentlemen sporting mustaches and vests. Margaret recalled Henry Luce telling her that in *Fortune*, "pictures and words should be conscious partners," that "the camera would act as interpreter," and that the magazine should have "the most dramatic photographs of industry that had ever been taken." Clearly he meant to give photography its head, to let it race where it would.

Henry Luce had his fingers continuously on the national pulse. He was not a man with a good eye, a visual orientation, or a connoisseur's love of art. He was not a keen admirer of photographs, yet he founded the first two major photographic magazines of the thirties, *Fortune* and *Life*, and thereby sealed a change in the very nature of reporting. Some say he was actively hostile to pictures, for all he really cared about were ideas and intellectual combat, and as he couldn't argue with a photograph, that rather lowered it on his scale of values. "The visual part of it was news to him," a *Fortune* editor says, "to get the word out." But whether he was hostile to photographs or indifferent, Luce understood earlier than most that they were a new means of communication. Believing that "business is essentially our civilization, for it is the essential characteristic of our times," Luce dreamed of giving business its own

literature, as history and politics had theirs; it was daring and shrewd of him to bring the camera in as an ally.

Margaret, who suddenly saw horizons opening beyond her expectations, was not yet ready to leave Cleveland for a full-time position. *The Story of Steel* had just been published for Otis, and her Cleveland studio was on the verge of a good deal of new business. Besides, she never wanted the certainties of a full-time job. "I always had the feeling," she said, "that I wanted to be partly independent, which is kind of a spiritual thing." She proposed working half-time for *Fortune*.

"Dear Miss Bourke-White," Lloyd-Smith wrote her on May 22. ". . . As to the $1,000-a-month proposition. I frankly don't know whether we can afford to put $12,000 a year in our budget or not. Nor, on the other hand, do you know whether half your time in 1930 plus the very sound advertising which FORTUNE would give you would be worth $12,000 or $120,000. The best way to find out, however, is to try it. While this letter is subject to formal ratification, I think I can safely accept your proposition."

Margaret wrote home the next day: "Mother dear, Full of all surprises. I'm being offered a staff position on a new industrial magazine that is being created to be launched next January. The possibilities are interesting, but there are certain executive phases to the position that I do not particularly care for—simply because I would rather develop as an industrial photographer than as an executive."

On May 29, Lloyd-Smith wrote to say that the directors had given final approval to the new magazine. On July 1, 1929, her proposition accepted, Margaret went to work half-time at $1,000 a month to build up an inventory of stories for the forthcoming publication. *Fortune*, which had first been called *Power*, was scheduled to begin publication at the dawn of the coming decade.

"If it ain't a success," one of her friends remarked, "people will be calling you Miss Fortune."

For Margaret, *Fortune* was like an invitation to the revels; in her notes, she spoke of "the atmosphere of enchantment over those early industrial *Fortune* assignments." No longer did she have to convince reluctant corporation officers with fancy speeches and low-cut blouses; someone on the staff made the arrangements for her beforehand. The staff writers, one of whom often accompanied her, were some of the brightest and most promising young men of the day; eventually they included the critic James Agee, the sociologist Daniel Bell, the economist John Kenneth Galbraith, and the writer William H. Whyte. Luce had decided that "the men who can read balance sheets cannot write. . . .

Of necessity, we made the discovery that it is easier to turn poets into business journalists than to turn bookkeepers into writers." He hired Archibald MacLeish, then working on the long poem *Conquistador* and too broke to feed his family. Luce made him an offer unprecedented in publishing history: MacLeish could work as long as necessary to pay his bills in any one year, then go home to his pentameters. In 1933, *Conquistador* won the Pulitzer Prize.

Archie MacLeish, who thought Margaret a modern artist, went with her to the Elgin Watch factory, where she photographed watch hands arranged like tiny sunbursts as they were touched up with the luminous paint that made them shine. The critic Dwight Macdonald, then just out of college but already a Trotskyite and "an engagingly irritating radical," spilled a suitcase full of rumpled clothes across the railroad station floor the instant he met her. They did a story on glassmaking in which her romantic lighting turned a traditional glassblower into a figure that might have been borrowed from a painting by that seventeenth-century master of candlelight, Georges de La Tour.

It was because Margaret could make industry ring with artistic echoes and could find high drama in business that her photographs became *Fortune*'s trademark and confirmed a widespread admiration for the potential of technology. Dwight Macdonald said sneeringly, "She made even machines look sexy," a remark that summed up his contempt for Luce's taste and enterprises. But Macdonald had it right. When Margaret focused on the boring, forbidding instruments of technology, they suddenly became accessible, beautiful, and unexpectedly glamorous.

Henry Luce went with Margaret to do a story on "The Unseen Half of South Bend." He carried her cameras through the foundries, the first of many men of high position to enjoy that dubious privilege. There was a lot to carry: her 5 × 7 Corona View camera with extra bellows extension and convertible lenses, a large wooden tripod, and a box full of thousand-watt Johnson Vent Lites with coils of weighty reinforced-rubber wiring. Once a ladle of molten steel slipped as she was photographing and began to splash fiery metal about the floor. Luce rushed forward instantly to rescue her equipment.

No one quite knew what to make of this new crew of business reporters. Luce found the South Bend Chamber of Commerce less than excited about his story idea; they had never heard of *Time, The Weekly Newsmagazine*, which he'd founded in 1923. No vice-president or foreman of the factory treated Luce and Bourke-White to three-martini lunches. At the noon whistle, the two of them were usually abandoned and had to find a sandwich wagon with the workmen.

Margaret wrote that the idea of a story dealing so broadly with South Bend was new to her; previously, she had only looked for the best angle

and the perfect individual composition. It had not occurred to her before working with Henry Luce that the "unseen half" of a subject should also be recorded.

Margaret became one of the chief instruments in the promotion of Luce's vision of the news. He had discovered her; he maintained her for years in the top ranks of his magazines. She held him in the highest respect, and by all accounts he returned the courtesy. Certain attitudes writ large in her makeup were enormously amplified in his: they both revered industry and both had a consuming curiosity, although Margaret's was still parochial. Luce charged through every factory with his head and shoulders thrust forward as if to bull his way into resistant information. His extraordinary curiosity, Margaret wrote in her notes, "is raised to the level of genius." Later, she pinpointed the quality that made him so effective in a mass medium: "Interested in what the average man is interested in. As though he was a sort of super-average man."

His achievement was of a different order of magnitude from hers, but their mutual respect must have been strengthened by that silent recognition that sparks between two people of similar ambition and will. Each was marked by a sense of destiny. Luce, the son of missionaries, had determined at an early age that he could be of great service and play a great role. Margaret, who had her own mission and her certainties, was already convinced she was "a great, great photographer," and there was only one other photographer so far who would say her nay.

Fortune bolstered her conviction; it set out to make her a star. The dummy had appeared in September of '29, addressed not to the public but to advertisers, whose esteem and money it hoped to elicit. One of her Otis Steel pictures covered a full page, with a caption that named her prominently: "The Photographer: Margaret Bourke-White of *Fortune*'s staff, now touring the U.S." Under another photograph: "Photographer Bourke-White imprisons the glow of molten metal," and her name appeared in the caption beneath yet another. Not one other photographer was given credit.

In the weeks between her *Fortune* assignments, Margaret took advertising photographs, which paid better than editorial work. She went to Boston in October to photograph the newly decorated lobby of a bank for a series of ads. She wrote in her autobiography that in every spare moment on that job she was reading *How to Understand Football* in order to impress a new beau from Harvard; she hadn't even had time to catch the newspapers. As she wanted to see the football game on Saturday, it was probably on Thursday, the twenty-fourth of October, that she decided she had to work all night in the bank. Nighttime was a good time to work; no one would be around to disturb her.

The bank's electrician helped her set up her brilliant Vent Lites.

Oddly, the bank was humming with officers, buzzing with conferences all evening long. Margaret needed long exposure times, even with her strings of thousand-watt lights, and as vice-presidents bearing memos kept dashing through her line of sight, she had to keep capping her lens to prevent their ghostly, speeding images from registering on her film. Irritated, the electrician began to mutter, "Oh, give the little girl a break," until one man responded with exasperation: "I guess you don't know. The bottom dropped out of everything." Out of what? she wanted to know. "Out of the stock market. Haven't you read the papers? They're carrying everything away in a basket."

No, she hadn't read the papers. In one day General Electric had slid from 315 to 283, Radio from 68¾ to 44½, Montgomery Ward from 83 to 50. At midday, a bankers' pool was formed that shored up the crumbling market for a while; the following Tuesday would be worse, and the bottom was still weeks away. But the ticker tape did not stop its furious unwinding until after seven in the evening, and rumors of speculator suicides and troops guarding the Stock Exchange flew through the air as fast as orders to sell.

Years later, a colleague remarked to Margaret that she must have been "the only photographer in the whole United States who was *inside* a bank that night." In the boom year of 1929, the stock market was on the lips of rich and not-so-rich alike, having become as earnest and popular a topic as baseball or Al Capone, and suddenly more urgent. If it is a measure of Margaret's self-involvement and intense concentration on her work that she stayed innocent of news all day, it is also a measure of the limits of her curiosity, which still had scarcely caught a glimpse of current history.

The great god Business had stumbled, but Henry Luce was singularly undaunted by the event. He thought the crash more reason than ever to publish *Fortune*. Interest in business had only increased, he said, because the problems of business affected everyone.

Luce had a sixth sense about the public's hunger and need for news. *Fortune* started off with thirty thousand subscribers. It cost a dollar an issue, ten dollars a year—real money in those days, when a newspaper cost two cents. Its large size (eleven and a quarter by fourteen inches) made it impressive, its heavy stock and luxurious reproductions made it both beautiful and prestigious, its attention to fine design gave it an inspired unity. The photographs, reproduced in gravure, a process of great richness, were set off by double black framing lines as if they had been matted for exhibition. There were wide margins, charts and illustrations in full color, and soon there would be first-rank artists, including

painters like Charles Demuth and Charles Burchfield. Luce had indeed succeeded in producing the most beautiful magazine in America. The *New York Times* said it was "sumptuous to the point of rivalling the pearly gates."

The lead article in the first issue was illustrated by Margaret Bourke-White. In fact, she had three articles and a portfolio of photographs in that issue; in effect it was Bourke-White's magazine. On the index page, beneath the table of contents, was printed the line "Photographs by Margaret Bourke-White." Although hers were by no means the only pictures, she might as well have been the only photographer, as she had been in the dummy. Under Time Inc.'s policy of anonymous journalism, no writer got a byline in *Time*, nor in the first issue of *Fortune*. Margaret Bourke-White was not just a name in *Fortune*, she was *the* name, as she was *the* photographer.

The lead had been chosen with great care. Margaret wrote that it had to be "an industry at the heart of American life and economy. Photographically it must be an eye-stopper—an industry where no one would dream of finding 'art.'" Parker Lloyd-Smith had first picked tractors: "The subject gave us a running theme which I could photograph, from the factory to the wheat harvest." Red tape ruled out tractors, so the photographer was sent to find undreamed-of art among hogs.

And so she did. She thought the Swift and Company meat-packing plant had "a Dantesque magnificence"; with her unerring ability to frame an abstracted detail, she saw hogs in the pen as endless curving backs, like waves of flesh, and lines of pigs strung up by their back hooves on a conveyor belt (Lloyd-Smith referred to this as the "disassembly line") as identical repeating forms, like identical units stamped out by machines. She spoke of her "pattern pictures of giant hog shapes," as she had spoken of her pattern pictures of industry.

Parker Lloyd-Smith, who went with her to Swift, showed up on the killing floor each day in a silk cravat and an irreproachable suit, his notebook in his slender hand. On the last day, they discovered a building they hadn't yet seen. Inside were great mounds of pig dust, the last, inedible, economically ground up remains of thousands of fattened hogs, mountains of crushed pig to be mixed with meal and fed to other pigs on their way to dusty death. The ocher mountains of dust gave off a stench so fierce that Lloyd-Smith turned pale, bolted for the car and closed himself in with the windows pulled up tight. Margaret simply set up her camera. The light was difficult, necessitating time exposures, and she held a workman in a pose up to fifteen minutes at a time, more than once. Afterward, she left her camera cloth and light cords behind her to be burned; there was no other way to kill the smell. The photograph that

ended *Fortune*'s first lead article looked like a pattern of high sand dunes in filtered light: pig dust, with no stench or sign of discomfort.

This story has an importance beyond its eye-stopping character. Writing about Bourke-White, Theodore M. Brown pointed out that the meat-packing story was a kind of primitive photographic essay, sketched out some years before the form would be fully developed. The essay was a major innovation in the history of photojournalism, establishing the photograph rather than the word as the primary carrier of information. In the full-fledged essay, communication could be complex, adding up to an impression larger than the sum of the individual images. Margaret's first essay is tentative at best, but clearly she and her editors wanted a story that could be narrated by the photographs, for even the tractors they first chose had attracted them for the "running theme . . . from the factory to the wheat harvest." The Swift Company story already marks Bourke-White out as a pioneer in her field.

Margaret's "Portfolio of Iron, Steel, Coal and Ships" in *Fortune*'s first issue paid a wholly private tribute to the two men who had meant most in her life. It opened with the photographs of ore heaps on the Cleveland Flats that echoed, consciously or not, her father's photograph of ore heaps on the trip to Canada. Also in the portfolio was her dramatic image of an arc welder at the Lincoln Electric Company—Chappie's specialty, Chappie's employer.

In March of 1930, Lloyd-Smith wrote Margaret, "I conceive it to be important for us and for you that no issue, for a while at least, should appear without your work." Nor did it. In every issue but one that year, *Fortune* published one, two, or three articles or portfolios credited to Bourke-White. It was *Fortune* that first spread her name far beyond Cleveland. "*Fortune* made her," a reporter wrote in 1940. "She didn't make *Fortune*, but if the magazine ever had a trademark, it was Bourke-White."

Fortune never had a huge circulation. Its very existence as a high-priced, luxury magazine about business during hard times amounted to a minor miracle, but it stayed alive and healthy, increasing its profits gingerly as the Depression deepened. The magazine quickly became a coffee table status item, looked at not by millions but rather by those who controlled millions, or aspired to.

It was also seen by everyone interested in photography, for *Fortune*, the magazine of big business, was the finest photographic magazine in the country. Six years after it was founded, Time Inc. claimed that although the magazine had been started to give business a literature, it "nevertheless became the biggest pictorial show in all magazine publishing," giving some photographers their first fame, and growing famous

from its photographers. What's more, the editors said, with the publication of *Fortune*, "Time Inc. gave the camera a greater opportunity than it had ever had before, and made unprecedented demands upon it. . . . *Fortune* further proposed that the camera should be a responsible partner of the research-journalist in the task of bringing together a coherent account of how things are and what is happening."

These were not idle claims. *Fortune*'s role in giving the camera authority and space was far greater than is usually acknowledged. The page size and quality of reproduction were unparalleled. The magazine often had the story written not before but after the photographs came in, quite the opposite of the usual practice and an index of the importance of the images. *Fortune* was both knowledgeable and bold about photography. The May 1931 issue carried Dr. Erich Salomon's informal, unposed photographs of William Randolph Hearst at home in San Simeon, ketchup bottles standing between his massive silver candlesticks. This was surprising photography at the time, unexpectedly intimate; it was the first visible evidence most people had that the rich and powerful actually slumped in their chairs and tugged at their earlobes as the rest of us do.

Time Inc. brought Salomon to America; he was a German pioneer of the small camera who photographed with a hand-held camera and available light. Many times in '31 and '32 *Fortune* featured his pictures of politicians caught in mid-gesture, of statesmen seen through the half-opened doors to their inner offices. Such unposed pictures, known as candid photography, were not an entirely new form but largely unknown to the public and a breakthrough for the press. Before, important men had studiously arranged their faces and put on their dignity for formal portraits.

In 1934, *Fortune* published photographs by the young Walker Evans; two years later, the magazine commissioned but did not publish a project by Evans and James Agee that eventually became *Let Us Now Praise Famous Men*, a book that in time would have a great influence on American photography. If Luce himself did not have an eye for photographs, his editors, with his encouragement, were preparing the ground for a photographic revolution.

Other fine photographers appeared in the pages of *Fortune*, but Margaret Bourke-White was the name people remembered. "After the eloquence of Margaret Bourke-White's pictures," Time Inc. announced in 1936, "there was little to be said in words about the titanic character of American industry—or of the beauty with which the imagination can invest a dynamo." It was Margaret who created what came to be known as "The *Fortune* picture." "During its first year—and perhaps for some

time thereafter," said an in-house *Fortune* biography of Bourke-White, "the big popular appeal of *Fortune* was its *illustrations*; and there is no denying that Bourke-White's work did the most to make them outstanding—also the intense little girl who took pictures for the big magazine of business added its fillip."

Margaret, who did not invent industrial photography, established its norms, its approach, the type of subject and the emotional atmosphere it would dwell on for years to come. Her photographs made machines look like art, which gave a new and sizable audience permission to admire both industry and photography. Even in the Depression America revered technology, and Margaret gave the country technology as Americans wished to see it. Factories in her pictures were invested with the drama of light, of monumental power, of startling views: industry as theater.

A grand cinematic quality hovers over some of her productions. The meatcutter in the story on hogs is as forcefully lit as a figure in a painting by Caravaggio—or in a German film of the twenties. Already in early 1930 Cecil B. De Mille was so taken with her work that he asked her to give up industrial photography and go into movies as a lighting specialist, but she was doing what she loved, and would not stop.

Margaret's unsung partner—he might almost have been called a collaborator—was Oscar Graubner, her darkroom technician. The beauty and conviction of her prints played a part in their success, and had the printing not been masterful, her imagery would have been limited, for her negatives were notoriously bad and often so underexposed they were nearly impossible to print. Yet she delivered to her clients prints of great finesse, perfectly suited to reproduction.

Graubner, a photographer himself, went to work for Margaret soon after she moved to New York. He was a minuscule man, exceptionally tidy and neat, and as silent as a shadow. Some thought him obsequious, especially to Bourke-White ("a kind of Uriah Heep," one *Life* staff member says), and some thought him anti-Semitic. He considered his boss a slave driver but admired her as one might a great master. Everyone who knew Oscar Graubner says without reservation that he was a superb printer; more than one photographer says he was the best darkroom man he ever knew.

Margaret sometimes developed her negatives herself if Graubner wasn't around—John Vassos, the talented designer who became a lifelong friend, recalls chatting with her in the darkroom while she worked —but she could never have hoped to match his skill in printing. Without fail he could bring out the contrast she so prized and find the detail in dark areas the eye could barely penetrate. She had found, early in her career, the man who could fulfill her perfectionist expectations.

Although black-and-white photographers take great pride in printing their own work, and some scorn those who do not, several leaders in the profession, including Henri Cartier-Bresson and André Kertész, have worked in tandem for years with a printer who knows their ways and their taste. Graubner was a kind of alter ego whose function was to realize Margaret's aesthetic; one former *Life* photographer even credits him with giving her her style. She had already evolved her style, had even, to some extent, evolved her printing style, before she moved to New York, but Graubner did make that style possible. He advised her technically, kept her cameras in perfect working order, loaded the sheet film and film packs for her, wrote to tell her, when she was out on the road, whether the latest batch of negatives was underexposed or over.

Most important, he became her second pair of eyes. He soon understood to the least gradation of gray what she was looking for in a print. They talked in code. She would murmur a syllable or two, wave her hand; he would nod, and go off to the darkroom to produce a picture that measured up to her strivings. Graubner enabled her to be Bourke-White.

One of the most salient characteristics of Margaret's industrial style is what she herself called pattern. The teachings of Arthur Wesley Dow and Max Weber had grounded her thoroughly in the potential of abstraction from realistic observation. In her industrial pictures, identical items often repeat themselves in what appear to be endless rhythmic lines of dynamos, hogs, wheels, plow blades, loops of coated paper—a repetition that stands for the mechanical processes of mass production. The pattern of light, shadow, and reflection on the surface may become as important as the underlying forms, imposing an abstract design on man and machinery. And she found in almost every factory all-over abstractions of a kind that painters seldom attempted in the early thirties and that did not come to the forefront until Jackson Pollock began his all-over paintings of the forties. The art editors of *Fortune*, talented and forward-looking, audaciously published several of these unorthodox photographs.

In these pictures, coils of wire, endpieces of wood, piles of metal disks, or bits of machine tailings, seen in close-up, splay over the surface in every direction with no indication of up or down, top or bottom, horizon or context—an apparent slice out of an endless chaos. At the time, several photographers were playing with all-over compositions, achieved easily enough by looking straight down at a group of objects, even a pile of leaves on the ground, and cropping out every stabilizing reference. In this respect as in some others, photography outpaced American painting in the thirties.

Most often Margaret would move in close or crop in the viewfinder so that only a telling shape or two appeared, with little of the context

that might have explained it. She advised photographers approaching machines to "Decide what is the best angle, what is the simplest thing to show just what you want to bring out, keeping everything else out, either by shadowing or bringing the camera closer." Her stunningly simplified designs isolated a part to stand for the whole, or a pattern for a process.

She meant these photographs to be symbolic. "I made a picture of plow blades—plow handles which symbolized the whole plow factory. An engineer would unquestionably have chosen some integral part of the plow manufacturing process. To do symbolic work . . . you must possess the feel of industry in your blood—that feeling which my father Joseph Bourke-White [sic] handed on to me."

In those long walks in childhood to the magic land of factories, he had imparted his creed of the beauty of utility. Now she repeated it as her own: "Ore boats, bridges, cranes, engines—all are giant creatures with steel hearts. They all have an unconscious beauty that is dynamic, because they are designed for a purpose. There is nothing wasted, nothing superficial. The realization of this idea will grow. It reflects the modern spirit of the world."

In reflecting the modern spirit of the world, Margaret had given herself a good start on the worthwhile life. Now all she had to do was invent the next steps in her life and her career.

10

A Woman in a Man's World

*When women tried to break free they accepted as their blueprint the
masculine pattern. There was no other example.*

Clara M. Thompson, "Working Women,"
1949 and 1953

Henry Luce hired Ralph Ingersoll, the talented managing editor of *The
New Yorker*, shortly after *Fortune* first appeared. He was taken on to
bring order to the rather remarkable anarchy at the new magazine.
"Lloyd-Smith," he says, "ran the magazine by letting the In basket pile
up till it ran over, then calling his secretary in to answer the first ten
letters. It didn't make for smooth organization." (By some accounts,
Fortune succeeded in large part because no one knew quite enough to
know that some things couldn't be done, and so they did them.) Ralph
Ingersoll, who worked with Lloyd-Smith and then took his place in 1931,
was a tall, stooped man with sad eyes, a mustache, measureless energy,
and an awesome hypochondria. He was referred to by one associate as
"twelve yards of quivering mucous membrane"; another remembers him
continuously popping pills and swigging milk of magnesia straight out of
the bottle.

He had been at *Fortune* only a short while when a woman he'd
never seen showed up one day in an absolute rage. She was slim and
dressed all in black, with her dark hair almost as short as a man's and
pulled back behind one ear. Explosively angry as she was, she didn't care
who heard about it, so Ingersoll heard. It seemed she had a lover. It
seemed that when she'd been awakened quite early in the morning by a
phone call about a railroad accident up the Hudson River, she'd leapt
right out of bed and gone directly to the scene to photograph it. The
abandoned lover was mad as hell, and the young woman was outraged
because he'd made a scene. "How can a man do such an insensitive
thing? He knows how important that picture story is to me!"

Certain assumptions underlay her wrath: that photography came
first, that any man who knew her should know that, that no man should

or ever would be allowed to stand in her way by putting himself ahead of her pictures. "Pictures," Ralph Ingersoll says, "were the only damn thing she cared about."

Ingersoll worked with Margaret for years, at three different publications. He never saw her in a temper after that day.

In 1929 and 1930, while Margaret was commuting to New York from Cleveland, she apparently felt the big city threatened to render her invisible. Eleanor Treacy Hodgins, *Fortune*'s art editor and a high school classmate of Margaret's from Plainfield, says, "She had been rather plain in high school. By the time I knew her at *Fortune* in 1929 she had turned into a very artificial glamour queen." She dressed all in black, sported a tall, fancy cane, and soon, just in case she wasn't noticeable enough, added a pair of Afghan hounds.

In the winter of 1929–30, she photographed New York's Chrysler Building in every stage of its construction. The building was promoted as the tallest in the world, but skeptics said the steel tower atop it was was nothing but an ornament added to bring it to record height; the Empire State Building, also under construction, would be the true victor. Margaret's photographs were meant to prove that the tower was integral to the architecture. She worked with a view camera eight hundred feet above the sidewalk, often in subfreezing temperatures, on a tower that swayed eight feet from side to side when the winds were up. A riveter taught her to relax and pretend she was only eight feet up; the problems were identical. It was really no more difficult than walking along the tops of fences to grade school in Bound Brook.

Sometimes the wind would take the tower through its full eight feet of sway. "With three men holding the tripod so the camera would not fly into the street and endanger pedestrians . . . my camera cloth whipping and stinging my eyes as I focused . . . I tried to get the feel of the tower's sway in my body so I could make exposures during that fleeting instant . . . when . . . the tower was at the quietest part of its sway."

It took more out of her than she knew. Once after photographing all day on a high, open scaffold, she hailed a taxi to go home and fell, unable to negotiate the step from the curb into the cab. Still, she loved heights, loved them so ardently she began to wire ahead on assignments to ask the hotel for a top-floor room, even if it was a tiny town with only a four-story inn. Height gave her a feeling of exaltation. One of the Chrysler construction crew said to her, "I feel like my own boss up there. Nobody can reach me to give me orders." There it was: independence, individuality, command, control.

Her daring was greatly, if not universally, admired. Her insurance

company was not happy, and moved to cancel her casualty policy. She had to assure them at the time that she was currently standing on terra firma, photographing automobiles that were safely rooted to the earth.

She fell in love with the Chrysler Building, especially with the stainless-steel gargoyles that jutted out from the sixty-first floor: gargantuan Chrysler radiator ornaments. She had decided to move to New York—but the Chrysler people didn't want her. They assumed she'd get married and give up photography like any good girl. *Fortune* helped her cause; she closed the Cleveland studio late in 1930 and opened one in the Chrysler Building beside the gargoyles. She wanted to live there; unfortunately, it was forbidden. New York City had decreed that no one but the janitor could live in an office building—so Margaret applied for the position of janitor. Too late: the job was already taken.

There were more adventures. She photographed a coal mine despite the miners' superstitions about women in the dangerous caverns where gas was a continuous threat. She got permission to go three miles down with hundreds of yards of insulated wire and enough lights to flood the gloomy mine shaft with daylight. The first shot blew a fuse and broke every light she had. Margaret walked back with the miners for miles through the narrow tunnels, singing every song she knew at the top of her lungs because the boss said the men were so nervous about her being there she'd better do something to distract them.

She began to be billed as the woman who had gone higher above the ground and lower beneath it than any other. Her name was in the news. "INDUSTRIAL PHOTOGRAPHER IS PIONEER" (1929) . . . "THIS DARING CAMERA GIRL SCALES SKYSCRAPERS FOR ART" (1930) . . . "DARING WOMAN GENIUS BRAVES MANY HAZARDS TO OBTAIN PHOTOGRAPHS" (1931). She went to Canada to photograph the logging camps of the International Paper Company, traveled by sledge and snowshoe in temperatures that reached twenty-seven below. Her lens kept freezing, and she had to prop the shutter up with pencils while she focused beneath her stiffened camera cloth.

She had built excitement into the very texture of her life. Photography itself never failed to thrill her: "The joy of making a beautiful picture. I don't know anything else quite like it. You're building. You're pushing your lens in closer and closer eliminating all the waste areas as you know just what you want to do." She was moving smartly and inexorably along the road to being a woman who did all the things women had never done.

Margaret told one reporter that it was harder for a woman to begin, "but once she gets started she has an easier time because her accomplish-

ments attract more attention than a man's would." Fame was not merely delicious, it was good business. In '31, when she invited the governor of New York to a party, she dangled before him the names of some of her other guests: "Believe It or Not" Ripley, Fannie Hurst, Will Durant, Christopher Morley, John Dewey, William Randolph Hearst, Jr., the editors of *Fortune* and the *Saturday Evening Post*—a motley and shimmering crew.

The man's world was a challenge for Margaret, like danger, like fame, and she thrived on challenges. No blueprints existed for a woman photographer in a man's territory. Pioneers do not have what are now known as role models. They may become models themselves in time, but first they must find a way to live in the day-to-day.

She found it exasperating to try to escape "these dreadful meshes of courtesy, and politeness and introductions" that men put in her way to take up her valuable work time. Worst of all was not having her work (which she equated with her cherished individuality) taken seriously. The most noxious male prejudice was the conviction that women lived for men and nothing else. In an article called "Men You Shouldn't Marry," Margaret warned independent-minded women against "the conventional idealist." One, the president of a steel mill, had once stymied her work. Sitting on a high crane, she had waited for the heat to pour all morning. When the lunch whistle blew, the president appeared on the floor to ask her to lunch at his country club. "Please let's not!" she said. "While we're gallivanting, the metal may pour." He, who knew the business inside out, told her there was lots of time, so she went—and missed the one moment she needed. "I know you aren't really angry," he said. "You gave me such a beautiful time! That would surely mean more than any picture to a lovely girl like you!"

She was still bitter about it several years later. "A conventional man," she said, "can never truly respect a woman's work. He always feels that a woman should subordinate herself to love, by which he means himself and others like him."

Margaret liked men. She never felt she had to make war on an army of males in order to make her way. "I think," she wrote in her notes, "one's attitude toward men is of the utmost importance to a woman photographer. Whether feels at home in the world of men—not bitterly competitive." Her complete acceptance of her own sexuality had made things easier for her: "One famous man photographer I know thinks her attitude toward sex has everything to do with whether a woman can get along as photographer in world of men."

Like many a young woman who has greatly preferred her father to her mother and found her sense of worth in some achievement that

paralleled his, she did not care much for women in the beginning. John Vassos, the Greek-born industrial designer who designed her studio and apartment, says, "She thought the average American woman was an idle bum. She talked about their lack of knowledge and of knowing the political picture." (This statement, probably made after she became more politically aware herself, would reflect a distaste for her own former ignorance.) Vassos goes on: "I don't think she cared for women. She thought they were inadequate people, misguided, and weak"—the opinion of a woman who, having conquered hurdles, feels scorn for those who languish at the starting line.

Although by the mid-thirties Margaret established a close connection to her sister, Ruth, she had almost no other close women friends until late in her life. With her erratic schedule and the enormous demands she made on her own time, she would have had to place her friendship where it counted most for her. It counted most with men.

She had created the unimpeachable individuality she coveted and had all the attractions of good looks and a vivid character. Her manner was brisk and assured but full of practiced accommodation, social ease, and a conviction that she was interesting. Her smile was brilliant and large; she knew it and used it often, which made her seem pleasant, humorous, and—the reason many women smile so much—both charming and compliant.

Reporters never failed to mention how trim and well built she was; female reporters added that she dressed smartly. When she gave up the cane and the hounds, she began to wear well-tailored slacks for work, at a time when slacks were still certain to attract notice. People who knew her invariably speak of her *presence*. "She had presence." "She was a presence." Ralph Ingersoll says, "It didn't take me long to realize she was a special character. She could establish that in a week, just by being herself. She didn't boast at all, but had absolute confidence in herself."

Such strength of character strikes the beholder as admirable or frightening, depending on his disposition. John Vassos found her both admirable *and* frightening in the extreme. "I really loved her," he says. (At this he pauses, then roundly declares in his heavily Greek-accented English: "I *never* fokked her." He recovers himself and goes on.) "I've never known a human being that had such a beautiful spirit. Like somebody with their open arms coming to you . . . There will never be another one like that again.

"She was a fabulous woman because of her terrific drive and energy. I never saw anything like it, never saw another person to equal that drive. It came out the minute you were in her presence, in her speech, in her moves. We'd go out to dinner; it was like a machine that you had with

you, not a human being. She was a strong individual, one of the strongest people I've ever known. . . . She dominated the people she knew very much. That was why she couldn't keep a lover." Her strength, her dominance, her need for control certainly affected her love life and sometimes cost her dear, but she kept more lovers, and longer, than Vassos knew.

He was entranced and repelled by the power of her will. "She was more or less like a poisonous snake. I wouldn't like to be under her clutches. My friendship with her was one of great respect for each other, like two gladiators that are awfully strong that decide not to fight. . . . We established the fact that we were not going to fight, and we got along beautifully." A vigorous personality prompts a vigorous response. Like a dragon or an angel—and there were many who were convinced she was one or the other—Margaret left in her wake no tepid reactions.

Margaret's strength, her drive, her career broke all the conventional expectations for womanly conduct. From the start, reporters took pains to note her femininity, and despite her short bob, her trousers, and the neckties she often wore, all of which had a certain timely cachet, she worked hard to remind herself and others that she was decidedly female. She had traditional yearnings that never quite withered, but no one had assured her entry into the kingdom of domestic bliss. Newspaper headlines with her name in forty-eight-point type kept telling her she could have everything else.

She said that her father was often in her mind during the period of her industrial photography and that she wished he might see where his influence had led. Perhaps she felt, deep down, uneasy about the strength of her identification with him, which would explain how hard she worked to maintain what she would have considered her other side. She clung to some of the conventional signals of femininity, like helplessness: "Peggy would step over corpses without any trouble in Calcutta," one man says. "She would walk up to a revolving door and wait for me to push it." She also cried readily, sometimes on cue.

She was straightforward, without a trace of the coquette. Vassos says she had "no coyness, no gestures, no artificial elegance, none of that, ever. She reached for a piece of bread, not gracefully; she would go for the bread, period." Yet she had developed a style that many thought stereotypically female. "Her subjects and the manner in which she handles them," a reporter wrote in 1930, "might suggest that Miss Bourke-White is personally of the amazon type, yet she is as thoroughly dainty and feminine as her pictures are virile and masculine." Another reporter, who acted as her guide in 1934, told a newswoman who asked him if

Bourke-White was a bit masculine that she was "as truly feminine as every man dreams of femininity."

And she flaunted her femininity at times, as if to reassure herself and her audience. Her little storm in the *Fortune* office about her lover's insensitivity immediately had one desired effect: it alerted everyone within earshot to the fact that she had a lover. When she commissioned a former assistant to take her portrait several years later, she brought along an evening gown so low-cut and clinging the photographer had difficulty keeping her sufficiently covered up for a proper portrait.

Women have never lacked reasons for parading their allure; Margaret's reasons included insecurity. During World War II, when she had reached forty, a psychologist she fell in love with still had to reassure her that she was womanly. He wrote her from the war zone after she had left it, to tell her a friend had been talking of her bravery. "[He] is paying inarticulate tribute to your courage and not casting any doubts on your essential femininity or your attractiveness to men. (No one ever did that but yourself, which as you know, is a somewhat involved psychological process. And even you are getting over that.)"

In the early thirties, Margaret had several lovers because she said she did not want love. Some of her suitors fell in love with her, some wanted to marry her, some said she touched them more deeply than they had ever been touched before. She kept her emotional life under strict control. It must have been work, controlling the fervor of as strong a nature as her own, but for a number of years she seems to have successfully channeled her passions into physical love and photography.

When she let herself go, the effects were unforgettable. In the 1980s, one elderly gentleman who had not so much as seen her for something like twenty years, exclaimed in a veritable fit of memory, "When she came, she came like a locomotive. Jesus, what a girl!"

She told them all that love didn't fit into her schedule yet. She even told a reporter she had no time for love. "Married? . . . No—not even in love," the article confided. "Except with life itself. Ask her about it and she will tell you she hasn't time."

Having more than one lover in her life was excellent protection against love, and the ultimate vindication for a wallflower. Too many lovers could be embarrassing when one arrived before the other had left and the three of them had to sit around drinking and avoiding the issue with elaborate civility, but usually she planned better. She traveled constantly and met new men wherever she went, men she might never see again, or not for years. Apparently she did not encourage anyone who truly cared for her to believe he was her only lover, for she set a high

store by her honesty, although not when it came to her age or her father's religion.

The men who loved her always admired that honest streak. In the beginning, she took it too far, and some of her lovers were stung. "What your telling me about your indiscretion in the Alps," one of them wrote, "did to my subconcious—is too gory to relate—oh Lord!" She learned fast. In subsequent years, she rarely said a word about previous entanglements, never about current ones.

When the roaring twenties loosened the knots of Victorian repression, no guidelines were issued on how women were to make the emotional transition to sexual freedom. It was not so easy. Clara M. Thompson, a prominent analyst who treated many successful career women in the thirties—women male analysts were reluctant to see—said that most of her female patients looked on extramarital affairs as a matter of course: "There is an increasing tendency in and out of marriage to have a sexual life approximating in its freedom that enjoyed by the males . . . but . . . the individual is confused and filled with conflict . . . old attitudes and training struggle with new ideas." Her clinical experience convinced her that "a great number of affairs seldom reassure a woman that she is accepted or loved."

For Margaret, the cynical edge to her Cleveland experience, when she discovered that she was thought to be one of the "perks" of a successful businessman's career, undoubtedly tinged her ideas on the war between the sexes. The double standard, like so many aspects of business, worked entirely to the advantage of men. Any woman who could do a man's work ought to have a man's advantages. And as she was living what was ordinarily regarded as a man's life, the life of a traveling journalist, an adventurer among men, so she adopted what had always been considered a man's prerogative—a lover in every port, and more than one at home. A certain sexual ease seemed to go with the territory. Margaret, unabashed and on occasion aggressive when it came to sex, is said to have noted in a diary that male prostitutes were an idea she could approve of.

No more willing to stay on safe and approved ground in her mores than in her work, she thus assured herself of adventure in yet another area of her life. Wherever she went, men pursued, and she, after succumbing, eluded them. One who had gone off to pan for gold in Idaho wrote to ask when she would think of settling down with him. The pilot who in '35 flew her on her first aerial assignment lifted her spirits so high that she took flying lessons with him until she stopped it all with a letter of farewell. Their friendship, she wrote, "had disappeared into the desert

. . . [where] it is blowing away in those multicolored spaces and has become invisible to pilots and photographers." She sent him in parting some photographs she'd promised; whenever it was over, her policy was to get out intact.

A well-known leftist editor paid her court, as did an editor of one of the big newspaper syndicates, a Wall Street banker, a real estate man, a couple of advertising executives, more than one *Fortune* writer. A *Fortune* assignment could resemble an odd little trial marriage, two people thrown together day and night for a week, two weeks, on stories that might be challenging and tense. From the start—and ever after—Margaret had neatly split her work and leisure personalities. By day she was cool, efficient, peremptory, driving, dressed in miner's clothes or parkas if need be. By night she switched into her glamour mode, dressed to the nines and flashing her thousand-watt smile.

The *Fortune* staff was heady with promise. Jack Vance, a poet and short-story writer who went with her to Canada in subzero weather, wrote her charming poems about nothing at all and in prose recalled "one glorious winter night in Ottawa . . . a night on which you wore, at first, the black dress with the pin at your right shoulder." His letters must have reached her in the midst of her romance with Frederick Kuh, a foreign correspondent for *Fortune*, who for decades maintained a strong affection for her across continents, oceans, and marriages.

> Probably the first quality that attracts me [in a man, she wrote] is wit, with a certain amount of nonsense thrown in. The second is a feeling of perception in the man. I don't care what his field is, so long as he is not stupid, and has a quick understanding of what goes on around him, that is enough. I have no particular specifications about looks, except that I am a little suspicious of men who are too handsome and tend to keep out of their way. I am always drawn to people who are very much interested in their work, whether it is reporting, flying, setting bricks, or anything else.

One man who met her specifications was Alfred de Liagre, the executive of a woolen company, a man of quick insight and adept at combining the soigné and the ridiculous. He could easily have filled in any gaps in her sophistication. Born and educated in Europe, fluent in three languages, de Liagre was old enough to be Margaret's father. His wit was as elegant as his tailoring, he sported a pince-nez, and he had a habit of casually tossing over his shoulder wine bottles that had done their last duty at supper.

He understood Margaret's deeper evasions. Writing about her "famous understatements," he said: "My psychoanalytical study of these understatements resolves itself into the observation that they constitute

a sort of premeditated and reenforced concrete basis of your existence—induced by self defense—and only at rare moments of genuine emotion a flicker of the real Susan"—he called her his black-eyed Susan—"unguardedly will break through this rational foundation of an accepted philosophy of life. . . . Give me the 'flicker'—that's *my* Susan."

De Liagre was married. So was Jack Vance, and so were a number of others. After all, when her Cleveland suitors had hovered round to take her dancing and sweep her floors, she had still been legally married to Chappie. But married men were also a pragmatic protection against love. In fact, in every respect but their ultimate availability, and sometimes in that respect as well, married lovers were ideal for her purposes.

The unmarried man who, it was rumored, wanted to marry Margaret was Maurice Hindus. He was a foremost Russian expert, a famous, even a heroic liberal, at a moment when people were hungry for authoritative reports on the menacing Red giant. Margaret probably met him in the summer of 1930. He was a moody man, soft-spoken, with a gentle manner, like someone who had lost in love and was pondering how to pay the debt. Men liked him. Women found him charming. One man who knew him said he had no temper; with Margaret he argued all the time.

John Vassos was with them often. "I used to separate them," he says, and adds that they came to him partly because "I would stop the arguments right there and insist upon some fun. They were very much attracted to one another, because they were both like cobras, two highly poisonous snakes, both of them. . . . One salvation was the fact that they didn't see each other much." He says they did not argue lightly but only about significant matters, including politics—which could not have been called Margaret's long suit. She did not think herself argumentative, nor does Vassos recall her arguing with anyone else; she was perfectly capable of controlling her temper. "With other people she was standoffish and quite charming. Nobody could penetrate beyond a certain wall she put up."

Hindus prized Margaret's photography, her energy, her drive, her naturalness and "lack of feminine guile," her exuberance, her ardor. "How damned lucky you are," he wrote, "that the camera—a kind of jalopy, I suppose it was—gave you enough guts to break with Chappie and start gallivanting on your own and give your nerves and glands and muscles something to get excited about and to outflow with vigor and freshness, which give you a kind of bridal beauty." He also understood that they were two of a kind, fated to enjoy each other only for a while. "But then I am old enough to appreciate that my dear Margaret is good

at turning away and that I have a genius for scampering away. . . . Not
that you are wicked or that I am villainous, but such natures as we are—
emotional and passionate, independent and capricious, outwardly gentle
but inwardly subject to tempests and sudden change of mood and im-
pulse . . ." Their romance, he implied, no matter how glorious, would
not last. Nor did it.

Vassos says that she tried to dominate Hindus desperately, but it
didn't work. "He wanted to marry her because that was the only way to
control her. She wouldn't have that. That used to frustrate him. They
had arguments over that over and over." They romanced and sparred as
if their lives depended on it.

And yet after years of silence, in 1946 they took up their passion
once more, this time without the obbligato arguments. Margaret's ability
to keep a lover as a friend never failed her. To nourish affection would
have been easier for her than for some because she allotted so little time
to regret. She said she learned from her broken marriage how to leave a
difficult experience behind "without bitterness, in a neat closed room,"
and all her life she fought, with astonishing success, to put the past aside
and go on with the present. As susceptible to suffering as anyone, she
knew better how to refuse to experience it.

Clara Thompson, who wrote extensively about the psychology of
career women, spoke of patients trying to come to terms with the success
that had formerly been reserved for men: "A young woman whose busi-
ness often threw her into sharp competition with men was proud of the
fact that she acted like a man in her sexual life. She had a series of lovers
to no one of whom she allowed herself to become attached. . . . Permit-
ting an emotional attachment to develop would have been acting like a
woman." It sounds almost as if she had Margaret in mind—and perhaps
she did. Thompson was Margaret's analyst.

Not long after Margaret moved to New York, she began seeing a
psychoanalyst, probably in 1931. Analysis had begun to acquire a mea-
sure of chic in New York at that time, but something more compelling
than fashion sends a woman into therapy. Margaret could not have
sustained a conventional analysis, for she traveled too frequently; she
would have gone regularly only when she was in town and able to break
free of assignments. The doctor she saw first was Harry Stack Sullivan,
already one of the most famous psychiatrists in America. From 1934 to
1943, he headed the William Alanson White Foundation; from 1936 to
1947, the Washington School of Psychiatry. Margaret, who had met him
by July of 1930, took his portrait and may have paid for part of her
therapy with photographs.

After a couple of years, Sullivan referred her to Clara Thompson, who later became the first director of the William Alanson White Institute. The switch to Dr. Thompson may have occurred as early as March of 1933, when Sullivan was already writing Margaret as "Dear Friend." Late in the thirties he helped again, with a specific problem. Margaret had such an abiding gratitude that at the end of the decade she had earmarked part of an insurance policy for him in her will, enough to pay his secretary's salary for ten years.

Peggy Sargent, who began as Bourke-White's secretary in 1935, says that even when cash was short Dr. Thompson's bills were paid promptly, and that whenever Margaret came back from a photographic assignment one of the first appointments she made was with Clara Thompson. In the few brief letters to Margaret from Dr. Thompson that are still extant, three problems are hinted at: her mother's insufficient appreciation of her; her dissatisfaction with the men she knew (at least prior to 1936); and, despite the confident exterior she presented to the world, her shaky and easily threatened belief in herself.

Margaret saw Dr. Thompson from 1933 or '34 until 1938 or '39, then again in the early forties. There are gaps in the record; the next existing letter from Margaret, in 1952, indicates she had been seeing Thompson recently, and the last recorded date on which an appointment was requested was in April of 1955. Margaret Bourke-White saw a therapist, at least now and again, from 1931 to 1955, while she was forging a career that was the envy of half the women in America.

11

"A Great Future in Russia"

*You have a great future in Russia—more real recognition, though very
little money, than in any other country in the world . . . Your
unparalleled capacity to dramatize the machine cannot possibly bring
you the same appreciation in America that it can in Russia, for the
Russians are the only people who . . . spiritualize the machine . . . I
truly believe Russia can give you great fame.*

Letter to Margaret from Maurice Hindus,
October 15, 1930

Margaret Bourke-White, who had longed to travel since she was a child,
boarded the S.S. *Bremen* on June 20, 1930, en route to Germany with
Parker Lloyd-Smith, the *Fortune* editor. (A year later, Lloyd-Smith
would inexplicably jump to his death, leaving his mother a cryptic note
about how hot the weather was.) It was Margaret's first trip to Europe,
and she traveled first class on the new flagship of the German line,
decorated in purest stripped-down, machine-aesthetic style, as befitted
the fastest ship on the Atlantic.

Fortune had decided Margaret should photograph the major Ger-
man industries. She proposed to cover the Soviet Union as well. The
editors were skeptical, with some reason. She wouldn't get into the coun-
try, they said. She wouldn't be allowed to photograph Soviet industry;
the Soviets had not allowed foreigners to photograph the Five-Year Plan.
Margaret decided to go ahead at her own risk: "For the professional
photographer from the outside world, it was a closed country. Nothing
attracts me like a closed door. I cannot let my camera rest until I have
pried it open, and I wanted to be first."

The first Five-Year Plan began in 1928. In less than five years, over
fifteen hundred new factories were built, and new industries were begun
from scratch. No country in history had industrialized so fast. Americans
were fascinated, mystified, frightened. "No one," Margaret said, "could
have known less about Russia politically than I knew—or cared less. To
me, politics was colorless beside the drama of the machine." But she
thought of the machine as both a key and a decoder: "In this industrial

age, if one understands the industry of a people, one comes close to the heart of that people."

Her photographs would be her passport. That's what Intourist, the Soviet state travel agency, had told her when she applied for a visa in New York. The head of the Soviet Union Information Bureau in Washington was so impressed with her pictures he'd offered to recommend that the Russians use them in their own magazines. "Your photographs will appeal to the Russians," he said. "They have the Russian style." Then he picked up the phone and called Sergei Eisenstein, director of the Russian film epic, *Potemkin*, who was then on a visit to New York. Yes, Eisenstein could see her, but he was leaving for Hollywood tomorrow.

Margaret, whose list of appointments read like a page from *Who's Who*, had to see President Hoover first. She photographed the President, then caught the midnight train back home to meet the director. Eisenstein took one look at her work and sat down to write her letters of introduction to artists in Berlin, Paris, and Moscow. Her photographs *did* have the Russian style—the sweep, the grandeur, and some of the abstract incident of Soviet film and still photography in the twenties. Films by Eisenstein and Pudovkin had already been released in the United States; Margaret, a film buff, might well have seen them and absorbed their lessons.

Despite such prestigious support, when she reached Germany her visa had not arrived. The Soviet consul in Berlin also told her her pictures would be her passport. He would write Moscow and recommend not only that she be admitted but that the government engage her to take pictures for them. So she waited. And waited. And waited. "I could not bear the thought of returning to the United States without the first industrial series of photographs to come out of Russia."

While her anxiety mounted, she photographed German industries, from the Leuna nitrogen plants to the North German Lloyd docks to the I. G. Farben Dye Trust, which had rarely permitted a woman inside, and never a photographer. She could not get into Krupp, which was even more obdurate on the subject of women. Outside a small village in the Ruhr, as she was photographing a wheat field with a line of smokestacks in the distance, Margaret was arrested as a spy. She had gone out without her passport; the local police held her in jail for nine hours. Interrogation was somewhat limited, as captors and prisoner spoke no common language.

Secretary of State Henry L. Stimson was quickly pressed into service to write a letter in her behalf; it did not move the police. The woman whose goal was to be a world figure gave some promise of becoming an

international incident, but her photographs saved her. Margaret showed the police her portfolio of the Chicago stockyards. The beauty of hogs, living, dead, and dramatic, convinced them she was not a spy but a photographer as she claimed.

After five and a half weeks of waiting for her visa, Margaret's hopes finally faded. She walked out at dawn one morning to shake loose her discouragement. As she passed the Soviet embassy she heard a whistle overhead; the Soviet consul stood at the window, waving the vital telegram.

As Russia was only beginning to emerge from devastating famines, Margaret had been warned that she would need supplies of canned food. She filled a trunk with potted cheese and beans that would prove necessary when she and her interpreter lived on cold beans in Russian trains for weeks. Food was available, if you could wait in line most of the day. On her return to America, when asked to give a ten-word description of how the Russians were doing, Margaret replied, "Little food, No shoes, Terrible inefficiency, Steady progress, Great Hope."

Inside the Soviet Union, her photographs *were* her passport. On her second day in Moscow, the vice-commissar of railroads and the president of the All-Russian Publishing House so admired her pictures she was made the guest of the government, with all expenses paid. But delays began immediately. No papers came. No official was ever in, even if she reached his office, and often she did not, for few taxis existed, the streetcars were so crammed with passengers they were frequently impenetrable, the dilapidated droshkys stopped work when the horses were tired. Her precious time in Russia was running through her hands.

Margaret's determination was tested in the fires of Russian delay and institutional confusion. "Nothing seemed too difficult after that. It trains you to push hard. Nothing accomplished otherwise. Nothing in this field could be as hard as that was. Russia was for me a stern task master."

Yet everyone wished to aid and honor her. "To the American businessman," she wrote, "photography or art-work of any kind is simply an instrument that crosses his consciousness once a month when his advertising manager comes around with layouts for him to O.K. But the Russians are an innately artistic people. They consider the artist an important factor in the Five Year Plan, and the photographer the artist of the machine age. It is for the artist to stir the imagination of the people with the grandeur of the industrial program. Thus I had come to a country where an industrial photographer is accorded the rank of artist and prophet."

The Revolution had elevated photography to a central role in society. Lenin spoke publicly of the camera's value as an instrument of

propaganda, education, and information, and at the inauguration of the Institute of Photography and Photographic Techniques soon after the Soviets came to power, the commissar for education had announced that every Soviet citizen would receive training in photography. Every revolution promises more than it can deliver, but if technical skills had not burgeoned under this program, enthusiasm had.

Margaret got permission to photograph in factories near Moscow while she waited in a state of increasingly ragged doggedness for the bureaucratic tangle to uncoil. At last she was presented with a sheaf of papers rich in guarantees. As the Soviet government had commissioned her to take photographs for Soviet magazines, all citizens were requested to assist her whenever she called on them.

They were eager to help. Few had ever seen an *Amerikanka*, none had seen one photographing the new Soviet industry that was gearing up to manufacture a future more glorious than any past. She spent one evening at a private apartment, fox-trotting the night away to American jazz records. Young men lined up in the hall outside the small apartment, waiting to lead the *Amerikanka* through the bourgeois dances their government frowned upon. Margaret did not speak the language but nodded and smiled prettily when it seemed called for. Days later, she found out that she had accepted five proposals that evening. One of her suitors had gone to the Marriage and Divorce Bureau the next morning and divorced his wife, simple to do in the Communist state; husband or wife merely went to the bureau and submitted a request, and that was that.

Finally, Margaret set out across the new Russia with her interpreter. First to Dnieprostroi, where the world's largest dam was being built by an American; then to Rostov, showplace of the new collective farms that marked the government's determination to feed its people; then south to Novorossisk, to photograph the biggest cement factory in the U.S.S.R.; and on to Stalingrad, where American engineers supervised a factory called Tractorstroi. The tractor was the most potent symbol of Stalin's plan to mechanize Russian agriculture. "The tractor," Margaret said, "is the new God of Russia."

There were shortages, but people were resourceful, and Margaret no less so. When her camera cloth blew away in the wind and was lost in the river Dnieper, she could not find another piece of dark fabric in all of Russia; for the rest of the trip she photographed beneath borrowed overcoats. When she needed to change her film and the only light-tight spot in an entire factory was a flooded basement, the electrician made her a raft of boxes and she floated through the maneuver. She found the Russians so excited about their new machinery that they marveled at it

noisily for hours rather than using it—often enough the workers were peasants who had never seen a piece of machinery more complex than a horse-drawn plow—or they assumed the machines could do anything and rode their imported cranes and tractors like cowboys riding broncos until they smashed them up beyond repair.

Margaret did not merely report what she saw but arranged it to the best possible advantage. If she wanted two workers in a scene where only one existed, she would scour the factory for someone who would look right in the picture. People were still "types" to her, or accessories, but she thought that Russians at least fell easily into dramatic poses; she worked on their portrayals with them or composed them to look better. Her Russian photographs have force and the beauty of stillness, although at times her lighting could be too spectacular for her subjects.

At a Russian editor's request, she gave a lecture on photography. "If the artist has an interesting mind," she said, "we are stimulated by his pictures. If he has a dull mind, his pictures bore us." She went on: "I abhor the kind of photography that blurs over the subject with a lot of soft focus tricks, and calls itself artistic. There is no reason for photography to imitate any other art. A photograph should not look like a painting. It should look like itself. It is a direct and expressive medium and should be used for what it is." This is a far cry from her pride in the "pseudo-Corots" that she took at Cornell. Margaret had not only dropped pictorialism but had shifted to the contemporary position of opposing it with the insistent zeal of a convert.

She took great pains to convey texture in her pictures. The lecture went on: "A photograph should never look as though the subjects were made of cardboard and pasted into place. Wood should look like wood. . . . Earth should be real living earth, and steel should possess the very essence of steel. How is this done? By careful attention to lighting so the quality of the material is brought out."

(Arthur Rothstein, who met Margaret in 1932 and was himself a distinguished photographer, says that Bourke-White influenced photographers by emphasizing "those things in photography unique to it, such as the ability to show texture and detail. Her pictures were mainly sharp and clear and full of gradations of tone.")

When Margaret's lecture on photography was over, the Russian audience launched a barrage of questions about American photography and technical matters, at length pursuing her to the door and down the steps, with questions still raining down. Margaret asked her interpreter afterward what all those questions were on the steps. " 'Oh,' she replied, 'they wanted to know, how old is she? How does she spend her evenings? Does she have any admirers?'

" 'And what did you tell them?'
" 'That Miss Bourke-White loves nothing but her camera.' "

When working for *Fortune*, Margaret would send thank-you notes and often photographs to every reporter, electrician, and public relations man who had carried her cameras and smoothed her way on an out-of-town assignment. A puzzling mix of great thoughtfulness and a debonair lack of concern, she could be exquisitely considerate up to the peculiar limits of her vision. An acquaintance recalls agreeing to take a present to Russia for her, only to discover that it was a large, heavy leather coat he had to lug across several countries to prove that Margaret cared.

Soon after her return from Russia in 1930, Margaret, who was a connoisseur of her own image, hired John Vassos to design her studio in the Chrysler Building. The studio announced that Margaret Bourke-White was poised on the edge of tomorrow: it was a streamlined, art moderne environment, all built-in curves and decorative angles, with an aquarium for tropical fish at eye level on the wall, venetian blinds of corrugated aluminum, and light fixtures of aluminum and frosted glass.

She continued to polish the effect. She had herself photographed perched with her camera, in her usual death-defying manner, atop one of the great chrome gargoyles sixty-one stories up. In '32 she acquired a live alligator for the studio. "Cleaners!" read a notice tacked up over the aquarium, "Please take care. Do *not* move this alligator. Thanks." When the first alligator was given a mate, the two were named Hypo and Pyro and lived on the terrace. Margaret then obtained yet a third, but lost it when the resident couple diced the intruder up and ate it for supper.

Her turtles were more peaceable, usually roaming the studio at will and sometimes sharing her secretary's sandwich. Peggy Sargent hated the alligators so passionately that once, when her boss was away on business for six weeks, she tried to starve them to death. Hypo and Pyro defied her by hibernating. They went back to hissing and snapping when Margaret and raw meat came back into their lives.

Dick Simon and Max Schuster, the young publishers who had started their own firm in the twenties and made their fortune on the first crossword puzzle book, came to lunch at the studio when word of Margaret's Russian trip got around. They thought she ought to write a book about the U.S.S.R., and so she did. *Eyes on Russia*, with Bourke-White's photographs, a preface by Maurice Hindus, and a dedication "To the memory of my father, who invented machines instead of photographing them," appeared in 1931 to good notices.

Several reviewers remarked that the author avoided politics altogether, but she had a breezy style, stories to feed the public hunger for

word of Russia, and photographs such as no American had brought out of that mysterious land. *Fortune* published a portfolio of her Russian photographs in February of 1931. In a nation where expertise comes easy, she was well on her way to being regarded as an expert.

In the summer of 1931, the Soviet government invited Margaret back. Soviet-American trade had increased from $48 million in 1913 to $177 million in 1930, and the Soviets needed American technicians, skills, and goods. In 1928, a group of Soviet engineers had commissioned an American industrial architect to build a forty-million-dollar tractor plant and outline a program for an additional two billion dollars' worth of buildings. The U.S.S.R. was eager to be recognized by the United States.

Although she photographed at length this time in Magnitogorsk, a giant industrial complex rising on the site of the richest iron ore in the world, Margaret no longer concentrated exclusively on industry. Increasingly she photographed both the men behind the machines and the little people on the side: three peasant women eating from the same bowl, or schoolchildren paying grave attention to her camera.

In 1930 she had been intrigued by the texture of workers, which seemed to her little different from the texture of concrete and steel. In the German electrical industries, she had declared herself "delighted with the earnest, bald-headed workmen. Their shaved egg-shaped skulls took the highlights from my thousand watt floodlights beautifully." By 1931, she had begun to think workers were worthy subjects for another reason: their association with what she considered the central enterprise of contemporary civilization. "Not only is the dynamo under construction beautiful, but the men who build that dynamo have a certain beauty —their faces have an artistic value because of the virility and importance of the work they do."

In moving from her first, wholly aesthetic concerns to more philosophical considerations, Margaret began the long-term course she gave herself in human-interest photography. During the winter of '32, the *New York Times Sunday Magazine* published six articles she wrote about her trip, illustrated, of course, with her photographs. She wrote about industrial processes and the relationship of Soviet workers to their bosses, but she also wrote about the children of communism and life in a remote village.

The first article dealt with the Russian woman. "In her longing for fashionable clothes, for adornment, for attention," Margaret wrote, "she is wholly feminine." She was also integrated into the world of work. "The Russian woman does not look on her job as an escape from domesticity,

or as an attempt to assert herself in a world of men. The articles which so frequently appear in our American magazines, debating the relative merits of women in the home as against women in business, would be incomprehensible to her. She is working, as the men work, to advance the great industrial program of which she feels she is part. She is never conscious of a conflict between her career and her personal life."

As for herself, if she felt a conflict she certainly did not let her personal life interfere with her career. She wrote from Moscow to a man in New York: "Boris and Maurice are still at each other's throats—each accusing me of being in love with the other. It is terribly amusing."

In the summer of 1932, Margaret went to Russia yet again, this time to make a movie. As she had been the first foreigner to bring still photographs of the Soviet industrialization out of Russia, she wanted to be the first to bring out moving pictures.

Margaret doted on movies; when she fell behind on films she wanted to see, she would go to four or five at a time on a single Sunday. Always alert to the possibilities of a new medium, she tried out the movie camera at home first, with the hope of making a new kind of educational short from her pattern pictures of industry, and she did make one short on the paper industry. A feature film on Russia would be a coup. Ralph Steiner sold her his Debrie camera, another photographer taught her to use the Eyemo in a steel mill, Eastman Kodak gave her some twenty thousand feet of free film.

She arrived at the New York dock an hour in advance of the ship's departure with her usual prodigious array of trunks and photographic equipment, plus five wooden crates of film marked *Nitrate*. Film at the time was made on nitrate stock, which is highly flammable. The crates were refused at the gate. Her assistant took a penknife, scraped off the labels, took the crates to another gate, and loaded them on board.

She stopped in Germany to photograph again, not industry this time but armaments. The German government, forbidden to rearm by the Treaty of Versailles, was making intense diplomatic efforts to win back the right to arm itself openly. In the meantime, German troops trained with dummy equipment. Margaret's pictures showed dummy tanks mocked up on automobiles and wooden antitank guns used to drill new experts in war. *Fortune* published her photographs of Germany's wooden army in January of 1933 in a long article that concluded: "But no matter how efficient [this army] may be, it is as yet no threat to the peace of Europe." History was beginning to force itself on Margaret's consciousness through the ground glass of her camera.

On this trip, if not on her earlier visit to Germany, Margaret visited

Kurt Korff, Kurt Safranski, and other German picture editors. Korff, Safranski, and Stefan Lorant were the primary shaping forces of the new photojournalism that grew up in Europe, primarily in Germany, in 1928 and 1929. Six or seven years before Great Britain or America had true picture magazines (for *Fortune* was only a preliminary stage), Germany had several successful illustrated weekly papers with large circulations. The *Berliner Illustrierte Zeitung* and the *Munchner Illustrierte Presse*, among others, published full-page pictures, photographic essays, and candid photographs. Here was the most advanced photojournalism of the day; in a short while it would influence America and Margaret's career.

 Her experiences in Russia contributed to a subtle change in Margaret's ideas about her photographic mission. On the second trip she had photographed fewer industrial subjects and begun to reevaluate the worker in terms of his work. The third trip, with its generous servings of adventure, moved her closer to the news.

 In '32 she traveled through the mountains of Georgia, no longer by train or plane but on horseback. (She had long loved riding, and seems always to have found a good use for whatever special skills she had.) The president of Georgia and seven commissars rode with her through the Caucasus, along the edges of sheer cliffs; for once a horse and not a reporter or a man of Henry Luce's stature carried her equipment. At night they slept in caves, and when food ran low—she had no trunkful of beans with her this time—the commissars would order a peasant to slaughter a sheep and roast it whole. In Georgian villages she encountered the Russian drinking bout, a wine horn drained at one draft after every toast; her hosts insisted on toasting her grandparents, her parents, her uncles and cousins and the husband they hoped the future would bring her.

 By chance she heard of Stalin's birthplace. She was certain it had not been photographed, for the Russians had not yet developed the cult of personality; indeed, they guarded against excessive interest in a leader's family. Margaret found the little town and photographed first the earthen-floored hut where Stalin had lived, then his great-aunt, then the sheriff who had once arrested his father for nonpayment of taxes. She went on to Tiflis to photograph Stalin's mother, who, she said, "had never quite understood what her son's job was. She had wanted him to become a priest and had sent him to study with the Jesuits. She was deeply hurt when he broke away to join the revolutionary movement, and began robbing post offices to further his revolutionary work."

 The cocoon of self-involvement that had wrapped Margaret away

from the world had burst open under the pressure of circumstance. A newspaper wrote of her in '34: "News sense she considers part of her equipment." She believed her Russian photographs were the most important work she had done, a belief that had to rest on their stronger claim on history.

On her third trip she exposed twenty thousand feet of silent film. Edward Tissé, Eisenstein's cameraman, gave her lessons, but even that was not enough to make her technically adept. At twilight as she was photographing Stalin's mother, the camera burst open and spewed the precious take onto the ground. Hastily, Margaret reloaded and ran off the scene once more in the dying light. News of her film, the first movies brought out by a foreigner, spread faster than gossip when she left Russia. Transatlantic calls, rare in 1932, reached her in Berlin: film studios offering to buy her footage sight unseen. But she wanted to edit and cut it herself, because she was a perfectionist, she said; no doubt she also wanted the glory for herself alone.

Twice she wrote her own film script. The opening shots and dialogue in one version: Margaret assures her publisher she'll finish correcting the galleys of her first book before the boat sails at midnight. She has only a couple of other things to do—take a picture of traffic, and one of eggs, and go to the dentist, buy an evening dress, some sweaters, an evening wrap. . . . She reads galleys in the taxi, then on the gangplank, as one man says, "What will I do without you, Peggy?" and another offers flowers and the stateroom fills up with bouquets from her many admirers.

An alternative opening: The ship leaves six minutes late in order to give her time to finish her galley proofs. Her escort, leaving the pier, realizes her passport and papers are in his pocket; a tender chases the ship to bring them to her. Her scripts painted her as a star, busy, frantically overscheduled, successful, fantastically popular (all of which she was), and so important that ocean liners would change their schedules for her.

Her real life was so packed with appointments and trips that Bert Kopperl, the teenage boy who helped out in the darkroom, routinely purchased stockings and lingerie for her and packed up her suitcases when she had to go on assignment. He recalls that she "danced around the studio by the hour doing rhumbas and tangos with her good friend Arthur Murray"—she had bartered portraits of him for lessons—then would dash out on assignment, dictating letters to her secretary in the crowded elevator on the way down and still dictating as she dashed along the sidewalk with her red cape flying behind and Kopperl struggling after under a mountain of camera equipment.

Her biggest problem with her movie was the film footage itself. She

was a photographer of deliberation, accustomed to composing with care and changing her position by a minute fraction to perfect the arrangement within the frame. She hadn't acquired the habit of seeing in motion; her film resembled a series of animated stills. Stalin's aunt stands in a doorway for an instant, as if posing for her portrait, then walks forward, obviously cued offstage. In New York, Margaret hired experts to cut and edit, but all she seemed to gain were higher bills. It did not take her long to realize that movies were not her forte. In 1933 she tried to sell her footage to Hollywood and let them do the cutting, but the negotiations stalled on the fear that the movie would appear to be propaganda.

The Soviet Union was a delicate subject. In 1932, when Margaret's Russian photographs had first been publicly exhibited in a theater lobby at the opening of a play called *Steel*, the proceeds of the play had been donated to the Workers School and the *Daily Worker*. The Bourke-White view of the U.S.S.R. was almost unfailingly flattering; there was much to admire in the new nation, and she had admired it all. She had neither seen nor photographed the exorbitant price in lives and freedom that Soviet citizens had paid for progress and for Stalin's consolidation of power.

On November 16, 1933, the United States finally recognized the U.S.S.R. Margaret's movie came to life again. In early '34 Hollywood bought one-tenth of her footage for approximately one-third of what it had cost her to make it. Two short travelogues were cut from her material—*Eyes on Russia* and *Red Republic*—the first one narrated by Margaret herself. Her first commercial movie opened in New York in October with *Our Daily Bread*, a Hollywood feature film that proved with cinematic finality that cooperation could triumph over poverty. Margaret never touched a movie camera again.

12

Fame and Wealth

*Within a decade [the twenties], the radio and the movie nationalized
American popular culture, projecting the same performers and the same
stereotypes in every section of the country.*

William E. Leuchtenberg, *The Perils of Prosperity,*
1914–1932

Margaret brought back from Russia the most extended photographic
account a foreigner had published, and it made her famous. Americans
wanted to know everything about the U.S.S.R. They read books, went
to lectures, listened to anyone who seemed to know how things worked
in the land of revolution. As capitalism crumbled bit by bit, the Soviet
Union looked like bedrock on which to build. It was a source of excite-
ment, hope, anxiety. Lincoln Steffens, the muckraking journalist, had
come back from Russia exhilarated and moved. "I have been over into
the future," he wrote in '31, "and it works."

Between *Fortune* and the Soviet Union, Margaret Bourke-White
became one of the best-known photographers in the United States. Not
that photographers in general were well known or well regarded in the
early thirties. In movies, newspaper photographers in baggy suits chewed
on cigars and wore hats that looked as if they'd been salvaged from car
wrecks. Newspapers didn't think much of their photographers either, and
rarely gave them credit beneath their pictures.

The art branch of photography fared little better. New York's Mu-
seum of Modern Art did not mount its first survey of the history of
photography until 1937; Beaumont Newhall's exhibition catalogue was
the first written history to appear in this country. The museum's photog-
raphy department, the first of its kind in the United States, would not be
born until 1940.

As photographic reproductions increased almost daily in number
and availability, the serious audience for photography remained small
and the number of photographers whose names were known to anyone
but art directors smaller still. Stieglitz was still the name to conjure with

in art and art photography circles, and Steichen's portraits and fashion photographs were known to a wide public through the Condé Nast publications. But Margaret Bourke-White had the makings of a heroine. She unfailingly generated good copy as she dared heights, brought eyewitness reports out of Russia, and always caught the eye, being young, attractive, stylish, articulate, and a woman. She was finding, perhaps creating, a new audience for her name.

She began to lecture on Russia and on careers for women in photography, the start of years of lecturing across the United States. As early as 1926, Aldous Huxley wrote that "the American public . . . is not content to admire works of art; it wants to see and hear the artist in person." That, he said, was why lectures were so hugely profitable in America and why authors could make more money lecturing than by continuing to write books. Lecturing wasn't so lucrative in '33, when no one could afford to pay high fees, but Margaret arranged her talks to coincide with her business travel.

If she needed the money, she needed the attention more. Her brother says, "Margaret was very concerned, always, with influencing people. The things that she said were designed to make an impression. The way she told her stories was calculated to be exciting, to catch attention." She was powered by a need to communicate, a need that is a strong force in a photographer. Late in her career, Margaret made notes for an article on "What Makes a Photographer": "An overpowering drive to show what he sees in the world to others—compulsion." She had a medium to suit her compulsion; she also had an instinct for changes in the means of communication.

Radio, for instance. Radio was a relatively recent phenomenon, the first commercial station having been established in 1920. Ten years later, Americans owned an estimated fourteen million sets, and radio advertising began to grow at the expense of newspapers. Margaret's Russian trips put her on the air by the beginning of 1932. Radio series aimed at women —*Women Who Do the Unusual*—began to feature her as well.

At the end of 1922, when Margaret had heard a radio for the first time, she'd thought it peculiar the way the scene jumped from a violin solo to a lecture in New York to a jazz band in Iowa. Ten years later, if you had turned the dial you might have picked up Margaret's rapid speech, full of emphasis and enthusiasm, perfectly articulate and almost too perfectly enunciated. Or someone imitating her: in 1935, CBS broadcast a play based on her experiences photographing the Chrysler Building.

If she wasn't being interviewed, she was endorsing a product. "First I'd better explain that I go back to Russia each year to study their progress

under the Five-Year Plan"—this was 1933—"and I always like to take along some of my favorite American food products. . . . The Maxwell House Company had come out with that new Vita-Fresh can . . . and I just said, 'That will be splendid. . . . I'll take several cans of Maxwell House to Russia!' " And so on. In print, she endorsed the Victor Library of Recorded Music. In an era of endorsements, movie stars endorsed refrigerators, stoves, and beauty in a jar, society women sold face creams. Photographers on rare occasions might endorse photographic products in specialized publications, but no other photographer had the name or recognition to be valuable to a coffee company or a record publisher.

The kind of rapid fame that made Margaret marketable was itself a by-product of social changes associated with the changing media. The culture was being homogenized. National magazines distributed the exact same messages to close to a quarter of a million subscribers; radio programs could put as many as thirty million Americans in touch with stars like Amos 'n' Andy at the same moment of the same day; movies, newsreels, and syndicated newspaper features sent names, faces, and images more rapidly across the country than ever before. In the second half of the nineteenth century, the stereograph and cabinet-card-sized photographs of entertainers had given America its first standardized images of fame, and in the twentieth century the movies had vastly extended the territory; now there were new and yet more extensive channels for the mass production of renown. The rapid spread of the new media—especially, of course, the picture magazine—made Margaret famous, made her, in a sense, possible.

Her photographs went to Brussels and Milan for international group shows. In 1934 she was listed in *Who's Who*; in 1935, numbered among the twenty most notable American women (she said that amused her); in 1936, named on a list of only ten (which included Evangeline Booth of the Salvation Army, the actress Norma Shearer, and Helen Hull Jacobs, the women's Wimbledon champion for the year).

For a while the dizzy spate of publicity seems to have turned her head, and from this time on there were always some who thought her arrogant (and always some who were jealous). But she soon assimilated her fame as if it had been owed her all along. No doubt she believed it had. She even won the imprimatur of Alfred Stieglitz; in 1932 she wrote her secretary, "Much praise today—Stieglitz says I am one of the world's great artists."

Robert Fatherley, Margaret's neighbor from 1938 on, says she wore her fame comfortably; Norman Cousins, a good friend for years, says she wore it unobtrusively. People in factories, at lectures, at parties, were amazed and delighted to find her so easy, so engaging, so free of airs.

With friends she had no side whatsoever, and no one ever accused her of braggadocio. She was not imperial; she simply expected the world would give her what she wanted.

Fame was an integral aspect of Margaret's career and her self-promotion an integral part of her character. She had talent to burn, but there were other talented photographers in her day whose names are blurred because they hadn't her command of the media. She remains to this day a model for women photographers and has also been the model for some men, most of whom would not admit it.

For women everywhere who wanted to make a lasting and recognizable mark upon the world, Margaret proved it could be done. A new dream of power had been released into women's daydreams as they entered careers in increasing numbers. It was a dream with little fulfillment, but that has never weakened the force of dreams. Only a few women achieved high positions in government and the arts in the thirties, and none became a business mogul except in a 1933 film called *Female*, in which the lovely president of a giant corporation, like Elizabeth I of England, refused to marry because she was unwilling to share her power. Margaret's highly visible career helped open a path to respectability for women and for photographers in general. She knew it would take more than a good eye to get her to her destination. Benjamin Sonnenberg, an early master of public relations, wrote her in 1933: "The more I encounter your success as a photographer the more I mourn that you are not in my field of bread and butter. You would have made such a swell press agent. You have such an ingenious sense of drama!"

In 1927, Margaret had unhesitatingly declared that she wanted wealth and fame. Money, however, never galvanized her energies as fame did. She liked a good income and what it could buy, especially smart clothes for first impressions. Beyond that, rich did not mean so much. She was driven by the need to be first but never to be wealthiest.

Which was just as well, for she was broke.

The public thought otherwise. The *Cleveland Plain Dealer*, February 1, 1930: "GIRL'S CAMERA IS $25,000 INCOME." *Time*, December 14, 1931: "Now at 26, her income is $50,000 a year." She did have plenty of work, but she was overextended, a poor manager, and extravagant. A friend from Cleveland wrote her in 1932: "As a photographer I am willing to stack you up against anybody I know, but as a businessman and a correspondent, you are a fine plumber."

The Bourke-White studio brought in $35,000 in the Depression year of 1934, but expenses were high. In '35, profits amounted to a mere $3,503.94. Margaret could not collect from clients who had cash prob-

lems, and everybody had cash problems, including the banks. On Friday, March 3, 1933, Herbert Hoover's last day in office, the banks of America —those that were still open—shut down. John D. Rockefeller, Sr., ran out of dimes for the first time ever during his daily golf game and handed his startled caddy a dollar. On Saturday, March 4, Franklin D. Roosevelt was inaugurated; on Sunday he declared a bank holiday. That Thursday, Congress passed a bill to deal with the banking crisis, and on Monday, March 13, banks proceeded to reopen in an orderly fashion.

As the Depression deepened, the nature of advertising changed. Margaret's talents had been exactly suited to institutional advertising, which left her free to determine the patterns that would stand for an industry. From 1930 to 1932, the *Saturday Evening Post* published her monthly institutional ads for stainless steel, but by 1932, American steel plants were working at 12 percent of capacity and freight shipments were half what they were in 1929. Institutional advertising became a luxury. Doubts about the redemptive power of the machine were slowly surfacing; in *Modern Times* (1936), Charlie Chaplin was driven mad by an assembly line and momentarily turned into a machine himself. The businessmen, bankers, and stock exchange that financed the country's industries took a drubbing from the Senate Banking and Currency Committee's investigation of unethical practices in 1932 and '33. Business advertisers gave up polishing their images in favor of selling their products.

Buick and Goodyear Tires took over as Margaret's staple accounts. (Will Rogers remarked that the U.S. would be the first nation in history to go to the poorhouse in an automobile.) Margaret would now be handed a layout detailing what she was to photograph—a professional pair of lovers standing on a hill beside a car; a boy playing ball in the street, narrowly saved from death by the Goodyear "Margin of Safety." She had no idea how to handle setups or hokum but was rescued on the job more than once by an advertising man who was romancing her.

"The real gift of the advertising business to me," she wrote, "was practice in precision. I never felt I was a very good advertising photographer, but the practice I got while I tried to be a good one was invaluable." Her self-assessments were usually astute. She was more than competent and turned out some handsome, art deco compositions now and again, but she was a good deal less than inspired in the advertising game. Assignments came in—and still her money worries mounted. She needed a bigger staff to handle the work; she had to pay their salaries when she went to Russia for weeks at a time; the Chrysler Building studio, small as it was, was more than she could afford. So she borrowed, sometimes from her mother, sometimes from everyone else she knew.

Remembering the Mungers' injunction to pay them back by putting someone else through school, she paid her brother Roger's college bills at Ohio State although she couldn't pay her charge accounts. When he transferred to MIT, she asked their Uncle Lazar to take over his schooling. Roger had many of his father's talents, and the investment proved out: an engineer and inventor who founded a highly successful firm to manufacture plastics for industrial use, he holds several patents and is the author of a textbook on reinforced plastics.

While Margaret fought the battle of her account books, the Depression was spreading across the country like a virus. By 1931, eight million people were out of work; by 1932, twelve million. The hit tunes gave the nation a melodic poverty: "Brother, Can You Spare a Dime" and "A Little Shanty in Shanty Town" and, most consoling of all, "Life Is Just a Bowl of Cherries." Movies told Americans to be glad they were poor or to forget their troubles at screwball comedies like *It Happened One Night* and *The Thin Man*, which promised that romance and private life could still be one big party, and never mind the bills.

The unemployed weren't so certain. Margaret's sister, Ruth, was as often unemployed as not until she became executive secretary of the American Bar Association, a position she held for life. Jobs just melted away, businesses closed. By 1933, one out of every four Americans was unemployed. That year, the national temper was so hot and unstable that many seriously anticipated a revolution and Lloyds of London offered Americans insurance against "riot and evil commotion."

By January of '33, Margaret was $2,500 in arrears on the studio rent. Within months a collection agency was stalking her about her department store bills; one after another, her charge accounts were cut off, and Kodak threatened to stop selling her film. She had to lower her fees to get work when wallets everywhere were pinched.

She moved to another penthouse studio, larger but less expensive, at 521 Fifth Avenue. Once again, John Vassos designed the interior. Matters did not improve much. When Peggy Sargent was hired as Margaret's secretary in 1935, one glance at the books convinced her they were written in red ink. "She was in debt to *every*body," Sargent says. "She didn't pull it all together in one loan. She'd get just a little bit of money and pay whoever was most demanding. . . . It was a hand-to-mouth existence. I went on vacation once with my salary check in hand, but I had to wait till I got a card from the office saying it was all right to cash it." With clients in arrears, who could pay bills? When Margaret took a three-day vacation with the Ernest Hemingways in 1935, one firm claimed she had spent too much of her time off the job and refused to pay.

One morning a process server showed up at the studio before Margaret did. The man sat himself down in the lobby with the resigned look of someone whose primary talent is waiting. After Peggy Sargent phoned her boss to warn her, Margaret called in regularly to ask if he was still there. He was. He sat all day like a patient vulture, clutching his piece of paper. Margaret outlasted him. She never appeared, he never returned. Then in May of '35 the landlord of her apartment building got a court order to evict her. She scraped up enough money to evade the law once more.

Margaret hired a business manager. That didn't help much either. In the spring of 1936 she invited Robert Yarnall Richie, a commercial photographer, to share her studio and costs; that was somewhat more effective, as he paid half the rent.

Her money problems persisted. In June of '36, Margaret wrote to Peggy Sargent: "Hate to write the news to you that I've bought two new suits. . . . They're Paris models and good bargains, but it's another $200 with hats etc. I should be upset, but [South America] is the place to pick up Paris things. . . . You should get another $250 from mother for taxes. She said she'd send a total of $500 if necessary." The records do not reveal whether Minnie paid the IRS while her daughter looked for work in her smart new suits.

Margaret was in search of the newest avenues to the forefront. First there was color. Magazines had long favored color reproduction, which Joseph White had yearned to perfect, but taking and reproducing color photographs were difficult matters. Before the thirties, most color photographers took autochromes, a glass-plate, three-color process, and a few mastered the carbro process, which was extremely laborious to print. Color film was exceedingly slow and reproduction so unreliable that commercial photographers had to work closely with engravers to get pictures that looked anything like their own.

In the early thirties, when film replaced glass plates, a film called Dufaycolor increased the speed to about half that of black-and-white, and a process known as Finlay color produced good color transparencies. Special cameras were devised, reproduction techniques improved. (Kodachrome, a good roll film for small cameras, was not produced until 1936. Agfacolor came soon after.) In advertising, color was soon at a premium. An art director told Margaret in mid-'33 that she'd be out of the running if she didn't do color photography. By fall she was experimenting with the Finlay process.

For the next two years Margaret photographed cosmetics, pianos, and tabletops in color for advertising and editorial work. She used Dufaycolor in a one-shot camera specially built to photograph live models.

For still life she used a three-plate camera that could produce only two or three shots a day. It was all quite complicated and the color rarely true: when she photographed whiskey early in '34 (Prohibition having been lifted at last) the drink came out a dainty pink. Margaret's color work did not measure up to her black-and-white. In 1940, *U.S. Camera* pronounced judgment: "Color came to Bourke-White—and became her white elephant. . . . Ever the experimenter, and never one to say no to any demand, she started doing garden arrangements, table settings, room interiors. . . . She had become such a fixture in a man's world that parlor, bedroom and bath were no longer any part of her creative make-up. . . . Color then was at least fifty per cent technique, and Bouke-White has never been too interested in that phase of photography."

Her black-and-white photomurals were far more successful. As Margaret's art depended on her sense of monumentality, murals were particularly congenial to her talent. Alfred Stieglitz once said to her, "If your pictures were the size of a postage stamp, they'd still be big. You see big."

Mural-size photographs were not new but suddenly seemed so and caused a brief flurry of excitement in the early thirties, when the technique for sensitizing paper in large sheets was perfected. Photography is closely bound to its own technology. Faster film, better light sources and paper, had made Margaret's Otis Steel pictures possible; faster film and better reproduction put more color photographs into magazines at a time when color was in demand. Now Hollywood, sensing something cheap and useful, became the largest consumer of photomurals, which cost much less to produce than painted backdrops.

The Museum of Modern Art in New York tried to promote murals for public spaces with a 1932 show of projects by painters and photographers, and Steichen's photomural on the theme of aviation went up in the men's smoking room at the RKO Roxy in Rockefeller Center. Margaret did murals for the Aluminum Company of America at the 1933–34 Century of Progress Fair in Chicago and for other corporations, but the murals that demanded most of her attention were for the rotunda of the NBC studios in Rockefeller Center. These went up in December of 1933. With someone else's name on them.

The subject was radio. She simplified and magnified details to represent the vital power of the medium, and, aware that another revolution in communications was brewing, gained admittance to NBC's secret laboratories where television was under development. In her mural, large, simple forms in bold patterns abruptly shifted to more complex patterns in different formats, like the odd disjunction when the dial turns from a violin solo to a lecture. The rhythm was fast, jazzy, bold, dissonant.

Her trouble began in November. A commerical photographer

named Drix Duryea, who had been hired to make the blow-ups, complained loudly to NBC that Margaret wasn't sending in her negatives or working fast enough. The pressure grew so intense that she collapsed several times and was too choked with tears to defend herself at meetings with her clients. But as she wrote in her diary, "This would be the biggest mural in the West and nobody was going to stop me." She laid her plans for the battle: "If the Drix Duryea angle develops a lot of complications, I think it will be rather fun to have a good fight."

The fight was so grim she chose not to mention the mural in her autobiography, although it stayed in place until the 1950s. Duryea claimed he'd designed it. (He was a photographer of apparent technical skill but only the narrowest distinction in the field, and he seems to have felt the pinch.) He also said some of her negatives were unprintable, a claim that might not have been so far off the mark. He and his backer declared that Margaret couldn't possibly be earning enough to pay for such a fancy office and apartment—they were right on that score—and therefore she must be being "kept." The fact that she was a woman and more successful than he clearly unnerved Duryea. His faction said scornfully that she had to be thirty-five or forty (she was then twenty-nine and admitting to twenty-seven) and that it was rumored she'd been married three or four times. They thought her work schedule inhuman and hinted she must take dope to keep it up. At the last minute before the opening, Duryea substituted some of his own photographs—one, she said, was an exact copy of one of her own—and signed the mural not once but four times with his own name.

For the first and last time in her life, Margaret paid a publicist; all other times she handled her fame far better than mere professionals could do. And she won. Duryea's pictures and his name came down, Bourke-White's went back up, her murals got written up in every paper in town, she was commissioned to decorate the Soviet consulate. It was time to conquer a new field.

In 1935, Margaret turned to aerial photography, which would remain vital to her career for the rest of her working years. TWA hired her to take aerial photographs of points of interest along the transcontinental run, then Eastern asked her to photograph their planes over the main cities on the eastern route. Aerial photography, which originated in the nineteenth century during the balloon era, had received a great boost from its success in reconnaissance and mapping during World War I. But its commercial use was still in its infancy; air travel had only recently become easy, comfortable, and lucrative.

Robert Y. Richie, who shared Margaret's studio and had himself

done some private aerial photography, lent her an aerial camera, helmet, and goggles, and taught her how to use the camera. (The camera, he says, he got back, "but not the helmet and goggles. Had to have those as a souvenir, she said.") TWA took an old Ford corrugated trimotor plane out of service, removed the doors and windows so she'd have a clear field to shoot, and strapped her in because she insisted on leaning out the door into the airstream to get a better angle. For a month, whenever she was in the air she ate and slept with a parachute strapped to her back just in case. She rose routinely at two-thirty in the morning for takeoffs so they could cover the two-to-four-hundred miles to their destination by sunrise, the best time for aerial photography.

The pilots of these little planes had run airmail or their own airlines and knew every nuance of windstream and weather. Margaret was cut off from everything, out in the wilds, keeping uncivilized hours, tied into her little plane as it nosed past mountains and fog, connected to an adventuring pilot a few feet away by speaking tube. She loved it. During a brief, passionate affair with a pilot she took flying lessons and learned enough to know precisely how the plane should bank or turn to give her camera range. More than once they made forced landings. Nothing could damp her enthusiasm. "Airplanes to me were always a religion," she said.

At the beginning of July 1936, Margaret needed a photograph of a plane full of passengers over New York, so she invited her friends to fill the window spaces. She asked her mother too; Minnie White, who worked at a school for the blind and each year took courses in nutrition and education, was studying at Columbia that summer. Minnie was as full of curiosity as ever. She registered at Columbia the day before the flight; after registration, she rose and asked permission to be excused from the first day of class so that her daughter could take her on the first airplane flight of her life. Minnie was then sixty-two and in a classful of college students; one imagines she made this announcement with a good deal of satisfaction. All eyes would have been on her as she uttered these words of expectation and parental pride—and then fell to the floor unconscious. She had suffered a heart attack and, without regaining consciousness, died two days later.

Margaret had always had great respect for her mother. Her upbringing had given her a lasting sense of family responsibility, which extended to supporting Roger partway through college. Minnie often lent her daughter money; Margaret arranged to keep her secure in her job by delicately promising to take pictures of the school where Minnie worked. Yet when Clara Thompson, Margaret's therapist, wrote her a condo-

lence letter, she noted that people may experience the greatest regrets when someone dies who has never appreciated them as they would have wished. Respect in family relations is invaluable, but still one longs for more.

Peggy Sargent, who saw Margaret in the office every day, says she never saw her very upset about her mother's death. What's more, she says, Margaret was away with a lover when she heard the news and did not want to break off her trip; she gave her secretary instructions about what should be done with the body.

Margaret left behind no private ruminations on her mother's death. When her father died, she had lost the person she loved most in the world and the course of her life had been profoundly altered, yet she devoted only two sentences to that event in *Portrait of Myself*. She wrote two pages about her mother's death, setting it apart as a short chapter on its own.

Possibly she thought she had not paid enough attention to Minnie when she was alive and would make up the lack by a large tribute to her memory. Indeed, Minnie had rebuked her daughter, gently, less than two years before her fatal heart attack. She wrote Margaret about one of the many Bourke-White interviews in the press: "It is the first of your interviews wherein I have seen mention of your mother"—she did not add that Margaret often mentioned her father—"and it certainly gave me a pleasant thrill to be remembered. How little we dreamed then, that we were making history!"

Margaret had evidently determined that her emotional energies should not be exhausted by mourning but focused instead on extracting a useful lesson from loss. By the fifties, when she wrote her autobiography, she saw both her parents' deaths in a positive light. "I know now," she wrote of her father, "that if we had been wealthy, and I had not had to work my way through college as I did after his death, I would never have been a photographer." Her mother's heart attack she saw, quite properly, as a lucky death, free of suffering, that occurred when Minnie was looking forward to a new adventure. Her estimates of both her father's and her mother's deaths were realistic, and her ability to find a sustaining core at the heart of loss was a blessing that must have given her life unusual equanimity.

But it is a little odd that she could switch into this mode so quickly and so thoroughly, without evidence of intermediate suffering. Her sister, Ruth, wrote her: "Your messages have been the greatest comfort, Peggy, turning grief into something like realization of triumph. How utterly right that it should happen this way, and before the fight to continue creating an increasingly active life had become too difficult."

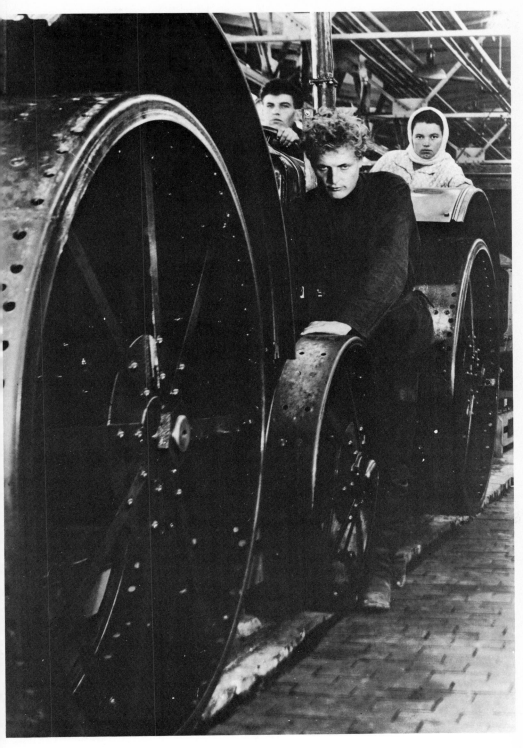

20. Tractorstroi, U.S.S.R., 1930

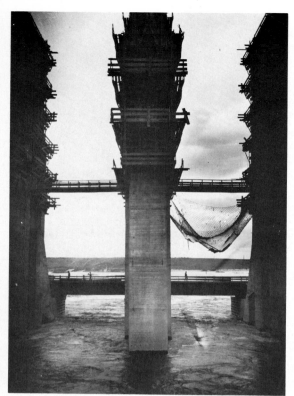

21. Dam at Dnieprostroi, U.S.S.R., 1930

22. International Paper and Pulp Co., 1930

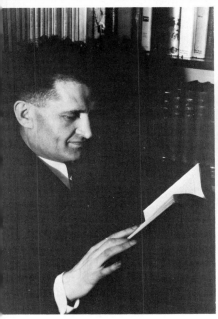

24. In Russia, 1932

23. Maurice Hindus, by Margaret Bourke-
White

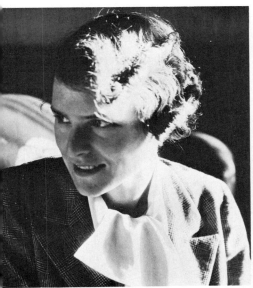

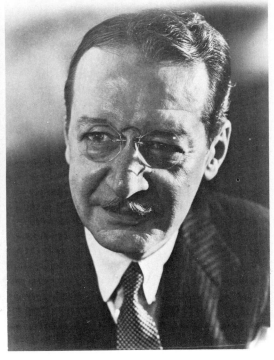

25. Margaret Bourke-White, by Barrett Gallagher,
1933

26. Alfred de Liagre, by Margaret Bourke-White

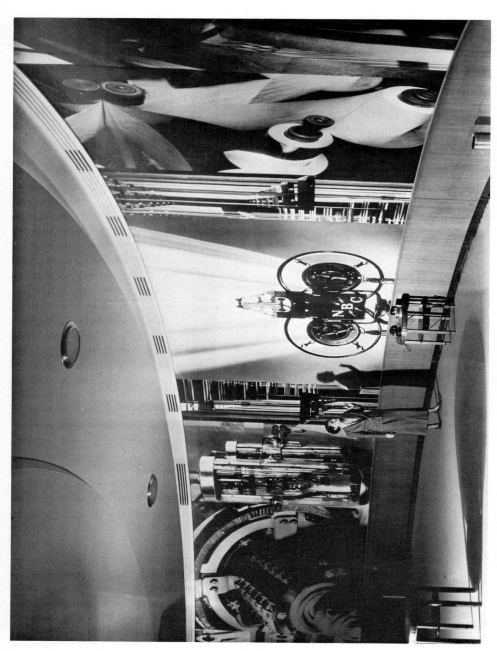

27. NBC mural, Rockefeller Center, New York City, 1933

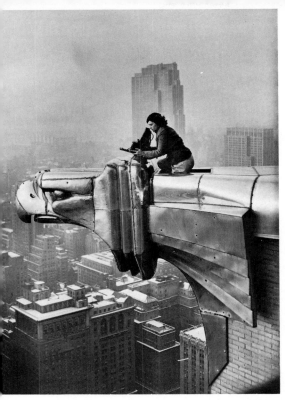

28. Outside the Bourke-White studio,
Chrysler Building, by Oscar Graubner

29. First issue of *Life*, cover by
Margaret Bourke-White,
November 23, 1936

30. Taxi dancers, Montana, 1936, lead story, first issue of *Life*

31. Flood victims, Louisville, Kentucky, 1937

32. Conversation club, Muncie, Indiana, 1937

(The sisters had become much closer as adults than they had been as children. Ruth once wrote that the most precious thing Margaret gave her was affection and understanding, which Ruth herself could not seek naturally—probably because she'd had so little from her mother.) The letter from Ruth about their mother's death is dated July 7, 1936, and is obviously in answer to more than one of Margaret's. Minnie was stricken on July 1 and died on July 3, when Margaret was out of town; by the time she was in touch with Ruth she had not had much time to marshal her reactions. Twenty years later, when Margaret wrote about her life, she gave her mother's death the space she had not been able to grant it when it happened.

While Margaret was trying out everything new—color, photomurals, aerial photography—the newest and most challenging aspect of photography was thirty-five-millimeter and small-camera work. Hand-held cameras had been marketed since the 1880s, when they were sometimes designed to be concealed in a necktie or hat and known as "detective cameras." Thirty-five-millimeter film, with its small negative and resultant compact cameras, became available in the second decade of this century.

By then, a few photographers, like André Kertész in Hungary and Jacques-Henri Lartigue in France, were already using small cameras regularly for spontaneous, unposed pictures of people out for a stroll or playing games—the actions of everyday life without the gloss of studios or literary scenarios. A new aesthetic was being born, which put a higher value on the realism of everyday life and the haphazard quality of snapshot compositions.

By the late twenties, when the Ermanox and Leica cameras had been introduced and faster film and lenses made possible indoor photography by available light, the new photoreporters, like Dr. Erich Salomon, began to take pictures of events that had never been seen by the public, such as diplomatic meetings and court trials. In an era of growing literacy and curiosity, an era that spawned the popular confession magazines, so-called candid photography satisfied the desire to learn something new, even something previously private, in the quickest possible manner. What's more, it bolstered the belief that people caught unaware revealed their true selves, and it reinforced the relatively new insistence that entertainers, artists, politicians, and the wealthy *owed* their public and their audiences personal revelations.

The Leica and Contax 35 mm cameras began to find a popular following in this country in 1932, when improved models with still faster film were introduced. *Fortune* reported in October of 1936 that sales of

Leicas had doubled each year, even as prices rose and the Depression deepened, but most professionals lagged behind the amateurs. Throughout the thirties, newspaper photographers almost universally carried heavy 4 × 5 Speed Graphics with flash attachments.

Margaret, too, relied on a large format. In the early thirties she used a 5 × 7 Corona View, a large camera with a slow speed that necessitated a tripod or, in cramped spaces, a stable rock or banister to lean on. She took with her as well a 3¼ × 4¼ Graflex or Ica Reflex for use when she was scrambling over scaffolds and rafters. (A little later she preferred a 4 × 5 Soho, and a 3¼ × 4¼ Linhof.) All her photographs were enlargements rather than contact prints, and she was proud of the fact that she never did any retouching.

The chief advantage of the large negative is that it registers very sharp detail that is preserved in enlargement; 35 mm film tends to get grainy when blown up. Margaret, who greatly admired Salomon's photographs in *Fortune*, was well aware of the new developments in journalism that went hand in hand with the new cameras, but in 1932 she told Arthur Rothstein she thought 35 mm still unable to deliver the quality she needed.

Her aims and aesthetic were almost antithetical to most miniature camera users'. She sought an enduring image of grandeur and an impression of monumentality, not a glimpse of the fleeting and awkward life of every day. Her highly educated and rather original sense of design overrode the fragmentary and unsettling compositions that the camera so naturally produces; her world was artistically ordered. Photography gives photographers a kind of control over the environment or subject. Many of the photographs taken of Margaret with her camera show her gesturing forward with one hand: do this, she must be saying; do that; move here; stand over there. Her large camera and studied approach made her control complete.

Yet she always needed to be up-to-date. In January of '35 she covered Bruno Hauptmann's trial for the kidnapping of Charles Lindbergh's baby, an unusual assignment for her, and she covered it with a Leica. The following summer she used the camera more extensively. "I am thrilled with my first thorough use of the Leica on a story," she wrote the man who had lent it to her. "When I started the job . . . I couldn't cure myself of the feeling that probably anyone who is accustomed to a large camera has when he turns to a small one—that nothing is happening when I push the shutter."

She continued to use the Leica off and on, and in '37 expressed a new approval of the results she was getting with the "candid camera." But the small camera did not suit her sensibility and never became her

major vehicle. It did, however, become an adjunct part of her equipment for the rest of her career. She preferred the Rolleiflex, which has a slightly larger negative, and the 35 mm Contax.

Her forays with the miniature camera were emblematic of a reach for new subject matter and a new approach. Advertising and industry were still her major subjects, but the self-involved girl who had failed to notice World War I or "the Crash" had begun to survey a larger world and to experiment in new areas.

In July of '35 she spoke to Ralph Ingersoll, the editor of *Fortune*, about developing a new style and subject matter, then wrote Eleanor Treacy (Hodgins), *Fortune*'s art director, about her

> growing interest in the lives of workmen. It seems to me that while it is very important to get a striking picture of a line of smoke stacks or a row of dynamos, it is becoming more and more important to reflect the life that goes on behind these photographs. This fringes on the candid camera type of photography, and also represents a point of view which I think is becoming increasingly important in regard to photography, and is something I have given much thought to lately.
>
> I happened to mention this to [Ingersoll] and immediately he talked to me about doing the automobile worker's family and others which you are trying to line up if they come through successfully. I am delighted that *Fortune* is going in for things of this kind.

Her perfectionism stood in her way. She fussed with the worker's family until they were more awkward than mannequins. Eleanor Treacy wrote her: "There is a general feeling that the pictures were too stiff and posed-looking, and I certainly think you didn't get the spontaneity in your candid shots that there might have been. . . . Never mind if the technical quality of the prints is not as high as you would like to have it for a while. I think it is better to sacrifice that a little in order to get life and action into your pictures."

Margaret plunged right on to the next set of family pictures, and this time *Fortune* published the photographs. The wife with her washing machine, the children playing, still looked posed, but at least they were no longer making such strained attempts to look natural. Margaret was working her way toward an entirely new kind of photography.

On March 16, 1935, she formalized her connection to the news, agreeing to devote at least forty-eight days a year to work assigned her by Acme Newspictures and the Newspaper Enterprise Association. NEA asked her to photograph President Roosevelt. Excited at the prospect, she dreamed that in his office she repeatedly knocked over her camera and tripod, leaving FDR's desk littered with the broken shards of flash-

bulbs. The actual portrait session went by without a hitch. Afterward, setting up for an exterior shot of the White House, she knocked her camera off the tripod and smashed it to smithereens.

For NEA she ventured far from her usual territory: to the backstage of Minsky's burlesque, to the Olympic Games, to the Newport Cup race. Her exploits in her new field became news events in themselves. As she told the story of the Newport races to a reporter, she was following Vanderbilt's *Rainbow* in a motorboat when the yacht turned and the motorboat careened in pursuit. Margaret ran forward to snap the yacht at an angle, tripped as she was running, and fell into the sea with her precious camera. Newspapers printed the story, which was true up to a point. Margaret did fall into the sea—but it wasn't an accident.

Don Hershey, who had organized Margaret's photography sales at Cornell, recounts a conversation he had some time later with a news photographer. "Do you remember Bourke-White going overboard on the Press boat at the Vanderbilt races?" the photographer asked. "Well, I was the guy who booted her. I was getting a rakish shot over the rail and all of a sudden Bourke-White was under me, leaning way out to get the same shot. I let her have it."

This was only the first time, not the last, that newsmen would use force to protect their private club from a woman. Margaret didn't play the game the way a woman was supposed to, with a sweet and retiring demeanor. She was at least as determined to get the best angle as any man seasoned in that rugged business. Carl Mydans, one of the early and distinguished *Life* photographers, recalls that once in the late thirties he and Margaret were both on the steps of St. Patrick's Cathedral in Manhattan, jockeying for position with a lot of newspaper photographers carrying big 4 × 5 Speed Graphics. Margaret was using a 3¼ × 4¼ mahogany-finished Soho Reflex, a beautiful piece of equipment and as tenderly polished as a piece of antique furniture.

When she breached the newspapermen's line, one of them turned and kicked her hard in the shins. "What are you doing here with that goddamn toy?" he snarled. She stood her ground but began to weep, more, Mydans thought, from frustration and the sense of injustice than from pain, and because she wanted that picture more than anything else in the world.

In the summer of '36 she photographed the presidential candidates. One day she told Robert Richie she needed the studio to herself that night to photograph Earl Browder, head of the American Communist party and running for President on the party ticket. "Next morning," Richie writes, "I happened to be first in the darkroom and was astonished at the prodigious amount of work that had gone on the night before. Not

25, but count them, Diary, 125 (5 × 7) black and white portraits of Mr. Browder in hangers on the drying wires. The gal was thorough if not confident."

The photograph, not commissioned by a news service, made the front page of the *New York Times* and was used as publicity by the party. The president of NEA called instantly, irate that Margaret was giving the Communist party publicity and working free-lance when NEA had signed her to an exclusive contract. Fortunately Margaret was out of town. She told her secretary to take the blame, for the studio needed the regular NEA stipend to cover salaries, but in mid-August the contract was abruptly terminated. Americans, though fascinated by Russia, were terrified of Communists. Margaret, with a staff to be paid, rent to be paid, creditors with annoying desires for money, and canceled charge accounts at every department store in New York, was once more without a steady income.

It looked like a disaster. She would repair it with a triumph.

13

The Struggle of the Great Masses

Politics has not been the usual diet of artists, not since Courbet went first to prison and then into exile for his activities in the Paris Commune of 1870. But American artists are awakening to the urgencies of their times. . . . They have come to understand that politics is something of vital concern to every citizen. . . . A social content has crept into art.

Elizabeth McCausland, 1936

The world is going to pieces and people like [Ansel] Adams and [Edward] Weston are photographing rocks!

Henri Cartier-Bresson, 1930s

The 1930s began a few months ahead of time, in October of 1929. Few foresaw how far-reaching the consequences of the first crash would be: Henry Luce, striking a realistic note of caution for the investors in *Fortune*, warned at the beginning of the decade that the slump might last as long as a year. The Depression came on slowly but official acknowledgment more slowly still. In March of 1930, President Hoover announced: "All the evidences indicate that the worst effects of the crash upon unemployment will have been passed during the next sixty days." Within sixty days, unemployment had topped four million.

In the first years the media and the government, both staying as silent and optimistic as possible, helped keep the Depression largely invisible while the economy slid inexorably downhill. State and private relief began to run out in the winter of 1931–32 while the Hoover government remained reluctant to institute federal aid. The following summer, the Bonus Expeditionary Force, a ragtag collection of veterans looking for benefits that hadn't been paid them, marched to Washington, failed to get the answer they wanted, and set up housekeeping in a dirty little encampment of tents within sight of the White House. At the end of July, the army under General Douglas MacArthur, accompanied by a

major named Dwight David Eisenhower, was called out to disperse the veterans of the Great War with cavalry, infantry, tanks, machine guns, tear gas, and drawn sabers. Eleven months later, Franklin Delano Roosevelt, accepting the Democratic nomination in Chicago, pledged himself to a new deal for the American people.

As the economy shriveled and desperation grew somewhat more evident, information about current affairs assumed a new importance in the lives of people who had not cared much before. "The depression," wrote Archibald MacLeish, "was one thing you *had* to know about." When Margaret ventured into the world of news photography, she was responding to a heightened nationwide interest in the events of the day.

She could no longer afford the blinkered vision of her early career. *Fortune* was changing even as she worked for it. In 1930, less than a fifth of the magazine's articles dealt with subjects other than business; in 1931, more than a third; in 1934, over half. MacLeish said that with the editorial changes that took effect in '31, "*Fortune* almost immediately became a more accurate and reliable historian of the period than any other publication in the country. And a great part of its improbable success was, I should guess, a consequence of that fact." He added that he thought it a better social historian than *New Masses*, a judgment that would have sent a shudder across every page of that extreme left-wing, socially committed magazine.

Fortune's staff was for the most part far more liberal than Henry Luce, but Luce rarely interfered directly with the magazine's policies. As he had in a sense invented investigative reporting with the corporate story, he understood the uses of critical journalism, and he so loved a good argument that he did not always care excessively which side it was waged on. (*Fortune*'s photographs, incidentally, continued to romanticize industry even as the text from time to time gave that up.)

While newspapers and radio generally glossed over the toughest problems of the time, *Fortune* began to feature them. A title in the February 1932 issue: "Housing: Need/Cross Section of a country in which one half the homes fall below the minimum standards of health and decency . . ." September 1932: "No One Has Starved . . . which is not true." October 1934 lead story: "On the Dole: 17,000,000."

Margaret, back from one of her Russian trips, wrote a Soviet friend: "I find it most interesting to talk with people who are in close touch with world affairs and I wish I understood better what forces are behind these unprecedented occurrences." Although she had returned from three trips to Russia almost as generously uninformed as when she started out, she was always hell-bent on self-improvement; now, setting herself an educational program, she became a devout convert to knowledge.

Among her circle of friends and lovers were many who could have

instructed her in world affairs, which she at last wanted to know about, and who would have thrown in a lesson on leftist causes. Most of the *Fortune* staff leaned to the left. John Vassos said his late wife was a Communist and several of his friends were secret agents for Russia. Frederick Kuh, an international correspondent and Margaret's sometime lover, contributed to leftist periodicals. She was also on close personal terms with Joseph Freeman, editor of *New Masses* and for a while one of the nation's most articulate spokesmen for communism. Freeman, a notorious ladies' man, claimed he was responsible for getting Margaret into Russia the first time; afterward, he translated love letters from Russian suitors for her. Then there was Maurice Hindus, who argued politics with Margaret day and night; not a Communist, he spoke with enormous sympathy for Russia and for the workingman everywhere.

One of these men must have given Margaret a reading list. A 1935 article about her said that "her reading runs the line from detective fiction to Lewis Corey, John Strachey, [Rexford] Tugwell, [Adolf] Berle, Adam Smith. She's interested in the causes of social conflict, the remedies. Politics and economics are a major preoccupation. She's eager to get underneath the things she photos." Her introduction to current history had convinced her that a deeper understanding would make her a better photographer.

In 1939, when asked which five books had most strongly influenced her, she added to *The Education of Henry Adams* and her reptile and grasshopper books John Strachey's *The Coming Struggle for Power*, published in this country in 1933 after having galvanized a generation of English socialists. Strachey thought that communism was "the one method by which human civilization can be maintained." What's more, he said, "To travel from the capitalist world into Soviet territory is to pass from death to birth."

Everywhere people talked of the promise of communism. America's intellectuals and artists were at an impasse, and deeply troubled. Only a couple of years earlier they had been sneering at Mencken's booboisie, at a materialism so deadening it had sent many of them posthaste to the cafés of Paris. Now that capitalism had failed so bewilderingly, the exiles had drifted back from the Café Flore and the Deux Magots to cheer on their country. They looked to the one economy that seemed—to outsiders at least—to be working for the good of its people, and they found in it the last, the only apparent hope. Early in the decade, Theodore Dreiser and Sherwood Anderson spoke of communism as the brightest outlook for the world's problems. Edmund Wilson wrote that Russia held the key to the future "as a model of what a state should be."

As the Nazis took over Germany and Mussolini consolidated his

power, hatred and fear of fascism drove more and more people to the left. When America finally recognized the U.S.S.R. in 1933, the left-liberal position became newly respectable. Margaret, who had brought home from the U.S.S.R. a lasting sense of goodwill toward that country, seems to have brought home an aroused conscience as well. A friend of hers said that "Russia . . . made her think socially and unsealed a deep well of sympathy for the plain suffering citizen of the world."

Naturally enough, she entered upon politics and good causes through photographic organizations. When she had neither much money nor much time, she gave small amounts of both and lent the large prestige of her name to various campaigns. In 1933 she contributed to the Photographic Workers' League fund for some striking workers. In 1934 she agreed to sponsor a fund-raising ball for the Film and Photo League, which made and distributed workers' films, popularized Soviet movies, and produced documentary films on unemployment and hunger in America.

Margaret also contributed to the Photo League, a highly influential group of still photographers who split off from the Film and Photo League in 1936 to further a dramatic and convincing form of socially concerned documentary photography. Although neither radical nor as programmatically leftist as its parent group, the Photo League even in its own day was thought to be left-leaning. Like many another important photographer, Margaret spoke once at the league, which also gave her an exhibition.

Her political awakening had a deep and permanent effect on her photographic career. People no longer seemed so incidental to her. She was about to assay the candid camera field, where people were all that counted. She was about to discover suffering.

In the thirties, artistic fascination with the machine was being tempered everywhere by a new recognition of the worker and his plight. In painting as in literature, social concern became a dominant theme. When Charles Sheeler photographed the Ford River Rouge plant in 1927, he pictured pure industry unpolluted by workingmen. A few years later, the Mexican painter Diego Rivera produced a vision of heroic workers rather than heroic machines at River Rouge.

Margaret credited the formation of her conscience, at least of her camera conscience, to an assignment for *Fortune:* the dust bowl of 1934. News of the drought was a headline catastrophe in the eastern newspapers in the summer of '34. Everyone knew that the overgrazed, overplowed plains had burned to powder dust and, rising into the already gritty air, were blowing across the sky. Yet no one knew the details, and no one had seen the story whole. It is symptomatic of *Fortune's* new

alertness to the value of news that Ralph Ingersoll gave Margaret one of the first photographic assignments on the drought in a national magazine. He gave her five hours to get ready to fly west and five days to get the story—but the newspaper accounts had been so spotty that no one knew where the infamous dust bowl was. She flew to Omaha to track it down.

Discovering that the drought reached north into the Dakotas and south into Texas, she chartered a plane to save time—she found out when it crashed, "gently," at the end of the trip that it was an extinct model—and flew by short hops over the whole territory, watching the parched earth below and the drifting sheets of dust for a place to set down and photograph. "The storm comes up in a terrifying way," she wrote. "Yellow clouds roll. The winds blow such a gale that it is all my helper can do to hold my camera to the ground. The sand whips into my lens. . . . Soon there is no photographic light." Indoors, people wore masks of wet cloth to filter out the omnipresent dust, which seeped under the windowsills, the doorsills, through chinks in walls. They told jokes about it: a pilot whose motor clogged in a sandstorm parachuted out, and it took him six hours to shovel his way back to earth.

In her autobiography, Margaret wrote that on this assignment, "suddenly it was the people who counted. Here in the Dakotas with these farmers, I saw everything in a new light. How could I tell it all in pictures? Here were faces I could not pass by." But it was all so new to her, even the general notion of human suffering was in some way so new to her, that at first she could only understand it through the suffering of the animals. "The toll is mounting," she wrote at the time, "of people who become marooned and die in the storms. But the real tragedy is the plight of the cattle. In a rising sand storm cattle quickly become blinded. They run around in circles until they fall and breathe so much dust that they die."

She was not yet equipped to express human despair. Her photographs of the drought rarely equaled the gravity of the subject, and she must have known that. Deep human emotion is, by and large, something a photographer must learn to convey, something a photographer must earn.

By mid-decade she had accepted the newly enlarged idea of the artist's responsibility to a culture under pressure. In 1936, in an article significantly titled "Photographing This World," she wrote:

As the echoes of the old debate—is photography an art?—die away, a new and infinitely more important question arises. To what extent are photographers becoming aware of the social scene and how significantly are their photographs portraying it? . . . The major control is the photographer's point of view. How alive is he? Does he know what is happening in the

world? How sensitive has he become during the course of his own photographic development to the world-shaking changes in the social scene about him?

She had thought of herself only as an artist until it occurred to her that the man who gave scale to her dynamos was also a cog in a political machine.

It is possible for hydraulic presses to rear their giant forms majestically in automobile factories, and for the workers who place and replace the metal sheets beneath the stamping block to be underpaid. It is possible for cranes to etch their delicate tracery against the sky, and for the iron miners to look from the front doors of their little homes across the deep-tiered stripping and see the derricks, exquisite but idle.

Never again would she see the derrick without thinking of the working-man behind it.

In the twenties, Margaret lost her innocence; in the thirties, her indifference. By the second half of the decade she was lending photographs to fund-raising exhibitions to aid agricultural workers, sponsoring the League of Women Shoppers (which organized boycotts and protests to promote the formation of unions in department stores), actively supporting leftist causes such as the American Youth Congress and aid for refugees of the Spanish Civil War. In August of 1936, when she received a letter from the painter Stuart Davis calling for the formation of an American Artists' Congress, she joined immediately.

The American Artists' Congress, which unified the artists of America, was formed in response to two crises: the economic collapse that had wreaked havoc on the artistic community and the threat of war and suppression of culture by Fascist forces. Membership was drawn from the most prominent artists of the day. The officers included the painters Max Weber, Stuart Davis, Peter Blume, and the painter and illustrator Rockwell Kent. The executive committee listed such eminent artists as Philip Evergood, William Gropper, Yasuo Kuniyoshi, Louis Lozowick—and Margaret Bourke-White. Roselle Davis, Stuart Davis's widow, says that the admission of photographers was a big issue, as the painters and sculptors did not consider them artists, but the photographers carried the day, and Berenice Abbott, Ansel Adams, Paul Strand, and Edward Weston all lent their support.

The congress agitated against cutbacks in funding for the Works Progress Administration (WPA), called for artists to ally themselves with the trade union movement and the working class in general, pledged to fight discrimination against Negro and Oriental artists in the United States, and organized exhibitions to help defend democracy, dedicating

one in 1937 to the peoples of Spain and China, both involved in devastating wars. In 1938, Margaret Bourke-White was elected vice-chairman.

On Valentine's Day 1936, eleven hundred people crowded into Town Hall in New York for the first meeting of the American Artists' Congress. A great banner across the stage urged the audience to "Unite. Defend culture against war and fascism." Rockwell Kent spoke on "What is worth fighting for?" the painter Joe Jones on "Repression of art in America," the muralist Aaron Douglas on "The Negro in American culture," Margaret Bourke-White on "The position of the artist in the U.S.S.R."

"I don't want to seem to be describing Utopia," Margaret said, "but this one fact alone—the freedom of the Soviet artist to experiment—points up more sharply than anything else I can think of the tremendous difference between the opportunities of the artist under a system like that in the Soviet Union and the lack of opportunity here. In Russia if an artist . . . wants to go on a trip to a distant part of the country to paint pictures of certain subjects he may be interested in, he is given the trip. His expenses are paid while he is away, and whatever pictures he may bring back with him he is paid for also." She added, "Every artistic experiment that individual artists wish to carry out they can. People in general have the notion that there is an art line laid down by the government but this is not true."

This statement had been true to a certain extent when she visited the Soviet Union, although long before her first trip some of the most progressive artists had had to emigrate to the West to carry on their experiments as they wished. When she was there, artists did hold high positions, received government subsidies, and were still permitted a certain latitude in approach so long as they stayed within prescribed limits. A guest of the government like Margaret was not likely to see the harsher side of this seeming paradise, and a woman of her initial political naïveté would not have framed the proper questions. The Stalinist purges did not commence in earnest until she had left the U.S.S.R., but as she spoke to the congress about Soviet freedom, millions were already dead and more were dying. The Soviet government's attitude to artistic experimentation made a mockery of her words, but she hadn't the knowledge —and most Americans did not—to realize how wrong she was.

From the mid-thirties on, Margaret would always stand on the left-hand side of the political spectrum. She subscribed to the *Daily Worker* and made murals for the Soviet consulate, and several of the organizations she supported were later assumed to be Communist fronts. But she was not a Communist, never joined the party, nor ever considered doing so. She had a conscience but not an ideology, a moral position but

insufficient angst or political fervor to be a party member. Never a joiner, always on call for traveling assignments, she was not so involved in political matters as the records suggest. She freely gave her sympathies, her goodwill, her name, and spare pieces of her time to the causes she believed in, but she was seldom an active worker, more often a name on a letterhead, a photograph in an exhibit, a guest lecturer who agrees to speak once. Her goodwill had many objects, but her passion had only one, and that was her career.

"I am not politically minded," she wrote in the fifties. "Toward the late Thirties I decided not to allow my name to be used on any letterheads or committees because I felt that being in an absolutely impartial position was very important to my work as a photographer." By the time she forswore even the loan of her name, she had become a photojournalist; impartiality was part of her equipment. Photography came before causes. Photography, in fact, *was* her cause.

Expanding awareness and concern made Margaret fret under the yoke of advertising. To photograph wooden models of rubber tires and knights in armor jousting in New York's Central Park began to gall her spirit. Among her notes on *Fortune* is a reminder to herself to preserve her independence: "The whole approach false—to do what you think the public will like. Do what you like. You should be miles ahead of anything the public has ever seen."

She believed, as the American Artists' Congress did, that artists must ally themselves with the working class. "Artists . . . playwrights, engineers," she wrote in '36, "all creative workers . . . will comprehend that in a large sense these problems apply to all workers whether they are building motor trucks, railroad trestles, power dams, or pictures. It is my own conviction that defense of their economic needs, as well as their liberty of artistic expression, will inevitably draw them closer to the struggle of the great masses of American people for security and the abundant life which they are more than anxious to earn by productive work." Not many years earlier, Margaret had told her cousin Felicia that she was working for the only people who counted, the managers of big business. She would never say that again.

Early in 1936, she had a dream. The cars she had been photographing advanced on her with their hoods raised, looking like metal beasts of prey with their jaws agape. Faster they came and faster, until as she began to stumble and the monstrous cars closed in on her, she woke up to find herself on the floor thrashing about with a strained back. She decided there and then never again to accept a photographic assignment unless she could handle it creatively and constructively.

That day she threw over her studio advertising career. A telephone call that very afternoon offered her a commission at a thousand dollars a picture, more than she had ever been paid. She refused it. The next commercial assignment she accepted was a freewheeling trip to South America in the spring of '36 to photograph coffee plantations at her own pace and under her own direction. She also advised her brother Roger not to go into advertising, saying he could do things in life that were much more useful and valuable than the artificial world of advertising could ever be.

She planned a summer project wholly devoted to social documentary. Her aroused conscience and deepening sense of humanity had thrust her far afield. It was almost as if she had been preparing to meet someone profoundly concerned with injustice, and she did. His name was Erskine Caldwell, and their meeting would radically alter both her life and his.

14

Social Documents

In the thirties, the United States became a pressing subject for its citizens. Sociologists like the Lynds in Middletown, essayists like Edmund Wilson and Walter Lippmann, novelists like Dos Passos in U.S.A., tried to explain Americans to each other. The critic Alfred Kazin, writing in 1942, said that "Underlying the imaginative life in America all through the years of panic, depression, and the emergency of international civil war was an enormous body of writing devoted to the American scene that is one of the most remarkable phenomena of the era of crisis."

Kazin remarks on a new dimension in this literature:

> What the documentary literature provided . . . was a register of a learning process, an example of a new social consciousness in whose greatest distinction was the very fact of that consciousness in itself, a sense of a grim and steady awareness rather than of great comprehension. In this respect none of the devices the documentary and travel reporters used is so significant as their reliance upon the camera. Ever since the daguerreotype had come into American life, writers had been affected by the photographic standard, but now they became curiously abject before it. Nothing in this new literature, indeed, stands out so clearly as its attempt to use and even to imitate the camera.

Dos Passos called one section of U.S.A. "Camera Eye," another section "Newsreel."

Margaret, unaware that she was making history, wanted to weld her photographs to documentary literature. She thought of doing a book, "based on a great need to understand my fellow Americans better." She did not consider herself a writer, but had "a very deep desire to enter somehow into people's lives with the camera."

At a cocktail party in January of '36, she swooped down excitedly on Maxim Lieber, Erskine Caldwell's agent, to say how much she'd like to meet the author and work with him. (The writer Malcolm Cowley, who

knew Margaret slightly in the thirties, describes his wife's reaction to her then: "She came into the room, her eagle eye traversing the whole room and picking out the celebrities. Then the eagle pounced.") Lieber was responsive; he told Margaret that Caldwell was eager to have a photographer with him when he revisited the South he had covered in such novels as *Tobacco Road*. And so Bourke-White and Caldwell met and agreed to join their talents to a cause.

Erskine Caldwell's dramatic stories of southern poverty and obsession introduced thousands of Americans to the power of the new naturalistic literature of social protest and concern. Critics compared him to William Faulkner, and Faulkner himself named him one of the best contemporary writers. He had earned a certain robust notoriety for the open sexuality of *Tobacco Road* (1932) and *God's Little Acre* (1933), which became the introductory sex manuals for several generations of American boys. But it was the dramatization of *Tobacco Road*, which opened on Broadway on December 4, 1933, that made him suddenly famous.

That play ran seven and a half years, breaking all previous records and scandalizing an unprecedented number of people. Southern governors spoke out against it, southern ministers preached against it, an unsuccessful attempt was made to suppress performances of it in Atlanta, and a Democratic congressman from Georgia denounced it from the floor of the House of Representatives as an "untruthful, undignified, undiplomatic and unfair sketch of Southern life." Caldwell had the distinction of being America's most banned writer.

He had been born in the South, the son of a Reformed Presbyterian minister who moved about constantly, partly because he preached so vigorously against injustice and inequality that he was rarely welcome for too long in one place. By the time Caldwell wrote his own tales of inequity, the nation was already aware of the South's problems. In 1933, when the federal government put into effect a plan to pay farmers to plow under part of their cotton crop, tenant farmers began to be thrown off their land and the Southern Tenant Farmers Union was organized amid threats of violence. Newspapers reported the events, and Americans became suddenly and acutely conscious of the extent of the sharecroppers' misery.

Yet even northerners thought Caldwell's novels too grotesque to be based on reality. In 1935, he went South to write a series of articles on sharecroppers for the *New York Post*: "In parts of Georgia human existence has reached the lowest depths. Children are seen deformed by nature and malnutrition, women in rags beg for pennies, and men are so hungry that they eat snakes and cow dung." (February 18, 1935) Still people said his books exaggerated. No one could believe his larger-than-

life southerners stripped by poverty of everything but their hunger, their lust, their anger and obsessions: Jeeter Lester, Ty Ty Walton. At length Caldwell decided to write a factual book on the subject himself. To bolster his case he sought out the decade's most convincing, most expert witness: the camera.

It was my intention [he wrote] to show that the fiction I was writing was authentically based on contemporary life in the South. Furthermore, I felt that such a book should be thoroughly documented with photographs taken on the scene.

Although I had taken photographs to illustrate the articles written for the *New York Post*, the photography was decidedly the work of an amateur and I had no illusions about my ability in that field. I was strongly in favor of having the best obtainable photographer to take photographs for that book.

Caldwell said he was impressed by Margaret's style and would give anything to work with her, but secretly he had his doubts. He didn't care much for her advertising photography and says he didn't hesitate to tell her so. Margaret, who claimed that Lieber had privately told her the famous author's misgivings, sent Caldwell letters emphasizing her recent conversion: "This is just to tell you that I am happier about the book I am about to do with you than anything I have had a chance to work on for the last two years. I have felt keenly for some time that I was turning my camera too often to advertising subjects and too little in the direction of something that might have some social significance."

But he had other reservations as well. Margaret said he was reluctant to work with a woman. Helen Caldwell Cushman, who was married to Caldwell at the time and was the mother of his three children, says the only woman he was ever reluctant to work with was Margaret Bourke-White. (Helen and Erskine divorced two years after this trip, so her memories may be colored by more than the passage of time. On the other hand, she became very fond of Margaret, and the two of them remained friends for many years.) She says her husband had been warned that Margaret was "quite unscrupulous financially," whereas Erskine was a stickler on such matters.

Helen adds that Caldwell hired his literary secretary (Margaret referred to her as Sally, not her real name) to accompany them on the trip south, keep a strict account of all expenses, and make sure Margaret paid her share. There were other problems. Helen recalls that just after Erskine and Margaret set out on their journey, she heard a lurid tale of a young wife who had killed herself when she found out her husband was in love with Bourke-White.

The trip was nearly canceled before it began. Margaret had too

many commitments. In the first half of '36 she completed her advertising and aerial assignments, signed a contract with NEA, sublet half her studio, traveled to South America. Also, a new excitement had swept through Time Inc. and caught her up in it: the firm was starting a picture magazine. Not a magazine like *Fortune*, with stories illustrated with beautiful pictures, but a magazine that couched its message in photographs and demoted the text to a supporting role.

Although in Europe there were publications that told the news primarily in photographs, in America there was none; photography was being offered a new role. It is not clear what role Margaret was being offered. The editors expressed interest in her forthcoming trip, and pictures by her appeared in all three trial dummies, but by mid-July, no one had offered her a contract. Besides, she had a contract with NEA that would have prevented her working full-time. At any rate, Margaret, a fierce guardian of her own independence, would not have readily given her full time to anyone or any enterprise.

Pressured for time, she had had to postpone the trip south with Caldwell more than once. All his life Caldwell has thought time and appointments too crucial to brook rearranging; finally, when she asked for just one more day, he angrily postponed the trip himself. The way he put it, it sounded like a new way to say *never.*

He was in Wrens, Georgia, when he called off the project. All of Margaret's new interest in news, politics, people, and humanitarian causes was concentrated in this book; she could not let it go. With little hope of bending Caldwell, she decided she had to get to him fast. In her autobiography she says she had only four days to put her business in order, but things were actually more urgent than that. She called Wrens on July 17, got the wire postponing the trip the same day, and arrived in Augusta by plane early the next morning. At breakfast in the hotel, she wrote Caldwell a letter.

"It seems to me that this work that you and I have planned is so important that I couldn't bear to see it hopelessly lost. . . . It was essential that I get my affairs in shape before leaving—simply for the reason that I have to earn my living and it is these jobs (which are now finished) that make it possible for me to carry the overhead while doing a really creative and socially important job like the book with you." She could not get a Western Union messenger, and the mail delivery was too late, so she hired a boy with a bike to take the letter. She thought Wrens was six miles away; it was just about thirty. All day she waited in the hotel, not daring to leave. She wrote to Peggy Sargent: "Caldwell coming to the hotel at eight tonight. [Sally] is here. . . . He talked with her . . . and

didn't sound hopeful but I'm not giving up yet. Will go on to Arkansas and do sharecroppers alone if it falls through."

She described Caldwell's arrival at the hotel in her autobiography:

> We went into the coffee shop, sat down at the counter and ordered hot coffee. While we waited to be served, Erskine Caldwell looked quietly down at his hands. We drank our coffee in wordless communication. When the last drop was drained, Erskine turned to me and smiled.
> "That was a big argument, wasn't it?"
> I nodded.
> "When do you want to leave?"
> "Now."
> And so we did.

Autobiographies are, or used to be, schooled in politeness, not least to their authors. Sally made notes on Margaret's behavior in which she reported an outburst of hysterics the evening of this allegedly monosyllabic conversation. Caldwell himself wrote his wife that Margaret had cried and begged and said she wouldn't make any trouble, so he had given in.

Margaret thought Caldwell looked like a man who never laughed, though audiences were paying good money to guffaw at his novels and his play. As they traveled the back roads from Georgia to Arkansas the first three or four days, he hoarded his speech like a miser. Margaret thought him an enigma but was certain she would soon decipher his personality, for her father had given her more experience with silence than most people ever get.

She had one clue she seems to have made very little of. The back seat and trunk were crammed with her equipment—Sally had to wedge herself in like an extra tripod—and in the trunk were two glass jars holding praying mantis egg cases. Margaret was no longer keeping snakes in her bathtub, but she was photographing the life cycle of the mantis for the new picture magazine and could not afford to miss the fateful moment of their birth. (This occurred quite spectacularly on a back road later in the trip, and she got pictures of two hundred tiny dragons swarming over each other on legs more delicate than reeds.) Just before Caldwell started the car the first day, she ran back to the trunk to make sure the mantis jars were safely stowed. The lid of the trunk came down suddenly on her head. "Erskine gave a delighted chuckle. Why, he can laugh after all, I said to myself, and Erskine said, 'I hope something funny happens every day like a trunk lid coming down on Margaret's head.'" It was not an auspicious beginning.

Nor did the early part of the trip go well. Margaret sent cheery

bulletins back home to reassure her staff, and possibly herself. On the twenty-first of July, she wrote Peggy Sargent: "The three of us get along beautifully and are having a lot of fun." Erskine's bulletins painted another picture. A few days later, he wrote home to Helen:

This is the worst trip I have taken so far—it must be the heat. But the trouble is, I suppose, we get on each other's nerves. . . . We had a scrap in Montgomery that could be heard for miles around—naturally she cried— but promised to follow my suggestions.

She had another spasm the next afternoon near Meridian, Mississippi. Yesterday Sally had one with her—and I don't know what will happen. If I get so I can get along with her, I may have to let Sally go home—she asked this morning if she could leave.

I don't know what would happen if I were left alone. The trouble is Bourke-White is in the habit of getting her own way—and so am I—what happens when we fall out is all that can be imagined. The whole thing is on a day-to-day basis now—and it may be called off any minute during the next week.

Margaret later told a reporter that Caldwell "didn't want a woman to do his pictures, most of all he didn't want me for he thought I didn't catch the spirit of what he wanted done and we certainly had a period of orientation if not squabbling." It sounds as if he had been directing her in one way or another, suggesting what to photograph and how she could capture the spirit and truthfulness of his books. Margaret would have bridled at direction of any sort, but Caldwell's influence may be partly responsible for the high emotional charge in her photographs. She found herself locked in a struggle for control right from the start. Peggy Sargent says of Caldwell, "I think he was a dominant figure. I think he wanted to be the controlling element, and for a while she was willing to let him be." In the beginning, however, she had trouble adjusting to second place.

Margaret said in her book that on the fifth morning of the trip, Caldwell came to her hotel room as usual to help with her cameras. This time he wanted to talk. "He said he didn't think we were getting anything accomplished. He felt like a tourist guide just showing somebody around. He thought we should give the whole thing up."

She claimed she was stunned because she hadn't even guessed that anything was wrong. "I tried desperately to tell him how much this meant to me, this opportunity to do something worthwhile, but I wasn't making much sense, because, of course, I was crying. Then suddenly something very unexpected happened. He fell in love with me. From then onward, everything worked out beautifully"—a transformation that in its suddenness rivals the recognition scenes in Shakespeare and is even less likely.

The truth was that Margaret was in trouble. Caldwell was moving through his natural element, covering roughly the same territory he had covered the year before for the *Post*, territory he knew from childhood and had repossessed in his novels. Having planned this book for two years, he knew precisely what he wished to say. He came expecting trouble from Margaret, and he got it. She was far removed from her own element and aggressive where he was retiring, accustomed to taking charge, militantly opposed to following anyone's orders. But she could not give up their project. It would not only verify the extensive changes she had made in her life but would place her in the forefront of the current documentary movement in photography. Nor could she easily give up Caldwell, whose stature and knowledge gave this project the stamp of authenticity. Margaret would do whatever was necessary to get her photographs. This time only one solution occurred to her.

"She raped him." That's how Maxim Lieber puts it. "I know that . . . from his own account. She was a very capable person." Sally had a more traditional turn of phrase. She told Erskine's wife that Margaret had seduced him.

No doubt Margaret was attracted to him. Caldwell had a celebrity that surpassed her own, and something else she wanted: a deep commitment to the battle for justice. He had been raised on the social concerns she had only recently discovered. "I am not an evangelist or anything," he said years later, "but how can a human being live without protesting?" He was a good-looking man, fair, freckled, blue-eyed, and powerfully built. Peggy Sargent, who never got along well with him, says she recognized that he had a magnetism; when he came into a room, a charged male-female reaction was set off. Sally had felt it too. Helen speculates Sally had had an affair with Erskine, "and so maybe she had her nose out of joint or something" and wrote her notes on the trip with a pen dipped in acid.

In the notes, Sally remarked that after one outburst of hysterics Margaret sat in Erskine's lap, that she staged another bout outside his door late one night until he took her in and kept her there till morning, that by the twenty-fifth of July "she received him in her bed after dinner (without clothes) for the night." Sometime that night Sally checked out of the hotel and went home.

"There was a note," Margaret said in her autobiography. "Sally explained she was sick of sitting in the back. She could work with one temperamental writer, or one temperamental photographer, she wrote, but nobody could compel her to put up with two temperamental artists in the same automobile." Margaret left out a discreet little note she'd made in one of the drafts for her book: "Whether the back seat was really

that bad or whether she was a little bit in love with Erskine herself I, of course, shall never know."

Margaret must have been a little bit in love with him herself. Her two prime suitors when she met Caldwell were Alfred de Liagre, who was married, and a man Peggy Sargent says she liked but thought was too "normal" for Margaret to really care for; clearly Margaret was still hedging her bets. But by the end of the trip Caldwell had already given her a special nickname, which bypassed Peggy and Maggie: "Kit," because she had "the contented expression of a kitten that has just swallowed a bowl of cream."

After Sally's departure, Erskine and Margaret wandered on alone through Arkansas, Tennessee, Mississippi, Alabama, Georgia, South Carolina. She used a 3¼ × 4¼ Linhof primarily, with a synchronized flash, several extensions for more than one bulb at a time, and a remote control. A single flash tends to flatten the subject, and Margaret always sought a sculptural representation, even speaking of photography as a kind of sculpture in which the photographer chips away the inessentials. Light thrown from several angles produces a more three-dimensional effect. Margaret was an early exponent of the "master-slave" lighting arrangement, where several lights are set out, all responsive to the master and the shutter release.

Caldwell would do the talking while she set up her equipment. Margaret was clearly a foreigner, the term for all northern folk; he would tell people she was down South on her vacation. If the people seemed especially intelligent, he'd say they represented farm and educational magazines. To get into black churches, they claimed they were working for a church periodical. Most of these people were wary of strangers and afraid the photographer meant only to mock them; Erskine's native accent helped put their suspicions to rest.

Caldwell would engage the farmer in conversation. That meant, according to Margaret, that one or the other would make a remark every fifteen minutes. She kept herself as inconspicuous as possible with a smaller camera, taking general shots. It was on this trip that she learned how to meld into the background when that was useful. She did not actually give up her habit of directing, but she seems to have acquired an edge of adroitness and to have learned when direction would not do.

Caldwell says, "She more or less relied upon me as a sort of official guide. . . . But once she got there, the whole situation was in her hands. She was in charge of everything, manipulating people and telling them where to sit and where to look and what not. She was very adept at being able to direct people. She was almost like a motion picture director. Very astute in that respect. That's how she achieved such a good effect, I

think, with her settings, and her people . . . not so much staging it, but helping people be themselves."

Often she would retire to a quiet corner with her remote control and let Caldwell carry on the conversation. If necessary she would wait an hour or more for the expression she was looking for to cross their faces. As she was not near the camera, her subjects did not know when to pose; the flash would catch them at some spontaneous moment. Margaret was to become an expert at this kind of posed candid shot in which she retained her own control but gave her subjects leave to let theirs go.

"Whether he was aware of it or not," she wrote, "Erskine Caldwell was introducing me to a whole new way of working. He had a very quiet, completely receptive approach. He was interested not only in the words a person spoke, but in the mood in which they were spoken. He would wait patiently until the subject had revealed his personality, rather than impose his own personality on the subject, which many of us have a way of doing." By "many of us" Margaret meant herself. For a photograph of a woman combing her hair before the wooden box that served as her bureau, Margaret carefully rearranged the little homemade objects atop the bureau to create a good composition. After they left, Erskine took her to task for making the woman's objects reflect her own taste rather than their owner's. "This was a new point of view to me," she said; it had not occurred to her before that imposing her superior aesthetic might be an intrusion.

Caldwell says, "One of the reasons, I think, that she liked doing those books that we did . . . was that it enabled her to deal with people, more or less for the first time. I think she wanted to get closer to people." She wrote in her notes: "While it represented a milestone for me to notice the expressive appealing face, and stop to photograph it, I still had far to travel before I learned to feel more, understand more, to work with people from the inside out—this would take time to grow. And later I was to discover that the quest for human understanding is a lifetime one that has no end in sight." Erskine's approach seemed to her to be based on understanding. She was learning.

In the South she saw sights she had never seen—people who slept on the floor and died there; the commencement of a lynching, called off by the arrival of the sheriff; shacks papered inside and out with newspapers to insulate the bare boards, the walls now full of ads for luxuries the inhabitants could never afford. Margaret was afraid she would find an ad she had taken herself.

After much searching she and Erskine found a chain gang. The captain would not let them photograph without a permit, waved his rifle, shouted threats. When Erskine drove past fast, zigzagging, the man fired at the tires and missed, perhaps purposely. Erskine had a school friend

in politics in a nearby town, where they went to commandeer a permit. The captain looked at the permit and flew into a fury. " 'The Commissioner, what the hell,' he hissed, 'he knows I don't know how to read.' " They must have given him a convincing reading, for Margaret took close-ups of the soup spoons tucked into the men's iron ankle cuffs and got down in the trench to look up at the gang in their striped uniforms. In *Portrait of Myself*, she recalled seeing other chain gangs twenty years later on a *Life* assignment on segregation. The chain gang she'd photographed in the thirties was a mix of blacks and whites. In the New South of the fifties, the gangs had become separate but equal.

They had got into a black revivalist church with ease, but the white Holiness Church in South Carolina did not want them there. Few people knew revivalism existed among whites; Margaret and Erskine were determined to get photographs. On Sunday she put a small camera in her jacket and Erskine filled his pockets with flashbulbs. The little church being locked from the inside, the two of them jumped in through a window. Margaret began taking pictures the instant she hit the floor, while Erskine changed flashbulbs as fast as he could. The congregation was "coming through" in a moment of religious ecstasy. Women danced about wildly and slammed into Margaret unconsciously, others writhed on the floor calling out "Amen! Amen!" all heedless of intruders and flashbulbs.

Caldwell had spelled out the implications of such scenes in a novel called *Journeyman*. "Lucy's body was inflamed with exertion. Her skin was hot and damp, and blood ran from her mouth where she had bitten her lips. But she had not come through even then. Her body still trembled. The motions she made sent screams and yells ringing through the timbers of the building. Men were prancing up and down like unruly stallions, and women shook themselves in time with her movements. Bursting buttons flew into the air like spitballs." As the frenzy in the Holiness Church began to wear off, Margaret and Erskine, afraid they would be noticed at last, leapt out the window and left town in an ungodly rush.

Later, when Margaret looked back on her life, she saw it as a continuous and upward progression, with the trip south as a major step. In her book she wrote that the drought

> had jolted me into the realization that a man is more than a figure to put into the background of a photograph for scale. The drought-ridden farmers had contributed to my education in a human direction, and here with the sharecroppers, I was learning that to understand another human being you must gain some insight into the conditions which make him what he is. The

people and the forces which shape them: each holds the key to the other.
. . . I realized that any photographer who tries to portray human beings in
a penetrating way must put more heart and mind into his preparation than
will ever show in any photograph.

Caldwell himself must have had a hand in shaping these ideas. "Merely
to see things is not enough," he wrote in '35; "only the understanding of
man's activity is satisfying."

Margaret's desire to go deeper and wider never left her after this trip.
Peggy Sargent thought that Caldwell had practically introduced Margaret to the idea of social conscience. In fact, her conscience had been
developing for some time, but it must not have been very visible. If she
had one before, her secretary said, you just weren't aware. Afterward, it
shone clearly in her work and in her life.

15

"Life Begins"

The great revolutions of journalism are not revolutions in public opinion, but revolutions in the way in which public opinion is formed. The greatest of these, a revolution greater even than the revolution of the printing press . . . is the revolution of the camera. . . . But it is also a revolution which has not been brought to use. Magazines and newspapers have made use of photographs, but not in their own terms. Photographs have been used as illustrations, but the camera no longer illustrates. The camera tells. . . . The camera shall take its place as the greatest and by all measurements the most convincing reporter of contemporary life.

Archibald MacLeish, telegram to Henry Luce,
June 29, 1936

The advent of the picture magazine amounted to a triumph for photography as an instrument of communication. It happened in the late twenties in Europe, in 1936 in America. Before *Life*, none of the illustrated periodicals in this country gave the news (or any other kind of story) principally and coherently in photographs. From 1914 on, the *New York Times* published a magazine called *Midweek Pictorial* that relayed events in pictures as the Sunday rotogravure sections did, but the photographs had little relation to each other and virtually no narrative thrust. In the late twenties and early thirties, several picture publications were launched without adequate planning or technology; they failed to fly. *Eyes on the World: A Photographic Record of History in the Making*, published in 1935 (with a frontispiece and numerous pictures by Margaret Bourke-White), was meant to inaugurate an annual photographic history of the world. There never was a second issue.

For some years photographs had been gaining a steadily stronger hold on the public imagination and playing a more crucial role in the communication of news. In 1919, the *New York Daily News*, then called the *Illustrated Daily News*, published its first issue, with a front page full of pictures; its logo was a winged camera. Within two years the *News* had the biggest circulation in New York; within five, the biggest of any daily paper in America.

In 1925, the Cowles brothers, using a new polling technique developed by a young man named George Gallup, discovered that the reader of the *Des Moines Register and Tribune* had a high level of interest in pictures and an even higher interest in groups of related pictures. When the poll results were applied to the rotogravure section, circulation increased by 50 percent. In 1937, a mere two months after *Life* appeared, the Cowleses brought out *Look* magazine.

As usual, technological advances had contributed to the changing appetites and attitudes of the culture: the small camera, faster emulsions, improved presses and engraving methods, a wire service to transmit the new photographs everywhere. By 1924, halftones were being sent by wire from Cleveland to New York; by 1935, the Associated Press Wire Service had networked the newspapers of the country.

Picture agencies arose in the twenties to ride the swelling tide of photographs. Ralph Ingersoll, who played a large role in shaping *Life*, wrote in May of 1936 that each week in New York, five thousand original photographs were offered for sale. Most, he said, were cheesecake, publicity shots, or bodies rudely interrupted by bullets, for "the only two members of the Fourth Estate to recognize the potency of the picture today are the press agent and the tabloid editor."

In the thirties, newsreels grew astonishingly popular. Time Inc. itself gave them a vital boost. Beginning in 1931, the radio version of *The March of Time* recreated current events, with actors impersonating the major figures, then in early '35, *The March of Time* came to the screen as a monthly newsreel, combining actual newsreel footage with reenactments of those few scenes no movie photographer had had the foresight to sneak into. *The March of Time* tackled critical issues the industry had previously neglected: Germany's rearmament, Nazi persecution of the Jews, Wendell Willkie arguing against the new TVA.

Within fourteen months, *The March of Time* was playing monthly to an estimated international audience of fifteen million. In 1936, Time Inc. touted its newsreels in a book called *Four Hours a Year*. Essentially photographic and designed to show advertisers how successfully the company had experimented with photojournalism, *Four Hours a Year* was also intended as a kind of preparation for *Life*.

By 1938, an observer could write that "it was safe to say that the average citizen acquired most of his news through the medium of pictures. Over twenty million Americans go to the movies each day of the week and the newsreel is a regular part of every motion picture program." Theaters that showed newsreels exclusively increased in number throughout the decade. The newsreel mania prefigured one aspect of our present camera-dominated society: a historian remarked that "Fi-

nally, by the late 1930's and the early 1940's, many scheduled events, such as political appearances, conventions, and campaigns were staged by their protagonists in such a manner as to conform to the requirements of newsreel coverage."

The world's new and crying hunger for photographs was so evident that everyone wanted to start a picture magazine. Ralph Ingersoll says that while he was working on plans for *Life*, he discovered that every ad agency in New York had a blueprint for just such a magazine in the top desk drawer. When Henry Luce first met Clare Boothe Brokaw at a dinner party in 1934, she told him that in 1931 when she was at *Vanity Fair* she'd prepared a dummy of a picture magazine and called it "Life."

Luce himself tested the limits of magazine photography long before he was certain that picture magazines were feasible. *Fortune*, as *Four Hours a Year* claimed, had given the camera "a greater opportunity than it had ever had before." *Time*, which in the twenties had relied on head shots alone, began to experiment (on Luce's orders) with multiple pictures of events as early as 1933, expanded its picture coverage in '34, and in February of '35 published the first candid photographs of FDR.

Luce established the first experimental department to plot a picture magazine in 1933 but disbanded it seven months later. At the end of '35, the second and final department swung into action. It was powered by a technical breakthrough.

R. R. Donnelley & Sons Company, printers for *Time*, had developed a fast-drying ink that could print on coated paper run through rotary presses. That meant that photographs could be better reproduced in quantity on better paper and at less cost than had ever been possible before. The printers were still uncertain the process would work; the innovation was such a closely held secret that company policemen guarded the plant until the day the first issue of the new magazine hit the stands.

Luce had decided the world needed a picture magazine. In May of '36, in the first draft of a prospectus for *Life*, he wrote: "We have got to educate people to take pictures seriously, and to respect pictures as they do not now do. . . . While people love pictures, they do not respect them." The final prospectus, written one month later, began with these words:

> To see life; to see the world; to eyewitness great events; to see strange things
> —machines, armies, multitudes, shadows in the jungle and on the moon,
> to see man's work—his paintings, towers and discoveries; to see things thou-
> sands of miles away, things hidden behind walls and within rooms, things
> dangerous to come to; the women that men love and many children; to see
> and to take pleasure in seeing; to see and be amazed; to see and be in-
> structed;

Thus to see, and to be shown, is now the will and new expectancy of half mankind.

Margaret went to work for *Life* a mere two months before it began publication. The last notes from her southern trip were made on August 12, 1936. On August 13, NEA terminated its contract with her—a calamity from which fate immediately plucked for her a new and yet more brilliant career.

"I think the best thing in the world was that fiasco over Earl Browder," Peggy Sargent says. "If it hadn't happened she'd have been tied up with a year's contract with NEA and couldn't have got out of it to work for *Life*." On September 4, a bare two weeks later, Margaret signed a contract to work exclusively for Time Inc. ten months a year for twelve thousand dollars per annum, with two months free to do any work that did not compete with the company's publications. By then, *Life* had a name but little else, Luce having just bought a faltering humor magazine called *Life* for its title.

It was something of a miracle that the first issue of the magazine came out at all. On October 23, Luce removed the editor who had been overseeing the creation of *Life*, summoned John Shaw Billings into his office, and asked him to step in as managing editor. Billings, then managing editor of *Time*, had had virtually no experience with pictures and was perhaps the only editor in all of Time Inc. who had not yet worked on the new magazine. Seventeen days before the first issue was to go to press, he took over.

Proper, austere, and impassive at work, Billings never removed his suit jacket and almost never said hello—"on an average, a new employee did not get spoken to for about a year," according to Edward K. Thompson, who would later be managing editor himself. Billings commanded enormous respect. He was by turns remote and paternal; for either side of him, his staff performed prodigies of work. Some found him terrifying, but Margaret admired him greatly and feared him not at all; she was impressed with his "cloak of Olympian calm."

John Shaw Billings cared more about news and more about visual impact than he did about aesthetics. He is said to have made no sharp distinction between news and features, so that the early years of *Life* (he was managing editor from '36 to '44) were a vigorous, sometimes raucous, and often visually unsophisticated mix. As it happened, he turned out to have a genius for pictures; he could pick the best photographs with the speed and decisiveness of a photographer snapping candids. *Life* was Billings's magazine, cobbled together on deadline each week by his authority, his tough-mindedness, his tastes, and his intuitions. He is thought by many to be the greatest editor the magazine ever had.

His picture editor was Dan Longwell, a breezy, fidgety Nebraskan "with the wind blowing through his armpits" and an aristocratic face. Longwell cared about fashion, art, society, theater, aesthetics—all the areas Billings did not cover. Newspaper clippings on the latest trends overflowed from his every pocket. Longwell had a new idea every minute, and if for one minute he did not, he borrowed one from someone with a deeper mind. "Longwell's mind was essentially that of an entertainer, not a thinker," according to *Life*'s Maitland Edey; he sounds like the ideal man for a mass-circulation magazine.

Early on, Longwell had recognized the significance of the 35 mm camera. Luce hired him in '34 to increase *Time*'s picture coverage, which he did promptly. Margaret was as devoted to Longwell as to Billings, and she had reason, for he later recalled that he had hired her, as well as the photographer Alfred Eisenstaedt, a recent émigré from Germany with extensive experience with 35 mm, at salaries higher than his own. *Life* had four photographers on the masthead of the first issue, and three of them were 35 mm men: Eisenstaedt, Tom McAvoy, and Peter Stackpole. Margaret was the only woman as well as the only big-camera photographer. *Life* needed to balance the small camera's journalistic spontaneity with the art and monumentality of Bourke-White's studied compositions.

Henry Luce himself gave Margaret her first assignment. He wanted photographs of the great chain of dams that the Public Works Administration (PWA) was constructing in the Columbia River Basin to control flooding. Longwell fished a clipping about the revival of frontier life in New Deal, Montana, out of one of his capacious pockets and suggested she stop off there. Fort Peck, the world's largest earth-filled dam, was rising at New Deal, a boom town that had sprung up around the construction.

Margaret went west in late October, about two weeks before the deadline for the new magazine. Her schedule was not impossibly tight, for her assignment was simply to bring back pictures for the magazine's inventory. Accustomed to the magniloquence of dams, she nonetheless discovered that New Deal had certain unique advantages. On October 27 she cabled Longwell: "SWELL SUBJECTS, ESPECIALLY SHANTY TOWNS GETTING GOOD NIGHT LIFE NOBODY CAMERA SHY EXCEPT LADIES OF EVENING BUT HOPE CONQUER THEM ALSO STOP TAKING AIR SHOTS TODAY EXPECT FINISH TOMORROW." (The ladies of the evening were shy because some of them had told their families they'd gone west to take jobs as typists. Their customers were equally shy, and once, after Margaret had photographed some taxi dancers and their partners, a full-scale brawl broke out. Fearful that her cameras would be destroyed, Margaret

backed into a corner; she was rescued by a flying wedge of construction workers.)

In New York, where Billings had been at the helm less than a week, the magazine was in magnificent disarray. There was no cover, no lead story, nothing for the section called *"Life* Goes to a Party." Longwell cabled her on the thirtieth: "HAVE YOU GOT GOOD FORT PECK NIGHT LIFE PICS SEND DETAILED INFORMATION ON WHAT YOU HAVE UP AGAINST IT FOR PARTY DEPARTMENT FIRST ISSUE FORT PECK MIGHT BE SWELL IF NECESSARY GO BACK THERE AND TAKE MORE."

Margaret wired back the next day: "THINK FORT PECK NIGHT LIFE WILL BE VERY GOOD OF SEVERAL BAR SCENES CROWDS WATCHING BOWLING BILLIARDS TAXI DANCERS AT WORK TWO OR THREE HARD SNAPS OF PROSTI-TUTES ALSO EXTERIORS THEIR ESTABLISHMENTS ALSO FAMOUS RUBY SMITH WITH HER BOY FRIENDS ALSO TYPICAL SHANTY TOWN ORCHESTRA ALSO AS-SORTED DRUNKS." Longwell was pleased: "GOOD WORK NIGHT LIFE. . . . WANT TO USE AS PARTY IF YOU HAVE ANY EXTRA ONES SHOOT THEM TO ME." That was November 3. *Life* now had a party story, but still no lead and no cover.

On the fifth of November, twenty-four hours before the final dead-line, the rest of Margaret's film packs arrived in the office. Ralph Inger-soll took one look at them, carried them straight to Luce's office, spread the photographs out on the floor, and said to Luce, "There's your lead story." Ingersoll and Luce themselves pasted it up, Ingersoll drafted Ar-chibald MacLeish to write the captions in a hurry, and the first lead story of the first true picture magazine in America squeaked past deadline onto the presses.

The staff was astonished to see Margaret's pictures. Turbines and pylons were her forte; no one expected human interest from her. Yet there were the dime-a-dance girls, their eager suitors, and the drinking crew at the Bar X, where the waitress's four-year-old daughter spent the evening sitting on the bar.

The editors were unaware of the extent of Margaret's preparation for a journalistic career. On the introductory page of the issue, opposite a picture of a newborn baby that was captioned "LIFE BEGINS," they wrote:

> If any Charter Subscriber is surprised by what turned out to be the first story in this first issue of LIFE, he is not nearly so surprised as the Editors were. Photographer Margaret Bourke-White had been dispatched to the North-west to photograph the multi-million dollar projects of the Columbia River Basin. What the Editors expected—for use in some later issue—were con-struction pictures as only Bourke-White can take them. What the Editors got was a human document of American frontier life which, to them at least, was a revelation.

The lead was settled on November 5. On November 6, Luce picked the photograph to go on the first cover. What he chose was Margaret's picture of Fort Peck Dam. Typically, she had placed two tiny figures of workmen in the foreground to give the scene scale; the dam looked as big as eternity itself. The original photograph was a horizontal shot with a lot of unfinished construction on the left-hand side; the editors cut the image in half so that the cover would show only the mighty repeating forms of an engineering marvel.

Margaret was still out West working on what she thought was "*Life* Goes to a Party" while these decisions were being made. She had gone to the little town of Corvallis, Oregon, to stay for a couple of days with Gil, her first boyfriend. He was married, with three rambunctious children under the age of six, but Margaret brought a new level of turmoil into the house. She was dressed beyond the ambitions of Corvallis; people turned and stared at her on the street. She wore a gray Paris suit with red accessories; when *Life* came out a fortnight later, with Margaret's black-and-white photograph of the dam on the cover, bracketed by wide red bands, Gil's wife decided that Margaret had looked like a walking *Life* magazine.

Cables sped continuously into the Gilfillan household. One told Margaret she had the lead, another that she had the cover. A cable from Longwell on November 13 establishes that *Life*'s perennial emphasis on American success was in the program from the beginning: "FRANKLIN ROOSEVELT'S WILD WEST AT WHEELER MONTANA RAN AWAY WITH THE FIRST ISSUE STOP ITS MAGNIFICENT BUT CANT MAINTAIN PROLETARIAN STRAIN THROUGHOUT YOUR SERIES NEED SIGNS OF PROSPERITY INDUSTRY BOOM ETCETERA NEED INDUSTRIAL BIG ACTIVITY ASPECTS NOW STOP."

Still the cables winged over the wires to Corvallis. "Mother," said the Gilfillans' six-year-old-daughter, awed by the excitement Margaret created, "will she have a flag on her grave when she dies?" The office wanted facts about all the pictures for the captions. Margaret wrote down everything: the amount of concrete in the piers, the amount of steel in the dam, the number of men at work on the job. But New York wanted to know only one detail: "STATE SEX OF BABY SEATED ON BAR IN BEER PARLOR."

The baby eventually caused an uproar. Readers were outraged to think a four-year-old girl would have to spend her evenings in a bar among the rowdies. *Life* had, on its first try, electrified its family audience and ignited a controversy that would set its circulation on a rapid upward course. The principal of schools in New Deal was moved at length to write the magazine that the child was not neglected, that only *Life*'s editors were exploiting her, that the night life of his town had been

vastly overplayed, and that he wanted them to send a more objective photographer—this time a man, please, and one who sleeps nights.

Margaret's photographs ran away with the first issue because they encoded all the messages *Life* meant to send. The image of Fort Peck Dam on the cover spoke of power, which Margaret was superbly qualified to summarize, and not merely power but American power, American know-how, the long-lived hope that in technology lay the promise of a better future. In November of 1936, that proposition belonged to Franklin Roosevelt. Later, Henry Luce would grow to hate FDR, and sometimes the magazine would make that quite clear, but this first story was essentially a congratulatory note to the President.

Fort Peck was a PWA project, meant to restore order to the land and work to its people. Between 1933 and 1939, PWA spent over six billion dollars in the process of constructing nearly 70 percent of new buildings for education in America, 65 percent of the city halls, courthouses, and sewage disposal plants, 35 percent of public health facilities and hospitals, and 10 percent of all the roads, subways, and bridges built in the land. Few communities were untouched. America was trying to build its way out of the Depression. Fort Peck Dam was a work-relief project, with a town that called itself New Deal.

The story about "Roosevelt's Wild West" opened with Margaret's picture of taxi dancers, one happy, one blank, one sad, and their eager swains of every age, an image of the necessity of pleasure and profit. The headline read: "1,000 MONTANA RELIEF WORKERS MAKE WHOOPEE ON SATURDAY NIGHT." The next pages presented an aerial view of a shack town, pictures of main streets papered with the store signs and ads that sometimes seem to be the true American landscape, lots of chummy bar scenes, a huge pipe for the dam's tunnel (to satisfy Longwell's plea for "industrial big activity aspects"), and the baby on the bar, dramatically appearing twice on facing pages. All of this fit under the rubric of human interest, but it also proposed a kind of roisterous, ramshackle, up-by-the-bootstraps new pioneer America that suited the magazine and the country just fine.

Although *Life* was a newsmagazine and even the first issue had its share of murder and death, the lead story was about normal, decent, useful, and pleasant (if admittedly rambunctious) behavior out West. Other stories were about Chinese schoolchildren in San Francisco, John Stewart Curry ("the greatest painter Kansas has produced"), Helen Hayes's childhood, a report on Brazil, one on Fort Knox, the black widow spider, golf in Gooneyville. The magazine was a vegetable stew of

picture journalism, a mix of fresh ingredients, leftovers, pepper, and a dash of dishwater.

Margaret's lead story was a historic document, not only because the boom town would disappear by the fifties and then would exist only in her photographs, but because it was the first true photographic essay in America. She wrote in her notes: "One of the things I really care about is being given credit for having developed this essay style." She had prepared her own way with her story on hogs in the first issue of *Fortune*, then made the real breakthrough in *Life*.

The picture essay would immediately become a prime mode of communication, and so it would remain, at least until the big photographic magazines bowed out, some thirty-odd years later. For over three decades, a mass audience acquired much of its information and pieces of its education via the form that Margaret had given it first. Not just a picture story, which might be merely a simple chronological account, the essay had wider ramifications and sometimes less neatly drawn perimeters. Strictly speaking, it was not solely Margaret's invention. She provided a wide range of material, then Ingersoll and Luce laid out a kind of road map of the western boom towns from her photographs. The essay has always been a collaborative effort.

Still, in November of 1936 no one at *Life* had much of an idea what a photo essay was. They were making up the history of photographic magazines as they went along. The form did not even acquire a title until March of 1937, when Henry Luce named it. "Fifteen or twenty years ago," he wrote, "people used to write 'essays' for magazines. . . . The essay is no longer a vital means of communication. But what is vital is *the photographic essay*." The genre that Margaret had pioneered was supposed to fill a vacuum in the literary world with photographs.

The first issue of *Life*, dated November 23, 1936, reached the newsstands on Thursday the nineteenth. That day, a score of Okies drifted into California out of the dust, General Motors hired yet another Pinkerton man to spy on union organizers, a dozen youngsters signed on for the Civilian Conservation Corps, and President Roosevelt, flush from a handy victory over Alf Landon and the highest stock market since 1931, went fishing for the day. Thousands were reading the newly published *Gone with the Wind*, Social Security was gearing up to begin its first payments at the start of the new year, and Eugene O'Neill had been informed one week earlier that he had won the Nobel Prize for literature.

Across the Atlantic, Edward VIII still occupied the throne of England; he would abdicate in two weeks to marry Mrs. Simpson. Rebel troops threatened Madrid. Adolf Hitler was not newsworthy enough that week to appear in *Life*'s first issue, but the magazine did find some room

for Winston Churchill fingering a sore tooth. Luce said once, "Today I may not be in a mood nor feel the need to read the finest article about the Prime Minister. But I will stop to watch him take off his shoe."

Time Inc. delivered two hundred thousand copies of the new magazine to the newsstands that day. They sold out within hours. Cities all over the country cabled for more copies of *Life*, sold those out, cabled for still more. The last order went unfilled; the complete press run of 466,000 had been sold. The home office was cautiously optimistic. The country was obviously curious about the magazine, but curiosity is quickly satisfied. Still, the second week sold out. And the third. And fourth. The presses could not print enough copies to meet the demand. An issue of *Life* became such a rare object that people gave cocktail parties on the pretext of having a copy.

Life's success was so brilliant that it had the unprecedented effect of running up staggering losses. No one had been certain a picture magazine would do well in the marketplace. *Life*'s guarantee to advertisers was 250,000 copies, and prepublication contract holders had the right to take additional ads later at the original rate. They took them in early '37, when *Life* was selling a million copies of each issue; the magazine took a loss with every order. By that spring, it was calculated that readers wanted five to six million copies of *Life* each week. The magazine could not be produced in such quantities; the new presses could barely handle a million a week, and coated paper could not always be turned out fast enough to print even that million.

The more copies *Life* sold, the more advertising it attracted, the greater were its losses. The new picture magazine's popularity was so stunning and so unanticipated that it was soon losing $50,000 a week and by the end of 1937 had lost $3,000,000. Time Inc. canceled its year-end dividend. Although *Life*'s circulation, reach, and influence grew at breakneck speed, the magazine did not turn a profit until January 1939.

The runaway demand for *Life* prompted a horde of imitators. *Look*, a monthly that had long been in the planning stages, came out in January 1937 and was an immediate success, although not on the order of *Life*. *Look* was soon followed by *Click, Pic, Photo History, See, Peek, Focus.* (Good names were scarce. A charter subscriber to *Life* had once suggested it be called *Fast and Luce*.) The new magazines vanished one by one in the twinkling of a shutter. *Life* and *Look* remained.

The explosive success of the picture magazine owed a good deal to the fact that it took so little of the subscriber's time. World War I seems to have marked the end of true leisure in America. In the twenties, everything speeded up. Assembly lines turned out cars in record time, the cars they turned out drove at record speed. Airplane travel and

airmail changed the way distance was regarded. So did subways. The Automat and the drugstore counter even speeded up the lunch hour.

Life began to be lived in a hurry, and people who wanted to know more wanted to take in their knowledge fast. The *Daily News* succeeded because of shorter stories and more photographs, *Reader's Digest* by digesting its articles. In 1922, the prospectus for *Time* declared that "People are uninformed because no publication has adapted itself to the time which busy men are able to spend on simply keeping informed." *Time* promised to save time. But by 1936 Luce was writing that some people just didn't have the leisure to read *Time* cover to cover; the picture magazine would be for them. Some said later that *Time* was for people who didn't want to read and *Life* for those who didn't want to think.

When Henry Luce wrote the prospectus for *Life*, he claimed to have divined a change in the world's visual culture: "Thus to see, and to be shown, is now the will and new expectancy of half mankind." He was right. Masses of people did indeed unconsciously begin to expect photographs in their daily papers, their magazines, books, and of course films. Photography was incorporated into people's lives.

In 1936, photography was not a new language; it only seemed to be one. It is difficult today to realize what a sense of discovery inhered in photography at the time. In 1934, when *Time* published candid photographs of Roosevelt in his office, no one had ever seen such unposed pictures of the President. In '38, *Life*'s publication of the first photographs ever printed of the U.S. Senate in session amounted to a national epiphany.

An editor who was with *Life* from the beginning says photography seemed so new then that even the staff had to be taught to read pictures, and that captions at first were written to help teach the public how to read the evidence. Some thought the picture magazine would kill off reading of the old-fashioned variety altogether. A 1938 *New Yorker* cartoon had one editor asking another if it was O.K. to refer to their subscribers as *readers*. But in fact *Life*, for all its claims to be a picture magazine, depended heavily on captions to carry the story.

The first half of the thirties had witnessed an enormous increase in amateur photography in this country. By 1932, Americans were exposing eighty-three million rolls of six-shot amateur film a year. As more and more people acquired the habit of photographic vision, the camera became nearly ubiquitous. In 1938, a journalist assigned to photograph Man o' War lamented that he could not get "unposed" pictures because the horse was so used to being photographed that he insisted on looking at the camera every time. *Life* and the picture magazine set the seal on the trend to a photographic perception of the world.

The mass media vastly extended their reach and vastly changed their

means in the 1930s. The decade was a turning point in the history of communications, when radio and photography began to supplant the printed word. An electronic revolution was in the making. Only a world war would slow the commercial release of television, which was already well along in the experimental stages. The ground was being prepared for society's ultimate dependence on photographically generated images transmitted in a flash to every home.

To Margaret, *Life* seemed like the perfect means to put her work into alignment with her new social awareness. She wrote Gil shortly after going south and just before *Life* began: "People don't realize how serious conditions in this country are. . . . The new job [*Life*] will give me more opportunity to work with creative things like this. . . . I am delighted to be able to turn my back on all advertising agencies and go on to life as it really is."

In the thirties, the idea grew that a new democratic art was being created. The proletarian novel was supposedly for the worker and sometimes *by* the worker. Painters sponsored by the WPA, putting murals up in post offices and airports, painting canvases about strikers and men on relief, felt that a new art was developing for the people. They may have been right, but the true honors for a new popular art belonged to photography. Photography, ideally suited to social documentary as well as to mass reproduction, reached an enormous audience. Many who pored over images taken for the Farm Security Administration or for *Life* did not consider themselves art lovers, but then, photography was not generally considered an art.

Time Inc. understood the democratic appeal of photographs, which was one key to vast circulation. An ad for *Life* in the December 1936 issue of *Fortune* sought to reassure the wealthy who might find their servants reading the same publication they were:

> The appeal of pictures is universal. Pictures answer the Great Inquisitiveness which is born in a living animal, part of its lust for life. . . . The Great Inquisitiveness makes you and your banker react to pictures much as your cook does, or your taxi-driver. The cook and taxi-driver, then, may find something in LIFE as interesting as you do. That will be as it should be. A magazine called LIFE would be a sorry thing if it turned out to be a snob.

Snobbish or not, *Life*, with its picture format, cut across social boundaries. Margaret's career itself illustrates the breadth of this revolution in journalism; her fame, which spread ever wider as *Life* grew, dramatized the power of the new photographer, a figure who was rapidly becoming the prime witness of the world.

16

"*Life* Likes Life"

The very rush around the magazine was food and drink to me.
. . . The breathless excitement of it. Holding five pages for the lead.
They have to be good—the best there is. Often thought I would die
rather than not bring back what Life *needs and this I really meant.*

(Margaret Bourke-White, Notes)

When Margaret signed the contract with *Life*, she agreed to give up her studio and Time Inc. agreed to supply her with an office, a secretary of her own choosing (she chose Peggy Sargent), a darkroom, and a salary for Oscar Graubner and two assistants. The contract did not mention her animals, but the alligators were adopted by an experimental school, and Peggy Sargent, who Margaret said had a "personal friendship" with the turtles, scouted the city's fountains for a decent home. Loew's Lexington theater, one of the old-time movie palaces, looked sufficiently grand for turtles who had lived in a distinguished penthouse. Sargent loitered in the lobby with a package of turtles until a moment came when she could sneak them into their new home undetected.

Margaret had the only darkroom and the only printer at *Life*. Most of the photographers prided themselves on doing their own printing, yet when editors sent them out on assignment after assignment in quick order, they began to realize that Margaret had a distinct advantage. She stayed out in the field shooting pictures while Graubner developed her film; meanwhile, they were laboring in the darkroom pulling prints.

Life soon hired more printers, photographers soon gave them their film. Oscar Graubner became head of the *Life* labs and printed for everyone, but most thought he gave his first allegiance to Margaret and never wavered. The opulent beauty of his prints had to be sacrificed to meet the magazine's weekly deadlines. On November 10, 1936, Peggy Sargent wrote her boss: "I can see that our attitude to your photographs will have to change. They don't seem to care so much for the beautiful workmanship that always had to go out from the Bourke-White studio but are just interested in having a good story told." *Life* was about communication,

and the aesthetics of the print and sometimes of the composition tended to take second place.

Yet Margaret still insisted on the best prints the darkroom, with its new limitations, could turn out. *Life* photographer Carl Mydans wrote:

> Maggie established a new measurement of expectation for the art of the photographer. Her influence on all of us is incalculable. It was from her that I learned to worship the quality of a photographic print. Day after day I watched her mark up pictures and send them back for reprinting until they met her standards. She was a perfectionist. Little that she ever did really satisfied her. "It's when my prints come out of the darkroom that I finally judge what I have done," she told me. "Sometimes I find something that gives me a thrill. More often I see what I failed to do, or what I did that wasn't right."

John Szarkowski, director of the photography department at New York's Museum of Modern Art, speculates that Bourke-White strongly influenced the *Life* photograph in the early years. "Her description of surfaces," he says, "was very luxurious, not just precise. Everything in her pictures looked like it was made out of some kind of polished synthetic, even the skins of the people. . . . My guess would be that even if only by example, that kind of luxurious technical quality, really an aesthetic, probably had a large influence on the magazine's standards."

In effect, Margaret set up the *Life* labs, practices, and standards. She was even responsible for one peculiarity of *Life*'s printing. Having made infinitesimal adjustments to the composition while she was photographing, she insisted her negative be printed in full, not permitting them to be cropped so much as an eighth of an inch along the edges by the negative holder. Cornell Capa, who worked in the lab in the late thirties, recalls hours of struggle with her negatives sandwiched between glass plates that made them the very devil to print. In time the lab printed the full negative for everyone, a practice know as "printing black"; a black area is allowed to show around the edges of the print as proof that the image has been printed to its edges. Margaret's demand became the custom.

(Although she insisted on preserving every fraction of her initial vision in the first print, Margaret was herself adept at cropping her photographs for a more dramatic image. *Life*'s editors also cropped for better layouts and visual impact; they began by slicing her cover photograph of Fort Peck Dam in half. Although she would not stand for any subtraction in the darkroom, she never once complained about losing half a photograph in the service of the magazine.)

Margaret also brought *Life* its first film editor: Peggy Sargent. In

Bourke-White studio days, Margaret had taught her secretary how to select the best negatives when film came back to the office from out of town. At *Life*, Sargent took over the editing of all the photographers' film, gleaning from the hundreds of pictures on the rolls a manageable group of images to be submitted to the editors; her choices were rarely faulted by photographers. The Bourke-White staff put an indelible stamp on *Life*.

Margaret needed excitement as musicians need practice, to keep her at top form. Because she treated every assignment as if it were the most important challenge in the world, her work paid her back with a high level of intensity. The rush, the pressure of spot news was itself enough to make the blood dance. In January of '37, the Ohio River swelled over its banks in one of the worst floods in American history, pouring into Louisville, Kentucky, at an unprecedented height and killing or injuring nine hundred people. Billings gave Margaret one hour's notice on the story, and she caught the last plane that landed in Louisville before the airfield was flooded out.

Muddy water surged across the highway into town. Margaret hitch-hiked on rowboats that were delivering food packages and searching for survivors marooned on high spots. Once she hauled her cameras aboard a large raft to take pictures of the water roiling across three-quarters of the city. Another time she chanced upon an undertaker who had hauled in a body floating past the door of his funeral parlor, only to discover the corpse was a neighbor. He insisted on showing Margaret how young he had made the corpse look; it was the last service he could perform for a friend.

Life ran the story as its lead. The first page was a picture of black men and women lined up with baskets and pails at a relief center, before a billboard of a smiling white family with the headline: "World's Highest Standard of Living—There's no way like the American way." The irony was tailor-made for her camera.

The same issue carried Margaret's four-page spread on the Supreme Court, which Roosevelt was trying to pack. The way one *Life* staffer recalls the Washington trip, she set up her tripod on the perfect spot from which to photograph the Capitol and began to shoot—in the middle of the busiest street in Washington. Streetcars stopped on the tracks; cars lined up behind her for blocks, honking and carrying on. The Washington office repeatedly telephoned and sent memos to New York: "Who is this crazy woman you sent down here, wrecking the town?"

Life's subject matter, aimed at the largest possible audience, ranged from spectacular to urgent to solemn, from silly to domestic to cute—

war, race prejudice, cancer, debutantes, horses that wore hats. In the same issue as the tragic flood and the portentous packing of the court was a humorous and fairly explicit picture story on how to undress for your husband. Undress was a staple part of the *Life* mix; the editors ran pictures of young women in their bathing suits or their undies on almost any pretext. In a family magazine in 1937, certain proprieties did have to be observed, and the airbrush man was fondly referred to as "the nipple obliterator." One commentator in 1938 said *Life* consisted of "equal parts of the decapitated Chinaman, the flogged Negro, the surgically explored peritoneum, and the rapidly slipping chemise."

Through the mix there always ran a strain of optimism that was a potent element of *Life*'s success. The Fort Peck cover sang the dream of recovery through technology; the flood story told of survivors. The underlying current of optimism in the American character, stilled by the dark years of the Depression, had resurfaced in the nation at least as early as Roosevelt's first election. Writers who went forth to explore their homeland found a sturdiness out there that gave them unanticipated hope. Photographers for the Farm Security Administration saw courage writ large in the face of frightful odds. Luce built optimism into *Life* from the start. In a confidential memo of March 1937, he said: *"Life* has a bias. (*Life* is in favor of the human race, and it is hopeful. *Life* likes life.) *Life* is quicker to point with pride than to view with alarm."

Henry Luce saw photography as a kind of remedy for the disheartening effects of the news. He wanted to feature normalcy, itself a corrective for the reporter's emphasis on disaster and crime. "While journalism accents the abnormal, the hopeful fact is that the photograph can make normal, decent, useful and pleasant behavior far more interesting than word journalism." In 1952, *Life* reminded its readers that "Back in 1937 . . . Henry R. Luce . . . predicted that photography could be useful in correcting that really inherent evil of journalism which is its imbalance between the good news and the bad."

Luce had already built the love of America into his magazines; *Life* was to be its celebration. Tex McCrary, reporter and radio interviewer, says that Clare Boothe Luce (she became Mrs. Luce one year before *Life* began) told him that in *Time* Harry was trying to say "Gosh" about America, in *Fortune* "My God," and in *Life* "Gee whiz." One *Life* writer says that "for a great many people *Life* discovered America. There was no TV, movies were never-never land, illustrated magazines were few. Everybody had seen pictures of the scenic wonders of America, but the American people had not been photographed in the ordinary occasions of life, or the extraordinary. Bourke-White helped define *Life* as a discov-

erer of America. All those pictures of farmlands, the contoured fields"—
Life made good use of her skill at aerial photography—"the hand of man
on the land . . ."

In '42, when American interests had become more international,
Life was still explaining America to Americans. An ad for *Life* in the
magazine proclaimed: "One of LIFE's functions is introducing the Ver-
monter and the Californian to each other. . . . Thus LIFE serves as a
force for creating understanding between widely separated, variously
occupied people."

In early 1937, the sociologists Helen and Robert Lynd returned to
the town of Muncie, Indiana, which they had studied in the twenties as
Middletown, and studied it once more. *Middletown in Transition* re-
vealed that good times were returning to the town, that federal aid had
contributed to visible improvements, and that Muncie, which had never
before voted Democratic, had gone for FDR in '36. *Life* decided to put
the news about America into pictures and sent Margaret to Indiana.

She took a series of portraits of townspeople that had the variety of
a collection of "types": a prissy-mouthed schoolteacher, a fat city father
sporting a big grin and a bigger cigar. Most telling were the set pieces of
families and clubs, which began with the richest manufacturer in town,
who had introduced "the first pink-coated fox hunt ever to astonish an
Indiana landscape," and ran all the way down the economic scale to two
poor hillbillies in a one-room shack.

Margaret had become expert at making poses look natural and adept
at keeping her subjects at it long enough to wear down their camera
shyness and catch them off guard. As she had known how to simplify
industrial subjects and present the detail that summed up a process, so
she knew how to simplify her human subjects and present a moment
that would instantly telegraph a message on the page. On occasion she
flirted with stereotype or caricature, but it worked remarkably well in a
mass medium and she knew it.

The Muncie story got the lead once more. *Life* called the story an
essay, "the first picture essay of what [Middletown] looks like," thus
calling attention to the camera's admirable power to bring to life the
words of sociologists. In smaller print, the magazine declared these pho-
tographs "an important American document," something *Life* meant to
specialize in.

Wilson Hicks, the former picture editor of the Associated Press, who
had been hired by *Life* in March to direct the photographic staff, wrote
her about the photographs: "You did a swell job. . . . I haven't seen all
the pictures you have taken in your career, but in my opinion these have
something that none of the others which I have seen have had."

After Billings and Longwell, Hicks was the most important shaping force on the new magazine. A connoisseur of talent who could instantly recognize a photographer in the making, he kept the magazine supplied with top photographers for thirteen years. "I trust in God and Wilson Hicks for pictures," John Billings said. Carefully dressed, his "black patent leather hair" parted in the middle and slicked down, Hicks sat with his feet upon his desk and his cigar jammed into his mouth and surveyed the photographic world with an icy stare. He knew how to encourage a photographer. Philippe Halsman, who took more *Life* covers than anyone else, recalled Hicks's reactions to an unusual picture: "He'd laugh; his eyes would light up; his hands would tremble; and he would look like a man who had discovered treasure! . . . We all tried to produce this excitement in Wilson Hicks, for his excitement was one of the great influences on our work."

But Hicks could also rage. He would sweep photographs off his desk in a fury. He had the Machiavellian notion that photographers would do better work if he pitted them against one another; sometimes he assigned two men to the same story. He inspired fear and chronic anger in most of his staff—"a fantastic genius when it came to photography, but the biggest bastard when it came to handling people," one of them said. Those he favored were devoted to him. Margaret once wrote that when she took a particularly dangerous risk to get a photograph, in the back of her mind she thought, "I'm doing this for Wilson Hicks."

Hicks once told an interviewer that the Muncie story marked Margaret's final transition into journalism and made everyone in the business sit up and take notice. He was right. Beaumont Newhall, who wrote America's first history of photography, wrote her to say that Muncie was the "finest piece of documentary photography" he had seen. Hicks, however, also thought Margaret had definite limitations. He said she remained "a photographer of things" long after leaving the industrial scene, and that the women in the Muncie story were little more than dummies.

Both the photographer Alfred Eisenstaedt and Richard Pollard, who later became director of photography at *Life*, also regard Bourke-White as primarily a photographer of objects, even of people as objects, and there is an element of truth in this estimate. She was as good at photographing people as most, and among the pictures of sharecroppers made down South can be found a moving account of humanity in decay. But at least before the second half of the forties, most of Margaret's photographs were more concerned with reporting than with emotion and psychology.

This concentration on the more public aspects of both public and

private lives was fairly typical of photojournalism in the thirties. Intimate details were still considered too personal for a family publication. Photojournalists were always eager to record the large and readily identifiable emotions, such as grief, fear, and joy, but psychological nuance was not considered the crux of their stories until after the Second World War. Margaret's working methods and sense of irony would have tended to distance her somewhat from her subjects, and her accustomed way of working, with a big camera, a battery of lights, and firm control over the direction, was less conducive to intimacy than the small camera was.

But the relative lack of psychological depth in many of her pictures of people can also be seen as one result of a continuing strength in her work: the ability to find the symbolic detail. "I made a picture of plow blades," she once said, "plow handles which symbolized the whole plow factory." In photojournalism she found the symbolic moment or the symbolic expression—and the symbolic moment, in an era when self-confession was not yet the order of the day, did not necessarily have a weighty emotional cast. The fat man grins around his cigar; the women of Muncie's Conversation Club wear their most ladylike hats and manners: such pictures symbolize city fathers and women's clubs as effectively as plow blades symbolized a factory. They amount to opinions that have been compressed to the size of an aphorism to be instantly grasped by the viewer.

Like *Life* itself, these pictures often tend to repeat a stereotype in a more visually compelling form than it usually commands. Margaret could produce with surety and apparent ease the summaries that made good journalism in the thirties and still constitute a major part of it today. However much she longed to find greater insight with her camera, much of her work was clearly intended to be the most efficient and pointed reporting of surfaces.

The up-and-coming trend in photography when *Life* began was 35 mm work. Eisenstaedt, McAvoy, Stackpole, Mydans, William Vandivert —the first men at *Life* took pride in the very idea of natural, spontaneous photography. There were always photographers around who used large cameras for portrait work and studio pictures, but still they regarded the 35 mm camera as the real challenge, the instrument of the future. In a sense, Margaret Bourke-White represented the old order, with its tripods, floodlights, and poses, and the younger men represented the new.

Yet if Margaret's equipment might have seemed old-fashioned and cumbersome to some, most photographers took up the large camera at some point, hoping that if they brought back negatives of as high quality as hers, they would have as high a percentage of their stories in the magazine. She was on her way to perfecting the posed candid picture, and nearly everyone used a method like Margaret's at one time or another.

Margaret and Erskine went south again in the spring of '37 to round out their book. Caldwell wrote the text, but they wrote the captions together, each making notations privately, then together choosing one caption or combination. Margaret was especially proud that the book was such a true collaboration. *You Have Seen Their Faces*, both a report on sharecropping and an indictment, came out in November.

It is odd that years later she would write with such pride of their captions. These were inventions, Margaret and Erskine's ideas of what might have been said or what best expressed the photograph's message. Critics complained that such fictions meant that the evidence had not been gathered scrupulously enough and the book was not truthful. In 1940, when the photographer Dorothea Lange and her husband, Paul Schuster Taylor, published *An American Exodus*, a book similarly dedicated to the nation's social problems, the text took a quiet swipe at Margaret and Erskine: "Quotations which accompany the photographs report what the persons photographed said, not what we think might be their unspoken thoughts."

Yet Erskine did the book expressly to present convincing evidence, and truth was the credo that underlay Margaret's photographic career. Caldwell was a fiction writer to whom truth meant the deepest dramatic expression, sometimes expressed by the most convincing myth. Margaret had believed since the early days of her career that the most dramatic and most symbolic views embodied the truest expressions. And so they chose drama above unembellished fact.

Still, the book was a publishing milestone, a force for social good, and a great popular success. The most important work of its day on sharecroppers and related social problems, it would soon influence the country's legislation. Its reviews ran from the *Southern Review*'s "as a student of farm tenancy in the South Mr. Caldwell would make a splendid curator of a Soviet Park of Recreation and Culture" to "a stirring and painful document, magnificently produced. It should provoke something of the effect that Swift's 'A Modest Proposal' . . . was calculated to make."

No one could be indifferent to this document. Erskine's anger was evident on every page; too evident, some said. The prose was strong but the message relentless and repetitive. Margaret's photographs were almost as theoretical and at least as forceful. The consequences of deprivation are unavoidable in these pictures, not only in the tight, downturned mouths and the skin mapped with lines but in the camera's unblinking stare at pellagra, goiter, shrunken limbs, retardation. Few of her contemporaries would so unsparingly document physical and mental disabilities. In the early pictures she recorded a few smiles and only at

the end gave way to unremitting despair, but throughout the book, her photographs are filled with anger and passion.

It was this theatricality that subjected them to the most serious criticism. Photographic documents of the social ills of America were not a new phenomenon—Jacob Riis's late-nineteenth-century pictures of New York slums and Lewis Hine's subsequent record of child labor are early examples—but the genre was being reformulated under the pressure of the Depression and the new regard for the camera's power, and the search was on for a new kind of factual and impartial truth. The chief instruments of the new social reporting were documentary films such as Pare Lorentz's *The Plow That Broke the Plains*, newsreels at their most serious, the Farm Security Administration, and, after the birth of *Life*, the picture magazine.

The FSA's photographic arm, founded in 1935 and headed by Roy Stryker, sent photographers far afield to document America in crisis: the dust bowl, migrant camps, sharecroppers, small-town life. Stryker believed his photographers' reports should be objective and unbiased. Arthur Rothstein, the first photographer hired by Stryker, said that his boss greatly respected Bourke-White's work but thought her style a little theatrical for an essay on southern tenant farmers.

But the FSA had paved the way for her. Photographers like Rothstein, Walker Evans, Dorothea Lange, Russell Lee, Carl Mydans, Ben Shahn, in '35 and '36, were establishing a style of reporting that gave photography a credibility beyond the printed word's. As their pictures were made for the government, they were free, and were soon reprinted in newspapers and magazines and brought back to the *Fortune* offices for study. In '37, when Margaret and Erskine were in the South, *Life* wrote her to promise they would wait for her sharecropper pictures. "The only thing we may do," her editor said, "is use a few of the Resettlement Administration's [the FSA's earlier name] pictures in a general take-out on the use of photography by the Roosevelt Administration. They have been extremely modern." Margaret took the FSA's general approach and added to it a more journalistic emphasis and a drama that came from her own love of spectacle, the depth of her new commitment, and the influence of Caldwell's crusading spirit.

In the summer of '36, Walker Evans photographed in the South with the critic James Agee. A publisher was prepared to bring out their book, but *You Have Seen Their Faces* scored such an enormous success that the competition killed it; the book finally appeared in 1941 but lost money. Called *Let Us Now Praise Famous Men*, it is recognized today as one of the signal documents of the thirties. Evans reportedly felt that Caldwell and Bourke-White's book exploited people who were already

exploited, but it was probably Agee who included in *Famous Men* a newspaper article in which Bourke-White burbled about her "superior red coat" and related how she and Erskine had bribed one couple with snuff to take their picture.

Yet Margaret had also expressed Agee and Evans's own philosophy of photography in that article: "Whatever facts a person writes," she said, "have to be colored by his prejudice and bias. With a camera, the shutter opens and closes and the only rays that come in to be registered come directly from the object in front of you." Agee himself wrote that photography's pure objectivity "is why the camera seems to me, next to unassisted and weaponless consciousness, the central instrument of our time."

The documentary camera was a different instrument in Evans's hands than it was in Bourke-White's. Walker Evans's complex but clear-eyed, dispassionate, seemingly uninflected and uninterpreted view of the world is recognized now as one of the great achievements of the time. His style exerted a major influence on subsequent photography and set a standard by which to measure documentary. If Bourke-White's imagery today occasionally seems excessive, that is precisely because Evans's apparently impersonal style has replaced in our estimation the more engaged and overt attitudes, highly valued at the time, that made Margaret's book so influential.

The influence of *You Have Seen Their Faces* extended far beyond its time to photographers whose styles were entirely different from Bourke-White's. Gordon Parks, a photographer for the FSA and later for *Life*, says, "I was very much in search of some way to express my own feelings about the situation in America as concerned race, discrimination, and minority groups, especially black people, since I was black. *You Have Seen Their Faces*, along with some of the FSA photos, opened my eyes to the possibility of using my camera as an instrument or a weapon against this sort of thing. For me, that book was a pretty important step."

Robert Frank, the Swiss-born photographer whose grainy, shot-from-the-hip, disaffected view of America in the fifties is still influencing photographers today, also credits Bourke-White's inspiration. Frank admired her book greatly when he came to America early in his career, finding it "rather straight and unpretentious and unartistic, purely documentary photography"—an attitude, although certainly not a style, that matched the one he adopted himself. "I thought she had a lot of feeling for the people," Frank says.

You Have Seen Their Faces established a new genre: the book in which photographs and text have equal weight. Although photographically illustrated books had long existed, the photographs themselves had

always been secondary to the text. This began to change in the twenties in Europe, in the thirties in America. *You Have Seen Their Faces* welded photographs and literature together in a new balance. Several reviewers thought it the beginning of a new art, and some thought the photographs had stepped up to a level of greater power than the words. The *New York Times* reviewer wrote that "The pictures produce such an effect, indeed, that it is no exaggeration to say that the text serves principally to illustrate them." Margaret had yet again pioneered new territory.

Time Inc. believed in anonymous journalism. Photographers sometimes got more recognition than writers, as when Margaret's name was duly inscribed beneath her *Fortune* photographs. The new *Life*, a picture magazine after all, felt it owed its photographers their names, although not with their pictures. An index to pictures ran in each issue, one narrow column with page numbers and names, usually in the back, often hard to find. Margaret said instantly this was not enough.

Two months after *Life* was founded, she was already fighting for her name and fully prepared to take the matter up with Luce himself if there was trouble. Margaret was generally regarded as Luce's protégée, and although no one at *Life* believes she got special treatment because of her relation to him, she did command a certain amount of awe. She was not above using her connection. In Washington in '37, shortly before she single-handedly fouled up the city's traffic, the reporter on the story said to her, "Peggy, I will do anything in the world for you except carry your damned bags." To this she coyly replied, "Sometimes Mr. Luce carries my bags for me."

Whoever got to Luce on the question of credits, Margaret won her point. By March, photographers were guaranteed their names on the story itself when it ran four pages or more. The stage was set for the appearance of photographers as stars. They were already the major players of the *Life* staff, and it stood to reason that if *Life* was putting photographs on center stage, the photographers would become stars in the eyes of the world, but it took most of a decade for the world to see it that way. Margaret Bourke-White was still the only name a large public knew.

She appeared in the Museum of Modern Art's 1937 exhibition, an honor not given other *Life* photographers. She published with Erskine Caldwell. A woman in her business still amounted to an unaccountable oddity; in 1940, *U.S. Camera* marveled at the strange fate that had made a woman "the most famous on-the-spot reporter the world over."

Once again Margaret endorsed products for advertisers. In '38 it was Camel cigarettes. (The cigarette companies enlisted many distinguished women in their campaigns; Alice Roosevelt Longworth appeared on the

back of *Life* in 1937 for Lucky Strike. But the federal government soon began to crack down on truth in advertising, and in 1944 Margaret was called before the Federal Trade Commission. She who often claimed to be devoted to truth and honesty had to testify that she had never been a regular smoker of Camels.) In 1939 she endorsed air travel and telephones, even endorsed wine in a full-page ad in *Life* magazine itself, where other photographers were lucky to get the photographs they had taken reproduced, much less pictures of themselves.

Life hired other women photographers, but the public did not know it. "Quite often when I arrived at a job destination," says Hansel Mieth, "people would ask me, 'Are you Miss Bourke-White?' I shook my head 'No' and gave my name. They would look puzzled. 'But Miss Bourke-White is the photographer for LIFE,' they would say. 'Yes,' I'd say, 'yes, but I'm not she. LIFE has a few other photographers.' This was always an awkward beginning, and I had to work doubly hard and yet make it appear so easy, to still their anxiety and mine."

But if the public lionized only Bourke-White, *Life* at least set it the proper example by bowing down to all its staff photographers. "When we went on a job and had a researcher or writer to go with us," the photographer Cornell Capa says, "they were privileged to carry our equipment. The photographer was in charge. We were kings and princes." The reporters acted as researchers, travel agents, assistants, lackies, and, with luck, diplomats. The photographer was the genius of the operation, but the reporter was its motor—and carried the cameras. Sean Callahan, who worked at *Life* and was working with Margaret on a book about her when she died, thinks she may have had a hand in establishing the tradition of "the reporter as sherpa." Not only did she have the requisite glamour before *Life* even began, she was also a woman, with heavy equipment, who would have needed and expected assistance.

Margaret Bourke-White became a prime instrument of *Life's* promotion. On the page with the photography index, *Life* printed a small picture of a photographer each week and a few words about the assignment. In the July 5, 1937, issue, when the magazine printed Margaret's elegant story of paper manufacturing, with its startlingly abstract aerial photograph of logs heading downriver to the mill, the editors breathlessly recounted how she had put on her flying suit, knelt in the open doorway of a four-passenger plane with its side door removed, and fastened herself in with a belt. "The plane banks, Miss Bourke-White leans far out away from the plane holding her twenty pound camera against the tremendous force of the wind. . . ." Her derring-do was better copy than the story itself, and *Life* knew it.

17

"Honeychile, Arctic Circle"

*I walked through the South from one city to the next and every night I
felt lonesome. I lay under a pine tree 'and cried all night. Sometimes I
cried because I was afraid my mother would die before I could see her
again, and sometimes I cried because I could not find a girl who would
let me love her as I wanted so much to love someone.*

Erskine Caldwell, *The Sacrilege of Alan Kent*, 1931
(The dedication page of the 1936 edition says: "For Kit")

Erskine Caldwell had fallen in love with Margaret in the summer of '36
and then could not loose her hold on his heart. He tried. He thought
time might release him from the excitement generated by her energy,
intensity, and sexual appetites, but he was baffled by love and frustration.
Margaret would not give in to him completely, and she was stronger than
women he had known. She valued her work and her independence so
highly that he was not certain where he fit in. "When I do think I may
see you again, the feeling is that I'll be merely another customer coming
into your house on a schedule that may or may not conflict with the
previous customer on the schedule, the following customer on the
schedule."

He recalls that she was "constantly alive and vivid in appearance
and even in repose was rarely without a tense and alert restlessness. This
characteristic expression was of a youthful liveliness and vigor of move-
ment and was enhanced by a graceful and model figure crowned by an
abundance of startling whiteness of premature white hair." (Margaret's
hair had begun to go gray—it was not yet truly white—in the mid-
thirties. She was delighted, and never tried to darken it. She looked, and
indeed was, so young and, as Caldwell says, so vivid, that her gray hair
attracted attention and made her yet more striking.)

His emotions were far too tangled up in her for him to fight free.
Malcolm Cowley saw the two of them in the winter of 1936–37, "at a
meeting in a mid-town hotel held to advance some left-wing cause. Cald-
well appeared late in the company of a spirited young woman, the pho-
tographer Margaret Bourke-White. . . . Now, the wife in Maine

forgotten, they were radiantly in love, so that their presence transformed the crowded room. . . . I felt that those two, absorbed in each other, gave focus and form to the slovenly meeting, while we others had become the wilderness in which they gleamed."

But Erskine had not forgotten the woman he had married in 1925. He was tormented by the division Margaret created in him. He wrote Helen, his wife, in the spring of '37 to say how wonderful she was to have stuck it out so long, adding that he wanted to be back with her as soon as he recovered from Margaret. "It's something like being given a term on a chain gang," he wrote. "I don't think I'll be on the gang for life, so just try to give me a chance to escape, or serve out the sentence." Helen, who met Margaret in '38, says she "could understand how he might be infatuated, as anybody was who had an affair with her. She was a very infatuating person." Erskine tried to go back home more than once but felt he was not alive there; his passion had reached a point where only Margaret spelled life.

By February of '37, he and Margaret had taken a room at the Mayflower Hotel in New York, although Margaret still kept her apartment on East Forty-second Street. She said to Peggy Sargent, "Here's my phone number. Don't give it out. We're registered as Mr. and Mrs. Caldwell." Sargent was shocked.

Margaret was too well known to live openly with a man but was quite capable of shocking. She sent her secretary often to a doctor's office to pick up a package; it was a long while before Peggy Sargent realized that the doctor specialized in birth control. When Bourke-White came back from the field to the *Life* office, she would drop her camera cases off in the lab for the lowliest technician to unpack. Sometimes dirty lingerie was tucked between the lenses, and once a very raw apprentice pulled a pale-tan, pliable, rubber disk from one compartment and held it up to the light. "What kind of a lens cap is this?" he asked before someone shushed him.

Yet as Maxim Lieber, Caldwell's agent, says, she was "conventional and conservative in the external formalities." Everyone who knew her speaks of her as a lady. Her poise, her reserve, her precise, rather cultured speech and tailored clothes made it all the more surprising when she crawled among the legs of a crowd of male newspaper photographers and popped up for a picture of the President. Margaret tried to make Erskine formal on appropriate occasions, but that was a struggle. Lieber picked him up once at the Mayflower; Erskine was outfitted in a tuxedo and tugging frantically at his collar and tie. "For God's sake, Max," he groaned, "take me out of this harness." Lieber does not say whether he meant something more than the tuxedo.

Erskine's life had not prepared him for evening wear. In Maine with his wife and children, during the years of trying to make a name and a dollar, he had lived with no electricity, fairly primitive plumbing, and a diet consisting largely of apples or whatever they could grow. His own accounts of his youth sound like the song of a naughty bard or a poor man's fabulist. His family had moved so often he got most of his schooling from his mother, and their moves had been rather crowded with adventure: they were arrested once for frightening horses with their car, held captive another time by moonshiners.

At nineteen, when a co-worker absconded with Caldwell's pay and he couldn't meet his rent, he was sent to prison for loitering and released only because a black prisoner, at great risk, smuggled a message out to Erskine's father—an incident that could have sealed his already strong commitment to blacks. He played professional football, sold building lots that were under three feet of water, was bodyguard to a Chinese, and worked as a cub reporter. Some of the stories are hard to verify, like the tale that was told of his being an innocent passenger on a banana boat smuggling gold from Honduras—sometimes the cargo was said to be guns—and afterward, hanging from a windowsill outside a New Orleans hotel room while the gold runners shot each other inside the room in an orgy of double cross. He says today there was "no action" on the trip.

Malcolm Cowley has speculated that Caldwell surprised himself in his fiction and needed to invent a persona with space for the startling feelings his own words had uncovered. "Caldwell was presenting himself as, in his publisher's words, 'the spokesman for simple people, good or evil, vicious or oppressed,' but there might be those who doubted his 'close personal knowledge of the underdogs of whom he writes.' The obvious answer was that he had been one of the underdogs."

He was immersed in his own fiction for long periods, for a time writing one story a day. Caldwell would travel somewhere with a few dollars in his pocket, live in a fleabag hotel on bread and cheese, and burn up the hours with work. He said he wrote *God's Little Acre* in three months and submitted the first draft. Apparently he believes and even remembers all the stories he has told about himself. He does not dissimulate; he simulates at a level so high it convinces even himself.

He claims he knew very little about Margaret's family, although he thinks he knew "slightly" about her father being Jewish and is certain she had no prejudices. Topics like background were not discussed. "We had no time for that," he says. "We were living in a fast lane." They were. Politics and work both raced ahead. America had not been mended yet and Europe was breaking apart. Spain was bleeding; Margaret and Erskine raised funds and worked for the cause. Margaret's job at *Life* was

like living in a whirlwind; it picked her up and put her down erratically. The whirlwind was her element, and she battened on the rush.

She kept racing away from Erskine on assignment and dancing away from him at home. He was torn between duty and passion and fear. He told her he had no close friends; she thought his essential loneliness intensified his love and need of her.

They were planning a vacation in the spring of '37. She drafted a cable to him, saying that *Life* wanted her to go to Muncie and perhaps to Canada afterward. "Am very worried lest if you have to wait for me you will lose interest stop I know you wished me finish everything here before our trip but fear any delay will have bad effect on you. . . . I miss you and love you and feel we belong together."

She loved him more than she had loved a man for years; that is to say, she loved him greatly, but with caution. He was the first man she had lived with since Chappie, but she did not want to be tied down. When she went to Canada after Muncie, she had a brief fling with a man who wrote her later that he loved her desperately—after his fashion.

Erskine presented problems Margaret could not handle. She thought she could handle silence, but Erskine would withdraw from his customary pleasant taciturnity into icy stillness with no provocation or warning sign, a state she referred to as "the white plague." His glacial trances, impregnable, hostile, and frightening, could last for hours or days, only to end in "violent tempests." His first wife says he might refuse to speak to her for ten days if she had been late to some occasion; the long silences would be weighted down with a heavy sense of transgression and punishment.

Erskine and Margaret went to dinner once with a *Life* writer who idolized him. In the middle of dinner Erskine's face turned white; a chill settled over the table like a malign presence. Margaret and the *Life* writer scraped up conversation for a while, but Erskine's silence ground down mere politeness and choked off everything else. Margaret, with her underlying attention to manners and her need to be liked, found the embarrassment unbearable; for years afterward she bore the memory of that dinner like a scar.

Yet Erskine could be so gentle, so thoughtful and warm. He combed her hair tenderly. He encouraged her ambitions, at least when they did not conflict with his needs. He made her a full partner in writing the captions for their book. And he loved her so much he had offered to leave his wife and children for her—if only she would have him.

In July of '37, on less than a day's notice, Margaret went to the Arctic. The recently appointed governor-general of Canada, His Excel-

lency Lord Tweedsmuir, had suddenly decided that he would tour the farthest reaches of his domain on an ancient wood-burning steamer, which was already plying the Arctic waters by the time *Life* got the news. Lord Tweedsmuir was better known to Americans as John Buchan, author of *The Thirty-Nine Steps* and approximately fifty other books. His journey sounded like a good story.

Margaret flew to Canada with her luggage full of peanut flashbulbs and the chrysalises of mourning cloak butterflies; during these years she was often attended by insect cases that were due to open soon. Her editors arranged to have her met by a small plane on pontoons. She was delighted with the cops-and-robbers aspect of the chase, hunting a lord across the Arctic tundra. The pilot sighted the S.S. *Distributor* on the Athabasca River and splashed down out of the sky with a surprise passenger.

Once aboard, Margaret explained her butterflies to the captain, who promised to stop when birth pangs started, so the ship's vibrations would not spoil her photographs. The little bundles began to wiggle; they would burst open soon. She taped them to a deck rail and stayed in her deck chair through the quarter hour of Arctic twilight and the nearly twenty-four hours of sun, eating meals off a tray. At last, the first chrysalis split open. The motors stopped on cue. "For thirty years," the captain said, "I've sailed this ship, and I never stopped it even if a man fell overboard, and here I stop it for a damn butterfly."

The *Distributor* stopped in tiny towns along the way to deliver supplies to trappers and give the governor-general the chance to make a speech. Margaret was frantic for a message from home. In the beginning she heard nothing from Erskine, although she sent him cable after cable. On July 23 she drafted a letter to him (it is not clear whether she sent it) that tried to sound urgent without sounding desperate: "The thing that makes it so terrible is that you have given me no indication that you have been receiving my messages. If I could only get one wire from you . . . I hate to tell you this but I must because then you will see how important it is for you to send me just one small wire."

Then at Fort Smith the radio operator came aboard smiling and announced, "We have been searching all over for someone who fits this telegram." Walking over to Margaret, he said, "We've decided you are the likeliest candidate." The cable was addressed to "HONEYCHILE, ARCTIC CIRCLE, CANADA," and the message inside the envelope read: "COME HOME AND MARRY ME. SIGNED SKINNY." (Skinny was the only nickname anyone ever managed for Erskine.)

At Fort Norman there was a cable from *Life* asking her to charter a plane and photograph the Arctic Ocean in summer, plus a cable ad-

dressed to "HONEYCHILE, ARCTIC REGION." This one she said was more troubling. "When in heavens name was I coming home? He missed me, he loved me, the new apartment he was moving into was an unfinished cathedral without me. Why wouldn't I come right straight home and marry him? Unsigned."

She couldn't come straight home and she didn't want to marry. *Life* had just given her another grand assignment in the air above the top of the world. It made her edgy to hear Erskine calling her back. He kept sending cables. When they docked at tiny fur-trading posts, a man would climb on deck with an envelope in his hand and ask whether anyone on board was named Honeychile. Radio operators in the Arctic zone had little enough to do; they listened to Margaret and Erskine's cables as if they were on a party line. That entire small world knew that Skinny Caldwell wanted to marry Margaret Bourke-White.

Margaret and Erskine had rented the apartment next to the single room she lived in on Forty-second Street and had broken through the connecting wall to make a one-bedroom flat. Erskine was there putting the final touches on their book while she was away. Construction proceeded as she steamed north, but although she had left the building with instructions giving Mr. Caldwell full authority, the management would not make a single change unless Peggy Sargent O.K.'d it. It would have been exasperating enough for Erskine to be thus continually reminded that he was Mr. Bourke-White in her apartment, but he had never been happy there. Margaret wrote Peggy Sargent: "He's very sensitive about the fact that when people come to visit him it looks as though he was living with me in my apartment."

People did visit him in Margaret's apartment. Helen, who had helped Erskine edit his previous books, came down from Maine to edit the work he'd done with Margaret. All she remembers of the decor are the black satin sheets on the bed. His children came. His mother-in-law came. A lawyer followed.

His troubles seemed to mount so steadily he feared the worst was yet to come: that Margaret would drop him. This might have prompted the marriage calls winging across the ice, but he was always afraid of losing her, and always pressing her to seal their liaison with a promise.

He had some reason to be afraid. She loved him without stint in his good moods. He was "difficult, tantalizing, charming, brilliant, inspired, unpredictable." She addressed her letters to "Adorable" and wrote him early in her trip, "I can't wait to get back to you. I think of it all the time." But he seemed to want not only to have her but to possess and dominate her utterly. When he could not, he retreated into an invalid state, sleepless, nervous, unable to eat—or he flew into a rage. She asked

him to see an analyst, and finally he did. He says today he went out of curiosity—doubtless true, as far as it goes. The doctor was Harry Stack Sullivan, whom Margaret herself had seen some years earlier.

Apparently she had told Erskine that her goodwill and their future depended on his seeing the doctor. It seems to have worked for a while. In her notes she wrote that he made "swift progress, so entrancing, so pleasant to be with. Even those tense muscles of the face, which I had noticed the first day we met, slipped off like a melting mask. At the end of one month he said he knew more than the psychiatrist knew, and stopped his visits." While his old life in Maine hounded him and his new life with Margaret balanced precariously between bliss and disaster, Erskine briefly feared he was going to pieces. He had more faith in a woman's ability to put him back together than in a doctor's.

The only planes available to Margaret above the Arctic Circle flew the Royal Canadian Mail. The mail routes had never been well mapped, so the pilots navigated by instinct, experience, and whistling in the wind. Margaret picked up two partners who chartered an old Ford seaplane, and they were off. One of her partners was a bishop who ministered to Eskimos and, after the custom of taking the name of his diocese as surname, was known as Archibald the Arctic.

As they flew north with the door of the plane removed and Margaret tied in so she could lean out over the sea with her camera, an Arctic fog rolled in with blinding swiftness and blotted out sea, sky, and land. They were flying inside a pearlescent envelope of space, without horizon, color, or boundary. No visibility, no landmarks, no place to land, and with the magnetic pole a bare two hundred miles away, the compass was useless. The pilot put the plane into rapid dives and spins, looking for a spot to set down on before he was forced to land on the open sea. He found a tiny, rocky island and brought the plane down in a rush, three hundred miles from the nearest inhabited area.

They could receive messages on the radio, and repeated calls begged them to report in, but their signal was not strong enough to send back word of their location. The thick Arctic fog might take weeks to lift. The plane had rations for two men for twenty days. With the pilot and copilot, there were five of them on the island.

Archibald the Arctic, a practical man, immediately claimed the island for his church, hanging his episcopal banner from the tail of the plane, and brewed tea. The little band of five on a rocky ledge in an ocean full of ice sang songs, played games, and hung on the radio, which every hour asked them to reply. Once the sending station announced a message for Honeychile: "When are you coming home? Signed Skinny."

That evening the fog cleared for an instant and the pilot raced them into the plane. They took off and almost at once flew into a heavy rainstorm. After two hours of storm, with night closing in and their gas gauge falling, they spotted a settlement below—just two frame buildings, one of them a church, and a few Eskimo tents. That was enough. They landed and found a store of gas. They were not only safe; they could get started for home.

On her way back to New York, Margaret changed planes in Chicago. Someone was being paged in the terminal, and the name had an oddly familiar ring. She stopped to listen. "Paging Child Bride, eastbound passenger for New York. Paging Child Bride. Will Child Bride kindly step to the ticket counter?" At the counter, a telegram awaited her: "WELCOME, WELCOME, WELCOME, WELCOME."

The October 25 issue of *Life* had both an eight-page article on Lord Tweedsmuir's Arctic journey and a three-page spread farther on in the magazine on Archibald the Arctic, including pictures of the island where the plane set down and one of Margaret in her parka, smiling her generous smile. She said this was the first time the magazine had ever run two separate stories by one photographer in one issue. The editors talked at length about putting Margaret herself on the cover but finally decided that a staff member would be too obvious an advertisement for the magazine. The cover sported a picture of a hunting spaniel instead.

At the end of the summer, *Life* sent Margaret to Hollywood, and she and Erskine took the trip they had been planning. For the second time in her career the cinematic quality of her lighting and the drama of her compositions impressed a filmmaker greatly. Warner Brothers offered her fifteen hundred dollars a week, much more than she could earn on her own, but she didn't hesitate to refuse. Hollywood was tinsel town, whereas *Life* looked like the global city of the future, with a road map to her dream of travel and adventure. "1937. Late summer," she wrote in her notes. "Backstage pictures of Hollywood for *Life*. Warner Brothers offered me a job. 'I couldn't leave *Life*. Why, *Life* sends me to the Arctic Ocean!' 'We'll build the Arctic Ocean for you on the Ninth Lot.' 'That's just what I mean!' "

Life gave her both adventure and freedom, and a woman who cherished her independence as Margaret cherished hers thrived on the fact that the editors trusted her and cut her loose. She had written Henry Luce from Canada: "I am very happy anyway in my work for LIFE. It is such a joy to be able to carry out ideas with so much freedom."

Her trip to California with Erskine was bumpy. He was adoring, entrancing, cooperative. He handed her flashbulbs on the job: the famous

author as photographer's assistant. He was also insecure to his bones and nervous that he had lost Helen for good. It was not that he wanted Helen; he wanted Kit, but she would promise nothing. His despair deepened, his need for Margaret intensified. In his rages he threatened all manner of things if she would not belong to him alone; when he calmed down he was her adorable Skinny.

Margaret saw the problems clearly—she was surely creating some of them—but she was herself half blinded by love. Uneasily weighing the merits of passion against her mounting anxiety, she considered leaving him. When Erskine drove her from California to an airport in Arizona on her way back to New York, she had made up her mind. Frightened but resolute, she looked for a place and a way to say goodbye as they drove through miles of desert and stark formations, a bleak setting for a breakup. He could not bear it and stopped the car to talk. "My ears still ring with his agonized words," she wrote. "You can't leave us, Kit. You can't leave *us*."

She could. She did. But not for long. Erskine wanted and needed her and did not give up easily. The pressure of his love, the strength of her own response, the peculiar force of his need for her soon brought her back.

At the beginning of the new year, Helen filed for divorce. The decree became final on April 18, 1938.

18

Politics, at Home and Abroad

Margaret Bourke-White's success rattled a number of her colleagues. Especially the men. Jim Hughes, W. Eugene Smith's biographer, says that one of the reasons Smith resigned from *Life* in 1940 was that Margaret was getting so many better assignments than he was. The few women who were hired to photograph for *Life* never became friends with Margaret, but only the men seem to have been jealous. Peggy Sargent thought Margaret herself blessedly free of jealousy; at any rate she had been brought up not to care overmuch what others thought.

Life photographers in the early days when traveling about would ask to use newspaper darkrooms to develop their film. Carl Mydans recalls:

> By this time her name loomed very large. A common discussion would take place: "Tell us about Bourke-White. Jesus Christ, I hear she shoots one hundred thousand negatives for one good one. She doesn't develop her own stuff. If my editor would give me as many sheets, I'd make the same kinds of pictures too." The logic behind that is ridiculous. It was sheer jealousy. If a man had been making the pictures Margaret Bourke-White had been making in those years, I think it fair to say the newspaper photographers would have said, "Gee, so-and-so is good."

The charge of overshooting always earned her ridicule. *Life* photographers all shot too many photographs, because there was no way to anticipate what the editors would want or the layout would demand. Film was inexpensive; it cost more to get to most assignments than could ever be spent on film. Margaret did not take many more photographs than other photographers did; she just took the same picture, or a minutely adjusted variant, over and over. As black-and-white film in the thirties was very slow, photographers automatically bracketed their shots, taking one photograph at the exposure that seemed right, then one at a greater and one at a lesser exposure. (Many still do.) Margaret went further. A lab assistant from the pre-*Life* days says, "I turned on the hot

water in the darkroom once by mistake. That batch went down the drain. All I can say is, we never missed them."

She explained her method nonchalantly to Ansel Adams, the landscape photographer: "I just set the shutter at 1/200th of a second, take a picture with every stop I have. I'm bound to get something." Adams, one of the great codifiers of photographic technique, replied, "Oh, my, that's super bracketing." Margaret said, "When I get out on a job, I have to get something. There isn't much chance of waiting. I'll learn." In fact she never did. *Life* photographer J R Eyerman says that in the late forties he finally taught her how to use a light meter; she had a drawer full of meters she didn't know what to do with.

And yet she always brought back the perfect pictures for the magazine. "Understanding is more important than the right exposure," she told an interviewer. "There's a responsibility to show truth." No one doubts that her photographs outweighed her technique. Howard Sochurek, a *Life* photographer, says that Bourke-White's photographs "make a great argument for the fact that the technical aspects of photography really aren't going to determine the content."

It was odd, though, that in all those years as a professional she never learned a few technical particulars. Insecurity rode on the back of her perfectionism: as it was impossible to know whether the best had been achieved, the only solution was to keep trying. Perhaps her father's legacy also kept her shy of technical expertise. Women were not then expected to be mechanical; the technical aspects of photography doubtless kept many of them out of the field. The daughter of an engineer might have had even more than the usual feminine reluctance to try her hand. At any rate, Margaret always found a man to handle technical matters for her.

Her technical lacks and her success were both highly visible at Time Inc. No other photographer had an office, or a darkroom, or a printer. For years, the *Life* ace photographers all shared a kind of bull pen, a large open area crammed with desks, directly outside Margaret's small but private office. That office was furnished with her specially designed desk and couch, her tropical fish, and the woman who was thought of as the queen bee herself.

No one ever regarded her as "one of the boys." Alfred Eisenstaedt says of her that "nobody liked her. She knew only a few people. She didn't bother to talk to people very much, very aloof, knew only a few photographers. She overlooked other people." The *Life* photographers repaired after hours to The Three G's, a dark and poky little bar across the street from the office, for a round or two of Scotch and soda and several rounds of stories about their travels and their conquests. Margaret never joined them.

She had an extensive life to tend outside the office and a career that required cultivating. Only Margaret published books with the author of *Tobacco Road* and went to the theater on his arm. Only Margaret, on assignment to cover a fancy dress ball, had her ball gown (in two shades of red) specially designed to let her scramble up ladders gracefully and leave the local belles hopelessly earthbound. Only Margaret came to the ball trailed by an escort of fifty sea scouts who had been assigned to carry her equipment.

Her staff thought her demanding. "She was the most maddening person," Peggy Sargent says. "When she had time to kill between planes, she'd call at two in the morning just because she wanted to chat. She could talk to me because I was her inferior. She hadn't friends she could talk to." But Sargent and others who worked with Margaret say she worked so hard she never asked more of others than she was willing to give.

Ordinarily she would cloak her requests in charm, which had become part of her technique. People who thought she would be an operatic diva were so astonished at her graciousness they thought they had invented her. One company officer who took her through a factory in 1938 wrote about it to a friend:

> Did you ever see a whole factory fall in love? It's quite a spectacle. . . .
>
> Those people expected a temperamental celebrity, high-hat and difficult to handle. Actually, they encountered a girlish personality, unspoiled and unassuming, with a charm that straitaway [sic] captivated . . . [and] somehow, made toting her heavy suitcase easy, stringing and holding lights for her a lark, and standing at her side ready with fresh film packs a place of privilege. . . .
>
> The thing became an epidemic. Workers who were supposed to have nothing to do with this expedition gathered around by the score to gaze. This is confidential. I might be held responsible for interfering with the production of the nation's arteries of communication.

Not everyone saw it that way. "It was coffee and darling, would you be a darling and a sweetheart," says a woman who worked for Simon & Schuster, which published her books. Another adds that "everybody was her messenger boy. Whenever she said anything nice or charming she wanted a favor." Once in a great while she forgot the charm altogether. One day she came into the darkroom where a young woman was packing gear for an assignment. Margaret threw down a fifty-cent piece and said, "Go down to the drugstore and get me a box of Kotex."

"One thing I learned above all else from Margaret Bourke-White," Peggy Sargent says, "is the kind of woman I didn't want to be, that centered in myself, that lacking in human relationships, that selfish." No woman is a heroine to her secretary.

Berenice Abbott says that an editor at *Life* once asked a colleague why he didn't use Abbott, to which the second editor replied, "We've got one prima donna. We don't need two." Joe Kastner, *Life*'s copy editor, who refers to Margaret fondly as "the lady with the beck and call," recalls a story told him by Paul Peters, the reporter who went out with her to do an essay on U.S. Route 1.

> I think somewhere out of Baltimore they stopped by some roadside stand to get a picture. Paul said to me, "You know, Joe, she acts like a queen, as if she were royalty, and you begin to think she *is* a queen and royalty after you've been with her awhile." He was irritated. She wanted things just so. She finally got her camera where she wanted it. There was a big tree there. She looked at Paul and said, "Is there any way to get this tree out of here?"
>
> He came back, as so many people did, goggle-eyed. Taken in is not the word. Taken over is more precise.

Margaret was far too ambitious and too driven to be consistently kind, and too uninterested in conventional opinion to play the game when there were more important things to do. (This despite the fact that she so wanted to be liked that a reporter said she always laughed at his jokes even when she didn't understand them.) Not having been raised to be charming or kind, she had had to develop charm and acquire thoughtfulness on her own. By the late thirties she possessed both to a high degree, but she generally spent them only where they counted most.

Most of the *Life* staff who thought her cool, indifferent, arrogant, or self-centered add that it didn't matter. She was a great photographer, which in itself was grounds for forgiveness. And she could play the role of Margaret Bourke-White so well that even people who knew they were being conned were pleased to cooperate. Joe Kastner says, "You were always aware of what she was doing. I didn't mind it. Neither did Paul Peters." It is hard not to admire a woman who could manipulate men so delicately that they respected her for it.

Margaret's political career was rather unremarkable, but her commitment to liberal causes was strong. Carl Mydans says that by 1936, "Margaret's social awareness was clear and obvious. All the editors at *Life* were aware of her commitment to social causes." In fact Margaret in those years was more politically active than the young men of goodwill on the staff; she had a public history of commitment that they never had.

The Spanish Civil War had become a kind of litmus test for the intellectual left, and Margaret and Erskine were so active in the relief effort that in late '38 the American Relief Ship for Spain planned a luncheon in their honor. She also contributed to the American League

for Peace and Democracy, one of the Communist party's most successful front organizations. The party was almost the only group in America that actively took up the fight against fascism. By the end of the decade, as disillusion with Russia spread among liberals and the necessity for a journalist to be impartial became increasingly clear to her, Margaret withdrew from active involvements.

Politics had never been her life, and she did not seek out politically charged stories to make her political point, nor refuse an assignment for political reasons. (Or for any other. Margaret was a professional. In *Life*'s first three years she photographed not only her big set pieces but such subjects as furriers, Mexican tourist pottery, an aerosol that made ducks sink. *Life* needed massive infusions of trivia. Margaret would contribute whatever was necessary.) *Life* photographers in general were not crusaders but photographer-journalists, observers with hungry eyes, and they did not work for a crusading magazine.

Life's politics were not clear-cut. Much of the staff stood to the left of Luce, but he was often a tolerant editor and only intermittently foisted his politics on the magazine. Never openly pro-Fascist, as *Time* was, *Life* in April '38 still thought it humorous to print photographs of Roosevelt, Hitler, and Mussolini making identical gestures that made them look like a cartoonist's dream of triplets. At the time, Luce was convinced that Hitler was "misunderstood," but when Henry Luce changed his mind he changed it hard. In 1939, before Americans had shaken off their isolationism, Luce wanted *Life* to come out so strongly for intervention that one editor asked another, "When is Harry going to declare war on Germany?"

In early '38, Margaret was assigned a story that would have satisfied her politics and her love of adventure at once; to cover Mayor Frank Hague of Jersey City. "Boss" Hague had crashed into national headlines on a dispute with the Congress of Industrial Organizations. A Jersey City law prohibited the distribution of printed matter without his consent. The police arrested some CIO members who passed out circulars in Jersey City, the rest were run out of town, and no one there would rent the CIO a hall for a mass meeting. Labor leaders called Hague a Fascist and a dictator. Hague cheerfully blasted them back as "Red Communists."

Life must have made a calculated decision to send Margaret to Jersey City. Word had come back that reporters were being beaten up and photographers' cameras smashed; it might have been thought that Bourke-White was too big a name to attack. During her first few days on the assignment, the local police, who were something like Hague's private militia, met her each morning with a limousine as she stepped off

the train from New York. She had an escorted tour of only what they wanted her to see, including the mayor's public appearances, when he orated beneath huge banners that blared, "REDS, KEEP OUT!" Rumor had it that his anti-Russian stronghold was in fact a major loading point for goods bound for Russia. Rumor also claimed that the city's slums harbored a large force of child laborers.

Margaret ducked out of her uniformed escort's reach to meet a reporter from one of the local papers, who knew the real story but could not print it. On the docks she found the cargo she was looking for, addressed to Odessa and Sevastopol. She worked fast, afraid to shoot more than three or four frames on a roll before dispatching someone to New York with the film. She could not evade nine hundred Jersey City policemen for long. In the back alleys she photographed one household that kept a young child home from school so the whole family could earn $2.50 a day making lamp shades. By now, certain the police were close behind her, she did not pause to reload her cameras but handed them to an assistant, who smuggled them out of town. At length the cops burst in on her, hustled her off to headquarters, opened her cameras, and ripped out the film. Margaret was calm. *Life*'s exclusive had already crossed the river to New York in her assistant's hands.

The *Life* story opened with a full-page portrait of the mayor, seen from slightly below as if he were a skyscraper. It showed him natty, suspicious, proud of his arrogance, and posed to convey the size of his authority. Over his pocket *Life* printed one of his own favorite statements: "I am the Law!"

This is a near-perfect portrait of Boss Hague, the way he will be remembered. Ed Thompson, a *Life* picture editor at the time, says: "She had her own way of depicting people. If somebody thought he was Napoleon, he'd turn out to *be* Napoleon." She caught the face a man wished to present to his public or the posture a public preferred him to assume. Like her industrial pictures and much of her photographic reportage, her portraits of men like Churchill, General Patton, and Nehru are essentially symbolic: they stand for the man's position or his public persona. Like her group portraits in Muncie, her single portraits are convincing shorthand summaries rather than in-depth studies. But they do convince. She could be counted on to do the job, and do it grandly.

Life had begun as an exploration and a celebration of America. It never fell out of love with the States, but it rapidly turned international because the world forced it to—its ads spoke of "the vast face of America" in 1936, but of "the boisterous newsfronts of the world" in '37 and '38. Americans who had set out to find their country realized by the end of the decade that the subject was too small.

3. Belmont, Florida, 1937, *You Have Seen Their Faces*

34. (Opposite) Maiden Lane, Georgia,
1936 or '37, *You Have Seen Their Faces*

35. Down South with Erskine Caldwell

36. Nazi rally, Czechoslovakia, 1938

37. "Boss" Hague, 1938

38. Ad in *Life*, 1939

39. Soldier in Soviet tank, U.S.S.R., 1941

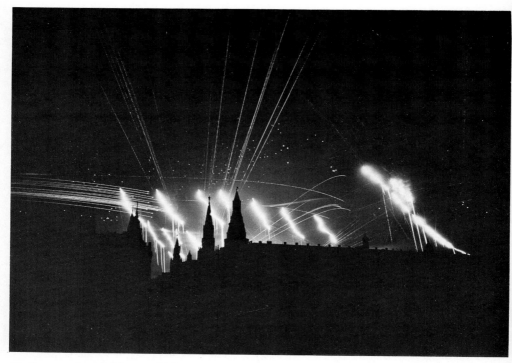

40. German air raid, Moscow, 1941

41. In army correspondent's uniform,
by Louise Dahl-Wolfe, c. 1942

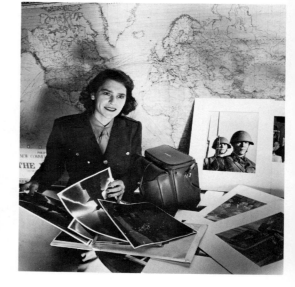

42. Brigadier General J. Hampton Atkinson,
Tunisia, 1943

43. Jerry Papurt, 1941 or '42

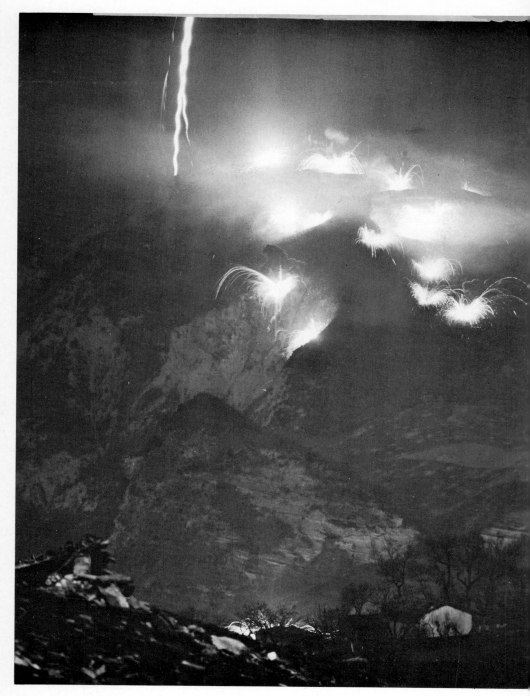

44. Night barrage, south of Bologna, Italy, 1944

In the spring of '38, Margaret was sent to the trouble spots of Europe: Spain and Czechoslovakia. Erskine, who had never before been across the ocean, went with her. They had been working furiously together, trying to keep alive the Broadway dramatization of Caldwell's *Journeyman*, but the play folded on March 11 after a brief run. They sailed for Europe on March 31.

They were planning another book together. When all went well between them, working with Erskine satisfied Margaret as almost nothing had ever satisfied her before. The combination of love and work gave a new edge to life. The success of *You Have Seen Their Faces* undoubtedly set her sights high.

When they left America, Glenn Miller was putting together his first jazz band, and Thornton Wilder's *Our Town*, a kind of mythic version of Middletown, was about to be published. Once in Europe, Margaret and Erskine could scarcely move as fast as disaster. While they were in Barcelona, still controlled by the Spanish Republicans, the Germans practiced the new tactic of aerial bombardment, a warm-up for a coming war.

They did not stay long in Spain. The book with Erskine had become so important that Margaret organized her trip around it. She did not want to do a "half-baked book," which was all a short trip would permit, and she needed as much time as possible in Czechoslovakia to ensure a good book there. In fact she stayed overseas five months, much longer than anyone had expected.

On March 12, Hitler's troops had entered Austria. The following day, *Anschluss* made Austria a province of Germany. In Czechoslovakia, three and a half million Sudeten Germans, whipped up by Nazi leaders and claiming they were a "cruelly repressed minority," demonstrated in the streets for *Anschluss* with Germany. If Hitler could neutralize Czechoslovakia's extensive defense system, he could unsettle the European balance of power and invade Poland or Russia with relative ease. The French, British, and Russians, committed to the defense of the Czechs, stood in his way. On May 28, *Der Führer* announced that he wished to "wipe Czechoslovakia off the map."

In Prague, where a predatory future lay in wait, Margaret and Erskine were given an official escort. Margaret wanted to get rid of officials in order to achieve some sense of the people, and succeeded at last with tears—"not planned," she wrote, "but as a result of weariness, but quite effective." Erskine's moods had been slicing across the trip like a guillotine. A government press officer and his wife, a particularly hospitable couple, had taken them to a small village, then at dinner found themselves frozen out for some monstrous and entirely unknowable offense. In her autobiography Margaret wrote: "I am sure Skinny did not intend

to cause this distress. I believe he was largely unaware of what was happening, for basically he was sensitive and almost uncannily perceptive about others. But this ungracious behavior prevented the closeness to the people we should have had."

Erskine could put her charm out of commission, but Czechoslovakia and its snarling sense of menace deserved every ounce of her attention. The two of them crisscrossed a land of farms and hospitality and hopelessness. Erskine would write about it afterward. When a vintner entertained them one afternoon, the man's grandmother packed up and left for good, fearing they were spies. When they visited the jail in Brno, the police inspector, embarrassed to admit his prison was full of refugees, let all the prisoners go. On a train, a German couple who could not convince a woman to move out of their compartment slapped her face, spit on her, and loudly yelled, "You Jewish swine! You'll be taught your place!" The editor of a German-language newspaper in Prague smiled when he admitted that the paper was merely a convenient front and warned them not to look too long at the degraded Czech architecture: "The stupid Czechs will succeed in contaminating us if we are not strong."

On May 19 came reports that German troops were mobilizing on the Czech borders; on the twentieth, the Czech army was partially mobilized. Margaret had not finished her work, but news was news. In the May 30 issue, *Life* printed a twelve-page story combining her photographs with those of John Phillips, a younger *Life* man on the scene. A large ad in the *New York Times* proclaimed that "Two of *Life*'s most famous photographers, Margaret Bourke-White and John Phillips, have been at the front for today's new issue of *Life*—one of the most important pictorial documents ever published." *Life* was beginning to promote its photographers as men and women who recorded history in the making, thus securing the magazine a historic role. No newspaper had the space or resources to print such an overview of a country.

Just before leaving Czechoslovakia in August, Margaret took one photograph that remained with her all her life. It was a picture of trees in the forests of Bohemia, the long, slender trunks of evergreens, silvery in the light, their bristle-textured branches cut off by the top edge of the frame. She had the picture enlarged to mural size and mounted it on the wall of the living room in the house she and Erskine bought in Darien, facing windows that looked out across the lawn to a real Connecticut forest; in essence, she lived inside one of her photographs.

In September, not long after she and Erskine reached America, Neville Chamberlain flew to Munich to meet Hitler and returned home

to a hero's welcome. "I believe it is peace for our time," he said to a populace eager to believe him. As the European powers signed away the little country they had manufactured after the First World War, Winston Churchill refused to join in the applause. "All is over," he said. "Silent, mournful, abandoned, broken Czechoslovakia recedes into darkness. . . . This is only the beginning of the reckoning."

Erskine wrote about the anti-Semitism they had seen. The two of them tried unsuccessfully to help their Jewish interpreter emigrate to America. Margaret assured the woman in a letter, "Certainly you will find no prejudice against your race here." Her "race" was also Margaret's, or would have been to the Nazis. She and Erskine witnessed appalling instances of anti-Semitism; possibly they struck even deeper chords of fear and outrage in her because of the secret she carried about. She included in their book a photograph of Talmudic students, and when she lectured about Czechoslovakia she listed the schools the government had set up for language minorities: "The Czech government had even built Hebrew schools where orthodox Jewish boys studied the Talmud. Pick up any newspaper of this last week and you will be able to guess what is happening to those orthodox Jewish families in the areas which Hitler has 'liberated,' as he likes to call it."

News photographers could not themselves make history but could affect the way it was perceived. Troubled times produced a new sense of mission. Photographers thought their pictures, their evidence, might influence public opinion and thereby alter the course of events, as television's coverage of Vietnam is said to have done in the sixties. In a radio interview Margaret said:

> It is my firm belief that democracy will not lose hold as long as people really know what is going on and that the photographer has a very valuable part to do in showing what is going on. I believe that fascism could not have gained the lead it has in Europe if there had been a truly free press so that the great mass of people could have been informed and then could not have been misled as they have been by false promises.

North of the Danube, by Erskine Caldwell and Margaret Bourke-White, was published to good reviews in April of '39 and drew a lot of attention because of its subject. But Margaret herself felt her pictures lacked an essential depth and failed to illuminate the country's crisis. She thought it was because Erskine's erratic behavior had kept them too distant from the Czechs. Whatever the reason, it must have been bitter for a perfectionist to realize she had not done her best.

Still Erskine was urging her to marry him. He published a collection of stories called *Southways* in 1938, dedicated to Margaret Bourke-White.

The two of them were news, with Walter Winchell's gossip column predicting they would wed and a Washington columnist sighing in print, "Miss Bourke-White, go ahead and marry the guy." When their ship docked in New York in late August, reporters and photographers fell upon them. Because the ship had not allowed a couple without a marriage license to book a cabin together, they had taken adjoining staterooms, one of which served mainly to store Margaret's luggage. The reporters who swarmed on board ship wielded tape measures to gauge the exact distance between the two cabins.

The reporters' questions made it clear they assumed a marriage was in the offing and merely wondered why the delay. Margaret was accustomed to poking her camera into people's private lives but not quite so used to having others poke into hers. "I'm not going to marry him," she said snappishly, "no matter how many photographers and reporters want me to."

"I don't want to get married," she told another reporter. "I like being single too much." That's what she told the world. She might even have said it to Erskine, for a while.

19

Patricia

February 28, 1939:
HONEYCHILE BOURKE-WHITE
HONOLULU CHAMBER OF COMMERCE IS PLACING ORDER FOR MARCH
SUNSETS AND WISH TO KNOW YOUR PREFERENCE. REQUEST FROM SS
LURLINE FOR YOU TO LEND YOUR CHARM AND GRACE TO DECK A FOR
FIRST MARCH SAILING. COUNTY CLERK OF RENO WISHES YOUR
AUTOGRAPH. I DONT WANT MUCH MYSELF. JUST ONE PREPAID WORD
SPELLED YES.

SKINNY

Erskine's gentle side had a grace all its own. When he and Margaret returned from Czechoslovakia he threw a welcome home party just for them in New York. "I was told to close my eyes for ten minutes," she wrote in her notes, "and during that time I could feel soft surfaces touching me on the cheek and the hands and the forehead. Little mysterious swishes of sound. What could it be? I hadn't the remotest idea. Then when I was allowed to open my eyes I found that Skinny had filled the whole room with beautiful balloons in all sorts of lovely pastel shades . . . and hanging to one of them was a lovely little gift. How could anyone resist a man like this?" He pursued her with surprises and singing telegrams. Her refusals were growing fainter.

Shortly after their return he rented a cottage on a Connecticut island where he could write. They liked the place so much that in October they bought a house in Darien. In an area that had carefully preserved its capital, its tweeds, and its distaste for Roosevelt, the houses had genteel names: Blueberry Hill, Round Hill, Rolling Hills. Margaret and Erskine called theirs Horseplay Hill.

The neighbors thought they were married. When a friend asked whether she'd marry again, she replied, "I am always trying not to." Later she wrote:

It was not that I was against marriage, despite my initial unhappy experience. But I had carved out a different kind of life now. To me it was of the utmost importance to complicate my life as little as possible. The very secret

of life for me, I believed, was to maintain in the midst of rushing events an inner tranquility. I had picked a life that dealt with excitement, tragedy, mass calamities, human triumphs and human suffering. To throw my whole self into recording and attempting to understand these things, I needed an inner serenity as a kind of balance. This was something I could not have if I was torn apart for fear of hurting someone every time an assignment of this kind came up. . . .

My first loyalty was to *Life*. There was no secret about it. My professional work came first. . . . Dashing off at a moment's notice around the globe is wonderful if you are doing the dashing yourself. But if you are the one who stays behind, it must be hard to bear.

A roving photojournalist is an imperfect candidate for marriage to begin with; being a woman merely complicates the matter further. The first loyalty of most news reporters is to catastrophe, the second to their profession. An ideal domestic life would be a heavy handicap; the majority tend to avoid married bliss either by choice or by failure.

Margaret secretly harbored a richly detailed, conventionally feminine notion of home but did not think the world would permit her two such satisfactory lives. In the history of marriage it has been quite common for the man to pledge his first allegiance to his work and for the woman to accede to his priorities; she takes what gains she can and pays what costs she must. Margaret had placed Erskine in a situation he was not prepared for. He was accustomed to a traditional wife and wanted one still, yet he was entranced by her firecracker energy at work and her joy in her swashbuckling career. He admired her talent and her work and generously supported both, but he was a needy man and never got used to being second. He must have thought marriage would give him possession of Margaret.

She thought she saw their problems clearly and wrote her hesitations down at the time: "Think he's insisting on the wrong thing. Both much too used to looking out after ourselves. Can't help but feel that he wants me to change a lot. Clear at very start that risk is great." Still, their passion could not be stifled. She tried to discount her constant longing to be with him and the pull of his love's wild urgency and wilder need. She was wary of such heat—"Don't think these ferocious things burn very long"—and she had reason, but then too, she was predisposed to control in everything. After she broke off with him in the desert, he must have won her back by the starkness of his despair, for at one point she was worried about what he would do if she left him and said she did not want the responsibility for any disaster.

By the time she wrote her autobiography, it seemed to her she had married him to make him whole. He was talented, he was "a fine and

very worthwhile man," but his exaggerated insecurities were dragging him under. "It is often said that a woman is most strongly drawn to the man who needs her most. I had always considered myself too selfish to be governed by such a move. But there must be something to it. Perhaps if I became his wife, it would lighten the burden of insecurity which he seemed unable to cast off. I would not be satisfied until I had explored all possibilities thoroughly. If marriage would help, I was willing to try." She noted that usually it is the woman who looks for her sense of security from the man.

Margaret and Erskine, both of whom had pushed their personalities to extremes in the service of their craft, occupied positions of prestige and command in the world's eyes, she in a slot ordinarily reserved for a man. They were constantly exchanging roles and slipping daily into and out of positions for which society had formulated no protocol. They were engaged in a byzantine struggle for control; occasionally it turned harsh.

Peggy Sargent thought Erskine the first dominant figure in Margaret's life. John Vassos, who saw Margaret as a controlling woman, says she tried to dominate Erskine, but down deep there was something she could not touch, and so she never quite succeeded. She married Erskine to repair his wounds, some of which she had caused, not merely by leaving him so often but by being so eager to do so. He frightened her by saying he literally could not live without her. She discovered that she, too, needed to be needed.

And after all is said and done, they were in love, and they were neither the first couple in history nor the last to marry on a poor prognosis.

By the time she said yes they were both in a hurry. On February 27, 1939, they flew to Reno, where marriage licenses were granted without delay. On the flight, Margaret drew up a marriage contract, which specified that they would talk out all quarrels before midnight, that he would be as courteous to her friends as to his, that he would try to control his moods and would not try to keep her from her work. He agreed to everything; he signed on the dotted line. This was to be a modern marriage, with the difficulties negotiated to a draw beforehand.

Reno struck them as a less than ideal spot for a wedding. They borrowed the pilot's chart and found a town not far away with the tinkling name of Silver City. When they hailed a taxi for a ride through the desert to their wedding, the driver warned them that Silver City was a ghost town, so they stopped along the way to pick up a minister. That put most of the wedding party in the cab. The Silver City church was locked, as if to guard against freeloading prayer. They combed the town to find a key. Erskine and Margaret thought the abandoned church in

the unpopulated city an enchanting spot, decked out in its disuse and solitude as if for them alone. The cabdriver and the local tobacconist stood up as witnesses at their wedding in the tiny chapel high on a bluff. Dust lay over the interior like the sediment of history, and through the windows mesa and desert stretched across miles to merge with sunset and sky.

Peggy Sargent wrote Margaret's sister, Ruth, that she was very pleased about the marriage, "for I think Miss Bourke-White seems happier than I've ever known her."

And so she was, although the threat of storm was ever present. When they were happy, life was as good as its sweetest promises. Except when insecurity blinded him, Erskine had a lover's mighty desire that Margaret be her best self. He wrote her that first year when she was away on assignment:

> Make haste to get back here and do those books on insects while you are in your prime. . . . I wish you could understand how important it is for both of us for you to do this creative kind of thing. It hurts me to see others doing the things you by right should do. I want my wife to be the one to produce these things of permanency. You have that God given element of scientific inquiry . . . and this talent combined with your other talent is something that nobody else in the world possesses. Not to use it is a sacrilege. . . . The world is going to be here a long, long time but a person has only a few short years in which to contribute his talent to it.

(By 1940, she had promised a publisher a children's book on insects. She would never deliver it.)

They had been married less than a year when he wrote this, and she was writing: "I love you so deeply. This time away from you has really done something very important to me. It has shown with surprising vividness how very essential is darling Skinny to his adoring Kit." Like all lovers at their best, each wanted the world for the other. Between the lines of his letter can also be read his unhappiness that she is away and between the lines of hers her reassurance to him.

Margaret's domestic side had once more been wakened by marriage. She loved the house in Darien. She played house with Erskine as if they were children at a tea party. They had acquired coon cats, a long-haired variety from Maine with six or seven toes. Margaret wrote home, "I miss the house and the cats and the garden and the china and table linens and the alphabet on your wall and the Sunday papers and you and the tray of after dinner coffee and the red stars and your kisses but most of all I miss YOU."

Erskine wanted to make their domesticity permanent. He wanted to have a child. A couple of months after their wedding, Margaret's cousin Felicia Gossman, then very pregnant, had cocktails with the two of them. Margaret said she looked as if she were due any minute. "Yes," Felicia answered, "it's funny meeting Erskine now, because I've been told that when a man first meets a woman, if she's pregnant, that's an image he'll never forget." To which Erskine replied, "Oh, I like to see women that way. All Margaret has given me so far is guppies."

He wanted a baby. In fact he wanted a girl. (He and Helen already had two boys and a girl.) Erskine may have thought Margaret was pregnant soon after the wedding; at least he made his intentions clear in a cable addressed to "CHICKIE BOURKE-WHITE: TELL THEM AT THE HEN PARTY THAT IT TAKES A ROOSTER TO MAKE A HEN LAY FERTILE EGGS.—COCK OF THE WALK."

Margaret too wanted a child, longed for one, but had her reservations. Erskine pressed her. She was fully aware what changes a baby would mean in her life. No doubt he was too, which may have been one reason he campaigned so hard to have one. A child would cement his final claim on Margaret. A child would keep her closer to home and still his fears that she would leave him.

She had wanted a child since she married Chappie. People who saw her ride like a tank over obstacles in the way of her camera thought her ironhearted and fixated on herself: a monster candidate for motherhood. But Betty Cronander, who knew her well, says, "She was wonderful with kids. God, she should have had ten. . . . She said that she knew that if she had a child she would be a good mother because she would do it so wholeheartedly."

She practiced on Erskine's children when they visited, making them her photo assistants or letting them help her edit. "I was very young when I knew her," says Jan, "but she treated me with respect and interest." "She seemed genuinely interested in me," says Erskine junior. Others who met her when they were children concur. One of the neighbors' boys in Darien says she could "scare the liver out of" him with a look "like a laser beam," but that she always asked his opinions, and "she made me feel I was important to her, this world celebrity making a little punk kid think he was important to her."

Erskine must have talked to Margaret about a baby long before they married. He, or possibly the two of them together, created a fictitious child as early as 1937, a child sufficiently real to deserve honor in the world's eyes. *You Have Seen Their Faces*, their first book together, was dedicated to "Patricia." In 1939, they began to speak of Patricia as someone real.

That year, the world was tumbling fast into a nightmare. A journalist had no choice but to pay attention. In the spring, Madrid fell, leaving Spain in the hands of a shrewd little Fascist named Franco. Hitler swallowed the last of Czechoslovakia, Mussolini invaded Albania. *Life* published excerpts from *Mein Kampf.* The World's Fair opened in New York, trumpeting "The World of Tomorrow," a world that would have to be postponed because of war. Scientists announced that they had split the uranium atom.

On August 23, Hitler and Stalin signed a nonaggression pact. Protected at last on the east, Hitler marched into Poland on the first of September, permanently shattering peace in our time. Two days later, England declared war on Germany. In the middle of October, Margaret sailed to England for *Life* with plans to continue on to Rumania, Turkey, the Middle East, and Italy. The *New York Post* reported that Erskine brought red roses to the ship when she departed. "Their goodbye kiss was long, long, long, and Miss Bourke-White did much better with the stiff upper lip than did her bridegroom."

Margaret paced the eerie streets of London night after night with her camera while the city nervously lay in wait for bombers. All London was blacked out; a pale moon counted the columns of St. Paul's dome and shuddered in the waves of the Thames. During the day Margaret wrote Erskine letters aching with love and fortified with admonition. "I want to be sure you're seeing people frequently to keep in practice so when I come back I'll find a very sociable husband." They sent yards of paper and stacks of yellow cables laced with banter across the ocean. Margaret wrote about their family; she included the cats. Erskine wrote about the daughter he wanted her to give him.

She referred to him as Papa and herself as Mama. She wrote to their pets as "Dearest Children" and urged them to take good care of Papa while Mama was gone. They were playing house, this woman who could walk through concrete walls and this man whose fantasies were so powerful he could embroider a past for himself and believe every thread in the fabric. "Isn't it darling," Margaret wrote him, "about Lottie climbing trees with Fluffie. That's sweet, for Mother and Daughter to climb trees together. That will happen in our family too, Sweet Thing." Erskine sent her a picture, perhaps one he drew, of Patricia. She wrote that she had put it next to a picture of Patricia's father, and the child looked over his shoulder in a cute way. Another time she cabled, "YES PATRICIA IS KNOCKING AT MY HEART TOO."

While Russia marched on Finland and the lights blinked out all over London, she dreamed the recurrent and elusive dream of family bliss.

The letters almost make it appear that she was pregnant, but she was not. Erskine never inquired, she never mentioned how she felt. Carl Mydans was in London for *Life* through November that year. One night he ran into an undergraduate who had been assigned to assist Margaret and was doing the usual work of assistants, walking the dog that had been given Bourke-White as a present. Mydans said hello and politely asked how Bourke-White was. "She's fine," the boy answered. "She just sent me out to get her some napkins." "Napkins?" "I think you call it Kotex."

Margaret wanted a baby, an ideal family, a perfectible life, but Erskine's devastating moods seemed to make her goals recede just as she approached them. She had exacted a promise that he would see another psychiatrist, this time Clara Thompson, her own doctor. (About the time of the marriage, Margaret and Dr. Thompson had agreed to a "year of grace." At some point when Margaret was having difficulty with Erskine, she saw Dr. Thompson again.)

When I come home, Sweetness [Margaret wrote Erskine], there is going to be a fine life for us. But you must do something to yourself first. You must do those important things about those sides of yourself you don't know about. You must must must!

I love you so much. But I love the good sides of my husband. (I must love the other sides too, or I wouldn't have put up with them so long.) . . .

Please, Sweet, see how earnest I am about this, because getting these things fixed, and realizing they have to be fixed, will make the difference in the kind of future we want to have, with Patricia, and all those things.

Erskine made the great effort for her. He went to Dr. Thompson that fall and, to judge from Margaret's letters, may have arranged to start therapy around the turn of the year. He had just finished *Trouble in July*, which was published in early '40, a powerful novel about a lynching and a sheriff who is loyal to a black man. It was the last of the big, robust, angry novels of his best period.

Erskine had agreed to edit a series of books on "American Folkways," yet another thirties effort to plumb the character of the country. Late in October, while Margaret was in England, he set out across America in search of writers. At year's end he came down with chicken pox and was hospitalized in Texas. Margaret wrote him in January, "I suppose this will postpone Dr. Thompson, but maybe you'll be going soon. I do hope so." After that, the letters do not mention Dr. Thompson—and scarcely mention Patricia.

But neither Erskine nor Margaret had actually given up Patricia. Margaret's happiness with him could run very high, and then her hopes would dance. She turned all her skills on her marriage, as if it were her

greatest assignment to date. Perhaps it was. At some point she was certain she had done the job and could have the reward. She got pregnant.

Ed Thompson recalls Wilson Hicks telling him the story sometime around 1940. "She came into Hicks' office and said, 'May I shut the door, I'm going to cry?' She did for a while and then said, 'Wilson, I'm going to have a baby.' Wilson says he cried a little himself, possibly for effect. She was moved, I think, and it is possible that those to whom he told the story were, a little. But nothing happened." Peggy Sargent also remembers being told that Margaret had asked Hicks for time off to have a baby. After about three months she came back, saying she was ready to go back to work.

Both Thompson and Sargent have the impression that Margaret was not pregnant but only announcing that she meant to try, and that she came back because she failed. A request for a leave of absence in order to try to get pregnant is so rare as to be virtually unique, and would seem like an unlikely occasion for tears. (More than one member of *Life*'s staff, on hearing the theory that Margaret wanted time off to conceive, immediately declared they would have thought Bourke-White could get pregnant all by herself.) She did not need time to get pregnant. She had done that successfully. But she did not carry to term.

Ed Stanley, an old friend, has a dim memory of Margaret's being pregnant around this time. His late wife once told an interviewer that Margaret tried to have a child but lost it. Rumors raced about the darkroom that she'd had an abortion; such gossip is notoriously unreliable, but in this case there were circumstances that could have fed the story. In later years, Margaret told her doctor she had been pregnant twice, once at twenty-one and once in her thirties, and that she had miscarried each time some two months into the pregnancy.

Circumstantial evidence, which is all there is to go on, suggests Margaret was pregnant in early 1942 and had an abortion. At the beginning of '42 she wrote to Edna B. Rowe, founder of a school for child education in Toledo, Ohio, for explicit practical advice. This letter is lost, but Miss Rowe's reply speaks of "the baby that I hope is to be yours" —which sounds as if Margaret might be pregnant but having trouble. Edna Rowe said she knew how much more significant immortality would be to Margaret with a daughter, and what joy she would have, and suggested she ask Dr. Arnold Gesell at Yale for someone who had worked with him to be nurse-governess. When the child reached two, Miss Rowe would select a teacher educated at her school to come to Margaret. In this as in all matters, Margaret's research was thorough and her expectations high.

Lee Scott, Margaret's secretary in 1942, says she saw a health report

saying Margaret had had a hysterectomy. Later medical reports make clear this is incorrect, and Scott herself was puzzled at the time, because once, unpacking Margaret's briefcase, she found a diaphragm and wondered why she needed it. Yet Scott is certain about the report. Perhaps what she saw was a record of a D and C. Abortion was illegal, but well-connected women with cooperative doctors could sometimes arrange a D and C that would do the job. Robert Sherrod, a *Life* writer, says that Margaret once told him she had had an abortion. However Margaret's pregnancy ended, her silence must indicate that the pain ran very deep.

Erskine is strongly opposed to abortion and has vehemently denied to his biographer that Margaret had one. Margaret, knowing his attitude, probably told him only that she lost the child. But then Erskine also says he has no knowledge of Margaret's pregnancy. His fabulist's memory might erase any element that would disrupt the structure of his story. Or perhaps he wanted that child so badly that the memory of its loss became too sharp to bear.

Lee Scott also says that sometime in 1942, Margaret and Erskine began to draw apart, Erskine going into a "deep freeze," and that the atmosphere in the house became uncomfortable in a way it had not been before. The likeliest scenario is that Margaret, full of high hopes, got pregnant, but soon after, Erskine retreated into one of his withering moods, she grew frantic, and they exploded into a violent and corrosive argument. Frightened and despairing, Margaret might logically have decided it would never work, much as she had decided once before that she could not raise a child alone and still have the career she dreamed of. An abortion might well have seemed the only answer.

Sometime during her marriage to Erskine, Margaret thought she might have everything she wanted. Life, as is its habit, disabused her. She never had children and never expressed regret, yet she had tried twice and was hungry for human experience and warmth. She would have turned her sorrow over in the light until she had found a good angle from which to regard it. With characteristic resourcefulness, she found one. In her book she wrote: "If I had had children, I would have charted a widely different life, drawn creative inspiration from them, and shaped my work to them. Perhaps I would have worked on children's books, rather than going to wars. It must be a fascinating thing to watch a growing child absorb his expanding world. One life is not better than the other; it is just a different life."

Betty Cronander says that Margaret told her she knew she could not have the career she had and children as well, and that after a great deal of thought she chose the career consciously and deliberately. She said something similar to her cousin Felicia: "If I didn't have the photographs,

I'd have children, but the photographs are my children." If the question was not that simple, she must have made herself look at it as if it were. The rewards on the childless side of the ledger were quite real.

As for the loss of the children she might have had, she covered that from the world in layers of silence that grew deeper over the years.

Back in 1939, while Margaret and Erskine played the game of Patricia, and on into 1940, as Margaret crossed into Central Europe, Erskine battled his demon loneliness. He wanted Margaret back, wanted her beside him, wanted her to travel about with him, and wrote her often to tell her so. He was riding on a crest of fame. In November of 1939, the Broadway production of *Tobacco Road* passed the record set by *Abie's Irish Rose* to become the longest-running Broadway play in history. In celebration, Forty-eighth Street was renamed Tobacco Road and the cast paraded to City Hall.

Yet Europe called Margaret loudly with its strident news. Once Germany had invaded Poland, Russia marched into that hapless land from its other border; Hitler and Stalin hungrily split the country between them. The war in the West hunkered down to a no-shooting contest. German troops broadcast friendly messages to the French lines after dark and signed off each evening with a recorded lullaby. In America, isolationism was slowly giving way under the crushing weight of events. On November 2, 1939, Congress repealed its embargo on armaments, permitting the United States to sell arms abroad.

War news from Europe had begun to take up more space in *Life* and in the daily newspapers. Photographic reports from Europe were at a premium; Margaret's trip to the Balkans took her into top-news territory. A technical breakthrough in April of '39, when Western Union instituted cable photos from London, had made it possible to send high-quality photographs of breaking news stories across the Atlantic fast. (Previously there had only been low-resolution radio transmission.) As *Life* was a weekly, it did not depend so heavily on yesterday's news, but every improvement in speed and quality of transmission bolstered the significance of photography as a prime means of communication.

As war raced across Europe, speed in reporting became ever more critical, eyewitnesses ever more valuable. The first worldwide radio broadcast had come over the air in 1930. Within the decade, listeners could expect radio news from anywhere, anytime. Edward R. Murrow had broadcast to America from Vienna in '38 as Austria fell and from London throughout the Munich crisis. While Margaret was in London in '39, William L. Shirer was broadcasting from Berlin as Hitler stalked prizes across the map of Europe.

The photographic agencies were the source of most current war pictures, but *Life* was already putting people in the field. *Life* photographer William Vandivert went on a British minesweeping mission, *Life* photoreporter Carl Mydans covered the war in Finland. Long before television, a war was being brought into America's living rooms in concrete detail and with up-to-the-minute dispatch. No doubt this coverage helped sway American opinion toward intervention.

In December of '39, Margaret left England for Rumania. Hitler and Stalin were jockeying for position in the Balkans; the question was, would Hitler invade? No one in Rumania was allowed to take so much as a family snapshot without official permission. Margaret found herself accompanied by the prefect of police, a member of the ministry of propaganda, a military officer, and often the city architect, and whenever she slipped out without this entourage for escort she was promptly arrested. At length she won official permission to photograph alone, but no policeman would believe she had such a document legitimately. She was arrested again.

Still she managed to take pictures of German tank cars loading up on Rumanian oil, a prelude to German occupation. In weather thirty degrees below zero, she froze her legs and was ordered to bed on pain of being crippled. Nothing could keep her from work. In the next city, she hired a cab and photographed out the window.

Erskine, who addressed cables to England to "Child Bride," had his magnificent trust in the international wire service repaid when his cables to Honeychile Caldwell and eventually simply to Honeychile reached Margaret in Rumania. Margaret, who was perfectly capable of circumventing a foreign government's security rules and then of outfacing and outwitting ministers and policemen, must have liked playing Erskine's sweet little barefoot girl. It has always cost a woman dear to be powerful and successful in a society that wants less of its women, but Margaret made certain that people remembered she was female, and sexual besides. She also kept in reserve for promising occasions a slightly overdone air of femininity, sometimes girlish, sometimes seductive, as if she were compounded of concrete and tulle.

With her talent for catching attention unimpaired, she traveled to Istanbul in the royal suite of a Rumanian ship, a suite complete with private swimming pool, private dining room, and private library. ("She was an expensive asset," says *Life* executive Allen Grover, "but nobody ever said she wasn't worth it.")

She traveled to Syria in March, photographing troops on camels under the high desert sun. Italy was next on her schedule. But Erskine constantly called her home, saying life without her was a nightmare—by

March she had been away five months. In February, Leonard Lyons printed in his gossip column an item directed at *Life*: "Margaret Bourke-White, now in Europe on assignment from your magazine *Life*, yesterday sent a valentine message to Erskine Caldwell, her husband. It read: 'Adoration, adoration, adoration, adoration, adoration, adoration, adoration, (signed) Your-want-to-come-home wife.' It was sent from Ankara and cost 70 cents a word."

Life, a family magazine, was dismayed to find itself in print keeping a husband and wife apart. C. D. Jackson, *Life*'s general manager, cabled Margaret to ask if she had any "serious painful feelings" and to offer to bring her home before the Italian assignment. She replied soothingly that all was well and she would go on to Italy. But she was already thinking she would not.

She was thinking of leaving *Life*. Ralph Ingersoll was courting her to join the staff of a paper he was soon to launch. In February and March, she let him know she might be seduced if the price was right. Ingersoll had been working on plans for a daily paper since the middle of '39, and Time Inc. had almost immediately begun to look on him as a rival. He wanted to publish what he said was the first true photographic newspaper in history, with over half the space and most of the burden of storytelling given over to pictures, an application of *Life*'s lessons to daily journalism. He also meant to found the only truly liberal paper in New York, for the New York press had been kind neither to FDR nor to the New Deal and had not championed the cause of racial tolerance. Not only was his proposition attractive, but Margaret was falling out of love with *Life*.

When she arrived in Ankara she discovered a free-lance man for *Life* had been there first; several important people refused to see a second *Life* photographer. And despite her scrambling about Europe in troubled times, the magazine had recently given her photographs little play. Photographs were always at high risk at *Life*. Stories got bumped when hot news came in, cut down when space was short and advertising long, dropped when time and events passed them by. In 1952, fourteen Life photographers sent back a total of thirty-five thousand negatives from the "I Like Ike" convention in Chicago. The magazine printed a large essay: fifty-six pictures.

Margaret was too smart to complain often, but in 1940 the system rankled. She wrote Wilson Hicks from Ankara in February regarding the *Life* essay on the London blackout: "It was heart-breaking to see that a series that we had gone in for with such inspiration working night after night, usually all night, could count for so little that only one picture [of mine] should be used. It gave me a feeling of futility that few things have."

Like everyone else, she wanted to be rewarded for her work, and she had been told she deserved rewards. She wanted exposure, recognition, fame. Time Inc. had given her all three, but not gracefully. After writing Hicks she wrote her lawyer: "The credit line problem, too, as you know, is a battle I have never completely won. . . . This is fundamentally because the whole organization is organized so that individuals shall remain as anonymous as possible. It is only because my past reputation was built ahead that I have as favored a position as I now have. But I find it somewhat humiliating to so frequently ask that I be given credits. And to so frequently protest that they are forgotten."

She had left her husband behind to cross the Atlantic into a disintegrating world, and "since early September . . . there hadn't been a thing in *Life* to justify my existence," as she wrote Erskine. "The trouble is, they're too rich and can afford to be wasteful with someone who's supposed to be their ace, but the so-called ace has only so many years to live and doesn't want to see the pictures taken in any one of them buried forever."

She wanted a $25,000 salary and would have settled for $14,000, but Ingersoll offered her less. Still, the new paper had stunning advantages. It promised to be another publishing milestone—she was collecting those by now. It promised to merge her political leanings perfectly with her work and to make Erskine happy by bringing her back to America early and letting her work with him on some stories. Erskine says that Ingersoll, a man as persistent as snow in Alaska, put pressure on her by promising the "great opportunity in her life to surpass all her previous achievements." Ingersoll and his project appealed to her idealism. "If it really is to be a new kind of newspaper, more original, more disinterested, more daring, and especially more liberal, that will be something that I could not bear to be left out of."

On March 2 she cabled C. D. Jackson from Syria: "IMPERATIVE I RETURN LATE MARCH BECAUSE AM CONSIDERING JOB WITH INGERSOLL'S PAPER STOP DEEPLY REGRET UNABLE DO ITALY AS HAD LOOKED FORWARD TO IT AND TERRIBLY SORRY INCONVENIENCE LIFE REGARDS BOURKE-WHITE." Time Inc. went into an uproar. Their star photographer wished to leave them for their arch rival. The day Margaret's cable arrived, Henry Luce stormed about calling her a bitch and threatened to take her off the payroll that very minute and let her hitchhike home from Syria. Instead he cabled: "JACKSON RETURNS NEXT WEEK STOP OBVIOUSLY CANNOT AUTHORIZE YOUR RETURN IN ORDER TO SEEK ANOTHER JOB STOP ARE WE TO UNDERSTAND YOU WISH TO RESIGN AS OF TODAY STOP REGARDS HENRY LUCE."

She wired Luce that she couldn't resist adventure. He wired back that they'd given her considerable cooperation in that matter for a de-

cade and signed, "Good luck. Henry Luce." "MANY THANKS FOR YOUR KIND CABLE," she wired Luce. "ITS LIKE LEAVING MY OWN FAMILY." She finished her assignment in the Near East and resigned on her return, as Jackson had, on calmer reflection, requested.

Her decision was compounded of pride, politics, and domestic longing. She had left the greatest commercial photographic vehicle of the decade for what might prove to be a greater one still—and for her husband. Erskine was implacably jealous of *Life* magazine, and he wanted her home. "It wasn't jealousy of other men because I wasn't interested in other men when I was with Erskine. But there was a terrible jealousy of my work which he understood very well. He loved my work and he encouraged me in it except that he wanted to make the choices. But if *Life*'s editors made the choices, he couldn't stand it. He would oppose it and find some way to undermine it."

Erskine obviously loved her, encouraged and respected her. He asked for the "privilege" of helping her select her clothes, because he wanted her to be second to none. But he also needed to control her. No one had ever succeeded in that since Margaret had broken free of Chappie and his mother. She had sabotaged Erskine's need to dominate her by pledging her first allegiance to the magazine, where he had no sway. She had written her independence into their marriage contract, which stipulated that Erskine was not to interfere with her assignments.

Her most lasting union had been consummated years before she met him. She was married to her work. Erskine never saw it quite that way. He says today that her professional life and her personal life were "fifty-fifty," and that "she balanced the two with intensities." On reflection he says that "in a sense," *Life* was indeed her first loyalty, "because she concentrated her life on what she happened to be doing at the time. Whether it was buying shoes or something else, that was the most important thing at the time. So *Life* magazine was her ultimate ambition, I think, her ultimate achievement."

Only she gave it up—for a better showcase and a new mission, for the chance to make Erskine happy, and for the child she was still planning at that moment in her letters and her dreams.

PM

Over one half of PM's *space will be filled with pictures—because* PM *will use pictures not simply to illustrate stories, but to tell them. Thus, the tabloids notwithstanding,* PM *is actually the first picture paper under the sun.*

Ralph Ingersoll, memo to staff,
April 22, 1940

When Margaret cabled *Life* from Syria that she wished to negotiate with Ingersoll, one of Wilson Hicks's associates wrote him a letter:

> You know, of course, that there has been talk from time to time about whether or not we couldn't get a hell of a lot more photographic talent for that amount of money so, while we all felt that Bourke-White was part of the magazine, nobody felt really much different from Mr. Luce. There is no doubt at all that she has had a great promotional value and that she has got us into places we couldn't have got into otherwise and also she is a lot better than her jealous fellow photographers will admit.

By the time *Life* was turning a profit, it had already begun to become the influential instrument it would be in the lives of those who grew up in the forties and fifties. To people in small towns, *Life* brought the news; indeed, it brought the world. By the end of 1938, when *Life* could refer to itself without gross exaggeration as "America's Most Potent Editorial Force," a research study reported that the magazine reached an audience of 17.3 million people. The next-largest audience was *Collier's*, at 15.9 million, at a time when the American population was approximately 130 million.

Margaret's promotional value would obviously be a sizable asset for a new newspaper like Ingersoll's *PM*. Lustrous names in the literary community also showed up on *PM*'s pages: Erskine Caldwell, who worked with his wife on the prepublication issues and again in 1941; the playwrights Ben Hecht and Lillian Hellman, the humorist James Thurber. Ralph Ingersoll could not promise any of them an army of readers like *Life*'s, but he offered a truly revolutionary idea in journalism: a paper with no advertising.

A New York daily run entirely by its staff and beholden to nothing but its readers and its ideology: no one had ever done anything so daring in the newspaper business. Ingersoll's idea for the paper was unremittingly, in fact hopelessly, democratic. At staff meetings the copy boy had an equal voice with the editors, thus supplying virtual textbook lessons in how to run a democracy and how not to run a paper. A newspaper team was eventually imported to make *PM* look like a business.

Ingersoll declared that *PM* would be liberal but not narrow. The prospectus said:

> We are against people who push other people around just for the fun of pushing, whether they flourish in this country or abroad. We are against fraud and deceit and greed and cruelty and we will seek to expose their practitioners. . . . We propose to crusade for those who seek constructively to improve the way men live together.

More than ten thousand people applied for jobs.

PM, a name that means nothing to most newspaper readers today, instituted several services that have since become standard in papers everywhere. Few dailies of the time carried radio listings because radio was thought to be competitive with newspapers, but *PM* acknowledged the immense influence broadcasting had on daily life and gave two pages to listings and to a "Listener's Digest." At that time, movie listings, even movie ads, did not give show times; the paper invented movie listings that did. *PM* was also the first daily to give extensive attention to consumer affairs, running a digest of news and sales in the others papers' paid advertisements, as well as health information, current food prices, the results of health inspections in restaurants. Some said that all *PM* really lacked was news, but it did make the news easier to find by dividing it into local, national, and foreign departments, as the newsmagazines did but the papers did not. What *PM* left out were the stock market tables, the crossword puzzle, and the gossip column.

The paper was a great and high-minded experiment in journalism. It was on the newsstands for eight years. In one of them it finally chalked up a profit.

PM depended on a technical breakthrough for the excellence of its photographic reproduction. A process of chill-set inks permitted a much finer screen than any newspaper used for printing halftones at high speeds, and thus a much sharper resolution. (If proof be needed that this was a major invention, let it be noted that the newspaper's ink did not come off on the reader's hands.) The photographic staff boasted distinguished names. Ralph Steiner edited the Sunday photographic section with a keen eye. He published the pictures that made Lisette Model's

reputation—monumental studies of rich Europeans looking like decayed monuments set up by some satiric hand on the boardwalks of Nice. The caption read: "Why France Fell."

PM's most famous discovery was Weegee, who did not need to be discovered but only to be recognized, a feat *PM* accomplished by giving its photographers credit when the *Times*, the *Sun*, the *Journal*, and the *Telegram* did not.

Weegee (who earned his name by arriving at so many murders so fast he was said to have a Ouija board) was the ultimate news photographer. He slept in his car, which was equipped with a police-band radio to wake him up when reports of murder and arson came in. He stank of unwashed clothes and unregenerate cigars. Sometimes he arrived at the scene of the crime before the law, and usually he could deliver pictures to the papers before anyone else by making a quick print in the mini-darkroom in the trunk of his car. He specialized in photographs of violence and tragedy, caught on the run, harshly lit and roughly composed, violent in form and content. Weegee took so many pictures of murdered men that at one point he flooded his own market and nearly went out of business.

Most of the other photographers at *PM* were newspapermen armed with Speed Graphics, restless when they were not covering robberies and fires. Margaret walked into the down-at-heels office in Brooklyn— "crummy offices," one man recalls, "with very few *grandes dames*"— wearing well-cut clothes, perfume, and her daily allotment of majesty. Her gray hair was tinted with a blue rinse because Erskine liked it that way. (On one story she covered for *PM* in New Jersey, an Irish tough looked at her in astonishment and exclaimed, "Jesus, lady, am I dreaming, or is dat poiple hair?") Once more she was the only photographer with a private office and a secretary, and the only one who didn't "hang out with the boys." Instead of a Speed Graphic she carried a Soho reflex, its wooden sides beautifully polished, its fittings of genuine gold plate (because gold didn't rust), or a $3\frac{1}{4} \times 4\frac{1}{4}$ Linhof. Of course she choked up the darkroom with negatives. At one point when she was photographing some office operations and ordering everyone around, the sports editor turned to the picture editor and said, "Who does she think she is, Margaret Bourke-White?"

An office that could contain, that *needed* Weegee might not seem like Margaret's ideal environment. In fact she was an unlikely and impractical candidate for a daily paper. She could and did take major news photographs, but fires and robberies were not the natural beat of a woman who would photograph the same monument ten times at ten different settings to make certain she had it right.

Ingersoll had a flair for promotion, which he had unleashed on the new enterprise. *PM* had aroused expectations that could not be met. When the first issue was published, on June 18, 1940, 372,000 copies were printed. That wasn't enough the first day, but readership dropped fast. *PM* cost a nickel in 1940, when the *Times* and *News* were two-cent bargains and a nickel could buy a subway ride or a hot dog.

Although the big spreads were few and the paper never did give half its space to pictures as it had promised, no paper had ever so honored photographs with reproduction of such quality. *PM* provided Margaret at long last with a forum for her nature work, which she had been looking for ever since she first thought of doing children's books on animals. There had been some who thought her attention to exotic insects excessive. Once a batch of mantis eggs hatched at *Life* while she was away on assignment, and Peggy Sargent came in in the morning to find the office in an uproar, with the fragile little dragons perched on every typewriter and telephone. Then, too, Margaret's office at *Life* was just outside the darkroom and her mantises lived in that office, except when strays escaped into the darkroom. The joke went around that someday Maggie's creatures would devour the technicians.

Everyone at Time Inc. knows the story about the exterminator who came to fumigate one of the offices and was purposely misdirected to Bourke-White's hideaway. No one ever told Margaret it was a joke; she always thought of it with real sorrow as an accident.

PM made her nature photographs a regular feature, running two pages of her pictures of eagles, or insects, or the stages of a rose between bud and full bloom, almost every week. She wrote the brief text material herself. All through the summer of 1940 she skittered about the city in pursuit of animals. "Meet me at the Roosevelt," she said to her new secretary over the phone. (Peggy Sargent, who had stayed on at *Life* when Margaret quit, never again worked for her directly.) "I'm having my hair done. And bring me a mouse to feed to a snake at the Natural History Museum."

Her nature photographs are extremely good of their kind, but they did not greatly enhance her reputation. Nor did *PM*. The paper was not the photographic showcase it had promised to be, and Margaret was already too big for it. She took pictures for *PM* in Mexico, in American factories, on Ellis Island. None of it was her best work. She needed time, scope, large subjects, large space on the page. She needed *Life*.

The paper ran into unexpected problems almost immediately. Its liberalism alone made it suspect. A mere three weeks after the first issue appeared, an unsigned letter circulated among New York newspapers saying that the staff members at *PM* were Communist party members or

sympathizers. Ingersoll moved quickly onto the offensive, printing the letter in *PM* itself with a disclaimer and challenging the FBI to investigate. It appears that the FBI made only one response to this challenge. It began to keep files on everyone on the paper's staff.

In fact the *PM* staff was left-leaning, although probably no more Communist than many another journalistic enterprise at the time. But the left-liberal audience that was its natural target had been disaffected and dispersed by the purge trials, the German-Soviet nonaggression pact, and the Soviet invasion of Finland. Ingersoll's timing was wrong. After the first issues, *PM*'s circulation fell; by September it was rumored to be down to sixty-five thousand.

On June 14, the paper's preview issue carried this bold headline: "NAZIS MARCH THROUGH PARIS." The Nazis kept marching. France fell and was divided. Hitler went sightseeing in Paris. German bombs fell on London; Britain's finest hour was illuminated by flame. The conflagration was news, big news, all the news, but *PM* was too new and inexperienced to take full advantage of the biggest story of the time. Late in the fall, Ingersoll himself flew to London and sent back brilliant reports on the war, but that was after he'd almost lost his paper. In September, with *PM* nearly bankrupt, Marshall Field had bought out the other backers at twenty cents on the dollar.

Margaret's experience at *PM* was so painful she chose not to mention it in her autobiography. By October, when *PM* was a mere four months old, she was negotiating with *Life* again. Somewhat surprisingly, considering the high dudgeon there when she left, the magazine took her back. *Life* did not put her on staff but contracted for her services for part of every year.

Her first assignment, beginning on November 1, was to cross the country with Erskine and send back a report on the state of America. In 1940, Erskine, whom critics generally accepted as one of the most important American novelists of the day, published a collection of short stories called *Jackpot*, dedicated to Margaret Bourke-White Caldwell. One of the stories, "The Visitor," tells of a boy who leaves his girlfriend because he falls for a school chum the girl has invited home for a visit. The author's foreword to this story is very brief: "I think if I were the reader I should be tempted to say, after having read this story, that if it failed to explain the characters, at least it had succeeded in explaining the author."

Erskine and Margaret set out on a trip across the country for a couple of months. He had already written one of the early accounts of a traveler looking for America at its whistle-stops, *Some American People*,

published in 1935. Since then, writers had flocked across the Midwest, the South, the prairie towns, the back alleys in factory cities, combing the country for clues to its psyche. The need to understand America was so pressing that the roads were clogged with inquiring reporters. On the 1940 trip, when Erskine asked a gas station attendant his political opinion, the man replied by handing him a neatly printed card:

> I am 36 years old. I smoke about a pack of cigarettes a day, sometimes more and sometimes less, but it evens up. I take an occasional drink of beer. I am a Baptist, an Elk, and a Rotarian. I live with my own wife, send my children to school, and visit my in-laws once a year on Christmas Day. . . . I wouldn't have anything against Hitler if he stayed in his own backyard. I don't know any Japs, but I've made up my mind to argue with the next one I see about leaving the Chinese alone. I'm in favor of the AAA, the CCC, the IOU, and the USA. . . . If you want your tank filled, just nod your head. If you don't want anything, please move along and give the next fellow a chance. I thank you. Hurry back.

Erskine and Margaret rode for a time in freight cars, and their Christmas card that year had a photograph of the two of them seated atop a train plying typewriter and camera. In passing, Margaret mentioned a new house in Tucson that would later play a big role in their lives: "We fell so in love with the unbelievable giant cactus that we bought a ranch while our work went on." She said that on the trip they were looking for an "everyday quality" in order to capture the true America. Seeking the routine reality of the nation, she repeated some of the subjects and tricks she had used in Muncie-Middletown, but something was wrong, and she kept falling out of the everyday into the merely humdrum.

Life never used the material. Erskine and Margaret put it together for their third book, *Say, is this the U.S.A.*, which was published in mid-'41. A photograph was printed full-page on every right-hand page and text on the left, so that photographs played an even larger role than they had in *You Have Seen Their Faces* or *North of the Danube*. Reviewers admired *Say, is this the U.S.A.* It was laced with Erskine's tangy humor and, as always, strong passages on racial injustice to blacks. Oddly, the photographs and text often seem to have no relation to one another, as if Margaret and Erskine had been on different trips. It was not Margaret's best work, and she knew it.

Her dream was to do her finest work with the man she loved. "And with all the temperamental difficulties none of it seemed as important to me as the fact that here was what I believed was a very creative and harmonious work that we were doing." Still, she could not cope with the destructive forces in the marriage. Her worries about Erskine's behavior

robbed her of the lightheartedness she needed for photography. "Even while you are in dead earnest about your work," she told an interviewer, "you must approach it with a feeling of freedom and joy; you must be loose-jointed, like a relaxed athlete."

Margaret's discretion was magnanimous; she rarely spoke ill of anyone, and she was respectful of both her husbands in her autobiography. But in her notes she spoke of Erskine's anger and withdrawal as if they were a new ice age that had settled into her life for a time of ruin and devastation. "The frigid wave surged upward . . . once begun there was no staying it. Until hard as I tried to stay aloof—as one can do with a stranger—when so close and in the same household there is no holding apart. In retrospect that seems to have been the goal. When I was ground down to fine dust then he magnificently, with spaciousness and good humor would raise me up." Erskine's unpredictable moods were like a strategy unconsciously devised to subjugate her, to dominate her totally through the twin masteries of fear and largesse.

Fifteen years earlier Chappie had also withdrawn from her, in silences so vast and punishing she had considered throwing herself off the roof. "Nothing attracts me like a closed door," she once wrote. "I cannot let my camera rest until I have pried it open."

It could not have been only the challenge; she must also have had a profound attraction to the idea of being mastered. She who sought control in everything had long feared that achieving it confirmed the loss of her femininity. In her marriage Margaret repeatedly endured being forced into a humiliatingly submissive role. She said that when she alone was affected she could try to bear it, but that when her work also suffered, then she could not. Work was the only safeguard of her independence and integrity.

The everyday America Caldwell and Bourke-White hoped to record in 1940 was no longer circumscribed by the country's boundaries and domestic problems. "Regardless of whether his life is unusual or ordinary, almost every American today realizes that the small world he once lived in has vanished, and that now he has come to grips with a larger world," Erskine wrote. The sea change he chronicled was precisely the shift that had altered the character of *Life* magazine and nearly forced *PM* into bankruptcy. Margaret and Erskine, having paid due attention to the horse traders and fraternal lodges of America, went off to find a world at war.

21

Return to Russia

I had always maintained that we ought at all costs to avoid waging war on two fronts, and you may rest assured that I pondered long and anxiously over Napoleon, and his experiences in Russia. Why, then, you may ask, this war against Russia, and why at the time I selected?

Hitler to Martin Bormann, 1941

Wilson Hicks had a hunch that the Nazis would invade the Soviet Union and that he might be able to put his star photographer in the path of one of the great news breaks of the decade. The Soviet ambassador to the U.S. had the same idea about the war. This notion had not yet fastened itself in many minds; Stalin himself was certain until the day of the German invasion that he was safe for another year.

At the Russian embassy in Washington one day, Margaret "casually mentioned that we would like to go to the Soviet Union," Erskine Caldwell says, "just casual conversation, but the way it happened was that someone in the embassy said, 'Well, if you want to go you'd better hurry up and get there before war starts.' " They advised her to go via China rather than Europe. The ambassador also warned her that photography had been forbidden for some years. She had already dealt with such problems a decade ago.

For a month she planned her equipment, then took with her five cameras, twenty-two lenses, four portable developing tanks, and three thousand peanut flashbulbs. She learned a little elementary mechanics in order to be able to repair her cameras in the field. Ralph Steiner says Margaret asked him for advice on how to photograph Stalin. She had not been able to get permission in 1932, and no foreign photographer could now; of course that made her all the more eager.

But the technical aspects had her flustered. "She was scared to death," Steiner says. "Stalin—how does she light him? Crazy Luce papers, you know, they were going to send three electricians and hire a plane full of lighting equipment. I said to her, 'You're out of your mind. They've got movie studios. They've got every light in the Soviet Union.'

Oh no, she wanted her own team." When she gave him a list of what she thought her electricians would need, he told her she'd blow up the Kremlin with such a display of power.

What she wanted to photograph most of all was war. As early as 1933, Max Schuster noted that "Margaret Bourke-White . . . has applied to the Inner Sanctum for first rights for photographing the 'second world war.' " Then in '36, when asked in a radio interview what picture she'd like to take more than any other in the world, she'd replied:

I'd like to photograph the *next* war . . . if there's *got* to be one. [*Italics in the transcript.*] I want to start with the *starving children* and war-widowed *women* back home—the *sinking ships at sea*—guns *behind* the lines—battles in *trenches* and in the *sky*—and after it is *over*, I want to photograph the *desolation* war has *left. That* sequence put *right* down in *black and white may* make folks see just *how* horrible war *is*—and perhaps *then* I shall have done *my* little bit toward *ending* wars for *all* time.

On March 20, 1941, Margaret and Erskine flew from Los Angeles to Hong Kong with 617 pounds of luggage, 600 of them hers. On the flight from Hong Kong to Chungking they sat on bales of money newly printed to pay Chinese soldiers. Margaret made a radio broadcast to the United States from Chungking, describing the devastation wrought by Japanese bombs. Across China and the Gobi desert the Caldwells' trip was plagued by failing planes and inexplicable delays. It took them thirty-one days from Hong Kong to Moscow. Margaret estimated they had spent twenty-four hours in the air.

Alice-Leone Moats, an independent correspondent, shared their thirty-one days of sandstorms, broken engines, and boredom. She liked Erskine, whom she thought nice-looking, if a bit of a hayseed and always a little out of his element. But when they finally took off after one long delay, he "presented a picture of such sartorial perfection that he took my breath away. He had on powder-blue gabardine trousers, very wide in the leg and with seams hemstitched in navy blue thread; a blue-and-white striped shirt; a white tie; a jacket with huge navy and light blue checks, and navy suede platform soled shoes cut out at the sides. . . . [Peggy] said, 'Skinny darling, I bet you're the best dressed man who ever traveled on this route.' " (Lee Scott, the Caldwells' secretary the following year, says that Margaret helped her husband pick out his clothes, an act that was unintentionally unkind.)

Moats was less than fond of Margaret. When room shortages threatened to separate the Caldwells, Margaret would cry, "But Skinny darling, I want to sleep with you! I don't want to be separated from you!" and leave Moats to a dormitory. Once, on being informed that there would

be no transportation for a week, Margaret and Erskine tried to charter a plane. Erskine composed wires to his Russian publisher and various high officials in Moscow. "As he finished each wire he handed it to Peggy, who would read it with gasps of wonder. 'Splendid, Skinny darling, simply splendid!' she would exclaim. 'What a great writer you are!' The admiration she felt for her husband was quite awe inspiring." Erskine looked pleased and said not a word, but they never succeeded in chartering a plane.

This account, penned in vinegar, sheds its own sour light on the effort Margaret made to keep Erskine happy and make her marriage run smooth. A woman who needed to be liked, she had studied the art of making a man feel valuable.

When the Caldwells and Alice-Leone Moats arrived in Moscow in early May, the Union of Soviet Writers made much of Erskine. His work, which depicted class and racial oppression in a capitalist society, made him a literary hero in Russia; Margaret thought him better known there than in America. She wrote Wilson Hicks that the spirit of experimentation, so prevalent earlier, had waned, and that people were playing it so safe it was difficult to meet and mingle with Russians, especially with officials. But thanks to Erskine's credentials the two of them were invited everywhere and met people with greater ease than foreign diplomats did.

Because the Soviets knew Margaret's earlier pictures of their country, she quickly won permission to photograph, with some restrictions, in the land where photography was forbidden. The only recent photographs of the U.S.S.R. that Americans had seen were by Russian photographers and released by permission of the government. Moscow was like an untapped gold mine for a prospecting photographer, and Margaret set out to bring back all the hidden treasure she could amass: pictures of streets, shops, parks, fashions, subways, schools, children, the latest cocktails.

One day she wandered into a church and, contrary to reports that religion was totally suppressed, found services in progress. She began to photograph instantly, knowing that Luce, a missionary's son, would be interested. The church officials told her that the government did not interfere with them, and although Margaret did not have permission to photograph religious matters, no one ever tried to stop her. She had stumbled on a scoop.

In October, shortly before she and Erskine arrived back home, Roosevelt began to offer the Soviets supplies in exchange for guarantees of religious freedom. Events had assisted Margaret again. Her religious essay suddenly became not only big news but up-to-the-minute news. Life gave it twelve pages.

From the beginning, Margaret thrived on Moscow. Her reporter's temperament propelled her into the streets. Erskine, however, stayed home. He sat in the hotel pounding out of his typewriter stories about poor whites and blacks in Georgia, when a whole new realm beyond the windows cried out for exploration from every side. Margaret was appalled. "It seemed to me," she jotted down, "he was barricading himself against new experiences and tending to withdraw into this world of his earlier activity where he felt . . . at home . . . making a retreat to Tobacco Road." She said it took him four weeks to come "out of his protective shell and take note of the world around him."

She may have been right about his motivation, and it is easy to understand her perplexity over any sign of incuriosity, but she judged Erskine by her standards and he had others. A good reporter, he sent back numerous stories to *Life* and to *PM*. (Ralph Ingersoll had bulldozed him into writing for the paper again.) Later, he published a diary of the trip: *All Out on the Road to Smolensk*. Caldwell's nonfiction writing has been sadly underestimated—but he was a still better fiction writer. The stories he had begun in Moscow would be published in '43 in a book called *Georgia Boy*; some of them are masterful. Margaret never quite understood that there were scales other than her own to weigh life on.

When the U.S.S.R. signed its nonaggression pact with Germany in 1939, *Alexander Nevsky*, Eisenstein's film about the medieval Russian hero who beat back invaders from the west, had been withdrawn from Russian movie houses in such a hurry that some theaters went dark in the middle of the reel. Now the prediction was that the film would play again soon. Foreign diplomats talked openly of a coming war; the newspapers, however, did not print one word against Germany. Stalin was playing for time. He refused to trust the reports of his own intelligence service, much less that of the British, who had pinpointed Hitler's planned date of attack on the U.S.S.R. Still, the Russian government had imposed restrictions. Foreigners, including diplomats, were not allowed to travel outside Moscow without government permits.

Margaret and Erskine wanted to see the Ukraine and the Black Sea area, both forbidden. With the help of the powerful Writers' Union and the Society for Cultural Relations with Foreign Countries, which knew Margaret's earlier photographs, the authorities were convinced that it would be useful propaganda to have the Caldwells report on their country. Permission was granted to go south in early June.

Immediately, the U.S. ambassador in Moscow cabled the secretary of state to complain that the Caldwells had been permitted to travel to places that diplomats were not. In response, the United States government imposed restrictions on Soviet diplomatic travel in this country.

No records indicate whether Margaret ever knew that her exceptional skill at circumventing the rules had precipitated this minor change in diplomatic regulations.

On June 22, German troops moved swiftly across the Soviet border against a force totally unprepared for so massive an attack. On the first day of the invasion, over eighteen hundred planes were destroyed. The Germans lost thirty-five. It was the greatest victory of a single day's battle in the history of military aviation.

Late that afternoon, news of the invasion, shorn of all details, came over the loudspeaker in the center of the small resort town where the Caldwells were waiting for war. At almost that exact moment, Joseph Goebbels, practicing his propaganda techniques at a private party in Berlin, announced to the guests that the Russian campaign would be over by Christmas.

Margaret and Erskine caught the first train for Moscow they could squeeze into. Everywhere they witnessed outpourings of patriotism. Trains were jammed with people going home to enlist. Within a few days, *Alexander Nevsky* came back to the movie screens.

In Moscow, the National Hotel installed the Caldwells in the corner suite that had been occupied by the leading German trade representative, last seen running out of the hotel without suitcases (and without paying the bill) at 7 A.M. on the morning of June 22. Gilded cherubs fluttered across the ceiling of their suite; china vases and stone ashtrays, a grand piano and a white bearskin rug lent splendor to the drawing room. The balcony, from which Trotsky had once addressed the trade unions, looked directly out on the Kremlin, Lenin's tomb, and Red Square. The balcony was a photographer's dream. The *Luftwaffe* would head straight for the Kremlin—and for the lens of Margaret's camera.

In June of '41, Margaret Bourke-White was the only foreign photographer in Moscow at what promised to be one of the critical battles of modern times. She had one problem: the military authorities had just issued a ukase proclaiming that anyone caught with a camera would be shot on sight. The U.S. government wanted to evacuate her anyway. The ambassador telegraphed the Caldwells to say he was advising all Americans to leave, then called them to the embassy to tell them how dangerous the situation was. They said, in effect, never mind.

Margaret commenced her own personal brand of siege, at which she was highly skilled: two weeks of daily letters, daily phone calls, daily visits to officials, and many influential people putting in a word for her. Alice-Leone Moats says she was told by a member of the British embassy staff that when Margaret was not making headway on some request she fell down and cried so loud and hard that the shaken British acceded to her demands. However she approached the Soviets, on July 15 she was

granted the privilege to photograph. Whatever she wished to take had to be arranged beforehand with the authorities, and sometimes so many officials were involved that she went to her destination in a convoy of three cars.

By July 3 the Germans had advanced so rapidly into Soviet territory that nearly a half million Russians had surrendered. In the Pentagon and other western military centers, it was estimated that the Red Army had not much more than a month of fight left in it. The prospect of Soviet resistance crushed under the wheels of the Nazi juggernaut was grimly contemplated in the West.

As the Germans drove east, conquering four hundred miles along the entire front in the first four weeks of the invasion, news in Moscow grew scarce. On July 3, Stalin spoke to the nation for the first time since the war had begun and exhorted his people to follow "scorched earth" tactics in retreat, in order to deny the invaders a pound of grain, a gallon of fuel, a telephone line, or a road to advance on. Heavy fighting took place at Smolensk, delaying the advance on Moscow. Then on July 19, the first bombs fell on Moscow itself.

A ukase had been issued ordering everyone into shelters in the Moscow subways when the siren sounded. (The stations were so large and so far underground that at the height of the raids 750,000 Muscovites slept in them every night; no one was ever injured there.) After their first vigil in the subway, Margaret and Erskine decided they could not afford to miss the news they had traveled around the world to witness. The second night, Erskine went to the radio station and Margaret to the American embassy, where the Russian wardens could not bother her while she photographed from the roof. The spectacle from the roof was ravishing: brilliant color, flashing light, and a symphonic chorus of planes droning overhead, bombs whining as they fell, the boom and deeper echo of the guns.

Margaret said that night would always be "one of the outstanding nights of my life." She wrote that being on an open roof in a bombing made her feel that human beings were so small they barely seemed to count in the scheme of things, but she also said that "the opening air raids over Moscow possessed a magnificence that I have never seen matched in any other man-made spectacle. It was as though the German pilots and the Russian antiaircraft gunners had been handed enormous brushes dipped in radium paint and were executing abstract designs with the sky as their canvas." Here was the first, and perhaps the only, spectacle that could surpass in beauty and profundity that almost mystical moment in her childhood when molten steel suddenly ran flaming through the dark.

Margaret hadn't full control over the photographs of the bombard-

ment. She could compose beforehand in daylight, then during the raid point the camera toward what looked like the sector of greatest activity and focus as best she could by the light of flares. (The Germans used magnesium flares to light up their target. Margaret herself, before the invention of flashbulbs, had used magnesium powder for illumination.) She would uncap the lens and seek shelter during an exposure lasting from a few seconds to between eight and twelve minutes, hoping that nearby blasts would not shake the camera and blur her film.

She was risking her life all the while. Under the circumstances, her timing and focus were remarkably astute, and some of her photographs of the night sky full of the long lines of tracer bullets and the hot tracks of flares above the spires of the Kremlin are beautiful objects as well as vivid accounts of the attack on the Russian capital.

After some time on the embassy roof that night, Margaret suddenly had an undefinable but certain feeling that something larger and deadlier than ever was heading toward her. Instantly she climbed back through the window into the embassy and lay down on the far side of the room. A bomb exploded barely fifty yards away, blowing in every window in the building and pouring glass over her as a heavy ventilator thumped past only a few feet from her head. Shaken, but with only minor cuts on her fingers that she was not yet even aware of, Margaret picked her way through the still-trembling house to the basement, across stair landings that were ankle deep in glass. When the all clear sounded and she realized that first-rate news photographs were going begging upstairs, she went back and left notes on the highest piles of glass: "PLEASE DON'T SWEEP UP GLASS TILL I COME BACK WITH CAMERA." *Life* ran her pictures as a lead in September. They were the first photographs Americans had seen of the Moscow bombing.

The Germans bombed Moscow twenty-two times before Margaret and Erskine left in late September. She must have photographed the bombardment almost every time. Usually she stayed at the hotel and photographed from the balcony and the windowsill. When the wardens came by to check on whether everyone had gone to the shelters, she dived under the bed to hide, and Erskine, whose football player's shoulders would not fit under the bed, hid in the corner behind the couch and pulled the white bearskin rug over his head and shoulders. At length the game became too tedious. They sat stolidly in the room and announced that they were Americans at work. The wardens eventually retreated.

Margaret would clear the vases and ashtrays away before the raid so that fewer objects would attack her when windows blew in and the building lurched uncertainly on its foundations. "It is strange how in a bombing everything in the room seems to rise up against you and become your enemy. . . . But once the bric-a-brac was stowed away, the place was my

workshop, and my whole attitude changed. It has always been my experience that a camera in my hands produces a subconscious transformation." This had happened to her up on skyscrapers, when walking on scaffolds seemed perfectly routine. "But I felt this ease only when working, when it seemed of some purpose."

Other photographers, too, have reported that a camera makes them feel quite ridiculously safe as they back out into traffic or advance under fire. The "subconscious transformation" in Margaret was even more thoroughgoing. As soon as she got out on a job with her camera, her very body chemistry seems to have changed. She was not merely tireless, she would forget to eat and could go almost without sleep for days at a time feeling no ill effects. She had such prodigious powers of concentration that all else was blocked out. *Life* reporter Richard Meryman once worked with her on a story about tenant farmers during an exceptionally hot summer. Dressed in a halter top and shorts, Margaret photographed a family working a cotton-picking machine. As she moved in on them from a middle distance, her halter came untied at the back and hung straight down from her neck. She never paused. Meryman circled behind her and gently tied it up. He thinks she never realized that anything had happened.

In Moscow she often worked most of the night, photographing and developing her negatives in the bathtub. The woman who was thought not to know her way around a darkroom developed all her film in Moscow to see what she had and show it to the censors.

From the west the Germans came steadily onward into the Russian winter. Factories Margaret had photographed in the thirties were being dismantled and shipped to Siberia to be rebuilt out of enemy reach. The Soviets destroyed the Dnieprostroi Dam to keep its power supply out of German hands; Russians wept when they heard their great dam had been blown to smithereens. In October, while the Caldwells were en route to America, Stalin and the government left Moscow and moved east.

Erskine, with Margaret assisting, made radio history while he was in Moscow. American broadcasting companies had been trying for years, unsuccessfully, to arrange live broadcasts from Moscow. Not even recorded broadcasts had been sent direct to the United States during the previous two years; the Soviets insisted on recording and censoring any material that foreigners sent out. American networks, which had accustomed the nation to eyewitness accounts, wanted only live reports. The Sunday after the invasion, CBS cabled the Caldwells that they must work a miracle by 6:51:15 P.M. for a series of reports from world capitals that evening.

The two of them swung into action. They spoke to every high official they knew; by then, they knew many. Twenty million people would be listening in America, they said; the Russians raised their eyebrows in appreciation. Three hours before broadcast time they won. Erskine dashed off a script, which was approved by the censors an hour and a half before airtime—for recording only. The Caldwells threatened to walk out if they could not do the broadcast live. With eight minutes to go, permission was granted. Erskine read his script while Margaret timed him, signaling when to speed up or slow down. The next night she went on herself. They alternated broadcasts for two weeks, but the reception was so bad that little got through. Still, the night after their first live report, the NBC man who had been trying to win permission for three years straight was allowed on the air live.

Margaret stopped her broadcasts at *Life*'s insistence: "OUR UNDER-STANDING WAS YOUR FIRST INTEREST WOULD BE IN GREAT PICTURE WORK . . . HICKS." Erskine kept on, which required more than a little bravery. He drove or walked to the radio station at night in the middle of blackout and bombardment. Once in the dark he fell down a manhole; he was hauled out and taken off by suspicious citizens for investigation.

Margaret tried repeatedly to win permission to photograph Stalin; it was not granted. For months other American correspondents in Moscow had been using every conceivable ploy to arrange interviews with the Soviet leader, but none had worked. At the end of July, Harry Hopkins, then the Lend-Lease administrator, arrived in Moscow as Roosevelt's personal envoy. Stalin badly needed American arms and goodwill. The two men went into conference almost immediately.

Margaret knew Harry Hopkins. She had once pressed him into service as her assistant while she photographed at Hyde Park. In Moscow on July 31, 1941, she trailed him all day, asking him to arrange a portrait session for her with Stalin. Hopkins spoke to Molotov for her, and Margaret won yet another impossible permission.

That evening she put on red shoes and fixed a red bow in her hair to please the Soviet dictator. Once she was inside the Kremlin, she was kept waiting for two hours outside Stalin's office while he talked to Hopkins. At last she was ushered into the room where the two men were meeting. She was shocked to find Stalin short, lean, and pockmarked. The statues of him throughout the country were as large as myths, and the scars on his cheeks were always touched out by Soviet censors; Margaret had imagined him enormous and bold. She gave the little speech she had been practicing in Russian, reminding him that she had photographed his mother on an earlier trip and had sent him the portrait. ("His

very own mother!" the interpreter exclaimed. "His real mother!") But Stalin did not respond. He neither said a word nor twitched a muscle.

She wanted to ask him to sit down and talk, hoping that would relax him, but she was so cowed by his granite immobility she did not dare. Later she seems to have believed that she had done so; she wrote in her autobiography that she had asked him twice, and noted elsewhere that "Stalin was one of the few subjects for my camera who would not obey me." She would say repeatedly that he was the most difficult subject she ever had.

Unable to order the ruler of the Soviets around, she sank to her knees, one of her favorite photographic postures, perhaps this time to give Stalin the stature she expected of him. As she knelt, her flashbulbs spilled out of her pocket. She and the Soviet interpreter, who had already been changing her flash, went bouncing over the floor after the errant bulbs. Watching this performance, Stalin unexpectedly began to laugh. Before Margaret's eyes the man of stone turned into a human being. She managed to snap two photographs of him faintly smiling before he reverted to marble.

The next day Roosevelt's personal envoy flew back to America with her photographs in his luggage. *Life* announced that Margaret Bourke-White was the first American photographer ever to take Stalin's picture and on September 8 ran her photographs of Stalin and Hopkins as the lead. Her pictures of the short, graying, pockmarked man with the slight smile and the rigid stance, the man whose resistance to Hitler was rightly expected to make the crucial difference in the war, were portraits of great historical import. She had scored another coup.

All that summer the cadre of foreign correspondents in Moscow had tried to win permission to see the front. No one knew exactly where the front was—German broadcasts placed it much closer to Moscow than Soviet broadcasts did—but every reporter wanted to be on the spot with a notebook in his hand. The Soviets were adamant: no reporters at the front. In July, Margaret won one great concession: "I already have extracted the promise from the Foreign Office that if there are any trips frontward, even though there is a Soviet law that women are not allowed at the front, that rule will not apply to me . . . inasmuch as I do the work of men." But by the beginning of September even she was worn down. She wrote *Life* that she was coming home.

Her editors would not let her give up. The photographs she was sending back had a quality that photography itself was rendering increasing rare: the quality of revelation. Everything she photographed was essentially unknown to Americans, or at best known only through a

Russian propaganda filter, for all other photographs came from Tass. Tass had not sent pictures of churches, nor of an unretouched Stalin. Margaret's pictures demonstrated what photojournalists pray for the chance to prove—that there are not only new ways to see the world but new things to see. In effect, she became America's eyes, seeing for everyone back home life and death in Moscow.

Overnight the U.S.S.R. had pivoted from the position of archenemy of the United States to an ally uncomfortable to live with but essential to survival. While Martin Dies's House Committee on Un-American Activities hunted Communists, America was forced to depend on Communist Russia to stave off the forces of fascism. The transition was bewildering and troubling to many; even the United States government hedged for a time. Margaret's photographs, contemporary radio broadcasts such as her husband's, and the many correspondents' reports from Russia were important propaganda that helped convince Americans the Soviets would fight valiantly for their homeland.

Life's editors were trying to enlist the support of Oumansky, the Soviet ambassador in Washington. Ed Thompson cabled Margaret from the home office to stay in Russia: "YOU'VE ANOTHER LEAD THIS TIME ON STALIN HOPKINS. . . . ALL HERE CONGRATULATE YOU STOP TOO BAD ABOUT FRONT BUT TRYING HERE OUMANSKY CABLE MOSCOW TELLING TREMENDOUS GOOD YOUR STORIES DOING SOVIET-AMERICAN RELATION STOP DON'T THINK YOU REALIZE TREMENDOUS SCOOP EFFECT OF TYPE PICTURES YOU SENT. . . . FEEL YOU HAVE GREAT MISSION. . . . THOMPSON." John Billings, the managing editor, cabled that she was "MAKING A NEW REPUTATION BY FINE MOSCOW WORK."

But Margaret could not stay in the U.S.S.R. A lecture contract she had signed before returning to Life from PM required her return by November 1. On September 15, before she and Erskine had figured out a way home, the two of them were suddenly told to prepare for a trip the next morning. When they reported in as instructed, five British and six American correspondents were waiting; they were all to go to the front.

A convoy of five cars drove them toward the Smolensk sector. The autumn rains, curse of armies (and of photographers), began almost as soon as they reached the highway and did not stop throughout the trip. It rained harder and longer than it had rained in the memory of living Russians. The light was impossible for photographs, and when Margaret sank in mud up to her knees it was equally impossible to find the best angle on the subject. She estimated that in one week at the front she had sixteen minutes of sunlight.

Still she photographed, wearing her red coat turned inside out so as not to attract enemy fire. She would slip away from the abundant ban-

quets and drinking bouts that Red Army officers held under the trees for the correspondents while enemy planes droned overhead. The plain of Yelnya, where fifty thousand Germans and twenty thousand Russians were reported dead, had been so trampled in the rush to death that, as the *New York Times* man wrote, "Rain pools in the trenches are stained with blood. The battlefield smells. A decaying hand sticks out of the mud."

But it was in a small town on the way to Yelnya that Margaret first encountered the great dilemma all war photographers face. A German bomb landed directly opposite her hotel. As the building shivered in the aftermath, she grabbed her camera and ran out. Four people from one family lay dead in a last grotesque embrace.

> It is a peculiar thing about pictures of this sort. It is as though a protecting screen draws itself across my mind and makes it possible to consider focus and light values and the technique of photography, in as impersonal a way as though I were making an abstract camera composition. This blind lasts as long as it is needed—while I am actually operating the camera. Days later, when I developed the negatives, I was surprised to find that I could not bring myself to look at the films. I had to have someone else handle and sort them for me.

While she photographed the family, the mother of a young girl on the sidewalk ran up and found her daughter dead. "Her desperate moans penetrated even my protective shell, and as I focused my camera on this vision of human misery it seemed heartless to turn her suffering into a photograph. But war is war and it has to be recorded."

Late in the afternoon of the last day at the front, the group reached a ruined town that Margaret knew would photograph well. It was twilight, but for once the hostile pall of clouds and rain was lifting. As she prepared to photograph, one of the correspondents called out that they were heading back to Moscow in five minutes. Margaret began to cry. A Russian official, seeing the tears on her cheeks, hastily arranged to send everyone but Erskine and Margaret to a banquet before departure and commandeered some soldiers to help string up lights. Her crying episodes give a certain force to Margaret's contention that women have an advantage over men in the field of photography because it is more difficult to throw them out.

On September 23, Margaret and Erskine left the U.S.S.R. in a British convoy crossing the Arctic Ocean. Lael Wertenbaker, a Time Inc. staff member who met them on their stopover in Great Britain, found Erskine a social trial. She thought Margaret out of character playing a wilting woman as Erskine charged across the norms of behavior. "He

was what one would call rude. It was not pleasant being with him. She was trying to cover this socially, whatever one does, and to palliate him. . . . She was being kind of a frightened wife, very subservient to him. He was very bad tempered, and she was trying to be the sweet wife. You'd think she was the original faded lady department if you didn't know she was Margaret Bourke-White."

Being an independent woman had certain small disadvantages. On the last leg home by Clipper across the Atlantic, there was no reservation for Mrs. Caldwell. The only seat left on the plane was reserved for a woman from Russia. Margaret was alarmed; she was going to be scooped. "What's her name?" she asked. "Margaret Bourke-White," the clerk replied—which meant she had both a seat and a scoop. The previous year in Mexico, the most elaborate explanations and arguments had not been able to prevent the hotel clerk from dragging Erskine bodily out of the room he was sharing with the woman whose last name was different from his own.

She had earned her name all over again in Russia. Wilson Hicks sent a cable to her plane: "WELCOME HOME TO THE PHOTOGRAPHER OF THE YEAR."

22

War on Land and Sea

From 1942 to 1945, the big story was the war. If you wanted to be part of everything, covering the war was being part of it. Being a war correspondent was sort of an elite kind of a military job. That made you want to do it more. The elite in the army, and in the world at large. Patting yourself on the shoulder, saying, "Gee, I was good enough to be a war correspondent." We were sitting in press camp and going out and getting shot at, saying, "Gee, we'd better go get shot at."

Ralph Morse, *Life* photographer, 1982

Margaret arrived home from the trip to Russia in time for Sunday supper. That evening she had to catch a plane to St. Louis to begin her lecture tour.

She had long been on the lecture circuit, but from here on in, lectures became an important part of her life and income. In 1953 she spoke fifty-five times on one tour. Her audiences were chiefly women's clubs, her fee was usually $500, with a top of $750. That was a high figure at a time when Eleanor Roosevelt got between $1,000 and $1,500. Margaret must have earned about $15,000 to $20,000 a year on lecturing alone, quite a respectable income at the time.

Women crowded into auditoriums to hear her speak on topics, such as war in Russia, that demanded everyone's attention. Disarmingly, she would offer to sing a song from her foreign travels in a voice that could politely be called earnest; that always got laughter and applause. In the evening she put on glamour: a gold-brocade strapless gown. By day she wore Paris suits and hats with birds' nests or witches' cones atop them; these must have looked smart to women who had not been to Paris, but today, in old photographs, they look like excursions in self-ridicule. With all her attractions, Margaret had the saving grace of not being impossibly beautiful. Women could identify with her; in the right suit and hat, they just might look like that themselves.

That she was good-looking was important because it established that women did not have to look like, say, Eleanor Roosevelt to be successful. Everything about Margaret also announced that she was a lady. Doris

O'Neil, director of vintage prints at Time Inc., heard her once and was impressed: "The audience responded to the fact that they were in the presence of a dynamic, exciting person just back from a dangerous mission. Also she was lovely and ladylike. You knew these qualities were not mutually exclusive. That was a double whammy." Margaret was walking evidence that the secret dream of her listeners, that they might be both feminine and successful, well-bred and daring, could come true.

She began to look on her lectures as preparatory material for her books. As an intimate friend said to her later, "You photograph vital things, you lecture because you think better that way and through that medium you can organize your material as well as your thinking, and then you write—and the mosaic makes a beautiful, orderly pattern."

Ralph Graves, who covered a story with her in Rockford, Illinois, in 1949, says that "her conversation, book, speeches would pick up not only the same anecdote but even the same words. It still sounded like conversation, even though she was in fact reciting. She was very good at that. . . . She could still talk naturally and entertainingly and not sound like a set speech at all. Then I'd go back and read the books and think, 'My God, Peggy, this is what you were telling me all through Rockford!' " As she stage-managed her photographic subjects, so she also stage-managed her spoken material, with results that always seemed candid and spontaneous.

The success of her 1941 lecture tour and the fact that *Life* had used several of her first-person written accounts from Russia may have given Margaret the idea of writing her own book on Russia. Erskine was then working on a book of his Russian diaries and a novel about the war. He says they never planned to collaborate on a book about Russia, despite the fact that they had already collaborated three times. But Lee Scott, who was secretary to both of them at the time, remembers otherwise.

Scott is one of that group, most of whom knew Margaret only at work, who thought her ladylike demeanor masked the heart of a monster. Scott considered her demanding, underhanded, and egocentric, with a rotten temper, no friends, and the irritating idea that it was a privilege to work for her. (Opinions about Margaret were never mild. Her closest friends and her lovers thought her "magnificent"; few of them can recall a single thing about her they disliked.) Lee Scott says, "They were going to collaborate on a book, as they had before quite successfully. Somewhere along the line she decided she wasn't going to collaborate. She was going to do her own book. (I could have advised her that wasn't the smartest thing to do.) She didn't tell him. She had to write a letter to him to tell him. I found about six drafts of that letter. I didn't type that one."

Margaret's independence was already a source of friction between her and Erskine, and now she was moving out on her own into what had been principally his territory: the written word. Erskine did write a book, called *Russia at War*, that was illustrated by Margaret's photographs, but it was not the kind of collaborative venture they had engaged in earlier. She never mentioned it in her autobiography, nor do the bibliographies of her work list it. Her own book, *Shooting the Russian War*, came out in '42, with text that far outweighed the photographs. Reviewers liked her book; it was once more clear she didn't know much about Russian history or politics, but she could spin a story. On the other hand, Erskine's novel, *All Night Long*, a tale of Nazi atrocities and the brave resistance of Soviet citizens, had little tension or emotional force. Deeply disappointing after the ribald vigor and angry conviction of his earlier novels, the novel was nonetheless a commercial success.

It looked almost as if an essential vitality had leached out of Caldwell's talent. Margaret said he "had a favorite saying which he repeated very often—so often that I think he convinced himself of the truth. 'The life of a writer is just ten years,' he would say. I did not agree with him at all. To me, the life of a writer—like that of the professional in any other creative field—is just what he cares to make it." Typically, she believed a man, or a woman, could take control of a career and of a life. But Caldwell, at least in his novels, gave great credit to forces in men they were too weak to circumvent.

Erskine's son Dabney thought his father and Margaret never got along very well; they seemed to be at odds too often. And Lee Scott shivered throughout the winter of 1941–42 in the icy atmosphere of Erskine's withdrawals from his wife. The warmth between Margaret and Erskine would recur after their bouts, and for a time she must have had enough hope to plan for a baby, for in early '42 she wrote Edna Rowe inquiring about the best way to bring up a child. Erskine's moods generally crashed down with no apparent cause, but perhaps the disappointment of Margaret's interrupted pregnancy had made his temper more volatile than ever.

Sometimes when Lee Scott was with them, Erskine would talk to his secretary but not to his wife. Scott thought Margaret asked for it by always putting herself first. She thought Erskine a "shy violet," but says he asked her to dinner once and she thought it was "just to get his wife's goat." Margaret herself was uneasy. She thought Erskine's moods were taking up a larger and larger share of their time together. "I didn't like the kind of person I was growing to be, in this marriage," she said. What she might not have liked was how open the struggle for dominance had become between the two of them.

Margaret was lured away from home again by the siren call of war. In the spring of 1942, she asked *Life* for an assignment overseas. American patriotism was running high. The hit song of the year began with the words of a chaplain to his men as bombs rained down on Pearl Harbor: "Praise the Lord and pass the ammunition." *Life* rapidly became a war magazine. In 1935, Dan Longwell had foreseen the publicity value of war when he recommended that Time Inc. found a picture magazine: "A war, any sort of war, is going to be a natural promotion for a picture magazine. The history of European illustrated magazines bears that out."

Margaret's editors arranged to have her accredited to the U.S. Army Air Forces; the Pentagon would have first claim to her photographs. She was the first woman photographer accredited in that war and for some time the only one. The Army War College took on with all solemnity the task of designing a uniform for her; it amounted to officer's uniform with an optional skirt. Designed especially for Margaret, this became the model for all women correspondents.

She was alight with an activist patriotism. She urged women to help the war effort: "I doubt if there's ever been a war in history where women could play such a vital part. . . . All women who can should be in those factories themselves. . . . My feeling is this: we're going through a vital phase of history, and why not be willing to have your life disrupted so you can be part of that vital phase of history." In the five months following Pearl Harbor, 750,000 women volunteered for work in war plants. In '43, *Life* gave Margaret the cover and eight pages for "the first comprehensive picture of women toiling in heavy industry," a story that returned her to the drama of industry with a new emphasis on the worker —and with a new worker to emphasize. She herself during the war was ordinarily addressed as "Sir."

As for her own war effort: "I felt that my special skills as a war photographer would help the most. I wanted Erskine very much to do something overseas but he had just gotten a big job in Hollywood and I was rather disappointed that he cared about that so much because he had always said that Hollywood was a place that you could go to but you could just stay a short time and it would corrupt you if you stayed too long. . . . Erskine seemed to feel that his ten years were up and he got the fattest job he could in Hollywood and also got one for me . . . that would have paid $1,000 a week in Hollywood while my country was at war. I just couldn't." Erskine was working on a film about the war, which might have done its bit for patriotism as well, but to Margaret, Hollywood was the place that wanted to build her the Arctic Circle on the back lot.

She wrote in *Portrait of Myself* that Erskine bought her a house in Arizona as a present but she could not accept it. In fact they had bought it together while researching *Say, is this the U.S.A.*, and had talked of moving there before America entered the war. Margaret had spent the winter and spring decorating it—long distance. By late July, Erskine was cabling her to decide about the job; he added that he was deeply hurt that she had made no definite arrangements for "a little Kit." She decided. By the first week in August she was on her way to England to photograph at a secret American airbase.

In England, Margaret photographed Churchill and Haile Selassie. (Selassie was the only emperor who ever carried her cameras. The king of England saw her, and her vivid blue coiffure, only from a distance. "Who is that woman with the remarkable hair?" he asked.) Her real mission was aviation, and she took pictures no civilian photographer had ever taken before.

Britain had concluded that daylight raids on Germany were not feasible; policy in the summer of '42 called for saturation bombing of urban sites by night to disrupt civilian life and morale. Americans believed that high-level, precision bombing of military targets and power stations in full daylight would be more effective and just as safe; they had just sent to England the first thirteen heavy bombers, the B-17s known as Flying Fortresses, big, fast planes that could cruise at high altitudes and were armed for defense and equipped with the new Norden bombsight.

Margaret photographed the thirteen Flying Fortresses as their transparent nose cones lifted into the air on their first mission. She also saw the safe return of the formation—an auspicious beginning for America's contribution to the air war in Europe. By the end of the year, the U.S. air force had flown twenty-six more operations, losing only thirty planes in over fifteen hundred sorties. Margaret's pictures sang the patriotic theme song of *Life* magazine, telling Americans they had cause for pride in their country.

The air force adopted Margaret; one of the crews asked her to name their plane. When she decided on *Flying Flitgun*, a christening ceremony was arranged through elaborate army channels. A piano and a small band were moved onto the runway, a special dispersal plan was drawn up in case of an air raid, and the commanding officer, Colonel J. Hampton Atkinson, read a flowery speech: "May the *Flying Flitgun* bring to the enemy the devastation its godmother has brought to the 97th [Bomb Group]."

She wanted desperately to go on a combat mission. A few newsmen

had been granted permission; Margaret was not. No one said directly that she could not go because she was a woman, but the message was clear. It was not the first time men had put obstacles in her way in order to protect her.

While Margaret waited for permission to fly into the thick of war, she was attacked in a battle that left her unarmed. Erskine was in Tucson, writing letters to her English airstrip and decorating the new house the way his Kit wanted it. He sent her tender messages: He was lonely and wanted her home. He worked better when she was there, so if she wanted him to write a good book, she should think about coming back. She was his only love and always would be.

The transatlantic mail was playing havoc with his feelings. He never got enough letters from her, and she seems not to have received all of his. On October 2 he cabled: "LAST LETTER RECEIVED SEPT. 10 LAST CABLE 20TH." That week she had a letter from him full of details about the house, his affection, and his plans for her return. Then there was silence for five weeks. No letter, no cable. It might have been due to the hostile Atlantic and the wartime mail.

On November 9 he broke the silence with a telegram: "HAVE REACHED MOST DIFFICULT DECISION OF LIFETIME STOP DECIDED THAT PARTNERSHIP MUST DISSOLVE IMMEDIATELY SINCE PRESENT AND FUTURE CONTAIN NO PROMISE OF ULTIMATE MANIFEST STOP NO SINGLE FACTOR OR COMBINATION COULD RECTIFY UNTENABLE SITUATION STOP BELIEVE ME WHEN EYE SAY EYE AM TRULY SORRY AND UNCONSOLABLE STOP PLEASE NOTIFY WEISS STEPS YOU WISH TAKEN." (Julius Weiss was Margaret's lawyer.)

Margaret cabled back almost immediately: "EXPLAIN REASONS MORE FULLY AND PLEASE TELL ME HONESTLY IF ANYONE ELSE INVOLVED."

On November 12 Erskine replied: "EYE HAVE WAITED FOUR YEARS FOR SOMETHING BETTER THAN THIS AND THE PRESENT AND FUTURE HAVE BECOME DISMAL APPARITIONS STOP SUCH IS LONELINESS."

He had staged a blitzkrieg campaign by cable. The battle was already over. She had only one sally left: "SUCH IS LONELINESS AND SUCH IS POETRY BUT SUCH IS NOT ANSWER TO DIRECT QUESTION STOP THEREFORE CAN DRAW ONLY ONE CONCLUSION AND SORRY YOU COULD NOT TELL ME OPENLY." That was the last cable she sent him. She did not have another letter from Erskine for nearly twenty years.

Peggy Sargent says she heard Margaret was ravaged by Erskine's abandonment, but Margaret herself would have denied that. She wrote to Julius Weiss on November 19, after waiting a suitable length of time for Erskine to reply to her cable:

I suppose by all the rules governing what is considered proper for a lady in these circumstances I should have felt desperate and devastated. My one feeling was relief. I have felt for so long that such a disproportionate amount of my attention went into worrying about whether someone was in a good mood or not, whether he would be courteous or forbidding to others, whether day to day life would be livable at all on normal terms, that I am delighted to drop all such problems for the more productive one of photography.

In a world like this I simply cannot bear being away from things that happen. I think it would be a mistake for me not to be recording the march of events with my camera when I have such remarkable opportunities, and when my work is put to such good use. Erskine has become interested in such different things lately. I do not understand his passion for big houses and comfortable living.

In the last few weeks I have been doing a good deal of work out at one of the airdromes, where I have officers' quarters, and when I come into that narrow cell with its tiny cot and little coke stove and wash stand, I think that this is all I want in the way of luxury—that it's the best in the world—as long as I am doing work I want to do.

. . . I care a reasonable amount about how it looks. While I'm not doing any worrying about public opinion I might as well be realistic about it. I suppose it does look better if the wife brings suit. . . .

The only thing I really care about in all this is the Connecticut house, which really seems like home to me. If I could keep it as a home I would be glad.

The relief Margaret spoke of in the letter must have been real. Still, that could not have been, as she claimed, her only feeling. It is clear enough that she was badly shaken, but she had a talent for believing her own propaganda. One week after Erskine's last telegram she reassured herself and *Life* that she was in a better situation than ever. Probably to protect her flanks in case gossip or newspapers spread the story, she wrote Wilson Hicks:

I am so happy in this work, especially now that I feel reasonably useful working for our U.S. Forces when we are in the war—I feel so *right*, somehow, that nothing, not even personal considerations are going to interfere. The work has always been first with me as you know. But now it is FIRST FIRST.

The world is moving along at such an exciting pace that I want to be right there photographing it every possible minute of the year.

On November 21, two days after she wrote her lawyer, he cabled that Erskine was instituting a suit against her, probably in Mexico, and that the Darien house would be hers.

When Erskine left her, Margaret immediately called her dignity into line and mustered all her defenses to protect the Margaret Bourke-White she had invented. Lincoln Barnett, the *Life* reporter who was with her in England, had the room next door to hers in their London hotel for three months while the marriage came apart. They often shared meals. "You will find this hard to believe," he told a reporter, "but she never mentioned it. In all that time, I never heard one word about her marriage."

Margaret decided later that she had always known "this was a five year marriage" (not quite four, actually; six since she'd met him) and that the span of it had to be fitted to the "very creative and harmonious work" they were doing together. In notes for her autobiography, she hinted at one regret, a hint she later deleted: "If we had had children, there would have been a different pattern of responsibility." She crossed out another sentence in which she justified the years with Erskine to herself: "As with Chappie . . . I was glad that it was a worthwhile man with whom I went through such a deep experience." What she told her public in her book was: "I was relieved when it was all over and glad we parted with a mutual affection and respect which still endures."

She could be magnanimous to herself, reminding herself that her experience had been worth it. She could be magnanimous to others too. She very rarely spoke ill of Erskine Caldwell.

Margaret had rebuilt her life before; she would do so again. A roving photojournalist measures out her life in assignments. Ideally, the next assignment will be as good as the last, or better; war, which is devilishly generous to photographers, makes that all the more likely. Margaret had heard rumors of news so vast it would engage all her energies and leave her no time to think of the past. All she had to do was to arrange to cover it.

The Allies were planning an invasion of North Africa. In July of '42, with Rommel's panzers within reach of Egypt, British troops dealt the Desert Fox his first defeat at the first battle of Alamein. This was a turning point in the war. Churchill argued heatedly and convincingly that the next major offensive should take place in Africa, and so it did. The operation was one of the best-kept secrets of the war, so secret that at the beginning of November, when the Germans spotted a great armada of Allied ships navigating the Strait of Gibraltar, the Nazi high command assumed it was bound for Sardinia or Sicily. By November 7 the reports were unmistakable even to the Germans: the fleet was approaching the north coast of Africa.

As Margaret told her story, when she heard rumors of the invasion

her editors had no inkling of it, and she could not breach security to ask permission to follow the troops. She had no doubt the home office would be happy to have her in Africa if only she could persuade the air force she belonged there, so she persuaded the military and let *Life* know about it afterward.

Ed Thompson's version is quite different. *Life* was only permitted a certain number of correspondents in each theater of war. Will Lang, already assigned to North Africa, had to be booted out before Margaret ever left England in order to get her to Africa, a move he protested bitterly. Thompson says it's possible Bourke-White did not know this but most unlikely, and adds that "with that woman's capacity for self-delusion, she could have believed they couldn't have had the invasion without her."

Although the authorities granted Margaret permission to go to Africa, they would not let her fly. It was too risky; no one was certain how strong the German air resistance would be. She was assigned to a large convoy to go by the safer sea route. "The upshot of that was," she wrote, "that those who flew—and this included most of the brass—stepped out on the African continent with their feet dry. I had to row part of the way."

In mid-December, a month after the invasion, Margaret sailed on the flagship of a large convoy. Her ship had once been a pleasure cruise vessel; it still had gilt filigree, lavishly overstuffed couches, and a grand piano. Now by some miracle of packing it held six thousand British and American troops, four hundred nurses, and the first five Wacs America had sent overseas to a war zone. Margaret was billeted in a cabin with some Scottish nurses.

Almost immediately the convoy headed into a storm so violent the captain had not seen its like in a lifetime spent at sea. Winds battered the ship at seventy miles an hour and sixty-five-foot waves tossed it about like a splinter. Two people were struck in the head by a flying sofa. Men and women broke legs and arms; one man broke his skull trying to navigate the grand staircase. In the main salon, where meals were served twice a day to the few hardy souls like Margaret who were not too seasick to sit up, plates and bowls flew through the air without warning, flinging food and soup in their wake and shattering in staccato crashes.

The captain insisted on lifeboat drills two and three times a day. The nurses, almost too ill to stand, marched out with the troops and clung to ropes for fourteen minutes of strict silence as the sea boiled about them. Margaret got permission to break out of line in case of enemy action and cover the attack from a site just below the captain's bridge. She repacked

her emergency musette bag, throwing out the extra socks and clothes and most of the chocolate and replacing them with her small Rolleiflex, some film, her favorite Linhof, and her five best lenses.

Past Gibraltar, the sea grew calmer. At a farewell party on December 21, the night before they were to reach Africa, Margaret was told that they had been followed for three days by enemy submarines.

At 2:10 A.M. on the morning of December 22, the ship was struck by a torpedo. The boat listed suddenly, hurling Margaret out of bed. The electricity was out; they raced into their clothes by flashlight. Everyone seemed to know without a word being said that the old pleasure cruiser could not last.

Along the passageways, the troops and nurses silently swelled forward to their life stations with a perfect discipline instilled by practice drills. Margaret broke through to her promised observation spot. The moon was brilliant, but not bright enough for photographs. A lone crewman ordered her to her boat station, but when she explained that she was the *Life* photographer he slipped away fast to his own station. Margaret was peculiarly alone. The deck sloped away steeply at a dangerous tilt, the ship's guns slanting off at odd angles. A voice blurred by distance was calling through a megaphone. It was the order to abandon ship.

"Funny how your attention changes," she noted later. "With the purpose to work, felt no conscious fear. As soon as knew work was impossible and must abandon ship, couldn't get to my boat station fast enough." The journey was torturous, over jumbles of wreckage and torn scraps of metal. When she reached her lifeboat she found the line in strict and silent formation. The boat had been flooded by the splash from the torpedo; there was some doubt whether it would stay afloat. Yet had all been well, it would have been launched before she got there.

She noticed that her mouth was drier than she could ever remember. "This must be fear," she thought. She seemed to stand off from herself and watch her own thoughts and movements. An inner voice told her this was one time when she had no idea what would happen. "There's a 50 per cent chance you will live. There's 50 per cent chance you will die." Later she would say this was the moment of greatest danger and greatest fear she ever experienced. She could not photograph; she had no bulwark against her terrors.

The nurse before her in line trembled uncontrollably, her body shaking so hard that her sling bag slipped off her shoulder. Margaret put it back, "a trifling thing, but I saw her trembling had stopped, and my own fear had left me." Her mother's lesson had come back to her from childhood: to face her fears—and then do something.

She saw those silent minutes on the listing ship as an almost religious

experience and a dividing line in her life, when she realized that concern for others can transcend the self. That night she crossed over to a profound new feeling of closeness to other human beings.

One of the lifeboats, the one the five Wacs were assigned to, was overloaded and would have to leave two people behind. A Wac said cheerfully that of course everyone couldn't go. Two of them stayed behind.

It was decided that Margaret's boat should chance it. They crowded in and sat in water up to their waists. Slowly the boat was lowered to the sea. Hundreds of men made their way down rope nets over the ship's side to an ocean alive with boats and rafts and struggling swimmers. "I could think of nothing but the magnificent pictures unfolding before me which I longed to take and could not. I suppose for all photographers, their greatest pictures are their untaken ones, and I am no exception. For me the indelible untaken photograph is the picture of our sinking ship viewed from our dangling lifeboat"—the worm's eye view she so loved, of a huge and powerful form—". . . against a backdrop of cumulus clouds so deceptively luminous that I found myself saying, 'If it were day, this would be a perfect K-2 sky.' " In 1942, she did not have the faster films that would later make such a photograph possible.

The lifeboat's rudder broke; they could only steer with the oars. The next boat capsized, nurses spilling out of it, some to drown. In the distance, someone shouted over and over, "I'm all alone. I'm all alone," until the cry faded into silence. Margaret's boat rescued a nurse with a broken leg, then picked up nine soldiers from rafts, which made sixty-four people in their small craft. A boat nearby was saving another raft. As a soldier reaching for a rope let go of the raft, a choppy wave threw it against him and cracked his skull. The skipper dived overboard and brought him back, but the young man died soon after.

The captain of Margaret's boat ordered them to bail, and everyone with helmets set to work. Across the sea came the strains of "You Are My Sunshine," and soon every boat and raft on the water took up the chorus. In the dark, the convoy they had traveled with had scattered for safety. One destroyer had stayed behind to drop depth charges, then it, too, steamed off. As it left, a muffled voice called through a megaphone, something about survivors. Margaret had not thought of herself as a survivor before. She resolved not to allow herself to be impatient until the end of the sixth day, not to think of the single can of emergency rations in her musette bag until the fourteenth. The destroyer slipped away into darkness. The moon set. They were alone on the sea.

In the morning, when the boat was nearly dry, the captain ordered them to jettison their helmets, but no one would, for too many nurses

were still getting seasick in theirs. Dawn broke over an uninhabited ocean. Like a reflex, Margaret's hand brought up her camera and she began to take pictures. She thought she would never again see anyone she knew to show them to and said she wondered how her editors would feel when they discovered she had changed assignments without notifying them and then failed to come back with the photographs.

Suddenly from the sky came the unmistakable drone of a plane. A British flying boat dipped over them; they would be saved. After a few hours the dim shape of a destroyer appeared on the horizon. It followed an erratic course, evidently picking up other survivors. Eight hours after they had entered the flooded lifeboat they were plucked from the sea. The destroyer kept on, seeking survivors. A lone soldier on a raft drifted closer, jerked up his thumb to the destroyer, and called out, "Hi, taxi!"

That evening they debarked in Algiers. Before dawn an officer woke Margaret and escorted her to the beach, where fifteen miles offshore a salvage crew was trying to save the burning ship she'd been on; she was to direct them to her cameras if there was time. There wasn't. The ship's deck started to melt and run like steel in a furnace. In the intense heat, the guns fired by themselves, one by one, and the depth charges exploded, hurling shrapnel about with fierce abandon. The ship's portholes began to melt and run down its side like tears, and distress signals burst on the air as it signaled its own death throes. Then the sea took over. The burning pleasure ship turned on its side and sank beneath the waves.

This night-long brush with death changed Margaret's photographic practices. The ocean had claimed her cameras; she would never again travel with such heavy baggage. She had gone to Russia carrying six hundred pounds; now she reduced her equipment to two hundred and fifty pounds, still much more than most photographers carried. She began to depend more often on the Rolleiflex, a smaller camera with a square negative. Although she would continue to carry a Speed Graphic and a Graflex with her to war, she now concentrated on a 2¼ × 3¼ when she wanted a larger negative. She also used the still smaller 35 mm camera, but only sparingly.

Life photographers were keenly aware that when Bourke-White fell she always seemed to land feet first with a scoop. Too often Margaret put other photographers in the shade. Eliot Elisofon, whom the army had not protected so carefully as it had a woman photographer, had reached North Africa with the invasion troops some time before Margaret rowed across the Mediterranean. News of Bourke-White's rescue spread fast. Elisofon grumbled to the home office: "I come here in the original operation. Have sense enough to get off and wait for a chance, and then

have her scoot in under my nose and she is lucky enough to be torpedoed on the way. I wonder if she'll get out a book on 'Torpedoed in the Med' or 'Afloat in a Negligee.' . . . Oh I've got the Bourke-White Blues."

Margaret did write an account of her ordeal, which *Life* printed with her photographs, although photographers did not often write their own texts. Alfred Hitchcock's 1944 movie, *Lifeboat*, which starred Tallulah Bankhead as a journalist who saves her makeup and her mink coat after a torpedo strike, was widely thought to be inspired by Margaret's adventure. Elisofon had some reason to be jealous.

Margaret was torpedoed and rescued on December 22, 1942. The next day, before the news had reached America, an article datelined Phoenix, Arizona, appeared in the *Norwalk* (Conn.) *Hour Newspaper* with her name in it. The article began:

Playwright Erskine Caldwell, 40, was honeymooning today with his 20 year old bride, the former June Johnson, following a marriage which revealed for the first time that he had been divorced from Miss Bourke-White, photographer and writer. The bride is a brunet and a senior at the University of Arizona. She has been active in school dramatics and will graduate in June.

"*Life*'s Bourke-White Goes Bombing"

Life's staff photographers and photographers on whose services it has first call total more than those employed by the world's largest news picture agency. Our picture operations are farther flung than those of all the newspapers of the United States combined insofar as use of staff in foreign fields is concerned. In scope of action on the newsfronts of the world there never has been anything in the history of journalism like the picture-getting activity of Life so far this year.

Wilson Hicks, speaking to *Life* ad salesman, June 1941

I felt I was running the war.

David Cort, foreign editor of *Life* during World War II, 1982

Margaret had scarcely landed safely in Algeria when she ran into General Jimmy Doolittle, who had cleared her permission to come to North Africa. He asked her immediately if she still wanted to go on a bombing mission and added that since she'd been torpedoed she might as well have a taste of the entire war. Then he picked up a field telephone and called the 97th Bomb Group, Margaret's *Flying Flitgun* companions, to say that Margaret Bourke-White had permission to fly a combat mission at the CO's discretion. Doolittle's chief of staff says he nearly fired General Jimmy for letting Margaret fly a combat mission. General Eisenhower himself, then the supreme commander, was unhappy with the decision, but by the time Ike found out, it was too late: Margaret had already survived war in the air as well as on the sea.

The CO of the 97th was Colonel J. Hampton Atkinson, the man who had spoken at the *Flying Flitgun* christening. Within weeks Atkinson became a brigadier general. It took him somewhat less time to fall in love with Margaret.

Hamp Atkinson was tall and lanky, with a rough kind of handsomeness and a Texas accent. Older than most of the pilots, he was, Margaret said, a brilliant tactician whose men trusted him completely and liked

him too; they knew him as a loyal and devoted commander who took the same risks they did. In private he was self-deprecating, often depressed, and jumpy. He had his reasons. His copilot says Atkinson had a hell of a time hiding his tuberculosis, which if known would have kept him out of the air.

Then, too, Margaret was carefully guarding herself against his affection. It was barely two months since Erskine had closed a door in her heart; her sense of trust had shut down for a time. The pain was worse than she wished to acknowledge and made sharper by her fear of abandonment. She would not tell Hamp she loved him and took her time to say she cared, yet she made him happy for a brief time in a perilous war. When Margaret asked to go on a combat mission, he did not hesitate to say yes.

Atkinson was Margaret's first wartime liaison but not her last. In places where women were scarce and death a constant promise, the atmosphere was charged with desire and longing. News that Margaret was sharing the CO's quarters spread faster than a military directive. If many of the men who photographed for *Life* had assumed before that she used sex to get what she wanted, now they were certain. A woman could not win in a man's world. Early in Margaret's career she was so successful she was rumored to be a front for a man; now men gave her credit solely for being female, and around *Life* she was soon labeled "the general's mattress." The world being what it is, some women certainly used sex for advancement, but whether they did or not, many of the women who went to war as correspondents were accused of it.

The talk would not have bothered Margaret overmuch. "It seems to me," she wrote, "that you can do one of two things: put your mind on your work, or worry about what people are saying about you. The two do not mix." Her own work appealed to her partly because it meant she would *have* to live outside convention, and she had no intention of cutting into her own chances for adventure by keeping up appearances and cultivating guilts.

In North Africa, she caused a stir simply by being a woman. At headquarters she amounted to an event. In the evening, when the entertainment was over, she left with the general, while every man there dreamed of what it might be like if she had left with him. In the morning, a guard was posted by the latrine while she showered. Out in the desert, the woman who had won permission to fly a combat mission became a legend. J R Eyerman, a *Life* photographer, visited one of the fliers' camps a short while after Margaret had been there. On a stretch of sand near the camp he spotted a small, square enclosure of barbed wire, like the walls of a tiny, empty room. This struck him as odd. The place wasn't

near the front; there was no need for barbed wire and nothing nearby
but more sand. Eyerman went over to investigate and on one side found
a small, hand-lettered sign. He bent over to read it. It said: "Miss Mar-
garet Bourke-White shat here."

While Atkinson was romancing her, another officer was also paying
her court. Imaginations raced in a land where women were veiled from
head to toe and American men made do on daydreams and pictures of
Rita Hayworth in a nightgown. Eyerman recalls that Margaret, when she
returned to Africa on a second assignment,

> had a full colonel from the Pentagon assigned to her, a West Pointer, tradi-
> tional . . . with a little military gray moustache that he twirled in the morn-
> ing with wax and a stunning military haircut by a good barber. . . . He was
> a very dignified man. He had all this good straight arrow American colonel
> quality. . . .
>
> One day he watched me work on her cameras a long time. Said, "I've
> heard a good deal about Miss Bourke-White." Hemmed and hawed. Finally
> turned to me and said, "Is there something expected of me?"
>
> I said, "If anything is expected of you, I'm sure Miss Bourke-White will
> let you know."

Wilson Hicks, who had the small-minded man's conviction that he
could get more from his photographers if he played them off against one
another, cabled Eliot Elisofon in Africa to say that Bourke-White had a
big lead on a bombing mission and to ask when he could expect the same
from him. Elisofon, already tearing his hair because Margaret had had
the good luck to be torpedoed, cabled back that he was sorry, but she
had one piece of equipment he didn't have.

With her healthy appetites and indifference to convention, Margaret
was never above sex and probably would not have been above using it if
nothing else would do to get the story, but she was simply too smart and
too resourceful to have had to resort to selling her favors. As for Hamp
Atkinson, who was a figure of courage and some glamour, she cared for
him for the duration and remained a friend and correspondent for a
decade. His affection had signaled her first step toward rebuilding her
emotional life after Erskine shattered her defenses.

Margaret had been assigned to a small oasis town called Biskra in
Algeria. Hills tinged with blue hugged the horizon; the sky, which
seemed immoderately large above the flat expanse of sand, was crowded
with baroque clouds. Headquarters were in a former casino called The
Garden of Allah. Before the war it had been a beacon for rich nomads,
who swayed in on camels across the blank sands to play chemin de fer
beneath the Garden's Moorish arches.

Briefings took place in the gaming room. Herbert Mitgang, now with the *New York Times*, was there while Margaret rearranged things for a better photograph. "Everybody jumped when she asked," he says. "Suddenly we see the general who normally would be giving us orders taking orders from this rather small woman. Why? First, she was there." (Although other American women came to North Africa as correspondents, Margaret was the only one on the base at the time.) "Second, it was publicity. *Life* was enormously powerful. Everyone was interested in getting credit for the division . . . if you got the attention of someone who could promote you. . . . Also, you weren't allowed to say where you were in letters home"—the men's letters kept recommending a certain movie with Humphrey Bogart and Ingrid Bergman, a reference to North Africa the censors scrupulously removed each time—"and if you were in *Life*, the folks at home would know."

The Germans were so close that Junkers planes skimmed the tops of date palms as they made bombing runs on The Garden of Allah. U.S. bombers in return flew over Tunis and Bizerte so regularly that the route was known as "the milk run." Eliot Elisofon, whose grudge against Margaret was beginning to fester, wrote the home office that he'd been told she "had the boys posing in trenches as if bombs were coming." This was a serious charge, for *Life* would not countenance fake photographs, but nothing came of it. Not even *Life*'s researchers could have checked that story.

Out in the desert, she practiced for the mission she was to fly, wearing heavy flight gear of fleece-lined leather. She learned how to use a portable oxygen bottle, which would give her three minutes off the main oxygen line while she dragged her bulky K-20 aerial camera from window to window across an obstacle course of metal equipment.

The mission's destination was a close-kept secret. Margaret had her hopes set high on a newsworthy target, and she got one. At dawn on January 22, 1943, when the fliers gathered for their orders, the briefing officer pulled back the covers from the map and pointed to the El Aouina airfield at Tunis.

When Anglo-Allied troops had landed on North African shores the previous November, Tunisia was neutral French territory. Despite the element of surprise, the landing went badly. Axis forces quickly took Tunis, its airfield, and the nearby port city of Bizerte. The Germans established a sufficient force in Tunisia to make that country a safe retreat for Rommel's *Panzerarmee Afrika* as it withdrew before a British tank force that at times outnumbered it nine to one. El Aouina became the staging ground for the ferrying of German troops from Sicily for the defense of Africa, as well as the exit port for troops retreating before the

Allies. Although the desert war was nearly over, the North African war was not, and the airfield was a key to German operations.

Margaret was assigned to the lead plane. Intelligence reported that the German planes from Sicily would be on the ground for half an hour before taking off for Italy again. The American squadron would feint toward Bizerte, then make a ninety-degree turn and slam their bombs into the airfield while Nazi planes were clustered there.

The Flying Fortresses took off down the desert runway, churning up a spume of sand, at 8:55 A.M. The formation flew over miles of trackless sand; viewed from above, the hills lay like wrinkles on the face of the earth. The fear of death had gripped Margaret for a brief time before takeoff; she had tried to push it aside. She looked on the mission with solemnity, as a task so new that all the rules and skills for it were unique. Later she wrote that she never thought she was assisting in the delivery of death. It was all too far away, miles below, where individuals could no longer be distinguished. War forced the mind into new thoughts, new patterns, new morals.

Margaret began photographing as soon as the plane was airborne, working as fast as she could before she had to put on electric mittens to keep her hands from freezing. She took pictures from every window, even from the radio-gunner's hatch, where the two-hundred-mph slipstream could have decapitated her had she stayed too long. When the temperature dipped below zero, little ice cubes began to form at the base of her oxygen mask; she had to pinch the mask periodically to make sure the ice from her own breath and saliva did not clog the feed line.

As the squadron crossed into enemy territory, the bombardier headed into the bomb bay to remove the safety pins. Margaret followed him into the dark and cavernous bay to watch, squeezing herself down between rows of bombs. The bombardier squatted to give the bombs his close attention; as he removed the yellow tags on the pins he tucked them between his lips. Margaret slipped a flashbulb into her camera and snapped a picture. Through the intercom she heard him cry out as the blinding flash went off, "Jesus Christ! They're exploding in my hands!" Startled to realize she had frightened him, she was nonetheless grateful that up to that moment he had forgotten she was on board. Her early career had been dogged by the superstition that women were bad luck in dangerous places; no man then would have forgotten she was there.

The squadron joined another group of planes on schedule and they continued in formation, thirty strong, the heavy planes seeming scarcely to move against the thin sheets of cloud. They feinted toward Bizerte; then, as the ancient city of Carthage gleamed white below them, the bombers turned sharply toward El Aouina and roared on to their desti-

nation. "So reassuring when approaching target," Margaret wrote in her notes. "Everyone saying OK, everything is OK. They check with each other, with other ships. OK." Now they were directly over the target. The bombardier released the bomb load. Thirty-five seconds to fall twenty-one thousand feet. "Tossup with the gunner over who would win his window seat—him or me? Didn't warn him that you trained yourself rushing the newsreel men out of the way." Afterward Margaret would hear that the crew had placed bets on her: "If we were attacked, would the waist-gunner knock me out so that he could defend our airplane, or would I knock out the waist-gunner so I would have room to take pictures?"

She was taking pictures as fast as her shutter would open. Over the target, when the intercom was reserved for urgent directives, the men were startled to hear something they had never heard on a bomb run before: a woman's voice crying, "Oh, that's just what I want, that's a beautiful angle! Roll me over quick. Hold me just like this. Hold me this way so I can shoot straight down." The plane was taking evasive action, weaving and changing altitude rapidly to avoid ack-ack; for a brief moment Margaret had the photographer's illusion that the moves were being made for the benefit of her camera. She was so busy she hadn't time to be frightened. "The sound and movement were so rhythmic. It was like music—and so reassuring."

Below her ninety tons of bombs were exploding. At first she could not interpret the smoky shapes that hovered in the air. Huge plumes of smoke towered above the airfield, white columns paired with black, with flashes of bright fire at the tip, as bombs ripped into concrete and metal. She was puzzled to see in the air close by the plane small black clouds with tentacles that seemed to grow as she watched—ack-ack that had missed their plane. (Making notes later about these patterns, she broke off to say, "As I write this I realize I don't want to sound like Mussolini's son, who wrote in rhapsody about the beauty of bombing.") The Flying Fortress was hit twice in the wing; luckily, damage was light.

As they left the target, German fighters suddenly swooped down on them out of the hazy clouds. Margaret's notes grow breathless: "Top turret gunner shot one down. He was head onto us. Only twenty yards away. They don't paint names on their planes or we'd have read them. They were making pass after pass, right smack in the nose. 'He didn't putter. Was on him like a duck after a ladybug.' 'Exchanged shots and adjectives.' " The Germans shot down two Fortresses that day, but Margaret's plane was not hit again. She was disappointed that no attacking enemy fighter had flown on a course she could photograph.

The mission was highly successful. Margaret's photographs showed

the fires on the airfield: forty planes destroyed by bombs, an estimated forty more put out of commission—a hard blow at Axis operations on the Continent. The war was turning. Four months later, the last of the German and Italian troops in Africa would surrender, the war on that continent would be over, and the Allies would see an opening to Europe through the southern tip of Italy.

On the bombing mission Margaret discovered that war imposes distances that obliterate the everyday notions of human connection. "The impersonality of modern war has become stupendous, grotesque. Even in the heart of battle, one human being's ray of vision lights only a narrow slice of the whole, and all the rest is remote—so incredibly remote." Ironically, that mission had a direct connection to the most impersonal act of war in history. Hamp Atkinson and Paul Tibbetts copiloted the B-17 she flew on. Two years later Tibbetts would pilot the plane that dropped the first atom bomb on Hiroshima. Margaret recorded a conversation she had with him sometime after the war.

"How did you feel when you were dropping the bomb?"
"I was very worried till I knew things were going all right."
"No I mean about all the people down there."
"Well you might say we were helping them in a way. They were so poor and miserable they would only die anyway."
To me, this was a startling illustration of the remoteness that had troubled me but multiplied a thousand-fold. East was remote from West even before nuclear complications.
Tibbetts was not to blame. Airmen in an actual separate sphere. Thought he had a kind heart if he came face to face. . . .
What are one's responsibilities. Even as a fotog.

Margaret hitchhiked to America on army planes soon after her mission was completed. On March 1, *Life*'s lead story was headlined: "LIFE'S BOURKE-WHITE GOES BOMBING—First woman to accompany U.S. Air Force on combat mission photographs attack on Tunis." On the first page of the article, the magazine printed a small picture of Margaret in her heavy leather flight suit—a picture that would briefly become an army pinup, the best dressed, or more precisely, the *most* dressed pinup in the history of the war.

Other women, such as Toni Frissell and Lee Miller, photographed the war, but Margaret, who had survived bombing raids in Russia, a torpedo attack in the Mediterranean, and a major bombing mission, had the name that burned into the public imagination. "Girl photographers" suddenly became so interesting that they provoked a rash of films before the end of '43: *Lifeboat; No Time for Love* (also said to be based on Margaret), with Claudette Colbert as a photographer in love with the

foreman of a crew digging a tunnel under the Hudson River; *The Sky's the Limit*, with Joan Leslie as a news photographer who falls for a flier; *One More Tomorrow*, with Ann Sheridan as a left-wing photographer married to a playboy.

Once more, by raising the public's level of interest, ever with a certain fanfare, Margaret's career contributed to the slow change in the status of photographers. Just three years earlier, Wilson Hicks had told a group of newspaper editors that "the most pressing problem about pictures today [is] the raising of photographers in general to the same level as writers." Hicks had a point. Until the naval aviation photographic unit was created to make use of Edward Steichen's talents, the navy billeted writers with officers and photographers with enlisted men.

Life had become a kind of acrobatic stand-in for a national newspaper. America had national broadcasting but no nationwide paper; *Life* brought the war home to everyone. No war, in either the nineteenth or the twentieth century, had ever been photographed (or, for that matter, reported) as widely as World War II. In World War I, civilian photographers were not allowed at the front on pain of death. The photographs that got past the censors for publication during that war tended to be distant images that conveyed little of the intensity of killing and being killed. But "World War II," as Wilson Hicks said, "was a photographer's war." *Life* photographers created a visual memory of combat for those who had not been there. The arrival of a *Life* photographer on a battlefield was in itself a kind of guarantee that Americans would think more about that particular battle, even if it was not militarily of top significance, than they would have had it gone unphotographed.

Life shared the government's goals and published something akin to government propaganda; during the war, opinion was nearly monolithic and high patriotism routine. *Life* itself boasted that it never failed to show the heroism of Americans or the horrors brought on by their enemies. Of Margaret's work, Tex McCrary, who interviewed her several times, says, "I felt that everything she did was a recruiting poster. . . . Everything she did seemed so clean, it was God Bless America. Even in the war, everybody was clean."

Government censorship was tight. Dirty work by Allied troops could not pass the censors. John Morris, then *Life*'s London picture editor, recalls "the candor of the British censor through whom I attempted to pass some pictures of the charnel of air-raid victims in Berlin. 'Very interesting,' he said. 'You may have them after the war.' " The government forbade the publication of pictures of dead Americans until September of 1943, although the press could, and did, print photographs of dead Chinese, Britons, Japanese, Germans, long before.

On September 20, 1943, *Life* printed its first pictures of Americans killed in battle: George Strock's photograph of three dead GIs on Maggot Beach at Buna (taken seven months earlier). Maggots were visible on the back of one of the corpses. Enlistment in the draft is said to have declined the following week, proving at once the value of government restrictions and the immense power of photographs.

When Margaret returned from North Africa in the spring of '43, the active sense of compassion and service she had cultivated earlier in political causes expressed itself in individual acts of thoughtfulness. She called the wives, sweethearts, mothers of soldiers she had met to say their men were well. She began a correspondence with Hamp Atkinson's mother. Throughout the war she carried messages home whenever she returned. She would drop notes to a man's relatives to say she was lecturing nearby or speaking on the radio and was going to mention their soldier by name. She went to a great deal of trouble to do little things for people she had met in the war.

People who did not know her well usually thought her aloof, distant, even somewhat arrogant. Wilson Hicks thought this was the impression a shy woman might make. Margaret had buried the painfully shy girl from Bound Brook under thick layers of charm and aggression, but shyness does not die easily; it merely goes underground. Hicks said, "She is shy, sensitive, talks all the time, disregards people because she is afraid of them." Also, she was so committed to her goals she couldn't spare time for chitchat. *Life* photographer Nina Leen recalls, "The very first time I met her I asked her if she would have lunch with me. She told me she was writing a book and there was no hope of a lunch for several years. I thought maybe I won't be hungry by then. I never asked again."

Margaret's aloofness was partly the product of her perfectionism. She wrote slowly and needed long periods of concentration, during which she cut herself off completely from social contacts for so long that lovers grew angry and she had to work hard at repairing her friendships afterward. She had become virtually incapable of halfway measures. A doctor who treated her later in life says, "Anything she touched had to be the best she could do, even her relations with people; otherwise, don't bother me."

But there were chinks in her professional armor, and sometimes tenderness would gleam through. It must have been about this time, not long after her divorce, that one or two staff members at *Life* had the peculiar sensation of feeling sorry for Bourke-White, or delicately touched by her. Hansel Mieth, the photographer everyone assumed must be Margaret Bourke-White, was editing negatives one day when Margaret pulled up a chair beside her.

She asked me how I was feeling toward her. "I don't know," I confessed awkwardly, "I've never had a chance to come to know you." She held out a beautiful-wrapped package. "When I came in this morning you looked so lovely in your black velvet dress with the red heart buttons, that I looked for something that would go with it and found this at Peck and Peck." I unwrapped the package. In its nest rested a soft red leather compact, in the shape of a heart, about the size of my hand. I was so moved that I did not know what to say. What was there to this woman? Was this a bid for comradeship? I hoped we would become friends. but we remained strangers.

When I watched her talk with people I was fascinated by her quick, radiant smile, but as soon as she turned away the smile would disappear as with the flick of a switch.

Peggy Sargent uses the same simile. "She could turn her personality on and off sort of like turning on an electric switch. I'd be working with her and it was all business. Someone would come in and she'd switch it on. . . . When the light was turned on she was vivid, she was very animated." In fact Margaret had developed what amounted to two personalities, both of them slightly overstated, one for work and one for after hours.

She had chosen a career that often demanded a suspension of her humanity. She had to ride roughshod over tired, reluctant, even grieving subjects; she had to shut off her own emotions in order to do the job well. Her concentration was so fierce it blotted out minor compassions. She once told Carl Mydans, "If anybody gets in my way when I am making a picture, I become irrational. I'm never sure of what I am going to do or sometimes even aware of what I do—only that I want that picture." Ralph Graves worked with Margaret when she used multiple flash, which required the reporter to change the bulb in each lamp after every shot. Twice she forgot what Graves was doing and tripped the shutter in the middle, burning his hand both times. Then she did it yet a third time, but that time he understood. A woman she was photographing leaned forward suddenly with a wonderfully animated look on her face. Boom. The flash went off in Graves's hand. "She turned to look at me . . . with an extraordinary expression: profound regret that she had done it to me again—coupled with absolute triumph that she had got the perfect picture at such a small cost."

Then there was the time near the end of her career when Clay Felker, who would later found *New York* magazine, went with her to photograph rhesus monkeys infected with polio in Dr. Jonas Salk's lab. The lab technician warned them both of the danger; they were to avoid being scratched at all costs. Felker says that after Margaret had photographed in the lab for a while, she decided she didn't like the light and asked him to go inside the cage with a flash. He declined.

Dora Jane Hamblin, a *Life* reporter, relates that Bourke-White could be almost equally hard on her subjects. (*Life* photographer John Phillips says, "Someone once said to me, 'The minute you stop caring about the comfort of your subjects, I know you're getting good pictures.' ") For a story on the Busch family of Anheuser-Busch fame, Margaret wanted Gussie Busch dressed up in his riding clothes, but he was in bed with an ice pack on a hernia and begged off. Margaret sent Hamblin to "deliver the body"; she had to tug the man's boots on for him because his pain was too great for him to do it himself. The shooting dragged on and on, "with Gussie getting more ashen and tight-lipped all the time. I finally pleaded with her to let him go and I shall never forget the reply: 'You reporters are all alike. These little inconveniences will be forgotten tomorrow and my pictures will live forever.' " Hamblin adds, "I'm now prepared to admit that she was right, but there must be more humane ways of preparing for eternity."

Deep down, the taint of inhumanity would have made Margaret uneasy, although nothing could have shaken her faith in photography's overwhelming importance. Still, her childhood instructions had indicated that she could make a large contribution to the world and be a good person at the same time. So she cultivated her own thoughtfulness. She carried home from war lists of soldiers' relatives to contact. She would jot down in her notebook for future reference the favorite foods, cocktails, songs of a man she'd just met and was interested in—small wonder so many men felt she'd brought them happiness they'd never known before.

A passionate woman, Margaret did not feel she could afford to let her generous impulses and longing for connections break through her everyday demeanor. The author and television critic Michael Arlen, who worked with Margaret on a story in the fifties, thought she had a lot of feelings but that they were "all over the map a lot of times" and that she had become disconnected from them. "Beneath that very confident, even brash exterior, she had tried to do a great many things, perhaps too many things, with her own nature," he says.

Her colleagues generally thought her determinedly humorless. Asked if she had a sense of humor, Ed Thompson, who worked with her at *Life* from 1937 on, answered, "Good God, no!" Her friends, on the other hand, who often heard her easy laughter, thought gaiety as instinctive to Margaret as enthusiasm. It was not so much that she was funny, but she could be counted on to be fun. The world was always new to someone with such zest; around the corner there was bound to be another cause of merriment.

Norman Cousins, a good friend for years, says she was "one of the

most fun-loving persons I've ever known." Cousins seems to have spent a good deal of time teasing Margaret. He spotted her once at the Darien station when she'd had such short notice on an assignment that she'd simply thrown most of her clothes into a wash basket. Cousins turned up his coat, affected a heavy accent, offered to help her, and promptly fell into the basket. When she realized who it was, she broke into her "deep, deep giggle, such a lovely sound." Margaret's sister-in-law recalls the time their dog mistook one of Margaret's hats for a wild animal and attacked it. Margaret sent the dog a clutch of beanbags with a note: "Since we seem to have the same tastes, and I just noticed these today and liked them very much, I thought you would like them too."

The truth of the matter seems to be that she could not handle such distractions as humor at work. People who worked with her often thought her quite one-sided; she was not. John Phillips, who'd been in Czechoslovakia with her, says that if she'd had more of a sense of humor she wouldn't have been the success she was. "Photography was her life, a means of being Bourke-White. . . . If she'd had a sense of humor, she might have seen something ludicrous in this single-mindedness."

Single-mindedness was valuable to Margaret; it was a basic part of her creed. It had been Joseph White's salient characteristic, the source of his fabled silence. Margaret so loved her father, who died and left her too early, that twice she married men whose silent remoteness surpassed his own. But society did not provide women with the kind of mates it gave to hard-working and successful men. When the first marriage failed her bitterly, she constructed a new life by unconsciously modeling herself on her father's driven, perfectionist example.

Carol Eyerman, a *Life* photographer, says, "I always felt that her work filled a large void in her life, that loving and being loved would have made an immense difference to her. . . . She seemed to have an arrogance that kept her from being close to people. It was sort of like she had been hurt enough. I wondered . . . why she had this protective shield around her."

Even people who were close to Margaret for a time seldom pierced the shield she had erected with such care. A man who spent too much of himself on her once told her she had a lens for a heart; she took that as a compliment and merrily repeated it. Another man who was very fond of her and became a trusted friend says that "Margaret was so involved with Margaret that I really don't know if she could be devastated."

But she could be, and she had been, and she built her defenses with the zeal of one who has been defeated in a war.

Purple Heart Valley

> *That was a winter of deep discontent for [General Sir Harold]*
> *Alexander's armies. . . . The mud was like glue at midday and like iron*
> *in the freezing nights. Cold winds and snow swept the jagged crags.*
> *Dead GIs lay in the crater valley they called Purple Heart, their throats*
> *eaten out by scavenger dogs. Trench foot and frostbite were common.*
>
> Cyrus Sulzberger, *The American Heritage Picture*
> *History of World War II*

Margaret had not been home two months before a longing to be on the battlefront possessed her. Nothing in civilian life could match the breathless wait on an airstrip for the formation to return, or the long, shivery rumble through the sky en route to a bombing mission. In May she wrote Wilson Hicks to say she was "homesick to get back to the war, and . . . only living for that day." Homesick is an odd term to use about a war. Margaret did not have another place for her heart.

The military was much less eager to welcome her back than she to go. General Eisenhower was more than a little hesitant about Bourke-White. A woman in the middle of a war was trouble enough, more trouble even than the average *Life* correspondent. But Margaret's successes, demands, and maneuvers were all outsize. *Life* was notified that "when last in North Africa she evaded PRO regulations, violated security and broke rules in other ways." Under the circumstances, her battlefront prospects did not look good. But her luck never deserted her. General Brehon Somervell, chief of the army service forces, which were responsible for getting ammunition and Spam to troops everywhere, knew something of Bourke-White's photographs of engineering feats and requested her camera. The army was concerned that the service forces on the ground, including the engineers and the medical corps, had been neglected while pilots were being turned into public heroes. *Life* had a strong card to play against Eisenhower's objections.

By August, Ike said yes, "with certain conditions," as an editor explained it to Hicks. "An officer must accompany her at all times. She must obey his instructions, or she will be tossed out." The army politely

agreed to say the officer was supplied for her assistance rather than her regulation. Hicks must not have told her the truth. She had been in the war zone less than two months when she cabled him to say that at first she had been "hounded by someone who seemed to think he knew more about what *Life* wanted than either you or I do. I had to go to bat very fiercely to keep our independence. It was pretty unpleasant but of course I won out in the end." Of course.

She chalked up her difficulties to being a woman and thought she was still being overprotected. She broke so many rules partly because she was certain that getting the picture was more important than regulations, but also because as a woman she knew she had a handicap and had to do more and be more. "You have to prove yourself, I think," she said.

She was constantly proving herself, some thought with overmuch pomp and circumstance. Dick Pollard of *Life* had himself assigned to a forward press camp in Italy, far out of reach, when he heard that Bourke-White was asking for him. He did not want to be one of her "spear carriers"; she would arrange others. "To put Maggie's methods in perspective," Pollard says, "*access* is all-important to the photojournalist. . . . Neither Ansel Adams nor [Edward] Weston had to worry about access to *their* subjects . . . Photo-journalists' subjects, to a large degree, were guarding their secrets or their privacy. Or both. We had to break down resistance. Many gifted photographers could have shot Bourke-White type pictures if only they could have conned the air force, for example, into that cooperation. . . . Okay, *Life*'s name helped; but in the end it was the photographer's persuasion. . . . Maggie's shameless spear carriers made the story work."

Margaret flew from America to North Africa in early September of '43. Two months earlier, the Allies had invaded Sicily and Mussolini had been arrested by the nation he had raised and ruined. On September 3, Allied troops landed in Italy proper, and on the eighth, Italy surrendered. Only the Germans were left to oppose the invading forces. Only the Germans . . . On September 9, the Allies launched an amphibious assault on Salerno. Nazi forces came within an ace of throwing them back into the sea. Still, on the first of October, British and American soldiers entered the city of Naples.

Margaret photographed the services of supply in North Africa for a couple of weeks. When her flying orders came through for Italy, she took off from El Aouina, the airport her plane had bombed, for Naples, a city tottering on blasted foundations. In early August, Allied air raids had smashed the city's water supplies; there was no bread, little food, scant housing, and as little water, right on the Bay of Naples, as in the desert. People lived on streets, in caves, on the edge of despair.

The Allies had bombed Naples and the withdrawing Germans had finished it. To make the port unusable, the Germans had scuttled and blown up everything that might float; the harbor was a mammoth tangle of metal and ships' hulls turned on their sides, as if some unimaginable monster had taken the entire port in its mouth, chewed it up, and spit it out again. With extraordinary finesse, the Germans had then proceeded to make the area near the docks almost impassable. They blew up buildings so precisely that the outer walls stood wavering on rotten foundations. They planted mines set to go off at the flick of a light switch or the touch of a piano key, or more simply when a certain amount of time had passed, so that the Naples post office blew up one sunny afternoon three weeks after the Germans had departed, ripping through long lines of Italian civilians waiting patiently for stamps.

The Allied engineers, being professionals themselves, could not help admiring the thoroughness and expertise of the German demolition teams. American engineers performed their own miracles of reconstruction, using overturned ships as piers, delicately bringing down shaky walls and using the rubble for fill in the harbor. Margaret photographed the ruins, the caves where people huddled in makeshift shacks, the still-larger caves that hid entire German airplane factories, now crumpled and shredded by the departing Germans.

On her arrival in Naples she needed a military pass from the commanding officer of CIC (Counter Intelligence), Major Maxwell Jerome Papurt. When she announced who she was, his face lit up. He told her how much he'd always admired her work. (In fact he could not remember ever having seen anything she'd done.) Margaret got her pass. Jerry Papurt got a date.

Stocky and gray-haired at thirty-six, Papurt had a homely face with sharp, kind eyes behind silver-rimmed spectacles. His mouth seemed to have more teeth than most people's; he flashed them often in a big and knowing grin. Friends called him Jerry but his men called him Pappy; they were intensely loyal to him and told stories of lives he had saved. Charming, bright, talkative, he was a womanizer of energy and invention. When he met Margaret he had a wife and a troubled marriage. Soon he was deeply in love with a *Life* photographer.

Divorce, war, and the closeness of death had realigned parts of Margaret's value system. Jerry seemed to her blessedly secure and stable. In civilian life he had been a professor of abnormal psychology in a university, the director of a home for delinquent children, a consultant on criminal rehabilitation and juvenile crime. He was marked by a professorial manner; she laughed delightedly when he asked her once, "Whom do you love?" In the army, he would eventually have a Purple Heart, a Bronze Star, and the French Legion of Honor.

Late in October, when they had known each other only a couple of weeks, a captured enemy agent told his jailers that thousands of delayed-action mines would explode when the city's electricity was finally turned back on that afternoon. A million and a half Neapolitans had to be evacuated to the nearby hills in a few hours before the engineers turned the main switch. The buildings of Naples had already been systematically checked, but no one underestimated German inventiveness. The main switch was turned: no explosions. Now the light switches in individual buildings must be tried. Margaret set up her camera with a view of CIC headquarters as Jerry went in with two of his men; he was unwilling to send them into danger anywhere he would not go first. A good photo-journalist focuses the camera on everything, no matter what her feelings. If the building blew, she would be recording his death.

But nothing exploded in Naples that day. The captured German's story had been a ruse designed to cause maximum disruption. It worked.

In the weeks to come, as Papurt went about the business of arresting Fascists and the Germans took to bombing Naples regularly at six-ten in the evening, Margaret found herself falling in love again despite all her fears and her precautions. In that bombed-out city of baroque splendor and squalor, she and Jerry spent their evenings singing songs together off key, wrapped in overcoats in an unheated palazzo, or dancing in a ballroom where the rain dripped through the ceiling. Margaret had difficulty gaining entrance to one club for a dance because she wasn't in uniform; she was surely the only woman to go to war with a gown by Adrian of Hollywood, "one of those little numbers that look prim on the hanger," she said, but "on, there was nothing schoolteacherish about it."

By early November, Jerry was begging her to marry him. Yet another man who felt she had opened a new world to him, he wrote his wife to ask for a divorce even though Margaret had not said yes. Margaret had put on a proud front after Erskine left her, but she had spells of abject panic when the shadow of abandonment hung black and heavy over her life. Patiently, Jerry tried to restore her sense of trust. He insisted he would be not simply satisfied but happy to know she was doing what she wanted when she was away on assignment. "I hope too," he wrote her, "that as time goes on you'll have fewer and fewer moments of panic. . . . I've told you this before . . . that no one can hurt you but yourself—don't let your fears spoil a really great love. If there is one thing in this world you can count on, it is my love for you. . . . Love me, too."

In Italy in 1943–44, Margaret took an interest in large political and social issues.

> It seems to me [she wrote] that if a progressive political philosophy were made clear, much terror of the future could be spared these civilians of occupied countries. . . . We Americans, moving on as a victorious army, have an opportunity to mold the world—an occasion almost unprecedented in history. Our soldiers buy that opportunity with the dearest possession they have. We have no right to ask them to lay down their lives unless we administer what they have gained with the full intelligence that their sacrifice deserves.

She was an idealist who counted on democracy to save the world, in a war that was being fought for ideals.

> The only way to leave constructive results behind us in these occupied countries—in fact, the only way to insure future peace in the world—is through education of the young. . . . If we had a living political philosophy, if democracy were an articulate passion with us, we would be able to communicate it to others. There is no use fighting a war unless we leave behind a better world, and to do that we must get the youth of Europe on our side.

Margaret had not written of such subjects before. She understood perfectly the limitations of photojournalism, and how facile the camera is at depicting the skin of things when the heart is what counts. She was looking for something wider and deeper.

She thought her writing marked another kind of progress: that she had learned to listen. She was always struggling against her initial indifference to people in general; now she felt impelled to write by what seemed to her a milestone on her path to sharper awareness of others.

> Why i write—began to HEAR
> What people said so indicative, revealing. So much THAT PERSON it is like a photograph. This the only kind of note I make—in jeep—freshness everything.
> And it's as tho saw machine patterns first
> Then later the man behind the machine
> then people
> then began to be aware of what they said.

It did not take long for the Germans to convince the Allied commanders that Rome was not so short a trip from Naples as they had supposed. General Mark Clark on the American side and General Sir Harold Alexander on the British, neither especially willing to cooperate with the other and neither with effective strategic plans to cooperate on, moved their troops out into the mountain gaps and the valley where the road wound through Cassino to Rome and dug in as winter came on in the mountains. The terrain before Cassino is spiny, jagged, and perfectly suited to defense. The rivers on the valley floor are too deep to ford. A

string of low mountains rings the valley like observation posts; the Germans were installed on the heights with a clear view of everything below. Whenever the Allies succeeded in forcing them to withdraw across a river, the retreating Germans blew the bridges; Allied engineers would race in to make repairs, often working under enemy artillery fire. Every yard of the advance to Cassino was marked with blood. They called it Purple Heart Valley.

Margaret went to the front to photograph the field engineers. (It was on this front that she saw the mobile printing presses based on an invention of her father's.) She was billeted for a time in a cell of her own in a monastery where fifty monks resided; in the field she often slept in a foxhole. The rain fell steadily, like some monotonous revenge, putting her lenses and sometimes her camera out of commission, costing her photographs she would have—and in fact had—risked her life for.

Several times she set out with her view camera and tripod, sometimes with several tripods. Most war photographers carried small cameras, generally 35 mm or Rolleis, and would have considered a heavy tripod an absurdity. Margaret needed one for night work if nothing else. An image of artillery fire at night could require a twenty-minute exposure; the return fire, if it was anywhere nearby, would have made the earth tremble so hard it is astonishing her pictures were not hopelessly blurred. *Life* published a photograph of her crawling up a mountainside with her tripod jutting into the air. A soldier remarked, "Just why the Krauts didn't lay it on with that tripod sticking up that way I'll never know. . . . She was pretty lucky."

She had never encountered shelling before; suddenly she was hurling herself repeatedly out of a jeep and into a ditch. On one trip her driver had to cross what the men called the Hot-Spot Bridge. A German observation post overlooked that bridge; there was no way to see the enemy, but at any moment a pair of German binoculars might be trained on their jeep. At dusk Margaret's jeep headed back to the bridge. The American gun crew that had been protecting it had been blown apart that afternoon by a German shell that scored a direct hit: "You could have carted the remains of that gun section away in a jeep," said the officer who told her. That day, Margaret said, she graduated.

"The school of thought I graduated from had been a soothing one as long as it lasted. I had had an irrational conviction that 'nothing could ever happen to me.' From then on, however, I never found myself in a foxhole without wondering whether I had tried my luck one too many times. After all, there is something to the law of averages."

Shelling, she said, was "intensely and horribly personal." Bombs were as remote as she had supposed; they fell without regard to some-

thing so small as a human being. But artillery looked for a specific target, a target that could do nothing but lie in a ditch and hope. Each day, when Margaret headed home from the front, relief and joy flooded through her veins—and shame as well. For the first few days, when she saw men who had been at the front for weeks and had had their faces wiped blank by an exhaustion even greater than their fear, she felt guilty at being free to go back to safety in the evening. "Later," she wrote, "I came almost to regret my voluntary position. My decisions to go to the front depended on no one but myself and my desire to do a thorough and honest job. I used to wonder whether, if I were under orders, it wouldn't be easier." Yet, free to choose not to risk her life, she always chose to risk it. "When you're a correspondent you get a sort of disease," she told her assistant in Italy. "Always afraid you might miss something."

And if she was afraid, no one ever knew about it. Jerry Papurt wrote her just after she'd left Italy: "Seems you've already become a legend and stories about your courage are being told and retold. You really made a terrific impression on every soldier with whom you came in contact or who saw you at the front. You're credited with being the coolest [illegible word] under fire they've ever seen—man or woman."

Colonel Michael Strok flew Margaret on several reconnaissance missions over enemy territory in an unarmed L-4 two-seater, the military version of the Piper Cub, fondly referred to as a Grasshopper. The Grasshoppers were slow planes, with a speed of seventy or eighty mph, much more maneuverable than the fast attack planes. If attacked, their only recourse was to take evasive action, preferably at very low altitudes where fighters could not follow.

Margaret would buckle herself in behind him, then Strok would nose the little plane up over the dead terrain pockmarked with shell holes full of rainwater that seemed to stare up at the sky like so many vacant eyes. He flew toward the enemy lines, past the repaired bridges of the Allied side, past the still-broken bridges of no-man's-land (too dangerous for engineers to venture into), over the intact bridges of the German troops, looking for signs of German artillery so he could radio enemy positions back to Allied gunners. On one trip, he says,

> about the time we had finished our photo mission, we sighted two German ME-109 fighters diving down out of a cloud deck and headed our way. I took evasive action—rapid changes in altitude and direction—rather violent corkscrew dives. I yelled for Peggy to hang on tight and to tighten her safety belt. As I looked back quickly over my shoulder to try to reassure her, she was calmly shooting rapid-fire pictures of the action with one camera while two others cameras and assorted equipment were floating in the cockpit and banging against the windows.

The ME-109s made one firing pass, pulled up and headed back to where they came from, assisted by our friendly anti-aircraft fire.

After we landed at our forward airstrip I was most impressed by Peggy's coolness and asked her, "Peggy, you are either the bravest person I've ever known or a damn fool—which are you?" She gave me that intense blue-eyed look and that mischievous grin and said, "Which do you think I am?"

At each point in Margaret's career she had found a mentor—Beme, Graubner, Caldwell, Wilson Hicks—and she continued to find some man to pave the way wherever she wished to go.

I think [she wrote] with every major photographic story there had been some man who, in his way, opened up his world for me and somehow stands for it in my mind. A man of stature from whom I could absorb a great deal. Perhaps it would be someone in the news-gathering field—a writer concerned with history in the making—who made wise suggestions, and whose findings, so generously shared, illuminated the whole situation for me. Some of these are extraordinary men with an astuteness and courage all their own. The lasting quality of some of these friendships had been a source of great happiness to me. Long after the job which brought us together is over, we are bound by ties of great affection . . .

Some of these men have meant more to me than either of my husbands. Perhaps fliers have meant the most, particularly certain of the seasoned ones whose early work meant pioneering in one way or another, and called for great daring and imagination. With men like this there was always a quick understanding, and if the work meant danger shared, that was always a bond. My most treasured memory of the war is the words of a superb flying officer. I had been planning to take a flight in which there were some elements of risk. Just before the takeoff, he said, "I'm going to fly you myself, because if you die, I want to die, too." Nobody died, but I shall always carry that short sentence like an invisible star.

Margaret spent one night photographing a Long Tom referred to as Superman, a 155 mm gun that was aimed at a German bridge on the road to Cassino. She had four cameras, and her assistant, assigned to her by the army, was poised with a Rollei to take pictures of the gun crew as they pulled the lanyard. The men were so excited to think that *Life* was taking their pictures that word got around, and relief crews from other batteries came up to help load film packs and move tripods when they were off duty. Margaret soon had a regular little industry going in the ranks of the artillery.

Her pictures of an artillery barrage at night, the explosions like great chrysanthemums of light against the dim mountain peaks, are almost as beautiful as her photographs of the bombing of Moscow. There was little else dramatic for the camera to focus on in that war of concealment,

nothing but mud, shell holes, bare mountains. At the gun battery, the task of coordinating four cameras with the moment of firing proved so tricky that it prompted a complex set of signals between gun crew and photographer. At length the GIs said it would be easier if she gave the commands. And so she shouted "Load! Ready! Fire!" whenever a round was due and her finger was ready to open the camera shutter. A brigadier general dropped by to see the crew around midnight and was quickly pressed into service operating one of Margaret's cameras while she gave the command to fire.

It must have been her assistant who took the photograph of Margaret herself firing the Long Tom. Presumably the brigadier general was not there at the time; no one of high rank would have permitted her to pull the lanyard. No one of any rank should have permitted her to shoot that gun, for the Geneva convention expressly forbade civilian correspondents from carrying or firing arms. All war photographs went through the censor, who might have been expected to confiscate this one, to the Pentagon, but somehow a copy of it reached the *Life* office, where it caused an uproar and then vanished without a trace.

The Eleventh Field Hospital, a line of tents painted with red crosses, had been set up so close to the battle line it lay ahead of the American heavy guns. Six miles away on a mountaintop, a German observation post looked down on it like a bird of prey. Shells screamed overhead in both directions; the nurses knew by the pitch which were our side's, which were theirs.

Margaret, who had previously photographed in an evacuation hospital five miles behind the front, arrived at the Eleventh at night and was billeted in a nurses' tent. She had barely arrived when a sound like a whirlwind rushed toward them out of the mountains where the Germans lay entrenched. Instantly the nurses dived under their beds. The whirlwind exploded; they came out again. Then it began once more, with the scream swelling and rising unbearably to a concussion that slammed against their ears. The shell had fallen thirty feet away, scoring a direct hit on the mess tent and cutting the camp's electrical circuits.

Margaret made her way to the operating tent, where the surgeons were working by the light of flashlights. She stayed in the tent all night as shells exploded close to the hospital group. Whenever the high scream of a shell came toward them, nurses and doctors dropped to the floor until the roar of the explosion shook the ground. Immediately everyone would scramble up to check the plasma bottles and transfusion needles of the wounded men on the tables, to change rubber gloves and sterilize instruments. Hour after hour this went on, while the casualties came in

in such numbers that blood supplies, plasma supplies, oxygen supplies were running short. The hospital staff and the gun crews, when they could be spared from their jobs for a minute or two, donated blood and then rotated back into position.

Margaret had arrived on an infamous night: January 20, 1944. A single division, the Thirty-sixth "Texan," had been ordered to establish a bridgehead on General Clark's drive into the Liri Valley against an especially well fortified part of the German line. The Germans controlled the heights on both sides of the path of approach. No commanding officer involved in the attack had full confidence in the strategy; still the division went in. The Germans, at minimal cost, cut them to ribbons. The Thirty-sixth had a 56 percent casualty rate among the riflemen and company officers; many of them were carried torn and bleeding into the field hospital where Margaret was photographing. "I had 184 men," a company officer told a reporter. "48 hours later I had 17. If that's not mass murder, I don't know what is."

Margaret photographed all night long. One Texan came in with his thighs cut nearly in two; he had lost so much blood he was getting transfusions in both arms rather than one. By flashlight, doctors struggled over him in battle helmets as German shells thundered by. The wounded man's lips were pale as cigarette smoke, his breathing so shallow he seemed to have given up oxygen. He whispered out a request for watermelon; the nurse said that was a sign he was near death. The soldier's pale mouth shivered slightly: "Cover up my feet. I'm so cold," and then he died. Margaret took one last picture of his feet in their muddy boots, with his rifle strapped between them to splint the legs an exploding shell had crushed.

It is said that a photographer values most the picture that cost the most, the picture, for instance, taken in dangerous circumstances. (That is one of the reasons photographers are so often poor editors of their own work; they judge by the wrong criteria.) The field hospital was Margaret's last story in Italy, and it meant an immense amount to her.

Once the assignment was finished, the War Department cabled *Life* that they wanted to send her home. They said they could no longer afford to assign a public relations officer to her and that she had been difficult at times and required more handling than other photographers. Margaret knew nothing of this, only that her assignment was completed. She parted achingly from Jerry Papurt, the two of them plotting how soon she might get back. On her way home, *Life* cabled that they would rush the medical corps story into print as soon as the films arrived. The films arrived at the Pentagon—but the Pentagon lost them.

Margaret herself said that she went wild. She had risked her life for

the drama and emotion of doctors in battle helmets and dying men begging for watermelon, and it was all for nothing. One package of film had come through, with the less dramatic evacuation hospital pictures, but the other package was gone. She flew to Washington and begged permission to lead a search through the Pentagon, where she went through shelves and files in a storm of desperation. She never found the other film. *Life* published the film they had, but the images weren't as good, and it wasn't enough. Years later, she said that the loss of the field hospital pictures was a wound that never healed.

In the spring of '44, Margaret gathered up her Italian notebooks and wrote *They Called It "Purple Heart Valley,"* a book that went through five editions. She had begun to look on every experience as material for a book. A correspondent who knew her remarks, "I know more photographers who want to be writers. *Life* photographers were princes then, performing the function and getting the money of anchormen now, the glamour boys, but like them, they had deep inferiority complexes about not being real journalists. A lot of them wanted to be taken more seriously. They felt that being a writer was really more being a journalist . . . and made them be taken more seriously."

Margaret was also a diligent letter writer. She wrote Jerry Papurt daily, and he wrote her once, twice, sometimes more often each day. He was transferred to London in May as the war moved farther onto the Continent. On June 4, 1944, Rome fell; on June 6, the Allies landed in Normandy. Margaret was ready to return to the war, having written her book in a matter of months, and Jerry expected her soon. Several times that summer he wrote that he would not be in a position to write her for a while, but she was not to worry. On the seventh of September he had permission at last to tell her he was in France. He'd been everywhere, on every front, moving around fast, heading for Germany. It was the most thrilling assignment of his life.

The army expressed its usual reluctance to let Margaret back into the war. Even photographers were leery of her reputed temperament. In London, John Morris received a request to get Margaret accredited to the Normandy invasion. "Word got around the London office," he says. "The photographers on the invasion team were aghast. They wanted no part of her." He went through the motions of requesting accreditation; it was categorically denied. But Margaret discovered a military need for publicity and appealed to it. The press had deserted Italy en masse in the fall of '44, in search of the bigger story in France. And still the troops in Italy fought a harrowing war over muddy terrain combed with mines, while German soldiers in the mountains stared directly at them along

the barrels of their guns. Morale in Italy was dangerously low. Margaret asked for permission to cover "the Forgotten Front." It was granted. In the fall of '44 she sailed by convoy back to Italy.

A close friend of Jerry's met her at the dock in Naples. Five days earlier, while Margaret was at sea, Jerry Papurt had been captured. The German radio announced this on October 24. He was wounded but alive when captured; that was all anyone knew.

Bits of news seeped out later. Jerry had been returning from the battle at Arnhem when the jeep he was traveling in strayed out of the narrow Allied spearhead and was attacked by a German patrol. He was wounded in both legs. In prison camp, despite his wounds, his sense of humor never flagged. By November the Germans put him in a hospital for prisoners of war.

The mail was erratic. For weeks after his capture, letters from Jerry kept trickling in on thin blue army V-mail paper, dated in September, talking of the fast-moving action at the front. Margaret worried frantically to think the Germans would find out he was with counterintelligence and torture him for information; later she found out he had fooled them on that score.

The Vatican had organized a department to try to trace prisoners of war on either side and to deliver messages by radio or whatever means were available. The maximum length was ten words; they would do what they could to get it through. Margaret wrote a shorter note: "*I love you. I will marry you. Maggie.*" Apparently this was the first time she had said so, although he had been working out marriage plans for some time. In her autobiography she said, "I don't know how I could have refused to marry a man like that—so fair in his judgments, so well-adjusted that he met the difficulties of life with humor." She was Jerry Papurt's passion, he was her safe haven. She never knew if he got her message.

Just before Thanksgiving the town where he was held prisoner was bombed by the Allies. One bomb scored a direct hit on the hospital, shearing it in half. Jerry was on the side that was hit. He must have died instantly.

The letters Margaret had written him before his capture kept coming back marked "Return to sender." For weeks afterward, Jerry kept up his gentle, ghostly pursuit of her through the mail; the U.S. Army Post Office continued to deliver his messages to her with care.

Again there are no records of Margaret's reactions to the heavy losses she suffered in the war; she wrote in her autobiography that the wound of losing her photographs never healed, but she would not write so personally of other losses. Presumably she threw herself into her work

with the energy of despair, hoping the fires of war would burn away her sorrow. Her anguish was certainly intense. As soon as she returned to America, she went to Cleveland to introduce herself to Jerry's brother and to a friend of the family. Evidently Margaret had heard another story of Jerry's capture, that he was out in the woods with a nurse when the Germans caught him almost literally with his pants down, and she wanted it on record that she did not believe it. Her grief was already great enough on every score.

If she was maintaining appearances right after his death, with her habitual self-protection, her work in Italy gave her an unusually good excuse. Her first assignments were in occupied Rome, where she walked a tightrope of humility and good behavior. In December, the Time Inc. bureau in Rome wrote the home office:

> I wanted you all in New York to know what a swell job Margaret Bourke-White is doing in Rome for us.
>
> Peg arrive here determined to overcome the reputation she suffers of causing troubles and headaches wherever she operates—it's something that's constantly on her mind now. During the month she's been in Italy she has worked quietly and graciously, has almost been painfully backward about asking the Bureau to help her out on even the simplest matters of transportation, equipment, money and the rest. . . .
>
> Peg has also won many friends for Time Inc. in every strata of the society which she is photographing, and by her considerate approach—and with very little asking—has the p.r. people here willingly doing handsprings for her.

At the beginning of '45 she went north with the 88th Division to a point ten miles before Bologna, where the rocky Italian terrain was still drinking the blood of soldiers. With the mountains deep in snow, the GIs had devised a new kind of camouflage, painting their faces, their clothes, their rifles and bazookas white. The mules that trudged supplies up the steep slopes wore white sheets and pillowcases with eyeholes cut in them, like ragtag versions of horses in medieval jousts, or, as Margaret put it, like members of the Ku Klux Klan. What with the frozen waterfalls, the white-faced men and frontline medics, Margaret found the scene tailor-made to her brand of photography: dramatic, unique, eminently suited to design.

She took three hundred pictures she thought were exciting. The press censor in Rome passed them, a courier took them "red bag" in the official army pouch to Naples airport for the flight to Washington. The courier must have stopped for a beer en route to Naples. The red army bag was stolen.

Everything that was not nailed down in that pinched and starving

country was stolen. Middle-class women in Naples went to a concert in coats cleverly run up by tailors from stolen army blankets. After a five-minute intermission, the orchestra returned to find all its instruments gone. A red bag in a jeep might mean food, an irresistible temptation. Rewards for its return were offered in the newspapers and on the radio, but the photographs became just another casualty of war, never to be seen again. Margaret noted that she went to bed for two days in a state of nervous collapse; that was more than she would admit to when Erskine left her or Jerry died. Somehow she pulled herself together and wired home to ask if *Life* could still use the story if she did it again. They could. She did. But the snow was gone, her eye no longer fresh, and "nothing was the same." *Life* printed the story, but Margaret always thought the better one was lost on the road to Naples.

When she worked on "the Forgotten Front" in the snow, Margaret heard enemy small-arms fire for the first time, which meant she was close enough to make a rifle worth a German's time. In the second campaign, after her photographs were stolen, the risks were greater still; she said she was close enough to hear them throwing hand grenades. She was a brave woman, and gallant, and evidently she cared more for photography than she did for her own life.

25

The Watch on the Rhine

Having paid her dues twice over to the army services of supply, Margaret was granted permission to cover the biggest story in the world: the Allied advance into Germany. In early March she flew to Frankfurt. She was back in Germany, where in 1932 she had photographed an army prohibited by treaty from rearming but training nonetheless with tanks mocked up on cars and artillery carved out of wood. It had been remarkably effective training.

In 1945, the Allies were pressing toward the Rhine, the great natural barrier beyond which lay the industrial heart of Germany and the road to Berlin. By early March, Hitler's thousand-year Reich had shrunk to the size that Germany had been a thousand years before. As pockets of Allied troops won toeholds along the west bank of the Rhine, the Germans blew the bridges to the central Fatherland and hunkered down among the smokestacks of the Ruhr.

General Patton, nervy, impatient, and hell-bent for glory, sent his tank troops in sallies across German terrain like light-horse regiments; he was determined to cross the Rhine before the British, who had been promised the first crossing on March 23. On March 22, Patton threw his troops across ahead of schedule but did not allow them to advance far; the news had to be kept from his superiors until just before Field Marshal Montgomery's scheduled assault. Two days later, as Patton prepared to cross again, this time with military sanction, Margaret took his picture. "Don't show my jowls!" he yelled at her, and "Stop taking pictures of my teeth!" Afterward, he asked for a photography lesson, and she gave him one.

Allied troops sailed across the Rhine and thrust into the German heartland. In the last week of March and the first week of April, more than three hundred thousand Germans were taken prisoner. The war lurched forward in spurts, faster than communication lines or mapmakers; soldiers often had no idea where the front was, and whether they

had outdistanced it. Cities surrendered, but German snipers and *Hitler-jugend* ferociously held on to what they could. "No time to think about it or interpret it," Margaret wrote. "Just rush to photograph it; write it; cable it. Record it now—think about it later. History will form judgments."

After the mortar fire died down in Frankfurt, German women came up from the cellars with dazed eyes and discovered that while they had been underground so long, lilacs and magnolias had bloomed beside the tottering walls of bombed-out buildings. Blinking in the sunlight, they plucked bunches of color from between the broken bricks and wandered aimlessly across the rubble with their arms abloom, cautiously skirting the new corpses in the streets.

Germany unraveled like a nightmare. Everywhere, the stench of death seeped out of crumpled buildings where bodies lay beneath great heaps of brick. In Cologne, Margaret photographed a hand that seemed to be reaching up from beneath a pile of stones for a typewriter labeled "Triumph." In that splintered city, GIs found an enormous underground vault and walked off with their arms piled high with embroidered linens, plush furs, and vintage wines. Afterward, they brushed their teeth with champagne.

In Bremen, Margaret located Hildegarde Roselius, a German woman she had met when Hildegarde was studying in America. Neither Margaret nor anyone she knew had found a single German who would admit to being a Nazi. Hildegarde admitted it proudly. In a kitchen that a bomb had left exposed to the street, Hildegarde said that her Führer had a firm and manly handshake, "a really *good* handshake," and that he never told a lie. England, she added, had started the war, a war that Germany could not have lost had there not been treachery somewhere. As for herself, she would do it all over again if given the chance.

On April 11, Patton's troops marched into Buchenwald a bare two hours after the Nazis departed. This was the first major concentration camp Americans had liberated. The army knew the camp existed; Buchenwald supplied forced labor to a nearby bomb plant, and pilots on raids had been instructed to steer clear of the camp. Stories about concentration camps had gone around, but the press had kept its counsel. No one was prepared for what was there.

In a monumental rage, Patton ordered his MPs to round up one thousand citizens of Weimar and force them to witness what had gone on at the edge of their city. The MPs, some of them shaking, rounded up more. The people of Weimar pleaded the same innocence that every German seemed to claim. As MPs herded them into Buchenwald, Margaret drove up with Percy Knauth, a *Time* writer who spoke excellent

German. At the gate, Knauth read the chiseled inscription with disbelief: "JEDEM DAS SEINE"—To Each His Own.

Margaret set to work immediately. A crowd of men in prison clothes stood silently behind barbed wire. She stood in front of them with a flash to take their picture; not one of them reacted. The camera, which automatically forces self-consciousness on its subjects, could not do so here; Buchenwald had stripped away self-consciousness and ordinary response. Liberated, the skeletal figures stare from her photograph with the eyes of men who have seen too much, their faces framed by wire, their lives by an unbearable past and an unimaginable future. No one registers joy, relief, or even recognition; it is as if they have died and yet are keeping watch. The frame cuts off the lineup on either side, making it seem like a fragment of a group that goes on forever.

Percy Knauth says that when he walked through the gate of Buchenwald he stopped short as if he'd run into a brick wall. The courtyard was "alive with a kind of subdued noise"; no energy existed to make more. In the yard a truck was heaped high with the naked, angular corpses of the recent dead, their feet and heads abruptly thrust out at passersby. These bodies should have been burned in the ovens, but when war pressed in too close, Buchenwald ran short of coal. Knauth spotted the body of an SS man stacked along with the others. "You could tell he was SS because in the first place he had some flesh on his bones, and second he had the SS tattoo on his arm. He was lying there on top of this pile of bodies with the wind gently rippling through his pubic hair. . . . I don't even remember writing it back at the press camp."

Margaret set out to photograph everything: the sharp bones and charred skulls in the furnaces; the shrunken figures, deformed by malnutrition, feebly lifting their arms to wave from their bunks; the lampshade of tattooed human skin; the German civilians who wept and fainted to see such horrors and kept exclaiming that they did not know. Those inmates who could walk watched with desperate satisfaction as civilians who had worked beside them in the factories recoiled from the jumbled heap of bodies, the gallows, the massed hooks for hangings, the ovens full of ashes. Every ten minutes a new body was piled atop the others. Too many were simply past help. For weeks they continued to die by the hundreds despite American care.

Throughout the war, government and the press had so carefully played down the story of the concentration camps that few people grasped the full horror of the Final Solution. Pictures like Margaret's made Americans believe in the Nazi atrocities for the first time; they could not be denied. Newsreels showed the camps to hushed audiences. Buchenwald, Belsen, Dachau—their images were etched on memory forever.

"Using the camera," Margaret wrote, "was almost a relief. It interposed a slight barrier between myself and the horror in front of me." When people asked her how she could bear to photograph such scenes, she elaborated on the self-protection she had employed before: "I have to work with a veil over my mind. In photographing the murder camps, the protective veil was so tightly drawn that I hardly knew what I had taken until I saw prints of my own photographs. It was as though I was seeing these horrors for the first time. I believe many correspondents worked in the same self-imposed stupor. One has to, or it is impossible to stand it." Twenty-five years later, looking at those photographs, she wept.

"Even though I did not realize how soon people would disbelieve or forget," she wrote at the time, "I had a deep conviction that an atrocity like this demanded to be recorded. So I forced myself to map the place with negatives." In these words rings her strong sense of the photographer's mission, responsibility, and power to sway minds. There were, and are still, many who share that sense. John Phillips says:

> I took pictures of a soap factory because if man can do it then man must be strong enough to have a look at it. You can't pretend it didn't happen.
> It's a mixed thing. We were freewheeling moralists. And if you got an execution you had quite a story, and it was part of your job. You were covering a war. . . . If you get involved, it leaves marks on you. It's difficult to be a photographer. You have to be enough of an SOB to break into places where you're really not wanted, and you have to be sensitive enough to understand what it's about in order to take a picture. A friend of mine says it's like driving up a hill with the brakes on.

Margaret, maintaining her own secret, did not mention Jews when writing of Buchenwald, but she made clear her outrage. Her book on Germany is shot through with anger at the many Germans she met who claimed to have saved a Jew, some saying modestly that they had joined the Nazi party to help their Jewish friends. Hildegarde told her that Germans had begun to protest when prisoners released from concentration camps asked to be served first in the stores while other Germans had to wait. "These people from concentration camps really are behaving very badly," Hildegarde said indignantly.

Germany was disintegrating in a storm of anger, despair, confusion.

> I know of no way [Margaret wrote] to convey the feeling of rising violence that we witnessed as we drove deeper into Germany: the waves of suicides, the women throwing themselves after their loved dead into newly dug graves, the passionate denunciation of friends and neighbors, the general lawlessness.

. . . In normal life one rarely sees violent emotion openly expressed; usually such torrents of fury and desperation as we were observing are released behind closed doors.

Margaret tried to take photographs that would explain the German people, but she never felt she understood them well enough herself. She needed a sense of order, but she might as well have been in the midst of a hurricane with a sieve to measure the force of the wind. She had too many turbulent emotions to cope with. Jerry Papurt had died less than six months earlier, and now on one day she was photographing skulls in furnaces and on another two German children killed by their mother when the German authorities warned that American soldiers would do worse.

Margaret tried, as people try, to keep some semblance of normal life and some spark of pleasure alive. Work was necessarily the chief organizing force in her life, but she found time to flirt with attractive GIs now and then. Maitland Edey, a Time Inc. colleague, says, "I remember drinking with her one night with a couple of young sergeants, one of them trying to outsit the other when I went to bed." Another correspondent who had a room next to Margaret's says it was quite clear that she loved men. Edey judged her to be "a kind of ice maiden, a very vivid one, with a kind of hot core." He had a vague sense that a sensual, passionate woman lived inside that vivid exterior, but guessed that her relations with men were primarily for physical satisfaction. "She seemed burning inside, but burning in the direction of wanting to get done what she had to do. Interpersonal relationships were sort of incidental to that." Percy Knauth felt she had such enormous joy in her photography that "by comparison with her work other things in life paled and just weren't that important."

After Knauth convinced a reluctant pastor to let Margaret photograph a German funeral, he "sweated blood" when she jumped into the open grave to photograph the minister from her favorite worm's-eye view. He says, "I think she liked to do and to get monumental things, and people were on a fairly small scale unless viewed against a monumental background like the dust bowl, the ruins of Berlin, or the sky as seen from a grave."

The disintegration of Germany proceeded on a mammoth scale. In Leipzig, where Bach was buried and Wagner baptized, the German police chief enthusiastically surrendered to an American captain on April 18, while in the middle of the city three hundred SS troops dug in to defend their town against attack. Margaret reached Leipzig with the lead troops; not till the next morning did Allied soldiers convince the Ger-

mans defending city hall to surrender. Bill Walton, a Time Inc. corre-
spondent, entered the building a short while after. He opened an office
door, slammed it again, and raced out to find Margaret.

Every office on the floor had its wood paneling, its Oriental rugs, its
romantic German landscapes—and its corpses. It was all very polite, very
tidy, as if a group of bureaucrats had come to a tea party and died amid
the chitchat. The mayor, his wife and daughter were slumped in their
chairs like a family taking a nap after an earnest discussion. The city
treasurer's head was bent to his desk beside the family documents. His
daughter rested peacefully on the leather couch, wearing her Red Cross
uniform. They were suicides, all of them, Nazi party officials whose
glorious Reich had gone up in flames. In the face of conflagration they
had carefully laid out their eyeglasses, their handkerchiefs and essential
documents, then taken poison together.

"Margaret came running and went to work like a demon," Walton
says. "She was a tiger. I've never seen her or any other photographer in
such concentrated action in my life. We both reacted with fascinated
horror, and not any deep regret. We were deeply anti-German. We hated
every German by then. They'd been killing everybody we knew."

In the afternoon of that same day, Margaret, Bill Walton, Maitland
Edey, and several other correspondents drove out of Leipzig to a suburb
called Erla in search of an aircraft factory the Eighth Air Force had
bombed. The front was so fluid that somehow they got ahead of Ameri-
can troops. An odd odor began to fill the air. As it grew stronger, they
saw in the distance a high fence of barbed wire staked out around empty
ground. They stopped the jeep, ran through a narrow gate in the fence,
and found themselves standing "at the edge of an acre of bones."

It had been a work camp for the aircraft factory. As American troops
approached, the Gestapo moved all but the weakest three hundred pris-
oners deeper into Germany to work in another factory. The day before
Margaret reached Erla, the camp guards set out pails of hot soup in the
mess hall, lured the remaining prisoners inside, nailed the door shut on
them, then poured gasoline on the building and threw hand grenades
through the window. The mess hall went up with a roar. A few men
burst out of the flames; the Nazis were waiting with machine guns. A few
escaped even the guards and raced through the fence to the meadow
beyond. These were gunned down by *Hitlerjugend* in tanks that had
been brought up for the occasion. When the correspondents entered the
camp, the ground was still hot. No one, not even American troops, had
reached Erla before them.

Thirty-seven years later, Bill Walton recalled the day they stumbled
on the Erla camp. "Some figures burned, halfway up the fence, still the

blackened, crucified figures trying to climb the fence. Not a soul had seen it, not even soldiers. You were reduced to screaming, it was so awful." Tears well up in his eyes as he speaks. "Margaret found it very hard to even start work. From somewhere off across the field"—now he is weeping—"came one man in the black-and-white-striped uniform of prison camps, trudging across, and from another direction another. They fell into each other's arms." By now Walton is crying uncontrollably; he takes some time to find his speech again. Eighteen people out of three hundred had survived. Margaret had described them embracing each other "while standing up to their ankles in bones."

Walton continues: "We were both just sobbing so we couldn't work. It was the greatest horror I ever saw. I went to other camps, saw bodies piled high, pale green in death, but this was so immediate, all in positions of agony. . . . Here they all were, brand-new, with a terrible smell. . . . I didn't take a note. You don't need to. There isn't a detail you can't remember."

But a photographer has only the moment, and no amount of recollection in tranquillity will put it onto film. Margaret made her notes with the camera: blackened, blistered bodies lie face down at intervals beside the barbed-wire fence, their knees bent, their feet reaching up into the air, as if death had caught them in full motion and they were trying still to run, hopelessly, into the smoldering earth.

In the weeks that followed, Margaret photographed without stop, trying to put on record events past understanding. She wanted to be everywhere. On aerial reconnaissance flights she worried that she was missing something major on the ground. Bill Walton thought she had an "infinite and educated curiosity," and that "her evaluations were way above average. I worked with a lot of people," he says. "She was one of the top."

Margaret's curiosity was so sweeping that she was intrigued by her own fall into the ranks of looters. (Maitland Edey recalls that "being exposed to the collapse of the German army day after day was totally exhausting. You got horribly coarsened very quickly.") Margaret told Betty Cronander, when they were working on *Portrait of Myself*, that looting was like "a fever and a passion," and that she was glad by then that she'd done it, because it made her understand the impulses behind such behavior.

Sometimes it was simply useful. The cellars of the rich invariably had stacks of fine monogrammed linens. Margaret would tuck clean sheets into her bedroll and leave behind dirty linens with someone else's monogram. Sometimes other motives took over. In Munich she "liber-

ated" a large green metal nude from the private apartment of Adolf Hitler himself and sent it out of Germany. En route to Paris, the statue disappeared. Someone had looted Margaret's loot.

On April 12, President Roosevelt died and Harry Truman was sworn into office. Joseph Goebbels telephoned Hitler to congratulate him. "Fate has laid low your greatest enemy," Goebbels said. "God has not abandoned us." Goebbels must have been wrong about God. Russia continued to press toward Berlin from the east, America and Britain from the west. Throughout April the roads in Germany were choked with refugees, and battalions of soldiers marched westward away from the advancing Russians to surrender en masse where they had more hope. On April 25, the day the United Nations was born, a patrol of American GIs met a group of Russians beside the Elbe River. By May, it was clear to everyone that the war was almost over.

Life had assigned Margaret to photograph the major industrial centers of Germany from the ground and from the air as they were captured, for an essay to be called "The Face of the Moon." The U.S. Strategic and Technical Air Forces would use her pictures for an analysis of heavy bombardment. On May 7 she took off for Kiel in a small observation plane. Kiel had surrendered, but no one was certain whether the RAF had yet secured the airstrip some distance from the city. "As it happened," she wrote, "our cub was the first American plane to land at Kiel, although this was unintentional on our part." They had circled so long over the harbor while she photographed that they were running out of gas.

As the plane came down toward the airstrip, they could see a large number of German planes on the field, some wrecked, some intact. There was only one plane with RAF markings. Had the British taken the field or had the Germans taken a British plane? When the pilot touched down he left the motor running in case they had to leave in a hurry. Giving Margaret instructions on how to throttle down if the little plane should begin to take off by itself, he drew his pistol and vanished into the hangar.

Margaret waited, nervously. A wind was up, and the light Cub sidled down the runway, picking up speed as it went. Thinking it better to be taken prisoner than to take off by herself, Margaret switched the engine off and sat tensely inside the plane. To her relief, the pilot returned with a British officer. The RAF had taken the airport with astonishing ease. Because the Luftwaffe knew their war was over, they had celebrated until dawn the night before, then welcomed their conquerors on unsteady feet.

That night, Generaloberst Alfred Jodl signed Germany's uncondi-

tional surrender; the war in Europe was over. At one minute before one on the morning of May 8, peace would officially begin. At dawn, Margaret set out again in the Piper Cub, heading toward the North Sea. As they flew forward, neither she nor her pilot knew they had passed the farthest forward position the Allies had reached. Nor had it occurred to them that news of the surrender had not yet reached every town in Germany. They soared back and forth over submarine pens as Margaret photographed the harbor near Bremerhaven, unaware that the army of occupation was some thirty miles behind them. Suddenly shots were fired at them from ack-ack emplacements at the far end of the city. Margaret was so engrossed in her photography that she did not notice. Unable to figure out why the pilot had put the Cub into such a steep rolling dive, she called out to him that the position was no good. He wasn't listening.

The plane's evasive action brought them quickly down to rooftop level at the opposite end of the city. The pilot swooped above the Rathaus, changing course as fast as possible. Instantly the city square filled up with people rushing out of houses, waving white sheets and handkerchiefs. While the far end of Bremerhaven was trying to kill them, the near end, equally unaware that their country had just been signed away, was surrendering to Margaret Bourke-White and an air force pilot in an unarmed Piper Cub. The two Americans decided they did not know of a graceful way to accept a city's surrender from the air and nosed their plane instead toward safer territory.

She flew over Coblenz, Frankfurt, Mainz, Munich, Nuremberg, the Krupp steelworks at Essen, I. G. Farben at Ludwigshafen, photographing the broken bones of cities, the hollow towns where the few buildings that still stood lay naked and open to the sky. Since February, British and American planes had been relentlessly pounding German cities into the dust. By March, fifty thousand tons of bombs had been dropped on Cologne; only 120,000 citizens remained of a prewar population of 700,000. Dresden, a city as splendid as a museum—Goethe claimed his life had been changed decisively by the opportunity to see it—had thought itself so safe from attack that its antiaircraft guns had been replaced by papier-mâché copies. Three waves of bombers fell upon Dresden on February 13, smashing the city's baroque glory into shards of burnt stone and literally tearing its populace to shreds. Margaret's aerial photographs of the burnt-out towns of Germany from the air show an eerie landscape of outlines where only the walls still stand, as if some ancient architect had jotted down careless, smudgy notes for a doomed civilization.

Back on the ground, she photographed the blasted industrial strong-

holds of the Ruhr. Margaret had been there before, years earlier, when the factories were not yet fully primed for war. In the early thirties she had been arrested as a spy while photographing smokestacks from across a German field; now she was free to photograph up close, where the smokestacks lay dismembered on the ground. Krupp had not permitted her inside to photograph for *Fortune*, yet now that Alfried Krupp was a prisoner, Margaret photographed him, interviewed him (part of her interview would be read at the Nuremberg trials), slept in what had been his private suite, and plied her camera freely throughout his maimed and broken steelworks.

Once *Fortune* had published her abstract, sonorous studies of German industry. *Life* did not publish her pictures of their monumental ruin, but they, too, were brilliantly composed; Margaret had an eye for devastation. The twisted girders and smashed I-beams signaled the final irony of the machine age: the technology that promised utopia had delivered Armageddon. Margaret herself never saw it that way. She did not lose her faith in machines, a faith her father had handed on to her when the century was still young.

Margaret's war pictures were important documents. *All* war pictures were important at the time, especially if they came from a zone no one else was covering, although not many of them have stood the test of time. Margaret's pictures had an additional punch because they had been made by a woman in combat. Some are still memorable after all these years, primarily the night bombardments of Moscow, her pictures of suicides and bomb damage in Germany, and especially the shattering images taken in concentration camps.

Once again, however, her career was more influential than her photographic style. In the Second World War, a new style of war photography began to evolve in the work of young men with small cameras. Robert Capa focused on war's effects on civilians or else waded right into the action, as he did to get his blurred images of the Normandy landings. A style that put the photographer in the midst of the action, or one that was openly emotional, grew gradually in pictures like Ralph Morse's helmeted Japanese skull stuck on a pole as a trophy, George Silk's blinded infantryman led by a native on Buna, W. Eugene Smith's American soldier carrying a tiny, fly-covered baby out of the jungle. The emphasis on action seen up close, on individuals, and on emotions *in extremis* would mature in the Korean War, sometimes at the hands of men who had tried out the style in World War II.

It was never Margaret's style. She was never an action photographer, seldom one with the will or means to probe psychological depths. Her subjects were large—bombardments, air raids, the devastation wrought

by bombs—and so was her style, which leaned on the big picture, the grand composition, the tripod, the aerial view. Unlike Capa, whose motto was "If your pictures aren't good enough, then you aren't close enough," Margaret was generally at her best working at something of a distance. George Hunt, later the managing editor of *Life*, sums her up as "a damn competent, good photographer, brilliant when the situation was right."

On Margaret's return to America, she began to write a book, in part to give a shape to her German experiences. That was harder than it seemed. Her sister, Ruth, when she read the first draft, wrote Margaret that the material was distasteful and the writing seemed to betray an unfortunate inclination to look on war as some grand adventure. Margaret went back to work on the manuscript.

She wrote very well, with a breezy, journalistic style occasionally touched by humor, moral outrage, pointed irony. She had, as might be expected, a good eye for detail, and her description was sometimes eloquent. Her books sold handsomely and kept her name and exploits before a vast public. In *They Called It "Purple Heart Valley,"* she had begun to voice her political convictions and her liberal idealism. In the new book, the voice grew stronger.

"*Dear Fatherland, Rest Quietly*" (the title comes from "Die Wacht am Rhine," which German soldiers sang as they marched to battle) was dedicated to M.J.P.—Jerry Papurt—"who died too soon." The book amounted to a set of vivid questions: Who are the Germans? How could they have done this, and why? She had no answers. Percy Knauth recalls many conversations with Bourke-White in Germany as she struggled to comprehend how a people so neat and orderly, so culturally advanced and apparently human as the Germans, could commit such atrocities or stand by and do nothing while inhumanity sank to new depths. The lesson that Margaret had learned from Erskine in the South in 1936, that "the people and the forces which shape them: each holds the key to the other," had become crucial to her work.

"*Dear Fatherland*" is saturated with Margaret's anger, her hatred of Germany, her commitment to democratic ideals, and her despair over the indifference of the American response.

> We turned our backs on our greatest opportunity to do something constructive with the youth of Germany. We had no plan, no desire, no willingness, it seemed, to teach a democratic way of life. We poured out lives and boundless treasure to win a mechanical victory and now we had no patience for the things of the spirit which alone can save us from another far greater catastrophe. . . . Unless we do, this war will be without meaning for us, and

some of the hope for a good world will die down in the hearts of men everywhere.

Nineteen forty-five was a good year for wondering what was to become of the world. Percy Knauth recognized Margaret's high aspirations. At that time, he says, the world was

a place that had room for hope, that allowed people to have ideals and to work for them. . . . I think she was an idealist before the war too, but she grew into a time and a situation that gave her scope to be one. . . . I think that in her pictures she liked to show that there was hope for us all. I think that goes back to her industrial work, looking for and creating beauty in something that was intrinsically ugly.

In 1945 it was so obvious that a terrible thing had ended, that we really did have a chance to start things off and do it better. She wanted to do things better. She wanted to do pictures better, to do prints better, to show the world better. She wanted it to be a better world.

The German experience had undermined a faith that Margaret wanted restored. Her fear and hatred of fascism, kindled during the thirties, only increased, and in "Dear Fatherland" she pleaded with her country to fulfill its mission of moral leadership and flesh out the dream of a democratic society. The war had placed her foursquare in a role she had first taken on in You Have Seen Their Faces: the photojournalist as crusader. In 1945, her politics, her writing, and her photography fused in a single cause.

India: A Pillar of Fire

Life had been eager since the end of the thirties to articulate a role for the United States as a major world power, a role that many had foreseen and that the war would make inevitable. In 1939, Walter Lippmann wrote in *Life:* "What Rome was to the ancient world, what Great Britain has been to the modern world, America is to be to the world of tomorrow." Henry Luce, in a controversial article called "The American Century," made clear in 1941 that he thought American hegemony a kind of holy mission: "The other day," he wrote, "Herbert Hoover said that America was fast becoming the sanctuary of the ideals of civilization. For the moment it may be enough to be the sanctuary of these ideals. But not for long. It now becomes our time to be the powerhouse from which the ideals spread throughout the world and do their mysterious work of lifting the life of mankind from the level of the beasts to what the Psalmist called a little lower than the angels."

From the pulpit of his magazine Luce assured his subscribers that Britain was ready to pass the mantle of leadership to America. "Among serious Englishmen, the chief complaint about America . . . has really amounted to this—that America has refused to rise to the opportunities of leadership in the world."

In the postwar world America rose to its opportunities. *Life* never let the country forget it. June 14, 1943: "Post-War Plans: Only National Interest Makes Sense—But 'Our' National Interest Is as Wide as the World." November 25, 1946: "World Power: The U.S. Has It and Knows It." September 12, 1949: "A New World Is Shaping Around the U.S., and the British Crisis Is Part of the Change." *Life*, in need of an eyewitness to the fall of the British Empire, sent Margaret Bourke-White to India.

The end of the war spelled the end of the biggest story in the world. *Life* and its photographers had to regear. Margaret, whose themes were always large, needed momentous events to match the levels of challenge

she had built into her working life. Wilson Hicks, who understood this, discussed Margaret's career with her and kept a shaping hand on it. Hicks cabled her while she was on a lecture tour that her next story would be India.

She arrived on the subcontinent in March of '46 and moved quickly to get a picture of Gandhi. She had heard him inveigh publicly and often, through a twentieth-century microphone, against twentieth-century machinery, against the tractor and the textile mill. Surveying the dry land, the hunger, the stupefying poverty of India which she was certain industrialization could relieve, Margaret never quite understood Gandhi's animus toward the machine.

When she made her appointment with him, Gandhi was staying with untouchables in a sprawling slum that smelled of human excrement. As soon as Margaret walked in, his secretary asked if she knew how to spin. The Mahatma's spinning wheel was the symbol of his drive to rid the land of British dominion. Like colonial empires generally, Britain siphoned off the raw materials of its colony to fuel the industrial plant at home. Indian cotton was turned into cloth in British textile mills, then sold back to India for clothing. Gandhi insisted Indians should break the chain of dependency by spinning their own cotton.

Margaret neither knew how to spin nor cared, but the secretary insisted that if she could not spin she could not understand the symbolism of the wheel. He was implacable. At last, because her pictures had to be on the plane that night, Margaret asked for a spinning lesson. When it was determined that she could spin well enough to understand, the secretary advised her that it was Gandhi's day of silence and she must not speak to him. Nor could she use artificial light; he didn't like it. Realizing that the hut would be dark, she pleaded for her lighting equipment and was finally permitted three peanut flashbulbs. She found Gandhi seated cross-legged on the floor in a hand-woven loincloth, reading newspaper clippings through steel-rimmed spectacles perched on his nose. He was seventy-seven, tiny, shrunken, and bald, and he had defied the greatest empire in the history of the world.

He paid no attention to the photographer who had invaded his reading time, and she was grateful, for the bare room was impossibly dark, with sun coming through one high window directly into her camera and her eyes, and she had to maneuver to avoid the halation. As Gandhi began to spin, she used the first of her three bulbs. The flash was delayed. India's heat and moisture frequently sabotaged her machinery. With only two bulbs left, she turned to time exposures, but her tripod soon froze with one leg at its minimum length and the others at the maximum. Carefully checking her flash, Margaret fired the second bulb. It worked

exactly as it should—but she had forgotten to pull the slide. At least the third bulb worked.

This sitting, which was every photographer's bad dream come true, resulted in a picture that has been endlessly reproduced. The spinning wheel up close in silhouette spreads its arms over the entire left half of the picture. Slightly behind it sits the Mahatma, wholly involved in studying the papers on his lap. His head is bowed to read, and the light from the window behind him clearly outlines his bald skull with the radiance of a discreet halo. Margaret has composed an icon for a secular saint, humble, meditative, graced by light, and accompanied by his symbolic spinning wheel much as western saints are accompanied by their emblems.

Margaret photographed Gandhi many times afterward. He called her, fondly, she thought, "the torturer." His inconsistencies puzzled her rational mind; it was not until she saw his self-sacrificing bravery in the face of India's convulsive violence that she began to think him akin to the saint she had made him out to be with her camera.

She also photographed Mohammed Ali Jinnah, the Moslem leader, whose features were as sharp as the creases in his western business suits. Jinnah would almost single-handedly bring about the partition of India and the creation of Pakistan. He was the rock against which Nehru, Gandhi, and their Congress party foundered and Mountbatten broke. "We shall have India divided," Jinnah said, "or we shall have India destroyed." Before he died, he fulfilled the first part of his vow and came close to fulfilling the second.

During her first few weeks in India, Margaret met, photographed, interviewed, and charmed scores of officials. Robert Sherrod, a *Life* correspondent on the scene, wrote to a friend: "She knew more about India after three weeks than most reporters learn in three years. She has more energy than anybody else in India, and she works like hell in spite of the deadly heat."

Her cultivated charm had matured to a diplomatic mastery. Sherrod and David B. Richardson, another correspondent, hosted a big party in April. Margaret arranged the invitations, decorations, everything. She invited warring officials who would barely sit down together at conferences: Hindu nationalists, Moslem separatists, Communists, British diplomats, and maharajahs; Nehru, Jinnah, Feroz Khan Noon—the future prime ministers of India and of Pakistan. They all liked Margaret, who dressed to provoke their delight in a backless halter-top dress cleverly run up from a sequined paisley scarf. Sworn enemies became gentlemen accomplices for a few hours, men who were professionally rude to each other reverted to politeness all evening. One British diplomat was heard

to exclaim, "Delhi has never seen the likes of this gathering. The catalyst certainly is Bourke-White."

Her diplomacy was subtle, her priorities clear. An Indian photographer named Sunil Janah was recommended as an assistant; she located him at Communist party headquarters. He agreed to travel with her because he was scheduled to photograph in the same region, and he thought it humorous that *Life* should pay the expenses of the Communist party of India. The two of them journeyed to a remote region by riverboat. At the last departure point, their host aboard the boat insulted Janah, who refused to go any farther on the trip. "I could see that [Peggy] was angry," he writes, "but she calmly sat down beside me. 'Look, Sunil,' she said, 'you know that I am on your side of the fence, no matter who and what these people are. They and they only can take us where we want to go to do our own work. It is not for our gains and satisfaction or whatever but for being able to tell the world what we may find with our pictures, isn't that what our job is all about? And if our personal feelings get in the way, at any time, don't you think we should get rid of them?' "

He has remembered this all his life. "I remember her not merely as a famous photographer I had worked with but as one of the finest human beings I have ever known, who used her sensitivity, understanding, and her great ability to voice our social conscience through her photography."

Alone, Margaret went north in April to Simla, new site of the freedom conferences and the summer capital of the British raj, a city of English churches, gardens, and bandstands sitting in the shadow of the Himalayas. She traveled with Gandhi, who insisted on traveling in third-class trains with his followers and his goats; as he had renounced cow's milk, the herd was essential. He needed, in fact, a group of third-class trains. One of his supporters once remarked that Gandhi ought to realize how much it cost to keep him in poverty. Margaret, the only unattached woman on the train, had her own small compartment, between Nehru's and Gandhi's; later she said she was the only American woman to have slept between the two of them.

On the train to Simla, between Nehru and Gandhi and the goats, Frank Moraes, a leading Indian journalist, fell in love with Margaret. Moraes, a good-looking man, his hair black and wavy, cut a romantic figure. A Christian who shared the nationalist views of Gandhi's followers, he drank heavily and smoked regularly among the ranks of ascetic Hindus. He spoke fluently with an upper-class British accent acquired at Oxford and had a slightly Victorian manner of address, a bountiful fund of amusing stories, and a journalist's inexhaustible file of knowledge.

He was married. His son says Moraes adored his wife and that they were "one of the bright young couples of Bombay," giving and going to expensive cocktail parties. The author Ved Mehta, who visited the Moraes household in India, says Frank ran an open house that always attracted interesting people. Mehta found him charming and "very youthful, as if a permanent undergraduate . . . wistful, a little sad." He had extensive free time in which to exercise his numerous social graces, and the ease of a man who likes and is liked by women. Mehta says he was "sexually active, but in a lost way, and lovable, but also in a lost way, like a child." In a warm haze of alcohol, affability, and quick intelligence, Moraes gave the impression of being gentle, sweet, and at the same time cool-headed, an image that he himself mocked.

He and Margaret were soon writing letters every day as she criss-crossed India. His were rapturous, speaking of sexual and emotional bliss. She approached him with her habitual caution and her personal insistence on honesty. Apparently she let him know early on that she insisted on her freedom.

Moraes had seen through the defensive fortifications Margaret had built so carefully. He wrote her that before he'd been interested in her he'd thought she had a streak of hardness.

> As I now know, it isn't hardness but the protective front which a hurt nature offers to an untrustworthy world. Far from being cocksure you're not at all certain of yourself, Darling. All that you've done and achieved you've realized at the cost of hard, sustained work. And you don't want to lose it. The most precious thing to you is Security—a thing you didn't have in your childhood; which you thought you'd achieved when you married Chappie but which was shattered overnight. . . . You're "hard" only in the sense that you'll fight like a tiger to hold what you have. Because what you have signifies to you what you've made of yourself in the face often of tremendous difficulties and obstacles—and if you lose that, you lose the Big Thing that matters—Faith in yourself—and you feel your world will collapse around you.
> . . . You've always been understanding but I've a feeling that you're afraid to show tenderness to anybody, although lately you've done it to me.
> . . . It's only people with great reserves of feeling who can really be tender.

Moraes willingly instructed Margaret in Indian politics. She had made it known as soon as she arrived in India that she intended to write a book, and "not a pretty picture book." She probed for information everywhere, pulling her notebook from her purse at formal dinners in a manner so straightforward and ingratiating that people did not hesitate to talk to her. David Richardson, commenting on her bright mind, her infinite capacity for hard work, and the magical, magnetic quality of her

striking looks, her poise and animation, says, "I don't think I ever revered any woman journalist the way I did her. . . . Up to then, many of us had assumed that if a woman was a journalist she would deal on an emotional level. . . . Up to then, women were sort of freaks in journalism abroad."

Moraes, who seemed to know everything, would have helped greatly with her book. She had met his publisher, who was to help her even more: Peter Jayasinghe, a man a dozen years or more her junior, with looks as aristocratic and elegant as *Burke's Peerage*. Two American women describe him as being the color of coffee with cream, with "velvet black eyes" and delicate hands fingering his luxurious tie, altogether more "handsome, stunning and beautiful than Tyrone Power in *The Rains Came*." He exuded a taste for high living. And he, too, fell in love with Margaret.

He drove her about Delhi in a yellow convertible, chasing along on assignments like a devoted puppy. He helped her so extensively with her research that she offered to share royalties with him, an offer he apparently turned down. Frank Moraes was extremely jealous of Jayasinghe, who dropped hints of his conquest. But Moraes had a much more severe problem with jealousy: his wife's. Beryl Moraes was going mad. Trained as a pathologist, she began to spend her days alone, methodically saying her rosary. A pretty, lively woman, she had become withdrawn and unkempt, her mind seething with suspicions of Margaret.

Dom Moraes, their son, a poet and author, was about eight years old when his mother came into his room one night to tell him about an American woman she'd met at a party the night before. His father, she said, had known this woman for years. He'd been with her in America all during the war when he claimed to be a correspondent in Burma. She demanded that Dom go with her to the woman's hotel and plead with her to leave Frank Moraes alone.

Dom Moraes wrote about the incident in his autobiography.

We went up to the American woman's room. She opened the door, a tough handsome woman in her forties [Margaret was forty-two], smart in slacks. A swell of shame swamped me, but my mother's hand was firm on my arm.

"I want to speak to you," she said in a high trembly voice, "about my husband."

The American woman looked very puzzled. However, she held the door open. "Do come in," she said. "We met yesterday, didn't we? Is this your little boy?"

My mother did not answer, but in the same high, trembly voice launched into an interminable speech about my father's misdeeds, which I tried not to hear. The American woman stared at her in amazement. When my mother paused for breath she said very kindly, "Look, honey, you're not

well. Come sit down a moment, and have a cool drink. You wait here,
Sonny," she said to me. "There's some picture books in that shelf there.
Don't worry, your Mommy's fine."

That afternoon, Beryl Moraes seemed to recover. She told her son
on the way home that she'd been "a silly ass." But her madness was not
to be stopped by talk, and her jealousy had cause. About this time, Dom
Moraes reportedly said he would like Margaret to be his mother because
she understood his father and himself and he could depend on her.
Frank Moraes was suffering. He cared deeply for his wife and wanted
her well. He even asked Margaret to postpone her second trip to India
because Beryl was improving. Not surprisingly, Margaret refused. Once
she wrote Beryl a letter, which she probably never mailed, saying she did
not want to do anything to hurt her or to spoil their friendship. No doubt
she meant it.

Certainly she was not the cause of Beryl Moraes's madness. Mrs.
Moraes would have found another fixation had Margaret not been there.
But for a woman who had so little wish to do harm, Margaret had left
behind her a wide swath of injured wives. She who did so much to raise
the status of women in her profession seldom conformed to feminist
ideas of solidarity. (Helen Caldwell Cushman remarks, "I don't say she
was above reproach. She was above self-reproach.") Beryl Moraes, in the
midst of a nervous breakdown after Margaret went back to America,
persistently imagined other people were Bourke-White in disguise. The
real Bourke-White could not trouble her much longer; the distance to
America was too great for grand passions.

India virtually submerged Margaret beneath its sprawl and clutter.
For months she was visually adrift and sent back little of consequence.
It took a disaster to focus her talents clearly. Jinnah announced to the
press that the Moslem state of Pakistan would be founded on "Direct
Action" if necessary. August 16 was to be the day of proof.

That day, the morning dawned white and thick with heat over the
bazaars, souks, and fetid alleys of Calcutta, a city already legendary for
its cruelty. At first light, Moslem mobs swarmed up out of the filthy
slums. Screaming, burning, rampaging for five days without stop, they
clubbed to death thousands of Hindus, leaving the streets clogged with
mutilated bodies and the Hooghly River awash with bloody corpses.
News of the massacre spread like fire in a high wind. Violence abruptly
flared across the country; civil war threatened to explode. The savagery
of religious fanaticism in Calcutta changed history in India, unleashing
hatreds and reprisals that in time split the country apart.

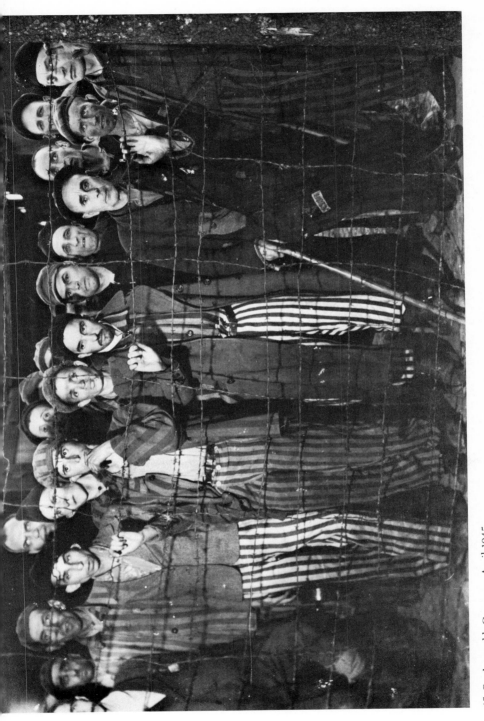

45. Buchenwald, Germany, April 1945

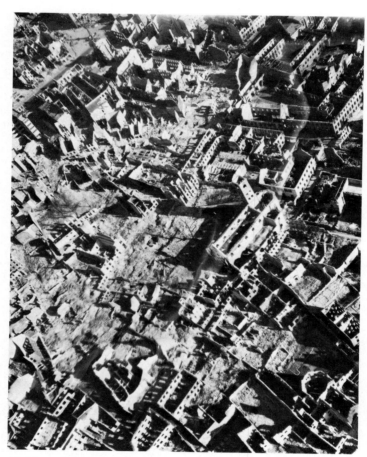

46. Mainz from the air, Germany, 1945

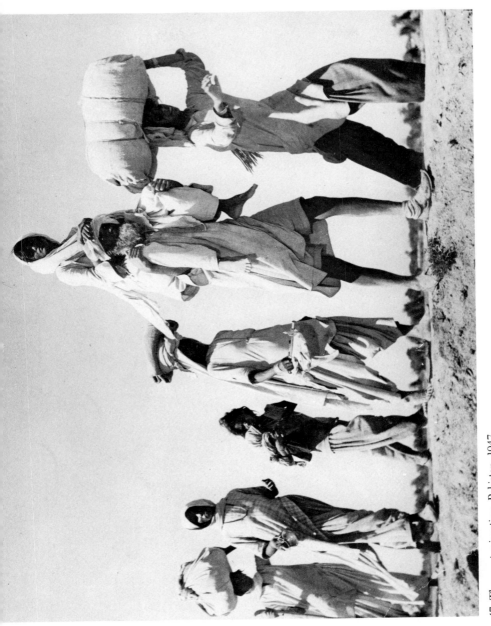

47. The great migration, Pakistan, 1947

48. Frank Moraes

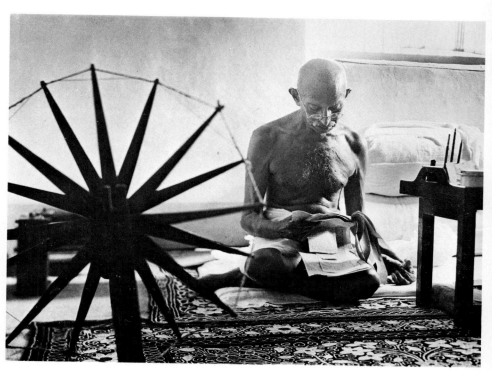

49. Gandhi, India, 1946

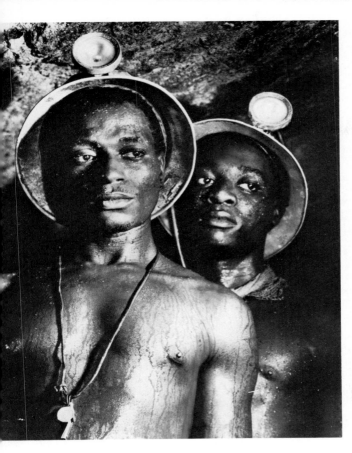

50. Gold miners, South Africa, 1950

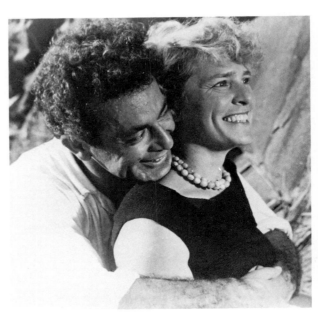

51. With Alexander Schneider

52. Nim Churl Jin and his mother, Korea, 1952

53. San Jacinto Monument from a helicopter, 1952

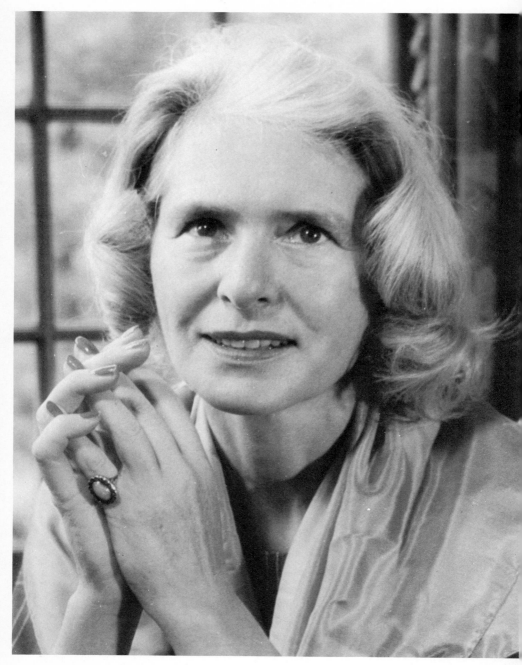

54. Margaret Bourke-White, late 1950s or early 1960s, by Frank Altschul

As soon as she heard the news, Margaret flew to Calcutta. An Associated Press photographer named Max Desfors had been there when the riots erupted; she realized he had come across something extraordinary and badgered him to tell her where. Unwilling to be scooped, he held back the information until he was certain his film had reached his London bureau, then admitted that a driver from the provost marshal's office had found a scene of unparalleled carnage. Instantly Margaret went to the provost marshal, wept when he seemed reluctant, finally got the same driver and found the same place.

The street was short and narrow. Small, single-story houses looked out blindly from locked doors and tiny vertical slits of windows. Lying like garbage across the width of the street and in its open gutters were the bodies of the dead. Some were eviscerated, others in pieces, all hideously swollen by death and exposure to sun. Some had been picked clean down to the bone by vultures, now the street's only live inhabitants, score upon score of them, moving slowly among the corpses. A few had eaten so much they could no longer fly.

David Richardson accompanied Margaret that day. "The sweet stench of death was so strong," he says, "that I clutched a handkerchief to my face while holding out a flashgun . . . to fill in the dark shadows among the clustered dead." Margaret was shooting 4 × 5 on a tripod so her pictures would not turn grainy if enlarged. In the grinding heat she put her head under the black focusing cloth and fired one sheet of film after another. The horrors she'd seen in Germany must have steeled her for yet more. "Like Germany's concentration camps," she later wrote, "this was the ultimate result of racial and religious prejudice."

Richardson heard footsteps—"a British colonel, resplendent in fresh tropical khakis and bright decorations, and accompanied, at two paces, by his Indian batman. . . . 'I say, old chap,' he asked me, jauntily pointing his swagger stick toward the black-hooded Peggy at her tripod and camera, 'taking a few snaps?' " Margaret's head shot out to glare at the man's retreating back, then she dived again beneath the cloth, where the lurid street hung with preternatural clarity upside down on her ground glass.

When Bourke-White showed Desfors a cable from her New York office that said, "Your vulture pictures simply magnificent," he realized he hadn't yet heard about his own. He cabled London. The return wire read, "Your bodies inedible for British consumption." Bourke-White got a double-page spread in *Life*.

Back in Darien in the fall, Margaret began to write her book. When writing, she gave up all semblance of social life, but she would not deny

herself certain pleasures. "Have felt I was living too fast to write it. And I care more about living than writing. I care a great deal about writing but more about living. This is a constant conflict. I dislike conflict and am against it—but this one will never be resolved until the book is written and sealed within two stiff covers." She would not entirely give up men. One longtime lover who had seen her to the plane in London was surprised that she hesitated to let him kiss her in public. He wondered if she was fearful of narrowing her options on the transatlantic flight.

In the States, there was a *Life* artist she cared about for a time, and she resumed the passionate affair she'd had with the Russian expert Maurice Hindus in the early thirties. Peter Jayasinghe flew to America to see her. Totally engrossed in her writing, she did not meet him at the airport and asked him to supper not that night but the next. He never quite forgave the slight and she, writing years later, said it was on her conscience still.

Still, he wanted to marry her. She refused him gently, asking him to stay her good friend. Marriage was out of the question. He was always hurt when her work came first, which was a fatal sign, and once he had committed the cardinal sin: he had given her an order. No one ever gave an order to Margaret Bourke-White, who had won such complete control over her own life, but Jayasinghe one day told her to clean her car. Responding with a rare burst of fury, she threw a wastebasket at him. She knew too much to marry him, but her affection for him was genuine, and they remained friends long after she became ill.

Another good friend, Ed Stanley, who had had an intimate, often interrupted relationship with Margaret since the early thirties, helped her extensively with most of her books. A journalist and a skillful editor, Stanley edited, rewrote, selected pictures, and wrote captions for her. In 1947 he persuaded her to recast her reporting along broader, more balanced lines.

Although Margaret had not overplayed her sympathies with Gandhi and the Congress party but had kept good relations on all sides, Ed Stanley thought she leaned too heavily on left-wing sources. He told her bluntly that she did not know enough to write the serious book she had in mind.

"That made her absolutely furious," he says, "not being accustomed to having her talents challenged. . . . I didn't hear from her for weeks and weeks. One day she called up and talked for three hours about going back to India. What should she do? I said one of the things is read one of the British histories of India. . . . You need to talk to some other people, not just to Frank Moraes . . . no matter how happy you are in his company."

About this time Margaret began to speak often about getting both sides of the story. She also began to plan a second trip to India, telling *Life* she would go on her own if necessary. Her luck held true: *Life* came through with an assignment, and CBS asked her to broadcast news of the upheavals to America. Back in India by the fall of '47, she studiously set about photographing the length and breadth of the society: jewel-studded maharajahs, peasants reduced by drought to eating leaves, moneylenders in houses aburst with crystal chandeliers that did not work, untouchables, bearded Sikhs immersed in the Pool of Immortality. One day she would photograph the men who worked in the mills of a textile magnate; the next day she would interview the magnate himself. "Really trying to understand what was going on in India," she wrote, "so I could make it clear in my book—this effort had a deep effect on me. I can't overestimate it. It was as though it helped me climb to a higher level of understanding." That was a long-term expedition for Margaret; her sights were always fixed on a higher level.

Halfway to Freedom, the most politically aware of all her books, is a balanced and intelligent, if not scholarly, assessment of a complex situation. She had made Ed Stanley's insistence on objectivity into her credo. Years later, receiving a photography award, she said: "The photographer must KNOW. It is his sacred duty to look on two sides of a question and find the truth." To illustrate, she spoke of her work in India.

In '47, when *Life* first wired Lee Eitingon, a reporter in India, that Bourke-White was on her way, Eitingon was tempted to quit. She had shared a room with Margaret in Paris one night near the end of the war, and Margaret had asked her to run her bath. She did not quit, and to her surprise found Margaret perfectly reasonable to work with, even quite helpful when Eitingon fell ill.

They traveled for five months in India, one American woman with an extravagant smile, a strong jaw, and a mass of gray hair, and a younger woman who was slim, dark-haired, and instinctively elegant, with finely chiseled features. (Ed Thompson, who later married Eitingon, cabled the two of them that they must be the biggest thing there since the Cherry Sisters. Eitingon cherished the compliment for years; neither she nor Margaret knew that the Cherry Sisters were a turn-of-the-century vaudeville act so prodigally inept that people came to see them on the strength of their bad notices alone.)

Assigned to cover an orgy of destruction that fifty-five thousand armed soldiers had been helpless to quell in northern India, Bourke-White and Eitingon were repeatedly warned that it was too difficult and dangerous for women. The warnings only pushed them farther into the field. Bourke-White's courage had already been on display in India.

When she was a guest at Sunil Janah's house in Calcutta, she never hesitated to go out with her camera into seething streets no Indian would face. Janah was often unnerved by her bravery, saying it might be all right for a white woman to go to Moslem headquarters, but if he went with her he would be butchered without fail. "Over my dead body," she would say, and convince him to come along. She said she would claim he was a black American, impossible on the basis of his looks; improbably, it worked.

Eitingon explains the bravery of women correspondents: "Both of us were whatever the female equivalent of macho is. The smells were so terrible, the officers accompanying us would have handkerchiefs over their faces. We would not. . . . That was part of the time and the period. Being women, we had to be tougher. There were very few women doing things like that. One felt more pride in not knuckling under to any feminine weakness." Weakness would have been forgiven of anyone, man or woman, in the Punjab that September, but it probably would have spelled death.

> At the stroke of the midnight hour, while the world sleeps, India will awake to life and freedom. A moment comes, which comes but rarely in history, when we step out from the old to the new, when an age ends, and when the soul of a nation long suppressed finds utterance. Jawaharlal Nehru to the Indian Constituent Assembly, August 14, 1947

Wholesale slaughter began in the Punjab somewhat before the partition of India. The boundaries of two new nations had split the Punjab in half. Five million Hindus and Sikhs lived in Moslem Pakistan's half, five million Moslems in Hindu India's. On August 15 in Amritsar, home of the Sikhs' most sacred Golden Temple, a roaring mob of Sikhs descended on a Moslem sector, murdered the men without quarter, stripped and raped the women and then marched them, trembling with fear and shame, through the streets to their deaths in the holy precincts.

That afternoon, the long-distance train that rolled into the Amritsar station was ominously vacant, with no one peering from its windows or waiting at its door to descend. Puzzled, the stationmaster looked inside. The compartments were heaped with murdered Hindus, a tangle of human bodies, severed heads, and bloody arms and legs.

Later, Margaret saw a group of Sikhs in all their dignity, their beards rolled and their uncut hair hidden beneath blue turbans, calmly sitting cross-legged the entire length of the platform in this same station. "Each patriarchal figure held a long curved saber across his knees—waiting for the next train." Mobs murdered with profligate abandon for six weeks straight, until the Punjab could count as many deaths in a month and a half as Americans suffered in four years in World War II.

Out on the plains, along the rivers where Darius and Alexander the Great had led their conquering troops, the convoys of refugees began to mass, Hindus headed in one direction, Moslems in the other. They came in high-wheeled carts pulled by bullocks with humped shoulders and crescent horns. They came in little purdah wagons with dark curtains, they came on donkeys, on foot, on improvised litters, on the shoulders of the strong. They walked away from farms and houses with a few possessions in bundles on their heads, then bartered what goods they had for food along the way. Many who survived walked into a strange land without money, a change of clothing, or a hoe to cultivate the alien earth. Ten million people trudged across the face of the Punjab in just over two months, the greatest migration in history. A lone plane on reconnaissance over the wretched procession one day counted a single column of eight hundred thousand refugees.

Margaret and Lee Eitingon followed the exodus in a jeep. A pillar of dust hung over the column by day, a pillar of fire rose from the campfires at night. The monsoon refused to come on time that year. Heat beat down relentlessly; the sky was like a shield of burning steel. Food was scarce and cholera rampant. Those too weak to go on lay down by the wayside to wait for death in a swarm of flies. More than once Margaret saw children pulling at the hands of their dead mothers, tearfully begging to be carried as the convoy marched on without them.

Families mourning a death along the way seemed to compose themselves for Margaret's camera into classic patterns of tragedy. She took memorable pictures of the dogged convoys, photographs like excerpts from some immense frieze symbolic of the grim fate of the dispossessed.

"That frieze—" Lee Eitingon says. "We were there for hours. It was the most painful experience of the trip. She found a group she liked. She told them to go back again and again and again. They were too frightened to say no. They were *dying*." Eitingon protested. Margaret told her to give them some money. "That wouldn't help them. These people just needed to move on. That's why she was such a good photographer. People were dying under her feet. . . . She thought herself a great humanitarian, but when it came to individual people. . . ."

Yet Margaret herself felt that the Indian experience forced her to think in human terms more than she ever had before, and indeed, whatever the cost to her subjects, she took stark pictures of starving peasants and refugees that convey a sense of humanity *in extremis* with directness, immediacy, and the compositional clarity of the "posed candid" that was her forte. Her photographs of India are her most sustained body of work. They offer a kind of stately, classical view of misery, of humanity at its most wretched, yet somehow noble, somehow beautiful. The rhetoric of the thirties has been toned down, but the subjects are still mon-

umental, still posed, still dramatic, and the philosophy of life is akin to that of *You Have Seen Their Faces*: despair over man's inhumanity to man, but a promise that human beings are worthy of compassion and may yet be saved.

When the monsoon finally broke in September, the rains were the worst in half a century. Walls of water as high as houses thundered down the Punjab without warning, straight across the paths of the struggling convoys. One night at dusk the soldiers accompanying Margaret found a vacant hut near the river Ravi; they set up camp. A British officer who had seen the jeep turn off the road hurried in to warn them of floods. They left instantly; even so, they ended up wading waist-deep in the dark, pushing the jeep through treacherous pools and currents. Others were less fortunate. Margaret photographed a meadow where four thousand Moslems had camped for the night and three thousand had died.

The convoys went on, past skeletal dogs gnawing on swollen bodies in the water, past drowned men buried by the floods, their hands still reaching for the sky. The refugees passed by, too numbed by loss, too concentrated on survival to cast a sidelong glance. Margaret photographed it all.

She was ready to return to America in January of '48, when Gandhi announced a fast and she canceled her reservations. He swore to fast to the death unless violence was quenched in Delhi and the warring factions vowed peace for India. The fast is a peculiarly Indian weapon that Gandhi used brilliantly. In a land where hunger is endemic, Gandhi asserted his claim on men who were blood enemies of each other but not of him. In his fragile state he forced them to consider their differences in an atmosphere of urgency.

Gandhi's philosophy of nonviolence was at stake in this fast, a philosophy that had defeated the British Empire but seemed to have no hold over his own people. He was seventy-eight. Within two days his life hung in the balance. Only at the last instant did every faction meet his terms. The little man with the dream that changed history had once more mobilized a community and a nation. He broke his fast.

Margaret made reservations again and arranged an interview with Gandhi, now nearly recovered, on the day before she left. Until that day, she had never reconciled herself to the inconsistencies of his thought. She spoke to him about the atom bomb, which had dealt the second great blow to her faith in rational idealism, already shaken to the core by the Nazis.

She asked Gandhi how he would meet the bomb.

I will go out and face the pilot [he responded] so he will see I have not the face of evil against him. I know the pilot will not see our faces from his great height, but that longing in our hearts that *he* should not come to harm would reach up to him, and his eyes would be opened. Of those thousands who were done to death in Hiroshima, if they had died with that prayerful action—died openly with that prayer in their hearts—then the war would not have ended as disgracefully as it has. It is a question now whether the victors are really victors or victims . . . of our own lust . . . and omission.

She was moved by the force of his spirit. What seems to have impressed her most was that, directly confronting the terror at the heart of the modern world, he still believed in the power of the human heart and the ultimate triumph of good. Margaret spoke of Gandhi afterward with reverence and some awe. He seems to have reconfirmed for her the faith she had inherited and the optimistic world view she had lived by.

She was surprised to hear herself wishing Gandhi good luck as she left the interview. At seventeen minutes past five that afternoon, as he was walking to the prayer ground to conduct a public meeting, a member of the RSSS, a militant right-wing Hindu sect, stepped out of the ranks of devotees waiting for the Mahatma and fired three bullets into his chest. Gandhi spoke the name of God and died.

Margaret raced back to Birla House, where Gandhi had been staying. His body lay on a straw mattress next to his spinning wheel. The room was filled with mourners—people who had been close to him and important Indian officials. No photographers. Margaret, who knew the people around him so well, was permitted into the room without her equipment.

At six-thirty, or so it was reported to the American embassy by several distraught Indians and subsequently to the American secretary of state, Margaret suddenly pulled out a concealed camera and set off her flash. The soft mourning chants of the Gita abruptly changed to loud indignation. Someone seized the camera and threatened to smash it. Instead, the film was removed and destroyed, the photographer was unceremoniously escorted out of the building and told to leave the grounds immediately. She did not. Surreptitiously she reloaded the camera, concealed it again, and tried, unsuccessfully, to regain entrance to the building.

Her scoop having been shredded by angry people who had trusted her, Margaret turned to Gandhi's public funeral. The body rested on a weapons carrier decked with flowers; its machine-age power stilled, it was pulled by two hundred and fifty sailors over a five-mile route to the cremation grounds. The throngs were so dense they seemed to go on forever, Moslems and Hindus, Brahmans and untouchables, the reli-

gions and castes that Gandhi had hoped to unite in life truly united for that moment by his death.

Margaret could scarcely find a place to stand. A vantage point for photographs was harder still. When the flames of the funeral pyre rose in the air, she scrambled atop the hood of a truck to photograph the fire before the light died. As she tried to hold the camera still for a long exposure, the two men in the truck began to shove her back down into the churning crowd. Margaret clung to the truck, snapping as fast as she could, begging for a foothold, and still they pushed her off. Suddenly the crowd started to yell at the drivers to let the woman stay. A Moslem woman shouted out with authority: "She has the agility of a snake, hair like flax, a face like the sun, and eyes like the eagle. You should learn from her zeal!"

Even Margaret's zeal could not produce first-rate photographs where speed was so essential and her control so limited. But Gandhi had given her hope that the promise that appeared moribund after Germany and dead after Hiroshima might yet be fulfilled. She wrote that in the night beside his funeral pyre, she had liked to believe "that a tiny flame was kindling in each of those million hearts. . . . His supreme sacrifice in the cause of tolerance and unity could mean the turning point for India. He had given his life to light the way." A woman with a face like the sun and eyes like the eagle does not easily relinquish her dream of humankind.

27

Gold and Diamonds, Love and Work

*She was the only woman whose achievement was significant in her
lifetime. And, I might add, no woman has since reached the stature as a
photographer that Margaret did.*

Carol Eyerman, *Life* photographer

By the end of the war, *Life*'s influence was on a steady rise. The maga-
zine ran a series of ads in 1950 that claimed with no more than the usual
exaggeration and rather more than the usual quota of truth that *Life*
affected the way people in various cities ate, lived, and enjoyed them-
selves: "*Life* has become part of the commerce and culture, the enter-
tainment and enlightenment of people."

By now, their star photographer, who had already become the leg-
end she had created, amounted to a kind of public institution. Canada
named a lake after her. America gave her one of its highest accolades,
and true proof of her popularity: the honorary degree, from Rutgers in
1948 and from Michigan in 1951; and, in 1947, an issue of *Real Fact
Comics* devoted to her life.

By war's end she was no longer reaching for glory; she had it in her
hands. Conscious of being Bourke-White, she was in a race with herself
to keep her myth alive and glowing. Possibly this challenge provoked her
to certain excesses. Once, photographing from a helicopter, she dangled
from a sling beneath its belly to get a better angle; photographers won-
dered how much better the angle could be. Even the intensity with
which she tackled her work and the hours she kept at it sometimes had a
slightly frantic edge, as if she still had to prove to herself that she was as
good as any man in a man's field. She had long since proved that to the
world.

Before the civil rights movement gathered force, *Life* magazine al-
ready had a good record on racial inequality in America. An editorial

315

backed Truman's civil rights program of '49 but claimed the real problem was economic. Another editorial, on the full rights of blacks to citizenship, followed Jackie Robinson's testimony before Congress after he became the first black player in modern major league baseball. At the end of '49, the magazine assigned Margaret Bourke-White to report on a massive case of racial injustice that was comfortably removed from the prickly situation at home. The target was South Africa.

In 1948, and '49, South Africa had elected a new and harsher government, annexed South-West Africa in the face of three United Nations resolutions to put that territory under international trusteeship, and hardened its repressive measures against native Africans and what the government officially referred to as "coloreds." Bourke-White's support of American blacks had been on public record since the publication of *You Have Seen Their Faces.* The new assignment, she said,

> underlined a dilemma in which I found myself with increasing frequency, both in and out of Africa. What are you going to do when you disapprove thoroughly of the state of affairs you are recording? What are the ethics of a photographer in a situation like this? You need people's help to get permissions and make arrangements; you are dependent on the good will of those around you. Perhaps they think you share their point of view. However angry you are, you cannot jeopardize your official contacts by denouncing an outrage before you have photographed it.

She was incensed at a system that put children to work in vineyards and then paid them part of their salary in wine so they became alcohol-dependent customers; a system that took black men away from their families for eighteen months at a time to work in the mines, then packed forty of them into a windowless room to sleep at night; that would not permit them to learn a skilled trade or to move from place to place without a pass; that arrested them in order to provide cheap prison labor for white farmers.

Margaret put to work the razor-edged diplomatic skills she had sharpened in New Delhi. She saw every official and every practice in a country that had recently hobbled the press with cast-iron censorship. After India, she was determined to photograph both sides, but racial barriers, high as barbed wire, prevented her from meeting native Africans. Then one day an African woman approached her and spoke her name. The woman, who had recognized her from a newspaper picture, was carrying a worn copy of *You Have Seen Their Faces.* Yes, she said, she would introduce Margaret to her people.

One Sunday, Margaret saw a group of gold miners dancing their tribal dances in sheepskin costumes. Two were so graceful she knew

instantly they would be her subjects in the mines. When she asked the mine superintendent their names he could not tell her; miners were "units," known only by the numbers tattooed on their forearms. He said these two worked in a spot so deep and so hazardous that visitors were not allowed, but he would move them to a better location for her. She fought this a long time, saying she had to photograph things as they really were or she wouldn't photograph at all. She won. The next day Margaret stepped into the mine cage and descended slowly into the darkness two miles below the surface of the earth.

The air in the tunnel where the two men worked was heavy and clotted. The dancers moved to a different rhythm now, slow and fierce, as sweat coursed down their bare chests and glinted in the light. Margaret set up her lights, posed the miners, and went to work. A strange depression weighed down her limbs, and time slowed down to a maddening crawl. Everything she did, every move the two Africans made, seemed to be happening in slow motion. She found it difficult to raise her hands and could no longer speak at all. She would not stop. "I knew I must keep on," she said later, "because it had been so hard to get permission." The superintendent, realizing she was in trouble, led her to a part of the mine where better air revived her. Afterward she learned that a man had recently died of heat prostration in that mine. "But at least I had my pictures, so it was well worth it."

The waist-length picture of these two miners, sweat running in rivulets down their bodies, was one of Margaret's favorite photographs. It is pure Bourke-White. Shot close up from slightly below, the men become monuments crowding out of the frame. One stands behind the other plausibly enough, unobtrusively posed. The lighting is richly sculptural, quietly dramatic, romantic. The two faces, noble and melancholy, are circled by their miners' hats as if by metal haloes; on some symbolic level these men represent the downtrodden who suffer but endure. The beauty of faces, bodies, light, and texture and the composition of powerful forms testify to the photographer's firm belief in the power of art and of humanity.

Design was Bourke-White's great strength and her sometime weakness. Her sense of monumentality and dramatic simplification was unimpeachable. The muscular compression of forms in a small space, the masterly distribution of design elements, give her photographs a poster-like clarity and power. The symbolic content is equally clear, the message unambiguous and instantly telegraphed, as it must be in a mass medium. But it is precisely this emphasis on design and symbolism that made some of her contemporaries regard Margaret solely as a photographer of objects. At times she reduced men and women to the status of message

carriers; she saw them less as individuals than as symbols or universals, a view that has its own values but seemed to lack the intimate humanity some photojournalists and documentary photographers were reaching for. As John Szarkowski, director of the photography department at New York's Museum of Modern Art, puts it, "The content of her work was quite highly abstract: *the* sharecropper, *the* miner. The content has the same abstract quality as the aesthetics."

Margaret had always believed in the power of photographs to move the world. As a close friend says of her, "She felt that by doing what she was doing she would make a better world. She didn't have to say it. It was obvious." As she left South Africa she wrote a friend that the country had made her

> very angry, the complete assumption of white superiority and the total fo-
> cussing of a whole country around the scheme of keeping cheap black labor
> cheap, and segregated, and uneducated, and without freedom of move-
> ment, and watched, and hunted, and denied opportunity. And all through
> such a mist of fulsome phrases, whether it's the vote, whether it's a clean
> house, whether it's a chance to go to school—the patronizing cover phrase
> "he's not developed enough for it."
> . . . and as the Dep. Commissioner of Prisons said to me "if you could
> see how they live in their primitive conditions in their Native reserves, you'd
> see how vastly better off they are here." The humanitarians! Better off when
> they put them in jail.

On her return, she said so often and so publicly that she now hated gold and diamonds that her lecture brochures used her statement as a selling point.

Among the South African tribes in their brilliant costumes Margaret took surprisingly strong color pictures that *Life* published at the center of her black-and-white story. She had been taking a few color shots for *Life* all along, in Muncie in 1937, in England, North Africa, Italy, Germany during the war. *Life* did not publish them. Color was not her strongest suit, and during the war color reproduction took as long as eight to twelve weeks, too long for news stories. Besides, the news and documentary traditions had an established bias against color, a bias that remained so strong for years that in a Technicolor era, filmmakers who wanted to project a strong sense of realism chose black-and-white film. Margaret herself preferred it. "Black and white," she said, "is a phrase that means reality."

But by the end of World War II, when Ektachrome made it possible for photographers to process their own color film and see quickly what they had brought back (only Kodak could process the earlier Koda-

chrome), many professionals added color to their repertoire. Improved printing methods also put more four-color pages into *Life*. Margaret came to the *Life* lab eagerly and humbly to ask for lessons. They taught her that with color film, exposure had to be much more accurate than with black-and-white. When using color in the fifties, Margaret Bourke-White, whose name had been synonymous with overshooting, sent back fewer pictures than almost any other photographer.

From South Africa, Margaret flew to France to meet a lover.

In 1950 she was forty-six years old and might have admitted to forty-four. She was aglow with good health and energy and more vivid than ever—often tan, with surprisingly white hair, a trim figure, easy animation, and the certainty that she would attract attention. She did not lack for men, but suitable mates had grown fewer with time and her unmatchable fame. Since Chappie, she had not thought marriage was an answer, although she had tried it; by now it did not seem especially realistic, or even especially desirable. Helen Caldwell Cushman recalls that Margaret never said she wanted to get married again. "She never mentioned marriage as a career, shall we say." Her career itself was too permanently wed to excitement for her to settle for marriage.

Yet her domestic yearnings were still strong. She had imbued her Darien house with as much of her own personality as possible for one who was away from home so often. The entrance hall was practically papered with her awards, the living room literally papered with her photograph of a Czechoslovak forest, the dining room full of her photographs of India. (In her bedroom, the wall opposite the bed had no room for photographs; it was mirrored along its entire length.) The living room had a leopard rug and chairs covered with impala skins from her African trip, and an ashtray she had successfully looted from Hitler's apartment. After she took cooking lessons in Japan in 1951, she served every meal on china made by great Japanese and Korean potters, with Korean brass bowls. As a part of her had always longed for tradition, now she devised rituals in her house: alone at meals with a man, she wore a kimono and insisted he wear one too, for a dinner that might include pressed seaweed and hearts of sea urchin.

Margaret stayed alone a good deal, in the company of a couple of six-toed coon cats named for one Indian god or another. As she slept under the stars in good weather and sunbathed nude during the day, plumbers and neighbors learned to announce themselves loudly as they arrived. Once a Jesuit priest came to visit and she called out to him, "Oh, Father, wait till I get my vestments on!" She had designed a life, designed her very self, for limited sociability, but independence has its

costs, and loneliness is likely to be one of the items on the bill. Many who knew her in the forties and fifties thought she yearned for emotional warmth of a kind she did not easily offer but was superbly capable of giving responsively. Beaumont Newhall, the photographic historian and curator, stayed in her house for a week in 1954 to select photographs for a one-person show. The week passed in "absolute isolation. No one came in, no parties, no 'meet my dear friend.' I had the impression she was very lonely and delighted to have company, companionship."

She did have male company from time to time. Mostly, now, they were much younger men. Some were attracted first by her fame; she didn't mind. Arthur Korf, a dentist who squired her about until he married, recalls that when they met he said something like, "You are the great lady," and she loved it. Margaret had an ageless supply of enthusiasm and extensive experience with charm and seduction. She liked a number of the *Life* reporters she worked with. They were very bright young men who were either interesting or promised to be so in time. Usually they had a built-in admiration for her, and were unlikely to expect more than she wanted to give. She for her part gave them as much as they might have asked for and more than they could ever have expected.

"She gave a young man her complete attention," one of them says, "and that's hard to resist. She would fasten those big eyes on you, look at you right in the eyes. You were the center of her attention. . . . On a one-to-one relationship, she not only listened with rapt fascination, staring at you all the time that you spoke, but she really made a man feel like a man, enormously. . . . She could be pushy and aggressive [at work], . . . then you walked in the door and like flipping a switch there was this completely feminine woman, raptly listening to the dullest things you could say." He thought her "the most feminine woman you'd ever get your hands on in a million years," and, amused at himself, confesses to what he liked best about her: "I was fascinated with her interest in me."

She said her liaisons added up to the right equation for her life.

There is always time for personal life, or you are working with someone who becomes your personal life. And if you are undemanding and if you have been married and divorced as I have . . . then it is wonderful, because you are not trying to clutch people, and you want them to treat you in the same undemanding way. Of course, everything doesn't always work out beautifully. You have heartbreaks and so do they, perhaps.

For the most part what you do is to build up very great friendships, that go on through the years. And these people keep coming back to you.

I have nothing to conceal. I feel that I have lived a very healthy, normal life and I have been able to keep in very good balance. I am very proud of that fact.

That sounds like her psychiatrist speaking, but Margaret herself speaks loud and clear in her belief that she should emerge from an experience without bitterness, leaving "that nice neat room behind me," as she claimed to have done with Chappie.

For my kind of life, that's it. There is nothing coldblooded or hard boiled about it, because these experiences are very deep ones. I mean, they are never trivial ones. But I don't believe in cutting into other people's lives. . . .

I don't need someone else to cling to and I don't have the need of security that a lot of women do. First of all not financial security but even more important, emotional security.

She who showed no interest in feminism had invented her own liberation. If it cost her more than she had bargained for, she was aware that life exacted its price. It was better, much better, to have a lover than not, and certainly better to have sex than not, and warmth, and companionship—at least until he wanted more of her than her career could spare. Still she did not need a man to feel whole, did not need marriage to seal her life with approval. And if her two husbands had hurt her immeasurably, she refused to consider that a definitive and delimiting statistic. In 1950, when she left South Africa for France, Margaret was deeply in love.

The man was Alexander Schneider, the violinist and conductor. He was close to her own age, with a sizable career and stature of his own. Today he says, "She was one of the most extraordinary women and personalities I met in my life. Very few people so intelligent, so much personality, knew exactly what they wanted and they achieved it because they wanted it. . . . We loved life together, loved going to museums, to see beautiful things, everything in life, eating, and good wines, everything, and human beings, intelligent, and all those things which really make life, you know, worth being and living."

Margaret flew to meet him in Prades, a tiny French town near the Spanish border in the Pyrenees, the site of a festival in honor of the two hundredth anniversary of Bach's death. Sasha Schneider (everyone calls him Sasha) had coaxed the great cellist Pablo Casals, premier interpreter of Bach, out of retirement in this little town to lead a gathering of the world's finest musicians through weeks of passacaglias and fugues.

Alexander Schneider was born in Russia of Jewish parents. His mother and his sister died at Auschwitz. Margaret told him early on that

her own father had been Jewish. "I don't think anybody knew," he says. "If she wouldn't have told me, I don't think I would have known. Nothing at all in her behavior . . . At first I didn't believe it. I said, 'You, half Jewish?' " He understood Margaret's hidden inheritance as a logical starting point for her liberal and humanitarian outlook. People of mixed religious background, Schneider says, "become much more wild about discrimination, more opposed to discrimination, feel much more about humanity, and about the stupidities, the stupidities of religions, and about the hurting. She felt terrible about it. They always feel that way, more so. . . . She hadn't experienced discrimination at all. I don't think her father was religious. But she felt very strongly as a human being."

Margaret said that Sasha had "the gift of excitement." He still does. His enthusiasms were always electric, his face mobile, with great winged eyebrows and the strong lines of a man whose expression betrays his every thought. His hair is rumpled and at the alert. His Russian-accented speech caroms across peaks and valleys. He spends money and buys gifts freely—"He's one of the most generous of men with money, oh my Lord," says one woman—and he is equally profligate with his energy. Schneider played with the Budapest Quartet for many years, later organized his own orchestra as well as outdoor concerts in New York in the summer, and has probably done more for young musicians than anyone in the field.

He has an infinite and irresistible fund of charm and the shortest possible fuse on an explosive temper. Of Margaret he says, "She was inside a very strong personality, I think, and very closed in and knew very well how to control herself, very well. I burst out or something, you know. She would listen calmly. . . . I was much too impulsive, she would let me break out, everything, she wouldn't break out, never. . . . An emotional person, very much so, all great people are more emotional than the others, but she controlled it."

His own emotions are opulently displayed. "He can cry," one acquaintance says, "like a Dostoevsky character." Margaret's next-door neighbor in Darien came out to get the paper early one Sunday and spied Schneider in his bathrobe on the front doorstep of Margaret's house, fervently playing Paganini to the trees in reverent thanks for the morning.

He liked to drive much too fast and once said he felt most alive after a narrow miss; not surprisingly, he found Margaret's fearlessness awe-inspiring. He also thought her love of life exactly as it should be. Asked if she liked lecturing, he replies, "She liked doing everything, my dear, what a question."

Schneider himself says that he and Margaret "were really wild. My life was certainly wild—every day parties, and friends, and making music, of course. But on a very high level . . . really very beautiful." He gave famous parties, as did *Life* photographer Gjon Mili, the friend who introduced them. As one great delicacy followed another at the table, Salvador Dali would show one of his movies, or Yul Brynner play the guitar, or Robert Flaherty speak for a while about how he filmed *Nanook of the North.*

It was, as Schneider says, beautiful. He was ebulliently affectionate in public; that was something new, and she liked it. It was obvious they were deeply, happily in love. When she was in New York, she lived at his apartment, crammed with books, Oriental rugs, *objets*, bibelots, photographs. His friends were surprised. Schneider generally went out with much younger women and burned them out in a few months. (Helen Caldwell Cushman, who met him with Margaret, says, "He walked in the room and every woman went into heat.") "Margaret and Sasha were very much in love," reports Hedda Sterne, an artist and an old friend: "About every three months this happens to him. This was more serious than the usual affair, and lasted longer too. He said grand passion lasts eight months. This may have been two or three years. . . . He's like a professional, a total nomad. Constancy has to do with people who live in time." Some friends had complained that it was unfair of him to make them have to get used to someone new so often.

In Prades, Margaret photographed throughout the rehearsal of a Bach cantata, shooting off flash in the midst of difficult passages until the entire orchestra was furious. Schneider says that "she'd sit right in front of Casals at rehearsals and everybody would want to kill her and Casals would pretend he didn't see *nothing*." The musicians worked up a cordial hate for the photographers. Gjon Mili sat on the marble knee of God to photograph in the cathedral and caused a holy uproar.

When Margaret was with Sasha, she put on the quiet, retiring, adoring personality she had worn with Erskine. "She was very feminine," says Karen Tuttle, who played at Prades. "Sasha brought that out in her character because he loved her so much that summer. He made her feel like a woman—never so childish or vulnerable before, I suspect." People who watched her photograph were puzzled by her after-work demeanor. She dressed in pastels, as if she were small, pretty, and dainty as a bonbon. "In combination with Sasha," says a musician, "anybody's a pastel personality. He's a trumpet section all by himself." Hedda Sterne thinks that when Margaret retired into the background with Schneider, she was making an intelligent response to "the dumb blonde era" so marked in art and movies of the fifties. "A woman had to hide her capa-

bility. . . . Margaret hid when she had to, didn't when she didn't have to. . . . Whatever she did about it she did right."

The following summer, in 1951, the festival was held again, this time in the nearby town of Perpignan. Margaret arrived late. Her relations with Schneider were coming unraveled, and she seems to have gone to the festival to mend the affair. He greeted her happily. It was almost the last time he spoke to her in Perpignan.

Without her, Schneider drank wine, acted jaunty, flirted with other women. It was a small community; everyone knew everything about everybody. Margaret went to parties alone. She held her head high, and the musicians all knew why she had to. Not once did she say she felt sorry for herself.

Once she went to a café where Sasha was having a drink with another woman. Margaret took a table across the room and sat staring at him as if she could pull him back with the strength of her yearning. He paid no attention at all. She began to cry. She always had tears in reserve, but no one there could have doubted her pain was real. She sat alone, tears slowly spilling down her cheeks, while he tossed off his wine and made jokes and tried to look unconcerned. A woman asked him how he could treat Margaret that way. As she recalls it, he responded, "I know I know I know, I treat women very badly. No more."

Clearly Margaret was desperate and desperately in love, to a degree that did not happen to her often. She might have thought that time and options were closing in on her and narrowing the opportunities for such profound feelings. In fact he was her last great love.

So she sat over a glass of wine and stared at him through her tears. Her persistence and courage had won against impossible odds before. Still, it seems she was almost asking for punishment, waiting for more of the same day after day for several weeks in a row. Once she had overstayed her time with Chappie, once with Erskine. Hope and longing are strong forces. At last in Perpignan she remembered she was not cut out to be a victim, told an acquaintance that she couldn't take it anymore, made a long-distance call, and went off to meet another man.

Schneider says they never really broke up but remained friends, and friends they did remain. She wrote about him affectionately in *Portrait of Myself*. His was one of her deep friendships, she said; she always treasured those, whatever they had cost.

She fell back on her independence. Some years later, in a speech on "Photography Is a Woman's World, Too," she said that the ties that really bind are a hindrance: "For a woman, the great stumbling block is marriage. A husband and children always have a prior claim. The woman

photojournalist should not have to go to her assignment with her thoughts torn between two interests, and she on no account should go out to work with feelings of guilt."

The most constant and reliable companion Margaret ever found had been introduced into her life by her father. "His positive contribution was to build in me the deepest respect for work," she wrote in her notes. "Work is a religion to me, the only religion I have. Work is something you can count on, a trusted, life-long friend who never deserts you."

28

Guerrilla Warfare

*February 1950: FBI director J. Edgar Hoover announces
that there are 486,000 "fellow travelers" in the
United States, and that he regards each one as a potential spy.*

McCarthyism is Americanism with its sleeves rolled up.
Senator Joseph McCarthy

At 41,000 feet, the sky was a deep cobalt blue, so hard and brilliant it hurt the eyes. The little jet hurtled ever faster through the brittle light, pacing the vapor trail of a big B-47. At 650 mph they would have passed through the sonic barrier; as they picked up speed, the plane trembled violently, and the pilot throttled down. Margaret's only real difficulty was shooting through the sun dazzle on the jet fighter's plexiglass dome, but the pilot had warned her that if her oxygen supply was insufficient she would have from two to twelve seconds of "useful consciousness" in which to eject into sixty degrees below and fall, unconscious, 25,000 feet until her parachute opened automatically. "Watch your fingernails," he'd said. "If they're turning blue you're not getting enough oxygen." She looked at her hands—at a new shade of nail polish called Where's the Fire. So the pilot hooked her into the intercom, where her every breath rasped in his ears as they tracked the brand-new B-47 with her camera.

She was photographing the Strategic Air Command for *Life* in the spring of '51. In the postwar weapons race, the U.S.A. and the U.S.S.R. concentrated on the development of more deadly bombs and more reliable airplanes to deliver them. In 1951, before the intercontinental missile was king, many believed that air power was the key to effective defense; there were moves in Congress to disrupt the traditional parity between the armed forces in favor of the air force.

The race was to the swift. The sonic barrier had been broken in 1947, and jet propulsion held the field. Margaret photographed on bases where security was so stringent that all personnel, including the cooks, carried weapons. She photographed a tanker performing its awkward

metallic intercourse with a bomber it was refueling in midair. She photographed and then flew in the fast, medium-range, all-jet B-47, a plane so new its details were secret. *Life* ran a newspaper ad before her essay appeared, saying she was the first woman ever to fly in the B-47. She herself had been told she was probably the last one as well.

She wrote a friend that she hated the planes and wished "that all this training and energy and technique were being applied to irrigation of dry land and fertilizer and better cows, instead of to an ingrown, unproductive, useless organization for scientific death if and when the time comes."

Her next assignment was America from a helicopter: a new viewpoint, higher than a skyscraper's, lower than a plane's. Margaret found from a precarious altitude what once her discerning eye had seen from the scaffolds of industry: a wealth of design elements, a host of implicit abstractions that human endeavor had engineered on the environment. "A New Way to Look at the U.S." was one of her finest, most majestic *Life* essays, the fulfillment of her notion of the airplane as the new "flying tripod," and a final, greatly expanded forum for her early ideas about making patterns out of industry. Now she made patterns of monuments, grain elevators, factories from above. On a beach where the sun spangled the foaming crests of gigantic breakers, tiny riders on horseback cast long shadows over the sand. In New York harbor, sightseers leaned out of the windows in the Statue of Liberty's crown to stare at the little chopper beating the wind.

The SAC story appeared in the August 27, 1951, issue of *Life*. On September 7, Margaret photographed navy helicopter rescue practice in Chesapeake Bay. She was strapped into the copter with an extra gunner's belt so she wouldn't fall out as she leaned far past the edge of the door to photograph. Late in the day it occurred to her to ask how to unhook the belt if anything should happen. It was so complicated she finally said in disgust that she could swim and would do without it. For the eighth time that day, the copter swung up over the volunteer splashing about in the water. She trained her camera on him, but the focus wouldn't hold because the copter's rotors were failing and it was going down, nervelessly sliding toward the safety officer in the water. The pilot swerved into a sideslip to miss him, and as they hit the water hard, slammed the vehicle onto its side so they could get out. Margaret found herself in the bay, with the sea heaving tumultuously as the helicopter sank fast. Her impatience with the extra belt had probably saved her life. The sea began to roll and pitch more heavily this time, from the downdraft of another helicopter which had been sent to the rescue now that practice was over.

It might have been the day of the crash that she read the first article about her by Westbrook Pegler. She picked up a paper on a train. Pegler wrote five articles about her between the fourth and the ninth of September, but Margaret was traveling so much she might have missed one. He was a widely read columnist whose pen was loaded with vitriol and energized by reactionary ideas. *Look* assessed him in 1944: "No other serious journalist has been more praised by conservatives, more damned by liberals, more quoted by all kinds. . . . Pegler is a definite power in our democracy. Yet his power seems almost exclusively negative, aimed at tearing down rather than at building up." An ardent red-baiter since the thirties, Pegler had warmed to the cold war as it gripped the postwar world. His column on September 4 was about Margaret's SAC story and the bomber with the secret details.

Pegler was incensed that Bourke-White had been cleared for this story. "In the compendium of the House Committee on Un-American Activities," he wrote, "Miss Bourke-White is cited thirteen times." That was probably the first she knew of it. Among the citations: the American Youth Congress, the Coordinating Committee to Lift the Embargo on War Material to the Communist Army in the Spanish Civil War, the Film and Photo League, and the League of Women Shoppers, all listed as Communist front organizations. What's more, she was divorced from Erskine Caldwell, himself cited twenty-two times in the compendium, and had collaborated with him on "three propaganda books, *You Have Seen Their Faces, North of the Danube,* and *Say, is this the U.S.A.*"

Pegler added that Bourke-White had produced two movies on Russia that were "sympathetic propaganda films." (This judgment was not entirely incorrect, but in 1951 it would not have mattered. Not long before, the author Ayn Rand had testified before HUAC that Hollywood's 1944 *Song of Russia* was propaganda because it showed Russians smiling, and "it is one of the stock propaganda tricks of the Communists, to show these people smiling.")

"I'll never forget that night," Margaret scribbled later about the evening she picked up that paper. "I was with a flier whom I loved very much and whom I think loved me very much—I never saw him again."

Another reporter was at work on Bourke-White at the same time. On September 5 the *New York Journal-American* wrote that two senators were querying the secretary of defense about Margaret's trip on the B-47, a plane she'd privately wished could be exchanged for better cows. Papers across the country picked up the news. Pegler reported that even after her record had been exposed to the secretary of defense, the Navy allowed her to fly in one of its helicopters. That helicopter fell "while carrying as an official passenger this woman, who, in 1936, made cam-

paign pictures, free, of Earl Browder . . . the Communist candidate for President." On September 9, Pegler soft-pedaled the message just enough to say that HUAC had never flatly stated that Miss Bourke-White was a Communist.

Pegler's repeated charges against Margaret gave him a handy platform for diatribes against the head of Time Inc., whom he referred to with unaccustomed eloquence as "China-boy Henry Luce" and "Fui-pi-yu." Margaret said the attack on her was essentially a personal attack on Luce by the Hearst papers, sparked by a report in *Time* that Marion Davies, mistress of the late William Randolph Hearst, said both she and W.R. had begun to find Pegler "boring and annoying."

Margaret's evaluation was probably correct, but it was her career, not Henry Luce's, that faced ruin. In 1951, the taint of communism was more than enough to irreparably stain a good name. Fear held the country in a vise. In 1950, some filmmakers who had put six months into a movie on Hiawatha gave it up because they suspected a film on peace among warring Indian nations could be construed as Communist propaganda.

Margaret intended to clear her name. Her agent set up a series of lectures for far less than her usual fees, to get her out on the road, where she met some hecklers. It was pointless to spar with Pegler, but Margaret spent weeks combing through her files and library records, trying to recall what causes she had lent her name to and which leftist magazines had printed her photographs without permission. At length she submitted a voluntary statement to HUAC—the committee never subpoenaed her—answering the charges on their list. Her statement reaffirmed her belief in democracy and her opposition to dictatorship of the left or of the right.

The FBI had been keeping a file on her since 1940. It began with the anonymous letter accusing the *PM* staff of being Communist, a document that had introduced the FBI to a number of talented people. In '41, shortly before Margaret went to Russia, an "unknown outside source" called her "one of the highest intellectual Communists in the United States." The FBI recommended that Bourke-White "be considered for custodial detention in the event of a national emergency," but in '43 the attorney general declared that there was no statutory authorization for the "custodial detention" list of citizens and that the classification system was unreliable. (Perhaps some of her wartime accreditation difficulties stemmed from these documents.) In 1944 the New Haven division wrote the director of the FBI that "there has been no indication that subject has ever been active in the affairs of the Communist party in the State of Connecticut" and that therefore no active

investigation was under way—not that that stopped the memos, or the accusations. Margaret never knew what was in her files. They were marked "classified" until 1980.

She was conscious as always of her place in history. Betty Cronander had suggested to Margaret that she write an autobiography, and she took the suggestion seriously: ". . . was to be the Education of a Liberal," she scrawled to herself. "Can one write that [illegible word] now. . . . Maybe I'm committing suicide by writing such a book. Maybe I'm crucifying myself." Elsewhere she noted, "If one is active has to get caught in this thing. Signs of the times like getting caught in industrial photography."

She had always been courageous under fire. Her most private notes to herself at this juncture in her life make clear how deep and wide her courage ran. "I'm so tired of mediocrity. Their fears would dissolve. Their fears are groundless. . . . I'm the one who should be afraid. I'm not afraid. Everyone else is afraid for me. I'm tired of all their fears. . . . Let's act emergency. [?] They'll catch our courage." Again, no doubt thinking of the singsong chorus of confessions that HUAC was conducting with breast-beating witnesses like Whittaker Chambers, she wrote, "I don't belong to Standard Brands. I'm not a reformed C'st. I don't stand so high, being I never was a C'st at all."

"Happiness is relative. I feel as alone now—as happy—adjusted. everyone says how well you look. as there isn't a man well there are men, yes But it isn't just a man Its that inner peace and security." She had reached a plateau that made her almost unassailable, as if pressure had driven her inward on her strongest resources: "I'm alone but I don't feel lonely—This is living too. I guess its the way I'll have to write the book. Good, I'm so happy. My head is working now."

She had an idea that would clear her name, and she went to see Ed Thompson about it. Thompson, who had taken over as managing editor of *Life* in 1949, was said to be "the best damn picture man in the country," and, according to the photographer Alfred Eisenstaedt, "the only man probably in the history of photography who could read negatives in the hypo upside down and could say, 'That's a cover.' " Often sardonic, sometimes insulting, concealing his tremendous erudition behind a "boys-in-the-backroom manner," he issued instructions in a mumble that might easily have been mistaken for a dead language, so that the entire office was constantly on its toes. Thompson guided *Life* through the peak of its influence in the fifties, when its funds, resources, and influence seemed to be limitless and television had barely begun to eat into its territory.

Margaret told him she wanted to go to Korea. In the autobiography she wrote that her reasons for going to Korea were different from other correspondents; she wanted to photograph the Korean people, whom

photographers had neglected. Thompson says her reasons were indeed different: "My strong impression was that she insisted on my wangling Department of Defense accreditation to go there [because] she felt the need to demonstrate that she was an ipsy-pipsy All American . . . because of the Pegler charges. She never felt like going to Korea during the early parts of the 'police action' "—which, by late 1951, had been going on for a grim year and a half.

Thompson's view of Margaret was clear-eyed and respectful. He understood her promotional value to the magazine, admired her photographs, liked her well enough because, he says, he was always in some position of authority and she was always rather charming to him. "She was who she was. I accepted it. With her rival photographers, there was a certain amount of feeling that she pushed her advantages a little too far. I didn't care. She was worth it."

Life had a platoon of first-rank photographers in Korea—John Dominis, David Douglas Duncan, Carl Mydans, Michael Rougier, Joe Scherschel, Howard Sochurek, Hank Walker—whose pictures spoke so eloquently of suffering and exhaustion that they helped to usher in a new era of respect and fame for war photographers. *Life* didn't need yet another photographer there. But the organization was behind Bourke-White on the Pegler issue. And besides, she was Bourke-White. "I had enough clout left over from the war," Thompson says (he had been a senior intelligence officer), "to get her cleared to go to Korea. It became an obsession with her. She had to prove Pegler was wrong."

She also had to maintain the life she had planned with such care since childhood. She wrote a friend in February, before her clearance came through: "I can't drop it. . . . It's too deadly serious. This is my whole life, this freedom to take trips. This is a way of life I've consciously developed. It's a way of life I've invented for myself. I can't have it chopped off because an utterly unprincipled madman happened to find it convenient to use me in a few columns. And particularly when the things I do are useful, and the things he is doing are barren and destructive. I can't have him impeach my patriotism in this manner." She flew to Japan in late March.

The 1952 May Day parade in Tokyo was as large and spectacular as its advance billing had promised: wave upon wave of students with rippling banners. *Life* had three photographers covering the event. Margaret worked atop a station wagon with her view camera on a tripod. As usual, she also had a pair of Rolleis with her, two other reflex cameras, and about her neck, two Nikons, the miniature cameras that were fast gaining popularity among photographers in the Far East.

Abruptly, as if at a secret signal, thousands of paraders linked arms,

burst into the strains of the "Internationale," and began wild snake dances through the street, their anger intensifying as the dance quickened. Frenzied groups surged around the station wagon, striking at Margaret with their banner staves. Someone threw a rock. Another. Another. She put down the tripod and shot all the film in her Rolleis. A rock crashed through the side window of the car. Students began to chant: "Yankee, go home. Go home, Yankee." Columns of Japanese police charged into the crowd, hurling tear gas bombs. The rioters charged back with their sharp staves. Margaret was coughing and crying; she couldn't see to adjust her reflex cameras. Rocks hurtled past her head; no demonstrator wanted his photograph on record. She never stopped. Examining her photographs later, she discovered that a bottle of acid had been flung at her and missed.

She picked up the Nikons with their thirty-six-frame rolls and shot the roll in each camera fast. She would hand the camera to the Japanese driver through the hole in the window and he'd reload. "My way was to key in the story with a view camera, or reflex of some sort," she wrote, "working for as beautiful and striking compositions as I could make. Then I cleaned up the corners with the miniatures. I had used miniature cameras to some extent ever since the Louisville flood in the middle 30's, but it took a Japanese riot to make a confirmed miniature camera user of me." Thirty-five millimeter became her mainstay because circumstances forced its virtues on her, but she did not yet know how to use it well. *Life* did not publish her pictures of the riots.

Helen Caldwell Cushman saw Margaret shortly before she left for Korea. Cushman recalls that Margaret remarked on how interesting it would be to meet some of the men she had known as lowly officers in World War II who had since risen to major and general. Some of them, she hinted, she had known very well indeed.

When Margaret flew from Tokyo to Seoul in late June or early July of '52, an army public information officer, Colonel Roswell Perry Rosengren, met her plane. He took her to dinner—part of the job—and afterward found her a telephone that could reach the combat lines. She was supposed to meet some general she knew who was at the front, if the two of them could make contact. They could not. She hung on the phone for some time but never got through. By the time she hung up, Ros Rosengren had taken the general's place.

For the next several months in Korea, she spent all her free time with Rosengren. The Tokyo bureau rarely saw her. All they knew was that she was at the Imperial Hotel with her colonel. After Korea, she and the colonel stayed friendly, mostly by letter, for some years. She never

signed with anything stronger than "affectionately." The colonel says theirs is the association he holds dearest in all his life.

The war that Truman called a "police action," that America was unprepared for, and that eventually claimed 130,000 American casualties, had been fought with a terrible bitterness. *Life* photographers recorded the details at every stage. Early in the war, as the marines had withdrawn before the Chinese onslaught, David Douglas Duncan asked a soldier, "If I were God and could give you anything you wanted, what would you ask for?" "Gimme tomorrow," the marine said promptly. *Life* photographers snapped a war where officers cried to learn they were out of ammunition and women fled gunfire with babies at their breast. Margaret would have to find some story that had not been done.

In early July there was a truce, in late July an armistice. She wanted to do a piece on civilian Korea and the unreported guerrilla warfare she'd been hearing about. Her editors said O.K. Ros Rosengren says he sent her out to the guerrillas—the army said they were "as fast as rabbits, and as cautious as virgins"—in the Chiri Mountains, where he could arrange an extra jeep in a convoy for safety.

In 1950, when the North Koreans invaded, they had overrun South Korea far south of the thirty-eighth parallel, but General MacArthur had pushed them deep into the north again after his daring assault on Inchon. As North Korean troops fled homeward, some of their soldiers slipped into the Chiri Mountains and formed guerrilla bands that still roamed freely after the 1952 armistice, puncturing U.N. supply lines, cutting communications, terrorizing peasants, one hundred and fifty miles south of the battle line and deep within territory that was under U.N. control.

As Communist cadres tugged at the country with political propaganda, promises of education, and terror, families were pulled apart along political lines. Sometimes, when a boy ran away to join the Communists, his mother climbed into the mountains to search for him and beg him to come home. Other times the village elders would aim their loudspeakers at the crags and dark pockets of stone, promising that they were feeding the guerrillas' families and that if the men returned there would be no reprisals. "Here," Margaret wrote, "was a war of ideas which cut through every village and through the human heart itself." She wanted the story.

She said it was not so simple to walk up to a guerrilla chief and say, "I'm from *Life*. May I take your pictures please?" She began to travel with the National Police and their Volunteers, teenagers who had barely outgrown their toy guns and now, armed with live ammunition, were stalking boys no older than themselves. Margaret disappeared into the

wilderness for weeks at a time, while the *Life* Tokyo bureau, raising guesswork to an art, sent film out to three places she might reach in hope she would touch down at one.

There is a Korean proverb that describes the country: "Over the mountains, mountains." The Korean mountains lie like a wrinkled crust along the country, steep and bony, pocked with boulders, scrubby vegetation, ravines and sharp dropoffs, a terrain that nature at her most militant might have designed for guerrilla warfare.

Margaret, who had turned forty-eight in June without acknowledging or being forced to acknowledge the depredations of time, sped over the hills with the police in an open jeep while typhoons sabotaged her cameras. When they stopped in command posts ringed by sharpened bamboo staves, she slept on a bedroll atop a table; a few feet away, Koreans yelled at each other through reluctant field telephones. She claimed to be rather flattered when she heard the guerrillas had put a price on her head.

On her last sortie with a police chief named Han she photographed eighteen guerrillas the Volunteers had killed that day. Rain ran down the mountainside in sheets, and the primitive road that would carry them into the valley doubled back on itself in one treacherous hairpin turn after another along the edge of a sheer cliff. Chief Han insisted she finish her work early so they could get down from the mountain by daylight. Their convoy of five jeeps was a perfect target in an ideal setting for an ambush. Margaret said what photographers always say: "Just one more, just one more." The chief was massively annoyed. She held the convoy up till the far reaches of twilight.

As night clamped down on the mountains, Chief Han sent a security force ahead to guard the most dangerous spots on the road. The convoy of jeeps slid hesitantly around the steep turns with its headlights off, slowly, slowly, in a blinding rain. Around one bend they spied above them a small blinking light. That was a police box, but the police never gave away their positions at night like that. The convoy stopped; the men jumped out instantly and pointed their carbines into the black air and driving rain. Suddenly shots rang out along the slopes a little way ahead of them where guerrillas lay in wait. An ambush had been laid by men who had expected them to return by daylight. The advance security police had flushed them out.

The chief called for a truck with a mounted gun to lead them down by a circuitous route. Later they found out that the guerrillas had caused an avalanche farther along their first road so that they would be hopelessly trapped. Chief Han pounded Margaret affectionately on the back and urged her always to remember to say "Just one more."

In her notebooks Margaret hurriedly wrote down how the police and the Volunteers had to supply evidence that they had really killed a guerrilla. At first they had brought back a severed ear as proof. "A colonel who gave me a knife—bring it back with an ear . . ." But ambitious men began to cut off both ears and claim they'd killed two guerrillas. Sometimes they brought in whole trays full of bloody ears. The requirements had changed. Now they would carry a curtained box to the chief's desk and dramatically drop the curtain to reveal an entire head. An American said to her, "It's the cruelty and banality of the Communists that makes it necessary for people to do these things."

Margaret took a photograph, never published in *Life*, of a severed head up close, hanging by its hair from an arm that comes into the picture from the right edge. Slightly behind, on the left, a Korean soldier with a large ax over his shoulder smiles broadly at the sight of this prize. The aesthetic of the photograph is more harsh and abrupt than her usual work. She generally leaned on classical principles of balance and containment in her compositons, even for scenes of horror, a legacy of her training in Clarence White's school and of her view-camera approach to composition. The ambiguous space of this Korean picture, and especially the disembodied arm, are the closest she came to the brusque cropping, spatial disjunction, and raw immediacy of the so-called snapshot aesthetic of some 35 mm photographers.

On the slopes of Mount Chiri-San, another police captain brought her a twenty-nine-year-old guerrilla who had surrendered the night before. Nim Churl Jin had been with the guerrillas for two years as an ordnance officer, making grenades from beer cans filled with glass and metal chips. He had bad lungs and a hacking cough. In the mountains he had been beaten for coughing; the sound could give away their position. He was sick, homesick, disillusioned. He wanted to go home but was afraid. His older brother, head of the family, was an ultraconservative rightist who had lost his chance in the village election and had gone into hiding when Churl Jin defected. Churl Jin, whose mother believed him dead, had never seen his own son.

Margaret asked if she could take the man home to his mother. The police chief agreed to be her guide and interpreter during the two-day drive to the village. Her expense account included a "hotel room for two nights for tame guerrilla."

When they reached his village, Churl Jin, who had been fighting back tears, stopped at the gate to his house and bowed deeply. As he stepped inside the courtyard, friends and relatives appeared as if by magic. His wife looked at him and said only, "My husband has come home." She handed him his son, who howled to be thrust at a stranger.

But his mother was off visiting another village and could not be found; she would walk back through the forest. Margaret was frantic. The crux of her story would elude her on some forest path. Determined to find his mother if they could, she called to Churl Jin to get back in the jeep.

They were scarcely out of the village when the young man dashed out of the jeep to greet a man walking on the road: his older brother. The brother looked at Churl Jin and shook his fist in anger. "What crime have you committed—you have been working against our country!" Both men wept. Their heads were bowed, they would not look at one another. "My old crime was wiped out by my surrender," Churl Jin said doggedly.

They drove on for miles as the sun sank lower and the light thinned out. "In a whole lifetime of taking pictures," Margaret wrote later, "a photographer knows that the time will come when he will take one picture that seems the most important of all . . . You hope the sun will be shining, and that you will have a simple and significant and beautiful background. You pray there won't be any unwanted people staring into the lens. Most of all, you hope that the emotion you are trying to capture will be a real one, and will be reflected on the faces of the people you are photographing."

The miracle she was looking for occurred. Churl Jin jumped out of the jeep again at the run, Margaret stumbling after. Coming toward them on a path through the rice fields she could see a woman who suddenly threw down her walking stick and began to run. By the time Margaret reached the two of them they had flung their arms about one another and the mother was crying, "I am dreaming. My son is dead." "Mother," he answered, "it is Churl Jin." Still clasping each other, they sank to the ground. She rocked him back and forth in her arms and sang him a broken lullaby. Margaret said she was crying so hard she could scarcely photograph.

She wrote that she had waited a lifetime to take the most important picture of all. Certainly the picture of Churl Jin and his mother embracing is the most spontaneous photograph Bourke-White ever took of a heightened emotion. A *Life* colleague once asked her what was different about the Korean assignment that affected her where others had not, "and she said very simply, 'This time my heart was moved.' " With all the horror, the misery and pain she had witnessed in a lifetime, she had seldom cried as she was working. She knew how to keep a professional distance, how to use the camera as a barrier, how to use her eyes and keep her heart in check.

She published this picture as one of her favorites and wrote that

after India, the Korean story was the most human she ever did. Elsewhere she said she could not have done it a few years earlier, because the human qualities could only be captured with the small camera. In fact, although the picture is strong, the story as a whole, with its additional images of grief, anger, and joy, is more memorable. The complex emotions of Churl Jin's reunion with his mother are almost too vast for one frame. Single images measure up to a sizable event only on rare occasions. Although many emotionally charged photographs are touching, a much smaller number are truly moving.

Margaret had been reaching for ways to make her photographs more deeply human and her own responses more profound ever since her trip south in '36. Rarely has anyone more consciously *willed* herself to an expression of humanity. Her entire Korean essay, with her photographs of guerrillas condemned to death, of relatives mourning a slain man, of an elderly mother singing a lullaby to her prodigal son, must have seemed like the culmination of a personal journey she had begun in the thirties. "I was to discover," she once wrote, "that the quest for human understanding is a lifetime one that has no end in sight."

In 1952, this quest would have assumed a new urgency because of a change occurring in photojournalism itself. In the thirties the small camera had pushed photography toward spontaneity; by the late forties, the push was toward a new emphasis on emotion. *Life* magazine first published a couple of essays that quietly marked this transformation in 1948. Most notable were Leonard McCombe's "The Private Life of Gwyned Filling" in May and and W. Eugene Smith's "Country Doctor" in September. McCombe's story followed a young working woman from job to date to home, then added to the standard sequence a picture of her in tears and one of an ashtray heaped with cigarette butts, an eloquent description of a mental state. Smith's doctor not only reacted feelingly to his patients but was pictured full-page standing exhausted in his surgical gown, doing nothing but nursing a cup of coffee. The photographic essay was subtly shifting from a concentration on external facts to a focus on interior states.

An ever wider and more sophisticated mass audience wanted more psychological depth and easier access to what had once been people's private lives. *Life* never made this newly emotional note its dominant theme; for one thing, there were not that many photographers who could handle it with the sensitivity it required; for another, the traditional essays still had their many uses. But by the mid-fifties the magazine was no longer selling its subscribers on the "mind-guided camera" it had touted in the early years but was promising them total immersion in the story:

it is this *other* kind of photography—the kind that captures, more vividly than words, the atmosphere, the personality, the emotions of an event . . .

Pictures like these bring *you*, the reader, into the picture. For these are the pictures in which you can *take part*, pictures in which you can step into the scene the camera records to participate in the action.

During the Korean War, photographers like Duncan and Rougier responded to the new sensibility and helped establish it. Margaret, ever in step with the main movements of her time, would have sensed the change as it began.

The younger photographers had been more influenced by her than they knew, for she had done an enormous amount to make the profession both respectable and glamorous. She had also set a high standard for quality and a blazing example of what kind of dedication would be required of a top photojournalist. But the new generation was not much influenced by her technique, not even by her fabled clarity or the wonderfully sculptural quality of the forms in her pictures. Nor did they copy her devotion to the large camera, her deliberate approach, or her way of seeing people. With 35 mm cameras, they were looking for something rougher, more spontaneous, more intimate. Margaret had been in the profession for a quarter of a century. She was still willing to learn from men who were not so much older than a quarter of a century themselves.

Her Korean essay ran as a lead story but was not quite as important in the canon of her work as she thought it. What it displays better even than humanity is her extraordinary resourcefulness and intelligence. Howard Sochurek, who himself took first-rate photographs in Korea, says, "I think it was a tremendous slap in the face to the rest of us who thought we knew the story. We'd been concentrating on the obvious, the front line, the fighting. Here was maybe a greater story that we'd missed." Noting that in Russia, India, and throughout her career Bourke-White got the story no one else got, Sochurek adds, "Her intellect permitted that. She was truly fascinated by the world and by great events. She was well read, capable as a writer and photographer. She had an intensity and charm and intellectual capacity, so that she was treated very seriously. . . . She had a remarkable combination of talents, interests, and capacities. That was why her pictures were remarkable."

The picture of Churl Jin's reunion with his mother, which Margaret thought the most important of her life, had for her an emotional weight that would not have been obvious on the page. Churl Jin's defection represented the ultimate triumph over the Communists; Margaret's photograph was itself a kind of loyalty oath freely offered in rebuke to Westbrook Pegler.

Margaret had an iron constitution. She ate native dishes, slept in noisy police headquarters, worked long hours in lashing rains, yet never got sick. She was known as Maggie the Indestructible. In Korea she had an odd difficulty. Her left leg had begun to ache a bit late in '51, before she left. When she climbed stairs, it did not do its proper share of the work. About the time she went to Japan her left arm also proved reluctant at off hours. After lunch one day in Tokyo she staggered for three steps upon getting up. Soon that was occurring often when she'd been seated for an hour or so. It was embarrassing. She took to dropping her gloves when she rose; with a little delay she could walk all right. She tried not to think about it.

Before she left Korea, Margaret slept in a little hotel room with walls of oiled paper. It was monsoon season. She tried to plug the holes in the paper walls with more paper, but nothing kept out the torrential rains. Then on her last night in Tokyo, in "an exalted state of mind" because she knew her Korean story was unique, she danced all night and forgot to eat for almost twenty-four hours. After that, she slept through her flight, missed the meals, missed a connection, took a flight with no meal service, then ate what they had: eleven little pots of cream for coffee. She woke up the following morning in a lavish hotel suite in New York, attended by a nurse and uncertain how she'd got there.

Ed Thompson remembers how. Margaret rented a car at the airport, drove to the Plaza Hotel, left her car in the middle of Fifty-eighth Street, and came into a meeting that Thompson was addressing. She wanted to speak. The chairman of the meeting shrugged uneasily, and Margaret launched into a completely incoherent speech. She must have been practicing for her lecture tour on Korea, for her talk, Thompson says, "included that goddam Korean song of hers"—she had learned one over there, and would sing it to audiences across the U.S.—"which I heard for the first but alas not the last time." Her luggage had been misplaced, so she asked a secretary to buy her a blue nightgown—"my colonel's favorite color."

A *Life* editor recalls being pressed into service with a colleague to get Margaret to a hospital; it looked as if she had extreme battle fatigue. She wouldn't go. With great effort the two men persuaded her to retire to her hotel room, then repaired to the bar to drink to their success. Over the rim of his glass one of them spied Margaret walking fast out of the lobby with her purse on one arm and the blue nightgown in its Saks Fifth Avenue package on the other. She had not been able to get a direct phone line to her room and was convinced the FBI would tap her phone from the hotel switchboard.

Life's editors were worried. Margaret was scheduled to begin a lecture tour quite soon. ("Perhaps," Ed Thompson says, "we should have worried about those clubwomen who were going to have to hear the Korean song.") Thompson and other editors were so alarmed at her incoherence and erratic behavior that Time Inc. hired a registered nurse to go along on the tour; the woman was billed as Miss Bourke-White's secretary, who was helping with a book.

Margaret came back to herself quickly, reining in her rambling speech after the first couple of lectures. A local branch of the American Legion, self-appointed guardian of the anti-Communist forces, tried to prevent her appearance but was unsuccessful. When her Korean story was printed as the lead in December, General Mark Clark, who had first known Margaret in Italy, wrote to congratulate her and to say it had been fine to have her there in Korea.

By the end of the year she had told thousands of Americans about the rigorous life of a Communist guerrilla and about what friends the United States had made in Korea. America had expressed its appreciation with wild applause. In California, state officials made a point of giving her a special introduction to both houses of the legislature.

In fact it was the most successful lecture tour of her life. Margaret considered it "a nationwide, 100% victory." That allowed her to dismiss Mr. Pegler from her mind. The Korean essay alone had taken care of that; it seemed to her that anyone who cast doubts on her loyalty after the article appeared would be "too silly."

Small wonder she placed such importance on that essay. The Korean War, which had smashed so many American lives, had made hers whole again.

29

The Greatest Assignment

Between ourselves and the actual experience and the actual environment there now swells an ever-rising flood of images which come to us in every sort of medium—the camera and printing press, by motion picture and by television. A picture was once a rare sort of symbol, rare enough to call for attentive concentration. Now it is the actual experience that is rare, and the picture has become ubiquitous.

Lewis Mumford, *Art and Technics*, 1952

The fifties were the decade of the photojournalist, who had finally won a starring role; the "art" photographer still had years to wait. News rolled off the presses in a steady stream of pictures that the public consumed as fast as images could be reproduced. After the world war and into the fifties, the shiny aura of adulation settled like a warm mantle about the grateful shoulders of photographers like Robert Capa, W. Eugene Smith, and Henri Cartier-Bresson. In 1954 the essayist E. B. White complained that editors paid more attention to photographers than they did to writers: "The act of photography has been glorified in the newspicture magazine, and even in the newspapers. . . . The editor continually points to 'best shots,' or 'newspicture of the week,' confident that his clientele is following every move of the shutter. . . . *Life* describes how Margaret Bourke-White leans far out of her plane to snap 'such stunning pictures as the one on p. 26.' "

Life, which had starred photographic journalism from the beginning, was richer and more powerful than ever. A 1950 survey estimated that over half the population of America saw one or more issues of the magazine in any three-month period, a total audience of some 62,600,000. The magazine's resources were enormous; in 1950, to cover one day in the life of a small town in Missouri, the editors sent out ten photographers and nine reporters. *Look* and *Collier's* also sold well in

this big decade for magazines; the picture magazine amounted to a household necessity.

In 1955, when "The Family of Man" opened at the Museum of Modern Art in New York, photography in general reached unprecedented heights of public recognition. "The Family of Man" was designed to illustrate the unity and goodness of humankind, but it advanced the cause of photography at least as much as the cause of optimism. It was eventually circulated to over thirty countries and seen by some nine million people, proving that photography could cut across language, cultural, and class barriers. Photographs could no longer be dismissed as minor; their imagery was too expressive, their power of communication too great.

Reviewing "The Family of Man," the *New York Herald Tribune* declared, "It can truly be said that with this show, photography has come of age as a medium of expression and as an art form." The *New York Times* art critic was moved to ask, "Has photography replaced painting as the great visual art of our time?" Not quite, she concluded, but it is "the marvelous, anonymous folk-art of our time."

The show included many *Life* photographers, among them Margaret Bourke-White. With this exhibition, photography won its struggle for worldwide recognition and to a lesser degree for worldwide honor, a struggle the picture magazine had waged for years. But a related medium was already crowding the still photograph. During one week in March of '51, one-fifth of the population dropped everything for several hours a day to watch Senator Estes Kefauver's congressional committee publicly investigate crime on television. The means of visual communication, more dominant than ever in the culture, were shifting tactics.

Fate has a number of ironies in its repertoire, timing among them. Even as the evidence of photography's temporary triumph mounted, Margaret's own camera was slipping from her grasp. Something was wrong with the body she had always trusted. It no longer obeyed her properly. The left leg, which had bothered her since '51, still gave her trouble, and she staggered when she rose. The left arm and hand began to ache. She saw a doctor, who could tell her nothing, and then another, who could tell her less. For two years Margaret made the rounds of specialists, but none could diagnose her. Whatever it was, she decided, it must be quite rare. Whatever it was, it was steadily growing worse.

In January of '54 she saw Dr. Howard Rusk, the man who founded and still heads what is informally known as the Rusk Institute in New York, one of the first medical institutes devoted to rehabilitation medicine. Rusk sent her to the institute's consulting neurologist, Morton

Marks. At last Margaret met a doctor who knew exactly what was wrong. The disease in its early stages can be difficult to diagnose, but not for a neurologist who has seen it often enough. She was forty-nine when Marks diagnosed her.

He said he would not name her illness because she might be discouraged when she saw someone in an advanced stage of the disease. "From now on," he told her, "exercise is more important to you than rest. If you skip one day, you'll fall back two. If you skip three days, you'll lose six." Marks instructed the chief physical therapist, Jack Hofkosh, to design a program of exercises "to help her save what she's got."

In time Margaret came to revere Hofkosh as a kind of earthly angel, but she was a woman who had never acknowledged limitations or obstructions, and that first day she did not mean to be reduced to saving what she had. Jack Hofkosh suggested that crumpling pages of newspaper into balls would strengthen the fingers of her disobedient left hand. To strengthen her wrist he recommended beating cake batter. She answered snappishly that she didn't bake cake.

He then advised that wringing out wet clothes under a warm faucet would also help her wrists; she shot back that she never washed her own clothes. (It had been rumored at *Life* for years, though never substantiated, that she expected female reporters to wash her underwear.)

Only a few weeks later, while working on her autobiography, Margaret realized with a stab of fear that her fingers were growing too stiff to negotiate a typewriter. She began to crumple newspaper. She began to wring out wet cloths, and to color in children's outline drawings with crayons in order to increase her control and precision. Typically, she attacked her exercises with a roaring energy and thoroughness. When she left her hotel room in the morning for an assignment, the floor would be covered corner to corner with crumpled newspapers, the bathroom strewn with wrung-out towels. Soon she regained a degree of control in the fingers of her left hand and could write once more; she felt as if she had invented a new hand for herself. But even with exercise the stiffness crept up on her and increased its hold, as if the pliable body she had always known were gradually being encased in a wooden box. To a friend she said, "I feel like a prisoner in my own self."

Her spirits were sustained by work. Later she said, "When I was working it was marvelous. . . . It was only . . . activities like eating and writing . . . not the first thing in my life as the camera is. Anything that had to do with straight photography, I felt simply wonderful." Fearful that she would be spared too much, and that *Life* would be reluctant to give her the adventurous assignments she craved, Margaret told no one she was ill. But people knew something was wrong. Reporters working

with her were puzzled by piles of paper balls. She needed an inordinate amount of help with her coat, and her normal brisk tempo had slowed down drastically. Occasionally her hand shook ever so slightly; Norman Cousins took a photograph of her with a small camera strapped to her wrist, and by the mid-fifties, reporters often had to load film for her. The correspondents thought she was getting old. Over the hill, they said.

Her editors, even when they suspected she was ill, knew she wanted to travel and sent her often into the field. One day in 1953, Michael Arlen, the writer, then fresh from college and assigned to *Life*'s religion department, told Mr. Luce his department was working on a big story about the Jesuits—because he didn't want to admit that their chief item at the moment was a nun's rock collection in Georgia. Thus was born an essay that took Margaret to Maine, California, and British Honduras in the winter of 1953–54.

Margaret and the Jesuits had an immediate and intuitive appreciation of one another's dedication. Reverend Professor James W. Skehan, now director of the Weston Observatory in Massachusetts, says hers was one of the great friendships of his life. "In her line," he adds, "she was as good as what we hoped we could do in our line." She knew from years of experience how the only female in all-male company could put everyone at ease. Once in a group of young Jesuits she discovered that a swarm of wasps had invaded the legs of her trousers. Calmly she asked the novice master what the procedure was for a lady among so many religious gentlemen. Quickly he announced to his charges, "All you novices face east!"

Michael Arlen, who was with her in Honduras, says she enjoyed the attention of the Jesuits enormously, "and certainly when a bishop or archbishop or monsignor would hove into view, like a general who's been told this other eminence is floating around and would come to greet her. . . . The two eminences would meet, then she'd go back to work."

Arlen says she knew how to handle anything: him, the Jesuits, crises that came up. "In her public roles she ranged from queen to princess, sometimes princess masquerading as a serving girl, but clearly one knows that the princess is only masquerading. . . . What might have been in some cases mere manipulation was overcome at some point by her own enthusiasms and good nature." He thought her very smart about people. "She knew just exactly what to do about me, how to get the most out of me. If somebody has the wit to notice one that much and to do something about it . . . I was very young . . . and she appeared to respect me a lot, which I think was very sweet of her. It was a very subtle process. She would say in effect, "*You* know all about this. Here's your wonderful script. Now I wonder if maybe we really want to do this some other way,'

and pretty soon we'd be doing it some other way, and she could have done it any way she wanted to."

In Honduras, Arlen and Bourke-White accompanied a priest on muleback as he made his rounds. In a tiny, dilapidated shack an old man lay dying in darkness. "Bourke-White wouldn't allow us to leave," Arlen wrote. " 'I need more pictures,' she said. I had seen her aggressive before, but not like this." They were asked to leave or at least stop photographing, for the dying man thought the camera would steal his soul. "Bourke-White began to cry, or something like crying. 'But this is so good,' she said. 'We must stay longer. We must.' "

For the next two days she was ill. Arlen noticed that the floor of her room was littered with paper balls. At last she said there was something wrong with her hand and arm. On the second day the priest took them to visit the old man again; he was about to die. "At one point," Arlen wrote, "the old man smiled, or seemed to smile. I looked at Bourke-White. Not having cameras, or at any rate not holding, working a camera, she seemed grave and uncertain. We went outside. 'My God,' she said, 'how is it possible *not* to be afraid of death?' "

Arlen asked her, some ten years later, whether she'd been afraid that night. "She nodded. 'I didn't know of what. Later, I wasn't afraid.' " On reflection he says he thinks she was frightened because she had strayed so far outside her experience she could not even arrange it in some understandable form. "She had dealt in knowns or had tried to make the world such a known thing to herself, to be able to control it through her camera, images you could put on paper to control them. . . . There was something *beyond* knowledge or control." She had of course recently encountered in the stiffening fingers of her left hand her own ungovernable mortality. The initial terror she felt must have been almost as frightening to her as death itself, accustomed as she had been since childhood to doing something about fear.

Life ran a big essay on the Jesuits in October of '54. In '56, A *Report on the American Jesuits* was published, with text by John LaFarge, S.J., then the distinguished editor of the Catholic magazine *America*, and photographs by Margaret Bourke-White. Margaret's illustrations for this book, which was given its official imprimatur by the archbishop of New York, provide an ironic coda to the religious history of a woman whose Irish mother had refused to have her children baptized, whose Jewish father remained a well-kept secret, and who said that work was the only religion she ever had.

One day when Margaret was checking some insurance forms, she found out she had Parkinson's. At first that meant nothing to her. Nat-

urally she researched it. She was amazed to discover it was not rare in the least but afflicted hundreds of thousands, among them Eugene O'Neill, the photographer Edward Weston, and Alexander Ruthven, the University of Michigan zoologist who had first heard her confess that her real ambition was to be a photographer. Parkinson's is a degenerative disease that progresses slowly but inexorably. It affects the motor centers of the brain that control voluntary movements, leaving intelligence undamaged, so that the victim ends up trapped in a body that will not comply while the mind knows exactly what is happening. Often the symptoms include tremor and increasing rigidity. Balance becomes a struggle. The face may stiffen into the Parkinsonian mask, essentially expressionless. In many, as the disease progresses, the capacity for speech becomes increasingly limited.

There is still no cure for Parkinson's, although there are now drugs that can dramatically alleviate many of its symptoms. Drugs were much more limited then, giving only partial symptomatic relief. A major ingredient of the prescription was and still is exercise; the worst effects of the disease can be postponed if rigidity is not allowed full possession of the body. "I often thought with thankfulness," Margaret wrote, "that if I had to be saddled with some kind of ailment, I was fortunate that it was something where my own efforts could help. I was amazed to see what the human body will do for you if you insist. Having to plug away at some exercise and finding I could make small advances gave me the feeling I was still captain of my ship—an attitude which is very important to me." In grave illness, the feeling of helplessness can be almost as debilitating as the sickness itself. With Parkinson's, Jack Hofkosh says, "Patients who give up early go fast."

Margaret's body had become a baffling place in which to live. Her left hand could no longer find her pocket and retrieve a key. She studied her right hand's movements as it sought a pocket and laboriously retaught the left hand how to perform the operation. She had to learn to walk all over again, teaching her rigid arms to swing, teaching each foot to lift up instead of shuffling along the ground, keeping her feet apart to give herself a broad base so she'd be less likely to fall. She walked at least four miles a day, trying to put back together the rhythms and movements of an ordinary gait she could no longer command. She walked in rain, in snow, in wind, a cat by her side, her Darien neighbors growing used to the muffled-up figure marching doggedly along, heedless of storms or snowdrifts. Her gait was awkward and required concentration. Only rarely did the fluid rhythms of a normal stride return; then walking once more became the sweet reward she thought it had always been.

The simplest movements became daunting challenges. She who had

walked lightly over scaffolds sixty stories above the earth had to think her way through twelve small steps merely to turn around in her own kitchen. Once she was imprisoned for an agonizingly long time in an open closet when her body obstinately refused to back out. Another time as she was breaking a fall her fingers got painfully smashed in a drawer; it took her half an hour to release her hand. On occasion she would discover to her complete surprise that she was leaning at a precarious angle like a reed in a gust of wind.

Margaret did not suffer the severe tremor that often accompanies Parkinson's; she thought that was because she was so determined not to. But she found even her mild disabilities acutely embarrassing, and a reporter who went with her on one of her last stories in 1957 says she took all her meals in her hotel room because she didn't want to be seen in public. At home she would find herself tilting crazily off balance if her cat's tail so much as brushed her leg. Meat lay on her plate untouched because her balky hands would not cut it. She panicked when faced with a group of people: would she fall and knock someone down?

Still she told no one she was ill. She thought later that the will toward secrecy was part of her affliction, that had she been able to tell people, someone could have reached out to help her. "Parkinsonism is a strange malady," she wrote. "It works its way into all paths of life, into all that is graceful and human and outgiving in our lives, and poisons it all." People knew but could not say so. By '56, reporters were asking the home office if Bourke-White was ill. The editors, hearing her arrhythmic walk in the hall as one leg dragged a bit behind the other, had diagnosed her disease long before she named it for them. *Life* continued to give her assignments, but after '57 she could no longer handle them.

Many thought her lonely in the fifties and lonelier in the sixties. Progressive disease is a lonely state at best, and Margaret's personal situation was unstable. The fifties brought her new occasional lovers and a new man she saw often when she traveled, but essentially she lived by herself. Her reputation persisted almost beyond her capacity to live up to it. By the time she was seriously ill, a man who worked with her a good deal says that although he did not have an affair with her, everyone assumed he did, and both his wife and his girlfriend were angry. Margaret, he says, had hinted she might be willing.

She had a few good friends but could have used more. Her brother lived in Cleveland, her sister, Ruth, in Chicago until her death in 1965. Joseph Liss, who wrote a TV script about Margaret in 1960, says he was in her house off and on for about three months and doesn't remember anyone visiting. Her invariable cheerfulness in itself seems to have stung

people into an uncomfortable awareness of their own inadequacies and fears. Margaret mentioned so often to Jack Hofkosh that she didn't want to be a burden on anyone that he thinks she must have contributed to her final loneliness.

Bradley Smith, a *Life* photographer who knew her well, thinks it was not that Margaret was so lonely but rather that she missed the excitement and glamour she had built into her life. She had put herself at risk countless times to keep her quota of excitement high. Smith notes that after a certain age it becomes much more difficult to swing from a helicopter and sleep on a railroad platform. Margaret had staved off the attacks of age; her body had ended up betraying her nonetheless.

Yet her longings for travel, intense since childhood, did not slacken. In 1955 she asked Henry Luce to promise her the assignment for the first trip to the moon. Luce, not an easy man to upstage, thought about it a long while and finally, deciding he didn't want to be first himself, gave her his blessing.

In 1961, Margaret wrote in her notes: "Strangely, as I look back, this was not an unhappy period"; she was buoyed by the sense of how much she could do for herself. She waged constant war against the progress of her disease. In the end, it was a battle she could not win, and eventually she said she realized she was trying to climb up an escalator that was going down. Many advised that she had best learn to accept the inevitable, but she swore she would never accept an illness. Her resistance seemed to her partly a carryover from her profession, "where the highest applause my editor could give me was 'Maggie won't take no for an answer.' If I could do so much to get pictures certainly I would do this and much more to get back my health."

There was a deeper reason still: her indomitable optimism. "Somehow I had the unshakable faith that if I could just manage to hang on and keep myself in good shape, somewhere a door would open.

"And that door did indeed open."

It was opened by Dr. Irving S. Cooper. In 1951, when Cooper was not yet thirty years old, he had accidentally torn a small artery during a brain operation on a patient with Parkinson's. Afterward, to his astonishment, the patient's tremor stopped and his rigidity eased. A year later Cooper performed the same operation on a patient with tremor, this time by design. The tremor disappeared. He continued to operate, with good results. By 1954 he had devised a more exact procedure: he injected a chemical into a precise spot deep within the brain and destroyed a part of the thalamus. Results were better still. Many in the medical profession refused to believe it. Cooper was too young, possibly too good-looking,

certainly too brash and egocentric to win acceptance. Older doctors knew the literature proved that tremor could not be cured by brain surgery without resultant paralysis.

Cooper filmed one of his first patients. The man's arms and legs shook so hard that the metal bed he had been confined to for three years rattled thunderously all day long. After two operations the patient walked out of the hospital on his own, tremor free, and found a job. When Irving Cooper showed this film, some of his colleagues proclaimed it a great breakthrough, others called it fraud. For years, his work was surrounded by intense controversy.

In 1954, Dr. Howard Rusk, who had supported Cooper from the beginning, recommended him to St. Barnabas Hospital in the Bronx, where the young surgeon was named head of the Department of Neurosurgery. Only there was no Department of Neurosurgery. Nor was there an operating room. A tiled room was converted to an O.R., a barber's chair to an operating table, and the department was proclaimed.

In '58, both Dr. Rusk and Dr. Marks suggested Cooper's operation to Margaret. It was not a cure. If successful, it would reverse some symptoms, perhaps dramatically, and thus delay the disease's progress. There was no guarantee. Nor could anyone offer Margaret anything else. She greeted the idea with joy and relief. Where she had been hopeless, now there was hope. In Margaret's register of attitudes, optimism amounted to a passion. In *Portrait of Myself* she wrote:

> By great good fortune, I am born in the right century, in the right decade, and even the right group of months to profit from the swift running advance of modern medical science. My greatest need comes at that pinpoint in time when I can reap the benefits of science and be made whole. By some special graciousness of fate I am deposited—as all good photographers like to be— in the right place at the right time.

Her head had to be shaved. Margaret showed her sister-in-law her wig and said, "You know, I'm so lucky. Wouldn't you know that when I have to have an operation that requires my head to be shaved, wigs would be in high style."

Friends asked if she was afraid. "NO!" she cried in her notes. "So overglowing with happiness that I had found the door and it had opened there was no room for fear . . . it was like a battle mission . . . if you understand and share the purpose of it, you can bear the fear . . . you can ride above the fear." Her illness, Betty Cronander thought, had become a kind of horrible adventure.

Arthur Korf, a former beau, and his wife, Ada, took Margaret to St. Barnabas the night before the operation, in January of 1959. Mrs. Korf,

a musician, spied an upright piano in the patients' sitting room. She sat down to play Liszt, and Margaret suddenly began to dance. Parkinsonians have difficulty walking; dancing, for some reason, is easier. Margaret danced about the room, around, around, whirling with joy, as the notes of Liszt's "Valse Oubliée" wove a pattern on the evening air.

Arthur Korf watched the operation. Margaret said it was a comfort to have a friend there. "I realized this was an assignment, the greatest in my life, and to accomplish it successfully I must be willing to travel anywhere and must try to learn everything. As long as I thought of it in the context of my work, it held no fears for me."

She was wheeled into the operating room under the bright lights and the masked faces of the doctors. A machine whirred slightly behind her shaved scalp, then a dime-sized hole was drilled in her skull. As the brain itself experiences no pain—not, at least, of the physical variety—she remained conscious the entire time. Through the small opening a thin rubber tube was inserted into the brain and worked down to the thalamus. Doctors standing above her in their green surgical gowns asked Margaret questions and issued instructions as Cooper probed for the exact spot of her difficulty. "Maggie, raise your arm." She could not raise it. The surgeon moved the probe a trifle. This time, without hesitation, her arm lifted easily, spontaneously giving a little wave at the end as if it were greeting the world.

Suddenly Margaret's future life seemed to fall into place with the clarity and beauty of a new creation. "I *knew* the doctors were doing precisely the right thing. I could tell by the kind of inner harmony and almost ecstasy I felt. In my mind I was saying, 'Keep at it, keep at it. Go right at it. Keep on digging. Get out all the Parkinsonism. Get it all out!' " A short while later, Cooper looked down at her said, "It turned out beautifully."

Her ecstasy persisted. "Something is GOING ON. (This is much more THAN JUST GETTING WELL.) I don't want to miss a word of it." She wanted to take a deep breath, wanted a breath more than she had ever wanted one before. "I was floating in a kind of half dreamworld. I was so lightly suspended there, I hesitated to move in the tiniest degree, and in the meantime the breath seemed to hover close like a wind-filled sail, like a bird's wing. Now I knew it was meant for me. I accepted the gift of breath and inhaled deeply, much, I suppose, as a baby does who needs just such a breath to be launched into the outside world."

In the next few weeks Margaret discovered anew how to swing her arm, tie the laces on her hospital gown, get into a car unaided. Two days after the operation she noticed to her astonishment that her left hand was thrashing about under a blanket as she spoke. She had gestured

without thinking, with a hand she could not previously have willed to type. New difficulties arose: trouble judging distances, lifting her feet, typing. With time, these improved. She was so determined to be well. The operation helped her a good deal; she was always convinced it did more for her than it actually did.

Jack Hofkosh, who saw her again for physical therapy, says that Margaret wanted explanations for everything and always, always asked why, but she never asked the one question everyone asks without fail: "Why me?" The question forced itself on her mind, but she adamantly refused to give it space: ". . . from whence come the trials by fire. Seems so purposeless, so undeserved. Undeserved is something we cannot judge and the very word had to be exiled outside of our consciousness or we could waste what little life we have ahead by complaining that we don't deserve such a fate." Margaret had long ago determined to squeeze as much from life as possible; nothing, not even Parkinson's, was going to stop her now.

"What Is Life For Not to Give Up and Die"

Oh, life, oh life: to be without such blaze.
But I am burning. No one knows my face.

Rainer Maria Rilke, 1926
(the last lines of his last poem, written as he lay dying)

Illness concentrated Margaret's mind as perhaps not even photography had done. Under assault by invincible forces, her spirit rang like crystal, and as she faced death, her embrace of life grew ever stronger. "Why do it at all," her notes say. "A bigger thing than self . . . I can't imagine giving up the fite . . . What is life for not to give up and die You're part of a great pool complex from which you can draw and to which you can also give. What is this spark which we want to keep alive to hand down."

Soon after her operation, she explored the inner recesses of her mind in a remarkable set of notes on her own psychology. Typing was still extremely difficult; sometimes the words are indecipherable, sometimes the grammar wavers, but her grasp of her own psychology was unflinchingly clear. The surgery had plunged her down the corridors of memory to a recurring encounter with her father.

As though the memory of my Father had lighted the way.

You accept the hardest missions. . . . You request the toughest assignment. You choose the hardest questions to answer in your school exam not just to please teacher and your mother.

Life is beating against the school windows. You must quickly open the doors and go out to learn and no door must be locked against you.

(In *Portrait of Myself* she wrote—she was speaking of photography —"Nothing attracts me like a closed door. I cannot let my camera rest till I have pried it open, and I wanted to be first.")

Privately she thought that Parkinson's, which seemed to magnify and exaggerate all her worst habits, brought with its other symptoms a fierce inferiority complex. It is yet another unholy aspect of a progressive

disease that it eats away at the sense of self-esteem. Margaret's self-doubt unfolded backward on her father. "Was I so sure with all my success and talents but with father, despite the grand way I always told the story got best minds in the country but no one could finish it." (She is referring to his last, incomplete design.) "Did I . . . doubt . . . father . . . authority for statements seems not higher than Mr. Aclymonta. Father's almost supernatural stature (his worth) to me dwindles in my eyes! Couldn't the same thing happen to me . . . during steel mills to luce stage, with my galloping self confidence, which was certainly dominant no doubts of self—but I feel a kind of switch over: maybe father and his sacred work wasn't as great as I thought it was. Maybe I not as great . . . I not the uniquely needed person I thought I was."

So she had been certain not only of her talent but of her place in history. Her identification with Joseph White was so strong that his stature and her own mirrored each other even as they shifted in her mind. Her very illness seemed to repeat his, as in some fateful myth. "It's the parallels in the paralysis that I find so striking . . . his left side was completely paralyzed. . . . He made up exercises for himself to bring back the power in his muscles." It was as if her body were as dependent on his experience as her vision had been. "He couldn't speak for twelve days" —less than a year before her operation, she who was so articulate had developed minor difficulties initiating speech. It was a harbinger of worse to come.

She was searching for clues to her existence. She analyzed her devotion to her father and his grip on her, which had not lessened in the thirty-seven years since his death. "There's something about all this and the extra compulsion in it to succeed. . . . Maybe its an achievement I want to take to my father maybe it's the very close identification this seems to inspire, or maybe it's just a little girl who adores and misses her father."

Once Joseph White had told her that "the portals of the mind stay open if you keep on wanting to learn. . . . Well I had journeyed to the deep inside of my mind I had taken the fearsome journey and returned unscathed, but deeply moved . . .

"Perhaps just a little girl who loved her father, and caught from him that spark that is the most precious gift of all that dedication to work and truth the straight look that all photographers . . . Or perhaps just a little girl who had loved her father and looked to him as the model in all things, and had not had the chance to mourn him when he died and no chance to impart, for you taught me this, father my thanks that you taught me the direct look on things."

She might have been walking across Bound Brook with him again as

he revealed to her wide-open eyes the detail in nature, the beauty of factories. She had stepped away on her own after a time to match that beauty in the world beyond. "If the little one could only show him what she had found . . . the engineer who vibrated at the poetry of it too he somehow managed to communicate."

Her doubts about him could not, did not, last beyond a page. He had inspired her, shaped her, handed her an unlimited legacy. What she had done she had done because of him and for him, and what she had become, even in her struggle, echoed him as well. She had lived her whole life as if she were standing, time and again, in a shadowy factory beside her father, her heart leaping up as a magical river of fire ran blazing across the dark.

Not long after the operation, Margaret went to the Rusk Institute for several weeks of physical therapy. She learned to walk again, to run again, to feel securely balanced in a crowd. She practiced loading a camera. She wanted passionately to work once more and believed she could. Not only had her childhood dreams been grander than most, she had also had the temerity to live them. Hers had been a daring design, so brilliantly executed that she might well have thought life had made one of its emptiest bargains with her, promising her control. She would live for twelve years after the operation, but she would never photograph for *Life* again.

Alfred Eisenstaedt, who had been on *Life*'s first masthead with her, came to visit her at Rusk. In no time he was taking pictures of her in her rehabilitation classes so that she would have a personal record of her progress. As the days went by, the pictures became a means of proving to *Life*'s editors that Margaret was better, and a means to a close and lasting friendship with Eisie. At length *Life* assigned a story to the two of them, she to write the text, Eisenstaedt to take the pictures. Together they watched Dr. Cooper do the same operation on another Parkinson's patient. During the operation, Margaret reached impulsively for the patient's hand just as it stopped trembling.

When Eisenstaedt photographed her, her hair, just beginning to grow back, sat close to her head like a boy's. She crumpled pieces of paper, learned to tango, catch a ball, enunciate more clearly. She learned how to type again beside a young man with malformed arms who hit the keys with a stick in his mouth. Ed Thompson struggled with the idea of putting Margaret's illness into the magazine—he knew that Maggie the Indestructible would never be well. *Life* ran medical stories all the time, but not about its own. Yet Margaret clearly wanted this. The story ran in June.

Margaret Bourke-White was back in *Life* magazine and back in the public eye. As she always had, she came to public attention by an unusual route and with unusual courage. She who had refused to tell anyone she was ill now told millions. In 1959, public confession of this sort was neither required nor expected of the famous. Only in more recent years has it become commonplace for movie stars to speak of their battles with alcoholism and for an ex-President's wife to publicize her drug addiction and her mastectomy. Not the first person of great reputation to reveal that life had crippled her, Margaret was still early, still a pioneer of sorts. As she had been before.

And yet another time: in 1960, on national television, *The Margaret Bourke-White Story*, with Teresa Wright as Margaret and Eli Wallach as Eisenstaedt, dramatized her operation. (The play was sponsored by the Breck shampoo company, which almost backed out when they realized the star had to have her head shaved for the role.) Margaret worked closely and eagerly with the people involved in her second confession. Her whole life had centered on communication. She had understood at every step how a new instrument or a new medium could create a new audience; now it was television's turn. Tex McCrary, who interviewed Margaret on TV before she was ever ill, says she taught the crew how to use stills in this medium she had not used before. She had an instinct for information, in whatever form it was delivered.

A photographer is someone with a need to communicate. So is a lecturer. So is a writer. By 1960, as Parkinson's took Margaret over, speech, writing, photography had all become arduous. She had given up photography and had to give up lecturing. Teresa Wright remembers her during the filming of the play: "She was so intense, it was almost like an animal when she stared at you, an almost ferocious intensity from the eyes, far beyond the meaning of what she was doing. Her concentration was so great on trying to communicate." She was still writing. In 1963, *Portrait of Myself* was published; there she told her life as she wanted it known, and enough people wanted to know it that way to make the book a best seller.

Margaret had built her life on a plan. She had missed out on two major items on the program—family and a stable home life—but she had packed the empty spaces to bursting with adventure and achievement. As she grew older, a need she had not previously considered cropped up: security. In 1949, long before any signs of illness, she had asked to participate in Time Inc.'s profit-sharing and retirement plans, a request that could not be granted because she was not on staff. (The

agreement when she returned from *PM* specifically denied her a staff position.) In '55, she wrote to the president of Time Inc.:

> Other people have families—children. I do not have. Life Magazine is my entire life. I have risked my life for it more times than I can count. I will risk it again. I am supremely happy in the work I am doing, and in my relationship with the magazine. I have no other basis or claim on my affections. I have no other heir.
>
> You know of course of my desire to will my life savings, house, etc. to the company—or someone designated—as part of the arrangement I so greatly desire.
>
> . . . There must be some way I can enjoy the rest of my life with more peace of mind and in terms of some additional security. Particularly when I am so happy to buy it with all I own.

In the late fifties, Time Inc. did find a way to put Margaret on staff retroactively, without asking for her savings or her house in return. The corporation gave her a much larger stake in the company than if she had just been taken on. She wrote Henry Luce that being a staff member meant even more to her than the additional financial security: "It gives me a wonderful feeling of *being in the family*, which has come to mean increasingly more to me as the years of this happy association go on. This goes very deep with me." As she had found in work a friend who would not desert her, so she had found in *Life* a family that would keep her close.

Parkinson's may spread, and Margaret's did. Not long after the operation the disease reached her right side. In 1961, Cooper performed a second operation, this time on the left side of her brain. She had been warned that her speech might be affected by the operation, and it was. She never again spoke with great ease, and over the years, although she understood everything, it became harder and harder for her as the disease progressed to find the right word and get the sentence out. Even though this operation was less successful than the first, Margaret referred to it as a triumph of surgery. Her ingrained optimism was a way of life, and not entirely misplaced. Jack Hofkosh believes that her surgery, her exercise, and her determination to live extended her life as much as five years.

Margaret, who had managed to find a positive side to two failed marriages, found the benefits even of her affliction. Her suffering deepened her humanity as nothing else could have done. She wrote a friend after the first operation that being ill and finding she could contribute to her own recovery "has been one the great experiences of my life. I would not be without it even if I had the power to wipe it out of my past. It

brought me closer to other human beings in a way I cannot put into words. To me it was a profound experience."

Margaret Bourke-White had seen more searing agony in her lifetime than most Americans ever witness. She had viewed the world's misery through a camera and through the protective screen of a reporter's objective distance. People who have miraculously escaped illness, pain, or loss sometimes form essentially literary notions of suffering, but a dose of the darker realities on their own bodies instantly deepens sympathy with the human condition. Margaret said her illness united her to people.

> I don't know why but I just felt these are the struggles that many people have to go through, I simply had not known much about it.
>
> Quite frankly, I was tough. . . . A photographer just has to get it, so that makes us very brusque and unfeeling, so you start out that way, and later you begin to sense some human values.

She had sought a heightened awareness all her life. It had arrived, by a road no one would wish to travel.

Those who knew her say that she was friendlier than before, and softer, and had a new warmth. She felt it herself, with the joy of arrival in a promised land: "I had been so successful in my new found human contacts that I felt I could open my arms and the whole world would come running in. I wanted to fill my house with people and I succeeded." A young Mexican woman who had some skill in physical therapy lived with her for a time. The woman had been twice married to and twice divorced from bullfighters, and twice while she was in Darien young men tried to climb through a second-story window to reach her. She had a child while she was in Margaret's house and named Margaret godmother.

Another young woman, Shigeko Sasamori, worked for Margaret for a while. One of the "Hiroshima Maidens," she had come to this country for facial surgery under Norman Cousins's sponsorship; her son is named Norman Cousins Sasamori. Margaret tried to take pictures of little Norman, whose mother describes a Margaret Bourke-White transformed by a camera in her hands: "A double personality. She's so sweet and so kind, yet come to the picture, she forgets. Baby or not, what she wants to take, she wants to take. Baby cry or scream, doesn't make any difference. She say, 'Just stay there, just stay there.' I say, 'Baby's tired now.' 'Just one more, just one more.' Takes a long, long time."

But Shigeko Sasamori learned a great lesson from the tough photographer. "Very, very wonderful woman, strong, always positive . . . She knows strongly she is sick, but doesn't feel it or see it. Amazing. A really

good teacher for me. She taught me that a normal life is possible. I myself have a handicap." (Her face is mildly disfigured.) "I know very well I have it, but most of the time I don't."

Strong. Always positive. Margaret's prodigious strength of character was never more grand than in the years of her body's weakness. She insisted she would never give up, and she never did. "She knows strongly she is sick, but doesn't feel it or see it." Joseph Wershba, now a producer for 60 *Minutes*, interviewed her for a newspaper in 1963. "She was so beautiful," he says, "it took me by surprise. Intelligent, witty. She was watching you and matching you in the game, checker for checker. I found her exhilarating, exciting. Not aware of her disabilities. She walked like an old grandma, but the light around her was not old, just temporarily out of order. There was a gracefulness about her, a luminousness."

She was transformed by her struggle into a battered shell that housed a surprising radiance, as if her fabled physical energy had been condensed into some kind of inner electricity. She seemed to shrink, but her eyes grew ever more alive and piercing. The photographer Barbara Morgan had Margaret to a party when she was so ill she had to be carried into the house from the car. Margaret was the center of everyone's attention. Barbara Morgan says, "I've never seen any other person with such an intensity, as if the physical frustration had found a spiritual outlet. This cripple was the most magnetic person in the whole room."

In the sixties Margaret had a new suitor, an older man named Karl Johnson. Joseph Wershba was in Darien once when Margaret and Johnson got up to dance. She had difficulty getting started, but once in gear it seemed to work. Wershba says, "You could see in his eyes he was saying, 'Come on, Margaret, the bodies don't mean anything. We're going to *dance*.' "

As the odds against Margaret grew higher and her options narrowed, her courage burst all bounds. She seemed no longer to know fear. She laughed at life at the very moment it struck her down. Her refusal to feel sorry for herself, her constant cheerfulness, left Betty Cronander feeling incapable of helping at all: "She might tease you and coax you to come running with her. You knew how hard it was for her—God, she'd take these awful falls. The thing is she would laugh about it and come bouncing up, tears rolling down her face maybe because she's all skinned up. She just had such courage it almost broke your heart."

Norman Cousins found her once on the floor on her back. She had been there for some time, unable to turn herself over or get up. The instant she saw him she burst into laughter. "Look!" she said, jerking her arms about helplessly. "I'm just like a turtle!" Earlier, when he'd visited

her in the hospital, she'd snatched off her wig and "cried out with laughter. She said, 'Look how funny I look!' What a beautiful woman she was." Beautiful indeed, to mock her own shiny skull when all her life she had counted so heavily on appearances.

In 1969, Margaret went into the hospital to try a course of L-Dopa. The drug had only recently been discovered; its efficacy led Cooper to give up his operation. L-Dopa, the ancestor of the more effective drugs used today, did not work for everyone. It could also have serious side effects. As Margaret prepared for her hospital stay, she wrote a *Life* colleague about the drug's apparent effectiveness: "You can imagine how I am looking forward to it." But who could imagine that? Unfortunately, it was too late for her; the treatment was counterproductive and had to be stopped not long after it began.

By then she could barely walk unaided and needed assistance for the most basic matters. Speech required prodigious efforts; at the end, a listener had to put his ear to her mouth to hear even the word or two she could manage. Sean Callahan, who worked with her in her last year, says that sometimes it was embarrassing to be with her; she knew it and was embarrassed in her turn. Still her will to live remained intense. Myrle Morgan, Margaret's companion in her late years, says Margaret wanted so badly to be in the mainstream of life that she would bulldoze her way into a revolving door, which she could not maneuver, or dive into the deep end of her pool and nearly drown. It became so frightening to take care of her that Morgan asked a doctor to lecture Margaret on the proper conduct of her life. Margaret lectured him back: "I do not want to live 'cautiously.' I believe just the opposite."

Implausibly, her spirit grew stronger as the disease locked her body up ever more tightly. Jack Hofkosh remembers her with a touch of awe: "She was a kind of individual you don't meet often, a person of infinite wisdom, like Bernard Baruch and Howard Rusk. I'm sure I became a better person because of my association with her. She was one of the rare ones."

At the end of her life Margaret was writing, by means of halting and laborious dictation, a second book about her experiences. She did not live to finish it, but the project gave her life. "Work," her father had written to her mother before Margaret was even born, "that's what we hear from all sides, that what we know to be our salvation." So Margaret had lived her life, and so she ended it.

Having risked her life and taken her losses, she could go forward still against insuperable odds because she had done what she set out to do, and experience had had the good grace to live up to her initial vision of progress. "I wouldn't want to change any of my life," she wrote in 1964,

"even if I had the chance, because it's been the life I wanted. . . . I think I've been particularly fortunate; even my two broken marriages and this illness have been important to my own growth and development." With her vision of the worthwhile life, her belief in progress and pursuit of perfection, Margaret was a figure from a nineteenth-century dream of progress decked out in twentieth-century ambitions. She set off on a journey across the major events of her time in search of an ideal self and an ideal accomplishment.

The cost of so much adventure had been high enough, and in the end life always costs more than anyone can give, but Margaret was not only fully prepared to pay but also owed nothing to regret. Mike White, her sister-in-law, says, "I think that if she had had to do it again, by and large she would have done the same thing. . . . I had the feeling that even though she was so very alone at the end, that if she had to make the choice of doing as she had done and having that loneliness or having a more conventional life but not accomplishing as much, she would stick by what she had done."

The lesson she said she had learned from Chappie's mother, to leave a bad experience behind without bitterness in a neat closed room, had worked. Besides, she valued the good in her life far too highly to ruin it with if-only or what-if.

The disease ground onward. In midsummer of 1971 Margaret took one of the crashing falls that are the great danger in Parkinson's. She cracked several ribs and was confined to bed in a hospital. The total rigidity she had been fighting off for so long now met no resistance, and her immobility brought on complications. On August 27, 1971, Margaret Bourke-White died at Stamford Hospital in Connecticut at the age of sixty-seven, having waged war against Parkinson's for nearly twenty years. It was a gallant battle—which, come to think of it, might be said of her entire life.

By a fitting coincidence, the era of the big picture magazine as the country's major source of information came to an end almost the moment Margaret's obituary was being written. The picture magazine had felt the hot breath of the enemy in the late fifties, as television moved in to usurp its advertising and its place. *Look* magazine folded a mere two months after Margaret died, the weekly *Life* magazine at the end of '72. Margaret Bourke-White's rise and decline were synchronous with the rise and decline of the first successful photographic magazines in America; her career writes their story in brief. She rode the tide of a new form of mass communication.

No still photographer is likely ever to repeat her success, for the

conditions of that success cannot be recreated. The still photograph is no longer the single central carrier of information, nor is the picture magazine. The media stars today are not photographers but anchor men and women. Bourke-White and her success belonged to the times, a fact of which she was fully aware. "The photograph responds to the period," she said, "if good." Having allied herself from the beginning to the history of her lifetime, she proceeded to take a picture of its face.

"My life and my career was not an accident," Margaret once said. "It was thoroughly thought out."

And again, in her notes: "Only by his action can a man make (himself/his life) whole. . . . You are responsible for what you have done and the people whom you have influenced. IN THE END IT IS ONLY THE WORK THAT COUNTS."

Postscript

In the 1930s and '40s, American photojournalism was a public and by and large a public-spirited undertaking. Photographers were expected to bring back a single image with a universal meaning, a précis of events or character, an essay that upheld some standard ideas of community, of country, of right behavior. Margaret Bourke-White was a public photographer in every sense: in the national magazines she worked for, in the kinds of events she chronicled, in the responses she meant to elicit. It was partly because she shared the national sense of optimism and the vague national wish for the betterment of humankind that she could make superlative visual summaries of so wide a range of subjects with so broad a popular appeal.

After World War II, 35 mm photographers began to explore more private states of mind. The culture was changing. In the fifties and particularly in the sixties, as McCarthyism choked off social documentary (which retreated into the magazines) and the Beat generation began its interior journey, photojournalism took on a personal cast. *The Americans*, a 1959 book of photographs by Robert Frank, marked a turning point. The book was poorly received by the press, but photographers paid it close and eventually reverent attention. The nation as Frank saw it was lonely, vacant, alienated, melancholy. The optimism, even the patriotism, that *Life* and Margaret Bourke-White stood for had petered out somewhere along the way to the drive-in movie.

Photographers of the new generation, from Diane Arbus to Lee Friedlander, Garry Winogrand, and beyond, after Korea, after McCarthy, after the civil rights marches, the early student protests and Vietnam, would celebrate the outsider and sing the angst of the mechanical culture rather than its romance. The grand vision of Bourke-White's work, its faith in mechanical and spiritual progress, was faintly suspect in a more cynical and uncertain era.

Robert Frank's photographs carried 35 mm candid photography to a kind of logical extreme. His pictures were grainy, contrasty, rudely cropped. They enshrined what had been thought of as the camera's deficiencies—its puzzling blurs, its careless habit of cutting people in half at the edges of the picture, its unkind tendency to hide a face behind someone else's shoulder. Frank's photography was candid where Bourke-White's was posed, raw where hers was polished; he depended on chance, quick reactions, and a suspicion that the center might not hold. Bourke-White's careful design of every frame implied that a sense of order ruled the world, or at least that photographers could divine enough order to explain it.

A parallel and simultaneous shift in taste centered on the cool, reticent, emotionally complex and ambiguous imagery of Walker Evans. In recent years, as photography has invaded the precincts of art, critics have taken Bourke-White to task for being a popular and commercial photographer, and for not being Walker Evans. Her work has been called "overly emotional and . . . ultimately superficial" and chided as "lacking subtlety or ambiguity."

It is true that neither *You Have Seen Their Faces* nor Bourke-White's early photojournalism succeeded because of subtlety or ambiguity. She worked for a popular audience in a more innocent time, when photographs were in a certain sense new and readers were newly discovering them. She was direct, and sometimes her passion showed through. Her best pictures are brilliantly symbolic, summary, telegraphic; they remain to teach us, and sometimes to rebuke us.

The career that Bourke-White identified with so totally, the travel, the success, the way of life that meant as much to her as the pictures themselves (and possibly more), have lost none of their luminosity over the years. Women entering the field of photography, as they do in greater numbers every year, have Margaret Bourke-White constantly in mind. They do not want to photograph like her anymore; they only want to step into her shoes.

It cannot be done. The terms of stardom have changed, for the still photograph no longer rules the world, and the space for pioneering has contracted. Bourke-White's star will not be moved from the place she carved for it in the firmament. She was one of a kind, and we should not expect that history will provide the context for another.

With all her achievements, her fame, her sense of excitement, and her unwillingness to entertain regret, Margaret Bourke-White got more of what she asked from life than most people can hope for. But then, her accomplishments were so vast she could be said to have given the world

as good as she got, and much of her achievement is still alive in memory and on the printed page.

Taken all in all, it was a good life—at least the woman who lived it thought so—and she lived it fully to the very last step on the road.

Acknowledgments

This book depends immeasurably on the great generosity of Roger White, Margaret Bourke-White's brother, who shared his memories without hesitation and granted unlimited access to his sister's personal, professional, and family papers, reserving no right of censorship or control. No biographer could have asked for more. I hope I have given a truthful picture of his sister and of the family that shaped her; if not, the responsibility is entirely mine. A note of thanks should be added for Roger and Bonnie White's kind hospitality on the many evenings I spent burrowing through the files stored in their basement.

I owe a very large debt indeed to the George Arents Research Library at Syracuse University, chief repository of Bourke-White's papers, to its capable and ever friendly staff, and especially to Carolyn Davis, manuscripts librarian. The assistance I received from the Time Inc. archivist, Elaine Felsher, and from the Archives staff, was on an equally high level—which is to say in each case extraordinary.

Special thanks are due to Jim Hughes, who checked the entire manuscript for technical matters, to Edward K. Thompson and Carl Mydans, both of whom not only offered what seemed like limitless information and assistance but also read all the material of the *Life* years for accuracy, and to Eleanor Treacy Hodgins, who reviewed the *Fortune* pages for me. I'm most grateful to my editor, Aaron Asher, for his extensive patience and even more extensive knowledge, and to others at Harper & Row, especially Marjorie Horvitz and Claire Reich. No thanks could ever repay my personal cheering section: my sons, Eric and Jeremy Goldberg, who with unfailing grace, humor, and care saw me through the perils of misplaced notes, balky word processors, and exhaustion; and Loring Eutemey, without whose intelligence, advice, and unending support this book would never have been however good it is.

Some of the people I interviewed were so knowledgeable or insightful about Margaret Bourke-White or so kind in providing material that

they have left an unusually large stamp on her story. These include: Michael J. Arlen, John Bryson, Erskine and Virginia Caldwell, Sean Callahan, Cornell Capa, Henry Cassidy, Florence, Joseph, and Robert Connolly, Norman and Ellen Cousins, Betty Cronander, Helen Caldwell Cushman, Maitland Edey, David Eisendrath, Robert T. Elson, J R and Carol Eyerman, Robert E. and Emeline Fatherley, Violette Gilfillan, Felicia Gossman, Ralph Graves, Don Hershey, Ralph Ingersoll, Madge Jacobson, Sunil Janah, George Karas, Joseph Kastner, Percy Knauth, Arthur and Ada Korf, Joseph Liss, Tex McCrary, Evelyn Openhym, Herbert Orth, John Phillips, Richard Pollard, David B. Richardson, Peggy Sargent, Alexander Schneider, Lee Scott, Robert Sherrod, Howard Sochurek, Edward Stanley, Ralph Steiner, Col. Michael J. Strok, William Sutton, Joseph L. Thorndike, Jr., John Vassos, William Walton, Joseph Wershba, Mike White.

I am deeply indebted to all of Bourke-White's friends, relatives, and colleagues who gave so unstintingly of their time and recollections: Berenice Abbott, Ansel Adams, Helen Barrow, Roz Barrow, General William H. Baumer, Sylvia Bothe, Francis Brennan, Stanley Burnshaw, Dabney Caldwell, Erskine Caldwell, Jr., Noel Clark, Cleveland Center for Contemporary Art, David Cort, Harold Costain, J. Robert Coughlan, Malcolm Cowley, Edward P. Curtis, Roselle Davis, Loomis Dean, Alfred de Liagre, Jr., Max Desfors, Alfred Eisenstaedt, Elin Elisofon, Morris Engel, Walter Engel, Jane Estes, John Fatherley, Richard Fatherley, Robert Fatherley, Jr., Clay Felker, Margaret Pollard Finn, Alan Fisher, Harvey V. Fondiller, Barrett Gallagher, Jean Snow Gold, Janet Caldwell Gooding, Manfred Gottfried, Kenneth Gouldthorpe, Mrs. Oscar Graubner, Allen Grover, Hansel Mieth Hagel, Dora Jane Hamblin, Jerry Hannifin, Richard Eads Harrison, Bernard Hayden, Andrew Heiskell, Milton Hindus, Laura Z. Hobson, Jack Hofkosh, Martha Holmes, John Horn, George Hunt, F. Jack Hurley, Burl Ives, Sidney L. James, Nan Gilfillan Jensen, Oliver Jensen, Yale Joel, Dr. Edgar Kahn, M. Peter Keane, Penn Kimball, Harvey Klevar, Bert Kopperl, John La Montaine, Maurice Lancaster, Nina Leen, W. Colston Leigh, Clare Leighton, Wilma Smith Leland, Ruth Lester, Jay Leyda, Maxim Lieber, Daniel Linehan, S.J., John Loengard, Stefan Lorant, Dwight Macdonald, Ray Mackland, Lydia Winston Malbin, Tom Maloney, Jerre Mangione, Jack Manning, Dr. Morton Marks, William T. McCleary, Leonard McCombe, Marion McCreary, Joann McQuiston, Ved Mehta, Edwin R. Meiss, Richard Meryman, Eve Metz, Helen Kirkpatrick Milbank, Herbert Mitgang, Alice-Leone Moats, Hugh Moffett, A. D. and Josephine Moore, Dom Moraes, Barbara Morgan, Myrle Morgan, John Morris, Mary Morris, Ralph Morse, Janet Murrow, Shelley Mydans, Beaumont Newhall,

Clara Nicolai, Doris O'Neil, Gordon Parks, Antony Penrose, Clarence Perrine, Gerard Piel, Tom Prideaux, Wallace J. Quick, Robert Yarnall Richie, Col. Roswell Perry Rosengren, June Rotenberg, Charles Rotkin, Arthur Rothstein, Roy Rowan, Dr. Howard Rusk, Libby Sachar, Eleanor and Daniel Saidenberg, Shigeko Sasamori, Albert Schneider, Max Robert Schrayer, Dorothy Seiberling, Helen Huston Shedrick, Andrea Simon, James W. Skehan, S.J., Bradley Smith, Col. Craig Smyser, Mrs. Paul Sogg, Peter Stackpole, Hedda Sterne, Vivian Campbell Stoll, William Sumits, John Szarkowski, Lee Eitingon Thompson, Paul Tibbetts, Joan Tower, Anne W. Tucker, Karen Tuttle, John F. Vance, Jr., Eli Wallach, Deleon Walsh, Myrna Papurt Weibel, Robert Weinstein, Julius Weiss, Lael Wertenbaker, Dr. Farley Wheelwright, A.B.C. Whipple, Edward and Muriel White, Frank White, Bernice Schrifte Woll, Barbara Wild, Lee Witkin, Teresa Wright, Will Yolen and Peter Pollard, Julius Zalon, Myron Zucker.

My thanks also to: Dr. Joffre V. Achin, Eve Arnold, Gordon Aymar, Hugo Block, Louise C. Boer, Hon. Robert Boochever, Col. Max Boyd, John Chamberlain, Charles Champlin, Everett Chapman, Jr., General Mark Clark, Charles Collingwood, Kathryn Cravens, Patricia Divver Dagg, Robert J. Doherty, John Dominis, General Jimmy Doolittle, Diane Douglass and Alpha Omicron Pi, Irene L. Dunham, John Durniak, Arnold Eagle, Henry Ehrlich, Andreas Feininger, Gene Fenn, Hazel Flucker, Mrs. Dean S. Gardner, Robert Giroux, Arthur Goldsmith, Nancy Hector, Steven P. Hill, Harold and Loraine Price Howell, Elinor Green Hunter, Seville Johnston, George E. Jones, Mark Kaufman, Orrin Keepnews, Doris Steinmetz Kellett, Etna M. Kelley, Victor Keppler, Dmitri Kessel, Betty Irish Knapp, Rachel S. Knibloe, Katherine Kuh, George Lambrose, Susan J. Landers, Bill Leonard, Max Lerner, Lee Lowenfish, Marshall Lumsden, Elizabeth Magnuson, Grace Mayer, Jack Newman, Ben S. Roberts, Clete Roberts, David Scherman, Bernarda Bryson Shahn, Anne Slavitt, Allan Sloane, Gabrielle Smith, Anne S. Stein, Gloria Stern, Ezra Stoller, Lou Stoumen, Robert S. Strother, Madeline Tourtelot, Willard Van Dyke, Donald Weadon, Marion Post Wolcott, Philip Wooten, Jr.

Notes

Chapter 1: Minnie and Joseph

PAGE

1 **dialogues fail them:** Joseph White, letter to Minnie Bourke, 1/21/97, personal material retained by the Estate of Margaret Bourke-White (hereafter "Estate").

1 **well and good . . . study in common:** Joseph White, letters to Minnie Bourke, 11/19/97, 11/18/97, Estate.

2 **builder in Dublin:** Florence Connolly's family history (Estate)—but no other family record—says Joseph was the second son of the earl of Mayo. In Joseph's letters of 1863 and '64, his last name is spelled Burke; it is not clear when the spelling changed.

2 **that horrid drink . . . Steady Man:** Letters of 10/4/1863, 11/8/1863, Estate.

2 **buildings in Dublin:** Obituary, *The Builder* (London), 11/18/1871, p. 911.

2 **emigrated to New York:** Florence Connolly's family history, Estate.

2 **to the sidewalk, and died:** Florence Connolly, interview conducted by Robert H. Connolly, 1/30/83.

2 **open and inquiring mind:** Margaret Bourke-White, *Portrait of Myself* (New York: Simon & Schuster, 1963), p. 15 (hereafter *Portrait*).

3 **stenography, and cooking:** Florence Connolly, interview conducted by Robert H. Connolly, 1/23/82. See also letter from Joseph White to Minnie Bourke, 1/7/98, Estate.

3 **not quite nice:** *Portrait*, p. 14.

3 **going to the Devil!:** *Portrait*, pp. 14–15.

3 **ashamed of herself:** Margaret Bourke-White (hereafter "MB-W"), typescript notes, n.d., Margaret Bourke-White Collection, George Arents Research Library, Syracuse University (hereafter "B-W Col.").

3 **I want to go ahead:** Letter from Minnie to "Joey," 9/25/97, Estate.

3 **back into mine . . . depend on ourselves:** Letters of 9/25/97, 3(?)/23/1898, Estate.

4 **English could pronounce:** Information on the White family comes from a copy of a diary written in 1896 by Max White and now in the possession of Felicia Gossman.

5 **virtues of that stock:** Letter of 12/13/97, Estate.

5 **in my estimation:** Letter of 12/6/97, Estate.

5 **as a vocation:** See Robert S. Guttschen, *Felix Adler* (New York: Twayne Publishers, 1974), pp. 41, 172, 152, 274, 35.

5 **pledged to marry:** Joseph White, letter to Minnie Bourke, 11/4/97, Estate.

5 **atheist minister:** Florence Connolly, interview conducted by Robert H. Connolly, after 1/23/82.

6 **perfect as possible:** Letter of 1/7/98, Estate.

6 **committing a crime:** Letter of 10/9/97, Estate.

6 **my wife keeps hers for me:** Joseph White, draft of a letter to Minnie's mother, 3/21/98, Estate.

6 **not be controlled:** Letter of 2/7/98, Estate.

6 **in wedlock as without:** Joseph White, draft of a letter to Minnie's mother, 3/21/98, Estate.

7 **she said yes:** *Portrait*, p. 15.

7 **between married partners:** *Portrait*, p. 11.

7 **Joe had one alone:** Estate.

7 **Harrison Avenue:** Birth certificate, B-W Col.

7 **on time since:** *Portrait*, p. 12.

8 **Minnie wanted so badly:** Typed manuscript for *Portrait*, n.d., B-W Col.

8 **help her with her work ... not be felt by you:** Letters of 12/18/97, 10/28/97, Estate.

8 **totally impossible:** Roger White, letter to MB-W, 7/5/32, B-W Col.

8 **from a single tree:** Marion McCreary, interview, 5/11/82. See also Marion McCreary, *Middlesex Chronicle*, 9/14/67, p. 8.

8 **his asparagus:** Florence Connolly, interview conducted by Robert H. Connolly, after 1/23/82.

9 **highly educated people:** Interviews, Barbara Wild, 5/11/82; Clarence Perrine, 5/11/82; Bernard Hayden, 6/29/82, telephone. Mr. Perrine provided valuable information about the town, 2/6/83, telephone.

9 **could teach the children:** Anne White, interview, 12/8/81.

9 **constructive curiosity:** Letter from MB-W to Kay Reese, 6/10/57, American Society for Magazine Photographers files.

9 **Search out:** MB-W, notes for *Portrait*, 3/5/59, B-W Col.

10 **Be unafraid:** MB-W, notes for *Portrait*, 3/5/59, B-W Col.

10 **then *do* something!:** MB-W, "The Best Advice I Ever Had," *Reader's Digest*, June 1957, pp. 60–2.

10 **read them studiously:** Florence Connolly, interview conducted by Robert H. Connolly, after 1/23/82.

10 **vitamins and digestion ... too much starch ... rare delicacy:** Roger White, interview, 12/6/81.

10 **Chewing gum . . . slang:** Mike White, interview, 12/8/81.

10 **silk stockings:** *Portrait*, pp. 21–2.

10 **cards ... funnies:** Charlotte Himber, *Famous in Their Twenties* (New York: Association Press, 1942), p. 104.

11 **I am good this summer:** MB-W, note to Minnie, June 1917.

11 **influence on her early life:** MB-W, undated notes for *Portrait*, B-W Col.

11 **broken soup plates ... Do it the hard way!:** *Portrait*, pp. 21–2.

12 **get it all down:** Florence Connolly, interview conducted by Robert H. Connolly, after 1/23/82.

12 **not reply to questions:** Minnie White, letter to MB-W, 2/17/(?), after Joseph's death, B-W Col.

12 **remember what she'd asked:** Interviews, Roger White, 12/7/81, and Anne White, 12/8/81.

12 **touched his food:** *Portrait*, p. 18.
12 **our salvation:** Letter of 1/7/98, Estate.
12 **strident blues:** Ibid.
12 **Braille press:** Letter from Minnie to MB-W, 8/23/31, B-W Col.; also family history by MB-W, 9/25/68, in Helen G. O'Connor, *Bibliography of Margaret Bourke-White*, University of Minnesota, 12/68.
12 **something to kill men:** MB-W, "Notes on Mother," n.d., B-W Col.
12 **officers ever saw them:** *Portrait*, pp. 20–1.
13 **success of his daughter:** Letter of 8/23/31.
13 **position and prominence:** MB-W, typed notes, n.d., B-W Col.
13 **cat's cradle on wheels:** *Portrait*, p. 20.
13 **derives from utility:** Filmore Calhoun, biography of MB-W, second copy, 6/12/56, p. 4, Time Inc. Archives.
13 **some kind of god:** She wrote about her "Father's almost supernatural stature" in an undated typescript (c. 1959–60), B-W Col.
14 **for years to come:** MB-W, *Portrait*, p. 18.
14 **wanting to travel:** MB-W, transcript notes, n.d., B-W Col. "Bourke-White" is an anachronism. As a child, she was Margaret White.
14 **so as to be prepared:** Minnie White's diary, 1911, Estate.
14 **she was smart:** Interviews, Barbara Wild and Clarence Perrine, 5/11/82; Bernard Hayden, 6/19/82, telephone.
14 **the high cliffs:** Etna M. Kelley, "Photography Is Fun," *The Portal*, n.d. (mid-'30s), p. 3.
15 **across Bound Brook:** *Portrait*, p. 78.
15 **in his mind's eye:** Winifred and Frances Kirkland, *Girls Who Became Artists*, New York: Harper and Brothers, 1934), p. 39. Checkers are mentioned in MB-W's seventh-grade diary.
15 **sure to light on them:** *Portrait*, p. 13.
15 **thought he'd be pleased:** Himber, *Famous in Their Twenties*, p. 104.
15 **under the piano:** MB-W, typed manuscript for *Portrait*, n.d., B-W Col.
15 **dining room windowsill:** *Portrait*, p.13.
15 **beside the fire:** Kelley, "Photography," p. 3. Also *Portrait*, p. 14.
15 **to leave them home:** MB-W, typed manuscript for *Portrait*, n.d., B-W Col.
15 **things that women never do:** *Portrait*, p. 14.
16 **record of what he has seen:** "The Kodak Manual," manuscript, George Eastman House, Rochester, N.Y. Quoted in Beaumont Newhall, *The History of Photography* (New York: Museum of Modern Art, 1982), p. 129.
16 **attention instead to bicycling:** Dorothy Norman, *Alfred Stieglitz: An American Seer* (New York: Random House, 1973), p. 42.
16 **visit Minnie:** Letter from Joseph to Minnie, 9/17/97, Estate.
16 **full of his photographs:** Florence and Joseph B. Connolly, interview conducted by Robert H. Connolly, after 1/23/82.
16 **designed for a camera:** Patent No. 1,496,503, granted 6/31/24.
16 **set them deep in space:** *Portrait*, p. 20.
16 **cigar box:** Hugh Seaver, letter to MB-W, n.d., B-W Col.
16 **in the bathtub:** Florence and Joseph B. Connolly, interviews conducted by Robert H. Connolly, after 1/23/82 and on 1/30/83.
17 **it was a stroke:** Roger White, interview, 12/6/81.
17 **unable to talk:** MB-W, "B-W Psycho," n.d., c. 1960, B-W Col.

17 **found the key:** Roger White, interview, 12/6/81.
17 **put on his trousers:** Florence and Joseph B. Connolly, interview conducted by Robert H. Connolly, after 1/23/82.
17 **bring back their strength:** MB-W, "B-W Psycho," n.d., c. 1960, B-W Col.
18 **the picture was taken:** Information about this trip from a 1919 trip diary in the possession of Daniel Wolf Gallery, New York.

Chapter 2: A Photographer Is Born

19 **going to accomplish:** Roger White, interview, 12/6/81.
19 **performing well was:** Ibid.
19 **all those people:** MB-W, handwritten notes, 9/2/57, B-W Col.
19 **vocational students:** Interviews, Libby Sachar, 5/11/82; Evelyn Openhym, 3/15/82, telephone.
20 **to clothe her:** Evelyn Openhym, interview.
20 **a young man's eye:** Interview, Clarence Perrine, 5/11/82.
20 **outraged:** Mrs. Harold S. Gardner, reminiscence transmitted by Mrs. Dean S. Gardner in a letter to the author, 7/26/82.
20 **the senior play:** Myron Zucker, letter to the author, 6/11/82.
20 **the war effort:** My thanks to Evelyn Openhym for sending me this poem.
20 **by an expert:** Letter from Mrs. George Dombo to MB-W, n.d., c. 1963, B-W Col.
20 **help you to progress:** Jessie Allen Fowler, character analysis of Margaret White, 5/27/19, B-W Col.
21 **consider worth while:** Letter from Mrs. George Dombo to MB-W, op. cit.
21 **meant to be a writer:** Libby Sachar, interview, 5/11/82. Information about Miss Gilbert from a typescript by MB-W, n.d., B-W Col.
21 **got his puppy:** Printed in October 1919 in *The Oracle*, Plainfield High School, B-W Col.
21 **passport to popularity:** *Portrait*, p. 23.
21 **self-sufficient:** Evelyn Openhym and Libby Sachar, interviews.
21 **than a birthmark:** *Portrait*, p. 22.
22 **totally, invisible:** *Portrait*, p. 24.
22 **aesthetic dance:** MB-W, manuscript for *Portrait*, n.d., B-W Col.
22 **work not dates:** MB-W, notes, n.d., c. 1950s, B-W Col.
22 **almost twenty-nine:** Interviews, Nan Gilfillan Jensen, 4/25/83; Violette Gilfillan, 4/27/83, telephone.
22 **people born mature:** Madge Jacobson, interview, 3/1/82.
22 **spoiled along the way:** MB-W, diary, Camp Agaming, Lake Bantam, Conn., summer 1922, November 1922, Estate.
22 **I don't need him:** Ibid., 8/12/22.
23 **animals she fancied:** Ralph Steiner, interview, 4/28/82.
23 **attractive to men:** Madge Jacobson, interview, 3/1/82.
23 **he was gone:** Roger B. White, "My Life," 1926, Estate.
23 **Joseph White's work:** MB- W, "B-W Psycho.," n.d., c. 1960, B-W Col.
23 **love of truth:** *Portrait*, p. 21.
24 **all MB-W has become:** Kirkland, *Girls Who Became Artists*, pp. 38–9.
24 **would explain everything:** Written for *Chicago Tribune*, n.d., B-W Col.
24 **mourn his death . . . on her shoulders:** Ibid., and MB-W, diary, 1922–25, 1/23/23, possession of Sean Callahan (hereafter "Callahan").

24 her tuition: Madge Jacobson, interview, 3/1/82.

24 Clarence H. White School: MB-W, typescript, n.d., probably '50s, B-W Col.

24 most mortal enemy: Charles Baudelaire, "The Salon of 1859," in *Art in Paris 1845–1862: Salons and Other Exhibitions*, trans. Jonathan Mayne (New York: Phaidon, 1965).

25 coiled about each arm: Mrs. Clarence H. White, "Camera's Eye View of Careers," *Independent Woman*, February 1937, p. 48.

25 get much beyond that: Dorothea Lange, quoted in *Symbolism of Light: The Photographs of Clarence H. White* (Wilmington, Delaware Art Museum), 1977, p. 24.

25 in-betweenness of things: Ralph Steiner, interview, 4/28/82.

25 photographic means will allow: *Photographic Art*, June 1916, quoted in *Symbolism of Light*, p. 25.

26 forgotten she'd ever done it: MB-W, letter to Minnie White, 5/10/29, B-W Col.

26 glass plates: MB-W, handwritten notes, 9/2/57, B-W Col.

26 chance is a poor photographer: *Symbolism of Light*, p. 13.

26 as he could possibly make it: MB-W, typescript, n.d., probably '50s, B-W Col.

26 senior year in college: *Portrait*, p. 29.

27 everything under the sun: Diary, Camp Agaming, summer 1922.

27 burst of light . . . the panorama: Madge Jacobson, interview, 3/1/82.

27 to send home: Ibid.

28 two thousand cards: Diary, Camp Agaming, 8/28/22, 9/5/22, 9/8/22, 9/9/22. Also Madge Jacobson, interview, 3/1/82.

29 fool's gold: Diary, Camp Agaming, 9/18/22.

29 drink me all in: Ibid., 10/6/22.

29 like the Amish: Max Robert Schrayer, interview, 4/22/82.

29 hop a freight car: Diary, Camp Agaming, October 1922.

30 a craving to now: Ibid.

30 she demurred: Ibid., various dates in October 1922.

30 snake . . . as a pet: Max Robert Schrayer, interview, 4/22/82.

30 power of machines: Edwin R. Meiss, interview, 4/29/82.

31 gave her diffusion: Diary, 1922–25, 1/6/23.

31 a night scene: Max Robert Schrayer, interview, 4/22/82.

31 reduced to conversation: Diary, Camp Agaming, November 1922.

31 Joe Vlack: MB-W's diary refers to "Joe Flack." Michigan alumni records list no such name. Joseph B. Vlack took a BSE in engineering in 1924.

31 her future fame: Ibid., 11/13/22. See also diary, 1922–25, November 1922.

32 worldwide significance: Letter from Dr. Ruthven to MB-W, 10/3/60, B-W Col. Also Alexander G. Ruthven, *A Naturalist in Two Worlds* (Ann Arbor: University of Michigan Press, 1963), pp. 20–1.

32 crowded museum conditions: Diary, 1922–25, 1/12/23.

32 a success: Ibid., 1/30/23, 2/2/23.

Chapter 3: First Love and Secrets

33 elected house president: Diary, 1922–25, 2/17/23, 2/18/23. Also diary, Camp Agaming, October 1922.

33 and she refused: Ibid., 1/19/23.
34 I'll kiss dozens more: For an account of 1920s morality, see Frederick Lewis Allen, *Only Yesterday* (New York: Harper and Brothers, 1931), ch. 1, 5.
34 gave herself away too easily: Diary, 1922–25, 1/17/23.
34 time to breathe: *Portrait*, p. 25.
35 knew he was just the same: Ibid.
35 I ever went out with: Diary, 1922–25, 2/24/23.
35 Let's play with x: Ibid., 4/26/23; also 2/6/23, 2/26/23.
35 Giggled . . . all evening . . . adorable little boy: Ibid., 4/28/23, 4/28/23, 6/10/23.
35 advised her on the lighting: Diary, 1922–25, 4/23/23, 4/24/23; also 3/6/23, 3/18/23. Most of the information on Chappie comes from this diary.
36 all desire and all fear: Ibid., 3/31/23.
36 easier for her: Ibid., May 1923, passim.
36 a fierce joy: Ibid., 9/19/23, also January 1924.
37 she was uncertain: Ibid., April, May, 1923.
37 mental telepathy roses: Ibid., 5/13/23, 5/15/23; also 5/1/23, 6/13/23.
37 six-thirty in the morning: Ibid., 6/16/23; also 5/18/23.
37 do it occasionally: Ibid., 5/30/23; also 5/19/23, 5/27/23.
38 told Chappie . . . she loved him: Ibid., 6/4/23, 6/25/23.
38 a long time ago: Ibid., 6/13/23.
38 shadow over the world: Ibid., 8/5/23. For the book project, see 6/25/23, 7/18/23; also August.
39 sorrow had struck her in the face: Ibid., 8/29/23, 8/30/23.
39 certainty that I love Chappie: Ibid., 8/27/23; also 8/19/23.
39 Sobbed liked a baby: Ibid., 10/9/23; also 10/29/23.
40 he was repentant: Ibid., 9/28/23.
40 anything I have ever done: Ibid., 9/21/23.
41 dreamed of every night: Ibid., October–November 1923.
41 critical and "curious": MB-W, letter to Minnie, June 1924, B-W Col.
41 to talk to her: Florence Connolly, interview conducted by Robert H. Connolly, 1/30/82.
41 abide her very well: Letters from Minnie to Margaret, n.d. and 4/14/30, B-W Col.
41 as a mud fence: Mike White, interview, 12/8/81.
41 firmly and finally: Roger White, interview, 12/6/81. See also diary, 1922–25, 12/17/22.
42 Jewish enslavement: Nathan C. Belth, *A Promise to Keep* (New York: Times Books, 1979), p. 36; also pp. 28–51.
42 his contemporaries: Roger White, interview. 12/1/81.
42 my camp experience: Diary, 1922–25, 12/19/22; also 9/23/22, 9/25/22.
42 like him very much: Ibid., 3/16/23.
43 for their own purposes: Belth, *Promise*, p. 72; also pp. 58–113.
43 *Mixed Marriage:* Diary, 1922–25, 10/4/23.
43 number of her visits: Ibid., 11/27/23; also 11/19/23, 11/20/23.
43 like an outsider: Ralph Steiner, interview, 4/28/82; Edward Stanley, interview, 3/5/82.
44 and find the truth: MB-W, "Words About Pictures," *Infinity*, June 1958, p. 7.

Chapter 4: White Fires, Red Fires

45 beating against his face: Diary, 1922–25, 9/4/23.

45 held on to me for an hour: Ibid., 11/9/23.

46 mangled his ideas up so: Ibid., 10/30/23.

46 waiting to be born: *Portrait*, p.12.

46 impressed by its "barbarism": Diary, 1922–25, 12/15/23.

46 sweetly apologetic: Ibid., 4/1/24. On her lack of sympathy, see 1/7/24.

46 unearthly joy . . . unendurable happiness . . . the art of love . . . for want [of] relief . . . not happy, Your lover . . . unresponsive afterwards: Ibid., 4/7/24, 4/21/24, 3/3/24, 3/9/24, 3/11/24, 3/20/24.

47 our difficulties over at last: Ibid., 5/11/24.

48 didn't have very close friends: Ibid., 5/22/23.

48 lending Margaret her wedding ring: A. D. and Josephine Moore, interview, 8/24/83, telephone. See also letters from MB-W to Minnie, 6/22/24 and undated, B-W Col. Also *Portrait*, p. 26.

48 a matter of registration: Undated letter, after 6/14/24, B-W Col.

48 change that situation right away: Josephine Moore, interview. See also letter from MB-W to Minnie, 6/22/24, B-W Col.

48 it were a crown: *Portrait*, p. 27.

49 responsibilities at home . . . be able to give them: Diary, 1922–25, 5/24/24, 1/14/25.

49 had not received from her husband: Undated typescript for *Portrait*, B-W Col.

49 unusual powers: Diary, 1922–25, 3/29/24.

49 hypo and the safety light: Ibid., 6/13/, 6/16, 6/18/24; also May 1924. See also MB-W, letter to Minnie, 6/22/24, B-W Col.

50 every sound carried . . . He studies too much: Letter from MB-W to Minnie, 6/22/24. See also diary, 1922–25, 6/23/24.

51 never want to see you again: *Portrait*, p. 27. See also undated typescript for *Portrait*, p. 5, B-W Col.

51 tears on his shoulder: A. D. and Josephine Moore, interview, 8/24/83. Also diary, 1922–25, 6/27/24.

51 this passion of ours: Ibid., 2/24/25.

51 whole wheat muffins and tea: Letter from MB-W to Minnie, undated, Estate.

52 he'd been before they married . . . to forget this day . . . and me desperate: Diary, 1922–25, 7/31/24, 8/15/24, 8/18/24.

52 withering withdrawals: Ibid., 1922–25, 1924–25, passim.

52 wish I had not loved you so: Letter of 2/23/26. See also letter of 3/8/25. B-W Col.

52 ultimate results: Letter of 2/19/16, B-W Col.

53 climbed back into the house . . . Diary of Disappointment: Diary, 1922–25, 2/3/25, 3/8/25.

53 make this come right: Diary, 1922–25, 1/3/25.

53 meet his obligations: Ibid., 11/17/24.

54 immoral use of a baby: MB-W, typed notes, n.d., B-W Col.

54 **Margaret Sanger's pamphlet:** John Reed, *From Private Vice to Public Virtue: The Birth Control Movement and American Society Since 1830*

(New York: Basic Books, 1978). My thanks to Lawrence Lader for this reference.

54 **never know the cause:** Diary, 1922–25, 12/6/24.
55 **Adore the baby:** Ibid., 12/21/24.
55 **Oh God:** Ibid., 2/18/25.
55 **no better than sheep:** Ibid., 12/8/24.
56 *The Woman Movement:* Ibid., 12/23/23.
56 **the man I love:** Ibid., 7/24/24.
56 **Certainly the family . . . personality:** *The Woman Movement* (New York: G. P. Putnam's Sons, 1912), pp. 183, 97, 210.
56 **photographs were overexposed . . . series on the city:** Diary, 1922–25, 4/9/25, 8/19/24.
57 **one of the teachers fell ill:** Himber, *Famous in Their Twenties*, p. 105.
57 **sense of release:** MB-W, handwritten note, n.d., B-W Col.
57 **I could ever have dreamed:** *Portrait*, pp. 28–9.
58 **try to possess someone:** Typed manuscript for *Portrait*, n.d., p. 7, B-W Col.
58 **never have been a professional photographer:** *Portrait*, p. 29.
58 **life as a housekeeper:** Letter from Gussie White to MB-W, 5/17/27, B-W Col.
58 **show that woman she was wrong:** Betty Cronander, interview, 1/17/83.
58 **college after her marriage:** MB-W, undated typescript for *Portrait*, B-W Col.

Chapter 5: The Region Occupied by Stieglitz

59 **stony attitude toward them . . . no interest in joining:** Letter to the author from Deleon "Dill" Walsh, 6/6/82. My thanks to Mr. Walsh for his informal canvass of his classmates at a reunion.
59 **Hungry for dates:** Quoted, without attribution, by Helen Huston Shedrick in a letter to the author, 6/6/82.
59 **a will of iron:** Letter from Helen Huston Shedrick, 6/6/82.
60 **any other way:** Don C. Hershey, interview, 7/28/82, telephone. Also letter to the author, 7/24/82.
60 **tops in her field:** Letters to the author, 6/6/82, 7/8/82.
60 **some thought it disgusting:** Dill Walsh, letter of 6/6/82. Also Helen Huston Shedrick, letter of 6/6/82.
60 **or when she could:** Don C. Hershey, interview, 7/28/82.
60 **a waste of her time:** MB-W, diary, 1927, Estate.
61 **give up waitressing:** Letter from Foster M. Coffin to W. Palmer Smith, 11/19/38, deceased alumni records #41/2/877, Dept. of Manuscripts and University Archives, Cornell University Libraries, Ithaca, N.Y.
61 **campus pattern pictures:** MB-W, "My First Job," *Ladies' Home Journal*, April 1957, p. 197.
61 **Pseudo-Corots:** *Portrait*, p. 31.
61 **shows in their offices:** Memo from the manager of Cornell University Residential Halls, 11/8/38, Dept. of Manuscripts and University Archives, Cornell University Libraries.
62 **an important person:** Interview, 7/28/82.
62 **rather than hurt feelings:** Letter, 7/24/82, and interview, 7/28/82.

62 **technical advice:** *Portrait*, pp. 30–1. Additional information generously given by Don C. Hershey. Margaret wrote in her book that she organized the sales force, but Hershey's account seems more likely.

62 **first woman to do so:** Don C. Hershey, letter to the author, 10/18/83.

62 **photographer or a real estate agent:** quoted in Robert S. Lynd and Helen Merrell Lynd, *Middletown: A Study in American Culture* (New York: Harcourt, Brace & Co., 1929), p. 25.

63 **Frances Benjamin Johnston:** See Pete Daniel and Raymond Smock, *A Talent for Detail: The Photographs of Miss Frances Benjamin Johnston, 1889–1910* (New York: Harmony Books, 1974).

63 **region occupied by Stieglitz:** Letter to the author from Don C. Hershey, 11/9/83. Also interview, 7/28/82.

63 **photo-feature:** newspaper article, probably from the *Ithaca Journal*, 1956, n.d., Dept. of Manuscripts and University Archives, Cornell University Libraries.

63 **dean of the architectural school:** Letters from George Young, Jr., 1927–29. Ibid.

63 **becoming a professional photographer:** *Portrait*, p. 31.

64 **Chappie visited her at Cornell:** Letter from Don C. Hershey to the author, 7/24/82.

64 **And I haven't:** Betty Cronander, interview, 12/2/82, telephone.

65 **or made her strong . . . following her career:** Betty Cronander, interviews, 12/2/82, telephone; 1/17/83.

65 **connections in the photography world:** Letter from Gussie White to MB-W, 5/17/27, B-W Col.

65 **and get work:** *Portrait*, p. 32. See also undated typescript for the book, B-W Col.

65 **her promised land:** *Portrait*, p. 32.

Chapter 6: "This Feeling of Rising Excitement"

67 **black to go with the red:** *Portrait*, pp. 42, 34.

67 **straight, sharp-focus photography:** *Portrait*, p. 30.

67 **better picture construction:** John Pultz and Catherine B. Scallen, *Cubism and American Photography* (Williamstown, Mass.: Sterling and Francine Clark Institute, 1981), p. 42.

67 **nature of his instrument:** "The Art Motive in Photography," address delivered at the Clarence H. White School in 1923. Reprinted in Vicki Goldberg, *Photography in Print: Writings from 1816 to the Present* (New York: Simon & Schuster, 1981), pp. 276–87.

68 **Russian magazines:** Diary, 1922–25, 1/5/23.

68 **learned that fast:** Ralph Steiner, interview, 4/28/82.

68 **ever sold commercially:** *Portrait*, p. 36, and MB-W, undated typescript, B-W Col.

69 **replace a single Bemis:** *Portrait*, pp. 36–7.

69 **and that's the truth:** *Portrait*, p.38.

69 **Shoot off your own cannon:** Typescript notes, "Bemis," B-W Col.

70 **a man in her apartment:** 1927 diary, 12/6/27, Estate.

70 **run her carpet sweeper:** 1927 diary, 1/6/27.

70 flowers sagged on their stems: *Portrait*, pp. 34–5.

71 it did not take: Madge Jacobson, interview, 3/1/82.

71 same time and the same place: 1927 diary.

71 cover for the book of photographs: MB-W, typed notes, undated, B-W Col.

72 never meant to be bought: 1927 diary, 12/11/27.

72 labelled it beautiful: NEA magazine article, 1929, n.d., no title, B-W Col.

72 take industrial pictures: MB-W, undated typescript, p. 14, B-W Col.

72 stop for Christmas Day: Calendar for *Portrait*, 1955, B-W Col.

73 policemen followed her . . . unlikely performance: MB-W, address, first "Choosing a Career Conference," L. Bamberger & Co., 6/28/34. Also MB-W, undated typescript, pp. 192–3, 201, B-W Col.

73 in my entire life: MB-W, undated typescript, B-W Col. The family says that Lazarus White designed the underpinnings.

74 under one roof: Albert Sidney Gregg, "A Tower That Dominates All Cleveland," *World's Work*, February 1930, pp. 54–6. See also George E. Condon, *Cleveland: The Best Kept Secret* (New York: Doubleday & Co., 1967), pp. 183–4, 192–3, 201.

74 better than things that were finished . . . all that industrial activity: MB-W, undated typescript, pp. 16, 15, B-W Col.

74 I worship factories: Rosa Reilly, "Why Margaret Bourke-White Is at the Top," *Popular Photography*, July 1937, p. 14.

74 knew immediately that was enough: Ibid., p. 18.

75 the Flats from necessity: Margaret Thomsen Raymond, "Girl with a Camera, Margaret Bourke-White," in *Topflight: Famous American Women*, ed. Anne Stoddard (New York: Thomas Nelson & Sons, 1946), p. 168.

75 understand most photographs: MB-W and William McGarry, "Your Business as the Camera Sees It," *Nation's Business*, April 1938, p. 30. Already in 1929 she had said, "I work for contrast": NEA magazine article, n.d. (1929), B-W Col.

75 my own technique: NEA magazine article, n.d. (1929), B-W Col.

75 emphasis on materials: Charles A . Beard and Mary R. Beard, *The Rise of an American Civilization*, Vol. II, *The Industrial Era* (New York: Macmillan, 1927), pp. 782–3.

77 upgrade her photographic equipment: *Portrait*, pp. 42–6.

77 develop in her kitchen sink: MB-W, 1927 diary, 1/4/28, Estate; also typescript notes, n.d., B-W Col.

77 instead of a photographer: 1927 diary, 12/6/27.

78 my horizon was enlarging: MB-W, typescript, n.d., p. 14, B-W Col.

Chapter 7: "Machinery Is the New Messiah"

79 Prampolini: "The Aesthetic of the Machine and Mechanical Introspection in Art." Strand: "Photography and the New God."

79 the business climate: MB-W, typed notes, "*Fortune* bits and pieces," n.d., B-W Col.

80 one every ten seconds . . . history of the world: William E. Leuchtenberg, *The Perils of Prosperity: 1914 to 1932* (Chicago: University of Chicago Press, 1958), pp. 179, 202–3.

80 reigning social class: Ibid., p. 187.

80 conduct of American society: From *Prosperity, Fact or Myth.* Quoted in Allen, *Only Yesterday*, p. 160.

80 works there worships there: Quoted in Leuchtenberg, *Perils*, p. 188.

80 conquered the world: Bruce Barton, *The Man Nobody Knows* (New York: Bobbs-Merrill, 1925), Introduction.

80 silent and infinite force: Henry Adams, *The Education of Henry Adams* (New York: Modern Library, 1931; first published 1918), p. 388. For Margaret's list, see *Boston Evening Transcript*, May 1939, B-W Col.

81 discovered the dynamo: MB-W, calendar for *Portrait*, 1955, B-W Col.

81 new Messiah: Quoted in Leuchtenberg, *Perils*, p. 187.

81 *Victory of Samothrace:* Filippo Tommaso Marinetti, first Furturist manifesto, in Joshua C. Taylor, *Futurism* (New York: Museum of Modern Art, 1961), pp. 124–5.

82 to take a look: MB-W, typescript notes, n.d., B-W Col.

82 architect and the artist: Jane Heap, "Machine-Age Exposition," in the catalogue *Machine-Age Exposition, May 6–28, 1927* (New York: The Little Review, n.p.).

83 on the company: John W. Hill, *The Making of a Public Relations Man* (New York: David McKay Co., 1963), p. 20. Hill's claim to this idea is probably extravagant. My thanks to Will Yolen and Peter Pollard for the reference.

83 volume . . . nearly doubled: See Stephen Fox, *The Mirror Makers: A History of American Advertising and Its Creators* (New York: William Morrow & Company, 1984).

83 promoting a corporate name: See Leuchtenberg, *Perils*, p. 199, and F. Jack Hurley, *Industry and the Photographic Image* (Rochester: George Eastman House, in association with Dover Publications, New York, 1980), p. 77.

83 at least two months: She wrote that he left for five, but in fact she saw him on 1/6/28 (perhaps not for the first time), finished the photographs on 2/25/28, and sold them to him on 3/21/28. Diary, Estate.

84 singing for joy: *Portrait*, p. 50.

84 I'll wear blue jeans: Hill, *Making*, pp. 20–1.

84 if anything happened: MB-W, caption to Picture of the Month, *World's Work*, September 1929, p. 43.

85 the book of Job: *Portrait*, p. 52.

85 path of the sparks: MB-W, "Possible outline," n.d., n.p., B-W Col. In *Portrait*, she credited herself with this discovery, a harmless bit of backpatting. The earlier manuscript is probably more reliable.

85 achieved in the darkroom: See *Portrait*, pp. 50–9.

86 jumping up and *shouting* . . . place to find art . . . should keel over: 1927 Diary, 2/25/28, Estate.

86 a dollar each: Ibid., 3/21/28.

86 wear good clothes . . . name my price: Ibid., 1/6/28, 4/3/28.

87 my photographic development: Letter of 11/18/34, B-W Col.

87 her best picture: *My Best Photograph and Why*, compiled and edited by B. Herbert Taylor (New York: Dodge Publishing Co., 1937), pp. 14–15.

87 has taught me so much: In a copy of *Halfway to Freedom* owned by Howard Daitz, to whom I'm most grateful for showing me his extensive collection of Bourke-White material.

88 industrial *activity:* MB-W, undated typescript, p. 15, B-W Col.

89 imitated today and live: 1927 Diary, 5/11/28.
89 truth and simplicity: Telegram to Roberts Everett Associates, 10/17/30, B-W Col.

Chapter 8: "I Can Do Anything I Want to with These Men"

91 Oh, they marry: R. LeClerc Phillips, "The Problem of the Educated Woman," *Harper's*, December 1926, p. 58.
91 sincere self for a little while: Handwritten note, n.d., Estate.
91 byline "Margaret Bourke-White": *House and Garden*, April 1928, pp. 118–19, 122–3; July 1928, p. 52.
92 lovelier and slenderer: 1927 diary, 1/13/28, Estate.
92 green dress . . . red dress: Ibid., 9/25/28.
92 Bourke-White Studio: Ibid., December, n.d., 1927.
92 willing to help her: Address at the first "Choosing-A-Career" conference, held at L. Bamberger & Co., 6/28/34, B-W Col.
93 get my picture: NEA magazine, 1929, B-W Col.
93 I like them: 1927 diary, 12/15/27.
93 like magnificent buffaloes: Ibid., 3/6/28.
94 much too interesting . . . be the exception: Ibid.
94 Oh delicious . . . Oh gorgeous world . . . more than you've got: Ibid., 4/2/28, 4/1/28.
94 than her relish: Off-the-record interview.
95 learned to mistrust: Undated letter, Estate.
96 matching gloves at that: 1927 diary, 9/25/28.
96 bracing, moving thing: Ibid., 9/25/28.
96 short love like this: Ibid., 10/1/28.
96 dread years in prison: Various letters from MB-W and others, 1930s, B-W Col.
97 and he will, too . . . to match my floor . . . ivory and green work room: 1927 diary, 4/3/28.
97 in my earlier work: *Portrait*, p. 110.
97 put one in for scale: Calendar for *Portrait*, 1955, p. 2, B-W Col.
97 flesh and blood: Telegram to Roberts Everett Associates, 10/17/30, B-W Col.
97 truly expressive of our age: *Brooklyn Daily Eagle*, 12/24/33.
98 Fitzgerald and Cabell are quoted in Arthur Schlesinger, Jr., *The Crisis of the Old Order* (Boston: Houghton Mifflin, 1957), pp. 145–6.
98 the people that count: Felicia Gossman, interview, 1/20/82.
98 things like safety: See Marjorie Lawrence, "Dizzy Heights Have No Terrors for This Girl Photographer," *New York Sun*, 4/25/29.
99 always vital and always difficult: 1927 diary, 2/25/28.
99 Firmer footholds, I guess: NEA magazine article, 1929, B-W Col.
99 live that story down: Undated typescript for *Portrait*, p. 18, B-W Col.
99 economics textbook: *American Economic Life*, by Rexford Guy Tugwell, Thomas Munro, Roy E. Stryker, 3rd ed. (New York: Harcourt, Brace & Co., 1930).
100 didn't think she was a great photographer: Ralph Steiner, interview, 4/28/82.

Chapter 9: Fortune and Men's Eyes

101 splendor of rotogravure: Frank Luther Mott, *American Journalism* (New York: Macmillan, 1950), p. 684.

102 delight in the ridiculous: *Portrait*, p. 63.

102 nearby stadium: Ralph Ingersoll, interview, 5/17/82.

102 frenzied intensity: Alexander King, *Mine Enemy Grows Older* (New York: Simon & Schuster, 1958), p. 196.

102 Better still, more beautiful: Robert T. Elson, *Time Inc: The Intimate History of a Publishing Enterprise*, vol. 1: 1923–1941 (New York: Atheneum, 1968), p. 130.

102 had ever been taken: *Portrait*, pp. 63–4.

102 get the word out: Eleanor Treacy Hodgins, art editor, interview, 5/13/82, telephone. Also Ralph Ingersoll, interview, 5/17/82.

102 characteristic of our times: Speech, March 1929, quoted in Elson, *Time Inc.*, p. 126.

103 kind of a spiritual thing: Typescript for *Portrait*, B-W Col.

103 Miss Fortune: *Portrait*, p. 65. The remark was made by John Love, who wrote *The Story of Steel*. Typed notes, B-W Col.

104 bookkeepers into writers: Elson, *Time Inc.*, p. 137.

104 home to his pentameters: Ibid., p. 138.

104 engagingly irritating radical. Charles J. V. Murphy, in *Writing for Fortune* (New York: Time Inc., 1980), p. 49.

104 even machines look sexy: Interview, 3/29/82.

104 wagon with the workmen: *Portrait*, pp. 67–8.

105 should also be recorded: *Portrait*, pp. 69–70.

105 level of genius . . . super-average man: Typed manuscript for *Portrait*, also handwritten notes after talking to her editor, B-W Col. See also *Portrait*, p. 69.

106 everything away in a basket: *Portrait*, pp. 71–2.

106 orders to sell: See Allen, *Only Yesterday*, pp. 326-31.

106 inside a bank that night: *Portrait*, p. 72.

106 business affected everyone: John Kobler, *Luce, His Time, Life and Fortune* (Garden City, N.Y.: Doubleday & Co., 1968), pp. 81–2.

107 rivalling the pearly gates: Elson, *Time Inc.*, p. 143.

107 to the wheat harvest: *Portrait*, p. 70.

108 sign of discomfort: *Portrait*, pp. 70–1; also D. Calkins, biography of MB-W for Eric Hodgins, B-W Col.

108 form would be fully developed: Theodore M. Brown, *Margaret Bourke-White, Photojournalist* (Ithaca, N.Y.: Cornell University, Andrew Dickson White Museum of Art, 1972), pp. 37–8.

108 appear without your work: Letter of 3/1/30, Time Inc. Archives.

108 it was Bourke-White: "American Aces, Margaret Bourke-White, *U.S. Camera*, May 1940, p. 44.

108 famous from its photographers: *Fortune*, December 1936, ad for *Life*.

109 what is happening: *Four Hours a Year*, issued by Time Inc., 1936, p. 20.

109 importance of the images: Eleanor Treacy Hodgins, interview, 5/13/82, telephone.

109 invest a dynamo: *Four Hours a Year*, p. 20.

110 **added its fillip:** D. Calkins, biography of MB-W.
110 **industry and photography:** On this question, see F. Jack Hurley, ed., *Industry and the Photographic Image* (Rochester, George Eastman House, in association with Dover Publications, New York, 1980), p. 79.
110 **would not stop:** Letter from MB-W to Frank C. Reilly, 3/3/30, B-W Col.
110 **suited to reproduction:** In a letter of 1933, Imogen Cunningham declared B-W's printing "abominable," her negatives worse. Cunningham belonged to f64, a group devoted to extreme sharpness of focus and printing. B-W's work retained the romantic bias of pictorialism. My thanks to Keith de Lellis for this reference.
110 **Uriah Heep:** Jean Shaw Gold, interview, 8/28/82.
110 **a great master:** Mrs. Oscar Graubner, interview, 5/13/82.
110 **while she worked:** John Vassos, interview, 3/6/82.
111 **giving her her style:** J R Eyerman, interview, 1/21/83.
111 **these unorthodox photographs:** Tom Cleland was *Fortune*'s first art editor, but Eleanor Treacy Hodgins says he soon stepped aside and left most of the work to her. Interview, 5/13/82, telephone.
112 **bringing the camera closer:** Reilly, "Why Margaret Bourke-White Is at the Top," p.33.
112 **handed on to me:** Ibid., p. 68.
112 **modern spirit of the world:** Edna Robb Webster, *American Magazine*, November 1930, p. 66.

Chapter 10: A Woman in a Man's World

113 **no other example:** *Interpersonal Psychoanalysis: The Selected Papers of Clara M. Thompson*, ed. Maurice R. Green (New York: Basic Books, 1964).
113 **mucous membrane:** see Elson, *Time Inc.*, p.149.
113 **straight out of the bottle:** Richard Eads Harrison, interview, 5/7/82.
114 **after that day:** Ralph Ingersoll, interview, 5/17/82.
114 **Afghan hounds:** Eleanor Treacy Hodgins, interview, 5/13/82. Ralph Ingersoll and Manfred Gottfried also recall her cane (interviews, 5/17/82, 8/16/82). Mrs. Oscar Graubner (interview, 5/13/82) also recalls the dog or dogs.
114 **quietest part of its sway:** MB-W, typescript, "Fortune bits and ends," B-W Col. See also *Portrait*, pp. 77–8.
114 **curb into the cab:** *Portrait*, p. 77.
114 **Four-story inn . . . give me orders:** MB-W, typed notes for *Portrait*, B-W Col.
115 **rooted to the earth:** Letter from MB-W's office to Continental Casualty Co., 8/16/32, B-W Col.
115 **already taken:** *Portrait*, p. 78. Some insist she lived in the building rent free, as Walter Chrysler's "guest." At some point she paid with photographs, and later fell short, but it's unlikely Margaret would have agreed to be "kept."
115 **something to distract them:** MB-W manuscript, "Bituminous," B-W Col.
115 **stiffened camera cloth:** MB-W, typescript notes, B-W Col.
115 **just what you want to do:** Notes from EBM (probably Elizabeth Magnuson) to MB-W, B-W Col.
116 **than a man's would:** "The Camera Is a Candid Machine: An Interview with Margaret Bourke-White," by T. Otto Nall, *Scholastic*, 5/15/37, p. 19.

116 **shimmering crew:** Letter to Governor Alfred Smith, May 1931, B-W Col.

116 **politeness and introductions:** Letter from MB-W to Alfred de Liagre, possession of Alfred de Liagre, Jr.

116 **others like him:** Gladys Oaks, "Men You Shouldn't Marry," *Delineator*, September 1936, p. 11.

116 **in world of men:** MB-W, notes, B-W Col. I have spelled out the many abbreviations.

117 **misguided, and weak:** John Vassos, interview, 3/6/82.

117 **confidence in herself:** Ralph Ingersoll, interview, 5/17/82.

118 **got along beautifully:** John Vassos, interview, 3/6/82.

118 **influence had led:** *Portrait*, p. 65.

118 **wait for me to push it:** Edward Stanley, interview, 3/5/82.

118 **for the bread, period:** John Vassos, interview, 3/6/82.

118 **virile and masculine:** C. A. Batchelor, "Personal and Confidential, Margaret Bourke-White," *Detroit Saturday Night*, n.d., 1930, B-W Col.

119 **dreams of femininity:** Letter from Martin J. Chicoine to MB-W, 10/16/34, B-W Col.

119 **a proper portrait:** M. Peter Keane, interview, 4/16/82.

119 **getting over that:** Letter to MB-W from Major M. J. Papurt, 1/29/44, B-W Col. Printed by permission of Maxine C. Papurt.

119 **what a girl!:** Off-the-record interview.

119 **she hasn't time:** Helen McLean Sprackling, "Child of Adventure," *Pictorial Review*, December 1934, p. 63.

120 **too gory to relate:** Chris Christensen, on a drawing he made for MB-W, Estate.

120 **struggle with new ideas:** "The Role of Women in This Culture," 1941, in *Interpersonal Psychoanalysis*, p. 219.

120 **accepted or loved:** "Working Woman," 1949 and 1943, ibid., p. 258.

120 **could approve of:** Letter from William Sutton to the author, 1/31/82, referring to a diary fragment by MB-W that I have not located.

121 **pilots and photographers:** B-W Col.

121 **pin at your right shoulder:** Letter from John Frazier Vance, 8/29/30, possession of John F. Vance, Jr. and by his permission.

121 **setting bricks, or anything else:** Letter from MB-W to Denny Prager, for an article on masculine allure, 7/24/35, B-W Col.

121 **last duty at supper:** Alfred de Liagre, Jr., interview, 9/15/82.

122 **that's *my* Susan:** Undated letter from Alfred de Liagre to MB-W, possession of Alfred de Liagre, Jr., and by his permission.

122 **women found him charming:** Henry Cassidy, interview, 1/10/83. Also Felicia Gossman, interview, 1/20/82, and John Phillips, interview, 2/25/82.

122 **wall she put up:** John Vassos, interview, 3/6/82.

122 **a kind of bridal beauty . . . change of mood and impulse:** Letters from Maurice Hindus to MB-W, n.d. and 6/9/46, B-W Col., printed by permission of Frances McC. Hindus.

123 **arguments over that over and over:** John Vassos, interview, 3/6/82.

123 **acting like a woman:** "The Role of Women in This Culture," p. 227.

124 **Dear Friend:** Letter in B-W Col. Helen Zwick Perry, author of a biography of Sullivan, mentioned the barter to the author in conversation and suggested that because of his homosexual leanings Sullivan may have thought himself, incorrectly, an inadequate therapist for a woman.

124 **salary for ten years:** Letters from Margaret Smith (Peggy Sargent), MB-W's secretary, to Sullivan, 11/8/39. Also MB-W's insurance policies, 4/9/40, B-W Col.

124 **appointments . . . with Clara Thompson:** Peggy Sargent, interview, 2/10/82.

124 **threatened belief in herself:** Letters from Clara Thompson to MB-W, 10/4/36, 11/29/54, 8/31/55, B-W Col.

Chapter 11: "A Great Future in Russia"

125 Letter from Maurice Hindus, B-W Col., printed by permission of Frances McC. Hindus.

125 **wanted to be first:** *Portrait*, p. 90.

125 **drama of the machine:** Ibid., pp. 91–2.

125 **begun from scratch:** Nicholas V. Riasanovsky, *A History of Russia* (New York: Oxford University Press, 1977), pp. 547, 550.

126 **heart of that people:** MB-W, *Eyes on Russia* (New York: Simon & Schuster, 1931), p. 22.

126 **Berlin, Paris, and Moscow:** Ibid., pp. 25–6.

126 **to come out of Russia:** Ibid., p. 30.

126 **the subject of women:** D. Calkins, biography of MB-W, B-W Col.

127 **photographer as she claimed:** *Fortune*, December 1930, pp. 89ff.

127 **the vital telegram:** *Eyes on Russia*, pp. 27–30; also *Portrait*, pp. 92–3.

127 **Steady progress, Great Hope:** *Eyes on Russia*, p. 19.

127 **stern task master:** Holograph and typescript notes, B-W Col.; also *Portrait*, p. 93.

127 **artist and prophet:** *Eyes on Russia*, p. 39.

128 **training in photography:** Grigory Shudakov, *Pioneers of Soviet Photography* (New York: Thames and Hudson, 1983), pp. 10–11.

128 **she called on them:** *Eyes on Russia*, p. 74.

128 **that was that:** Ibid., p. 62.

128 **new God of Russia:** MB-W, lecture, n.d., B-W Col.

128 **through the maneuver:** *Eyes on Russia*, pp. 80, 57.

129 **gradations of tone:** Arthur Rothstein, interview, 5/5/83.

130 **nothing but her camera:** *Eyes on Russia*, pp. 63–6.

130 **prove that Margaret cared:** Dr. Edgar Kahn, interview, 7/20/82, telephone.

130 **move this alligator:** Kirkland, *Girls Who Become Artists*, p. 36.

130 **ate it for supper:** MB-W, typescript notes, B-W Col.

130 **back into their lives:** Peggy Sargent, interview, 2/10/82.

130 **and so she did:** Letter from MB-W to Max Schuster, 8/10/60, Special Manuscript Collection Schuster, Rare Book and Manuscript Library, Columbia University.

131 **$177 million in 1930:** Peter A. Bodanov, "Our Customers, the Soviets," *World's Work*, December 1930.

131 **billion dollars' worth of buildings:** This was Albert Kahn. See *Architectural Forum*, August 1938.

131 **thousand watt floodlights beautifully:** *Eyes on Russia*, p. 28.

131 **the work they do:** MB-W, lecture on Russia, n.d., B-W Col.

132 **career and her personal life:** MB-W, "Silk Stockings in the Five-Year Plan," *New York Times Sunday Magazine,* 2/14/32, p. 4.

132 **terribly amusing:** Letter from MB-W to Joe Freeman, October 14, n.d. Joseph Freeman Papers, Rare Book and Manuscript Library, Columbia University.

132 **on a single Sunday:** Violette Gilfillan, interview, 4/27/83, telephone.

132 **on the paper industry:** MB-W, holograph notes, B-W Col.

132 **free film:** *Portrait,* p. 96. Also Ralph Steiner, interview, 4/18/82; Jay Leyda, interview, 3/5/84.

132 **loaded them on board:** M. Peter Keane, interview, 4/16/82.

133 **German picture editors:** Wilson Hicks, *Words and Pictures* (New York: Harper and Brothers, 1952), p. 40.

133 **future would bring her:** *Portrait,* pp. 99–100.

133 **his revolutionary work:** *Portrait,* pp. 101–2.

134 **part of her equipment:** Virginia J. Fortiner, "Outstanding Woman Photographer Banked on Industry," *Newark Evening News,* 9/13/34.

134 **important work she had done:** Letter from MB-W to Rose D. Mayer, 5/23/32, B-W Col.

134 **make her technically adept:** Letter from MB-W to Jacques Beauvois, 8/25/34, and script by MB-W, B-W Col.

134 **in the dying light . . . a perfectionist, she said:** *Portrait,* p. 102.

134 **bring them to her:** MB-W, scripts for movie, B-W Col.

134 **mountain of camera equipment:** Bert Kopperl, *With Two Wheels and a Camera* (Hicksville, N.Y.: Exposition Press, 1979), p. 24.

135 **appear to be propaganda:** Letter to Frank Altschul, 9/25/33, Frank Altschul Papers. Herbert Lehman Suite, Rare Book and Manuscript Library, Columbia University.

135 *Daily Worker:* Form letter from the Workers School, B-W Col. The play was by John Wexley.

Chapter 12: Fame and Wealth

137 **continuing to write books:** Aldous Huxley, "The Present Fad of Self Confession," *Vanity Fair,* May 1926, p. 108.

137 **to catch attention:** Roger White, interview, 12/6/81.

137 **in the world to others—compulsion:** MB-W, notes for an answer to a query from Bruce Downes, *Popular Photography,* n.d., B-W Col.

137 **at the expense of newspapers:** Mott, *American Journalism,* p. 679.

137 **beginning of 1932 . . . feature her as well:** Typescript for WRNY program of 1/26/32; script by Rose D. Meyer, 9/24/32. B-W Col.

137 **jazz band in Iowa:** MB-W, diary, 12/28/22, Callahan.

137 **Photographing the Chrysler Building:** Letter from MB-W to Sanford Griffith, 2/19/35, B-W Col.

138 **Maxwell House to Russia! . . . Library of Recorded Music:** Benton and Bowles script, 11/9/33; advertising copy, B-W Col.

138 **champion for the year:** The ten were named on 1/5/37 by United Press. Her amusement was noted by Helene Courtridge in "Photos = Margaret Bourke-White," *Mademoiselle,* June 1935, p. 42.

138 **world's great artists:** Letter from MB-W to Ethel Fratkin, n.d., B-W Col.

138 **wore her fame comfortably ... wore it unobtrusively:** Robert Fatherley, interview, 12/15/82; Norman Cousins, interview, 4/16/82, telephone.

139 **sense of drama:** Letter from Benjamin Sonnenberg to MB-W, 2/28/33, B-W Col., printed by permission of Ben Sonnenberg.

139 **a fine plumber:** Joe Fewsmith, letter to MB-W, 1/16/32, B-W Col., printed by permission of Joseph Fewsmith, Jr.

139 **mere $3,503.94:** Income Tax Reports, 1934–35, B-W Col.

140 **John D. Rockefeller, Sr.:** Malcolm Cowley, *The Dream of the Golden Mountains: Remembering the 1930's* (New York: The Viking Press, 1980), p. 178.

140 **what they were in 1929:** Leuchtenberg, *Perils*, p. 248.

140 **poorhouse in an automobile:** Quoted in Arthur M. Schlesinger, Jr., *Crisis*, p. 204.

140 **good one was invaluable:** *Portrait*, p. 80.

141 **evil commotion:** Cowley, *Dream*, p. 154.

141 **arrears on the studio rent ... charge accounts ... Kodak:** Letters from the building management, 1933; letters to and from the studio, April 1933, and interview, Peggy Sargent, 2/10/82; notes of 8/25/33 and balance sheet, 6/30/33. B-W Col.

141 **all right to cash it ... he never returned:** Peggy Sargent, interview, 2/10/82.

142 **evade the law once more:** Court order, 5/20/35, B-W Col.

142 **half the rent:** Robert Y. Richie, interview, 1/3/83, telephone.

142 **$500 if necessary:** Letter from MB-W to Margaret Smith (Peggy Sargent), B-W Col.

142 **didn't do color photography:** Note among the 1933 papers, B-W Col.

143 **three shots a day:** Letters from the Bourke-White studio, 6/12/35 and n.d., B-W Col.

143 **that phase of photography:** *U.S. Camera*, May 1940, p. 46.

143 **you see big:** MB-W, typescript, n.d., B-W Col.

143 **painted backdrops:** Julien Levy, Foreword to *Murals by American Painters and Photographers* (New York: Museum of Modern Art, May 1932), p. 11.

143 **in Rockefeller Center:** See "Margaret Bourke-White, The Deco Lens, Apr. 2–Apr. 30, 1978," Joe and Emily Lowe Art Gallery, Syracuse University, Syracuse, N.Y.

143 **television was under development:** MB-W, speech to the New York Times Advertising Group, 1934, B-W Col. The murals are reproduced in *Architectural Record*, August 1934. They were removed in the mid-fifties and disappeared.

144 **nobody was going to stop me:** MB-W, diary, n.d.

144 **have a good fight:** MB-W, letter to Mary Margaret McBride, 12/13/33, B-W Col.

144 **dope to keep it up:** "Notes after conversation with Peter Keane, 'Statements made by Mr. Drix Duryea,' " 1/12/34, B-W Col.

144 **mere professionals could do:** She hired Mary Margaret McBride, a writer who was about to launch one of the most popular careers in the history of radio. MB-W, typed notes, n.d., B-W Col.

145 **a souvenir, she said:** Robert Y. Richie, letter to the author, 12/16/82.

145 **best time for aerial photography:** MB-W, calendar for *Portrait*, p. 5; MB-W, letter to H. M. Hasting, 10/12/35; MB-W, interview on WNEW, May 8, n.d., B-W Col.

145 **always a religion:** MB-W, "Rough draft, Four Decades," B-W Col.

145 **died two days later:** *Portrait*, p. 106. An obituary says she was born in November 1873, but her cousin Florence Connolly, in a family tree, wrote that it was 1874. B-W Col.

146 **as they would have wished:** Letter from Clara Thompson, 10/4/36, B-W Col.

146 **done with the body:** Peggy Sargent, interview, 2/10/82. Betty Cronander says MB-W thought funerals were barbaric, but she went to her uncle's in '53.

146 **making history!:** Letter to MB-W from Minnie White, 11/14/34, regarding an interview in *Pictorial Review*, B-W Col.

146 **have been a photographer:** *Portrait*, p. 20.

146 **had become too difficult . . . could not seek naturally:** Letters to MB-W from Ruth White, 7/7/36 and n.d. (c. 1963), B-W Col.

148 **never did any retouching:** MB-W, "Questions Most Frequently Asked Me," n.d. (first half of the '30s), B-W Col.

148 **quality she needed:** Arthur Rothstein, interview, 5/5/83.

148 **I push the shutter:** MB-W, letters to M. F. Agha, 2/1/35, 8/17/35, B-W Col.

149 **things of this kind:** Letter from MB-W to Eleanor Treacy (Hodgins), 7/9/35, B-W Col.

149 **action into your pictures:** Letter to MB-W from Eleanor Treacy (Hodgins), 10/21/35, B-W Col.

149 **attempts to look natural:** "Success Story: The Life and Circumstances of Mr. Gerald Corkum . . . ," *Fortune*, December 1935.

149 **Newspaper Enterprise Association:** Agreement, B-W Col.

150 **her precious camera:** Janet Mabie, "Snapshotting a Snapshotter," *Christian Science Monitor*, weekly magazine, 9/25/35.

150 **I let her have it:** Don C. Hershey, letter to the author, 7/24/82.

150 **anything else in the world:** Carl Mydans, interview, 4/9/82.

151 **if not confident:** Robert Y. Richie, letter to the author, 12/26/82.

151 **abruptly terminated:** Peggy Sargent, interview, 2/10/82. Also Lucille Scott Midcap, "Margaret Bourke-White, The Photojournalist and the Woman," M.A. thesis, University of Florida, 1976, p. 50. Also letter to MB-W from NEA, 8/13/36, B-W Col.

Chapter 13: The Struggle of the Great Masses

152 **crept into art:** *Springfield* (Mass.) *Union and Republican*, 3/1/36. My thanks to Anne W. Tucker for this reference.

152 **photographing rocks!:** See Robert Cahn and Robert Glenn Ketchum, *American Photographers and the National Parks* (New York: The Viking Press, 1981), p. 133.

152 **as long as a year:** Elson, *Time Inc.*, p. 141.

152 **next sixty days:** *New York Times*, 3/8/30, quoted in Schlesinger, *Crisis*, p. 165.

153 **new deal for the American people:** See Frederick Lewis Allen, *Since Yes-*

terday. (New York: Harper & Brothers, 1940), p. 81; Schlesinger, *Crisis*, pp. 257–64.

153 **had to know about:** Archibald MacLeish, in *Writing for Fortune*, p. 8.

153 **in 1934, over half:** Dwight Macdonald, " 'Fortune' Magazine," *The Nation*, 5/8/37, p. 528.

153 **socially committed magazine:** MacLeish, *Writing for Fortune*, p. 8.

153 **unprecedented occurrences:** MB-W, letter to Kalet Sadjaia, n.d., B-W Col.

154 **Freeman:** On Freeman's claim, see Daniel Aaron, *Writers on the Left* (New York: Harcourt, Brace & World, 1961), p. 367. A letter he translated is in the B-W Col.

154 **underneath the things she photos:** Courtridge, "Photos = Margaret Bourke-White," p. 42.

154 *Coming Struggle for Power: Boston Evening Transcript*, May 1939.

164 **civilization can be maintained . . . from death to birth:** John Strachey, *The Coming Struggle for Power* (New York, Modern Library, 1935), pp. ix, 407.

154 **what a state should be:** Edmund Wilson, "What I Believe," *The Nation*, 1/17/32.

155 **left-liberal position:** See Aaron, *Writers on the Left*, p. 170.

155 **suffering citizen of the world:** Louis Fischer, *Men and Politics, An Autobiography* (New York: Duell, Sloan and Pearce, 1941), p. 191.

155 **some striking workers:** Note of thanks from the league, 11/27/33, B-W Col.

155 **hunger in America:** Letter to MB-W from Tom Brandon, 5/12/34, B-W Col.

155 **Photo League:** See Anne W. Tucker, "Photographic Crossroads: The Photo League," a special supplement to *Afterimage*, 4/6/78. Tucker is writing a book about the league, which dissolved under McCarthyist pressure in 1951.

155 **gave her an exhibition:** *Photo Notes* (League bulletin), June 1939, p. 2; December 1939, p. 5.

156 **to track it down:** Ralph Ingersoll, interview, 5/17/82; also interview with MB-W by T. Otto Nall, *Scholastic*, 5/15/37, p. 23; *Portrait*, p. 107.

156 **his way back to earth:** MB-W, "Dust Changes America," *The Nation*, 5/22/35, p. 597.

156 **faces I could not pass by:** *Portrait*, p. 110.

156 **so much dust that they die:** MB-W, "Dust Changes America," p. 598.

157 **changes in the social scene about him . . . exquisite but idle:** MB-W, "Photographing This World," *The Nation*, 2/19/36, p. 217.

157 **unions in department stores:** Letter of January 1935 to the N.Y. Committee to Aid Agricultural Workers, also notes regarding the league, 1936, B-W Col.

157 **Spanish Civil War:** FBI memorandum, 3/27/41, obtained under the Freedom of Information Act.

157 **all lent their support:** Roselle Davis, interview, 1/28/83.

158 **elected vice-chairman:** Form letter to members, 12/9/36; letter to members, 12/23/37; letter to members, 9/27/37; letter to MB-W, 1/11/38. B-W Col.

158 **American Artists' Congress:** On the speakers and their topics, see Elizabeth McCausland, *Springfield Union and Republican*, 3/1/36.

158 **this is not true:** MB-W, speech, B-W Col.

159 **my work as a photographer:** Voluntary statement, 1/15/52, FBI files, obtained through the Freedom of Information Act.
159 **public has ever seen:** MB-W, holograph notes, B-W Col.
159 **earn by productive work:** MB-W, "Photographing This World," p. 218.
159 **creatively and constructively:** *Portrait*, p. 112; also typed calendar for *Portrait*, 1955, B-W Col.
160 **advertising could ever be:** Roger White, interview, 12/6/81.

Chapter 14: Social Documents

161 **even to imitate the camera:** Alfred Kazin, *On Native Grounds* (New York: Reynal and Hitchcock, 1942), pp. 485, 493.
161 **fellow Americans better . . . people's lives with the camera:** *Portrait*, p. 113; calendar for *Portrait*, 1955, B-W Col.
162 **the eagle pounced:** Malcolm Cowley, interview, 5/1/83.
162 **talents to a cause:** Maxim Lieber, interview, 3/31/82. In *Portrait*, Margaret wrote that she first met Erskine when she arrived in Georgia in July, but both Lieber and Caldwell remember otherwise.
162 **best contemporary writers:** James Korges, *Erskine Caldwell* (Minneapolis: University of Minnesota Press, 1969), p. 5.
162 **unfair sketch of Southern life:** *New York Times*, 12/1/35, 9: 7; 5/10/36, 10:1.
162 **too long in one place:** Korges, *Caldwell*, p. 7.
162 **the sharecroppers' misery:** Arthur M. Schlesinger, Jr., *The Coming of the New Deal* (Boston: Houghton Mifflin, 1959), pp. 60–1, 78.
163 **take photographs for that book:** Erskine Caldwell, *Call It Experience* (New York: Duell, Sloan & Pearce, 1951), p. 163. Today he does not recall taking any photographs.
163 **impressed by Margaret's style . . . hesitate to tell her so:** Letters from Maxim Lieber to MB-W, 1/13/36, and from Erskine Caldwell (hereafter EC) to MB-W, 3/25/36, B-W Col.; undated letter from EC to the author in answer to a query of 3/2/82.
163 **some social significance:** Letter from MB-W to EC, 3/9/36, B-W Col. On Lieber, see *Portrait*, p. 115.
163 **work with a woman:** *Portrait*, p. 115.
163 **in love with Bourke-White:** Helen Caldwell Cushman, interview, 1/20/83. David Eisendrath, who worked with MB-W later, says she had a habit, quite possibly unconscious, of letting someone else pick up the tab. Interview, 5/19/83.
164 **way to say *never:*** In *Portrait*, Margaret said she asked to postpone only once, but an undated letter (1936) to Helen from EC makes clear that was not the case. Erskine Caldwell Collection, Dartmouth College Library.
164 **early the next morning:** "Sally's" notes, 7/17/36, 7/18/36, given to Helen Caldwell Cushman, who can no longer locate them. They are reproduced in William Sutton's unpublished biography of Erskine Caldwell, Rare Book Room, University of Illinois Library, Urbana-Champaign.
164 **the book with you . . . if it falls through:** MB-W, letters to EC and to Margaret Smith (Peggy Sargent), 7/18/36, B-W Col.
165 **And so we did:** *Portrait*, p. 121.
165 **he had given in:** Postcard from EC, 7/20/36, Erskine Caldwell Collection,

Dartmouth College Library. Also William Sutton's unpublished biography of EC.

165 **lid coming down on Margaret's head:** *Portrait*, p. 124.

166 **during the next week:** Undated letter, postmarked 7/26/36, Erskine Caldwell Collection, Dartmouth College Library, reprinted by permission of Erskine Caldwell. MB-W's letter to Margaret Smith (Sargent), B-W Col.

166 **if not squabbling:** *Tucson Star*, 12/4/40, Erskine Caldwell Collection, Dartmouth College Library.

166 **willing to let him be:** Peggy Sargent, interview, 2/10/82.

166 **give the whole thing up . . . everything worked out beautifully:** *Portrait*, p. 125.

167 **very capable person . . . Margaret had seduced him:** Maxim Lieber, interview, 3/31/82; Helen Caldwell Cushman, interview, 1/20/83.

167 **live without protesting:** William A. Sutton, *Black Like It Is/Was: Erskine Caldwell's Treatment of Racial Themes* (Metuchen, N.J.: The Scarecrow Press, 1974), pp. 26-7.

167 **charged male-female reaction:** Peggy Sargent, interview, 2/10/82.

167 **out of joint or something:** Helen Caldwell Cushman, interview, 1/20/83.

167 **in the same automobile . . . shall never know:** *Portrait*, p. 125; typescript, notes for *Portrait*, B-W Col.

168 **to really care for:** Peggy Sargent, interview, 2/10/82.

168 **bowl of cream:** *Portrait*, p. 130.

168 **chips away the inessentials:** "This Is New York," 8/26/57, B-W Col. Information on equipment from *You Have Seen Their Faces* (New York: Modern Age Books, 1937).

168 **suspicions to rest:** *Portrait*, p. 126.

169 **helping people be themselves:** EC, interview, 12/1/82.

169 **some spontaneous moment:** *You Have Seen Their Faces*, p. 51.

169 **might be an intrusion:** *Portrait*, pp. 125-6.

169 **get closer to people:** EC, interview, 12/1/82.

169 **no end in sight:** Loose typed page, B-W Col.

170 **separate but equal:** *Portrait*, p. 132.

170 **like spitballs:** Erskine Caldwell, *Journeyman* (New York: The Viking Press, 1938), p. 210. First published in a limited edition in 1935; dramatized in New York in 1938, but despite great efforts by MB-W and EC, it failed.

171 **show in any photograph:** *Portrait*, pp. 135-6.

171 **man's activity is satisfying:** Erskine Caldwell, *Some American People* (New York: Robert M. McBride & Company, 1935), p. 4.

171 **you just weren't aware:** Peggy Sargent, interview, 2/10/82.

Chapter 15: "Life Begins"

172 **daily paper in America:** Simon Michael Bessie, *Jazz Journalism: The Story of Tabloid Newspapers* (New York: E. P. Dutton, 1938), p. 16.

173 *Look* **magazine:** Arthur Rothstein, *Photojournalism: Pictures for Magazines and Newspapers* (New York: American Photographic Book Publishing Co., 1956), pp. 97-8.

173 **newspapers of the country:** Mott, *American Journalism*, p. 682.

173 **the tabloid editor:** Ralph Ingersoll, "Notes on Picture Magazine," p. 1, Time Inc. Archives.

173 audience of fifteen million: Elson, *Time Inc.*, pp. 225–40.
173 preparation for *Life*: Joseph L. Thorndike, Jr., interview, 8/3/82, phone.
173 every motion picture program: Bessie, *Jazz Journalism*, p. 234.
174 requirements of newsreel coverage: Raymond Fielding, *The American Newsreel, 1911–1967* (Norman: University of Oklahoma Press, 1972), p. 149.
174 top desk drawer: Ralph Ingersoll, interview, 5/17/82.
174 called it "Life": Elson, *Time Inc.*, p. 243.
174 hit the stands: Ibid., pp. 201–2, 272, 284; William Stott, *Documentary Expression and Thirties America* (New York: Oxford University Press, 1973), p. 129n.
174 do not respect them . . . of half mankind: Quoted in Otha C. Spencer, *Twenty Years of Life: A Study of Time Inc.'s Pictures Magazine and Its Contribution to Photojournalism*, diss., University of Missouri, 1958, pp. 169, 173.
175 to work for *Life:* Peggy Sargent, interview, 2/10/82.
175 he took over: Elson, *Time Inc.*, pp. 293–4.
175 about a year: Loudon Wainwright, "Life Begins: The Birth of the Late, Great Picture Magazine," *Atlantic Monthly*, May 1978, p. 65.
175 Olympian calm: MB-W, notes, B-W Col.
175 between news and features: *Great Photographic Essays from Life*, commentary by Maitland Edey (Boston: New York Graphic Society, 1978), p. 9.
176 through his armpits: Muriel White, interview, 1/20/82.
176 not a thinker: *Great Photographic Essays*, p. 10.
176 salaries higher than his own: In '63, Longwell said her salary was equal to his, plus salaries for Peggy Sargent and Oscar Graubner. Letter to MB-W, 7/10/63, B-W Col.
176 New Deal, Montana: See *Portrait*, p. 141; Longwell letter to MB-W, 7/10/63, B-W Col.
177 wedge of construction workers: Col. Craig Smyser, interview, 8/30/85, phone.
177 onto the presses: Cables, Time Inc. Archives. See also *Great Photographic Essays*, p. 1.
178 aspects now stop: Time Inc. Archives.
178 when she dies: Violette Gilfillan, interview, 4/27/83, phone.
178 bar in beer parlor: MB-W, "Assignments for Publication," in *The Complete Photographer*, Willard Morgan, ed. (Dobbs Ferry, N.Y.: Morgan and Morgan, n.d.), p. 318, B-W Col.
179 one who sleeps nights: *Life*, 12/21/36.
179 built in the land: Schlesinger, *Coming of the New Deal*, p. 288.
180 exist only in her photographs, Beaumont Newhall, diary, 2/11/54–12/15/54, possession of Beaumont Newhall.
180 this essay style: MB-W, calendar for *Portrait*, 1955, p. 9, B-W Col.
180 *the photographic essay:* Wainwright, "Life Begins," p. 73.
181 take off his shoes: Ibid., p. 58.
181 January 1939: Elson, *Time Inc.*, pp. 297–302, 377. Also "It was a cool Friday in November . . . ," Time Inc. Archives, and "The Current Fad for Picture Magazines," *Literary Digest*, 1/30/37, p. 20.
181 *Fast and Luce:* Spencer, *Twenty Years*, p. 177.
182 keeping informed: Elson, *Time Inc.*, p. 7.
182 would be for them: Wainwright, "Life Begins," p. 59.

182 read the evidence: Joseph Kastner, interview, 2/23/82.
182 film a year: *Fortune*, October 1936.
182 at the camera every time: Jackson Edwards, "One Every Minute," *Scribner's Magazine*, May 1938, p. 17.
183 life as it really is: MB-W, letter to Dr. F. A. Gilfillan, 10/15/36, B-W Col.

Chapter 16: *"Life* Likes Life"

184 in the darkroom pulling prints: Carl Mydans, interview, 4/9/82.
185 did that wasn't right: Carl Mydans, "Unforgettable Margaret Bourke-White," *Reader's Digest*, August 1972, p. 72. Peggy Sargent letter about prints, B-W Col.
185 the magazine's standards: John Szarkowski, interview, 2/21/85, phone.
185 devil to print: Cornell Capa, interview, 4/24/83. Harvey V. Fondiller pointed out to me that she initiated the lab practice.
186 airfield was flooded out: MB-W, "Assignments for Publication," p. 315. Allen, *Since Yesterday*, p. 209.
186 the American way: *Portrait*, pp. 149–50; *Life*, 2/15/37. Allen, *Since Yesterday*, p. 305, says such ads were put up by the National Association of Manufacturers, partly to counter union influence.
186 wrecking the town: Francis Brennan, interview, 7/26/82.
187 nipple obliterator: *Great Photographic Essays*, p. 8.
187 slipping chemise: Bernard DeVoto, *Saturday Review*, 1/29/38, quoted by W. A. Swanberg, *Luce and his Empire* (New York: Charles Scribner's Sons, 1972), p. 145.
187 view with alarm: Wainwright, "Life Begins," p. 73.
187 more interesting than word journalism: Quoted in *f.y.i.*, Time Inc. house organ, 12/11/72.
187 good news and the bad: *Life*, 9/1/52, contents page.
187 Gee whiz: Tex McCrary, interview, 5/10/82.
188 hand of man on the land: Oliver Jensen, interview, 5/4/83.
188 variously occupied people: *Life*, 11/9/42.
188 I have seen have had: Memo from Hicks to MB-W, 4/27/37, B-W Col.
189 Hicks for pictures: Elson, *Time Inc.*, vol. 2, p. 44.
189 influences on our work: Philippe Halsman, from a 1970 article on file at The International Center of Photography.
189 handling people: Ralph Morse, interview, 2/15/82.
189 this for Wilson Hicks: Letter from MB-W to John Durniak, 9/27/63, B-W Col. On Hicks, see also R. Smith Schuneman, ed., *Photographic Communication* (New York: Hastings House, 1972), p. 10.
189 take notice . . . more than dummies: Fred Ringel, interview with Wilson Hicks, 4/7/53, International Center of Photography, printed by permission of David Hicks. My thanks to Phillip Block for this reference. Newhall letter to MB-W, 5/10/37, B-W Col., printed with his permission.
189 people as objects: Alfred Eisenstaedt, interview, 1/21/82. Dick Pollard, letters to the author, 4/2/82, 8/2/82.
190 whole plow factory: Reilly, "Why Margaret Bourke-White Is at the Top," p. 68.
191 caption or combination: *Portrait*, p. 137.

191 *Southern Review:* Quoted in Korges, *Erskine Caldwell*, p. 16.

191 **magnificently produced:** from review of 11/21/37 by Hudson Strode, newspaper title missing, in the Fred Ringel files, International Center of Photography, New York.

192 **southern tenant farmers:** Arthur Rothstein, interview, 5/5/83.

192 *Fortune* **offices for study:** Ibid.

192 **extremely modern:** Letter from Dan Longwell to MB-W, 3/11/37, Time Inc. Archives.

192 **competition killed it:** Brown, *Margaret Bourke-White*, p. 76 and n. 65.

192 **already exploited:** Stott, *Documentary Expression*, p. 222.

193 **central instrument of our time:** James Agee, Walker Evans, *Let Us Now Praise Famous Men*, 2nd ed. (Boston: Houghton Mifflin, 1960), p. 11.

193 **pretty important step:** Gordon Parks, interview, 3/25/82.

193 **feeling for the people:** Robert Frank, interview, 12/13/82, telephone. My thanks to Lee Witkin for mentioning this direct influence.

194 **to illustrate them:** Ralph Thompson, *New York Times*, 11/10/37. Forerunners of *Faces* include Charles Morrow Wilson's *Backwoods America*, 1934, and M. Lincoln Schuster's *Eyes on the World: A Photographic Record of History in the Making*, 1935.

194 **if there was trouble:** Letter from MB-W to Julius Weiss, 1/26/37, B-W Col.

194 **carries my bags for me:** Letter from Robert Sherrod to the author, 9/11/82.

194 **four pages or more:** Letter from Margaret Smith (Sargent) to Julius Weiss, 3/4/37, B-W Col.

194 **reporter the world over:** *U.S. Camera*, May 1940, p. 43.

195 **regular smoker of Camels:** *New York Times*, 4/5/44, p. 30.

195 **pictures of themselves:** *Life*, 8/7/39.

195 **their anxiety and mine:** Hansel Mieth Hagel, letter to the author, 6/9/82.

195 **kings and princes:** Cornell Capa, interview, 2/4/82.

195 **reporter as sherpa:** Sean Callahan, interview, 1/14/82.

Chapter 17: "Honeychile, Arctic Circle"

196 **customer on the schedule:** Letter from EC to MB-W, n.d., B-W Col., reprinted by permission of Erskine Caldwell.

196 **premature white hair:** EC, letter to the author, n.d., answering a letter of 12/12/81.

197 **in which they gleamed:** Malcolm Cowley, *And I Worked at the Writer's Trade* (New York: The Viking Press, 1978), p. 116.

197 **recovered from Margaret . . . serve out the sentence:** EC, letters to Helen Caldwell (Cushman), 4/22/37, 5/10/37, Erskine Caldwell Collection, Dartmouth College Library, the latter printed by permission of Erskine Caldwell.

197 **very infatuating person:** Helen Caldwell Cushman, interview, 1/20/83.

197 **Margaret spelled life:** Undated letters from EC to MB-W, B-W Col.

197 **Sargent was shocked:** Peggy Sargent, interview, 2/10/82.

197 **someone shushed him:** Ibid., 2/10/82.

197 **picture of the President:** *Portrait*, p. 147.

197 **out of this harness:** Maxim Lieber, interview, 3/31/82.

198 **whatever they could grow:** Janet Caldwell Gooding, interview, 5/19/83, phone; also Maxim Lieber, interview, 3/3/82.
198 **orgy of double cross:** Caldwell, *Call It Experience*, p. 55; Sutton, *Black Like It Is/Was*, p. 57; *Newsweek*, 2/9/35, p. 40; biography by EC, 1939, B-W Col.
198 **"no action" on the trip:** EC, letter to the author, 4/8/85.
198 **one of the underdogs:** Malcolm Cowley, *Writer's Trade*, pp. 120–1.
198 **the first draft:** Caldwell, *Call It Experience*, pp. 75, 87, 130.
198 **living in a fast lane:** EC, interview, 12/1/82. On Spain, various letters, B-W Col.
199 **need of her:** *Portrait*, p. 171.
199 **feel we belong together:** MB-W, handwritten cable message, B-W Col.
199 **after his fashion:** Letter to MB-W, 8/18/37, B-W Col.
199 **transgression and punishment:** Helen Caldwell Cushman, interview, 1/20/83.
200 **one small wire:** MB-W, handwritten message, B-W Col.
201 **marry Margaret Bourke-White:** *Portrait*, pp. 153–60. Also calendar for *Portrait*, 1955, pp. 11–12, B-W Col.
201 **in my apartment:** See MB-W, letters to Margaret Smith (Sargent), n.d. and 7/30/37, B-W Col.
201 **black satin sheets:** Helen Caldwell Cushman, interview, 1/20/80.
201 **Margaret would drop him:** Letter from EC to MB-W, n.d., B-W Col.
201 **inspired, unpredictable:** MB-W, typescript notes, n.d., B-W Col.
201 **think of it all the time:** MB-W to EC, 7/26/37, B-W Col.
202 **out of curiosity:** EC, letter to the author, 4/8/85.
202 **stopped his visits:** MB-W, typescript notes, n.d., B-W Col.
202 **than in a doctor's:** EC, undated letters to MB-W, B-W Col.
203 **welcome, welcome:** *Portrait*, pp. 160–8, and *Life*, 10/25/37, pp. 114–18. I have used the figures in the *Life* article rather than those in the book, as they were recorded closer in time to the incident.
203 **advertisement for the magazine:** MB-W, typescript notes, B-W Col.
203 **just what I mean:** MB-W, typed calendar for *Portrait*, 1955. Also, MB-W, letter to Roger White, 11/8/37, B-W Col.
203 **so much freedom:** MB-W, letter to Henry Luce, 5/27/37, Time Inc. Archives.
204 **brought her back:** See *Portrait*, p. 171, where she says she could not leave him. But she was still writing her Canadian lover, who wrote on November 30 that emancipation seemed to have agreed with her. B-W Col.

Chapter 18: Politics, at Home and Abroad

205 **better assignments than he was:** Jim Hughes, conversation with the author, December 1984.
205 **free of jealousy:** Margaret Smith (Sargent), letter to MB-W, n.d., B-W Col.
205 **so-and-so is good:** Carl Mydans, interview, 4/9/82.
206 **never missed them:** M. Peter Keane, interview, 4/16/82.
206 **I'll learn:** Ansel Adams, interview, 9/2/82, phone.
206 **didn't know what to do with:** J R Eyerman, interview, 1/21/83.
206 **to show truth:** John Horn, notes for the Ed Murrow *Person to Person* show, 1955, courtesy of Mr. Horn.

206 **determine the content:** Howard Sochurek, interview, 6/25/84.

206 **overlooked other people:** Alfred Eisenstaedt, interview, 1/22/82.

207 **carry her equipment:** MB-W, typescript notes about the Aksarben ball, 1938, B-W Col.

207 **friends she could talk to:** Peggy Sargent, interview, 2/10/82.

207 **arteries of communication:** Herbert W. Forster, letter of 1/15/38, B-W Col. Ironically, this letter was sent to Mr. and Mrs. Alfred de Liagre.

207 **darling and a sweetheart:** Roz Barrow.

207 **wanted a favor:** Helen Barrow, interview, 1/14/82.

207 **box of Kotex:** Carol Eyerman, interview, 1/21/83.

207 **that selfish:** Peggy Sargent, interview, 2/10/82.

208 **we don't need two:** Berenice Abbott, interview, 11/13/83, phone.

208 **taken over is more precise:** Joseph Kastner, interview, 2/23/82.

208 **she didn't understand them:** Elise Hancock, "Margaret Bourke-White (1904–1971)," *Cornell Alumni News*, April 1972, p. 15.

208 **neither did Paul Peters:** Joseph Kastner, interview, 2/23/82.

208 **commitment to social causes:** Carl Mydans, interview, 3/9/82.

208 **Relief Ship for Spain . . . League for Peace and Democracy:** Various letters, B-W Col.

209 **Hitler was "misunderstood" . . . declare war on Germany:** Swanberg, *Luce*, pp. 157, 170.

210 **in her assistant's hands:** *Portrait*, pp. 150–2; *Life*, 2/7/38; Norman Thomas in Rita James Simon, ed., *As We Saw the Thirties* (Urbana: University of Illinois Press, 1967), p. 120.

210 **to *be* Napoleon:** Edward K. Thompson, interview, 2/17/82.

211 **after a brief run:** Notes and letters, B-W Col. Margaret invested $3,800 in this play and lost it all.

211 **a good book there:** MB-W, letter to Margaret Smith (Sargent) from Prague, 1938, n.d., B-W Col.

211 **Czechoslovakia off the map:** On the Czech crisis, see John Toland, *Adolf Hitler* (Garden City, N.Y.: Doubleday and Company, 1976), pp. 459–95.

211 **but quite effective:** MB-W, letter to Margaret Smith (Sargent) from Prague, 1938, B-W Col.

212 **we should have had:** *Portrait*, p. 170.

212 **if we are not strong:** Erskine Caldwell, Margaret Bourke-White, *North of the Danube* (New York: The Viking Press, 1939).

212 **documents ever published:** *New York Times*, 5/27/38. My thanks to John Phillips for calling this to my attention.

213 **beginning of the reckoning:** Toland, *Hitler*, p. 495.

213 **against your race here:** MB-W, letter to Ruth Korner, 11/22/38, B-W Col.

213 **"liberated," as he likes to call it:** MB-W, "Lenses Behind the News," address to the Advertising Women of New York, 11/14/38, B-W Col.

213 **by false promises:** Script for WMCA broadcast, January 1939, B-W Col.

213 **distant from the Czechs:** *Portrait*, p. 170.

214 **reporters want me to:** *Portrait*, p. 169. On their cabins, Peggy Sargent, interview, 2/10/82. The columnist was Dixie Tighe, in the *Washington Herald*; Tighe and Winchell, B-W Col.

214 **being single too much:** *New York Post*, 8/30/38.

Chapter 19: Patricia

215 **word spelled yes:** Cable printed by permission of Erskine Caldwell.

215 **resist a man like this:** MB-W, typescript notes, B-W Col.

215 **Horseplay Hill:** EC, interview, 12/1/83.

215 **always trying not to:** Letter from Mrs. W. Sloane Lane to MB-W, 5/21/39, B-W Col.

216 **hard to bear:** *Portrait*, pp. 159–60.

216 **for any disaster:** MB-W, handwritten notes, B-W Col.

217 **willing to try:** *Portrait*, p. 171.

217 **dominant figure in Margaret's life:** Peggy Sargent, interview, 2/10/82.

217 **she never quite succeeded:** John Vassos, interview, 3/6/82.

218 **sunset and sky:** *Portrait*, pp. 171–3.

218 **happier than I've ever known her:** Letter from Margaret Smith (Sargent) to Ruth White, 2/28/39, B-W Col.

218 **contribute his talent to it:** EC, letter to MB-W, 12/1/39, B-W Col.

218 **never deliver it:** MB-W, letter to Dodd, Mead, 10/5/40, B-W Col.

218 **adoring Kit:** MB-W, letter to EC, 11/24/39, B-W Col.

218 **I miss YOU:** MB-W, letter to EC, 1/28/41, B-W Col.

219 **so far is guppies:** Felicia Gossman, interview, 1/20/82.

219 **cock of the walk:** This undated cable was filed with 1939 material, B-W Col. William Sutton dates it 5/1/39 in his unpublished biography of EC. Printed by permission of Erskine Caldwell.

219 **she would leave him:** Harvey Klevar, author of an unpublished biography of EC, says that according to EC's third wife, if he felt insecure about a woman's love he urged their having a child. Letter to the author, 2/24/82.

219 **do it so wholeheartedly:** Betty Cronander, interview, 12/2/82, phone.

219 **respect and interest:** Janet Caldwell Gooding, letter to the author, 5/14/83.

219 **genuinely interested in me:** Erskine Caldwell, Jr., interview, 1/20/83.

219 **think he was important to her:** Robert Fatherley, Jr., interview, 5/3/83, phone.

220 **than did her bridegroom:** *New York Post*, 10/17/39.

220 **very sociable husband:** MB-W, letter to EC, n.d., B-W Col.

220 **Sweet Thing . . . in a cute way . . . at my heart too:** MB-W to EC, 10/30/(?); 11/5/39; 12/12/39. Also, various letters, n.d., B-W Col.

221 **call it Kotex:** Carl Mydans, telephone conversation, 4/26/83.

221 **year of grace:** Clara Thompson, letter to MB-W, 9/24/39.

221 **saw Dr. Thompson again:** Edward Stanley, interview, 3/5/82.

221 **all those things:** MB-W, letter to EC, 11/11/39, B-W Col.

221 **I do hope so:** MB-W, letter to EC, 1/31/40, B-W Col. EC says now that he doesn't recall why he saw Thompson: "Perhaps more of a social visit???" Letter to the author, 4/8/85.

222 **but nothing happened:** Edward K. Thompson, letter to the author, 8/23/82.

222 **ready to go back to work:** Peggy Sargent, interview, 2/10/82.

222 **but lost it:** Edward Stanley, interview, 3/5/82; Elizabeth Ann Crotty, phone interview with Mrs. Stanley, 6/12/78, in Crotty, "Margaret Bourke-White as Seen from the Perspective of Selected Photographs, Writings, and Associates," Masters Thesis, Syracuse University, 1978, pp. 57–8.

222 **to come to Margaret:** Edna B. Rowe, letter to MB-W, B-W Col.

223 **had had an abortion:** Robert Sherrod, interview, 9/16/82.

223 **Margaret's pregnancy:** EC's opposition: letter from Virginia Caldwell to the author, 4/5/84. His denial: letter from Harvey Klevar to the author, 5/24/82. "No knowledge," letter from Virginia Caldwell in answer to my query of 10/9/83.

223 **a different life:** *Portrait*, p. 308.

223 **career consciously and deliberately:** Betty Cronander, interviews, 12/2/82, telephone; 1/17/83.

224 **photographs are my children:** Felicia Gossman, interview, 1/20/82.

224 **paraded to City Hall:** Memo from Margaret Smith (Sargent) to Wilson Hicks, 10/18/39, B-W Col.

225 **prelude to German occupation:** MB-W, "Assignments for Publication," pp. 316–18.

225 **photographed out the window:** Filmore Calhoun, biography of MB-W, 2nd draft, 6/12/56, Time Inc. Archives.

225 **wasn't worth it:** Allen Grover, interview, 5/4/82.

226 **go on to Italy:** Lyons column and cables, Time Inc. Archives.

226 **cause of racial tolerance:** Ralph Ingersoll, memo to *PM* staff, 4/22/40, New York Public Library. Also Penn Kimball, interview, 3/10/84, phone.

226 **fifty-six pictures:** Dora Jane Hamblin, *That Was the LIFE* (New York: W. W. Norton & Company, 1977), p. 41.

226 **futility that few things have:** MB-W, letter to Wilson Hicks, 2/3/40, Time Inc. Archives.

227 **that they are forgotten:** MB-W, letter to Julius Weiss, 2/27/40, not sent, B-W Col.

227 **justify my existence . . . buried forever:** MB-W, letters to EC, 2/3/40, 2/25/40, B-W Col.

227 **Ingersoll offered her less:** MB-W, letter to EC, 2/28/40, B-W Col.

227 **all her previous achievements:** EC, interview, 12/1/82.

227 **bear to be left out of:** MB-W, letter to Julius Weiss, not sent, 2/27/40, B-W Col.

227 **Regards Bourke-White:** 3/2/40, B-W Col.

227 **hitchhike home from Syria:** John Shaw Billings Diary, 3/3/40, South Caroliniana Library, University of South Carolina.

227 **Regards Henry Luce:** 3/2/40, Time Inc. Archives.

227 **considerable cooperation:** n.d., B-W Col.

228 **my own family:** 3/17/40, Time Inc. Archives.

228 **way to undermine it:** MB-W, typescript for *Portrait*, n.d., B-W Col.

228 **second to none:** EC, letter to MB-W, 1/12/40, B-W Col.

228 **with intensities:** Letter from EC to the author, 7/3/83.

228 **her ultimate achievement:** EC, interview, 12/1/83.

Chapter 20: *PM*

229 **fellow photographers will admit:** Unsigned letter to Wilson Hicks, 3/5/40, Time Inc. Archives

229 **audience of 17.3 million:** The study was commissioned by *Life* and reported in an ad of 12/12/38.

230 *PM* look like a business: Penn Kimball, interview, 3/10/84, telephone.
230 applied for jobs: J. A. Lukas, "Reconsideration: Where Are You Now, PM Spinney?", *New Republic*, 9/9/72, p. 26. Prospectus quoted in *New York Herald Tribune*, 5/19/40, p. 4.
230 chalked up a profit: Lukas, "Reconsideration," pp. 27, 29. Also, Penn Kimball, interview, 3/10/84, telephone.
231 *Telegram* did not: Morris Engel, interview, 3/23/83.
231 very few grandes dames: Farley Wheelwright, tape made for the author, 9/23/83.
231 3¼ × 4¼ Linhof: Walter Engle, interview, 8/22/83, telephone.
231 Who does she think she is: William T. McCleary, interview, 5/17/83, telephone.
232 that wasn't enough: See *PM*, 6/19/40.
232 subway ride or a hot dog: Morris Engel, interview, 3/23/83.
232 every typewriter and telephone: Peggy Sargent, interview, 2/10/82.
232 Natural History Museum: Sylvia Bothe, interview, 2/6/84, telephone.
233 letter in *PM:* 7/12/40.
233 on the paper's staff: Penn Kimball, interview, 3/10/84, telephone. FBI memo on MB-W, 10/15/40, obtained under the Freedom of Information Act.
233 twenty cents on the dollar: Lukas, "Reconsideration," p. 26.
234 Hurry back: Erskine Caldwell and Margaret Bourke-White, *Say, is this the U.S.A.* (New York: Duell, Sloan and Pearce, 1941), pp. 10–12.
234 the true America: Ibid., pp. 177–8.
235 a relaxed athlete: Himber, *Famous in Their Twenties*, p. 111.
235 would raise me up: MB-W, typescript and notes for *Portrait*, B-W Col.
235 pried it open: *Portrait*, p. 90.
235 then she could not: MB-W, notes for *Portrait*, B-W Col.
235 to grips with a larger world: *Say, is this the U.S.A.*, p. 4.

Chapter 21: Return to Russia

236 the time I selected: In Toland, *Hitler*, p. 650.
236 rather than Europe: EC, interview, 12/1/82. EC gives MB-W complete credit for this trip; she gives credit to Hicks: *Portrait*, p. 174.
236 for some years: MB-W, *Shooting the Russian War* (hereafter SRW) (New York: Simon & Schuster, 1942), pp. 4–5.
236 cameras in the field: SRW, p. 5.
236 permission in 1932: MB-W, letter to Russia, 1/29/32, B-W Col.
237 display of power: Ralph Steiner, interview, 4/18/22.
237 second world war: "News Note" from Max Schuster, 7/31/33, B-W Col.
237 ending wars for all time: Transcript, MB-W, interview on WABC, 8/31/36, B-W Col.
237 Japanese bombs . . . hours in the air: SRW, pp. 6, 15, 26; also script for radio broadcast, 4/21/41, B-W Col.
237 unintentionally unkind: Lee Scott, interview, 8/29/82.
238 chartering a plane: Alice-Leone Moats, *Blind Date with Mars* (Garden City, N.Y.: Doubleday, Doran, 1941), pp. 160, 161, 167, 168. Also interview, 9/21/83, telephone.

238 **foreign diplomats did:** MB-W, letter to Wilson Hicks, 6/4/41; another, 5/20/41; also memorandum from Hicks to Roy Larsen, 11/17/41, Time Inc. Archives. See also EC, *Call It Experience*, pp. 195, 198.

239 **world around him:** MB-W, two sets of undated notes, most likely for *Portrait*, B-W Col.

239 **sadly underestimated:** For a reestimation, see Scott MacDonald, *Critical Essays on Erskine Caldwell* (Boston: G. K. Hall & Co., 1981), Introduction, and Sylvia Jenkins Cook, pp. 375–91.

239 ***Alexander Nevsky:*** SRW, p. 30.

239 **attack on the U.S.S.R.:** Toland, *Hitler*, pp. 657–8.

239 **go south in early June:** SRW, pp. 41–2.

239 **diplomatic travel in this country:** Cable, 6/5/41, National Archives.

240 **history of military aviation:** Barton Whaley, *Codeword Barbarossa* (Cambridge, Mass.: MIT Press, 1973), picture caption, n.p.

240 **over by Christmas:** Toland, *Hitler*, pp. 671, 673–4.

240 **lens of Margaret's camera:** SRW, pp. 55–6.

240 **never mind:** *Portrait*, pp. 175–6. MB-W here says the penalty for photographers was imprisonment. I have used the account in SRW, possibly exaggerated but closer in time to the event.

240 **acceded to her demands:** Alice-Leone Moats, interview, 9/2/83, phone.

241 **convoy of three cars:** SRW, pp. 72, 105.

241 **fight left in it:** Toland, *Hitler*, pp. 674–5.

241 **fell on Moscow itself:** SRW, p. 65; Riasanovsky, *History of Russia*, p. 517.

241 **ever injured there:** Henry Cassidy, *Moscow Dateline* (Boston: Houghton Mifflin, 1943), p. 95.

241 **sky as their canvas:** SRW, pp. 86–9, 115; *Portrait*, p. 179.

242 **on the Russian capital:** One of these photographs was copied recently by the painter Jack Goldstein, who "recycles information" by using preexisting images in his paintings. My thanks to Robert Sherrod for this information.

242 **come back with camera:** *Portrait*, pp. 176–7; SRW, pp. 89–90.

243 **seemed of some purpose:** SRW, pp. 118–19.

243 **anything had happened:** Richard Meryman, interview, 8/7/84. Re her energy, see Himber, *Famous in Their Twenties*, p. 111; Reilly, "Why Margaret Bourke-White Is at the Top", p. 68; MB-W, letter to Dan Longwell, 5/27/37, Time Inc. Archives.

244 **great picture work:** Hicks cable, n.d., B-W Col. On the broadcasts, see SRW, pp. 125–7; *New York Times*, 6/30/41, 5:8. In SRW, MB-W claims she stopped because she felt pictures were her first responsibility.

244 **citizens for investigation:** Erskine Caldwell, *All Out on the Road to Smolensk* (New York: Duell, Sloan & Pearce, 1942), p. 33.

245 **reverted to marble:** *Portrait*, pp. 182–4; SRW, pp. 205–17; Calhoun biography of MB-W, p. 21, Time Inc. Archives; MB-W, notes, B-W Col. Both SRW and *Life*, 9/8/41, say she didn't dare ask Stalin to sit.

245 **ever to take Stalin's picture:** On 9/1/41, *Life* published a letter from James Abbe saying he had photographed Stalin in 1932.

245 **I do the work of men:** MB-W, letter to Wilson Hicks, 7/20/41, Time Inc. Archives.

246 **fine Moscow work:** Undated cables, Time Inc. Archives.

246 **by November 1:** MB-W, cable to Billings, Hicks, Thompson, 9/2/41, Time Inc. Archives.

247 **out of the mud:** Cyrus Sulzberger, *A Long Row of Candles* (Toronto: Macmillan, 1969), pp. 164–5.

247 **has to be recorded:** SRW, p. 231. For this trip, see SRW, pp. 220–38; *Portrait*, pp. 186–7; EC, *Road to Smolensk*, pp. 174–83. Also Henry Cassidy, interview, 1/10/83.

248 **she was Margaret Bourke-White:** Lael Wertenbaker, interview, 4/2/82, phone.

248 **the clerk replied:** *Portrait*, p. 188.

248 **different from his own:** EC, "An Evening in Nuevo León," *Harper's Magazine*, November 1940, pp. 605–7.

248 **photographer of the year:** Wilson Hicks, cable to MB-W, 10/31/41, Time Inc. Archives.

Chapter 22: War on Land and Sea

249 **income at the time:** W. Colston Leigh (her agent), interview, 1/14/83, telephone. Also, letters from MB-W to J. Hampton Atkinson, 4/5/53, B-W Col., and to Col. Roswell Perry Rosengren, 1/13/54, possession of Col. Rosengren.

250 **not mutually exclusive:** Doris O'Neil, interview, 2/24/82.

250 **beautiful, orderly pattern:** Jerry Papurt, letter to MB-W, n.d., B-W Col. Printed by permission of Maxine C. Papurt.

250 **all through Rockford:** Ralph Graves, interviews, 4/1/82, 2/24/82.

250 **never planned to collaborate:** EC, interview, 12/1/82.

250 **didn't type that one:** Lee Scott, interview, 12/1/82.

251 **he cares to make it:** *Portrait*, p. 196.

251 **at odds too often:** Dabney Caldwell, interview, 5/4/82, phone.

251 **putting herself first:** Lee Scott, interview, 7/29/82.

251 **in this marriage:** MB-W, notes, "EC Divorce," B-W Col.

252 **magazines bears that out:** Quoted in Wainwright, "Life Begins," p. 61.

252 **accredited in that war:** Ed Thompson says she asked to be sent to war; interview, 2/17/82.

252 **all women correspondents:** *Portrait*, p. 197.

252 **vital phase of history:** MB-W, interview on *L.A. Friday Morning*, 5/14/43, tape, B-W Col.

252 **new worker to emphasize:** *Life*, 8/9/43.

252 **I just couldn't:** MB-W, typescript for *Portrait*, B-W Col.

253 **decorating it—long distance:** Lee Scott, interview, 7/29/82; also, EC's letters to MB-W, summer and fall of '42, B-W Col.

253 **a little Kit:** EC, cable to MB-W, 7/20, no year (1942), B-W Col.

253 **sorties:** Max Hastings, *Bomber Command* (New York: The Dial Press/James Wades, 1979), pp. 121–5, 181–2. For MB-W's part, see *L.A. Friday Morning*; calendar for *Portrait*, 1955, p. 15; B-W Col.; *Portrait*, p. 199.

254 **Erskine's abandonment:** Peggy Sargent, interview, 2/10/82.

255 **minute of the year:** MB-W, letter to Wilson Hicks, 11/17/42, Time Inc. Archives.

255 **house would be hers:** Letters and cables between MB-W and EC, MB-W

and Julius Weiss, August–November 1942, B-W Col. EC's cables are printed with his permission.

256 **one word about her marriage:** Hancock, "Margaret Bourke-White," p. 12.

256 **which still endures:** *Portrait*, p. 197. See typescript for *Portrait* and notes for it, "EC Divorce," B-W Col.

256 **coast of Africa:** Toland, *Hitler*, p. 722; Corelli Barnett, *The Desert Generals* (New York: The Viking Press, 1961), pp. 192–255.

257 **invasion without her:** Edward K. Thompson, telephone conversation with the author, 4/21/85. Thompson says Lang was so angry he quit and was quickly rehired by *Time*; I have not been able to confirm this.

257 **row part of the way:** *Portrait*, p. 203.

260 **sank beneath the waves:** *Portrait*, pp. 204–6; MB-W, "Women in Life-boats," *Life*, 2/22/43, pp. 48–54; calendar for *Portrait*, 1955, and tape, *L.A. Friday Morning*, B-W Col.; MB-W, "The Best Advice I Ever Had."

260 **wanted a larger negative:** Etna M. Kelley, "Margaret Bourke-White," *Photography*, August 1952, p. 41.

261 **Bourke-White Blues:** Robert T. Elson, *The World of Time Inc.: The Intimate History of a Publishing Enterprise*, vol. 2: 1941–1960 (N.Y.: Atheneum, 1973), p. 45.

Chapter 23: "*Life*'s Bourke-White Goes Bombing"

262 **so far this year:** Wilson Hicks quoted in Elson, *Time Inc.*, vol. 1, p. 472.

262 **on the sea:** On Doolittle: Edward P. Curtis, interview, 5/11/84, telephone; also *Portrait*, pp. 217–18. On Eisenhower: Col. Max Boyd, interview, 12/10/84, telephone.

263 **same risks they did:** *Portrait*, p. 222.

263 **out of the air:** Paul Tibbetts, interview, 1/7/85, telephone.

263 **a perilous war:** Letters from J. Hampton Atkinson to MB-W, March–July 1943, B-W Col.

263 **two do not mix:** MB-W, *They Called It "Purple Heart Valley"* (hereafter *PHV*) (New York: Simon & Schuster, 1944), p. 109.

263 **while she showered:** Herbert Mitgang, interview, 8/11/82, and Maitland Edey, interview, 12/18/82.

264 **shat here:** J R Eyerman, interview, 1/21/83.

264 **Bourke-White will let you know:** J R Eyerman, interview, 1/21/83.

264 **equipment he didn't have:** This is how various staff members recall this cable. Elisofon himself said years later that he'd said, "I don't have the same equipment she has." Speech made at Ohio University, receiving the Carr Von Anda Award for MB-W, 4/14/69. My thanks to Elin Elisofon for this reference.

265 **folks at home would know:** Herbert Mitgang, interview, 8/11/82.

265 **as if bombs were coming:** Eliot Elisofon, letter to Wilson Hicks, 1/27/43, Time Inc. Archives. My thanks to Elin Elisofon for this reference.

266 **German operations:** Henri Michel, *The Second World War*, vol. 1, trans. Douglas Parmee (New York: Praeger Publishers, 1975), pp. 397–9, 499–502; *Portrait*, p. 219; *Life*, 3/1/42, p. 19. Aouina is variously spelled.

267 **mission was highly successful:** *Portrait*, pp. 228–33; calendar for *Portrait*,

1955, and tape, *L.A. Friday Morning*, B-W Col.; MB-W's notes, Time Inc. Picture Service; *Life*, 3/1/43, pp. 17–23.

268 **so incredibly remote:** *Portrait*, p. 226.

268 **even as a fotog:** MB-W, notes, B-W Col.

269 **enlisted men:** Carl Mydans, *More Than Meets the Eye* (New York: Harper and Brothers, 1959), p. 9. Wilson Hicks's speech, in Louisville, Ky., November 1940, Time Inc. Archives. On the films, see *Life*, 1/3/44.

269 **a photographer's war:** Wilson Hicks, "The News Photographer," 1/14/48, Time Inc. Archives. On WWI photography, see Jorge Lewinski, *The Camera at War* (London: W. H. Allen & Co., Ltd., 1978), pp. 63–70.

269 **everybody was clean:** Tex McCrary, interview, 5/10/82.

269 **after the war:** John Morris, "This We Remember," *Harper's Magazine*, September 1972, p. 73.

270 **draft . . . declined:** Alfred Appel, Jr., *Signs of Life* (New York: Alfred A. Knopf, 1983), pp. 11–15.

270 **never asked again:** Nina Leen, interview, 3/23/82, phone. Wilson Hicks on MB-W: Fred Ringel's notes on an interview with Hicks, 4/7/53, International Center of Photography, New York.

270 **her friendships afterward:** *Portrait*, p. 302.

270 **don't bother me:** Jack M. Hofkosh, interview, 5/3/83.

271 **flick of a switch:** Hansel Mieth, letter to the author, 6/9/82.

271 **very animated:** Peggy Sargent, interview, 2/10/82.

271 **I want that picture:** *Life*, 6/27/69, Editor's Note.

271 **such a small cost:** Ralph Graves, interview, 2/24/82; *Life*, 9/10/71, Editor's Note.

271 **He declined:** Clay Felker, interview, 2/16/82. By the time this happened, Margaret was ill.

272 **you're getting good pictures:** John Phillips, interview, 2/25/82.

272 **preparing for eternity:** Dora Jane Hamblin, letter to the author, 3/11/82.

272 **with her own nature:** Michael Arlen, interview, 3/3/82.

272 **Good God, no!:** Edward K. Thompson, interview, 2/17/82.

273 **such a lovely sound:** Norman Cousins, interview, 4/16/82, telephone.

273 **like them too:** Anne White, interview, 12/8/81.

273 **this single-mindedness:** John Phillips, interview, 2/25/82.

273 **protective shield around her:** Carol Eyerman, letter to the author, 1/25/83.

273 **could be devastated:** Arthur J. Korf, interview, 10/18/82.

Chapter 24: Purple Heart Valley

274 **living for that day:** MB-W, letter to Wilson Hicks, 5/3/43, Time Inc. Archives.

275 **you have to prove yourself:** MB-W, interview with Joel Alderman, Voice of America, August 1963, tape, B-W Col. Letter (5/3/43), memo (8/12/43), and cable (11/16/43) to Wilson Hicks, Time Inc. Archives.

275 **made the story work:** Richard Pollard, letter to the author, 4/28/82.

276 **fill in the harbor:** See MB-W, *PHV*, pp. 25–39; John Ellis, *Cassino: The Hollow Victory* (New York: McGraw-Hill Book Company, 1984), pp. 26, 40–1.

276 **Legion of Honor:** Myrna Papurt Weibel, interview, 4/14/83, telephone; *Por-*

trait, pp. 309–10; letters from Jerry Papurt to MB-W, 1/23/44–4/15/(?), B-W Col.; undated articles in Cleveland papers, courtesy of Myrna Papurt Weibel.

277 **It worked:** Norman Lewis, *Naples '44* (New York: Pantheon Books, 1978), pp. 43–4; *PHV*, pp. 28–9. MB-W does not say this story was about Papurt, but evidence in *PHV* indicates it was.

277 **Love me, too:** Jerry Papurt, undated letter to MB-W, B-W Col. Printed by permission of Maxine C. Papurt.

278 **their sacrifice deserves:** *PHV*, pp. 36–9.

278 **on our side:** *PHV*, pp. 109–10.

278 **what they said:** MB-W, typed notes for *Portrait*, B-W Col. See *Portrait*, p. 234.

279 **she was pretty lucky:** Biography of MB-W, 5/7/48, Time Inc. Archives.

280 **wouldn't be easier:** *PHV*, pp. 60–2.

280 **man or woman:** Jerry Papurt, letter to MB-W, 2/4/44, B-W Col., printed by permission of Maxine C. Papurt. On her reaction to shelling, see *PHV*, pp. 177, 147–53.

281 **Which do you think I am?:** Michael J. Strok, letter to the author, 6/28/82.

281 **an invisible star:** *Portrait*, p. 308.

282 **command to fire:** *Portrait*, pp. 239–42; *PHV*, pp. 157–61.

282 **caused an uproar:** Gerard Piel, interview, 7/6/83; also, Dmitri Kessel, interview, 4/9/82. My thanks to Drew Middleton for the information on the Geneva convention.

283 **don't know what is:** Ellis, *Cassino*, pp. 90–110. The quote, p. 110, from R. H. Adelman and G. Walton, *Rome Fell Today*, (Boston: Little, Brown and Co., 1968), p. 154. MB-W did not say the date; evidence points to it.

283 **shell had crushed:** *PHV*, pp. 111–32; *Portrait*, pp. 243–8.

283 **than other photographers:** Teletype from Ray Rackland to H. Robinson for Wilson Hicks, 12/14/43, Time Inc. Archives.

284 **wound that never healed:** *Portrait*, pp. 248–50.

284 **taken more seriously:** David B. Richardson, interview, 6/23/83, telephone.

284 **assignment of his life:** Jerry Papurt, letter to MB-W, 1944, B-W Col.

284 **categorically denied:** John Morris, interview, 7/12/82.

285 **to her with care:** *Portrait*, pp. 309–10; letter from MB-W to Paul Sogg, 11/16/44, and from Lt. Albert A. Monnet, Jr., to Mrs. Papurt, 6/25/45. My thanks to Myrna Papurt Weibel and Mrs. Paul Sogg for these references.

286 **did not believe it:** Mrs. Paul Sogg, interview, 4/14/83, telephone.

286 **handsprings for her:** Tom Durrance, letter to Fill (probably Filmore Calhoun), 12/9/44, B-W Col.

286 **army bag was stolen:** *Portrait*, pp. 255–7.

287 **its instruments gone:** Lewis, *Naples '44*, p. 86.

287 **throwing hand grenades:** *Portrait*, pp. 256–7; calendar for *Portrait*, 1955, p. 25, B-W Col. *Life* cable to MB-W, 2/8/45; memo for Sheehan from Vondermuhl, 10/23/45, Time Inc. Archives.

Chapter 25: The Watch on the Rhine

288 **she gave him one:** MB-W unfinished manuscript, possession of Sean Callahan. Also John Toland, *The Last 100 Days* (New York: Random House,

1965), p. 259, and MB-W, *"Dear Fatherland, Rest Quietly"* (hereafter Fatherland) (New York: Simon & Schuster, 1946), pp. 19–31.

289 History will form judgments:" *Portrait*, p. 258.

289 corpses in the streets: *Fatherland*, p. 38.

289 if given the chance: Ibid., pp. 3–10.

290 at the press camp: Percy Knauth, interview, 4/14/82.

291 impossible to stand it: *Portrait*, pp. 259–60.

291 she wept: Sean Callahan, interview, 1/14/82.

291 map the place with negatives: *Fatherland*, p. 77. See also her caption notes, Life Picture Service.

291 with the brakes on: John Phillips, interview, 2/25/82.

291 Hildegarde said indignantly: *Fatherland*, p. 136.

292 behind closed doors: Ibid., p. 61

292 she loved men: Kathryn Cravens, interview, 12/7/83, telephone.

292 incidental to that: Maitland Edey, interview, 12/31/82.

292 weren't that important: Percy Knauth, interview, 4/14/82.

292 seen from a grave: Ibid.

292 town against attack: Toland, *The Last 100 Days*, pp. 398–400.

293 killing everybody we knew: William Walton, interview, 11/11/82.

293 acre of bones: *Fatherland*, p. 77

294 detail you can't remember: William Walton, interview, 11/11/82. Also *Portrait*, p. 259; *Fatherland*, pp. 76–80; Maitland Edey, interview, 12/31/82.

294 Coarsened very quickly: Ibid.

294 impulses behind such behavior: Betty Cronander, interviews, 12/2/82, phone, 1/17/83.

295 looted Margaret's loot: *Portrait*, p. 264.

295 not abandoned us: Toland, *The Last 100 Days*, pp. 377–82.

295 on unsteady feet: *Fatherland*, pp. 57–8.

296 safer territory: Ibid., pp. 58–9.

296 a doomed civilization: See Toland, *The Last 100 Days*, pp. 140–50; *Life*, June 4, 1945, pp. 21–7.

298 aren't close enough: Robert Capa, quoted in Lewinski, *Camera at War*, p. 92. Capa himself wrote that his Normandy pictures were only blurred by a darkroom error: *Slightly Out of Focus* (New York: Henry Holt and Company, 1947), p. 151.

298 some grand adventure: Ruth White, two undated letters to MB-W, B-W Col.

298 key to the other: *Portrait*, pp. 135–6.

299 hearts of men everywhere: *Fatherland*, pp. 174–5. Edward Stanley, a close friend who worked with MB-W on several of her books, says he had to finish the last part of this one when she left the country.

299 a better world: Percy Knauth, interview, 4/14/82.

Chapter 26: India: A Pillar of Fire

300 leadership in the world: *Life*, 2/7/41, pp. 65, 64.

302 to be with her camera: *Portrait*, pp. 272–8.

302 fulfilling the second: See Larry Collins and Dominique Lapierre, *Freedom at Midnight* (New York: Avon, 1976), p. 36.

302 **the deadly heat:** Robert Sherrod, quoted by Will Lang in a memo to Wilson Hicks, 6/5/46, B-W Col.

303 **certainly is Bourke-White:** Robert Sherrod, letter to the author, 9/1/82. David B. Richardson, letter to the author, 6/15/83. *f.y.i.*, 5/27/46.

303 **through her photography:** Sunil Janah, undated letter (1983) to the author.

303 **between the two of them:** *Portrait*, pp. 280–1.

304 **expensive cocktail parties:** Dom Moraes, *My Son's Father: An Autobiography* (London: Secker and Warburg, 1968), pp. 6–7.

304 **that he himself mocked:** Frank Moraes, letter to MB-W, 1/28/47, B-W Col. Ved Mehta, interview, 10/8/82. Also Robert Sherrod, interview, 9/16/82.

304 **insisted on her freedom:** Frank Moraes, letter to MB-W, 8/3/46. Also letter of Monday, 1/21/(?), B-W Col.

304 **really be tender:** Frank Moraes, letter to MB-W, 8/3/46, B-W Col. Printed by permission of Don Moraes.

305 **in journalism abroad:** David B. Richardson, interview, 6/23/83, telephone.

305 ***The Rains Came:*** Helen Barrow and Rosalie Barrow Callahan, interviews, 10/14/82.

305 **apparently turned down:** MB-W, undated letter to Peter Jayasinghe, B-W Col.

306 **a silly ass:** Dom Moraes, My Son's Father, pp. 13–14.

306 **depend on her:** Dom Moraes, letter to the author, 12/17/85.

306 **spoil their friendship:** MB-W, undated draft of a letter to Beryl Moraes.

306 **above self-reproach:** Helen Caldwell Cushman, interview, 1/20/83.

306 **Bourke-White in disguise:** Frank Moraes, letter to MB-W, 12/16/46, also 22/9/47, B-W Col.

307 **religious prejudice:** *Portrait*, p. 283.

307 **her ground glass:** David B. Richardson, letter to the author, 6/15/83.

307 **British consumption:** Max Desfors, interview, 7/25/83, telephone.

308 **within two stiff covers:** MB-W, handwritten notes, n.d., B-W Col.

308 **Transatlantic flight:** Frederick Kuh, letter to MB-W, 11/2/47, B-W Col.

308 **Maurice Hindus:** See letters from him to MB-W, 1947, B-W Col.

308 **on her conscience still:** *Portrait*, p. 302. She does not name the man, but Jayasinghe's letters make it clear.

308 **wastebasket at him:** Peter Jayasinghe, letter to MB-W, 2/6/49, and other letters, B-W Col.

308 **you are in his company:** Edward Stanley, interview, 3/5/82. David B. Richardson says that in India MB-W often said, "Ed says I should get more of this or that." Interview, 6/23/83, telephone.

309 **level of understanding:** MB-W, calendar for *Portrait*, 1955, p. 26, B-W Col.

309 **her work in India:** MB-W, "Words About Pictures," *Infinity* (American Society of Magazine Photographers), June 1958, p. 7. (Speech at the Photojournalism Conference at the University of Miami.)

309 **bad notices alone:** Hamblin, *That Was the LIFE*, p. 61.

310 **improbably, it worked:** Sunil Janah, undated letter to the author, 1983.

310 **any feminine weakness:** Lee Eitingon, interview, 2/17/82.

310 **murdered Hindus . . . in World War II:** Collins and Lapierre, *Freedom*, pp. 314–15, 329.

310 **waiting for the next train:** MB-W, *Halfway to Freedom* (New York: Simon and Schuster, 1949), p. 6.

311 **eight hundred thousand refugees:** Collins and Lapierre, *Freedom*, p. 369.

311 **marched on without them:** *Portrait*, p. 287.

311 **came to individual people:** Lee Eitingon, interview, 2/17/82.

311 **she ever had before:** "Margaret Bourke-White, Favorite Pictures," *ASMP Annual*, 1957, p. 134.

312 **the struggling convoys:** Collins and Lapierre, *Freedom*, p. 395.

312 **three thousand had died:** *Portrait*, pp. 287–90; *Halfway to Freedom*, p. 5.

313 **lust . . . and omission:** *Portrait*, pp. 295–7. The Richard Attenborough movie *Gandhi* showed MB-W interviewing Gandhi's wife, who died in 1944, two years before MB-W reached India.

313 **entrance to the building:** Confidential memo to the secretary of state from the charge d'affaires at the American embassy, New Delhi, 2/3/48, National Archives, courtesy of Richard Gould.

314 **learn from her zeal!:** *Halfway to Freedom*, pp. 242–3. Also Collins and Lapierre, *Freedom*, pp. 515–19.

314 **to light the way:** *Halfway to Freedom*, pp. 243–4.

Chapter 27: Gold and Diamonds, Love and Work

315 **enlightenment of people:** *Life*, 10/23/50.

315 **Canada named a lake:** The lake, northwest of Montreal, was named in '43 but not put on a map until after the war; letter from International Paper Co. to MB-W, 10/29/43, B-W Col.

315 ***Real Fact Comics:*** May–June 1947.

315 **proved that to the world:** Suggested by Michael Arlen in an interview, 3/3/82.

316 **before you have photographed it:** *Portrait*, p. 322.

316 **introduce Margaret to her people:** Ibid., p. 139.

317 **well worth it:** Ibid., pp. 315–16. Also, tape of interview with Joel Aldeman, Voice of America, August 1963, B-W Col.

318 **as the aesthetics:** John Szarkowski, interview, 2/21/84, telephone.

318 **It was obvious:** Alexander Schneider, interview, 4/12/82.

318 **put them in jail:** MB-W, letter to Ranga, India, 4/14/50, B-W Col. I have cleaned up her spelling and abbreviations a bit.

318 **too long for news stories:** Ray Mackland, interview, 7/14/82. Her principal South African story was published on 9/18/50.

318 **that means reality:** As reported by Tex McCrary, 3/12/82.

319 **any other photographer:** Herb Orth, interview, 1/28/82; William Sumits, interview, 5/25/82.

319 **a career, shall we say:** Helen Caldwell Cushman, interview, 1/20/83.

319 **hearts of sea urchin:** On the Darien house, see MB-W, typed manuscript about it, also photographs, B-W Col. Also Beaumont Newhall and Helen Caldwell Cushman, interviews, 9/11/82, 1/20/83.

319 **get my vestments on!:** Helen Caldwell Cushman, interview, 1/20/83.

320 **to have company, companionship:** Beaumont Newhall, interview, 9/11/82.

320 **You are the great lady:** Arthur Korf, interview, 10/18/82.

320 **her interest in me:** Off-the-record interview.

321 **emotional security:** MB-W, draft of *Portrait*, B-W Col.

321 **worth being and living:** Alexander Schneider, interview, 4/12/82.

322 **gift of excitement:** MB-W, "Penmanship," May–June 1962, B-W Col.

322 **oh my Lord:** Karen Tuttle, interview, 12/20/81.

322 **she controlled it:** Alexander Schneider, interview, 4/12/82.

322 **thanks for the morning:** On Schneider, see Joseph Wechsberg, "Profiles: The Budapest," *The New Yorker*, 11/14/59. Also interviews with Robert Fatherley, Jr., June Rotenberg, Hedda Sterne, Karen Tuttle.

323 **really very beautiful:** Alexander Schneider, interview, 4/12/82.

323 **went into heat:** Helen Caldwell Cushman, interview, 1/20/83.

323 **people who live in time:** Hedda Sterne, interview, 11/2/82.

323 **didn't see nothing:** Alexander Schneider, interview, 12/14/82.

323 **a holy uproar:** Lael Wertenbaker, letter to MB-W, 5/19/62, B-W Col.

323 **vulnerable before, I suspect:** Karen Tuttle, interview, 12/20/83.

323 **trumpet section all by himself:** June Rotenberg, interview, 9/15/84.

324 **she did right:** Hedda Sterne, interview, 11/3/82.

324 **to meet another man:** Interviews, Eleanor and Danny Saidenberg, 4/2/84, and Karen Tuttle, 12/10/82. Also MB-W, notes for a letter to Clara Thompson, n.d. (1951), B-W Col.

325 **feelings of guilt:** *The Professional Photographer*, Convention Issue, April 1965, p. 136.

325 **never deserts you:** MB-W, typescript notes, B-W Col.

Chapter 28: Guerrilla Warfare

327 **when the time comes:** MB-W, letter to Robb Sagendorph, 3/10/52 (probably misdated from '51). See letter to him 4/1/('51); also *Life*, 8/27/51.

327 **flying tripod:** Ken Fanizzi, "MB-W, Chronicler of History," *News Workshop* (New York University: Department of Journalism, n.d.).

327 *Actual rescue mission: Life*, 4/14/52, p. 140, and MB-W, notes for *Portrait*, n.d., B-W Col.

328 **at building up:** Roscoe Drummond and Glen Perry, "Westbrook Pegler: Tonic or Poison?" *Look*, October 1944, p. 33.

328 **show these people smiling:** Victor S. Navasky, *Naming Names* (New York: The Viking Press, 1980), p. 29.

328 **never saw him again:** MB-W, handwritten notes, B-W Col. Learning to read MB-W's scrawl is akin to learning a new language. I have reproduced only what I feel certain of, sometimes with elisions.

329 **was a Communist:** Two of Pegler's articles also concern Angela Calomiris, a photographer who joined the party for the FBI and in 1947 was instrumental in having the Photo League branded subversive. See her book, *Red Masquerade* (Philadelphia: J. B. Lippincott, 1950).

329 **boring and annoying:** *Time*, 9/2/51. See MB-W, typescript of research she did into her own political affiliations, B-W Col.

329 **Communist propaganda:** Lawrence Lader, *Power on the Left: American Radical Movements Since 1946* (New York: W. W. Norton & Company, 1979), p. 79.

329 **met some hecklers:** W. Colston Leigh, interview, 1/4/83, telephone; also "School Speaker Sidesteps Condemnation for Atrocities," *Philadelphia News*, 11/10/51.

329 **or of the right:** Statement in FBI files, obtained under the Freedom of Information Act.

329 **highest intellectual Communists . . . no active investigation:** FBI docu-

ments on MB-W, 100-3518-1, 100-3517-5; 100-3518-8; 100-3518, 7/16/43; 100-3518-5; obtained under the Freedom of Information Act.

330 **Betty Cronander . . . autobiography:** Betty Cronander, interview, 1/17/83.

330 **My head is working now:** MB-W, two sets of handwritten notes, one on a mailing dated 10/1/51, B-W Col.

330 **best damn picture man:** Michael J. Arlen, "Green Days and Photojournalism, and the Old Man in the Room," *Atlantic*, August 1972, p. 60.

330 **That's a cover:** Alfred Eisenstaedt, interview, 1/21/82.

330 **boys-in-the-backroom manner:** Dorothy Seiberling, interview, 1/25/82.

331 **photographers had neglected:** *Portrait*, p. 329.

331 **"police action":** Edward K. Thompson, letter to the author, 2/25/82.

331 **She was worth it:** Edward K. Thompson, interview, 2/17/82.

331 **Pegler was wrong:** Ibid. Other people, including Ed Stanley, worked on her clearance. Also, MB-W went to see Anna Rosenberg, recently appointed secretary of defense, and won her support. MB-W, letter to Robb Sagendorph, 2/2/52, B-W Col.

331 **in this manner:** Ibid.

332 **miniature camera user:** *Portrait*, p. 328. On the riot, see ibid.; Fanizzi, "MB-W, Chronicler"; Stanley Rayfield in "The Story Behind the Stories in Life," brochure for salesmen, May 12, 1952; MB-W, lectures in San Francisco and Wisconsin, 1952–53, B-W Col.

332 **known very well indeed:** Helen Caldwell Cushman, interview, 1/20/83.

333 **in all his life:** Col. Roswell Perry Rosengren, interview, 8/2/83, telephone, and letter of 8/9/83.

333 **marine said promptly:** Marguerite Higgins, *War in Korea* (Garden City, N.Y.: Doubleday & Company, 1951), p. 196.

333 **convoy for safety:** Roswell Perry Rosengren, interview, 8/2/82, telephone; *Portrait*, p. 331.

333 **human heart itself:** On Korea, see *Portrait*, pp. 330–56.

334 **for guerrilla warfare:** See William Manchester, *American Caesar: Douglas MacArthur, 1880–1964* (Boston: Little, Brown and Co., 1978), p. 545.

335 **to do these things:** Tape of MB-W's Korean notebooks, also cable from MB-W to Time Inc., 8/11/52, B-W Col.

335 **tame guerrilla:** "Behind the Lenses," lecture, 1/13/53, B-W Col.

336 **scarcely photograph:** Tape, Town Hall interview, KMJ Fresno, 1/23/53, B-W Col. See also *Portrait*, pp. 349–56; *Life*, 12/1/52, pp. 30–1; MB-W, caption material, Life Picture Service.

336 **my heart was moved:** Memo for Cal Whipple from Jo Sheehan, 4/23/56, Time Inc. Archives.

337 **the small camera:** "MB-W—Favorite Pictures," *ASMP Picture Annual*, 1957, pp. 134–41. Calendar for *Portrait*, 1955, p. 32, B-W Col.

337 **no end in sight:** MB-W, loose typed page, B-W Col.

338 **participate in the action:** Letter to *Life* subscribers, from the Circulation Director, 1/55, Time Inc. Archives.

338 **her pictures were remarkable:** Howard Sochurek, interview, 6/25/84.

339 **not to think about it:** *Portrait*, pp. 358–9.

339 **how she'd got there:** MB-W, revised chapter for a book she worked on in the '60s, B-W Col.

339 **colonel's favorite color:** Edward K. Thompson, letter to the author, 4/28/83.

339 package on the other: Sidney L. James, interview, 10/15/82.

340 along on the tour: Edward K. Thompson, letter to the author, 4/28/83.

340 but was unsuccessful: *New York Times*, 10/9/52, 80:4; 10/19/52, 36:1.

340 her there in Korea: Mark Clark, letter to MB-W, 12/17/52, B-W Col.

340 houses of the legislature: MB-W, letter to Peter Jayasinghe, n.d. (1953), B-W Col.

340 too silly: MB-W, letter to Frank Altschul, 12/19/62; another letter to Altschul, 4/14/(?) Frank Altschul Collection, Herbert H. Lehman Papers, Columbia University Libraries, Rare Books and Manuscripts.

Chapter 29: The Greatest Assignment

341 the one on p. 26: E. B. White, *The Second Tree from the Corner* (New York: Harper and Brothers, 1954), p. 158.

341 62,000,000 people: Alfred Politz, *A Study of the Accumulative Audience of Life*, Alfred Politz Research, Inc. (New York: Time Inc., 1950), passim., cited by Otha C. Spencer, *Twenty Years of Life*, p. 285.

341 Nine reporters: Hamblin, *That Was the LIFE*, p. 35.

342 nine million people: Helen Gee, *Photography of the Fifties* (Tucson: University of Arizona, 1980), p. 5. *New York Herald Tribune*, Don Langer, 1/30/55, sec. 4, p. 7. *New York Times*, Aline Saarinen, 2/6/55, p. 10x.

343 save what she's got: *Portrait*, p. 359. On MB-W's "mysterious malady," see pp. 358–83.

343 new hand for herself: *Portrait*, pp. 360–1.

343 prisoner in my own self: Arthur J. Korf, interview, 11/2/82.

343 felt simply wonderful: Joseph Liss, taped interview with MB-W, 1959, Joseph Liss Collection, Boston University, Mugar Memorial Library.

344 do in our line: Reverend Professor James W. Skehan, interview, 6/7/83.

344 novices face east!: Nancy Newhall, letter to MB-W, 4/4/55, B-W Col.; also Father Daniel Linehan, interview, 6/7/83.

344 go back to work: Michael Arlen, interview, 3/3/82.

345 any way she wanted to: Michael J. Arlen, interview, 3/3/82.

345 Later I wasn't afraid: Michael J. Arlen, "Green Days," pp. 61–5.

345 beyond knowledge or control: Michael J. Arlen, interview, 3/3/82.

346 very important to me: *Portrait*, p. 364.

346 give up early go fast: Jack Hofkosh, interview, 5/31/83.

346 had always been: *Portrait*, pp. 365–6.

347 be seen in public: Kenneth Gouldthorpe, interview, 11/23/82, telephone.

347 poisons it all: *Portrait*, p. 364.

347 might be willing: Off-the-record interview.

347 remember anyone visiting: Joseph Liss, interview, 8/9/82.

348 her final loneliness: Jack Hofkosh, interview, 5/3/83.

348 betraying her nonetheless: Bradley Smith, interview, 9/7/84.

348 his blessing: Joseph L. Thorndike, Jr., interview, 8/3/82. Luce wrote about her request in *Fortune* in '55.

348 not an unhappy period: Notes for Wisconsin speech, probably '61, B-W Col.

348 escalator that was going down ... never accept an illness: *Portrait*, pp. 366–8.

348 get back my health: MB-W, notes, B-W Col.

348 **door did indeed open:** *Portrait*, p. 368.
349 **intense controversy:** See I. S. Cooper, *The Vital Probe: My Life as a Brain Surgeon* (New York: W. W. Norton and Company, 1981), passim.
349 **at the right time:** *Portrait*, p. 380.
349 **in high style:** Anne White, interview, 12/8/81.
349 **above the fear:** MB-W, typed notes, B-W Col.
349 **horrible adventure:** Betty Cronander, interview, 1/17/83.
350 **on the evening air:** Arthur J. and Ada Korf, interview, 11/2/82.
350 **held no fears for me:** *Portrait*, p. 371. To give the 1960 TV broadcast about Margaret more drama, Joseph Liss wrote Alfred Eisenstaedt into the script as the watching friend.
350 **greeting the world:** Arthur J. Korf, interview, 10/18/82.
350 **turned out beautifully:** *Portrait*, p. 371.
350 **miss a word of it:** MB-W, typescript notes, B-W Col.
350 **the outside world:** *Portrait*, p. 371.
351 **Why me?:** Jack Hofkosh, interview, 5/3/83.
351 **deserve such a fate:** MB-W, disk of dictated notes, B-W Col.

Chapter 30: "What Is Life For Not to Give Up and Die"

352 **Rilke:** From Wolfgang Leppman, *Rilke*, verse trans. Richard Exner (New York: Fromm International, 1985).
352 **to hand down:** MB-W, typescript notes, B-W Col.
352 **wanted to be first:** *Portrait*, p. 90.
352 **inferiority complex:** MB-W, letter to Miss Dant, 7/25/59, B-W Col.
353 **difficulties initiating speech:** Howard A. Rusk Institute of Rehabilitation Medicine, records, 5/26/58.
354 **managed to communicate:** MB-W, "MB-W, Psycho.," B-W Col.
354 **to take the pictures:** *Portrait*, p. 377. Also Joseph Liss, taped interview with MB-W, 1959.
354 **into the magazine:** George Hunt, interview, May 1983, telephone.
355 **it was delivered:** Tex McCrary, interview, 3/12/82.
355 **trying to communicate:** Teresa Wright, interview, 5/19/83.
356 **buy it with all I own:** MB-W, letter to Roy E. Larsen, 1/29/55; also memos from MB-W, Edward K. Thompson, Allen Grover, 1949–50, Time Inc. Archives.
356 **house in return:** MB-W willed her photographs, equipment, and papers to Syracuse University, which gave her a show and an award in the '60s. Most of her money went to Roger's children and to research on Parkinson's.
356 **very deep with me:** MB-W, letter to Henry Luce, 8/8/58, B-W Col.
356 **triumph of surgery:** *Portrait*, p. 382. On her speech, see letter from MB-W to Dr. Robert McGrath, 12/1/61, B-W Col.
356 **as much as five years:** Jack Hofkosh, interview, 5/31/83.
357 **a profound experience:** MB-W, letter to Walter Reagles, 7/31/59, B-W Col.
357 **sense some human values:** Joseph Liss, notes from taped interview with MB-W, 1959.
357 **Mexican woman . . . Shigeko Sasamori:** MB-W, manuscript for the book she was working on when she died, ch. 11, 9/9/68, B-W Col.
358 **most of the time I don't:** Shigeko Sasamori, interview, 1/21/83.

358 a luminousness: Joseph Wershba, interview, 8/24/82.

358 in the whole room: Barbara Morgan, interview, 7/22/82.

358 We're going to *dance:* Joseph Wershba, interview, 8/24/82.

358 almost broke your heart: Betty Cronander, interview, 1/17/83.

359 beautiful woman she was: Norman Cousins, interview, 4/16/82, telephone.

359 looking forward to it: MB-W, letter to Ruth Lester, 11/7/68, possession of Ruth Lester.

359 embarrassing to be with her: Sean Callahan, interview, 1/14/82.

359 believe just the opposite: Myrle Morgan, letter to Roger and Mike White, 6/18/69, B-W Col., printed by permission of Myrle Morgan.

359 one of the rare ones: Jack Hofkosh, interview, 5/3/83.

359 to be our salvation: Joseph White, letter to Minnie Bourke, 1/7/98, possession of Roger White.

360 growth and development: MB-W, in Roy Newquist, *Counterpoint* (New York: Rand McNally & Company, 1964), p. 63.

360 stick by what she had done: Anne White, interview, 12/8/81.

361 if good: MB-W, handwritten notes for *Portrait*, n.d., B-W Col.

361 thoroughly thought out: MB-W, "Off the Tape Comments," Joseph Liss Collection, Boston University, Mugar Memorial Library.

361 the work that counts: MB-W, notes, n.d., B-W Col.

Postscript

364 superficial: Jonathan Green, *American Photography* (New York: Harry N. Abrams, Inc., 1984), p. 41.

364 ambiguity: Anne Wilkes Tucker in *Observations, Untitled* 35 (The Friends of Photography), 1984, p. 47. See also Stott, *Documentary Expression*, pp. 216–28.

Selected Bibliography

A fairly extensive bibliography, especially useful for dates of *Fortune* and *Life* articles, was compiled by Theodore M. Brown in Sean Callahan, *The Photographs of Margaret Bourke-White* (New York, Bonanza Books, n.d.).

Frequently cited titles and picture sources:

Allen, Frederick Lewis. *Only Yesterday* (New York: Harper & Brothers, 1931).

———. *Since Yesterday* (New York: Harper & Brothers, 1940).

"American Aces: Margaret Bourke-White," *U.S. Camera*, May 1940.

Arlen, Michael J. "Green Days and Photojournalism, and the Old Man in the Room," *Atlantic*, August 1972.

Belth, Nathan C. *A Promise to Keep* (New York: Times Books, 1979).

Bourke-White, Margaret. *Eyes on Russia* (New York: Simon & Schuster, 1931).

———. *Dear Fatherland, Rest Quietly* (New York: Simon & Schuster, 1946).

———. *Halfway to Freedom* (New York: Simon & Schuster, 1949).

———. *Portrait of Myself* (New York: Simon & Schuster, 1963).

———. *Shooting the Russian War* (New York: Simon & Schuster, 1942).

———. *They Called It "Purple Heart Valley"* (New York: Simon & Schuster, 1944).

———. *U.S.S.R. Photographs* (New York: Argus Press, 1934. Portfolio).

Brown, Theodore M. *Margaret Bourke-White, Photojournalist* (Ithaca, N.Y.: Andrew Dickson White Museum of Art, Cornell University, 1972).

Caldwell, Erskine. *Call It Experience* (New York: Duell, Sloan and Pearce, 1951).

Caldwell, Erskine, and Bourke-White, Margaret. *North of the Danube* (New York: The Viking Press, 1939).

———. *Russia at War* (London: Hutchinson and Co., n.d.).

———. *Say, is this the U.S.A.* (New York: Duell, Sloan and Pearce, 1941).

———. *You Have Seen Their Faces* (New York: The Viking Press, 1937).

Collins, Larry, and Lapierre, Dominique. *Freedom at Midnight* (New York: Avon, 1976).

Cowley, Malcolm. *And I Worked at the Writer's Trade* (New York: The Viking Press, 1978).

———. *The Dream of the Golden Mountains: Remembering the 1930's* (New York: The Viking Press, 1980).

Edey, Maitland. *Great Photographic Essays from Life* (Boston: New York Graphic Society, 1978).

Elson, Robert T. *Time Inc., The Intimate History of a Publishing Enterprise,* Vol. 1: 1923–1941 (New York: Atheneum, 1968).

———. *The World of Time Inc., The Intimate History of a Publishing Enterprise,* Vol. 2: 1941–1960 (New York: Atheneum, 1973).

Green, Maurice R. (ed.). *Interpersonal Analysis: The Selected Papers of Clara M. Thompson* (New York: Basic Books, 1964).

Himber, Charlotte. *Famous in their Twenties* (New York: Association Press, 1942).

Kirkland, Winifred and Frances. *Girls Who Became Artists* (New York: Harper & Brothers, 1934).

Korges, James. *Erskine Caldwell* (Minneapolis: University of Minnesota Press, 1969).

LaFarge, John, and Bourke-White, Margaret. *A Report on the American Jesuits* (New York: Farrar, Straus and Cudahy, 1956).

Leuchtenberg, William E. *The Perils of Prosperity, 1914 to 1932* (Chicago: The University of Chicago Press, 1958).

Mabie, Janet. "Snapshotting a Snapshotter," *Christian Science Monitor*, weekly magazine section, September 25, 1935.

Margaret Bourke-White, The Cleveland Years, 1927–1930 (Cleveland: The New Gallery of Contemporary Art, May 8 to June 5, 1976).

Mott, Frank Luther. *American Journalism* (New York: The Macmillan Company, 1950).

Nall, T. Otto. "The Camera Is a Candid Machine: An Interview with Margaret Bourke-White," *Scholastic*, May 15, 1937.

Reilly, Rosa. "Why Margaret Bourke-White Is at the Top," *Popular Photography*, July 1937.

Schlesinger, Arthur M., Jr. *The Crisis of the Old Order* (Boston: Houghton Mifflin, 1957).

Silverman, Jonathan. *For the World to See: The Life of Margaret Bourke-White* (New York: The Viking Press, 1983).

Stott, William. *Documentary Expression and Thirties America* (New York: Oxford University Press, 1973).

Sutton, William. *Black Like It Is/Was: Erskine Caldwell's Treatment of Racial Themes* (Metuchen, N.J.: The Scarecrow Press, 1974).

Toland, John. *Adolf Hitler* (Garden City, N.Y.: Doubleday & Company, 1976).

———. *The Last 100 Days* (New York: Random House, 1965).

Wainwright, Loudon. "Life Begins: The birth of the late, great picture magazine," *Atlantic Monthly*, May 1978.

Writing for Fortune (New York: Time Inc., 1980).

Index